Edouard
Manet

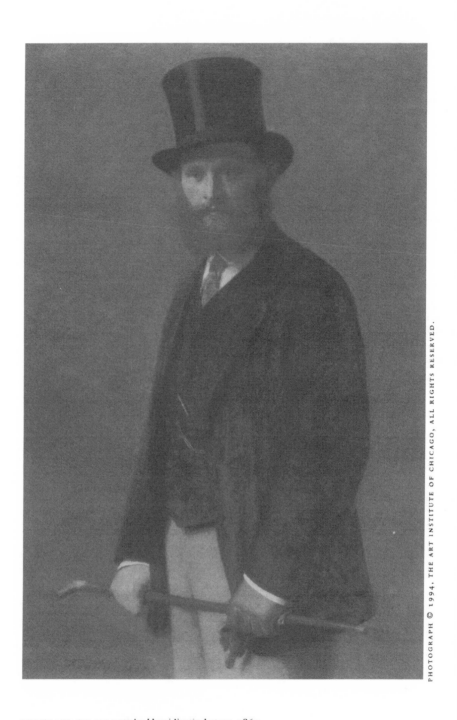

PORTRAIT OF MANET by Henri Fantin-Latour, 1867.

Oil on canvas, 117.5 x 90 cm. *Art Institute of Chicago, Stickney Fund, 1905.207.*

Edouard Manet

Rebel in a Frock Coat

BETH ARCHER BROMBERT

THE UNIVERSITY OF CHICAGO PRESS

Also by Beth Archer Brombert

Cristina: Portraits of a Princess
A Concert of Hells (novel)
The Voice of Things (editor and translator of
 works by Frances Ponge)

Excerpts from *Degas* by Henri Loyrette. Copyright © 1991 by Librairie Artheme Fayard. By permission of the publisher.

Excerpts from *Manet et ses oeuvres* by A. Tabarant. Copyright © 1947 by Editions Gallimard. By permisson of the publisher.

Excerpts from *Souvenirs d'un marchand de tableaux* by Ambroise Vollard. Copyright © 1937 by Editions Albin Michel. By permission of the publisher.

Published by arrangement with Little, Brown & Company

The University of Chicago Press, Chicago 60637
The University of Chicago Press, Ltd., London
Copyright © 1996 by Beth Archer Brombert
All rights reserved. Originally published 1996
University of Chicago Press Edition 1997
Printed in the United States of America
03 02 01 00 99 98 97 6 5 4 3 2 1

Library of Congress Cataloging-in-Publication Data

Brombert, Beth Archer.
 Edouard Manet : rebel in a frock coat / Beth Archer Brombert.
 p. cm.
 Originally published: Boston : Little, Brown, c1996.
 Includes index.
 ISBN 0-226-07544-3 (pbk. : alk. paper)
 1. Manet, Edouard, 1832–1883. 2. Painters—France—Biography.
 I. Title.
 [ND553.M3B76 1997]
 759.4
 [B]—DC21 97-3321
 CIP

For Victor

Könnt'ich dich in Liedern preisen,
Säng'ich dir das längste Lied,
Ja, ich würd'in allen Weisen,
Dich zu singen nimmer müd!

— Justinus Kerner

For Neva

In Memoriam

Nobody . . . ought to read poetry, or look at pictures or statues, who cannot find a great deal more in them than the poet or artist has actually expressed.

— Nathaniel Hawthorne
The Marble Faun

You can be sure that a painter reveals himself in his work as much as and more than a writer does in his.

— Denis Diderot
Salons

Contents

List of Illustrations

At the end of 1874, when Edouard Manet's name had gained wider notoriety than fame, a friend wrote to tell him about the bookplate he had devised for him: "It is your bust on a pedestal with the motto *Manet et manebit,* which in Latin plays on your name, meaning *he remains,* and in the future *manebit, he will remain.*"[1] There is no doubt that he has.

Many critics see Manet as the great dividing line between traditional art and modern art, as an historic event that changed both artists and viewers. There is a *Before* Manet and an *After* Manet. André Malraux spoke of him as one does of a political or religious leader: "In order for the pictorial tradition to be sundered, as was the literary tradition by the great poets of the nineteenth century, it was necessary to await Manet."[2] He may have been willing to consider himself a rebel, but he would have been horrified to hear himself called a revolutionary. Yet it was he who radically altered the way reality was represented. His contribution to the development of modern art can be seen graphically in the arrangement of the recently installed galleries of nineteenth-century European painting at the Metropolitan Museum of Art. His paintings occupy the entire central gallery through which the visitor passes, from the neoclassicism of Ingres and the romanticism of Delacroix that preceded Manet, to the impressionism, fauvism, and symbolism that followed him, abutted at either end by Courbet's realism.

Today Manet's paintings no longer shock museumgoers, but their

originality is still apparent, their compelling quality continues to arrest the gaze from far away. Manet cannot be confused with any of his contemporaries. In 1870 a contemporary critic, Edmond Duranty, noted, "In any exhibition, at a distance of 200 paces, there is only one painting that stands apart from the others; it is always a painting by Manet."[3] Repeatedly discouraged, Manet never stopped betting on the future. "Those who live in the next century," he said, "will see better."[4]

Many of Manet's contemporaries won prizes, received public and private commissions, and were enshrined in museums within their lifetime — honors that for the most part eluded Manet in his; most have been forgotten by all but a few doctoral candidates in art history. Even so, Manet was hailed in his day as the leader of a new school of painting. It was his vision of reality that launched the concept of modernism and the style that came to be known as impressionism. Once viewers' eyes became accustomed to this "new painting," his works had an immediate appeal, however little they were understood.

Understanding Manet has been the least concern of critics for much of the century since his death. It was enough to analyze his uniqueness in terms of color patches and the use of black and to identify his sources, all of which are undeniably important. Kenneth Clark in 1958 challenged the prevailing view of art as "an activity which can be studied in isolation" from a painter's thoughts.[5] To look for meaning in Manet was as irrelevant as looking for a program in the music of Bach. A key to the nature of Manet's art — a key largely left unturned, or at least not turned far enough — was inadvertently provided by Baudelaire: "What is the modern concept of pure art? It is the creation of a suggestive magic, containing at the same time the object and the subject, the world outside the artist and the artist himself."[6]

It was Zola's contention that when Manet "groups together several objects or several figures, he is only guided in his choice by the desire to achieve beautiful patches [of color], beautiful contrasts," that if he places a nude woman in Le Déjeuner sur l'herbe, she "is only there to provide the artist with an occasion to paint a little flesh."[7] A number of art historians over the past two decades have become interested in other aspects of Manet's art. A sizable literature now exists on Manet's Paris; on his sources, technique, light, and palette; and more

recently on the historical, social, and political context of his paintings. But little attempt has been made to relate Manet's works to his personal views or sentiments.

Zola and generations of critics after him defined Manet negatively: he has no interest in beauty, subject, or emotion; composition does not exist for him; he does not set himself the task of representing a thought or an event; he has no imagination; he has no sense of perspective; he cannot work without models, be they live, old master paintings, or photographs; his works make no reference to anything else and are merely a kind of activity. "He painted the way a child plays, joyfully. Nothing preconceived, nothing deliberate," wrote one, reducing Manet to a kind of Grandpa Moses, his gifts of eye and hand seemingly all he had. "If Manet has taken his place among the masters of our times, it is because nature endowed him with the most amazing pictorial instinct. . . . This man was an artisan of genius."[8] And yet he was called upon to join the realists, rally the naturalists, and lead the impressionists, until it was seen that in fact he had disappointed the first by not following their ideology, the second by not observing their subjects, and the third by not adhering to their technique.

As a man, he has been variously described as hungry for official recognition, a superficial dandy, an unrepentant bourgeois who could indulge his frivolous tastes because of a private income — unlike "genuine" artists, whose limited resources went into the materials of their art — a man without ideas, social consciousness, or political commitment, who even when he chose a subject of contemporary significance remained outside it, a detached observer, amoral, apolitical.

Among the many paradoxes that characterize Manet, the first is the notion handed down by his boyhood friend and classmate Antonin Proust that he was not a reader, which came to mean he had little culture outside the visual arts. Curious, then, that some of his closest friends were writers, men like Baudelaire, Zola, and Mallarmé, who would hardly have spent hours with him almost every day if he had nothing between his ears but a pair of eyes. "What do you think an artist is?" Picasso once testily asked. "An imbecile who has only eyes if he is a painter, ears if he is a musician, a lyre in every chamber of his heart if he is a poet, or even, if he is a boxer, only a few muscles? Quite the contrary, he is at the same time a political being

constantly alert to the horrifying, passionate, or pleasing events in the world, shaping himself completely in their image."[9]

Manet, presumed by various critics to have been motivated by "pure instinct" and to have painted pictures that were a "pure problem of color," was in the daily company of poets, novelists, journalists, and art critics at a time when all forms of art were a serious matter, when late afternoons were spent in cafés loudly discussing theories of art, social reform, and political dissension. In Manet's day, the front pages of leading Paris newspapers were filled with articles on art exhibitions, and writers such as Gautier, Baudelaire, and Zola were commissioned to do entire series of articles on the works shown in that year's official exhibition. An intellectual primitive, however polished his boots or tall his top hat, would not have been tolerated beyond a first encounter.

When Manet began painting in his twenties, the nineteenth century was in its fifties. During that half century, France and much of Europe had changed more radically than over the preceding half millennium. The old values, laid down by church, state, and society, had been repeatedly challenged by a sequence of revolutions and counter-revolutions in France: the Revolution of 1789, the Terror of 1793, the coronation of a revolutionary general as emperor of France in 1804 and his defeat at Waterloo in 1815, the subsequent restoration of two reactionary monarchs, the "Three Glorious Days" of 1830 that inaugurated France's first constitutional monarchy, the revolution of 1848 that ushered in the Second Republic, the coup d'état staged by its elected president, Louis-Napoleon Bonaparte, nephew of the first emperor, who in 1852 crowned himself Napoleon III, emperor of the French.

An unimaginable world had evolved during those years. Trains had changed the concept of speed, not accelerated since a horse was first mounted. Industrial machines had changed the concept of time, until then counted in hours of manual labor. Streets were now illuminated at night and patrolled by police, giving rise to a nocturnal public life. A prosperous middle class dictated taste and entertainment. Women were gaining recognition as creative, educated, independent beings, and a new class of kept women, demimondaines, rivaled so-called respectable women in elegance and in the celebrity of the guests who attended their receptions. The betterment of humanity was a growing concern, and wealth, not birth, was a mark of an individual's impor-

tance. The old images of gods and heroes were no longer representative of this new world. Baudelaire saw poetry in the frock coat, and Manet saw artistic subjects in quotidian poses. He wanted to break away from the theatrical gestures and historical subjects of classical painting and depict real people. Beggars and gypsies could evoke ancient philosophers. Prostitutes could portray ancient goddesses or biblical maidens. To the literal-minded viewer they were ordinary people, which was disconcerting. In a society accustomed to the sanctified figures of academic art, these figures from daily life could not be regarded as aesthetic, let alone inspirational.

Despite his innovative ideas, Manet was neither a social radical nor a cultural revolutionary. He was rooted in classical culture, and when he quoted from his illustrious predecessors it was not to be irreverent. As Meyer Shapiro so aptly observed, "An original modern painter might find in the old examples not just a lesson in form or the logic of a composition, but the conception of the subject, the posture of the individual figure, and in the allusion to that art of the museums, a mask for meanings in his own work — a mask that adds to the ambiguity of the whole."[10] However, Manet was so depersonalized by his critics that his wit, intelligence, intentions, even his ambiguities were swept aside in favor of a technical appreciation of his work.

Among the fascinations Manet holds is the range of contradictions surrounding him: he longed to enhance the prestige of his name and social position by pursuing the least bourgeois of professions; he hungered for critical and popular success but refused to yield to the taste of the day; he was the leader of a new school who dissociated himself from it as soon as it gained cohesion; he was a man of public diversions and the most private of lives; as a painter he was vilified for lacking feeling and imagination and even accused of plagiarism. Nevertheless, a few critics within his own lifetime considered him one of the greatest painters of the day, and in our time his position in nineteenth-century art is undisputed, though often for contradictory reasons.

Two irrefutable facts remain: Manet's paintings continue to fascinate; his work and his life continue to mystify, which may account for some of the fascination. No matter how swollen the Manet bibliography, some of the enigmas will doubtless persist, since no single explanation can unravel the complexities of this man and his genius. But a new tack might lead us to less traveled waters, offering us glimpses of

the man behind the easel and fresh views of his works through the sensibility of the man.

The provocative writer Georges Bataille, in his 1955 monograph — a rare foray into art criticism — saw Manet divorced both from his work and from his personality, on the one hand elegant and self-assured, on the other hesitant and impulsive. To Bataille this demonstrates instability. "But this instability," he explains, "is well suited to the impersonal nature of the risk, the only risk Manet took in a life that was entirely impersonal. Manet was somewhat superficial, but he was driven, obsessed with a goal that overwhelmed him, that left him unfulfilled, exhausted, that he understood with difficulty, and that was surely beyond him." The language is more poetic than Zola's, conveying the romantic image of the artist possessed by a demonic urge, but even so, in Bataille's view, Manet remains a kind of automaton, lacking intention, intellect, and even imagination ("Manet n'avait pas d'imagination").[11] This view is no more satisfactory than Zola's. The intensity of Manet's portraits, the mystery of his group pictures, his choice of subjects, even the poignancy of his flower still lifes are hardly characteristic of aloofness or impersonality, and even less of pure happenstance. Something of the man has to be in the painter, a man more complex than the one presented by previous writers. How could the life of so dynamic a personality be so irrelevant to his lifework?

It was this unanswered question that led me to think about attempting a biography of Manet. My research for a previous biography of a nineteenth-century figure placed my interests in that period. I was already familiar with the world of Manet, but it was *The Fifer* that first drew me to his painting many years ago. Apart from its technical brilliance, I was struck, and still am, by the powerful emotional response it elicits. Free of any sentimentality, it conveys to me a sense of the fragility of youth and the horror of war. My conviction of Manet's disturbing originality was intensified by the retrospective exhibition of his works in 1983, as was my desire to understand what makes him so compelling. Surely it had to be more than color and form.

It is said that he who would learn must teach, or, in this case, must write. Fired by the passion of the art lover, I have looked long and hard at Manet's paintings and pored over published works and manuscript documents, using the methods of the historian, the literary critic, and the sleuth. I have approached Manet with the assumption

that behind his artistic production lay a complex individual who, like most artists of every genre, inevitably inserted himself into his art, if only in the cryptography of dream language. I have tried to look at his paintings as a synthesis of the man's experiences and the artist's vision.

A professional art historian once ruefully commented to me that art historians have tended to shut out the nonprofessional, as though art history were a cult to be shared only by the few priests who serve it. It is in large part to nonprofessionals that this book is addressed. By bringing the painter into a closer relationship with his paintings, I hope to enhance the pleasure Manet's works have already given modern audiences.

It is also my hope that art critics and art historians will find something new and valid in this biography, which has so richly benefited from their labors. The intention of this book is to add to the existing literature, not to substitute for or detract from it.

Twelve noon. The bells toll as mourners enter the church of Saint-Louis d'Antin on the rue Caumartin. The third of May, the loveliest month in Paris. A spring day, too mild for the winter-weight black serge frock coats or the black gowns buttoned to the chin, black veils cutting off air in their descent from wide-brimmed hats. The streets are lined with people, as though waiting for admission to the opening day of the Salon, but the mood is somber. Silent crowds stand waiting, stretched above the tracks of the Gare Saint-Lazare like a thick black cord, from one end of the rue de Saint-Pétersbourg to the other — from the Pont de l'Europe, past the windows of his studio on the corner, to the Place Clichy, passing in front of his apartment on the other side of the street farther up. The procession finally emerges from the church led by the two brothers, Eugène and Gustave, and their cousin, Jules De Jouy. The pallbearers are Antonin Proust, Claude Monet, Emile Zola, Philippe Burty, Alfred Stevens, and Théodore Duret. They are followed by the widow, the mother, the sister-in-law, other members of the family, and a horde of grieving friends. The procession continues south and west to the rise behind the Trocadéro, where a small cemetery nestles below old trees. From an upper-story window one would see the Seine shimmering below. After proceeding along the cemetery's main avenue and turning left, the troop halts beside an open grave near the intersection. A breeze blows up from the river rustling the new leaves of the horse chestnuts, heavy with clusters of white blossoms. It is a tiny plot, three feet by six. But it is enough for the mortal remains of Edouard Manet. A gray granite headstone will bear his name and dates. No more. No mention of what he did. Not even a cross. But a bust of him will be sculpted by his brother-in-law and placed above the headstone.

Over the next decade, he will be joined first by his brother Eugène, then by his sister-in-law Berthe, and long after by his wife.

Antonin Proust steps forward.

"It is with deep feeling that I speak over this grave that carries away a master of French art and in the same moment separates us from a devoted friend.

"Our friendship dates from our schooldays, and that friendship remained so steadfast that no one better than I can offer sincere homage to that man of heart and talent whose wit was so French and whose goodness was always inexhaustible.

"Manet revealed himself from the very beginning. At the outset, in fact, he shook off traditions that were too observant of the cult of things past. I would like to retrace the life of Manet and recount his long and painful struggle during which he manifested a courage that nothing managed to daunt. But that, I confess, would be impossible for me to do. What I do want to say is that those great qualities of heart and mind were present both in the artist and in the man. His talent, if not always even, always held the mark of a master. No one more than Manet delighted in the successes of those who followed his example.

"However tenacious artistic prejudices may be, it is nonetheless astonishing that works like Boy with a Sword did not go immediately into public collections. We hope to see them there soon. I have been told that by giving Manet the Legion of Honor, I accomplished an act of courage. That is a mistake. What I did was only an act of reparation.

"The injustice of the critics destroyed Manet's life, despite his great courage. Along with an unfinished lifework, he leaves a wife and a son who, during the long hours of his agony, demonstrated their admirable devotion.

"Sleep in peace, my friend, we will not fail to keep the oath we solemnly take over your grave to watch over those you leave behind. Adieu, Manet. Adieu."[1]

Edouard Manet

A Manet an Artist?

Nothing in Edouard Manet's background can account for his singular talent. Descended from eight generations of recorded landowners in the countryside northwest of Paris, his father, like his father before him, had been schooled in law at the University of Paris. Clément Manet, Edouard's grandfather, who died in 1814 at the age of fifty, had for years been the enterprising and respected mayor of Gennevilliers, where the family's property lay, and before that a member of the Parisian judiciary. Clément's son, Auguste, followed in his footsteps, moving from legal clerk, after receiving his diploma in 1821, to supervisor of personnel at the Ministry of Justice seven years later, to a judgeship in a lower court. Proof of his achievements was the coveted red ribbon he wore in his lapel as a chevalier in the Legion of Honor, awarded two days after the birth of his first child. Auguste Manet wore the mantle of centuries-old respectability with appropriate seriousness. He upheld the traditions of his class, was soberly dressed by good tailors, made a proper marriage to a young woman with an inheritance, lived with all the solid, understated comforts of a prosperous Parisian, and sired three sons, who were expected to carry on in much the same way. The major responsibility would, of course, fall to Edouard, the firstborn.

Edouard's mother, Eugénie-Désirée Fournier, as wellborn as her husband, came from less predictable stock. Her father, Joseph, who had made and lost a fortune in an import-export business in Sweden, was still residing there when a successor to its throne was being sought because the heir presumptive died unexpectedly in 1810. Since

no other suitable candidate could be found among Swedish royalty, the emperor of France, Napoleon I, was consulted. Although he did not pronounce himself officially, he did give the nod to one of his generals, Jean Baptiste Bernadotte, at that time a marshal of France and governor of the German electorate of Hannover. Joseph Fournier's incredible brashness and diplomatic skill contributed in 1810 to the adoption of Bernadotte as crown prince and in 1818 to his coronation as King Charles XIV of Sweden. Despite his successful intervention, Fournier was not the kind of courtier the king of Sweden wanted attached to his name or person. Passing himself off as spokesman for the emperor in the absence of the French chargé d'affaires, Fournier had managed to convince the Swedish electors that Bernadotte was the only choice France would consider. Subsequently scorned in official reports as a person of no rank, no consequence, and no official function, Fournier appears to have been appointed French vice-consul to Sweden after Bernadotte became crown prince.

When Eugénie was born in 1811, the third child and only daughter, her father asked the new crown prince to be her godfather. His gift to his godchild was a less than regal coral necklace, a parsimony redeemed when Eugénie became a bride and he gave her six shares transferred out of his personal investments, a cash gift of six thousand francs, and an elaborate ormolu clock. On the death of her father in 1824, Eugénie and her only surviving brother, Edmond, became heirs to Marolles, a property in the Ile-de-France. At the time of her marriage, on January 18, 1831, to Auguste Manet, a man fourteen years her senior, Eugénie thus had a respectable dowry. One year and five days later, at seven in the evening, Edouard was born in an imposing building still standing at 5, rue Bonaparte, then called rue des Petits-Augustins, on the Left Bank close to the Seine. A stone portal leads to a large courtyard surrounded by the three sides of this four-story apartment house, a fit residence for an upper-middle-class family, even though it stands opposite the Ecole des Beaux-Arts, famous for its indecorous students and their indecent costume balls. Other members of the Manet-Fournier family also lived there, including the relative closest to Edouard in his boyhood, Edmond Fournier, his maternal uncle, godfather, and first artistic mentor.

Edmond Edouard Fournier, born in 1800, was less than four years younger than his brother-in-law, but a generation younger in spirit. Rotund, a cheerful sensualist, outgoing, and affectionate, with a

Vandyke beard and a dapper wardrobe, Edmond also had an eye for art and a talent for drawing. A career officer in the artillery, he was a captain at the time of Edouard's birth and a colonel by the time he resigned. After the revolution of 1848 Fournier felt it would be a betrayal to serve the government that had toppled his sovereign, Louis-Philippe. Auguste Manet, opposed to Louis-Philippe or any other monarch, did not see eye to eye with him in this matter as in much else. He felt so strongly that Edmond should remain in the army and serve the new republic that a rift ensued — later worsened by a quarrel over his mother-in-law's estate — which was never to be healed. After 1851 Auguste never spoke to Edmond.

From 1828 to 1841 Auguste served in the personnel division of the Ministry of Justice, rising from supervisor to chief of personnel, whose duty it was to assemble the files of prospective judges in the Department of the Seine. His salary was then twelve thousand francs.* When in 1841 the minister of justice resigned and his section heads resigned with him, Auguste was appointed judge of the Court of the First Instance, a trial court for the Department of the Seine that heard both civil and criminal cases. Within less than a year, Auguste permanently left the criminal court for the civil court, which heard paternity suits, contested wills, conjugal separations, and the like. For Auguste this was a sinecure; as a judge he was tenured for life. And for a man with little ambition and little fondness for the government of Louis-Philippe, this was the perfect position. A more ambitious man of Auguste's experience might not have been content to remain in that post, for he might reasonably have risen all the way to the appellate court. But this lower court was a safe, secure, apolitical appointment; he could maintain a low profile and his rigorous habits. It also paid the handsome annual salary of twenty thousand francs.

Auguste had kept his distance from his colleagues at the Ministry of Justice — which was not the way up the hierarchical ladder — rarely if ever receiving them at his home. A moderate republican under the constitutional monarchy that was to end in 1848, he separated his professional life from his social life, sharing his political

*At that time a skilled worker made less than fifteen hundred francs a year, a museum curator made up to five thousand; ten thousand francs was a good middle-class salary.

views only with close friends. Although his was not a particularly extreme position — Louis-Philippe had become the subject of public caricature as a traitor to his earlier liberal principles — republicanism was doubtless suspect in official circles. Auguste, in any case, could afford to think and act independently. His considerable revenues, from salary, leased property, investments, and his wife's inheritance, placed him in a very comfortable situation. Translated into present buying power, his income would have been in excess of two hundred thousand dollars, in view of the low cost of domestic help and foodstuffs from the family's property.

Here was a man who in many ways typified his class and station, an upper-class civil servant, with the limitations that vocation implies, who understood life as duty, order, family tradition, and the esteem of one's peers. Even his peccadilloes were ones he shared with many of his equals: he regarded artists as bohemians and bohemians as contemptible, but his well-shod feet had not infrequently crossed the threshold of bordellos. One can imagine him taking the same route every day for years from his apartment on the rue des Petits-Augustins, across the Seine to his office at the ministry on the rue Cambon, without raising his eyes to notice the change of colors in the Tuileries gardens. Summer holidays were generally spent at the Manet family's ancestral property downriver at Gennevilliers, then fertile wooded countryside, now a Métro stop for a working-class suburb of Paris. The company Auguste received twice weekly was anything but frivolous: law professors, a few enlightened clerics, and the translator of Sir Walter Scott, Defauconpret by name, who headed the Collège Rollin, a private school for upper-class boys situated behind the Panthéon.

Less is known about Eugénie Manet, although she outlived her husband by twenty-three years. She had enough musical training to sing at even more fashionable gatherings than those held at her home. And she seems to have been as affectionate as her husband was stern. As often happened at that time, this was not a marriage made in heaven. At thirty-four, Auguste decided it was time to produce heirs. How he found Eugénie is not known, but she probably had little to say in the matter. She was twenty years old, convent bred, and in no position to choose a husband. Another might have been worse. In this, as in most events of her life, she had to yield to superior forces. If anything sweetened her life, it was surely the attachment of her firstborn child.

There is little doubt that Edouard's artistic temperament and charm came from Fournier genes. But the Manet side gave him a sense of his own worth, a capacity for digging in his heels when it mattered, and a dedication to achievement even in adversity.

When Edouard was seven, he was enrolled as a day student in a school run by a priest, Abbé Poiloup, in Vaugirard, then a municipality outside Paris, now in the fifteenth arrondissement. The boy's docile manner disarmed his teachers, so that serious complaints about his meager progress did not reach his father at first. Five years later, now ready for a secondary education,* Edouard was sent off to the Collège Rollin, whose headmaster, Monsieur Defauconpret, had so often dined at the Manet table. Forty-five state lycées had been founded in 1802 and under Napoleon I provided the best possible preparation for liberal professions. However, since sixty-four hundred scholarships were granted, upper-class families were unwilling to have their sons rub elbows with scholarship boys. It was said at the time that the emperor would have found it easier to send a hundred thousand more conscripts to the battlefield than to convince such families to send a thousand more students to his lycées.

Like almost all the other students at the Collège Rollin — though within walking distance of his home — Edouard was one of four hundred boarders.[1] Thursdays and Sundays were spent at home. The school, though private, imposed the same demanding curriculum as the great public lycées: physics and chemistry, natural history, mathematics, history, philosophy, Greek and Latin, rhetoric (which covered French literature and grammar), English or German (the latter apparently much less popular). All students throughout France, on completion of the final year, were expected to have covered the same program. Those who went on to university faculties (law, medicine, humanities) or special training (engineering, teaching above the elementary level) also had to pass the feared national examination for the *baccalauréat,* commonly known as the *bachot.* However uniform and democratic the intention of French education according to the

*In the French system, elementary school begins with the twelfth grade; secondary school, whether a public lycée or private collège, starts with the fifth grade. In the nineteenth century the final year was called *rhétorique;* it is now called *première,* first grade.

Napoleonic Code, it was not necessarily of equal quality, despite the yearly inspections of all schools, public and private. The observation of the inspector who visited the Collège Rollin in 1847 is very revealing, both of the school and of the political viewpoint of the writer: "In the teaching of rhetoric at the Collège Rollin, particularly in the upper classes, there is a certain sluggishness that is largely attributable to the composition of the student body, almost all of whom come from rich families and thus think themselves exempted from work." *

The new school proved to be no more motivating than the last. In fact at the end of his first academic year, Edouard was not promoted and had to repeat fifth grade. During that first year at Rollin he met another new boy, Antonin Proust (unrelated to Marcel Proust), who remained a close friend for life and whose reminiscences provide many of the details of Manet's life. Edouard longed to be back home. He missed his mother, his brothers, his comforts, and the evenings beside his Uncle Edmond, who often had a sketch pad open and whose rapid drawings — a skill fairly common among army officers in those days before cameras — delighted Edouard. Before long Edouard was filling his notebooks with sketches of his classmates instead of class notes.

The setting of a private collège or public lycée was indistinguishable; both suffered from a long tradition of austerity that flourished into the twentieth century. Most schoolchildren took for granted the chill grimness of their surroundings, but for a boy with an eye like Edouard's, it must have been a daily torment. Formerly an Augustinian convent, where under the ancien régime young girls were sent into claustration by their families, the building had lost none of its forbidding severity. As described by Antonin Proust, the classrooms were poorly lit, the classes overcrowded, the seats and desks cramped, the walls bare of even a map.

There were few pleasures for Edouard during the school week. One was the company of Antonin Proust, who shared the same upper-class Parisian background (his was even more distinguished and affluent than Edouard's). The other was gymnastics, at which

*Rhetoric, as of 1821, comprised the translation of Latin and Greek prose into French, composition in Latin and French, and Latin poetry. By the time Edouard was a student, it also included modern languages and history.

Edouard was "singularly proficient," according to his friend. The most eagerly awaited moments were the biweekly reprieves from confinement on Thursday and Sunday. Uncle Edmond often took Edouard and Antonin to one of the museums in the city. Since his own son was so little drawn to art, Edmond was as delighted by these visits as the two boys, both of whom were deeply interested in painting.

At that time, in addition to the Louvre's great collections, the Musée du Luxembourg exhibited works by living artists bought by the state, and the Pourtalès Gallery of the Louvre held an impressive number of Spanish paintings. This Spanish collection (commonly known as the Spanish Museum) consisted of works secretly purchased for King Louis-Philippe in the mid-1830s, when Spain was embroiled in a civil war over a daughter's right of accession to the throne. Louis-Philippe allocated more than a million francs to this enterprise, which he placed in the hands of Baron Taylor, a noted authority on Spanish art. Taylor bought about four hundred canvases, only some of them masterworks, and the collection was officially opened to the public in 1838. Four years later an English collector, Frank Hall Standish, bequeathed his important collection of Spanish works to the French king, who by then owned around five hundred paintings, among them eight Goyas, nine El Grecos, twenty-five Riberas, thirty-eight Murillos, and eighty-one Zurbaráns, according to official records. A younger contemporary of Manet's, painter Jules Breton, remembered fifty years later the shudder of fear and pleasure those strange works had given him as a boy: "It has remained with me like a dream filled with terrifying mystery, wild ecstasy, pious blackness and flashing brightness."[2]

It is interesting to note the difference between Breton's vision of Spanish painting and Manet's. Breton was evidently struck by the somber religious works of Zurbarán and others, whose awesome monks, bleeding Christs, and mutilated martyrs reflected the violent mysticism of the Spanish church. In contrast, Manet seems to have been drawn initially to Goya's stark figures and dramatic use of black as a color and above all to Velázquez — his unprettified portraits, his awareness of himself as artist, his demonstration that what the canvas mirrors is not so much reality as the artifice of the artist. Manet's single visit to Spain, in 1865, confirmed his youthful attraction to the artist he considered "the greatest painter there ever was."

Spain had long fired the French imagination. Every schoolboy had

read Cervantes' *Don Quixote*, ever since its first French translation in the mid-seventeenth century. And even young adolescents, trained by a more demanding school program than we can imagine today, were not insensitive to the more serious side of Don Quixote. Aside from his pathetic and often hilarious adventures, he represented tragic idealism in a corrupt world and the need for realism to survive in it — a prototype for modern literature's antihero. This grotesque figure, mocking the popular image of Spanish chivalry, clearly left its mark on Edouard the schoolboy; he would reappear in the artistic imagination of Manet the man. Other influences from Spain also had entered the canon of French literature: Don Juan, first portrayed in a drama by Tirso de Molina in 1630, was taken up by Molière thirty-five years later; in 1637 Corneille centered his most successful tragedy — required reading well into the twentieth century — on Spain's legendary hero, El Cid; Lesage's picaresque novel of 1715–35, *The Adventures of Gil Blas,* set in Spain, has long been regarded as a forerunner of the modern European novel. Gil Blas would reappear in Manet's adult work. In the nineteenth century the romantic imagination would be inflamed by the Spanish heroes, heroines, and settings of Hugo's *Hernani* and *Ruy Blas,* Mérimée's *Carmen,* Gautier's *Tra los montes,* Musset's *Contes d'Espagne* — the list goes on.

It is not an exaggeration to stress the importance of Spain in the collective imagination of nineteenth-century France. When Edouard saw Spanish paintings for the first time, there was already a cultural context for them — a very different phenomenon from the discovery of Japanese prints by French artists of his generation or of African masks later on. In this light Baudelaire's defensive letter of 1864 to an art critic who accused Manet of copying Spanish painters was either a joke on the critic (quite in character for Baudelaire) or an example of reckless good intentions: "At the time when we were enjoying that marvelous Spanish Museum, which the stupid French Republic, in its abusive respect for private property, gave back to the [royal family], M. Manet was a boy serving on board a ship."[3]

Attested by his companion Antonin Proust, Edouard regularly visited the Spanish Museum until the revolution of 1848, after which Louis-Philippe was forced to abdicate and later took his collection with him. He also was doubtless taken to another fine collection of Spanish paintings owned by Marshal Soult, minister of war, which re-

mained on view until its sale in May 1852. Edmond Fournier had personally been seeing to his nephew's artistic education for some time, not only for Edouard's edification but also because Edouard was the one member of the family with whom Edmond could share his love of art. Antonin Proust's recorded memories of outings to the Louvre in the company of Edouard and his uncle date from years prior to 1848, because after the revolution Edmond resigned his commission and moved to Poncelles, in the Parisian countryside — not only out of town but out of Edouard's life as well.

When they were all living in the same building, Edouard saw his uncle daily, but once Edmond moved away, visits were limited to the summer, when Eugénie Manet took her boys to visit her brother and his family. Those memorable afternoons looking at paintings certainly took place before Edouard boarded the ship mentioned by Baudelaire at the end of 1848. Edmond also had assumed the cost of drawing lessons when Edouard's father protested against the uselessness of such a class, offered as a supplement to the school program and thus not covered by tuition fees. It was probably less out of stinginess than out of principle that Auguste refused to pay: his first son was to enter the law, and drawing classes were no preparation for that. This myopic injunction against any artistic effort surely left its mark on Edouard and may only have encouraged his determination a few years later to devote himself to art.

As it turned out, the drawing class was not an inspiration for the future artist. In all traditional art classes, even at the level of secondary schools, students were obliged to make drawings of ancient statues after plaster models or engravings in specially prepared manuals. Edouard was excited by the idea of living models, real people, and his gift for quickly capturing what he saw was prodigious. Antonin Proust commented on the speed and accuracy with which Edouard sketched paintings during their visits to the Louvre. It was much more fun for him to draw the heads of the other boys in the class, with their cowlicks and snub noses and big ears, than to crosshatch the idealized frozen features of a Roman emperor. Naturally Edouard's classmates were incited to do the same. This cost Edouard and the others a month's suspension from drawing class — not much of a punishment, after all. By then he much preferred his gymnastics class, where he enjoyed first place.

Although Edouard had to repeat fifth grade, he seems inexplicably to have skipped the next grade, and during the following academic year of 1846–47, he was, not surprisingly, found remiss in third grade: "His work is entirely inadequate. He shows no interest in classical studies, works little, and is often distracted." In Latin he ranked forty-second out of sixty-six. However poor his reports, they were no worse than those of other students who turned out to be literary giants. Baudelaire, for instance, in second grade, was reported by his head teacher as given to "much frivolity; not very conversant with ancient languages, too lax to correct his faults."[4]

The notion of the genius as delinquent schoolboy is almost a cliché. Michelangelo, also the son of a magistrate, so neglected his studies that he is assumed to have had virtually no formal education. And Velázquez, a hidalgo, scion of landed gentry, was bored with anything that could be learned in a classroom and left school at thirteen, to the chagrin of his parents.

There is no doubt that Edouard was exposed to a sound classical education, much of which was surely absorbed despite his lackluster grades. His school records[5] furnish a precise picture not only of his performance but also of his curriculum, which included Latin, Greek, history, mathematics, English, and drawing, beginning with his first year at the Collège Rollin. Latin and Greek were taught in two classes each, *thème* and *version,* one translating into French and the other from French to ensure command of the grammar as well as comprehension. Edouard's only consistently respectable grades were in English ("fairly good"), drawing ("very good"), and conduct ("fairly good"). In the two terms of his second year at Rollin he managed to rank second and eighth in history, showing unexpected promise. As for math, the records report, "to date, this pupil demonstrates a fair amount of enthusiasm and application but has far to go."

It is easy to imagine how upsetting those reports were to Edouard's father. No Manet had ever been found that lacking. Edouard evidently took after the more fanciful Fourniers — all charm and little substance. When, on top of his dismal performance at school, Edouard announced that he was not interested in the law, that the law bored him, that he had no intention of becoming a lawyer, and that he wanted instead to become an artist, Auguste lost his customary judicial composure. It was bad enough to learn from the head-

master that his son had done poorly in Latin, but to discover that his "ideas are confused," that "in rhetoric his compositions are generally weak and insufficiently prepared," and that "his handwriting will do him a disservice" indicated that Edouard was deficient in the most elementary discipline for a lawyer and did not even have a legible hand.

The significance of rhetoric in the formation of Edouard's intellect warrants some explanation here. Until the twentieth century rhetoric was not only the term used to designate the final year of a secondary education in France, but it was also the culmination of a twelve-year program in humanistic studies. Greek and Latin in the earlier years prepared the student with a knowledge of the ancient texts that had served as models throughout Western civilization. Centuries of pedagogy had gone into refining the program of the *classe de rhétorique* as it was taught in a nineteenth-century secondary school. Rhetoric was a compendium of ancient and modern culture assembled to provide exemplars of masterful prose for future practitioners of liberal professions: jurists, preachers, teachers, writers, statesmen. This required a familiarity with ancient masters such as Homer, Cicero, Livy, and Pliny. In the eighteenth century the list was extended to include the new "classics" of French writing: Mme de Sévigné, Bossuet, Corneille, Racine.

There were four basic precepts of rhetoric: where and how to find the historical examples and familiar quotations to construct a text (*inventio*); how to organize the text (*dispositio*); how to use figures of speech and other stylistic techniques (*elocutio*); how to manipulate syntax to give substance to a sentence (*amplificatio*). In the process some students learned to appreciate a piece of great writing; some even embarked on a literary career simply because they had discovered the beauty of language and wanted to emulate their elders. Along with the mastery of language, they also learned how to communicate with audiences, both readers and listeners. The importance of this kind of teaching in the case of even so undistinguished a student as Edouard — more visually than verbally gifted — should not be underestimated. It unquestionably honed his use of language (he was a master of the well-turned quip), provided him with the background to read and discuss literature with outstanding men of letters, and may well have entered into his early approach to painting. Velázquez,

Goya, Watteau, Chardin, the brothers Le Nain, were all to be used for the expression of original or personal ideas in art, just as Homer and Cicero had provided the language of rhetoric.

The wrangles between father and son continued throughout the spring. Under no circumstances would Auguste consider a career in art for his son. Art students were hardly unfamiliar to Auguste. When he moved into 5, rue des Petits-Augustins before Edouard was born, he knew that the former convent of the same name, directly across the street, had been transformed into the national school of fine arts. The yearly saturnalias of that unkempt, unwashed, unpressed bunch sullied the neighborhood with their lewd costumes and public disorder. But had anyone told him that a son of his might become an artist, one of those irresponsible, unsavory characters who spilled out of those handsome brick buildings, he would have looked contemptuously down his patrician nose at such nonsense. A Manet an artist? Did Edouard not recognize his responsibility to his family, to his name? How could he disgrace them — he especially, the firstborn, destined to carry on the family name and reputation? Auguste had planned it all since his sons were born: Edouard would enter the law, Eugène would study medicine, and Gustave — they would see later.

In the meantime, Edouard's rebelliousness had to be broken. Friends and family were enlisted — the dean of the Faculty of Law in Paris, and a cousin who was a respected jurist — to persuade Edouard that he was being headstrong and foolish, that the law was a fine profession, that he owed it to the family to pursue this career. There were scenes and tears and threats — all for naught. Edouard, until then gentle, respectful, almost timid in his father's presence, suddenly at fifteen became intractable. If he were forced into law studies, he would simply run away from home. Nothing on earth could make him ruin his life just to please his father.

In France, even today, career decisions are made early. Entrance exams for professional schools, which in America follow an undergraduate degree, still take place in the summer of a student's last, in some cases next to last, year of secondary school. Schools that prepare students for the liberal professions, military and naval academies, government and business administration, and the like have few openings, and one must qualify for admission to them. By the spring

of 1847 Edouard had decided that he would consider a career in the navy. He loved the sea, had excellent coordination, and with his background was a natural officer. This was not exactly what his father had in mind, but it was more honorable than a Manet among the hooligans in the building across the street.

The age limit for application to the naval academy* was sixteen at the time. Edouard, though he would not reach that age until the following January, would be obliged to take the exam in July 1847 even if he was academically, and above all psychologically, unprepared after the emotional upheaval of the preceding months. There was still the chance of a second try the following year if he failed the first time. In March 1847 a new rule, to become effective in 1849, extended admission to eighteen-year-olds if they had completed an eighteen-month tour of duty on a naval vessel. In July Edouard took the exam. On the French scale of 20, Edouard's performance was less than brilliant: 11 in French, 9 in math, 7 in Latin; "A waste of time," his examiner commented. In August another regulation reduced the tour to twelve months, and in October yet another abridged the entire duration to the mere crossing of the equator aboard a commercial vessel.

An enterprising shipowner placed one of his ships at the disposal of young men of good family for this purpose. Along with a few instructors who were to prepare them for the exam, a group of sixteen- and seventeen-year-olds would sail — naturally to the profit of the owner — on the merchant vessel *Havre et Guadeloupe* bound for Rio de Janeiro with assorted cargo.

His mediocre performance in third grade notwithstanding, Edouard was relieved of yet another year, presumably out of his need to comply with the age limit of the naval academy and out of deference to his father, a friend of the school's director. In July 1848 he finished his secondary education after a year of supplementary rhetoric. That final year was no more glorious than the preceding ones: "In no aspect of his work or conduct have we been able to determine any im-

*Known between 1840 and 1913, and in most French biographies of Manet, as the Ecole Borda, after Charles de Borda, an eighteenth-century mathematician and naval officer.

provement." But he was out of school, and an armistice was declared in the Manet household. His father had agreed to let him prepare for the naval exam by joining the voyage of the *Havre et Guadeloupe*. For Edouard a few months at sea would be a joyful adventure, compared to the thought of law school; in that light even the exam was a bagatelle. For the next few months, until embarking, he was free to do what he liked best: roam the streets of Paris, sketch pad in hand.

2.

At Sea

On December 2, 1848, Edouard began the first of his letters from the *Havre et Guadeloupe*. They comprise one of the few documents we have of his thoughts and impressions written in his own hand.[1] His teachers may have despaired of his progress, but their efforts were not entirely wasted. These letters, covering a period from December 1848 to April 1849, reveal a not always legible hand but a thorough command of syntax, a facility with language, and a sophistication of observation and feeling that are at odds with the "mediocre" of his final year's grade in rhetoric. Previous biographers seem not to have found anything noteworthy in these letters, some even going so far as to allege that "Manet does not have the eye of a reporter. . . . He retained nothing of his trip to Rio."[2] He may not have brought back any jungle pictures, but his discovery of tropical light and his physical experience of the sea were retained with such vividness that, long after, they would determine the way he painted light and water.

Accompanied by his father, Edouard left for Le Havre with another young man who, like him, was embarking on the shipboard classroom. Auguste Manet remained with Edouard until December 8, when the ship set sail after a week's wait for suitable winds. Instead of the cool independence one might expect from an adolescent finally liberated from an oppressive family situation, Edouard writes with delicate tenderness, candidly expressing affection for his mother, to whom most of the letters are addressed (note the elegant turn of the opening sentence).

Dear Mama,

I would regret that you did not come with me all the way to Le Havre had I not feared another separation* and the farewells that are always so painful; you would have seen our magnificent vessel where we shall be as comfortable as can be; we shall have not only the essentials but even more, a degree of luxury and all the comforts to console and reassure the sad mamas who came to see their children off. I spent today arranging my belongings in my locker. There are thirty-six beds, I sleep in a hammock, and Maindreville in one of the beds.

Are we leaving tomorrow, I do not know, but at four o'clock we are going aboard, and we shall place ourselves in readiness while awaiting a favorable wind. This morning all of us filled out the forms required by the navy and we were listed with the ship's crew. We are twenty-six on board, including a cook and a Negro chief steward. We have, in addition, a very attractive lounge in the stern where there is a piano.

Good-bye, Mama dear. I am pleased to leave though very saddened by our separation; and I hope that what Madame Maindreville tells you will completely allay your fears; the comfort we are going to enjoy astounded me.

Good-bye, Mama dear, I kiss you with all my heart.

<div style="text-align:right">

Your respectful son,
Edouard M.

</div>

[P.S.] I was very touched by the kindness of Jules Munich who waited for me at the train station to say good-bye.

Penned every few days from the time of his embarkation in Le Havre to his departure from Rio on April 10, 1849, these letters often read like a diary — entries made on successive days with the knowledge that they would not be received until a passing ship bound for France could take them to their destination. The wealth of detail and observation, the concern for bringing his family into this new existence, and the humor and sensitivity of these entries make them much

*"*Je regretterais que tu ne sois pas venue m'accompagner jusqu'au Havre si je n'avais pas craint une nouvelle séparation. . . .*" Insofar as possible, original punctuation has been retained.

more interesting than one would expect of a seventeen-year-old whose compositions, only a few months before, had been found to be inadequate.

While still docked, the routine on board began at 7:30 A.M. with "Clear the decks!" and inspection. There was "recreation" until 9:00, followed by breakfast, classes from 10:00 to noon, lunch, classes again from 2:00 to 4:00 P.M., dinner, study time from 6:00 to 8:00, and lights out at 10:00. "Recreation" consisted of climbing the masts, "which promises to make me very agile." As for the food, "everything they serve us is excellent: two meat dishes and dessert at every meal." Already Edouard's interest in good living and clothing was evident: "We have a real sailor's outfit: oilskin hat, flannel shirt, pea jacket, linen trousers; very becoming costume. There are always a hundred or more gawkers staring at us from the pier."

At last, on December 8, by then accustomed to sleeping in a hammock, Edouard announced their departure for the next day: perfect weather and the promise of a good wind. The sails were ready for hoisting; only the sheep and pigs had not yet come aboard. He inserted a very personal note into this letter, indicating that the disagreements of the preceding months had been smoothed over and also how much he had been affected by them: "Papa is coming aboard tomorrow to say good-bye. I have been very happy to have him here until my departure. He has been so kind to me during this whole stay." The rigid bourgeois and somber judge must have felt uneasy about the thought that his firstborn would shortly sail across an ocean, and would have been understandably fearful. Despite Edouard's appreciation of his father's attentions, he began every letter but one with *"Chère Maman,"* and closed with *"Adieu, chère petite Maman, je t'embrasse bien tendrement."* He never failed to enumerate the other members of the family when sending his fond greetings. Although he expected that his father would read his letters, it is not surprising that Edouard found it easier to write to his mother, with whom he had a close, affectionate relationship. In many respects, she was to remain the first lady in his life.

Any anxiety he may have had about the trip was camouflaged by his reassurances to his mother:

We are delighted to be leaving even though we couldn't be better off than we are here in every way; for we have serving us four pa-

thetic little cabin boys and two apprentices who are kept in tow
with kicks in the butt and punches, which makes them hop to,
I can assure you. Our chief steward, who is black as I already men-
tioned and is responsible for their training, really lets them have
it when they are out of line; as for us, we do not exercise the
right that falls to us to hit them, but are saving that for important
occasions.

He also reported that a "charming yawl" was going with them for ex-
cursions along the coast of Rio de Janeiro and expressed such enthu-
siasm that even the most doting of mothers could only congratulate
herself on his good luck. "I am sorry that you did not see our ship; it
is one of the loveliest and best designed in Le Havre; they have come
through with more than was promised, one cannot ask for more; they
have even provided fishhooks and rods so we can fish for sharks, etc."
However, this was not a summer camp; there was strict military disci-
pline. One wonders how Mme Manet reacted on learning that "the
officers though gruff are really nice chaps; we too will have to behave,
for we are subject to the same punishments as the sailors. Those who
do something foolish will immediately be placed in irons; one thinks
twice about that, believe me."

As for the commander of the vessel, Captain Besson, Edouard was
very taken with him. "He is always polite and very kind to us, though
he knows exactly how to maintain his dignity and how to command
absolute respect." After an invitation to dine at the captain's table,
Edouard declared, "Decidedly, a charming man; he knows how to
play the host." But the second in command made a very different im-
pression: "a true brute, a sea wolf who keeps you on your guard and
really pushes you around."

Four days later he wrote to his mother for the first time since cast-
ing off: "I would have liked to write day by day, telling you what we
did, but seasickness and bad weather prevented me. I will from now
on." He related the colorful departure, the cannon salvos, the waving
figures on the pier, the shimmering sky and calm sea. Little effort is
needed to visualize this scene in the bright tones of the "open-air"
palette that the future Manet and his impressionist friends would be
producing twenty years later. All that first day, he told her, he was
very proud of himself for being a born sailor, seeing all his comrades
bent over the railings. But that very evening, after the last sight of

land slipped away, his own maritime baptism began: "I will gloss over the next three or four days; I was horribly seasick. The weather turned fearful; someone who has not seen the sea as turbulent as we saw it cannot picture it; no one can imagine those mountains of water that surround you and suddenly engulf the whole ship, or the wind that makes the rigging whistle and is so powerful at times that the sails have to be hauled in. On those occasions, I can assure you, I often missed the charms of the paternal hearth." This physical experience of the sea's violence may well account for the apparent shift of emphasis in one of his most striking paintings, *The Battle of the "Kearsarge" and the "Alabama"* (1864), in which the sea virtually displaces the subject of the naval engagement.

The storms threw them far off course, taking them to the coast of Ireland, where he saw "the ocean in all its fury." In the process he discovered the monotony of life at sea — nothing but sea and water, even on calmer days. "There is nothing to do, for even our teachers are sick and it is impossible to stand on deck because the ship pitches so violently. Sometimes during dinner we all fall over one another and the platters of food on the table go with us."

At last good weather, four days later. Laundry was festooned from the riggings, bedding set out to air, and their quarters swabbed down — "you could not go below without your gorge rising; it was pestilential." Later that day the student-sailors were assigned positions on the masts, as on warships: "I am one of the topmen of the mizzenmast." The respite in the weather was brief, for the night brought more violence. "A poor sailor was hit on the head by a hoist, which did not prevent him from working the next day as usual."

Edouard was beginning to see that a sailor's life was not a happy one. "All those men are really amazing, always uncomplaining, always cheerful in spite of the hardships of their job, for it is no fun to take in a reef of sails while perched on a yardarm that is often lashed by the swell, to work night and day no matter what the weather; and all the more amazing since they all detest their career." This is the first sign of a disenchantment that would grow over the months to follow. There is, of course, no proof that Edouard was ever genuinely set on a career in the navy. He may only have chosen the lesser of two evils. At least he had always loved the sea, albeit from the shore or close to it; there was light and air and color.

Ten days passed before classes finally began, yet even then, when

teachers and students were presumed to have hardened stomachs, the ship's constant rolling and pitching in the deep troughs that pursued them made writing very difficult. With a little good weather they would make landfall in Madeira within a week; letters from the ship would go ashore in the longboat. The next day, because the captain had already seen that the trip would take longer than anticipated, bread was rationed: a small piece at each meal plus some hardtack. That was apparently a great hardship for Edouard. "You Parisians," he wrote, "don't know what hardtack is, especially when it has to be eaten at every meal. . . . As for me, I am hoarding bread and whenever I can, I snatch some and hide it in my locker; I can assure you nothing goes to waste on board."

In spite of the shortage of bread and the bad weather, Edouard had not lost his capacity for observation: "This evening the sea was more phosphorescent than usual, the ship seemed to slice through blades of fire; it was very beautiful." He also described a comical scene that nonetheless aroused his compassion: "Past the coast of Portugal the sun has grown much warmer and so today the crew took advantage of it to wash the three cabin boys; a large tub was brought on deck and the three urchins were thrown in and rubbed down with a pumice stone by a sailor; they emerged snow-white where they had been black before. That enforced cold bath can't have been very pleasant."

Edouard's Parisian traveling companion, Maindreville, was still seasick, as was the math teacher, but Edouard told his mother what they did hour by hour once they were better organized: their day began at 6:30 A.M., everybody on deck for inspection; breakfast at 8:00; classes from 8:30 to 9:45; after a fifteen-minute break, math at 10:00 for his group; lunch at 11:30; literature class for his group at 1:00 P.M.; recreation at 2:30; English for all the groups at 3:00; dinner at 4:00; recreation until 7:00; study hall until 9:00; lights out.

By December 22 Edouard's morale was at its lowest. He was ready to confess the depth of his discouragement: "It seems to me months since I came aboard. How boring is the life of a sailor. Nothing but sky and water, always the same thing, it's stupid." But a few days later he penned a detailed account of a very merry Christmas celebration with champagne, Havana cigars, and songs that lasted until 4:00 A.M. For days they had been tacking about, unable to approach Madeira, their first landfall in eighteen days. The end of 1848 was upon them. "How lucky Eugène and Gustave are [to be at home]; we shall try, we

poor denizens of the *Havre et Guadeloupe,* to find some small consolation for being able to do no more than wish you a Happy New Year from so great a distance."

On December 30 they finally sighted Porto Santo, a minuscule island in the Madeira archipelago, little more than a strip of beach, and in the distance the "black hyphen" that was all they could see of Madeira, its black rock and black sand the birthmarks of its volcanic origin. In a postscript Edouard asked that his father register him for the entrance exam he would take on his return, specifying that he wanted to take it in Paris. The last day of the year they caught porpoises, which he described as "extraordinary fish, with a bird's beak and a jaw full of sharp little white teeth, whose meat, sautéed in a frying pan, tastes like beef." Because of rough seas all hope of seeing Madeira was lost, and they were bitterly disappointed, particularly since they could not post their letters or take on fresh fruit and water.

New Year's Day, 1849. A letter of greetings to the entire family and an account of the festivities: all the sailors came to the students' quarters to wake them with a porpoise pâté, the captain offered them Madeira wine, and they played games all afternoon. In the "game of the goose," one had to decapitate the "goose" with a saber while blindfolded. Bad weather again kept them belowdecks, but one of the sailors who had a vast repertory of operas and operettas sang into the evening, and champagne flowed.

By January 5 they were almost within reach of the Canary Islands, but again high seas prevented a landing. On January 6, in the first letter addressed to his father, Edouard described his first close view of land: the 11,000-foot peak of Tenerife's mountain, "its summit covered with snow, is a chunk of rock whittled to a point. The capital lies in a bay. Nothing could be lovelier than this little town with its white houses bathed in the sunlight; we watched it disappear with sorrow. Here it is a month since we left where ordinarily it takes 12 days to cover this distance; we have therefore had every kind of weather and will be old sea dogs when we come back." The first whale, sighted only a few feet from the ship, was "a monstrous animal! It shoots water to a prodigious height and jumps out of the water, making it possible to see almost all of it."

On January 6, Epiphany, the entire crew drew lots for king. In commemoration of the Magi, the one who found a dried bean in his slice of the traditional cake was crowned. "It was our black [chief

steward] who had the bean; he chose as his queen the captain, who gave him a glass of kirsch and a gift of cigars."

Every day they had rifle practice and hoisted and trimmed the sails at the commands of Captain Besson, who hoped to make real sailors out of the would-be cadets. In each entry of his journal-letter, Edouard described the high point of the day: they passed the tropic of Cancer; saw schools of flying fish, "as large as small carp but much slimmer," one of which flapped on board; passed two English brigantines but, after a month at sea, had not yet seen a French ship. They were hungry for news "to allay our anxiety over what has happened and is happening in Paris; we limit ourselves to conjecturing on the outcome of nominating one presidential candidate or another."* The heat became suffocating while they sat for five days in the Doldrums on a sea of glass: "The Seine is surely no calmer." They prayed for a storm to get them out of there, since it is possible to spend a month in that latitude without a breeze; heat and thirst became a perpetual torment. Two weeks had passed since he had begun that letter. At last they were within a few nautical miles of the equator and had sighted eight ships. For the benefit of the uninitiated, Edouard added that "the equator is usually crossed at the same degree, which explains the convergence of so many ships."

On January 22 the great event took place. The ceremony began with the appearance of an astrologer, Old Man Equator's son-in-law, who shimmied down from the highest mast to tell the captain what route to take and then climbed back up to find out whether the Old Man would allow the ship to pass through his domain. After dinner a shower of dried kidney beans and buckets of water from the top masts alerted them that an equinoctial messenger had arrived, followed by a Breton peasant carrying hens, eggs, and crepes. A letter to the captain was read aloud stating that Old Man Equator would permit them to pass and that he would come aboard the next day. "The Breton peasant then started to play all kinds of pranks and flung a handful of flour in the captain's face, while the messenger flicked his whip against our legs hard enough to knock us over."

In the morning a tent was pitched on the forward deck, everyone

*The Second Republic was in its infancy. Edouard rightly feared that if Louis-Napoleon became president, it would not survive.

was lined up on the poop deck, and a procession came forward, con-
sisting of a sexton, a priest, and a choirboy, while a bell called them
all to the baptismal Mass. "Then came Old Man Equator and his
wife, all dressed up, you really have to have seen it! Neptune, a bar-
ber, two policemen, and last, the Devil and his son. The Old Man
paid his compliments to the captain and presented his better half,
then the priest delivered the most hilarious sermon." The first to be
baptized were two lifeboats that had never before crossed the equa-
tor. Then the dignitaries went under the tent, and the two policemen
escorted the prospective initiates one by one.

> First you are taken to the altar where you make confession; the
> priest then makes you take a dozen oaths; you take Communion,
> then you pass into the hands of the barber, who brushes your face,
> neck, etc., with paint and then scrapes it off your skin as well as he
> can with a two-foot wooden razor; and that's not all. You are told
> to rinse yourself off in a large tub of water beside the altar. I, who
> did not take this lightly, did not wait to be asked; he nonetheless
> grabbed me by the legs and made me take one of those dives that
> can do you in. No sooner do you think you have finished than just
> outside the tent you fall into the arms of the Devil, who was none
> other than our Negro steward, and who smears you all over with
> his tail dipped into some kind of black substance.

Once the initiates were baptized, no distinction was made between
teachers, pupils, and officers; they all showered as well as they could
with a pail of water, all of them black to the waist, obliged "to scrub
for two hours with melted grease, which made us stink to high
heaven . . . and here we are, sailors at last; we have crossed the equa-
tor; there is many a ship's captain who has never crossed it."

The verve of Edouard's narration, the self-mockery, and the flow of
his prose make such passages, which go on for pages, a delight to
read. Whereas most of his contemporaries stressed his charm, humor,
and quick repartee, none of them communicated the impression that
he was at all literate. Antonin Proust's remark that "he read little and
wrote nothing" was taken too literally. He did not keep a journal, he
did not write articles or publish a method of painting. He may not
have been a particularly motivated student, and he may well have
been an academic underachiever. But he was not what the French call

un cancre, a dunce. Language, written as well as oral, was certainly one of his gifts, and his use of it proves how much he had in fact learned; his vocabulary is varied, as are his constructions, and his grammar is impeccable. What letters have survived all testify to his ability to turn a phrase, express a sentiment, and describe a scene.

On January 30, with Rio only a few days away, they were all busy repainting the ship: "This coquetry will cost us some delay since we are making a detour in order not to arrive until we are all spruced up." At that point Edouard was still paying lip service to the idea of a naval career, for he added in the same entry, "I remind you, dear Papa, of my wish to take my exams in Paris, which is preferable; I would not want to take them in the provinces; all my comrades moreover are doing likewise."

Monday, February 5, at anchor at last, after two months of countless storms. But even the safe arrival had its mishap. Because the Portuguese speakers guarding the two fortresses of the bay could not understand the French speakers on board, two warning shots were fired, which would have been followed by a direct shell had Captain Besson not decided to drop anchor then and there. Once the sanitation officers came aboard, the ship was finally allowed to anchor in the roadstead. But the students were not to go ashore until Thursday. "By now I've really caught on to the tricks of the trade, and now for two months we will be spared the little miseries that make an apprentice sailor; we will finally drink *fresh water*, and no longer eat *salted meat* every day."

Some days later, after his first shore leave, Edouard penned a voluminous letter to his mother recounting everything he had seen. He had already mentioned in a preceding letter how attractive he found the bay of Rio; he had spent almost a week admiring it from a distance, since they did not finally go ashore until the Sunday following their arrival. He was met by a young Frenchman his own age, contacted through a friend in Paris, who took him to his mother's modest house a few minutes outside the city. The young man's mother had a hat shop in Rio — not the society a Manet would normally frequent — "but don't be alarmed by her title of milliner, she is out of the ordinary and her son is a charming boy, more refined than most of us. I will admit, however, that on my first visit it seemed strange to be in a shop, but I am used to it now." He asked his mother to write a note of thanks to the boy's mother for her generous hospitality. Even

if Edouard was well aware of his own social position, his remarks prove that it did not blind him to the quality of an individual, just as his request for a thank-you note from his mother indicates her role in teaching him courtesy and open-mindedness.

Edouard's young host took him to visit the city after lunch that first Sunday on land, and Edouard communicated his impressions:

> The city, though fairly large, has narrow streets, but for a European with any artistic sense it has a character all its own. To begin with, the only people one sees in the streets are Negroes and Negresses; Brazilian men go out very little and Brazilian women even less. The latter are seen only when they go to Mass or in the evening after dinner; they stand at their windows and at that time you can look at them at your leisure, whereas during the day, should you chance to catch a glimpse of them at their windows, they retreat at once.

What made a profound impression on him was the condition of the blacks, who accounted for three-quarters of the city's population. "All . . . are slaves; all these poor creatures look downtrodden; the power that whites have over them is extraordinary. I saw a slave market; for us this is really a revolting sight." The age and inexperience of the writer is what makes a passage like this so striking. True, France had abolished slavery in its Caribbean colonies in March of 1848, after the revolution of the previous month, but slavery was not a burning issue in France or in the French press, as it was in England at the time. What this passage reveals, in addition to keen observation and intellectual curiosity, is a respect for human dignity. The fact that he communicated his outrage to his mother — and, though the letter was addressed to her, one can safely assume to his father as well — suggests that political and social consciousness was taught along with manners in the Manet family. No detail escaped Edouard's attention, which makes his description of the way blacks were dressed more a condemnation of their condition than an account of local color. "The Negroes [*Les Nègres*] have only a pair of trousers for clothing, sometimes a linen jacket, but as slaves, they are not allowed to wear shoes. The Negresses are naked to the waist, some wear a scarf that falls over the chest. They take great pains with their appearance."

He was very taken with the "magnificent" black eyes of Brazilian women — only the country's white inhabitants were referred to as

"Brazilian" — and by the way they wore their hair in a braid. Unlike European ladies, they went about hatless and in very light, unconstricted dresses "quite unlike our fashions," but never alone; they were always accompanied by their slaves or their children and were generally married by the age of fourteen. In the space of the few weeks covered by the letter, Edouard had made detailed observations and comparisons one would hardly expect of an untraveled adolescent. For instance, he had visited a number of churches — in itself surprising for so young a tourist — and found them in poor taste, all lit up and gilded: "They do not stand up to ours." He also noted that all the monks in an Italian monastery were heavily bearded, unseen in France; Brazilian women were carried through the streets in sedan chairs, even though there were trams drawn by mules (whereas in France horses were used); only paper currency and copper coins were in circulation (as opposed to gold and silver in France); and everything was very expensive.

On Thursdays, their day of shore leave, they left at four in the morning for an all-day excursion in the countryside. They would swim and picnic in what he considered the most beautiful nature imaginable, abounding with gorgeous flowers and exotic fruits. Only the reptiles, against which they had been warned, spoiled what would have otherwise been a paradise. The most significant piece of news in the paragraph, slipped in between two descriptions of pelting rains and picking wild fruits, was that a drawing teacher, presumably French speaking, was sought but not found in Rio, and so the captain asked Edouard to conduct a class for his companions: "Here I am elevated to the rank of drawing master; I must tell you that during the crossing I made a reputation for myself; all the officers and teachers had me do caricatures of them and the captain himself asked me for one to give his family as a Christmas present. I had the good fortune in all of this to perform to everybody's satisfaction."

The major event of his stay in Rio, and perhaps the major disappointment, was Carnival. In a letter to his cousin, he declared that "Brazilian women are generally attractive but don't deserve the reputation for flirtatiousness attributed to them in France; no one is more prudish or stupid than a Brazilian woman." Although it was the custom on the Sunday afternoon before Mardi Gras for the ladies to throw wax balls filled with water at the men passing before their windows, and permissible for the men to throw them back ("as for me, I

took ample advantage of [the custom]"), no contact was made between the participants in this simulacrum of a flirtation. In the evening a masked ball was held — which Edouard compares to the opera ball in Paris — "where only the French were distinguishable."

Judging by his remarks in letters to his cousin and to his brother ("our Carnival was not much fun"), his adventures fell far short of his expectations. But something more important than a passing flirtation seems to have taken place. A duality arose in him that would become a major factor in the modernism of Manet's paintings: "The Carnival is a very strange thing; *I saw myself in it, like everyone else, as victim and actor*" [emphasis added]. The germ of Manet's future vision, as seen in works such as *Music in the Tuileries* and *Ball at the Opéra*, had already begun to grow in the seventeen-year-old.

He spent Carnival far from the frenzy of the city, on a three-day excursion to an island in the bay of Rio — "at a charming house, *toute créole*" — accompanied by a number of local bachelors. Much as he enjoyed the luxuriance of the rain forest, he was less enthralled by the fauna and was in fact bitten by "some kind of reptile," as he reported only to his brother Eugène. His foot became so badly swollen that he was confined to the ship for two weeks. By the time of that letter, March 11, he already knew that he would not be ready to take the exam on his return: "I do not expect to be admitted this year; we are less able to study undisturbed on board than on land."* This suggests that neither he nor his classmates made much progress in their studies. His final word on his stay was anything but enthusiastic: "As for this beautiful land in the Americas, I hardly dare pronounce myself, for despite the rich natural setting, it rains constantly and in sheets, lasting four and five days at a time. All told, I am not enchanted with my stay [in the bay of Rio]; *I have been tormented and bullied so much that more than once I was tempted to go off on a spree [courir une bordée]*" [emphasis added]. Apart from the second officer, described as *"un vrai brutal"* in an earlier letter to his mother, he never spoke of being abused, so that we do not know the context of his

*Although registered for the exam to be given on July 5, 1849, Edouard did not take it on his return to Paris in June. He still had another year to prepare and, as we now know, had no wish to take it at any time. It has often been reported that he took it and failed once again.

complaint. But the expression *"courir une bordée"* is a nautical colloquialism that means going from dive to dive on a spree of drink or women or both, presumably without permission. But the cadets were too closely chaperoned for any such escapades.

He was more than ready to come home, as he told his cousin: "Now that I know Rio really well, I am eager to see France again and be among you all once more." He was not overstating his acquaintance with the city, for the presence of many French inhabitants made it possible to ask questions and understand the answers, in addition to what he saw himself. As for the Brazilians and Portuguese, he found them lackluster and inhospitable, and the life of the streets, always a passion for him in Paris, understandably disappointing for a Parisian accustomed to cafés, shops, and fashionable strollers.

Not only was he a keen observer of his immediate surroundings, he also was interested in what was going on outside Brazil. To his brother he related the discovery of important mines in "California, a brand-new territory": "All the ships are headed there, a bottle of beer costs 150 francs . . . entire crews and captains as well are deserting their ships to go into the interior and collect the gold; it's unbelievable. The most basic necessities are sold there at exorbitant prices since gold is so plentiful: it's a great occasion to make a fortune." Was he tempted to join the throngs? It seems so, but in the end he apparently had had enough adventures to last him for a while.

In his last letter before returning to France, Edouard told his father that they were loading coffee and a few passengers on board and repeated his concern over Louis-Napoleon, expressed earlier to his cousin in an ironic remark ("Don't go nominating him emperor; that would be too funny"): "Try to keep for our return a healthy Republic, for I am very much afraid that Louis-Napoleon is not very republican."

Louis-Napoleon had in fact been elected president of the Second Republic on December 16, 1848, a week after Edouard's ship had sailed from Le Havre, but the news had evidently not reached them until their arrival in the bay of Rio. Ever since the revolution of February 1848, which Edouard had witnessed, there had been a provisional government consisting of distinguished writers and politicians such as Alphonse de Lamartine, Louis Blanc, and Adolphe Crémieux. Edouard's fears regarding Louis-Napoleon's intentions were well-

founded, though not fulfilled until 1852, when a unanimous plebiscite, encouraged by troops in the streets, declared him emperor. That Edouard wrote to his father and cousin about this, and in these terms, indicates the political orientation of the family and the interest it awakened in the young boy. It is certainly not common for someone so young to foresee with genuine anxiety the precariousness of a newly established republic: his distrust of Louis-Napoleon was voiced in three different letters. If at seventeen and thousands of miles from home he could be anxious about the political situation in Paris, there is no reason to believe that as a man, living in the capital during tense situations, he would have become apolitical, as was later alleged by critics who knew little about him besides his paintings.

All told these letters reveal a great deal about their writer. For one, the eagerness to share with his family his impressions and his tastes indicates the measure of his affection and the candor of his nature. So many adolescents, not overfond of letter writing in the first place, are more likely to be reticent, especially after being browbeaten by an authoritarian father. But there is no trace of rancor for having in effect been forced into this only alternative to law school, except for the cryptic remark to his brother about having been tempted to jump ship and drown his humiliations. But even this is mitigated a few paragraphs later by his pride of métier: "We have become very hardy seamen; we hoist sails if not better than at least as well as the warships anchored around us and have received many compliments." It is also true that he was writing to a younger (by a year) brother who was having trouble at school, the very same Collège Rollin, and perhaps did not want him to idealize naval life. It was only to him that Edouard complained about having shore leave only two days a week, as in school on land, which made the time anchored offshore even more tedious than being on the high seas.

Perhaps most significant at that moment was his recognition that he would not become a naval cadet, for two reasons: first, his six months on the *Havre et Guadeloupe* were too fragmented by bad weather and shipboard duties to prepare him for a second and final examination, and second, some "stupid" new ruling, not explained, "makes entrance into the academy almost impossible." Equally important were his appointment as drawing master and his much-appreciated caricatures. One of the few surviving drawings from that

trip is of a shipmate, Adolphe Pontillon, who went on to become a naval officer and later married Berthe Morisot's sister. He appears in an ink sketch as an unsteady Pierrot.

By the time he returned to France on June 13, 1849, Edouard had assembled a portfolio of drawings and had learned a number of things, not all of them nautical: first, that a life at sea was not for him, and second, more determining, that his first inclination, art, was in fact his true vocation. After the excitement of his homecoming had abated, he announced his decision to study painting. And this time his father yielded.

3.

The Doubling Begins

To understand what Edouard Manet was about to learn, and above all what he was going to rebel against, we must go back a bit to see what the art world was like in the mid-nineteenth century. All study, virtually all professional activity in the arts, had traditionally been within the Académie des Beaux-Arts.[1] Founded in 1648, when Louis XIV was ten years old and had been king of France for five years, this was not a mere bureaucratic innovation. The principle behind it was the basic tenet of any autocratic regime or ideology: the canon of instruction determines the production of the instructed. In its early years the Académie was a vigorous institution that accepted into its ranks artists well under the age of forty. After preparing with a master, they took their classes in life drawing at the Académie and demonstrated their proficiency in various competitions, the most important being the Prix de Rome. Winners were (and still are) granted a subsidized residence at the Villa Medici in Rome for the purpose of studying firsthand the masterworks of ancient and classical painting, sculpture, and architecture. At the end of their stay, laureates were required to submit a work on a subject imposed by the Académie. If the work was accepted, the artist took his place as a new academician. Over the decades fewer new members were installed in the Académie, and because membership was for life, the institution became sclerotic.

After the Revolution of 1789, the newly formed Institut de France presided over four academies of arts and sciences, which continued as learned societies that bestowed prizes on deserving specialists, the highest honor being that of membership. The teaching arm of the

Académie des Beaux-Arts was now a separate body, the Ecole des Beaux-Arts, but it was still subject to the same small group that selected those who taught in it. In 1832 the academies reached their present number of five. The two best-known are the Académie Française, whose forty lifetime members still control the official use of the French language and enshrine writers when a place becomes vacant, and the Académie des Beaux-Arts, also with forty members distributed among the arts (painting, twelve; sculpture, eight; architecture, nine; engraving, four; musical composition, seven). The position of such academies was, and has remained, strictly conservative: "Academies exist to preserve traditions, not to create new ones," declared one of the permanent secretaries of fine arts in the 1830s when railing against romanticism. Original genius in any field has rarely gained the approval of the Académie.

Even when the Ecole des Beaux-Arts was allowed to administer itself, the influence of the supervising Académie was not so easily shaken off. Almost two centuries of academic despotism had created a uniformity of instruction and established the norms of taste. The formation of an artist was based on his mastery of the techniques of drawing the human body, and that, as well as the subjects depicted, was entirely controlled by the Académie. Until 1830 anatomy, life drawing, and perspective were taught exclusively by the Académie; before that time no private studio was allowed to have live models. The very term for the carefully outlined and shaded representation of a live model arranged in a classic pose is *académie*. It is hardly surprising that *academic* came to mean artificial and hackneyed.

All instruction was built around an unwavering curriculum of drawing, initially from engravings — first copied as line drawings, then as shaded drawings — and later from plaster casts of ancient sculptures. The technique was the same for both — lines and cross-hatching — but the casts introduced the technique of modeling, which creates the illusion of volume or a third dimension achieved through the relationship of light and shade. From engravings and casts, the student advanced to drawing live models, then to painting them, and finally to copying old master paintings, after studying composition, which had its own rigorous rules for perspective, focus, and framing. Since antiquity all the arts had been taught and learned on the basis of earlier models. Poets, painters, playwrights, composers — all began by copying and imitating. As André Malraux points out,

"Michelangelo, El Greco, Rembrandt imitated; Raphael imitated, and Poussin, Velázquez and Goya; Delacroix, Manet and Cézanne . . . whenever documents allow us to go back to the origin of a painter's works, or a sculptor's, or any artist's, we encounter . . . the dreams, the anguish, or the serenity of another artist." For artists do not emerge full-grown from a formless world, but "from their struggle against the forms imposed . . . by others."[2] In the best sense, the sense Malraux intended by these remarks, earlier models were supposed to teach aspiring artists forms and means of expression, but they were not meant to paralyze the artist's originality, if he had it in him. On the contrary. Even in so modern an artist as Picasso, "the last of the giants," according to art historian Mary Gedo, we encounter such "giants of the past" as Delacroix, Velázquez, Manet, whose masterpieces "Picasso reinterpreted."[3]

In painting, accurate copies came to be regarded as proof of an artist's ability; today we regard them as indicative of an artist's predilections. An anecdote reported by a younger contemporary of Manet's corroborates the high esteem in which copies were held. Distressed by the bad press her son's paintings were receiving, Mme Manet protested: "But he copied Titian's *Madonna of the White Rabbit*. You must come and see it in my house, it is a fine copy. He could paint differently from the way he does. . . . If at least he painted portraits like Robert-Fleury."*[4] Before Manet's time, and even after, a copyist's skill was admired enough to be marketable. Under the July monarchy a Museum of Copies had been instituted, which commissioned copies of important works for public buildings. This provided both a testing ground for young talent and a source of income for a growing body of artists. Private buyers who could not afford originals also bought copies of old masters.

Tradition entered not only into the development of the artist but into public taste as well. Under the sovereigns of France public taste had been fashioned by the paintings sanctioned by the Académie, which also reflected the monarch's desires. The justice and sagacity of

*Robert-Fleury, pupil of Paul Delaroche and five years younger than Manet, was a history and genre painter, winner of medals and honors. His career was well established by the age of twenty-nine, enough to make any mother envious.

the ruler could be demonstrated in official portraits and allegories drawn from mythology and history. Even the French Revolution used art to extol itself and its heroes. When Louis-Philippe, the "Citizen King," came to power in 1830, he too saw art as a useful tool and was determined to direct its course. His ambition was to institute a new French art constructed from historical subjects. In 1831 he inaugurated a yearly Salon,* which invited the rapidly evolving middle class — the future art patrons — to refine its appreciation of art by looking at the many hundreds of paintings and sculptures selected by a jury of artists chosen by members of the Académie. "The diffusion of culture under his reign led to a demand for art that he could easily exploit for his own benefit and that he recognized for its political consequences."[5]

The advent of romanticism in art in the 1820s, exemplified at its greatest by Delacroix, shook the establishment with its lack of finish, dramatic use of color, scenes of violence, emotion, and subjects neither regal nor Olympian. The idealized subject was replaced by the individual. This was an artistic revolution, a rebellion against the Academic style, which academicians defended as tending "toward the noble and refined." Academic art demanded impeccable draftsmanship that imitated every detail of the model, and rejected as careless and slipshod the "unfinished" look of romantic painting when compared with the invisible brushwork of classical or neoclassical painting; its heightened, often unnatural color, reduced modeling, and limited outlining. Academic art looked to classical art for "the image of moral beauty in physical perfection, [as] a means of redirecting the mind . . . to lofty realms of grandeur, purity, and the ideal."[6]

That kind of art put Salon viewers at their ease, but romantic painters had made an impact. The new connoisseurs had become more sophisticated and wanted "an art they could understand at a glance but which would also be something new and modern."[7] It was from this need that the *juste-milieu* style was born, a blend of aca-

*So called because members of the Académie had exhibited their works since the seventeenth century in the Salon of Apollo in the Louvre. During the fifteen years of the Bourbon restoration (1815–30), the Salon was held only six times.

demic subjects and rigorous drawing with the looser technique of romantic painting. In the end it satisfied neither the traditionalist school nor the avant-garde, but it was what the public enjoyed and what became official art. The public itself was largely composed of the *juste-milieu*, so called before the term was applied to art. They were the conservatives, the upper stratum of the bourgeoisie, convinced of neither the divine right of kings nor the power of the people; they upheld the middle-of-the-road — *juste-milieu* — policy of their constitutional monarch, Louis-Philippe. They represented an important segment of Salon-goers — bankers, brokers, contractors, developers — the newly enfranchised who no longer had to have property to vote, so long as they could pay two hundred francs in direct taxation for that right. When less prosperous citizens protested against this onerous requirement that kept them from voting and seeking public office, Louis-Philippe's dynamic minister François Guizot encouraged them to "get rich" — *enrichissez-vous* — which became the slogan of the July monarchy. Until 1848 fewer than a quarter million French men voted. The wealthier among them constituted the clientele of a new category of professionals who came to be known as *marchands de tableaux*, art dealers.

These clients wanted familiar subjects — mythological nudes, biblical or historical figures in large works, domestic scenes and landscapes in more affordable smaller works. But they wanted them in a style less classical, less polished than that of the Académie, whose last great exponent was Ingres. The new style was to have clarity of line, but not the smooth sculptural perfection of Ingres; more natural color than the classic chiaroscuro or the muddied romantic palette; poetry without Gothic nightmares or ugliness — in short, truth *and* beauty. This blend of past and present, of classical values and modern views, idealism and reality, echoed the aesthetic theory propounded in the 1830s by Victor Cousin, France's most influential philosopher during much of the century: "To reject no system, and accept none entirely . . . to select from everything that appears to be good and true, and is thus durable, this is eclecticism."[8] This eclecticism had a profound effect on the thinking of intellectuals and artists, fashioned the *juste-milieu* style, and was remarkably long-lived in a century of so many rapid changes. A half century after its birth, it was still vigorous, still serving as a model against "avant-garde" art.

* * *

When the subject of Edouard's future was resumed in the summer of 1849, his father saw before him a tanned, lean, muscular young man who, not yet eighteen, was already balding, bearded, and self-assured. Edouard's exposure to stormy seas, tropical heat, and naval discipline had taught him the self-control and self-reliance needed to overcome physical and moral ordeals. He had learned not to be cowed by the second officer. His talent had been given official recognition when he was appointed the ship's art teacher. He could now stand up to his father, not as a rebellious adolescent but as a man, confident of his abilities and of his desires.

Auguste Manet was neither a fool nor a bully. He knew when to give in, even if grudgingly. Edouard seemed to have the makings of an artist; he had managed to compile a whole portfolio of drawings during his six-month voyage. It remained to be seen how successful he would be; talent was not enough. Perhaps having a painter in the family was not all that disgraceful. After all, there had been painters like Jacques-Louis David, a member of the Académie, wealthy and esteemed all his life. Edouard could attend the Ecole des Beaux-Arts. Fortunately, the new director of the Ecole, Charles Blanc, was a friend. As a student at the Ecole, Edouard might win a Prix de Rome, refine his talent in Italy, and return to Paris already launched on his career. Weren't most Prix de Rome winners assured commissions and exhibitions in the Salons?

That was not what Edouard wanted. Even though Charles Blanc's appointment had followed the 1848 revolution and should have represented a new order, instruction at the Ecole des Beaux-Arts remained as academic as it had been under the Bourbon restoration. There was instead a painter of excellent credentials, Thomas Couture — a pupil of Baron Gros, himself a pupil of David — who two years before had won the gold medal of the Salon for his *Romans of the Decadence,* immediately purchased by the government for the Luxembourg, the museum of contemporary art. The work, a huge canvas portraying dozens of figures in as many poses, has a classical subject but is executed with a very modern touch; still today it is considered an amazing piece of painting. The ancient Romans were depicted as natural figures, for whom real people had posed and who served to inject a message of social criticism. These decadent Romans

represented the hedonistic Parisians of the day, who would be re-
placed by a new order just as Roman self-indulgence had been re-
placed by Christian altruism. Another notable aspect of the painting,
in its relation to the future Manet, is its references to earlier art: Rai-
mondi's engraving after Raphael's *Judgment of Paris* and Titian's
Pardo Venus, among others.[9]

Couture's pupils — the maximum he accepted was thirty —
worked from nude models and received biweekly visits from the mas-
ter for 120 francs a year, payable in two installments. His was only
one among a number of independent studios. François Picot's was
equally esteemed, and the rivalry between the masters was played out
by their respective pupils, who mocked each other's work. Either of
these studios could prepare a student for the Ecole des Beaux-Arts
and its arduous competitions. But Couture did not encourage his
pupils in that direction, perhaps still nurturing a grudge because he
had repeatedly competed for the Prix de Rome but failed to win. Any-
thing that smacked of the Académie was anathema to him, as was its
opposite — realism. In the preface to his *Méthode et entretiens d'ate-
lier,* he maintained, somewhat speciously, that he had never learned
anything from the academic tradition. He considered himself an au-
todidact not only in painting — "I have never been able to learn from
academic methods" — but even as regards general culture. The most
recalcitrant of schoolboys by his own admission, he claimed to have
acquired what little he knew merely from his "experience of life, his
observations, and the bits of information and books that reached him
like flotsam." A declaration of humility? Not from Couture. A formal
education in his opinion was a "useless luxury," a "standard slipcover
over the mind." All those gentlemen who "speak syntactically and cite
Latin aphorisms" struck him as mere "social parrots."[10] He neverthe-
less urged his students to read voraciously — "absorb, you are young,
digestion is easy for you" — and he recommended "Homer for prim-
itive simplicity, Virgil for rhythm, Shakespeare for passion, and
Molière for beautiful language."[11]

Auguste Manet could hardly denigrate a painter of Couture's repu-
tation, even if he was not a member of the Institut de France. But with
the Ecole des Beaux-Arts just across the street, it seemed unnecessary
to trek all the way across the Right Bank to a studio below Mont-
martre's windmills. On a street now called rue Victor-Massé, Cou-
ture's studio was a few steps south of the Place Pigalle. This was to

become and remain the southeastern edge of a large and varied artists' quarter, Batignolles, a quarter Edouard would make his own for the rest of his life.

Thus began a six-year apprenticeship that gave rise to a tangle of contradictions and conflicts. What Edouard did during the six months between his return to France in June 1849 and his first class at Couture's studio in January 1850 we do not know.[12] But we do know that during the latter part of 1849 a young Dutchwoman residing in Paris was hired to give Edouard and his younger brother, Eugène, piano lessons. Though repeated from one biography of Manet to another, this is not an obvious circumstance in view of the ages of the boys: seventeen and sixteen. However, one of Edouard's early letters from the *Havre et Guadeloupe* may shed some light. He informed his mother that there was a piano on the ship, a detail that might have served as an index of the comforts on board but would have been of greater interest to her if he had previously studied the piano and could thereby keep it up. Musical proficiency was much more widespread in well-heeled families of the nineteenth century than it is today. Eugénie Manet herself had a trained voice and often sang in her own salon and at *soirées musicales* elsewhere. Was it at one of those musical afternoons that she met Suzanne Leenhoff, perhaps as an accompanist? This young woman, in need of pupils to support herself, might then have been hired to continue the piano lessons begun years before.

Suzanne Leenhoff was the daughter of the organist of the Groote Kerk, the great Gothic cathedral of Zaltbommel, a prosperous town in southern Holland on the banks of the Waal River, a tributary of the Rhine. Among the many mysteries surrounding Suzanne is why a nineteen-year-old girl had left her family and come to Paris.[13] If it was to continue her studies at the conservatory or with a private teacher, no mention of either was ever made by any of the people who knew her and heard her play, nor is there any mention of public performances; her only known appearances at the keyboard were at informal gatherings after 1862. The earliest and most flattering portraits of her already show a matronly blonde of Rubensian proportions. Among the few verbal snapshots of her, there is no discrepancy in the way she was perceived. She was placid, plump, and an accomplished pianist. Her reported predilection for Schumann, however, suggests a romantic sensibility in addition to technical proficiency. As described

by a Manet relative, Suzanne looked much older than her young years and was *"très forte même sur le piano* [a double pun on the instrument, pianoforte, and the adjective *fort,* here in the feminine, which can mean proficient, loud, and corpulent]. She has a fine musical talent, but being Dutch has the shape and size associated with her countrywomen; otherwise she is blond and gentle."[14] Having little claim to being a heartbreaker, she may also have been undemanding, patient, and submissive.

Suzanne was not the kind of woman to attract the mature Manet, but Edouard was not yet eighteen when they met, and barely eighteen when he started attending Couture's studio. Moreover, Edouard was totally dependent on his father at that time and for years after. "Professional" women required money, and proper young ladies exacted marriage for a kiss. A compliant young woman of decent background was not without interest. Suzanne herself was doubtless lonely, with few opportunities to meet proper young men other than her pupils, whose families would not have considered her a social equal. Great musicians might be regarded as equals — Chopin, Liszt, Thalberg, also gave lessons for which they were paid — but they were celebrities, they were men, and their "pupils" were aristocratic ladies with considerable command of the keyboard. A nubile girl, not even French or the pupil of some famous pianist, who went around Paris teaching beginners had little social standing.

What may have begun as friendly sympathy between Suzanne and Edouard clearly evolved into a very different relationship by 1851. Its very nature reinforced, if not engendered, a side of Edouard that until then had not been evident. On the outside Edouard remained as affable, open, and generous as he had been since childhood. Inside, like the hollow wooden doll containing ever smaller effigies, was a very private, complex person who, out of need rather than lack of morals, learned how to protect himself by any means available, including deception. There were now two poles to Edouard's world, and an interior geography whose roads he shared with less than a handful of people. On those secret byways Edouard was to map his life as a man and as an artist.

According to Antonin Proust, in 1849–50 Edouard was of average height (at that time, little more than five foot seven), carried his svelte, muscular body tall, and walked with a brisk step that had a character all its own — a rolling gait he may have acquired walking barefoot on

the deck of a sea-tossed schooner. However well he imitated the drawl and slurred syllables of the Parisian proletariat, he could never manage to make himself sound vulgar, even though his natural voice had the huskiness of the typical *parigot*. His breeding came through in spite of himself. His soft red-blond beard, partly masking the teasing upturned corners of his mouth, harmonized with his already-thinning fair hair. And his clear eyes never missed a detail worth noting or a chance to smile. Summing him up, Proust said, "Few men have ever been so captivating." A fellow painter, Giuseppe De Nittis, an Italian transplanted to Paris, loved him for his "sunny soul" and his infectious gaiety. In addition to his physical charm, he had a quick mind, a sharp but never malicious tongue, and a warmth that not even his later detractors could deny. "No one has ever been kinder, more courteous, or more dependable. Never did I hear a nasty word from him about anyone. . . . He was feared because he could express himself with a sharpness, an originality . . . that marked the ridiculous, the mean and the mediocre with an ineradicable stamp. His is a kind of joyful mockery that makes contempt barely perceptible."[15] Much of this was already apparent by the time Edouard entered Couture's studio.

Thomas Couture was thirty-two when he announced in print his intention to open a school. His enormous success at the Salon of 1847 entitled him, he thought, to regard himself as a *chef d'école*. The text of his announcement proposed nothing less:

> M. Couture opposes the spurious classical school which reproduces the works of bygone times in a banal and imperfect fashion. He is even more hostile to that abominable school known as "Romantic" and views with disfavor the tendencies toward petty artistic commercialism.
>
> His teaching is based above all on the great art of ancient Greece, the Renaissance masters and the admirable Flemish school. He believes that it is necessary to study all of these schools in order to reproduce the wonders of nature and ideas of our time, in a noble and elevated style. . . . Such are the bases on which M. Couture's school is founded.[16]

His pupils were virtually unanimous in their appreciation of their master and his methods.[17] All except Manet, according to Antonin

Proust, who remembered nothing but frictions and discontent. Proust himself had enrolled in Couture's studio, so it is hard to discredit his account of Manet's years there. It must nevertheless be tempered not only by other accounts but also by the fact that Manet remained with Couture, despite the heated repartee between them, for six years, well after Proust had ceased attending classes to become a journalist.

Couture had very definite ideas about the techniques of art and communicated them volubly on his biweekly visits to his students (he later published them in his *Méthode et entretiens d'atelier*). Short, round as he was high, and convinced of his superiority over the other painters of his day, he would light a cigarette and perorate on his own greatness while commenting on the work done by his pupils. His teacher had told him that he would be the Titian of France; Couture believed him. Much as he despised academic pedagogues, he shared with them, as did Delacroix, the conviction that drawing was essential to great painting. "Musicians will tell you: scales, scales. I tell you: drawings, drawings." Moreover, like Delacroix, he believed that a great artist had to be able to sketch quickly. Delacroix had said that if an artist lacked the skill to draw a man falling out of a fifth-floor window in the time it takes for him to hit the ground, he would never produce "monumental work."[18] Manet had that gift before he became an art student.

Couture also argued for spontaneity — "Give three minutes to looking at a thing and one to painting it" — and for retaining the immediacy of the *ébauche*. In his view, and in his work, this preliminary roughing-in of paint on canvas should show through the finished work. Whereas the *ébauche* had provided an underpainting for the Venetian painters of the sixteenth century, Couture saw it as a means of expanding the range of middle tones by thinly spreading a single tone with a large brush over the various surfaces of the underpainting. Moreover, it served to conceal the effort that went into producing the finished work by leaving visible those craggy surfaces without thick layers of multiple tones. He also shared with academic teachers the practice of copying museum art, though not in the slavish academic manner but in a personal interpretation. Couture felt that whatever his pupils looked at, whether ancient statues or old master paintings, they should see with their own eyes. "Originality," he declared in a chapter he wrote on the subject, "is a matter of conveying one's impressions accurately."[19] And it was the *ébauche* that was to

keep those first impressions vivid, without the addition of extraneous details.

Another cardinal rule of Couture's was purity of color, which could be achieved only by mixing colors as little as possible. That meant that pure tones were applied in different thicknesses, spread more or less densely on the underpainting, which gave the effect of half tones. "Why set out to mix half-tones?" he asks in his *Méthode et entretiens.* "However clever you may be, your flesh tints will take on colors that do not belong to them and will look wrong. A half-tint simply means a less bright light, and this you can achieve by a judicious softening of your principal light over the surface of the underpainting."

The underpainting, or *ébauche,* was thus of major importance, and for that Couture had his personal recipe. First a "sauce" of heated oil and terebenthene (similar to turpentine), then a mixture of black and red-brown oil pigments to produce a bistre tone.* The drawing was previously traced and sketched onto the canvas with charcoal, which he preferred to chalk. "Tap the canvas like a drum so that the charcoal falls off. Then dip your sable brush — a long one — into your sauce, then into the bistre and trace all your contours," Couture instructed his students. These culinary "sauces" and "juices," as they were ridiculed, this brown *ébauche* that was Couture's requisite for all painting, was what exercised Manet. Couture was not alone in his use of this dark underpainting. From early in the century, painters had been imitating the dark canvases of old masters, darkened with soot and grime rather than a deliberately dark palette. Bitumen, a black-brown tone less red than bistre, had traditionally and generously been used for the painted sketch, so that after 1855 much of earlier nineteenth-century painting was rejected as too dark by the outdoor painters who rebelled against its use: *"A bas le bitume!"* (Down with bitumen!) was their battle cry.

Perhaps the most important lesson Manet learned from Couture, along with the retention of the sketch in the completed work, was how to evoke rather than represent literally. There had been earlier attempts in this direction — late Titian, late Hals, Velázquez, Rembrandt, Goya — but they had not gone as far as Manet would go. The

*Bistre is a brownish color obtained by boiling the soot of wood in water.

sum total of Couture's teaching was to play a greater role in creating "éd. Manet," as he often signed his works, than Antonin Proust and others have been willing to recognize. That Manet himself was aware of this is shown by his assiduous attendance of Couture's classes for six years, however vehemently he faulted them. What Proust reports are Manet's vituperations, which are colorful as well as illuminating; they are the first gospel of Manet's views on art. But what he thought he owed Couture, we are told by neither Proust nor by Manet's first biographers — Zola, Bazire, and Duret, all of whom had known him personally, though later than Proust.

Keeping in mind that Couture's studio was on the ground floor — nothing like our notion of a studio flooded with even daylight from a glassed north wall — we can hardly blame Manet for being exasperated. "I don't know what I'm doing here," he complained to Proust. "The light is false, the shadows are false. When I come into the studio it seems to me I'm entering a tomb." Nor can we blame him for railing against the mannerist poses into which models contorted themselves. That was the way models had been posed for centuries, to make their muscles flex and their anatomy visible. It was done for the benefit of the students who had to learn how to represent the body with all its volumes. And the models themselves, professionals with a pride of métier, were convinced that they were performing a great service for art.

It is in this context that we must understand the exchange between Manet and the veteran model Dubosc, recounted by Proust. Edouard had thrown up his hands at the poses taken one day. "Can't you be natural! Is that how you stand when you buy radishes at your greengrocer's?"

Dubosc proudly replied that Delaroche* had nothing but praise for him and that it was offensive for a "young man," clearly meaning a nobody like Manet, to teach an experienced model. When Manet had the even greater temerity to retort, "I did not ask you Delaroche's opinion. I am giving you mine," Dubosc was beside himself with rage.

*Paul Delaroche, a member of the Institut de France, died in 1856 at the age of fifty-nine after a distinguished career as a history painter and portraitist. Couture studied with him for four years after the death of his first master, Baron Gros.

"Monsieur Manet, thanks to me, more than one painter has produced compositions that led him to Rome [the Prix de Rome]." Manet was unimpressed: "We are not in Rome and have no wish to go there. We are in Paris and intend to stay here."

One day Manet went even further in his determination to obtain naturalness from the models. He managed to cajole one of them not only into a simple pose but also into retaining some of his clothing. When Couture came in, he wanted to know who had dared defy his methods. Learning it was Manet, he asked him pointedly, "Are you paying the model not to undress? Come now my boy, you will never be any more than the Daumier of your time."

Daumier was known only as a lithographer at the time (his paintings are little known even today), a social and political caricaturist of his own era and a gifted draftsman whose realistic portrayals of the man in the street were askew just enough to convey his mockery. To Couture, "realism" in art, art that did not seek to ennoble the subject but represented the ordinary as ordinary, was intolerable.* However much Daumier may have been appreciated in his day, the comparison was clearly unflattering to Manet, who for once left without the last word. But on second thought he told a group of his friends later, "The Daumier of my time? After all, that's as good as being its Coypel."[20] The Coypels, a family of seventeenth- and eighteenth-century academic painters appointed to the court, were known for their nymphs and satyrs.

This slight to Couture was perhaps even more acerbic than being likened to Daumier, since Couture fancied himself more original than the conventional painters of historical subjects. In the final analysis, his techniques were his only claim to originality. His dictum — "Make sure first of all that you have mastered material procedures; then think of nothing and produce with a fresh mind and hearty spirit whatever you feel like doing" — did not produce works of genius. In this, at least, he was modest: "I do not claim that I can turn out geniuses to order, but I do train painters who know their job." The posturing generals, the simpering Venuses, the epic heroes in their

*See Couture's *Réaliste* — a painter seated on an antique head sketching a pig's head before his easel, his umbrella and knapsack in the corner evoking the new movement of plein air, or outdoor, painting.

cuirasses, the Roman consuls and Greek gods no longer had any meaning in the mid-nineteenth century. There were now trains, gas lamps in the streets, and machines in the factories. It was time for art to reflect modern life. "At the time Manet appeared on the scene," notes Théodore Duret, a friend and art critic, "a conflict had thus arisen between the artists in favor, determined to maintain an outdated tradition, and those students who were . . . aspiring to create art forms suited to new needs. Couture was among those who wanted to maintain indefinitely the formulas of the past."[21]

Couture's *Méthode et entretiens* nonetheless reveals how innovative he really was, and how far-reaching was his influence on Manet, even if Manet neglected to admit it. In a remarkable passage that replies to the rhetorical question "What is left for artists to do today?" now that such great masters as Raphael, Michelangelo, Veronese, Rubens, Rembrandt, Greuze, and Watteau had exhausted the problems of color, composition, and subject, Couture says:

> I would have rendered you a pitiful service indeed if my teaching were to bring you to this kind of despair. *Everything is new, everything remains to be done.* Human nature is always the same, but changes of governments, religions, beliefs, make human feelings appear in new guises; they take other forms, other aspects, and necessarily give rise to new arts. I did not make you study the old masters so that you would always follow trodden paths. Those lessons were indispensable to give you fluency in the language. Now that you possess it, speak; *but speak in order to relate your own times.* Why this antipathy for our land, our customs, our modern inventions? . . . You say, "But the ancients never did anything like that!" For the very good reason that such things did not exist.[22]

Far from "formulas of the past," Couture went on to propose subjects of astonishing modernity — the locomotive, workers, soldiers, public spectacles — each of which is described and discussed with a freshness of vision that makes one wonder why he did not attempt them himself, since he was among the first to recognize the academic decrepitude into which French art had fallen.

Fifteen years later, in a letter to Manet, Baudelaire would write the cryptic remark that has often been quoted but never explained: "You are only the first in the decrepitude of your art."[23] Small consolation

for the humiliations Manet was then suffering over *Olympia*'s reception by critics and public alike. Yet Manet must have understood that Baudelaire, though chiding him for his petulance, was telling him that art had become so vitiated that Manet had no right to expect understanding or approval, nor was he the first in that uncomfortable position. Delacroix also had been vilified, and there was no question in Baudelaire's mind about Delacroix's genius. It would take more than one or two paintings to revitalize art, even if those works were by the most outstanding painter of the moment — Manet himself. What is both surprising and troubling is the absence in all of Baudelaire's writing of any response to Manet's paintings. All that remains on record is a general appreciation of Manet's talent (in a letter to Mme Manet) and specific admiration for his 1862 lithographs. But much of what Baudelaire wrote about the painting of modern life seems to have sprung from ideas disseminated in Couture's classes, which could easily have been transmitted by Manet during the late 1850s and early 1860s, when they saw each other almost daily. The introduction to Couture's *Méthode et entretiens* is dated November 15, 1866. Even if he did not put pen to paper until then, he had been communicating his ideas in his classes for close to two decades.

Couture's role in Manet's life may have gone beyond the studio. That Manet endured Couture's jibes and arrogance for so long proves not only how diligent an art student he was but also how important Couture was in his development. It is not hard to see Couture in the role of surrogate father. Between them was a generational gap not only in age but also in their views of painting. A similar gap separated Edouard and his father in their views of a career. Just as Auguste Manet hoped his son would become a jurist like him, so Couture was said to have wanted to mold his pupils in his image. But he did not want slavish imitators: "You are all trying to be little Coutures," he berated his students, "as though it were worth a rabbit's fart merely to be a little Couture!" Nonetheless, the only kind of originality he tolerated was his kind. One can hear the rebellious offspring seeking to emerge from the shadow of the "father" in the altercation over a painting Manet had done of a noted model, Marie the Redhead. Before Couture arrived, the other students had applauded its candor and strong draftsmanship, worthy of Ingres. But the master, after admiring the work done by all the others, stood in front of Manet's easel and said only, "When will you decide to paint what you see?" Manet,

emboldened by his success with his fellow students, replied, "I paint what *I* see and not what it pleases others to see; I paint what is there and not what is not." This was an insolence Couture could not swallow. "In that case, my friend, if you aspire to being the leader of a school, go start one, but not here."[24] Manet stormed out, but after pouting for a month, he returned to the studio at his father's insistence.

Auguste had acquiesced to his son's desire to study art, but that did not mean approval. What proof was there, beyond a few admittedly talented sketches, that Edouard would ever amount to anything in so chancy a field? Edmond Fournier also could produce talented sketches. That had not made him a Salon painter or a member of the Institut of France. Paris was full of amateur sketchers and mediocre painters. Law, medicine, or engineering could be learned and practiced; one did not have to be a genius for that. But art? Learning the techniques did not make an artist. That was in the realm of metaphysics.

Edouard understood that not until he had successfully competed for a prize, had a painting accepted at a Salon, or, better yet, won a medal would he gain his father's approval. In a family like his, the expectations were obvious, as were the standards of measure. His grandfather had been so respected a mayor, citizen, and jurist that a street had been named after him in Gennevilliers. His father wore the red ribbon of the Legion of Honor and had a tenured seat on the bench. His uncles and cousins were career officers or lawyers; the stamp of success, professional and material, was on every one of them. So long as he was an apprentice artist, Couture was his only source of approval. His fellow students might applaud, hang a garland on his easel, offer him a drink to celebrate his return to the studio, but only the master could satisfy his need for approbation. And Couture, doubtless irritated by Manet's insubordination, perhaps even resentful of his originality, refused to grant him that.

Emulation, the determination to outdo, or defiance, the determination to do differently, enters into every relationship of this kind. For Manet the problem was compounded by the presence of two father figures. Couture he would outdo, on his own turf; his father he would defy, and in more than one way.

Two mother figures also can be perceived in Manet's early life. He was deeply attached to his mother. They shared an artistic sensibility,

the capacity for affection, and a genuine interest in each other, as evidenced by the letters from Rio. That almost all were addressed to her indicates the ease and the pleasure he had communicating with her. Her temperament was very different from her husband's, and Edouard surely sensed that much was lacking in their marriage, however correct — like everything else in the house. Proust's description of Auguste and his style of living can be read as the approval of a like-minded upper-bourgeois Frenchman, though not without a touch of irony: ". . . not a discordant note. His furnishings, the way he dressed revealed the cult of simple and moderate things that are the mark of French taste." Proust understood art and artists, shared a long friendship with Edouard, and knew intimately the stolidity and philistinism of many of his countrymen. The word *cult* here reveals more than taste; it is an ideology, one that was imposed on Eugénie by her husband. This may have colored Edouard's attitude toward his piano teacher, Suzanne Leenhoff. She was gentle, lonely, and talented, and she appreciated him. She offered him her love. By becoming her lover, Edouard, so to speak, killed two birds with one stone: he "married" his mother; he challenged his father, defying his father's judicial and patriarchal morality not only by seducing a young woman but by seducing the very woman his father employed to teach his sons — an analogue to the woman his father had married to raise a family.

Manet was a diligent student. He spent his days at Couture's studio and his evenings at the Académie Suisse, beside the Palais de Justice on the Quai des Orfèvres. This was a studio opened by a former model — a man by the name of Suisse, of whom Cézanne has left a portrait — where no method was taught and the only expense was a small fee for the models. From seven to ten in the evening, budding artists could work from live models. Monet, Pissarro, Guillemet, and Cézanne all went there in 1861. In good weather Manet made working excursions to Fontainebleau, where the Barbizon painters were experimenting with painting landscapes out-of-doors in natural light. It had only recently become possible to work outside the studio: pigments could now be bought in tin tubes, and easels were collapsible, thus making an artist's equipment portable. While Manet was assuredly determined to make rapid strides, his devotion to his art also provided him with greater liberty than he might otherwise have had. Suzanne's apartment was a brisk walk from Couture's studio, on the rue Fontaine-au-Roi, a working-class quarter to the east bordering on

Belleville. No longer obliged to account for every hour he spent away from home, he was nevertheless held in check by his father's tight purse strings.

On January 29, 1852, Suzanne gave birth to a son, named Léon-Edouard. She was two years and three months older than Edouard, who had celebrated his twentieth birthday just six days before Léon was born. Many illegitimate births at that time were listed in the municipal records without a father's name, which was not required by law. In this instance, the father's name appeared simply as Koëlla, no first name; the mother's as Suzanne Leenhoff. She must have conceived the child in April or early May of 1851. Once Suzanne's condition could no longer be disguised, she doubtless had to give up teaching. Deprived of her income, she would have been destitute unless she returned to her family in Holland. But that she did not do. Instead her widowed paternal grandmother, Suzanna van Aanholt Leenhoff, left Holland to come and live with her in Paris (she may have come even earlier). In view of this, some speculation does not seem out of place. Since Edouard's monthly allowance was doled out with a tight fist,[25] it is not improbable that he was forced into taking his mother into his confidence in order to support Suzanne. It is also not improbable that a promise was exacted or volunteered that he would marry Suzanne as soon as he became financially independent — that is, when he was established in his career or had come into money of his own. According to Léon's baptismal certificate, he was not baptized until he was almost four, which at the time was uncommon in view of the high infant mortality rate caused by such widespread diseases as diphtheria. This seems to indicate that the ceremony was postponed month after month, year after year, in the hope of regularizing an impossible situation. Finally, on November 4, 1855, in the Dutch Reform church of the Batignolles, Suzanne's grandmother and namesake presumably served as Léon-Edouard's godmother* and Edouard, a twenty-three-year-old Catholic, as his godfather.

This alone should indicate the true nature of the relationship between the three principals. Ecumenical attitudes of today were hardly prevalent in the nineteenth century. Godparents were expected to be

*Although the names are identical on the certificate of baptism, it is highly unlikely that a mother would be the godmother.

of the same religion as the parents, since they were responsible for the spiritual and moral upbringing of the child in the event of the parents' demise. One can only marvel that the pastor who performed the ceremony consented to such an arrangement, however liberal-minded he may have been, unless he had received from the godfather his solemn vow to marry the child's mother as soon as circumstances permitted. The baptismal ceremony, with Edouard as godfather, would thus have served as a provisional marriage, baptism being a holy sacrament, as well as a provisional recognition that the child was his, suggested by Edouard's name. It is not uncommon for a child to be given the name of a godparent, but Edouard was anything but a suitable one. In the eyes of anyone who knew him, even his presence as a guest at this baptism would have appeared strange. Later the child was passed off as Suzanne's godson and youngest brother. She already had two: Ferdinand, eleven at the time of Léon's birth, and Rudolphe, eight. She also had two sisters.

Until the death of Suzanne's grandmother in 1860, Suzanne, Léon, and later her two brothers lived together on what is now the rue Nollet, just northwest of Place Clichy and a few minutes' walk from the Manets' apartment on the rue de Clichy, to which they had moved in 1855. The presence of Suzanne's grandmother, who had some means of her own, and the two young boys who came to Paris to study art may have made a convincing family portrait. Victorian morality — observed on both sides of the Channel — dictated that appearances were all that really mattered. In notes that Léon wrote long after Suzanne's death, he speaks of her grandmother as *la grandmère* but never refers to Suzanne as *mère,* instead calling her "Moedge," which sounds like a corruption of *moeder,* the Dutch word for mother. Nor did anyone in Suzanne's lifetime ever speak of Léon as her son. After his great-grandmother's death, Léon's notes reveal, Suzanne, Edouard, and he shared a one-bedroom apartment on the rue de l'Hôtel de Ville, across the street from the *mairie* (town hall) of Batignolles: "Before their marriage, in 1862 and 1863, Eugène [Manet's second brother] often came [to visit]. . . . I slept on a folding bed in the living room."[26] This leaves no doubt that at least one member of the Manet family was fully apprised of the situation.

Since then many other details have come to light that render patently false this whole concoction of relationships. The society of the time sanctioned the double lives conducted by many middle- and

upper-class men, so long as they remained undiscovered. Many bour-
geois marriages, not unlike royal marriages, were contracted to pro-
tect family properties and fortunes by providing heirs and a suitable
setting for raising them, and for entertaining guests. Decorum was
preserved by appearances: the paterfamilias presiding at his dinner
table. Manet's probity was as zealously guarded by memorialists who
had known him for decades (Bazire, Duret, Proust) as by those who
had known him only at the end of his life or not at all (De Nittis,
Blanche, Tabarant, Moreau-Nélaton). What some did was to provide
all the pieces of the puzzle and then, when they were all fitted to-
gether, deny the image that emerged. Others simply maintained total
silence. Suzanne's reputation and the family's name no longer require
such masquerading. In the context of this biography Suzanne and
Léon constitute a crucial psychological factor in the development of
Edouard's personality and in the evolution of his art, both of which
can be seen as a series of contradictions and camouflages.

The Making of Paris

The Paris Edouard Manet beheld when he left Couture's studio was a city in the midst of radical transformation by an urban planner of unparalleled vision. Baron Georges-Eugène Haussmann, Paris born and bred but of German Protestant origins, became prefect of the Seine in 1853 at the age of forty-four. A trained musician (at the Paris Conservatory) and lawyer, he also had a gift for finance, which he practiced before entering politics. His daring ideas and even more daring schemes to finance them produced the central Paris that we see today, along with diatribes against his use of public funds. One of them, punning on E.T.A. Hoffmann's *Contes fantastiques* (Fantastic Tales), attacked him in a widely read work titled *Les Comptes fantastiques de Haussmann* (Haussmann's Fantastic Accounts). Half a billion francs had been borrowed between 1867 and 1869 alone, not counting all the money spent during the preceding years. But there is no doubt that Haussmann left something to show for it. Not since Rome had been renovated by its Renaissance popes had urban planning been conceived of with such largesse, and never before had anyone undertaken to rebuild the center of an ancient capital, including its municipal services.

Library shelves are stacked with volumes written on the "Haussmannization" of Paris, some deploring the eviction of the poor from the center to make way for the dwellings, businesses, and entertainments of the new leisure class, others commending the city's new water supply, the vast expansion of the sewers, the additional bridges, and the illumination of the streets (only a decade earlier, streetlamps

had been left unlit when the moon was out). Marxists demonize Haussmann for having amalgamated the moral and physical life of the city into solid capitalism. Romantics lament the loss of twisting old streets, of variegated neighborhoods where artisans mingled with jurists and workers lived on the upper floors of buildings occupied by gentry. Even that great champion of modernism, Baudelaire, in "Le Cygne" (The Swan), mourned the Paris that was no longer: "Le vieux Paris n'est plus. Le coeur d'une ville / Change plus vite, hélas, que le coeur d'un mortel." And Hugo railed from his self-imposed exile against the transformations he had not yet seen.

Still others see Haussmann as a dynamic innovator who transformed medieval mazes, some of them filthy cobbled alleys lined with hovels, into tree-lined avenues with paved sidewalks radiating from grandiose new spaces such as the Place de l'Opéra, the Place de la Nation, and the Etoile, as well as from previous constructions. Like it or not, the city familiar to twentieth-century visitors is the city memorialized by artists and photographers of the late nineteenth century, the city Haussmann built: the broad, straight thoroughfare of the rue de Rivoli, the oases of shaded parks and flowering gardens, the sandstone apartment houses with their tall windows and wrought-iron railings, the Gare Saint-Lazare and its radiating streets commemorating the capitals of Europe.

During the seventeen years of his tenure, 1853–70, Haussmann replaced more than three hundred miles of twisted alleyways and haphazard streets with eighty-five miles of open thoroughfares. Under his aegis were created a new opera house, the grandiose avenue de l'Opéra descending from it (constructed from both ends toward the middle, like a tunnel, it took more than twenty years to complete), the boulevards that transect it, and the central markets, Les Halles, under glass-and-steel pavilions (now demolished). He may have "torn down half of Paris to build the other half," as was grumblingly said at the time (he did indeed tear down twelve thousand buildings), but he spared most landmarks, even enhancing them as the focal points of his radial streets or the terminals of his straight ones. The price was high in the number of dispossessed, and perhaps even in the uniformity of the center's new appearance. Much of the city, however, was left intact, such as the noble sixteenth- and seventeenth-century quarter of the Marais on the Right Bank and the aristocratic eighteenth-century quarter of Saint-Germain on the Left. Haussmann left his

mark on the Left Bank by bringing it into the heart of modern Paris when he opened up the Boulevard Saint-Michel, connected the Boulevard Saint-Germain and the Boulevard Raspail, and rebuilt the Ile de la Cité.

One social historian, responding to the frequent charge that Haussmann segregated rich neighborhoods from poor ones, maintains, "In the final analysis, he mixed the population more than he fractionalized it. If, in fact, one looks for the idea, or rather the intuition that inspired the totality of his enterprise, one recognizes that far from wanting a differentiated growth for Paris, he felt that a modern city is characterized by the plurality of its centers of interest and that it was thus essential for life to circulate freely in it."[1] In all the polemics over Haussmann's transformations of Paris, it is frequently forgotten that renovations had already begun in the 1830s under the reign of Louis-Philippe and that extensive demolition had taken place during those eighteen years. There is, however, a major difference in the order of magnitude. Haussmann, unlike his predecessor under the previous monarch, was not content to lengthen a few streets and increase the number of streetlamps. He went about his renewal in all directions at once, without priorities. Hospitals, bridges, railway stations, the opera house — everything was planned simultaneously.

The grandest project of those years was the connection of the Tuileries to the Louvre. Begun in 1852, it was miraculously finished in five years. The construction site had become the destination of Sunday strollers, who, for one sou, the equivalent of today's penny, could buy a brochure describing the "Louvre of Napoleon III." Privately owned art galleries, a new institution then, hastened to profit from the many strollers with money to spend. Some were open for business even on Sunday, when the seductive new department stores were closed. On the fashionable rue Lafitte, they displayed works by painters familiar from the Salons: Bonvin, Decamps, Fromentin, Gavarni, Chassériau. On the more popular Boulevard Montmartre, one could see works by less conventional painters, among them César Ducornet, born without arms, who had learned to paint with his right foot.

The new streets and renovated quarters — some safe for the first time with police to guard them and streetlamps to light them; the green parks; a major new church, Saint-Augustin; the splendid new square in front of Notre-Dame that allowed one to see its facade from

a certain distance; and the new Orangerie in the Tuileries invited Parisians to participate in the grand spectacle of the city's new beauty. The wish of Napoleon III, and of the genie who would fulfill it, was to make Paris second to no other capital (specifically London, where Louis-Napoleon had lived in exile) in splendor, comfort, and modernity. By the time the so-called Louvre of Napoleon III was completed, Paris had a population of more than a million; it was already a metropolis. A decade later the population had almost doubled (1,825,000), and the inclusion of formerly suburban districts had more than doubled the dimensions of metropolitan Paris. A city of that size could no longer tolerate bad water, outbreaks of cholera (nineteen thousand perished in 1832 and another sixteen thousand in 1849), and crime-riddled streets, nor would the regime tolerate serpentine alleys, where it was impossible to put down insurrections.

Haussmann's Paris is a monument to the wealth, progress, and security of the bourgeoisie — a ruling class that had come into its own after the revolutions of 1830 and 1848, that traveled in trains, made products with machines, ate in restaurants, chatted in cafés, and made money with money. Haussmann laid out the Bois de Boulogne, which became — with its lakes for rowing in the summer and skating in the winter, its zoo (now an amusement park for children), and its bridle paths and avenues — a controlled countryside for the pleasure of city dwellers. The Bois was not limited to the leisure class. Banker and baker, empress and salesgirl shared the spaces and the facilities. A lithograph of the time shows Emperor Napoleon III in the Bois skating beside Empress Eugénie, her sleigh pushed along the ice by imperial aides, while ordinary Parisians skate or ogle in the background. The gardens of the Luxembourg Palace were reduced and redesigned to make room for the Boulevard Saint-Michel. Railway stations were built or rebuilt to circle the outer ring of the center, and broad avenues cut through convoluted streets to provide easy access for the efficient circulation of goods and people and the rapid deployment of troops in the event of civil disorder. The memory of barricades erected with paving blocks in 1848 was a powerful reason for macadamized pavement and straight thoroughfares.

Much of Haussmann's Paris engaged in the kinds of financial services that became the industry of New York in the 1980s — acquisitions and mergers, real estate ventures, stock speculations — and enjoyed a similar boom in real estate development. Likewise, Hauss-

mann's Paris saw a steadily rising population of homeless, a widening gulf between rich and poor, an explosion of luxury goods and available sex, and an epidemic of venereal disease. Syphilis rampaged throughout the period, as deadly and as widespread as that other pox, smallpox, which had intermittently devastated Europe. In French they even bear the same name, distinguished by degree: *petite vérole,* "smallpox"; *vérole,* "syphilis."

The period saw the rise of a new class of millionaires ("Now that money is everything, the Bourgeois who wants to be somebody is obliged to become a millionaire: the conquest of a million is the only thing that can distinguish him from the Bourgeoisie," remarked a contemporary), a generalized spending frenzy, and, most notable, private life in public places. Whereas the home had previously been the locus of middle-class entertainment, restaurants, cabarets, cafés, and ballrooms now took over as the site for flirtations, discussions, and business deals. Anybody could get rich, anybody had a right to an opinion (after the first eight years of Napoleon III's rule), and anybody could go anywhere. Money was power.

This was Manet's Paris, and he was one of the fortunate, along with a few of his fellow painters (Degas, Fantin-Latour), who had the status and the means to participate in its pleasures. But there was more than one face to the city and to its more sensitive inhabitants. This was the time of the *homo duplex,* or "two-sided man" (a term dear to Baudelaire) — decadent and progressive, clinging to old forms (academic art and bourgeois propriety) while reaching out for new expressions (realism, impressionism, steel and glass, world's fairs). This was at the heart of what Baudelaire called *modernité* — "the transitory, the contingent, that half of art whose other half is eternal and immutable."[2] The gaiety, promiscuity, and progressivism of the second half of the nineteenth century was underlaid with an awareness of loss, of individuality, of values. Whereas earlier art had continued to re-create aspects of the eternal — gods, heroes, Christ, saints — the art of the nineteenth century made a decisive break with the past, despite brief restorations of monarchy and neoclassicism. Here was a world in flux, without the foundation of time-tested mores, taste, morality, even images.

Baudelaire, whom Manet not only read but also saw on a daily basis, dwells on the problem of duality — life and death, spirit and flesh, God and Satan — in much of his work, as did the German and

French romantic poets who had preceded him. But he departs from these ambivalences in one of the most important poems of *Les Fleurs du mal* of 1857, in which he proposes plunging into the unknown depths of the abyss to find something *new* (his emphasis): "Plonger au fond du gouffre, Enfer ou Ciel, qu'importe / Au fond de l'Inconnu pour trouver du *nouveau*." That newness had to be found in the everyday world. This was the modern spirit of the old romantic duality: the human dilemma was eternal, but it had to be in modern dress and modern settings. Everything had to be observed, experienced: "Curiosity," Baudelaire wrote, "has to be considered the starting point of genius." His views on art and modernity evolved over a number of years. He eventually consolidated and published them in 1863 under the title "The Painter of Modern Life," widely held to be the source from which Manet drew his ideas about art. Baudelaire and Manet are generally assumed to have met in the salon of a common friend, Hippolyte Lejosne, in 1858. But even earlier, according to Antonin Proust, they had sat together over lunch, often in the company of Proust and other writers, at the Rôtisserie Pavard and at Dinocheau's, where one spent little and talked a lot.

Eleven years older than Manet, Baudelaire was chronically incapable of managing his inheritance and was finally reduced to receiving it in monthly installments. Though a published writer, and even something of a celebrity for the notoriety of the now classic *Les Fleurs du mal,* he was not a successful one. In 1857, when the collection was published, he, his publisher, and the printer were prosecuted for offending public morals. Each was fined, and six poems were suppressed. Baudelaire was constantly in debt, constantly reassuring his mother of his imminent success, constantly making grandiose plans that never materialized: newspaper articles, plays, "novels that would never emerge from their embryonic outlines."[3] He repeatedly borrowed money from Manet and became a frequent visitor to his studio. Until his departure for Brussels in 1864, they saw each other almost every day. On his return to Paris in 1866 — less than a year before his death and in the final stages of his fatal disease — Manet often visited him at the nursing home near the Etoile where he was confined. Suzanne Manet, one of the few "respectable" women of whom Baudelaire ever spoke kindly, provided him with music during his last months when syphilitic paresis had attacked his nervous system and he could neither walk nor speak, beyond a few syllables. Like

Baudelaire, Suzanne was a great admirer of Wagner and was known to play transcriptions of his operas, which she doubtless did when she sat down at the piano in the nursing home.

Baudelaire's sharp intelligence, his gift for language, and his intuitive response to art made him a stimulating companion for Manet. Theirs was never an intimate friendship, as proved by Baudelaire's total surprise when Manet left for Holland to marry Suzanne and the fact that the formal *vous* was never replaced by *tu,* as in the case of some of Manet's close friendships. But over the six years of their daily conversations they certainly talked about art, artists, and theories of art. Manet himself had already been exposed to Diderot's ideas about "realistic" subjects and poses and to Couture's documented interest in such radically progressive subjects as workers, laundresses, and trains. Baudelaire's essay "The Painter of Modern Life" is presumed to have been written between 1859 and 1860, though not published until 1863. Baudelaire thus had ample time to have seen what Manet was painting between 1859 and 1863. One cannot help wondering why he did not choose to identify Manet as "the painter of modern life." He chose instead to apply this designation — with extreme delicacy, merely by his initials, C.G. — to Constantin Guys, a newspaper illustrator. Was it because Baudelaire would have diminished his stature as "prophet" had he recognized Manet as the "messiah" foreseen in the essay? Or did he really not see that Manet was already doing what he claimed Guys was foreshadowing in his drawings of pleasure-seeking Parisians?

Although Baudelaire had written about the "heroism of modern life" as early as 1846, the ideas expressed in "The Painter of Modern Life" suggest that Baudelaire, whose idol and model ever since his first Salon articles of 1845 had been Delacroix — a painter hardly concerned with "the poetry of our cravats and patent leather boots" proposed by Baudelaire — may have acquired more ideas about modernity in painting from Manet than vice versa. In any case, outside of a brief mention of Manet's etchings, he never recognized Manet's achievement, at least not in print, not even regarding the groundbreaking work whose genesis he had followed from day to day, and in which he himself appears: *Music in the Tuileries.*

It is interesting to note the progression of Baudelaire's thinking, from rebellion against traditional values to the discovery of modern life, unidealized, and the desire for something new (the artificial,

makeup, the city, drugs, "anywhere out of this world"). This is the setting for the painter of modern life: not the Cythera of Venus, or the gardens of the Petit Trianon, or the battlefields of Napoleon, but the streets of Paris in all their elegance and sordidness. This is his subject: the man in the top hat and frock coat, the dandy who observes everyone and everything but reveals nothing of himself. The ideal modern artist must thus become this unobserved but "passionate observer" who watches the world yet remains hidden. He is a flaneur (a stroller), a tourist in his own land, whose scenery of choice is the crowd, "a prince who always preserves his incognito." He delights in "the rippling, moving, fleeting, infinite" multitude. Here is the artist as voyeur, seeing but unseen, "a mirror as immense as that crowd; a kaleidoscope endowed with consciousness."[4]

From this it is but a few strokes to the outlines of Manet's personality as a man and as a painter. Baudelaire put into words what Manet put on canvas, leading to the likely conclusion that they honed each other's ideas. George Mauner, one of the few to recognize in Manet more than merely a "temperament" (Baudelaire's term) behind his art, raised an intriguing problem:

> There is no doubt that when, in an effort to know the man, we compare Manet's paintings with the curiously unsatisfactory chronicles written by his friends — Bazire, Proust, Zola, Duret and others — we are faced with an inconsistency that leads to the conclusion, difficult as it is to accept in view of the artist's legendary worldliness, that Manet was secretive, that much of what puzzles us was intended to do so, that much of what appears enigmatic is indeed rooted in mystery — in short, that Manet cultivated the disturbing character of his pictures.[5]

What Baudelaire in his "Painter of Modern Life" enjoined the modern artist to do — "extricate from the fashionable what it contains of the poetic in the historical [moment] . . . the eternal from the temporary"[6] — cannot be achieved merely by portraying life with the kind of neutrality generally ascribed to Manet. While Baudelaire was molding a painter of modern life, he also was asking for more than a mere observer: "If the artist is not true to the constellation of his time, he will produce a work that is false. If, on the other hand, he has no sense of the moral and external meaning within the images he sees

and attempts to reproduce, the work will be fashionable but empty."
This second charge might be raised against the very exemplar Baude-
laire proposed, perhaps disingenuously — Constantin Guys, a pho-
tographer with a pen — or of certain contemporaries of Manet, but
not of Manet himself, whose every work is endowed with a thinking
presence, a personality. Manet saw a painter as more than a transla-
tor of images: "One has to have something to say, otherwise good
night. . . . It is not enough to know one's métier; one also has to be
moved. Science is all very fine, but for us [painters] the imagination is
worth more."[7]

Paris, the Paris of the 1860s and 1870s, was Manet's means of
avoiding either of Baudelaire's charges. The city — with its pristine
exterior, its soiled underside, its hollow entertainments — provided
the makings of an enormous duality: a two-sided mirror, a Janus
optic simultaneously looking forward and back, a spectacle and se-
cret life. In the words of T. J. Clark, "Paris was *parade*, phantasmago-
ria, dream, dumb show, mirage, masquerade. Traditional ironies at
the expense of the metropolis mingled with new metaphors of specifi-
cally visual untruth."[8] Seeing all this, Manet might have exclaimed,
"Paris, c'est moi!"

During his years with Couture, Manet not only had acquired the
techniques of studio art taught by the master; he also had gained the
experience of portraying life, death, and art. On December 2, 1851,
Louis-Napoleon fulfilled Manet's foresighted fear that he would be-
tray the republic. A coup d'état staged in the streets of Paris resulted
in lines of corpses in the cemeteries. This was Manet's first experience
of the politics of death. He would have others.

Edmond Bazire, Manet's friend and first biographer (his book
came out nine months after Manet's death), recounts how Manet left
Couture's studio with Proust to see what was going on in the streets.
They heard galloping hoofbeats, trumpet calls, and drumrolls ac-
cented by rifle shots. On the rue Lafitte, street of art dealers, they
were suddenly faced with a cavalry charge and no way to retreat.
Crushed against a doorway, they fell into the haven of an art dealer's
shop. When they emerged, after the cavalry had passed, they contin-
ued their wandering but were picked up by a patrol and kept over-
night in the station house for their own safety. The next day,
December 3, released into silent streets, they watched the executions
in front of the Hôtel Salandrouze, and on the fourth, with members

of Couture's class, they went to sketch the corpses laid out on the paths of the cemetery of Montmartre. "Many years later," Bazire wrote, "Manet remembered the episodes he had witnessed. He had only to revive his memories to reconstruct the horrifying drama of those executions and to retrace their sinister look and cold ferocity."[9] Bazire was evidently thinking of the execution of Maximilian that Manet would paint in 1867.

The coup d'état was not just two days of slumming for two nineteen-year-old art students. It was the beginning of a new era. Louis-Napoleon, limited by the constitution of 1848 to one term as president, had been preparing to fulfill what he had always believed to be his destiny. As president he had sent troops to put down Mazzini's republic in Rome, laying cruel siege to the city, thereby restoring the Holy See to Pius IX, who had fled when Rome was declared the capital of the new republic. With the church, the political right, and the army now behind him, Louis-Napoleon dissolved the National Assembly, called for a plebiscite to revise the constitution, and made sure voters all over France were intimidated by the presence of soldiers at the polling places into seconding his will. On December 2, 1851, when the National Assembly building was occupied by the army, the workers rose up in rebellion. The repression was brutal. Exactly one year later, Louis-Napoleon, son of Napoleon's stepdaughter* and erstwhile champion of republicanism, had himself crowned Emperor Napoleon III. Dreams of Napoleonic glory were revived while republicanism languished. This was when Victor Hugo left France in protest.

Barred from the ballot, persecuted, and exiled, republicans could only bide their time during the first eight years of Louis-Napoleon's iron rule and watch with horror as the hard-won freedom of the press was stifled. The rebuilding of Paris and other provincial cities, the construction of railroads, and the establishment of investment banks all contributed to imperial grandeur and tempered opposition from those in the middle class who benefited from such innovations. For

*Hortense de Beauharnais was Josephine's daughter. She married Louis, Napoleon's brother, who became king of Holland. Her dalliances have raised questions about Louis-Napoleon's legitimacy. His younger half-brother was fathered by the bastard son of Talleyrand, himself an illegitimate child.

republicans of the Manets' stripe — upper-middle-class conservatives in many respects but die-hard supporters of republican institutions — this was a time of trial. Manet's letters from his Atlantic crossing clearly indicate the political atmosphere in which he was raised, and subsequent letters over the years confirm his republican commitment.

In July of 1852 Manet made his first trip to Holland and saw Dutch paintings in their natural setting. Early the following year he traveled to museums in Kassel, Dresden, Prague, Vienna, and Munich, where, according to Bazire, he copied a portrait by Rembrandt. That summer he did nature studies in Normandy during a walking tour organized by Couture for his pupils. In September 1853 he stayed for more than a month in Italy, making the grand tour with his brother Eugène to Venice, Florence, and Rome. Bazire tells us that "in [Manet's] albums of that period, the entire trip is, so to speak, engraved day by day, stopover by stopover. His draftsmanship, which was his first, and enduring strength — he who was accused of not being able to draw — recalled the thousand motifs seen and immediately reproduced. He left sketches of fountains and mural decorations captured on the move with extraordinary verve."[10]

He was surely well acquainted with Italian art of the Renaissance before he went to Italy. There were masterpieces in the Louvre and volumes of engravings of old master art. An art student was expected to have a broad knowledge of the art of the past, even if he never left his hometown. Installments of Charles Blanc's encyclopedic fourteen-volume *Histoire des peintres de toutes les écoles* had begun to appear in 1849,[11] and engravings and copies had been available long before that. The majority of artists, who never won a Prix de Rome, which would have enabled them to study the original works, thus had a reasonable familiarity with the masters of the preceding centuries.

Among the copies made by Manet during his travels, most are of Italian paintings, copied either in Italian museums or in the Louvre, which, as Beatrice Farwell points out, is strangely contradictory "for a painter whose style is generally regarded as having derived much from Spanish and Dutch realism."[12] Of the extant copies, three are Titians (*Madonna of the White Rabbit, Jupiter and Antiope,* and *Venus of Urbino*); one a Tintoretto, the self-portrait; one a Filippino Lippi, the head of a young man; one a Rembrandt, *The Anatomy Lesson;* and one a Brouwer, *The Drinker* (or *The Smoker,* as it is variously known). There are also two copies of Delacroix's *Dante and*

Virgil (the only modern painting among his copies) and one copy of a painting formerly attributed to Velázquez, *The Little Cavaliers*. The quality of these copies was appreciated in Manet's lifetime. All but the Tintoretto self-portrait, which Manet gave to his brother Gustave, were bought by collectors. In addition to the painted copies, a number of his drawings after Italian artists (Andrea del Sarto, Ghirlandaio, Parmigianino) have survived.

Perhaps even more important than learning techniques and styles from the works of the great masters was the experience of drawing and painting from paintings rather than life: "the model is already reduced to two dimensions."[13] This was to prove a formative experience: the painting seen not as the illusion of reality, but as the reality of itself. Manet's exposure to Italian painting, both in Italy and at the Louvre, also taught him the vocabulary of pagan subjects and Christian symbols, as well as light and color, which he learned above all from the Venetians. The painted copies indicate his interest in old masters, but the drawings indicate that the interest lay not in their composition so much as in their rendering of the human form — its contours, shading, and movement.

In addition to the lessons taught by earlier artists, Manet had acquired ideas about painting from many sources before he ever started painting in oils. Proust recalls that Manet read Diderot's *Salons* while still at the Collège Rollin. Diderot, animating genius of the *Encyclopédie*, polymath extraordinaire, and France's first art critic, started reviewing the Salons in 1759. His articles, collected and published in book form, set a standard for later writer/art critics such as Gautier, Baudelaire, and Zola. In 1767, Diderot was already railing against the artificiality of studio models and academic painting: "Go to the parish church, linger near the confessionals, and you will see the true attitudes of piety and repentance. . . . Go to the tavern and you will see the true gestures of angry men. Seek out public places; be an observer in the streets, gardens, markets . . . there you will acquire accurate ideas of natural movement in the actions of life."[14] Describing the superabundance of details in a Boucher painting, he asked indignantly in the same passage, "Must a painter paint everything? Can't he leave anything to my imagination?" If ever anyone expressed the essence of Manet's art viewed in its totality — as he wished it to be seen — it was Diderot, almost a century earlier: "The truth of art is not concerned primarily with visual resemblance but with psycholog-

ical and moral verity." It is a great pity that Manet's only comment about Diderot, recorded by Proust, concerns Diderot's objection to portraying certain items of modern dress, condemned to falling out of fashion: "That's just plain silly," Manet argued. "One has to be of one's time and do what one sees, without worrying about fashion." This remark, dating from his years at the Collège Rollin, has often been quoted to prove that the adolescent Manet already had definite ideas about portraying modern life.

Manet more than likely also read the growing body of art criticism that was being published in the daily newspapers. Parisian newspapers regularly devoted numerous pages to the yearly Salons, but the International Exposition that opened on May 15, 1855, produced reams of opinions and explanations of the works shown; the articles were supposed to serve as a guide to the viewer. In addition to international pavilions displaying the latest technologies in farming and industry, twenty-eight exhibitor nations sent works of art, for the first time. French artists alone submitted 8,000 works, of which only 1,872 were accepted. Close to a million (935,601) visitors saw 41 canvases by Ingres and 35 by Delacroix, along with the thousands of other paintings and sculptures accepted.[15] Théophile Gautier waved the national banner: "Italy, having exhausted its mine of marvels, is now resting. . . . France, on the other hand, has grown. No pencil today draws better than hers, no brush paints better than her brush."[16]

There was no doubt that France was in the forefront in every way. Following the revolutions of 1789 and 1830, much of eighteenth-century French art had been dismissed as frivolous and overdecorated. But one of the period's most perceptive critics, Théophile Thoré, had recently restored its importance and given it new status. Thoré went beyond chauvinism to the notion of a European school, and in time a universal school, "to which nothing human would be foreign." The study of art would "grasp the analogies and harmonies that link [the various national schools] in a grand unity."[17] This idea was not lost on Manet, who, during the early 1860s, would attempt to fuse past and present, Italian, Spanish, and French, into a new vision of painting that may have been influenced by Thoré.

When Manet set up his easel in his first studio, he brought with him a considerable amount of intellectual baggage. He had studied not only the great masters of the past, but also the works of the modern French masters of the previous generation: Delacroix and In-

gres, representing romanticism and neoclassicism, respectively, and Courbet, the leader of the realist movement and the sensation of the 1855 International Exposition. Dissatisfied that only eleven of his paintings had been accepted for the Salon, Courbet set up a one-man show in a hastily constructed pavilion adjoining the official exhibition hall where he displayed forty paintings and four drawings, charging one franc for entrance and two sous for his manifesto, "Le Réalisme." Realism was a radical departure from the past. Its subjects were peasants, provincial townspeople, the activities of ordinary people in ordinary life; its purpose was not to tell a story, refer to Scripture or to some historic event, or preach a homily, but rather to portray the immediate, the momentary. "There is no need to return to history, to take refuge in legends, to summon powers of imagination. Beauty is before the eyes, not in the brain; in the present not in the past; in truth, not in dreams,"[18] declared Jules-Antoine Castagnary, the evangelist of realism. The sentimentality of literary painting and the hagiography of history painting were to be avoided at all cost. In his review of the Salon of 1857 Castagnary proclaimed the birth of a new art, "humanitarian art." For him, that Salon marked "the glorious date of the advent of humanity as the purpose of art. The momentum it has initiated will cease only when the theme has been exhausted, which is to say with the disappearance of humanity."[19]

To Couture realism was a betrayal of art: "Thanks to modern progress we have little to depict. The Laocoön* is replaced by a cabbage." He had nonetheless proposed trains and working-class figures himself. Even though Baudelaire took up the spirit of Daumier's slogan *"Il faut être de son temps"* (one has to be of one's own time) in his "Painter of Modern Life," he did not have in mind the kind of subjects Courbet's realism embraced, which some influential critics equated with ugliness. An uproar in the press had greeted Courbet's groundbreaking canvases *Young Ladies of the Village* (his own sisters), *Burial at Ornans* (his birthplace in the rural countryside southeast of Besançon), and *The Painter's Studio, A Real Allegory of Seven Years*

*One of the greatest ancient Greek statues, in the Vatican collection, showing the Trojan priest of Apollo and his two sons in a death struggle with a sea serpent. Having warned the Trojans not to touch the wooden horse, Laocoön was punished by a god defending the Greeks.

of My Life, shown for the first time in his privately held exhibition. To Parisians the young ladies in the first painting were provincial upstarts in their tacky Sunday best, playing at benevolent patronesses.[20] As for the scene of the burial, with its assemblage of small-town notables and anonymous inhabitants grouped without the usual perspective — a burial, moreover, that did not even identify the deceased — such a subject might interest Courbet's fellow inhabitants of Ornans, but not Parisians. Courbet was not even granted the quality of his craft. "You are in no way an artist," Maxime du Camp informed him in print. "Your friends have doubtless indulged you; they told you that your painting was original; it is common and easily achieved."

Just as Couture and Baudelaire disdained rural realism, they shared a distaste for the new medium of photography, which in Baudelaire's case is surprising given photography's poetic ability to capture the evanescent in all its spontaneity. Baudelaire, though interested in the portrayal of modern life, found the expression of his artistic taste in Delacroix's passionate, imaginative treatment of historical, biblical, and exotic subjects. Subjects for the modern artist could be found in top-hatted, frock-coated, patent-leather-booted gentlemen, fashionable women, urbane cafés, and city parks (and, for some, the seedier side of a metropolis: its morgue, shabby suburbs, and sordid taverns). All of this was being absorbed by the open mind of a young painter about to embark on a professional career.

Manet's studio companion on the rue Lavoisier was a gentleman of impeccable dress and breeding, Count Albert de Balleroy, four years older and a much appreciated painter of animals and hunting scenes. Sharing the cost of the studio was not only a financial boon; it also provided Manet with a colleague of compatible background and habits, and easy entrée into the art world of which Balleroy was an established member. From the studio, a few blocks behind the Madeleine, it was a short walk to the fashionable cafés on the Boulevard des Italiens, such as Tortoni and Bade. There they were less likely to meet other artists than other well-dressed young men and lorettes*

*A term that entered the language in 1840, referring to kept women, lower ranking than demimondaines, who got their name from the newly established quarter of Notre-Dame-de-Lorette, in the ninth arrondissement, where many lived.

dawdling over tea *à l'anglaise.* In 1851 Auguste Manet had moved his family across the river to a larger apartment on the more elegant rue du Mont-Thabor, immediately parallel to the rue de Rivoli and just below the Place Vendôme. Edouard was, therefore, close to his studio and to the center of Paris. Four years later the family moved again, this time farther north to the rue de Clichy, the epicenter of Manet's professional and personal lives for the next three decades.

By 1856 Manet had finished his copying and struck out on his own with two Christs — one a powerful head, heavy-browed, heavily bearded, framed by a sunburst, titled *Christ with a Reed;* the other, *Christ with a Hoe,* possibly the same model but more delicately rendered. He was not to return to this subject until almost a decade later, by which time his view of Christ would be affected by a book that rocked the literate world. A young priest, Abbé Hurel, whom Manet was to paint in 1859, had long been close to the Manet family. He was young enough to become and remain a close friend of Edouard, who gave him *Christ with a Reed* (Suzanne would later give him his own portrait). The two Christs of 1856 were apparently part of a larger project for *Christ and the Magdalene,* which Manet never completed. By curious coincidence, Hurel became vicar of the church dedicated to Mary Magdalene, the Madeleine (a neo-Greek temple intended, after repeated false starts, to be the pantheon of Napoleon's Grand Army; it was finally consecrated as a church in 1842), in the fashionable quarter of the new *grands boulevards* and expensive new brothels. One wonders about the conversations between the two men that might have led to such a project. Did they revolve around the theme of repentance and redemption?

In 1856 Manet's liaison with Suzanne was in its sixth year and Léon was four. Thoughts of a "fallen woman" and his own contribution to her transgression cannot have failed to cross his mind. In January 1852, when Léon was born, Manet had just turned twenty. If, as seems to be the case, he held himself responsible for the paternity of this child, his remorse and panic could have led to effusions of devotion and promises of rectification, which he may have meant sincerely when he made them. Lacking the means at the time, lacking perhaps the desire as well, he could not "redeem" this woman or her progeny with legitimation. But his fundamental decency, that goodness recalled by everyone who ever knew him, must have created a weighty dilemma for a young man whose entire life was still ahead of him. An-

other, less honest, might have told his mistress, as legions of young men of good families did at the time, that they could not assume responsibility; that although they may indeed have been very much in love, they had never entertained any thought of marriage; that even if they had, they would be disinherited. Literature and sociological statistics are full of abandoned ex-virgins from the provinces — nannies, housemaids, shopgirls — and not only in France.

Manet could, at best, be called a nominal Catholic. In his entire production of some five hundred works, only six depict religious subjects, five of them Christs, none on the cross or in the traditional scenes of adoration. Only one, of a monk praying (1865), may concern itself with faith. Like its many Italian and Spanish forerunners of monks or saints in prayer, it has in the foreground the most common emblem of vanity or mortality — a human skull, seen in profile on the ground. But here the monk is not contemplating the skull, nor does the skull appear to be much more than a studio prop. Was Manet ironically suggesting the vanity of prayer, showing us that even the most fervent believer ends up, like everyone else, a pile of hollow bones? Although his friendship with Abbé Hurel would continue throughout his life and Hurel would absolve him after his death, neither he nor any other priest would be summoned while Manet was still conscious. His contact with Catholicism seems to have been more intellectual than devotional.

Following his self-styled graduation from Couture's studio in the spring of 1856, Manet produced a bare handful of works. Up to 1858 his total production consisted of a dozen paintings, seven of which were copies. If he did not destroy a large number of canvases, then he was little drawn to his easel outside of class. Apart from the two Christs, he also did an interesting oil portrait of his classmate — a young, dark-haired, clean-shaven Antonin Proust, very different from the Edwardian Beau Brummell of Manet's 1880 portrait of him — that is a credit to his budding skills as a portraitist. He would spend the rest of his life perfecting them, constantly challenged by the difficulty of rendering a single figure: "It's damn hard to make a canvas interesting with only one person. And it's not enough to get the likeness. There's also the background that has to be supple, alive, for the background lives. If that is opaque, dead, then there's nothing left."[21] There is more than a likeness in this portrait. Bright light illuminates the right side of Proust's face as he looks off to his left in serious con-

centration. The strong jaw and chin, expertly shaded, and the furrowed brow attest to the character of the sitter's face and to the artist's ability to render detail without falling into the photographic slickness of traditional portraits.

In the winter of 1859 Manet set out to produce something truly innovative. Until then, though no longer enrolled as a student, he had maintained fairly cordial relations with Couture, never failing to show him the copies and sketches he made in his travels. Nor was Couture above asking Manet's opinion of his own work. Having just completed a portrait of a well-known opera singer, he showed it to Manet, who expressed his admiration but found the colors dull, overburdened with half tones. "So," Couture replied, "you refuse to see the succession of intermediate tones that proceed from shade to light." Manet had been struck under equatorial sunlight by the unity of tone in light. At the risk of brusqueness, he thought it was preferable to pass from light to shade without all the fussy coloring that the eye does not see, reserving that for shadows, which, unlike light, are extremely varied in their coloring. Couture apparently took Manet's remarks good-naturedly, but after Manet's departure he remarked to someone, indiscreet enough to repeat it to Manet, that Manet was "off his rocker." Hearing this Manet vowed that he would show Couture: "I'll give him a picture that'll knock his socks off."[22]

The painting he produced was *The Absinthe Drinker*. Presumed to have been suggested by a poem of Baudelaire's, "Le Vin des chiffoniers" (The wine of the ragpickers), it portrays a familiar street figure from the Bréda district, notorious for its brothels. The model, known only as Colardet, was so pleased with his sessions in the studio on the rue Lavoisier that he became an unwelcome and persistent visitor. The resulting *Absinthe Drinker*, which underwent various transformations — standing, sitting, lengthened, quoted in a later painting, adapted for an etching — was Manet's first "modernist" statement. He posed an alcoholic ragpicker with the attributes of his existence, in the same way that a Zeus would be shown with his thunderbolt or a Saint Sebastian with his arrows. But to be sure that this derelict would be seen as no less imposing a subject than his classical predecessors, Manet placed him in the context of Velázquez's philosophers — *Menippus* and *Aesop* — also derelicts, similarly dressed in cloaks tossed across their shoulders like the togas of their ancient forerunners. (In 1865 Manet would paint three more philosopher-

beggars, which indicates that the theme was not a passing fancy. The figure, whether street musician, drunk, or beggar, had a long tradition of representing the emptiness of worldly glory — in 1865 a bitter reminder of Manet's failure to achieve the kind of fame he sought.) By adding the bottle below Colardet's feet, Manet points again to Velázquez, the master he admired above all others, who often placed attributes at the feet of his figures. This was also the first of Manet's paintings to use acid yellow as an accent, a signature touch that would reappear in the presence of a whole or partly peeled lemon, a handkerchief, a patch of light, or the binding of a book. And it was the first of many paintings that would not be understood — not even by Couture.

Manet had followed Couture's "brown gravy" recipe and worked the paint as Couture had taught him. But all Couture had to say about the painting was "Mon ami, there is only one absinthe drinker. It is the painter who produced this piece of lunacy." Manet was understandably miffed. He grumbled to Proust, "I was stupid enough to make a few concessions to him. I foolishly prepared my canvas according to his formula. That's the last time! It's a good thing he said what he did. It makes me stand on my own two feet." Manet would never again turn to Couture for approval. The days of trying to please any father figure were over.

The Absinthe Drinker marks the beginning of Manet's personal approach to art. In choosing a modern, unheroic subject but enhancing it with the grandeur of both Salon size (almost three by four feet) and a reference to museum art, he endowed it with a significance that has as little to do with the depiction of misery as its likely inspiration — *Le Vin des chiffonniers*. The ragpicker of Baudelaire's poem, seen "in the red light of a streetlamp" (as is *The Absinthe Drinker*), is likened to a poet, the bard of humanity, who "pours out his heart in glorious projects" and "inebriates himself with the splendor of his own virtue."

> To drown the rancor and lull the indolence
> Of all those old wretches who die in silence,
> God, moved by remorse, created sleep,
> Man added Wine, the sacred son of Phoebus.

Baudelaire's poem, like the painting, is set in a "muddy labyrinth," the bowels of the huge city. But the setting, however detailed in the

poem or mere suggestion in the painting, does not serve as an indict-
ment of social injustice. Rather it is the ragpicker, this marginal
denizen of the city, who is the emblem of the artist, and whose wine,
like the artist's art, can dull the pain of life through its illusions of
greatness and justice. What makes *The Absinthe Drinker* so impor-
tant is that it already incorporates the essence of Manet's originality,
that extraordinary blend of timeliness (the modern city, urban fig-
ures, contemporary problems, in this case absinthe itself, a serious
menace to the health of the nation), timelessness (the evocation of old
master art and literature), and the subjective reference through an ob-
jective subject.

For the next few years, Manet would exploit this approach, which
would be no better understood by his admirers than by his detractors.
Gathered in Manet's studio three days after *The Absinthe Drinker*
was rejected by the Salon jury of 1859, Manet, Baudelaire, and
Proust were discussing the influence of contemporary artists on each
other, among them Couture. "The conclusion," Baudelaire sug-
gested, "is that one has to be oneself." To which Manet replied,
"That's what I've always told you, my dear Baudelaire. But was I not
myself in *The Absinthe Drinker?*" Baudelaire's noncommittal reply
indicated that he was not convinced. "So now," Manet grumbled,
"even Baudelaire is putting me down. In that case, everyone is." Not
quite everyone, for Manet learned that Delacroix, a member of the
Salon jury that rejected the painting, had cast an affirmative vote.
Manet was to suffer far greater disappointments a few years later
with two of his most famous works. He might well have remembered
his bitter words about *The Absinthe Drinker*: "I painted a Parisian
type. They don't understand. They might understand better if I did a
Spanish type."[23] A year later his "Spanish figure" granted him the ad-
miration he had failed to achieve with *The Absinthe Drinker*.

The year 1859 saw the production of a few other works, one of
them associated with Baudelaire. Manet had hired an impoverished
child living near Manet's second studio on the rue de Douai, to the
great delight of the boy's uncaring mother. The boy was supposed to
clean Manet's brushes and keep the studio in order. He served as the
model for a charming work titled *Boy with Cherries,* in which his
rosy-cheeked face smiles out of a "brown gravy" background as he
clutches a sheet of greengrocer's paper spilling over with plump red
cherries. Grateful to be liberated from the misery of his family, he was

devoted to Manet and to the sweets and liqueurs Manet kept in the studio. One day, after reprimanding him for pilfering yet again, Manet left the studio and on his return found the boy dangling from a rope attached to a nail in the ceiling. Manet was so upset by this that he could no longer bear to be in the studio and moved yet again. Manet evidently told the story to Baudelaire, who composed a "prose poem," a very short story titled "The Rope," dedicated to Manet. The unnamed painter who relates the entire story begins his tale with a noteworthy preamble.

> "Illusions," my friend said to me, "are probably as numberless as are relationships between people, or between people and things. And when the illusion vanishes, that is, when we see the individual or the thing as it exists outside of our minds, we experience a strange feeling, equally compounded with regret for the lost phantom, and pleasurable surprise at the novelty, the real thing. If there is any phenomenon that is obvious, trite, unchanging, and unmistakable, it is maternal love. It is as difficult to imagine a mother without maternal love as light without heat. Is it thus not perfectly legitimate to attribute to maternal love all of a mother's words and actions that regard her child? And yet, listen to this little story that had me singularly mystified by the most natural of illusions."

The painter goes on to relate the boy's suicide, his own horror, and his obligation to inform the boy's mother. To his amazement the mother was impassive, "not a tear rolled from the corner of her eye." All that interested her was obtaining from the painter what remained of the rope, a talisman that she could sell, fiber by fiber, which the painter understood only when the other tenants in the building began asking him for it. One of Baudelaire's biographers sees in this "a private allegory in which he is denouncing [his mother's] scale of values where maternal affection took second place."[24] Equally relevant might be the painter-narrator's disillusionment with maternal love.

The suicide occurred in 1860, and "The Rope" was published four years later. In 1860 Léon Leenhoff was eight years old. By that time Manet knew that any opposition his father might have to his marriage to Suzanne was moot. Auguste Manet had been stricken with paralysis in October 1857.[25] After a leave of thirteen months, he had regained the use of his legs, but not his speech. In January 1859 Mme

Manet sent a letter tendering her husband's resignation. It was this certainty of Edouard's imminent independence that informed the painting known as *La Pêche* (see Chapter 5), a virtual wedding announcement, in which Manet and Suzanne, in obvious portraits, stand together on one bank of a river as Léon sits fishing (hence the title) on the other.

With marriage now a foregone conclusion, the question of legitimizing the child may have been raised. Suzanne's insistence throughout her long life that Léon was her brother leaves little doubt that she did not want her reputation sullied. This masquerade did not leave Manet indifferent, as his later paintings demonstrate. Long before the paintings, Manet told Baudelaire the story of the neglected child who had committed suicide. When Baudelaire's painter-narrator asks, "Is it thus not perfectly legitimate to attribute to maternal love all of a mother's words and actions that regard her child?" we are struck by the irony of the remark at the thought of Léon taught to call his mother "sister" or "godmother" and his father "brother-in-law" or "godfather." Only at age twenty did Léon learn that his legal name was fictitious, that his entire existence was a lie. A number of Manet's later works, to be examined in succeeding chapters, reveal his response to this awkward family triangle. Since he could not alter the situation, his only defenses were his art and his irony.

The Double-Edged Sword

The new decade ushered in a new stage in Manet's personal and professional lives. In the summer of 1860 he rented a new studio on the rue de Douai and an apartment on what is now the rue des Batignolles, which he shared with Suzanne and Léon until his marriage, while still residing with his parents. These as well as his future studios and apartments were all within the same quarter, radiating from Place Clichy, which encompassed his parents' apartment and the cafés he most often frequented: the Guerbois at 9, avenue de Clichy and the Nouvelle-Athènes on the Place Pigalle. This northern district, much of it newly constructed, was the essence of the new Paris, the ideal setting for the new painting that Manet would produce.

This was where the new Quartier de l'Europe branched out from the Place de l'Europe just above the tracks of the new Saint-Lazare railroad station. From there Parisians could cover the distance to Normandy and the seacoast in hours or reach idyllic countryside along the Seine for Sunday picnics. A few blocks to the south, Victor Baltard's great new church, Saint-Augustin, the first such edifice to be constructed with metal girders, was under construction as of 1860. Two years earlier the first of his glass and steel pavilions for the central markets, Les Halles, had been inaugurated. Streets bearing the names of the cities of Europe — Rome, Saint Petersburg, Amsterdam, Madrid — were crowded with construction crews putting up apartment buildings in the style instantly recognizable as "le style Haussmann." All trains led to Paris, the capital of Europe, and this quarter,

traversed by the newly opened Boulevard Malesherbes, was a symbol of everything that was modern and innovative in Paris. One could watch from week to week the disappearance of the old, the sordid, and the chronically poor, to be replaced by more apartment houses and tree-lined avenues for the growing number of well-to-do Parisians.

In 1860 Manet began painting at full throttle, turning out in that one year as many paintings as he had produced during the preceding five, most of them masterworks. In addition to the painterly problems they represent, a number of the early ones subtly reveal personal concerns. *The Surprised Nymph* (reworked between 1859 and 1861 and preceded by three oil studies) shows a seated nude in the classic iconography of a Susanna,* modeled by Suzanne Leenhoff[1] (Fig. 3). The pose — from body position to draping — is an almost literal quotation from Rubens's lost painting of the same motif, preserved in an engraving Manet assuredly saw. At its most simplistic, the painting can be seen as an overt acknowledgment of his august predecessors, whose consorts also had served as models, and as a covert acknowledgment of his model's name and birthplace in the Low Countries (which in Rubens's time included his native Flanders and what is now Holland). It also can be interpreted as a private joke in its reference to the scurrilous accusation against the biblical Susanna that does apply to this modern Susanna. The personal nature of this work is borne out by the fact that Manet never submitted it to any Salon in Paris, nor did he part with it. (In 1861 he sent it to the yearly exhibition of the Imperial Academy in Saint Petersburg, but in Paris it was shown only once during his lifetime, at his private exhibition in 1867.) In his inventory of 1871 it was priced at the extravagant and unsalable figure of 18,000 francs and was still among the ninety-four paintings in his studio at the time of his death, after which it was sold for only 1,250 francs.

There has been some controversy over whether this nude was cut out of a larger work in which the bather was intended to represent

*Susanna, in the Book of Daniel, was accused by two rejected old suitors of having illicit relations with a young man. Her iconography stems from Diana at the bath, but in Christian iconography she became a symbol of chastity and thus a morally suitable subject for a nude.

Pharaoh's daughter at the Nile (Manet's biographers Tabarant and Duret say no). X-ray evidence and an oil sketch that contains the same nude with other figures do, however, confirm Antonin Proust's assertion that Manet had projected "a large painting, *Moses Saved from the Waters*, begun on the rue Lavoisier [thus before 1860], which he never finished, of which only one figure survives that he cut out of the canvas and titled *The Surprised Nymph.*" It is hard to believe that this choice of subject could have been purely gratuitous. And in view of the many identified models for this figure — Giulio Romano's *Bathsheba*, Boucher's *Diana*, Rubens's and Rembrandt's *Susannah* — Manet did not have to look for yet another biblical story to ennoble his subject. But on an allegorical level, the "finding" of a baby boy is certainly relevant to his model and serves as one more veiled reference to the intimacy between the model and the painter. Although he did not show the work in Paris until years later, discretion may have been as important a factor in his decision to cut the Nile scene from the canvas as his determination to paint a striking nude. By retaining only that figure, indeed the best part, he could disguise her as a nymph, reinforced by the addition of a satyr peering through the trees (removed after Manet's death), thus obviating any association with Suzanne or Léon. But they were nevertheless on his mind. Over the next two years Manet would produce a number of works that bear witness to this preoccupation.

As a painting, *The Surprised Nymph* is significant as Manet's first known nude and a direct antecedent to two subsequent nudes — *Le Déjeuner sur l'herbe* and *Olympia* — who engage the viewer in a visual dialogue far more scandalous. What Manet did here, beyond pitting his nude against those of the old masters (a challenge taken up by every great artist), was to establish by her gaze that this is not a traditional Susanna, but a specific one. In place of the leering elders usually portrayed, he inserted himself in dual roles: as the painter using a model to create a painted figure rather than an imitation of nature, and as the lover proprietarily examining his mistress, who in turn eyes him with bemused suspicion. What Rosalind Krauss, in her excellent analysis of the work, speaks of as "the immediacy — indeed, the privacy — of this new relationship"[2] between the spectator and the painting has its origin, in my view, in the intimacy expressed by the diminished separation between model and painter. Not only does their exchange of glances indicate their proximity, but, far more im-

portant, it trespasses the frame. Aside from rare exceptions (Veláz-
quez and Goya come to mind), the frame had always been an in-
violable barrier between painting and viewer. In traditional
representations of Susanna, her gaze remains within the frame — up,
down, sideways, any direction but out. The significant difference be-
tween Manet's representation and Rubens's (apart from the absence
of an elder) is Susanna's glance: Rubens's figure looks over her left
shoulder toward the lower right edge of the picture. Only portrait
subjects had the right to invade the viewer's space, and they were pre-
sumed to be personages of repute. No nude ever looked straight at the
viewer, even if her credentials were scriptural.

gaze outside frame

Here one is brought into direct contact, as though it were the
viewer who had surprised Susanna. The painter and viewer, formerly
objective observers, are merged, perhaps unintentionally, into one
voyeuristic optic. That Manet later intended the viewer to be a partic-
ipant, a voyeur like himself, seems obvious when one looks at his two
later masterworks *Le Déjeuner sur l'herbe* and *Olympia* — a concept
that may have followed from the realization of what he had done in
his *Surprised Nymph*. In fact throughout the 1860s Manet, as we
shall see, would reinforce the beholder's presence by the unwavering
gaze of many figures.

Some time before embarking on *Le Déjeuner sur l'herbe* and
Olympia, Manet had told Proust while watching women bathing in
the Seine, "It seems that I will have to do a nude. Well then, I'll give
them a nude!" The traditional hierarchy of subjects for painting was
headed by the figure, followed by landscape and genre. In figure
painting, whether historical or allegorical, the hallmark of a painter's
skill was the nude, since nothing is more difficult to render than flesh.
But the nude was made presentable to the mixed company of Salon-
goers by being desexualized, given the idealized contours of a piece of
ancient sculpture and the recognizable identity of a mythological or
biblical figure. *The Surprised Nymph* was the first and last nude
Manet would paint by the rules, but something of it would serve him
later.

An interesting detail demonstrates how memory can function in a
painting. Proust's description of that bucolic Sunday scene at Argen-
teuil, both of them lying on the riverbank watching the splash of
white sails against the dark blue of the water, seems to be recalled in
the wooded landscape around the surprised nymph. The intense blue

of a patch of sky, the light brushstroke of cobalt at the water's edge, and a cobalt iris along the left side of the painting recapture the blue of the remembered scene. This bit of landscape, with its slanting tree trunks and branch overhanging the water, evidently pleased Manet enough for him to quote it almost exactly in the upper right of *Le Dé-jeuner sur l'herbe.*

Another painting from 1860 for which Suzanne seems to have been the model is *Woman with a Pitcher.* She is seen pouring water into a basin with her left hand, the third finger prominently displaying a ring. Here she is bathed in a golden light reminiscent of Venetian paintings. It is *La Pêche,* however, begun the same year, that is the most overtly autobiographical (Fig. 7). Attired in seventeenth-century dress, Edouard and Suzanne appear in undisputed portraits, confirmed by Suzanne herself. Manet painted himself leaning on the hilt of an unsheathed sword, its point in the ground. This is the first time that this weapon appears in a work having a personal connotation; it will reappear in others. The composition of the painting was borrowed from two works by Rubens (*Castle Grounds,* showing Rubens and his wife, and *Landscape with Rainbow*), which again, like *The Surprised Nymph,* points to Suzanne's national origin.

The modifications Manet made in his use of Rubens's portraits of himself and his wife are worth noting. Their heads are turned sharply to the right, in such a way that if Edouard and Suzanne had been similarly reproduced, they would necessarily be seeing Léon in the background. Instead Manet averted their gaze by turning it obliquely toward the right forefront, leaving his raised index finger to point toward the back. He also substituted the solid walking stick in Rubens's hand with a slender rapier in his own. Although Charles Moffett claims that "the meaning of the painting remains elusive," he identifies some of its conventional symbols: the dog is an emblem of fidelity, the rainbow evokes a covenant, and the church spire signals marriage.[3] As for the sword, it too has a long history of symbolism: virility, authority, the ability to wound.[4] Its presence here in Manet's hand — rather than hanging in its scabbard from his belt, which would have made it an expected accessory of the period costume — seems to be self-referential. Here, exceptionally, we see Manet himself with the sword, whereas in other works to be discussed it stands for him.

Manet's thorough familiarity with old master paintings granted

him equal familiarity with the attributes of gods and saints, as well as the symbolism of gestures and objects, used over the centuries as a means of immediate identification. If symbolism is based on the principle that "nothing is meaningless, everything is significant, and that nothing is independent, everything is in some way related to something else,"[5] the repeated and gratuitous presence of the sword deserves notice.

Manet produced four works in which a sword appears without specific reference to costume or activity. In each case it is represented in a nonfunctional position: leaned upon in *La Pêche* (1860–61), held by a child in *Boy with a Sword* (1861), hanging on a wall in the frontispiece to *Polichinelle Presents "Eaux-Fortes par Edouard Manet"* (1862), and laid aside in *The Luncheon* (1868). All four works also are linked by the element of disguise. The couple in *La Pêche* are in costume, as is the subject in *Boy with a Sword,* and the Polichinelle figure is, of course, pure masquerade. The modern dress of the male figures in *The Luncheon* loses its actuality through the scene's evocations of another time (a pile of ancient armor sits in the foreground) and place (Vermeer is suggested by this scene of arrested action in which a servant participates, as is Dutch still life in the overhanging knife, the dangling lemon peel, the crisply ironed tablecloth, and the delftware sugar bowl).

All of these elements direct the attention away from the obvious: the picture is not about young manhood in the nineteenth century. One is reminded of Meyer Shapiro's suggestion that Manet's backward glances at earlier artists might provide "a mask for meanings in his own work, a mask that adds to the ambiguity of the whole."[6] Linda Nochlin further observes that "disguise, whether fancy dress, travesty or outright theatrical costume, is an ambiguous constant in [Manet's] work" and that he would characteristically "tuck himself modestly into the margin of the scene ... both a participant in and the observer-constructor of the painting."[7] This "ambiguous constant," these masks and disguises, would seem to point to camouflage, deceit, fakery, something hidden — at the very least, an implication of meaning beneath appearances.

In *La Pêche* Léon is seen sitting alone in the background, fishing, separated from Suzanne and Edouard by the river. More than a dozen times in Manet's paintings, Léon served as a model or was inserted in one way or another; no other member of Manet's immediate family

was painted as frequently, nor in such disturbing works. Although some critics remain unconvinced of Manet's paternity, it requires an effort to ignore the evidence of it. Manet painted Léon again and again, in ways that seem to cry out the boy's identity.

It is also impossible to overlook the striking language of the will he wrote in 1882, by which time Léon was thirty years old and entirely self-sufficient: "I designate Suzanne Leenhoff, my legal wife, as my sole legatee. She shall bequeath by testament everything I have left her to Léon Koëlla, known as Leenhoff, who has given me the most devoted care, and *I believe my brothers will find these dispositions entirely natural*" (emphasis added).[8] He then stipulated an outright bequest of fifty thousand francs to Léon — the only bequest in the will (outside of a painting to be chosen by Théodore Duret, who was to arrange for the posthumous sale of his works). And finally, below his signature, he added, "It is clearly understood that Suzanne Leenhoff, my wife, will bequeath to Léon Koëlla in her will the estate I have left her."

With a widowed mother to whom he owed a lot of money, two brothers, a niece, and any number of needy friends, it might seem curious that Léon was Manet's sole beneficiary, after Suzanne, but it is "entirely natural" if Manet was his father. Fifty thousand francs was a very large sum. And to make a point of saying that his brothers would find his testamentary arrangements "entirely natural" indicates his certainty that they understood Léon's moral, if not legal, right to inherit. One is hard put to understand why Manet would have been insistent about the succession of his estate if Léon had not been his son.

Manet had good reason to be concerned. Never recognized by his parents, Léon had no claim whatever to their estate. It was not enough for Suzanne's maiden name to appear on Léon's birth certificate to make him her legal heir, in view of the fact that he was born out of wedlock. The marriage contract between Suzanne Leenhoff and Edouard Manet stipulated that the dowry of ten thousand francs given to him by his mother would be returned to her "in the event that her son should predecease her without descendants." On Manet's death the official inventory of his estate contains the following paragraph: "Madame veuve Manet mère [the widowed mother of the testator] exercises the right to reclaim the dowry given to her son as agreed in his marriage contract, since Monsieur Manet died childless."[9]

This was to become a matter of contention, revealed in unpublished letters between Mme Manet, her son Gustave, and her nephew Jules De Jouy, an attorney and Manet's legal executor. Eugénie Manet may have had outwardly pleasant relations with her daughter-in-law until Edouard's death, and even after, since they continued to live together until Eugénie's death less than two years after Edouard's. Her letters to Suzanne give no indication of conflict, but those to her blood relations are quite another matter.

To get a true picture of family life in France, one should *chercher l'héritier* (look for the heir). Quite clearly, Suzanne was clamoring for more than her due, according to the letter of the marriage contract. In a letter to Jules De Jouy, Gustave quotes from his mother's letter to him: "There are some things," she wrote, "that I will not reconsider, namely the crime she committed out of affection for that dear boy [*brave garçon*] who is merely a victim of his unfortunate birth. She wanted more than she was entitled to have, that is the punishment of her crime, let her suffer it."[10] Cryptic though this may appear, it can be deciphered. Suzanne's "crime" was her misguided notion of propriety, which denied Léon his rightful name. She had been determined that her past as Edouard's concubine be erased, that it not be known that she and Léon had been clandestine figures in Edouard's life for more than a decade. She and her son would have been regarded with contempt by the society the Manets frequented. It did not matter if a few intimates knew the truth and others suspected it; what mattered was maintaining appearances.

Now she was claiming that the ten thousand francs were hers, arguing that the dowry should remain in Edouard's estate since he had not died childless. But Eugénie, who had swallowed her displeasure for decades, was adamant: Suzanne had made her bed; let her lie in it. Léon had been sacrificed out of Suzanne's pretense at respectability, and for decades the entire family had lived out a lie because of it. That too was "more than she was entitled to have." It should have been enough that Edouard had made an honest woman of her by marrying her. Moreover, Eugénie had lent Edouard large sums of money, which he had made no provision to repay. In a letter written four months before he died, she foresaw what would happen: "I will never see a penny of the money Edouard owes me. . . . I have already ruined myself for my *two sons* [emphasis in original, referring to Edouard and Eugène]; I am not going to reduce myself to poverty." The contested

ten thousand francs would not cover the debt by a long shot, but at least it would repay some of it. She had to ensure her own independence, not knowing how long she would live or what her needs would be. Her will would provide for her survivors.

As for Suzanne, it was not until 1900 that she officially recognized Léon as her illegitimate and only child to ensure his right of inheritance. His birth certificate alone was not enough to guarantee that right, since the presence of a father's name, Koëlla,[11] would have required proof that his mother had been married to such a person, then widowed or divorced, and that there were no other Koëlla offspring to contest Léon as her heir. Not even in 1900 was the name of the father revealed: ". . . in the presence of witnesses, Madame Suzanne Leenhoff . . . widow of Edouard Manet in her first marriage, not remarried, recognized as her natural son the child designated above."[12] After fifty years of camouflage, Suzanne herself declared Léon's bastardy.

Adolphe Tabarant, who knew Léon in his later years, was never made privy to the truth, but after candidly presenting the evidence he had amassed, he came to a reasonable conclusion: "When . . . Manet married Suzanne Leenhoff, Léon, recognized by his mother [on the birth certificate] and whoever was his father, was twelve [sic] years old. It was necessary to conceal his origin, by any means, and that is why, out of excessive respect for hypocritical morality, for 'what-will-people-say,' Manet, so free-spirited, lent himself to this machination which, we are convinced, pained and poisoned his life, all of which would explain the specific compensatory wishes in his will."[13] That this situation "pained and poisoned his life" seems undeniable, as it seems undeniable that the guilt, the exasperation, and the disgust it engendered had to rise to the surface from time to time.

Even at this distance it is disturbing to know that Léon was denied the education he should have received merely by virtue of growing up in the Manet household. No respectable bourgeois was a *primaire,* someone who never went beyond elementary school unless he was in some way deficient — which does not seem to have been Léon's case. In Bazire's convoluted construction *"c'était un fils que ce beau-frère"* (this was a son, this brother-in-law), we hear not only the ring of truth concealed, but also the justification for his having been raised within the Manet family even if he was never recognized as a Manet. From the time Edouard and Suzanne were married, Léon lived openly

with his "sister" and "brother-in-law," not to mention the clandestine cohabitation of the preceding eleven years. At fifteen — the age at which an upper-class son was receiving a lycée education that would make him admissible to a university faculty (arts and letters, medicine, law) or to a military academy — Léon went to work as a runner in the bank owned by Edgar Degas's father.

La Pêche is thus the first in a group of "confessional" paintings, and the first step toward compensation or reparation. The church and the rainbow signal the promise of marriage, the dog augurs fidelity, and the tip of the sword buried in the ground implies an oath to wound no more. The presence of a sword is a significant departure from Manet's likely model, Rubens's self-portrait with his second wife, in which Rubens's left hand rests on a walking stick rather than a sword. Since Léon is encompassed within the "promise" of the rainbow and is highlighted, like the couple, by a patch of sunlight, reparation would seem to apply to him as well. This is further emphasized by the pointing dog and Manet's pointing right finger, both directed at Léon. Once the union is legitimized, so will be its fruit; the sin will be absolved.

As Moffett has proposed,[14] Manet may indeed have intended a pun both in the title and in the action of the painting. Léon is fishing, as are the three men in the boat. *Pêcher*, to fish, is a homonym of *pécher*, to sin. A fellow painter who knew Manet in his later years remembered that "Manet adored puns, which are now so out of fashion."[15] *La Pêche* may, therefore, be understood as an allegory of Manet's honorable intentions and a confession of his past transgression. This is the only time he ever painted Suzanne at his side, or placed himself in any painting in which she appears.

The year before, Manet had painted *Spanish Cavaliers and Boy with Tray*, adapted from a canvas in the Louvre then attributed to Velázquez, in which Léon appears for the first time, as a serving boy. This image of Léon reappeared in 1861 in *Boy with a Sword* and yet again in 1868, in *The Balcony*, quoted exactly from *Spanish Cavaliers*. Clearly this denotes a preoccupation of some importance. In *Boy with a Sword* we can see as much a portrait of Manet's inner state as of Léon (Fig. 4). The authority represented by the sword throughout the history of Western art is here given a parodistic twist. The boy is visibly unable to wield this heavy weapon placed in his small hands. The rightful wielder of the sword, the one with authority, is absent.

The disproportion between the sword and the bearer implies a burden more than anything else. This is not a young cavalier of the Spanish court with a sword scaled to his own size, but a child with a borrowed prop and a haphazard costume. The plain white collar, drab brown breeches, and sagging gray hose are perhaps more suggestive of Dutch villagers than of Spanish grandees; the very inauthenticity of the boy's clothing betrays his false identity. He is not a noble page; he is merely dressed up to suggest one, and rather shabbily at that. The sword, however, a mark of privileged classes, endows the boy with his father's station, but only within the limitations of a disguise: Léon's true identity as a Manet is concealed under his false identity as a Leenhoff. This is the first time Manet placed Léon in the center foreground, an *ecce filius* so to speak. *Boy with a Sword* can thus be seen as a cryptic avowal of their kinship, the sword serving not only to identify the father[16] but also, perhaps even more important, to emphasize his invisibility.

The same year 1860 also saw the production of two magisterial canvases, *Portrait of M. and Mme Auguste Manet* and *The Spanish Singer*. Both were accepted for the Salon of 1861. It was Manet's first official recognition, and at the same time his baptism by critical fire: "What a scourge to society is a realist painter! To him nothing is sacred! Manet tramples even the holiest ties. The *Artist's Parents* must have cursed more than once the day when a brush was put into the hands of this unfeeling portraitist"[17] (Fig. 1). Later critics have seen this work as characterizing the less frivolous side of the Second Empire, its austere upper middle class, described by Françoise Cachin as "the image of a social type and the depiction of a severe intimacy, in which time has laid a stern dignity on the father and a serene melancholy on the mother." Even more pertinent is her observation that "they are close, but separate . . . seemingly with no link between them but the black of their garments."[18]

When Cachin wrote these lines, it was not yet known that Auguste Manet was paralyzed at the time he sat for the portrait or that syphilis was the cause of his condition — although there had been hints by a few of Manet's contemporaries.[19] In view of their remarks, the specialty of the doctor who treated him (venereal diseases), and the recent research that has revealed his symptoms and the course of his illness, there can be little doubt that Auguste was afflicted with paresis, a generally fatal neurological form of tertiary syphilis.

The painting, therefore, carries more than a portrait of class or judicial severity. By the time it was finished, Auguste probably had no more control over the use of his hands than of his speech. The closed right hand is not so much clenched as useless, and the left, resting between the buttons of his coat, is an ironic reminder of Napoleon's heroic pose. The downcast eyes stare blankly. This is a still-living effigy of a soon-to-be-defunct high official, his mark of distinction, the red ribbon of the Legion of Honor, visible on his lapel. The once voluble jurist and stentorian father is now a tight-lipped invalid. His wife, standing above him, conveys her physical and moral strength through her verticality and her competence through her mending basket. She has every reason to be preoccupied, but the direction of her gaze suggests that her thoughts go beyond the wreck below her. In fact she is not even looking at him. They are indeed very separate, and doubtless have been for some time.

The absence of any dialogue in this painting — a psychological truth of striking newness, which appears in Degas's portrait of the Bellelli family from the same period — suggests not only the privacy of their thoughts but also the silence of Auguste's aphasia. The discovery of his father's transgressions (Auguste did not catch syphilis from his wife), along with the knowledge of his own, would serve Manet in his future portrayals of unspoken and unspeakable secrets, noncommunication even between intimates, unfulfilled and unavowable longings, the inability to reach across silence, and the pretense of bourgeois propriety.

How much of this was and would be conscious and how much a spontaneous expression of suppressed concerns is impossible to determine. But no artist is so single-mindedly involved with his craft that his psyche ceases to function. Projected onto the canvas, as onto the written or notated page, are the tensions, longings, pleasures, and moods of the human being. In Manet's work painting becomes analogous to music: it conveys emotion, even thoughts, in a nonrhetorical manner; understanding is subliminal. Manet's painting is not concerned with describing the death of Socrates, the birth of Jesus, the plague in Chios, or the wreck of the *Medusa*. Unlike Delacroix, who, to use André Malraux's distinctions, "dramatizes" his subjects, and Courbet, who, though he abandoned the conventional subjects, still "represents" them, Manet "pictorializes" them: "What Manet attempts in certain canvases is the pictorialization of the world."[20] Even

if Manet's primary concern was to establish the primacy of what was painted over what was represented, a complex process of overpainting can be imagined, which might be likened to a palimpsest.

Despite his legendary spontaneity — "Il n'y a qu'une chose vraie. Faire du premier coup ce qu'on voit. Quand ça y est, ça y est. Quand ça n'y est pas, on recommence. Tout le reste est de la blague" (Only one thing is true. Getting down on the first try what one sees. When it's there, it's there. When it's not, one starts over. All the rest is bunk) — he constantly reworked his canvases. His approach may have been intuitive and spontaneous, but his many revisions prove how very deliberate every choice was. Nothing was left to chance, not even the position of a hand. Each new layer added something where something else had been painted over. Over each effacement, partly visible or discovered through X ray, another "text" was superimposed. This layering, like the overwriting of a palimpsest, made possible as many subconscious insertions as conscious pentimenti. Each reworking toward the solution of painterly problems allowed the expression of personal themes that may never have crossed Manet's mind when he first projected the work. The creative process is determined not only by the medium but also by the inner vision.

Along with the portrait of his parents, Manet's professional debut at the Salon of 1861 included his first modern "Spanish" work, *The Spanish Singer*. (Before that he had done two interpretations in the Velázquez manner, *Velázquez in the Studio* and *Spanish Cavaliers and Boy with Tray*.) Although it netted him an honorable mention, his first official distinction, and the glowing praise of Théophile Gautier ("There is a great deal of talent in the life-sized figure, broadly painted in true color and with a bold brush"),[21] Hector de Callias, another contemporary critic, saw this figure not as a realistic portrayal of a Spanish guitarist but as the "idiotic figure of a mule driver," in a room smelling of the "combined odors of cigarette smoke and onions."[22] The young painters of Manet's age were struck by its originality, which they saw as midway between realistic and romantic, and came to him in his studio as to a master. But, as John Richardson observes, it was "Manet's . . . elimination of half- tones [that] justifies us in regarding *Le Guitarrero* [as it came to be called after Gautier's review], and to a lesser degree the double portrait [of his parents] as signposts for the development of XIXth century art."[23]

For Manet both works fulfilled his quest for spontaneity: "Can you

believe it," he told Proust, "I painted the head the first time around. After two hours of work, I looked in my little black mirror and it was all there. I didn't add a single brush stroke. As for my mother and my father, I got them down in one shot, just as you see them." He also admitted to thinking about Hals and the Spanish masters while painting his *Spanish Singer:* "No one will ever convince me that he [Hals] wasn't of Spanish origin. Which wouldn't be so surprising. He was from Mechelen."*

The death of Auguste Manet on September 15, 1862, released Edouard from the constraints that had hampered his financial and artistic independence. With his share of his father's not inconsiderable estate, he was hardly a rich man, but his security and comfort were ensured. He would never have to sell a painting to eat or pay the rent. He could afford to dress well and meet his similarly cravatted, top-hatted friends at the Café Tortoni or the Café de Bade on the Boulevard des Italiens. He could maintain a comfortable studio, not just to hold his easels and brushes, but where he could receive visitors in private.

He had been dividing his time between the cramped quarters of the little apartment rented for Suzanne and Léon and his parents' apartment, where his friends were invited to his mother's Thursday receptions. The only person who visited the secret family and is mentioned by name in Léon's unpublished notes was Eugène, Manet's younger brother. Léon also remembered that during those years when he was a boarder at the Institution Marc-Dastès, a primary school on the Place de la Mairie near the apartment, "Manet came to take me out every Thursday and Sunday."[24]

Now that he had his inheritance, Manet could afford to marry the woman to whom he had been committed for more than a decade. Although he had been living with her more or less since 1860, following the death of her grandmother and the irreversible incapacitation of his father, his social life — one might even say his private life — had been led elsewhere, in his studio, in cafés, or in the upper-class comfort of his parents' apartment. This is how he would continue to live.

*Mechelen was a small town in southern Belgium, part of the Low Countries, most of which remained under Spanish domination until eight years after Hals's death in 1666.

His mother would continue to be his hostess for the more formal receptions, he would receive his intimates or professional acquaintances at his studio, and he would spend his late afternoons strolling along the streets and stopping for refreshment and conversation in a café. The pattern of separation between his private existence and his family life was already set before he married and would continue long after.

Auguste Manet did not die easily. With textbook accuracy, his death occurred within the observed period: "Untreated general paresis . . . is generally fatal. The duration of life from the onset of identifiable mental symptoms to death usually ranges from a few months to five years."[25] A great deal more was known about venereal disease in the nineteenth century than is commonly assumed. In fact by the 1860s almost everything was known except the bacterial cause (the spirochete *Treponema pallidum* was not described until 1905) and an effective cure. Since neurosyphilis rarely appeared in people affected after the age of forty, one may assume that despite his judicial severity, Auguste was no more faithful a husband in his younger years than many of his peers. His conjugal duty had been fulfilled early on. By 1835, when he was only thirty-eight, the last of his three sons was born, after which relations between the spouses may have ceased — not uncommon among the well-to-do when enough children had been produced. Eugénie was only twenty-four when her last child was born. Had her husband continued to claim his legal rights, it is reasonable to think that she would have produced others over the years. Or perhaps it was she who banished him from her bedroom. She does not strike one as a woman whose senses were easily stirred, nor was that expected of a wife. Marriage was not presumed to be related to passion.

For pleasure there were women practiced in the art of sensuality, available not only in various shapes and colors but also in various classes and establishments, with commensurate variations in price. Not since Renaissance Rome and Venice had a city been so generously endowed with the handmaidens of Venus. There is a striking resemblance between the two periods in the importance, notoriety, and different categories ascribed to such women, and even some of the names taken by the more successful among them, such as Olympia — not a name for a streetwalker, but rather for a courtesan, a woman whose lovers kept her in style.

In the 1830s there were roughly thirty thousand prostitutes of all

categories in Paris. By 1870 the number had more than tripled. In London at mid-century there were fifty thousand registered prostitutes and as many venereal patients a year, and London prided itself on superior facilities for examining prostitutes on a regular basis. English doctors found examining rooms and instruments in Paris and Vienna antiquated and unhygienic. During the Second Empire (1852–1870), doctors appointed by the prefecture of police to examine registered prostitutes boasted that they could examine a patient every thirty seconds.[26] Ever since the July monarchy (1830–1848), prostitution had been carefully regulated in an attempt to eliminate unregistered, thus unexaminable, carriers of disease.

If AIDS is the scourge of the late twentieth century, syphilis held a similar position in the nineteenth, without the benefit of mass media to alert and alarm a global audience. "Of all the contagious diseases that can affect the human species, and that can cause the greatest harm to society, there is none more serious, more dangerous and more to be feared than syphilis."[27] These lines were written in 1836 by the man called the "Linnaeus of Prostitution," Alexandre Parent-Duchâtelet. Two years later an American-born French physician, Philippe Ricord, definitively distinguished syphilis from gonorrhea and classified its three stages. Dubbed "the Voltaire of pelvic literature" by Oliver Wendell Holmes, Ricord barred no one from contagion, neither judge nor paterfamilias: "a skeptic as to the morals of the race in general," Holmes said of him, he would have subjected "the Vestal Virgins to treatment."[28]

Despite the advances in medical research, and the relative availability of condoms, syphilis continued to rage. As early as the sixteenth century, Italian anatomist Gabriel Fallopius had advised the use of condoms, then fashioned of animal membrane and poetically known as Cytherean sheaths, a reference to the birthplace of Venus. By the 1840s they were already made of reusable vulcanized rubber, and in the better brothels of nineteenth-century Paris they were sold by the sous-maîtresse, the "second in command," along with cigars and soap. As early as 1728 the effect of syphilis on the entire body, and particularly on the central nervous system, had been recorded. In 1846 the medical world was informed of the precise symptoms of one of the disease's two most common tertiary stages, tabes dorsalis, a form of neurosyphilis that affects the lower body. Yet some denied the evidence and persisted in rejecting syphilis as its cause.

Few present-day physicians, practicing since the discovery of penicillin in 1945, have ever seen a case of tertiary syphilis. But in the nineteenth century, when early symptoms were ignored or misdiagnosed and treatment with iodine, mercury, and bismuth was rarely adequate to stem the spread of the disease, deaths from tertiary syphilis were legion. Since not every untreated case developed into late syphilis, even those who knew they had the disease, Baudelaire for one, did not believe that their lives would be curtailed. And there were those who thought that a case of syphilis was the badge of true manhood.* Before tertiary syphilis could develop, many died of tuberculosis, especially poor prostitutes. But the better-fed upper classes often survived into middle age before their hidden disease caught up with them. Syphilis was so common that Baudelaire could write, punning on *syphilisés-civilisés:* "We all have the republican spirit in our veins, just as we have the pox in our bones. We are democratized and syphilisized."[29]

Prostitution was a major fear, a major business, and a major issue in the Second Empire. Many remarked with disgust that prostitution had become the symbol of the period. One of the literary masterpieces of the period, Flaubert's *L'Education sentimentale,* is filled with the metaphor of prostitution. It was nevertheless recognized as a necessary institution, a "safeguard of the stability of mores, an obstacle to the multiplication of adulteries, and to the development of erotic behavior in bourgeois women."[30]

The age-old fear was that a woman who experienced pleasure would seek it promiscuously, destroying the bloodline of her offspring, or, worse still, would turn to other women. This latter was the great terror of Parent-Duchâtelet and others, particularly with regard to prostitutes, who were likely to indulge in lesbian relations in prison. Every effort had to be made to obstruct this most reprehensible vice. These esteemed researchers seem to have overlooked the fact that acts of lesbian coupling were the most popular paying spectacle for hidden viewers. The men who paid to watch seem to have been untroubled about the moral health of their society. The fear of les-

*Heard in the refrain of a popular student song: "Et on s'en fout / d'attraper la vérole / et on s'en fout / pourvu qu'on tire un coup" (And who gives a damn about catching syphilis, so long as you get laid).

bianism was doubtless fed by the knowledge that few prostitutes experienced any pleasure in the exercise of their profession. In brothels, hospitals, and prisons, the women knew they were always under potential surveillance but were undeterred. Even greater was the fear that married women would discover with each other pleasures they did not have with their husbands.

Rather than attempting to curb or condemn prostitution, authorities argued that policing was necessary. The overriding purpose of regulation was to keep prostitution behind closed doors and off the streets, and to register prostitutes: "The history of regulation will be of an untiring effort to *discipline* the prostitute; the ideal being the creation of a category of prostitute-nun, good 'workers' but automatons and above all unresponsive [*mauvaises jouisseuses*]."[31] A brothel could not operate on the ground floor or open its windows, hence the term *maison close,* and the choicer establishments had to provide separate entrances and exits so that clients would not meet by accident. The only kind of prostitution that had to be eliminated — a task greater than any Herculean labor — was the "clandestine" kind, *la fille insoumise* (an unregistered prostitute), and there laws were stringent. A prison sentence, more readily given than a fine, was supposed to teach repentance. Prostitutes alone were punished. Their clients — "Arthur" was the equivalent of today's "John" — were not held guilty of any wrongdoing.

Auguste Manet was sixty when he suffered what was reported to the Ministry of Justice, in 1857, as a *congestion cérébrale,* a stroke — a more respectable affliction than neurosyphilis, and a reasonable first diagnosis for a partial paralysis. For the next five years Edouard watched his father degenerate in the same way his friend Baudelaire would five years later. Those were the five years during which Manet acquired an understanding of human nature and human relationships that he might not have gained had his father's private life remained secret. The sight of his father dethroned must have added a touch of cynicism to an already-sharpened wit, in addition to the horror of this firsthand acquaintance with a destructive disease. The knowledge of his mother's humiliation and Suzanne's predicament may not have affected his own sexual behavior, but it surely affected his vision of women. As his gallery of female subjects increased, one strikingly individualized woman after another came forward. Each one had not only a very personal physiognomy but also a personality, a self-

awareness, and an air of self-reliance. One need only look at a few ex-
amples to see the difference between Manet's choice of female sub-
jects and the way he rendered them, and those of some of his peers
who are even better known for their portrayal of women.

Degas, as great an artist as that period produced, expressed an in-
terest more dubious than admiring in his obsessive repetitions of bal-
let dancers. The corps de ballet was assumed to be as available to
paying clients as a burlesque chorus line. The female seems to be
subsumed in this display of legs and tutus; there is hardly a distin-
guishable face or feature among these pubescent ballerinas. Berthe
Morisot, who as a woman found Degas's personality unpleasant ("he
has wit and nothing more"), quoted Manet's opinion of him with re-
gard to women: "He is incapable of loving a woman, even of telling
her so, or of doing anything [*il est incapable d'aimer une femme,
même de le lui dire, ni de rien faire*]."[32] Quite his opposite, Renoir is
reported to have said, "If God had not created woman I am not sure I
would have become a painter." But what Renoir created when paint-
ing "respectable" women is a doll-like creature, all rosy, flounced,
and beribboned, a passive woman of the hothouse variety — the ide-
alized *femme d'intérieur,* with her children, piano, and books. In con-
trast, his lower-class women, seen under dappled light in the arms of
their "Jules" (lovers) at a dance hall or lunching at a *guinguette* (tav-
ern) have an energy and an individuality that appear to stem from
their sexual availability. Toulouse-Lautrec did not share Degas's
misogyny or Renoir's rosy vision, but the women accessible to him
were public women, and on paper or canvas there is a sordid same-
ness to them. Unlike the others, Manet's women have a life of their
own. They are modern women, women who are not defined by their
husbands or their children, women with a strong personal identity,
many of them his social equals. No two are alike. Each one would be
recognizable if met in the street, and each arouses our curiosity.

Manet was a complex man, full of contradictions: compassionate
and generous on one side, rapier-tongued on the other; a man whose
sharp and ready repartee could wound but rarely did; a dandy, a café
idler, a boulevardier, yet an indefatigable worker with unshakable in-
tegrity when it came to his art; a mind receptive to ideas and influ-
ences but already unmovable at twenty in his views regarding art;
open, sincere, and outgoing, yet so private that the dozens of people
who knew him well were unable to provide a clear account of his per-

sonal life. His friends tell us that he was one of those rare men who knew how to talk to women, but no one can tell us who his lovers were. His was an original mind whose ideas are largely known to us through the quotations of others. Here was a man whose personality left an indelible impression on everyone who knew him, yet later writers, claiming that nothing was known about him outside of his paintings, felt obliged to invent characteristics for him. He has been described as "timid" and "inhibited with women," so tied to his mother's apron strings and his father's purse strings that he never missed a meal at home.

The gulf that separated Manet's public life from his private life is not all that mysterious. It reflects the way many men of his time and class lived and serves as the backdrop to one of Manet's most consistent themes: the seen and the unseen, the outside and the underside, the way things are and the way they appear. The very concept of the viewer/voyeur is embedded in a commonplace of sexual practice at the time: "The upperclass client of the bordello does not appear in the literature or the painting of the period for the simple reason that in reality he is never seen there; and that is probably what explains the immense attraction that voyeurism holds for him; the concern for discretion gives rise to the erotic power of the violation of another's intimacy."[33]

Manet went one step further. He allowed the object viewed to view the viewer, thereby throwing into stunning disarray patterns long established. And through the doubling and duplicity of his own life, he discovered the reverse image of the hero, of the heroic gesture, the heroic act. What nineteenth-century writers would contribute to literature, Manet would contribute to painting: the disturbing figure of the antihero.

6.

A Turning Point

The year 1862 represented a great deal more for Manet than his liberation from financial dependence on his father or from restrictions against his marriage to Suzanne Leenhoff. That year was a veritable watershed, marking the divide between the gifted beginner and the incomparable master, the rebellious youth and the self-sufficient man. When he turned thirty in January of that year, he was still without an income he could call his own, but his dependence was less humiliating with his mother holding the purse strings. She was and would remain indulgent and supportive. However disappointed she may have been that Edouard would not have the kind of wife she might have wished for him or however regretful she was that this unsuitable marriage had become necessary, she would not have counseled him to disclaim his obligation; debts had to be settled, promises kept. Suzanne was not some cocotte to be paid off when she claimed to be pregnant.

Auguste Manet, severely incapacitated by 1862, would remain an impediment in Edouard's life for another nine months. Even if his role in delaying the marriage cannot be determined with any certainty, a number of reasonable surmises can be made. Edouard was clearly far too young to marry at the time of Léon's birth in 1852. Ten years later, by which time he was no longer an art student and certainly of an age to take a wife, Suzanne was scarcely suitable in the eyes of his parents. Suzanne had nothing but the clothes on her back. She was a piano teacher of beginners. One hired people like that; one did not marry them. If at least she had the vivacity or grace to compensate for

her lack of fortune or social position. In Paris, where elegance and charm counted for more than talent or virtue, how could Suzanne be presented as the daughter-in-law of Auguste and Eugénie Manet?

Apart from her ability at the keyboard she seems to have left no impression on the people who knew her. Among the few who mention her no one has reported a noteworthy remark, a sign of sensitivity outside of her playing, a reference to her intelligence, or a memory of her participation in the lively dinners that took place every Thursday around her husband's table — over which Eugénie presided, not Suzanne. In the many memoirs written by Manet's friends, the only anecdote concerning Suzanne is recounted by Giuseppe De Nittis, and that adds little to her persona. De Nittis, fourteen years younger than Manet and a painter of distinction, came to Paris in the 1860s from Naples, quickly becoming a great admirer of Manet's work and personality. His recollections of other artists and critics of the time are so pungent yet at the same time so fair-minded that his view of Manet cannot be ascribed to mere hero worship. Manet emerges from his account as a convincingly exceptional individual. Moreover, his memories of Manet did not have time to become hagiographic since he outlived him by only one year.

About Suzanne Manet, he recalled an anecdote that she had related to him. It would seem that one day Edouard was following a typical Parisienne — pretty, slender, and flirtatious — when Suzanne confronted him: "This time I caught you in the act!" To which Edouard, never at a loss, retorted, "Isn't that funny. I thought it was you!" De Nittis comments, "Now then, there was nothing of the willowy Parisienne in Mme Manet, who was a rather fat placid Dutchwoman." But he gallantly, though unconvincingly, defends her honor by adding, "He was certainly faithful in spite of appearances."[1] She was apparently good-humored, and De Nittis describes her as kind, simple, and direct, blessed with an unshakable serenity. Such a woman surely added stability to a marriage, if little excitement.

Until the end of Edouard's life it was his mother (Fig. 2), known as a woman of refinement and intelligence, who continued to receive his guests at her Thursday dinners. Although there may have been benefits in joining the two households once Eugénie was widowed and Edouard was married, each of them had the means to live separately. Since Eugénie maintained her role as her son's hostess, one may assume that he did not find his wife up to the task. One can only won-

der about Suzanne's ostensibly meek deferral to her mother-in-law for more than twenty years. Did she accept her subservient position in her own home out of indolence, or did she resent a situation she was powerless to change? As the wife of a famous figure about whom so many people wrote, Suzanne might have been remembered by someone as more than Dutch and a pianist, had she been at all memorable.

A number of Suzanne's unquoted, unpublished letters,[2] written after Edouard's death (by which time she had spent more than thirty years in Paris, twenty of them in the stimulating company of Edouard's friends), reveal little more than a bland practicality. Even Antonin Proust, Edouard's oldest, closest friend, who would have known her better than most others, wrote her strictly business letters without a trace of the long-standing relationship that might have bound them in the grief of their loss. As she grew older, her letters grew duller and more repetitive. Moreover, the replies to her letters intimate the dulling effect she had on her correspondents. The problem was not linguistic; her French was absolutely fluent. Perhaps her correspondence with her siblings, should that surface one day, will reveal another side of her. All we know from Edouard's contemporaries is that she was kind, buxom, impassive, and a good pianist.

An unsubstantiated rumor has it that Auguste Manet forced his attentions on her when she came to give his two older boys piano lessons. Though not inconceivable — she was, after all, little more than a servant — this does not stand up under scrutiny.[3] It was not Auguste who brought Suzanne into the family, as is alleged, but rather the musical Eugénie who would have hired her in late 1849 to teach the two boys. Edouard's liaison with Suzanne was already under way by 1850. Léon was born in January 1852. It is hard to believe that Edouard would have served as godfather to his mistress's child, begotten during their affair by another man, let alone by his own father. Had that been the case, Auguste would certainly have seen to it that Suzanne left Paris hastily in the early stages of her pregnancy, well provided for, and under threat of dire consequences if she ever reappeared. He was in a position to make even the most extravagant threat believable. And that very position made it imperative that he not be charged with moral turpitude; his own court was one that heard paternity cases, among other civil suits. Nor is it plausible that Suzanne would have simultaneously offered herself to both father and son. It is just as implausible that Edouard would have lived

with and married, after a thirteen-year affair, the mother of his father's or any other man's bastard.

A striking parallel to this question of undeclared and misattributed paternity, in circumstances and era, can be seen in the case of Georges Bizet. In 1862, when he was twenty-three, his mother died. He apparently sought consolation in the arms of their maid, Marie Reiter, who had lovingly nursed Mme Bizet. Nine months later she gave birth to a boy. He was given his mother's family name and a paternity vaguely attributed to Georges's father, in whose employ Reiter remained, with her son, until the death of Adolphe Bizet in 1886. Georges Bizet had died at the age of thirty-six, eleven years before his father. When the elder Bizet died, Reiter went to work for Georges Bizet's widow, by then remarried. Once Reiter's son was grown, she revealed the truth to him. A recent biographer of Bizet observed that this case was "very similar to that of all the 'natural' children born during that turning point of the centuries." Georges Bizet fathered another son with the woman he married, but he never lost sight of his natural son, who lived in his father's house. "Thus, Georges Bizet rejected the paternity of Jean Reiter, evidently for reasons of propriety and social destiny. . . . What damage resulted from this refusal of paternity, this transfer of guilt onto his father? Motivated and required by the spirit of the times and the dominant system of appearances in social and familial relations . . . it seems impossible that this *amputation* of paternity would not have left psychological traces on him."[4] The same may be assumed in Edouard's case. How did so many years of hypocrisy affect his thinking, his feelings? His intimate existence was a fabric of lies — to the world, to Léon, to himself. And after so many years of pretense, was there any substance left to his relationship with Suzanne?

The combination of secrecy and duration in Edouard's relationship with Suzanne confirms its intimate nature. If Proust knew about her, as is probable, he maintained absolute silence to the end. No friend is known to have met the future Mme Edouard Manet, nor was any mention made of her existence. Baudelaire, Manet's daily companion between 1860 and 1863, informed a mutual friend, the photographer Carjat, in a letter dated October 6, 1863, "Manet has just announced to me the most unexpected news. He is leaving this evening for Holland whence he will bring back *his wife* [emphasis in original]. He does, however, have some excuses, for it would seem that she is very beautiful, very kind, and a very fine musician, so many treasures in a

single female individual, isn't that monstrous."[5] Are we to understand that only so rare a creature could exonerate a man for marrying?

The death of Auguste Manet marks the passing of what might be called the negative influences in Edouard's life — obstacles, secrets, concealments — as well as the negative responses to those influences — guilt, embarrassment, constraint. During that same year a clear break with his personal preoccupations seems to have taken place, giving rise to freer, more ambitious, more extroverted paintings. Both periods are vividly documented in his work. The reflective, self-referential paintings preceding and including part of 1862 would come to a halt for the next five years. Precisely when this turning point occurred is uncertain, since the date of the paintings does not contain the month. But sometime during those twelve months of 1862 a change in outlook was clearly encouraged by a number of factors: the relative success of the 1861 Salon, the support of the young painters who turned to Manet as their leader, the resolution of his personal situation, and, perhaps more significant than has been recognized, Manet's meeting with Victorine Meurent. Not only his representations of her, starting in 1862 with *The Street Singer,* but all the works that followed have a new vitality, a freedom of movement, and a newly discovered sensuality.

The eight Spanish paintings, followed by *Le Déjeuner sur l'herbe* and *Olympia* of the following year, convey a sense of the living body with all its appetites. If we compare the bashful nymph/Suzanne, clutching her fleshy arms to hide her breasts, her heavy legs tightly crossed, with the inviting *Young Woman Reclining in Spanish Attire* or *Lola de Valence,* whose Spanish costume and dancing feet instantly evoke the heart-quickening rhythm and physicality of Spanish dance, we not only see but feel the difference. Even the two still lifes of that part of 1862 denote a heightened sensuality. A platter of oysters suggests more than fresh seafood, and the sombrero and guitar more than a head covering and music.

In the early 1860s Manet cut a striking figure. His sparse blond hair was usually covered by a tall top hat; he tended to wear well-cut jackets nipped at the waist and was fond of light-colored trousers and English jodhpurs that flattered his slender feet (Fig. 37). Whether standing at his easel or seated in a café, he was always well groomed and dressed for town. Paint-spattered smocks and berets were not for

him. A sketch by his towering painter friend Frédéric Bazille shows him working at his easel wearing a top hat as though dressed for a fashionable event. When he put down his brushes, he picked up one of his slender walking sticks, with which he is always portrayed, and set out in his rolling gait across Paris, whistling as he walked. Proust tells us that his bantering conversation was often punctuated by "a nodding of the head or clicking of the tongue . . . [the latter being] the supreme manifestation of his admiration." He often made this sound while looking at works by artists he especially admired: "Jongkind, Whistler, Bracquemond, Desboutin, Guys, the early landscapes of Claude Monet, the works of Degas, Pissarro, Sisley, the studies of Berthe Morisot and Mary Cassatt, Gauguin, Renoir, Cézanne, Caillebotte . . . but particularly when looking at some aspect of nature that especially captivated him, he would make the sound very loudly, like a rider urging on his mount."

If we look at Manet's total output (excluding copies) before 1862, even allowing for his inexperience and insecurity, what becomes apparent is the almost exclusive devotion to single, introspective figures, portraits of either identified or anonymous sitters. The few exceptions are *The Students of Salamanca,* a literary work evoking the picaresque novel *Gil Blas,* amusingly in Manet's own Gennevilliers countryside and his first landscape; the two improvisations on *The Little Cavaliers; La Pêche;* and, most notably, *The Spanish Singer.* The date of 1862 for *Music in the Tuileries,* accepted by current scholarship, would seem to be justified by the astounding originality of the painting, both within Manet's oeuvre up to that time and compared to other works of the time. Earlier writers[6] dated it 1860, arguing that since the date is in a different color from the signature, Manet must have altered it later. But to place *Music in the Tuileries* before *La Pêche,* and two years before *The Old Musician,* is to ignore the intervening works, which are still concentrated on static poses of classical subjects (*The Reader, The Surprised Nymph, Boy with a Sword*). It seems more likely that Manet would have first tackled *The Old Musician,* a less difficult technical enterprise in spite of its monumental size (almost six by eight feet) and a work that still looks back to the great masters, to allegory, and to realistic detail in the rendering of figures and objects.

In *Music in the Tuileries* (Fig. 11) Manet created an amalgam of

many of his artistic interests: contemporary life, portraiture, color, outdoor light, his awareness of himself as artist and of the canvas as artifice, and his emulation of past artists. Assumed by some to be his first work without backward glances at museum painting, it nevertheless incorporates the museum, as well as other works of his own period, into a "snapshot" of Parisian life. For his inspiration Manet used a work that so fascinated him that he did an oil copy of it, two free paraphrases of it, and an etching that went through four stages. *The Little Cavaliers,* attributed in Manet's time to Velázquez, depicts thirteen Spanish gentlemen, among them Velázquez and Murillo. It was not only the position of the groups that Manet admired enough to paraphrase; it was also the portrait of the presumed artist and his celebrated colleague among the beau monde of their day that tickled his fancy.

In *Music in the Tuileries,* there are at least thirteen identified portraits of Manet and his contemporaries scattered among the nameless and numberless fashionable people in this outdoor gathering place (his brother Eugène; the painters Fantin-Latour, Monginot, and Albert de Balleroy [his former studio-mate standing beside him at the far left of the painting]; the writer/critics Baudelaire, Gautier, Champfleury, Aurélien Scholl, and Zacharie Astruc; Baron Taylor, the expert on Spanish painting; Jacques Offenbach, whose music depicts the spirit of that Parisian life; Mme Lejosne, who often received Manet and Baudelaire at her soirées; and a veiled lady variously identified as Mme Loubens or Mme Offenbach). "Manet, with a typical mixture of ambition, impudence, and delight in visual puns, represents himself as the 'Velázquez of the Tuileries' and Albert de Balleroy as his companion Murillo."[7] There is an additional element of humor in Manet's having squeezed so vast a social panorama into a canvas smaller than that of the single figure of *The Surprised Nymph.*

This was Manet's first depiction of *la vie moderne,* and it was an accurate one: "At that time the Château of the Tuileries, where the emperor held court, was a center of opulent life which extended to the gardens. The band concerts held there twice a week attracted a sophisticated and elegant crowd."[8] Among them was an elegantly dressed painter who set up his easel and painted away as though he were in his studio. Proust tells us that "Manet went to the Tuileries gardens almost every day from two to four, doing outdoor studies,

under the trees," and that Baudelaire was his frequent companion. If Baudelaire was impressed with the result of those afternoons, he left no record of his reactions. Could he have been displeased with his recognizable but almost caricatural portrait? All of Manet's other friends are portrayed with considerably more detail; Baudelaire is a mere silhouette in profile. If he was blind to what Manet had achieved in this and later paintings, it would not be surprising. According to Michael Fried, Baudelaire also was blind to the fact that Delacroix, of whom he spoke only in hyperboles, had utilized his predecessors in much the same way as Manet: "Delacroix's unembarrassed exploitation of the past remained a secret to Baudelaire."[9]

Others were more openly admiring of this new leader of a school not yet formed. At the Café Tortoni, where Manet often had lunch before setting to work in the Tuileries gardens, a group of young admirers would assemble, and when he returned between five and six, they would pass his drawings around to murmurs of approval. "Manet could believe for a moment," Proust tells us, "that in this land of France where, in Voltaire's words, only success is successful, he was in his glory."

It is difficult for us to understand the kind of fury *Music in the Tuileries* provoked when it was exhibited in a gallery on the Boulevard des Italiens. Opened in 1860 by Louis Martinet, a former painter who became an official in the Ministry of Fine Arts, this gallery was to become a major venue for the new artists whose works failed to find a place on the walls of the yearly Salons. One spectator threatened to resort to violence if Manet's painting remained on view any longer. A polemical aspect, which would elude us today, may have been perceived in the work, and that was its unembarrassed declaration of originality. A new kind of painting was born in that canvas, which rejected the ancient myths still used by Bouguereau and Cabanel, as well as the modern political myths of David and Delacroix and the social myths of Millet and Courbet. Here was the new myth of present-day Paris. As one twentieth-century critic has observed, "From a theoretical point of view Manet's entire crime consisted in the fact that he had treated his friends in the gardens of the Tuileries as gods."[10] Within the scope of this new mythology everything that had been done and said in the past could be done anew — allegory, satire, social commentary, nudes, portraits — and better.

Manet was to achieve what Edmond Duranty considered the most

difficult task for a painter: "the truth of color and light." Art critic and novelist, founder of the short-lived but groundbreaking journal *Réalisme*, Duranty was Manet's exact contemporary, sometime enemy, and longtime friend. In 1857, when Duranty published these words, Manet was just starting out on his own. If he read Duranty's article, which is highly likely, he must have recognized his own ideas, already expressed in conversations with Proust: "In art, it takes great genius to reproduce simply and sincerely what one has before one's eyes, from an earthenware dish to the face of the most majestic of kings. . . . The best draftsman is the colorist. . . . Drawing is not the exterior contour of a form; it is everywhere, in the middle, above, below, wherever there is light and shadow."[11] Manet had already seen the truth of color and light before he entered Couture's studio, and gifted craftsman that he was, he could translate what he saw, "simply and sincerely," into color. *Music in the Tuileries* is the work that gives us the first clear indication of the path Manet was to forge for himself and for art after him.

In many respects *The Old Musician* is the more intriguing of the two paintings, particularly with regard to iconography (Fig. 9). In this monumental canvas Manet undertook the intrepid project of a complete portrait of the artist and his art. Here he assembled a network of references that, taken together, result in a visual wholeness before we understand the parts. This kind of complexity goes far beyond anything Zola ever imagined when he sang Manet's praises as a painter while reducing his genius to sheer technique. The painting seems first of all to acknowledge Courbet, Manet's immediate predecessor to whom he was compared as a second-generation realist, and specifically Courbet's huge canvas *The Painter's Studio, A Real Allegory of Seven Years of My Artistic Life.* Manet seems to be summing up the last decade of his own artistic as well as personal life. The entire work pays homage to a number of the great masters of the past and, most significant, places the artist himself in their midst. The figures point to Velázquez (the old musician recalls one of the Spanish master's beggar-philosophers), Watteau (the boy in white is virtually quoted from *Le Petit Gilles*), Courbet (the old bearded figure on the extreme right recalls the one on the extreme left of *The Painter's Studio*), and Manet himself (his own *Absinthe Drinker* reappears).

The Velázquez model for the central figure is doubly important for its evocation of an authentic figure of Manet's own time who was a

descendant of the seventeenth-century beggar-philosopher. The *chif-fonnier,* or ragpicker, was a commonplace in the nineteenth century. The streets and the literature of the period were rife with this figure, bowed under his sack, a lantern in one hand, a crook in the other, collecting after dark what those more fortunate had discarded. An early romanticized model was that of the leading role in *Le Chiffonnier de Paris,* performed by the celebrated actor Frédéric Lemaître in 1847. A later avatar of this figure in popular literature was Liard, "a Diogenes in a tattered frock-coat, whose aphorisms were sprinkled with Latin quotations,"[12] who was appreciated for his kindness, honesty, morality, and oratory.

Uncontained trash and garbage were habitually left out on the streets in the evening. Not until 1884 was the trash can invented and made mandatory by Poubelle, a successor to Haussmann's office of prefect of the Seine. Poubelle has the dubious honor of having given his name to the most universal and least appealing object in all of France, *la poubelle* (the trash can). During the Second Empire Paris was home to twelve thousand ragpickers, divided into four classes. The lowest were the *piqueurs,* whose survival depended on the speed with which they could evaluate a pile of trash. Next in line were the *placiers,* whose expertise was passed on from father to son. Known within the trade as *biffins,* they had the benefit of a particular quarter where the concierges gave them first dibs on silk or wool remnants, old clothes, and food scraps in exchange for services such as window washing and rug beating. *Chineurs* bought and sold on their own, walking through the streets in the morning crying, "Bottles, clothes, rags, metal." Their early-morning chants could still be heard well into the 1950s.

The peons had to classify all their pickings to sell them to the great magnates of the trade, the *maîtres chiffonniers,* who then sold their stocks of orange peels to cordial makers, corks to wine sellers, and, most profitable of all, human hair to wig makers. These painstakingly retrieved hairs, separated by color, length, and thickness and amounting to one hundred pounds a day, were collected from the combings of Parisian heads and valuable because a hair pulled out is stronger than a cut hair. Those who could afford the best-quality braids and postiches may never have known the source of the raw material they wore in their plump chignons.

The *chiffonnier* was, therefore, an easily recognized figure in

Manet's day. Having been taken up by the theater and the press and endowed with the additional attribute of philosopher, the character evoked more than pity, however miserable his lot. If Manet portrayed his old musician of 1862 and his two beggars and ragpicker of 1865 without emotion, it is not because he lacked compassion, but because these were familiar and interesting urban types. Their clothing and general appearance were so common that Manet had no need for an authentic beggar off the streets to model for *The Ragpicker;* his brother Eugène posed for the painting.

A little-noticed detail, the implausible grapevine on the left of *The Old Musician* — previously associated only with its analogue in Velázquez's *Los Borrachos* — harks all the way back to antiquity. The grapevine, depicted here with realistic clusters of white grapes, recalls the legendary contest between two Greek painters of the fifth century B.C. As recorded in Pliny's *Natural History* (35, 65–72), Zeuxis won for having produced so realistic a likeness of grapes that birds tried to pluck them from the picture. He nonetheless invited his younger rival, Parrhasius, to show his painting, and when it was presented, Zeuxis asked Parrhasius to draw aside the curtain so that the picture might be seen. When he realized that the curtain *was* the picture, he handed over his prize, acknowledging that he had deceived only birds, whereas Parrhasius had deceived an artist. Manet assuredly read Pliny while at the Collège Rollin, but even if he had not, this ancient rivalry was well-known to artists of the time. Manet's allusion to this story would link Courbet the realist with Zeuxis the "grape maker," and Manet himself with Parrhasius the consummate artist — not the man with brush and palette looking at his canvas, as Courbet had portrayed himself in *The Painter's Studio,* but the old musician, a recognized emblem of the artist as commentator on past and present, looking out at the viewer, which might suggest looking ahead to the future.

Another possible association with Parrhasius is his celebrated painting of the people of Athens, a work known only through the description and praise of ancient writers. Pliny (35.72) lauds the artist's ingenuity in depicting the Athenians not only as "angry, unjust and inconstant, but also placable, clement, compassionate, boastful, noble, humble, fierce and timid — and all these at the same time." This panorama of figures, each different from the others, suggests the challenge of the crowd in *Music in the Tuileries* — a vastly ambitious work of numerous precise portraits, each distinguishable amid the

crowd of anonymous figures, themselves individualized. Just as critics have seen a relationship between *Music in the Tuileries* and Couture's *Romans of the Decadence,* so Couture himself may have thought of surpassing Parrhasius's masterwork, and Manet of surpassing them both.

Bearing in mind Manet's habit of multiplying references and layering inferences, one is irresistibly drawn to a more personal reading as well. As art historian Harry Rand has recently said of Manet's work in general, his "picture gains meaning incrementally."[13] *The Old Musician* has long been regarded as Manet's first painting of modern Paris (depending on which date is accepted for *Music in the Tuileries*). Most catalogue descriptions speak of it as representing the new homeless who had recently been dispossessed of their slum quarters, demolished just about the time Manet did the painting.

Various studies have identified the sources of the composition and the figures. But the discovery of sources does not reveal their significance. Most earlier critics, and even more recent ones, claimed that Manet turned to his predecessors because he lacked compositional imagination. Many of these same writers also denied Manet any intellectual content, seeing his works as little more than random snatches of modern life, often equated with the new technology of photography. What they failed to see is that Manet was deeply engaged in a complex interweaving of observation, memory, and thought, which constitutes the same kind of all-embracing process that enters into the creation of literature. Poets and novelists draw on a recapitulation of their art, consciously or unconsciously reworking metaphors, myths, and language while simultaneously reaching into personal experience. "The citations and paraphrases from art history in Manet's work represent a sometimes witty, but more often intensely serious dialogue with the past," Rand observes.[14] It is this seriousness that characterizes the mystifying aspect of Manet and his paintings. He could be understood by his contemporaries — with sympathy or hostility, depending on the viewer — as a neutral observer of his time, as a clever and even irreverent manipulator of past art. But to credit a man of such flawless tailoring with complex ideas seemed an oxymoron: a critical *flâneur,* an intellectual *boulevardier,* an original *pasticheur?*

Manet had presumed that at least his fellow painters and a few cultivated art critics would recognize his allusions and understand that

he was drawing on the past in an attempt to create a total art of painting in which the past and all its national schools (Italian Renaissance; seventeenth-century Spanish, Flemish, and Dutch; eighteenth- and nineteenth-century French) were finally joined under his brush. Later the list of schools also would include Japanese masters.

At the same time, these allusions seem to be self-referential. Manet may have revealed more than he wished to be understood, while mistaking what he thought would be understood. The old musician seated in the center foreground is clearly the central figure toward or away from whom all the others are directing their gaze. This figure has been recognized by others as a symbol of the artist — the itinerant musician, the peripatetic philosopher. But is this not Manet himself? The bow — like the sword, walking stick, paintbrush, or baton — is yet another attribute that Manet used to designate himself. Here the bow points to the figure based on Watteau's Gilles. Also in 1862, Manet appeared as Polichinelle in his frontispiece to his etchings; he would reappear later in the same costume in *Ball at the Opéra*. Like the seventeenth-century Pulcinella of Italian commedia dell'arte, Polichinelle's attribute is a bat or a baton, dating from his earliest avatar in ancient Roman comedy, when a phallic object was used for gross comic or mock heroic gestures. Later a new character was born, who would be known as Pierrot by the end of the seventeenth century. "A note in the collection of scenarios left by . . . the first Italian troupe in which Pierrot appeared by name, suggests that Pulcinella was his progenitor."[15] In France Pierrot and Gilles had become one and the same figure by the eighteenth century. The genealogy of this figure is not as arcane as it might seem, for these commedia figures were very well known in Paris, where until 1862 a number of theaters, among them the Funambules, performed plays written for these characters by playwrights such as Champfleury and Duranty, both familiar to Manet. Gilles in *The Old Musician* can therefore be understood as not only an artistic offspring but a metaphoric one, steadfastly looking away from his "disguised" progenitor, whom he must not recognize and by whom he is not recognized.

The figure of the girl also has a history, but hers is graphic. Radiography has disclosed that her legs were three inches longer and her hair was pulled back in a bun, making her look quite a bit more mature. Her face is averted from our gaze, and the lost profile makes it as

impossible for us to know where her glance is directed as to see her features. Nor do we know anything about her relationship to the child she carries, except that in the first version she could have been its mother; in the final version she can only be its sister. The little boy in white, toward whom the musician's bow is pointing, is linked to the group of four, and particularly to the musician, by the tight curve of their placement. Although the boy is the focal figure, the central figure is the musician. It is his eye contact with us that brings us into the picture. The vitality of his personality and the enigmatic quality of his expression solicit our attention. Is that furtive smile on his lips meant to tease us into unraveling the riddle of this strange assembly?

Although Manet may have chosen to portray these alienated figures as representative of the new Paris, in which the poor were displaced by new constructions to house the new rich, the quotation of his own *Absinthe Drinker,* his first work to be submitted to a Salon and rejected, marks the painting with an obvious personal significance. The old musician is disengaged from his particular art by his appearance as a nonperformer: his instrument lies idly in his lap. He might just as easily have been shown playing his violin or raising his bow preparing to play it. Instead, though his bow serves only as a pointer, the instrument identifies him as an artist rather than a ragpicker or a beggar. Ten years after Léon's birth certificate identified the father as an *"artiste musicien,"* Manet donned the costume of an itinerant musician, an artist, like himself a "marginal" type, unrecognized by the artistic world of Paris and relegated to the edge of the city, where Manet's studio bordered on the very quarter from which the old fiddler was displaced.

The close group that the old musician dominates, but that his gaze ignores, is composed of a young mother/sister whose pose denotes concealment from us and whose original haircomb recalls Suzanne; a young boy whose costume identifies his filial relationship to the Polichinelle of Manet's symbolic self-portrait that same year; and an older boy whose fraternal gesture toward the boy in white — and whose head gestures toward the musician/artist — suggests the fraternal role Manet would be forced to play in public toward his own son once he married the boy's mother. The so-called old Jew at the far right has a number of resonances. In Courbet's *The Meeting,* the bearded figure was modeled after the traditional image of the wandering Jew, who had become symbolic of society's victim and of the messianic,

and often neglected, herald of new ideas. There can be little doubt that Manet had Courbet in mind when he conceived of *The Old Musician.*

In Manet's canvas the old Jew also can be seen as a patriarchal figure, referring both to Courbet, his artistic predecessor, and to the "marginal" figure of Manet's own paralyzed father. As for the placement of the figures, Georges Bataille rightly remarks that they are like "actors on stage taken unawares as they wait for the curtain to go up . . . not a carefully arranged pose, but a natural disorder arrived at by chance."[16] Bataille's words could serve to describe the way a dream image is constructed — a mental snapshot that captures a psychological event with the kind of spontaneity that Manet endorsed — but that is not at all the case here. This is a studio picture with models posing. All the greater is Manet's genius for offering us this dumb show, as charged with meaning and as little improvised as the one devised by Hamlet.

One final detail seems to set the mood of the painting. In the left background is a clearly delineated plant in an otherwise amorphous setting — a thistle. In biblical iconography the thistle became the symbol of earthly sorrow and sin when God cursed Adam (Gen. 3:17–18): ". . . cursed is the ground for thy sake; in sorrow shalt thou eat of it all the days of thy life; thorns and thistles shall it bring forth to thee." The association of thistles with thorns in this passage later endowed the thistle with a Christological symbolism: the crown of thorns, the mocking of Christ.[17] Was Manet, master of the quip, the pun, engaging in a bit of self-directed irony here? Was he to be condemned to a joyless existence in retribution for his sins? And did he see himself mocked by those who were blind to his originality as Christ had been mocked by those who had remained deaf to his message? In a caricature that appeared in a newspaper a few years later, Manet is depicted as Christ surrounded by his Batignolles "disciples."

Although he would continue to construct his paintings in similarly complex fashions, *The Old Musician* and the etching for the 1862 frontispiece were the last of their particular kind for a long while. The sad Polichinelle, the mysterious musician, the searching boy with the sword, and the betrothed couple in *La Pêche* are all allegorical figures whose interest would pale once Manet's personal life was regularized. Even before his marriage in October 1863, the weight of his unavowed responsibility was relieved by the certainty that he would fulfill his obligation to Suzanne. These allegories of his private world

enmeshed in allegories of his artistic vision may have alleviated his uneasiness, perhaps even his guilt, at the same time that they carried him to a new consciousness.

Victorine Meurent assuredly played a major role in this transformation. When Manet met her, she was self-sufficient, street-smart, and older than her eighteen years, as girls growing up in poverty often are. A spunky Parisian from working-class parents with little hope of a brilliant future except as a courtesan if she were lucky enough to meet the right man, she started out as a model. In addition to Manet she posed for Thomas Couture, Alfred Stevens, who later became her lover, and other painters in Manet's circle. Remarks quoted by Proust indicate that Manet must have met her early in 1862, if not earlier, since the scene he relates preceded *The Street Singer* of 1862. On seeing a girl come out of a tavern — the setting of *The Street Singer* — Manet asked her to pose for him. When she laughingly declined, he turned to Proust: "I still have Victorine." And it is indeed Victorine who posed for *The Street Singer*.

For thirteen years Victorine was Manet's constant model. Her great talent lay in changing her appearance the way a good actor changes personality from one role to another. If we examine the paintings he did of her, we can see the fascination she held for him. He may never have loved her — nothing in his portrayals of her expresses any such emotion — but she clearly excited his imagination. She also seems to have loosened his bonds to bourgeois propriety.

Aside from prostitutes and models, a man of Manet's station would have had little occasion to know women like Victorine. Had he become a bohemian, like many other artists of bourgeois background, that would not have been the case. But Manet did not move into a garret or wander around in a threadbare jacket; he never abandoned his upper-class habits. Nor was he ever seen in the kind of artists' hangouts frequented by an apostate bourgeois like Courbet. Victorine was more than a passing fancy. For more than a decade he painted her in everything from her own naked flesh to a matador's *traje de luces*. With her Manet could continue to explore the motif of appearances — the hidden face of reality, the other side of the grand gesture, the lie, the bluff, the travesty — that had entered his work since 1861; only now the focus was no longer personal. With Victorine his horizon expanded along with his senses. She introduced him to other mores, views, and values. The candor of her poses, her

unflinching gaze, and the evident pleasure Manet took in molding her features and forms are all a far cry from the sculptural nudes of Salon paintings and the stiff-necked, albeit fake, morality of Manet's upper-class world. The stolid bourgeois viewer could savor with impunity the pink curves of Cabanel's wave-borne Venus or the gleaming firmness of Ingres's sylph in *La Source* because these marble-smooth bodies were not intended to suggest real women; they were the idealized forms of ancient sculpture in technicolor.

For centuries men had depicted women in ways that not only neutralized the unavowable male response to the female body but also "relegated [women] to visual objectivity."[18] Women could be made to represent the amoral pagan world (Venus), the origin of sin (Eve), or, more subtly, the vehicle of redemption (Mary). A nude goddess could be as lascivious as a pornographic photograph so long as she had a mythological name and kept her eyes off the viewer. But a real woman painted unclothed — presumed to be a prostitute, since no respectable woman would have posed naked — was an offense to public morals, despite the frequency of contact between just such women and the male viewers who claimed outrage at Manet's depictions of Victorine's nudity. The hypocrisy went even further. When contemporaries of Manet's painted their own mistresses from the demimonde as Dianas or naiads, there was no public outcry, because to have recognized the model would have been to incriminate oneself.

A century before, Diderot had pointed out that "a naked woman is not at all indecent; a woman attired is. Imagine the Medici Venus before you and tell me if her nudity offends you. But slip two little embroidered mules on that Venus's feet, roll a pair of white hose over her knees and fasten them with pink garters . . . and you will keenly feel the difference between decent and indecent; it is the difference between a woman one sees and a woman who exhibits herself."[19] This description immediately brings to mind *Olympia* — one fringed silk mule encasing her foot, the other just fallen from her toes, her expensive embroidered shawl cradling in its silken folds her pale flesh, clad only in a teardrop pearl on a black silk choker. At first glance this would be a fine example of Diderot's woman on exhibition, the image of a woman as men wish to see her "in a culture designed by men for the benefit of men."[20] Kenneth Clark states frankly, "No matter how abstract, any nude that does not arouse in the viewer at least some slight quickening of sexual interest is bad art and false morals."[21] But

there is more to Manet's portrayal of Victorine than a slight quickening of sexual interest.

If she represents anything important for Manet, it is precisely the break with false morals, or, to put it positively, she is the incarnation of truth. In depicting her as herself in *Portrait of Victorine Meurent,* as a nude in *Le Déjeuner sur l'herbe* and *Olympia,* or as a costumed figure, he made no attempt to prettify her. As Beatrice Farwell writes in her brilliant study of the nude in Manet's works, "By painting exactly what he saw, by exaggerating and taking pleasure in the sensuous process of seeing, he avoided the pitfall of trying to make Victorine beautiful, and instead made her visually real. . . . This feature of Manet's art, constant throughout his career from 1862 on, is an integral part of his visual candor, his outspokenness, in the face of traditions that pressed for a more conventional concept of beauty."[22] On Manet's canvases Victorine remains what she was: a female body, a model, a girl from one of the poorest quarters of Paris. Little is known about her life, but thanks to Margaret Siebert's biography we know where she lived at various times, how she earned her living, whom she knew — which tells us quite a lot about her.[23]

She was born on February 18, 1844, in a six-story building consisting of one- and two-room apartments, with a tavern occupying the ground floor. The street, now named rue Popincourt in the eleventh arrondissement, was in "a popular quarter of laborers, burdened with numerous children, living on inadequate wages, who had no resources to protect them from unemployment or illness."[24] It was a neighborhood of tinsmiths and copperworkers, laundresses and wool carders, stonecutters and cabinetmakers. Victorine's father was an engraver of some kind, perhaps employed by the factory on rue Popincourt that produced bronze bases. There is a record of one such base ordered by Thomas Couture for a footed Oriental bowl. It was there that Couture may first have seen Victorine, who began modeling for him in December 1861 and continued through January 1863, according to his own expense accounts.

Manet may have met her at one of the dance halls where the classes mixed easily — that is, upper-class men mixed with lower-class women. These *bals populaires,* like the much more elegant opera ball, were well-known venues for meeting unattached, or at least available, women — not necessarily prostitutes, but shopgirls, servants, and young women whose virtue was a small price to pay for the chance to

meet a man with more means and better manners than the local laborers and who were prepared to perform a range of services, from model to mistress. Or Manet may have seen her in the shop on the rue Maître-Albert, in the Latin Quarter, where he had his copperplates etched and where Victorine lived in the early 1860s — 17, rue Maître-Albert is the address beside her name in his notebook. It was a street even more dismal than the one on which Victorine was born, its most "respectable" dwellings the dingy rooms rented by housemaids.

In view of Manet's comment — "I still have Victorine" — after he had been refused by the girl he approached on the street, *The Street Singer* cannot have been his first painting of Victorine. More than likely his portrait of her is the first extant image we have. In it she appears in modest attire, a wide ribbon tied in a flat bow around her red hair, which is gathered into a crocheted snood. She is already wearing the black cord around her neck that would become her hallmark. Her blouse is white, trimmed with black, the ribbon slate blue, but the general effect is gray, making one think at once of a grisette, a shopgirl who most often sold fashion accessories such as buttons and ribbons. Jacques-Emile Blanche, Manet's younger colleague, recalled this portrait years later in his memoirs: "How often does the chance meeting of a painter and a model decisively influence the personality of his works! I consider the head of Victorine Meurend [*sic*], wearing a blue ribbon in her hair, as the keynote of the . . . colors on Manet's palette. . . . Let us call this class of artists [Corot, Manet, Alfred Stevens] the painters of colorful grays and tone on tone harmonies [which] had their origin in Spain."[25]

A nineteenth-century phenomenon, a grisette was a girl of the working class or lower middle class, without the vulgarity of the urban underclass or the coarseness of the proletariat. The term *grisette* came from the cheap cloth of her dress, tinted a drab gray. She generally gave herself to artists and students in a long-term relationship and became the melodramatic heroine of fictional and operatic renderings of bohemian life. Eventually abandoned, often tubercular, and generally reduced to prostitution, she rarely reached the age of thirty and even more rarely escaped from her miserable garret to the opulence enjoyed by a well-kept cocotte.

From a letter Victorine wrote in August 1883, when she was thirty-nine, to the recently widowed Suzanne Manet, we can extrapolate something of her behavior during the years she posed for Manet:

You doubtless know that I posed for a large portion of his paintings, notably for Olympia, his masterpiece. M. Manet was concerned about me and often said that if he sold his pictures he would set aside a gratuity for me. I was young then, and carefree. I left for America. When I returned, M. Manet, who had sold a large number of pictures to M. Faure [the noted operatic baritone, who was an avid collector of Manet's works], told me that a share of that was mine. I refused, thanking him warmly, and added that when I could no longer pose I would remind him of his promise. That time has come sooner than I expected.[26]

Models like Victorine lived from hand to mouth. To refuse even a few sous could be the difference between eating and going hungry. Her refusal indicates that she was solvent, or pretended to be. But more important, her pride suggests a relationship of parity between them. Had she been no more than a hired model, she would not have rejected his offer of a bonus. If, however, there had been a more personal relationship between them, platonic or intimate, such a gesture is much more plausible. Naturally she accepted payment for her work, but a bonus from a friend or lover would have demeaned the relationship by emphasizing her status as a hireling. Her refusal speaks highly of Victorine's independence and personal ethics, both of which are confirmed by the way Manet portrayed her. Here was a woman more honest, more generous, and more admirable than many a so-called *femme honnête*.

Victorine came from a world in which women rarely got to marry the men who made them pregnant. Of necessity they learned to deal with such problems on their own and were consequently strong and fiercely self-reliant. The fact that Victorine was baptized the day after she was born indicates the brief life expectancy of children born in such circumstances. Victorine was not one to be concerned about what people said; hypocrisy may well have been the greatest mortal sin in her theology. It takes little imagination to see the charm, freshness, and integrity that Manet found in her. She was herself a living symbol of his own aspiration in art — *faire du vrai*, "to paint the truth" — and what he was later to term *la vraie vérité*, "the real truth."

Although a paragon of upper-class taste and refinement, Manet had another side. Whereas others less well-born affected the manners

of English gentlemen, Manet affected the manners of the Parisian underclass — Victorine's class. He may have forced his husky-voiced drawl and his loose-hipped strut, but he genuinely had the biting wit, the quick retort, and the ironic flirtatiousness typical of the *parigot*. This side of his personality, which was temperamentally and culturally alien to Suzanne, he could share with Victorine. There was much they could share, perhaps sex as well, without guilt or complications. Once Manet was married, he was entitled to have a mistress. Victorine was not without artistic talent herself. She may not have been painting when she first began posing for him, but her artistic sensibility and critical eye were doubtless apparent at the time. In 1873, after a ten-year hiatus, she posed for him again, by then ostensibly serious about painting. For technical guidance, however, she did not turn to Manet, or to another established painter and sometime lover, Alfred Stevens, but to a minor artist, Etienne Leroy. Soon after, her works began to appear in the Salons: her self-portrait in the Salon of 1876, from which Manet was excluded; in 1879 *A Sixteenth-Century Citizen of Nuremberg;* and in 1885 *Palm Sunday.*

Victorine is emblematic not only of Manet's break with the past but also of his grasp on the future, his conception of a new sensibility expressed in familiar language. However revolutionary this was, it was not anarchic. Manet was not militating for upheaval, which would come later and would not be led by him, but for the replacement of a spent order by a brighter one. Just as republicanism was hardly radical in terms of political theory but a threat to Napoleon III, so Salon juries viewed any apostates as undermining their own validity as established artists. Manet's break was with the immediate artistic past, with stultified forms and saccharine beauty. His revolution was one that evolved from a return to those pasts — the Italian Renaissance, seventeenth-century Spain and the Low Countries, eighteenth-century France — in which form, technique, and content were integrated among themselves and within the culture of the time.

What was lost forever in Manet's painting was the security of an iconography that affirms power, stability, even beauty. Whereas earlier painters portrayed humanity made divine in Mary and divinity made human in Christ, Manet shows us that humanity is simply humanity. There are no gods, demigods, divinities, or heroes. Manet's was the era of the antihero, that modern figure who rarely understands what is happening or why, who mimics the poses and gestures

of heroic figures but in the end is only a performer. Polichinelle became a perfect emblem, along with Manet's *Mlle V . . . in the Costume of an Espada* or *Pertuiset, Lionhunter.* These are the heroes for the second half of the nineteenth century, to be continued in the twentieth with Charlie Chaplin in the tattered attire of the City Englishman.

One of Manet's younger contemporaries, Jacques-Emile Blanche, though a confirmed partisan writing with much insight, still sold Manet a bit short:

> He was, with Courbet, the last painter in the old master tradition. Rather than a *precursor*, he was a *culminator*. Never perhaps has an artist been less understood, more poorly defined during his lifetime; misunderstood by others and by himself . . . famous for theories he never held but which journalists and writers formulated for him, out of amusement, or out of personal interest, like Zola. The nobility of his most cursory works . . . still eludes even a Degas who was as much an *intellectual* as Manet was not.[27]

Rather than the end of a line, as Blanche views him, Manet might more fittingly be seen as a bridge, joining the tradition behind him with a new approach to painting, continuing the past and heralding the future; not an iconoclast overturning altars, but a man with a vision, convinced that the future would prove him right. Just as in his dress he did not affect the grungy look of the bohemian artist, but toiled at his easel impeccably turned out, so he conserved the tradition of high art while molding it to his own needs. Whereas others saw him as the firebrand of a revolution, he saw himself entering the pantheon of painting through the front door, his works accepted by the Salon and hanging in the Louvre.

Venus Observed

The three paintings of 1862 for which Victorine posed amply demonstrate her histrionic talents and Manet's imaginative use of them. *Portrait of Victorine Meurent* reveals a candid and rather attractive face, with the creamy skin of a true redhead, confirmed by her precisely painted red-blond eyelashes. This, we may assume, is a reasonable likeness of Victorine, neither prettified nor, as a few early critics complained about some of his other portraits of women, *enlaidie*, uglified. In *The Street Singer*, she is seen playing the first of her many roles. Manet has endowed her with the waxy pallor of a poorly nourished waif, clearly not her own enviable complexion. The deep shadows above her nose — ridiculed by one critic as eyebrows "moved from their horizontal position to a vertical one . . . like two dark commas"[1] — and her eyes reddened with fatigue lend pathos to this face made-up as though with greasepaint.

The actuality of the figure has already been mentioned. Victorine assumed the pose — presumably of the woman Manet had seen coming out of a dingy café — as easily as the character. Her petticoat seems more accidentally than provocatively revealed as she clutches the guitar against her skirt, and its broad white brushstrokes serve to echo the same white vertical brushstrokes of the waiter's apron seen behind her. The fact that Victorine played the guitar and that cherries — "fruit of paradise," variously signifying sexual love and reward for virtue — reappear beside her in *Le Déjeuner sur l'herbe*, painted the following year, suggests a personal association with Victorine. Manet seems to be using them as attributes for her in the way that he

uses a cane to designate himself. In addition to her reputation for punctuality, patience, and discretion, Victorine was an exemplar of a certain kind of Parisian woman of the mid-nineteenth century — physically uninhibited though not coarse, using whatever talents she had to make her way in life, with a sense of her own worth and a mind of her own.

Manet was later to tell Proust that he had "not done the woman of the Second Empire, but the woman since then." Victorine, however, represented a number of types current during the Second Empire, and so recognizable that viewers were outraged to find them on public display in the sacrosanct precincts of the Salons. They were not the types that ennobled art, which was why they met with so much hostility, especially since they were women in "unbecoming" roles. The portly Louis François Bertin, portrayed by Ingres in 1832 to represent what Manet called "the Buddha of the wealthy, glutted, triumphant bourgeoisie,"[2] was hardly an inspirational, romantic, or noble subject. But he was the conquering hero of the first half of the nineteenth century, icon of the ruling class engendered by the French Revolution. Victorine represented what his money could hire or buy. Women like that were either the sores of society or its most traded commodity.

In each of the works where Victorine appears, Manet has her playing a different part, but she is never so disguised as to become unrecognizable. Whether identified by name or not — *Mlle V . . . in the Costume of an Espada* of 1862, *Woman with Parrot* of 1866, or *Gare Saint-Lazare* of 1872 — we are never allowed to forget that Victorine is in costume. Manet had various techniques for undermining the suspension of disbelief with which we generally view a painting or a play and which allows us to accept as real what we know is not. An earlier example of this process is astutely cited by Kathleen Adler. Speaking of *The Spanish Singer* (1860) and Manet's ironic reference to the tradition of musicians as subjects in romantic painting, she sees the left-handed guitarist playing a guitar strung for a right-handed player as "an implausibility that introduces a note of parody threatening to undermine the convention of this type of genre painting. Once the incongruity is observed, the figure ceases to be convincing and becomes instead the image of a man pretending to be a guitarist."[3] She also sees similar effects in other works, thus precluding this one from being accidental.

Because of such effects we respond, even if unconsciously, to the

model, not the subject, and particularly to Victorine's personality, which crosses over the frame and enters our space as though in direct contact with us. And when Manet painted Victorine in the nude — first in *Le Déjeuner sur l'herbe*, then as *Olympia*, both in 1863 — he undertook the daunting task of mingling contradictory ideas: classical and modern, mythic and actual, genre and portrait, precision and fluidity. Just as we never forget Victorine, so we are always aware of Manet. His own personality and his attraction to the real world are reflected in the directness of his color: no half tones, no circumlocutions. All of his works reflect his humor, wit, irony, teasing, mockery, erudition, his playful use of symbols. As George Moore notes, "The work of the great artist is himself, and being one of the greatest painters that ever lived, Manet's art was all Manet; one cannot think of Manet's painting without thinking of the man himself."[4] Moore, the English critic and playwright, twenty years Manet's junior, of whom Manet did a series of portraits in 1878–79, had come to Paris to study painting. He was one of the rare observers, if not the first, to stress the singular rapport between the individual and his work, which Moore considered the sine qua non of the true artist. "Impersonality in art really means mediocrity. If you have nothing to tell about yourself . . . you are not an artist."[5]

Mlle V . . . in the Costume of an Espada is the first canvas that treats the theme of the antihero, which Manet was to explore over and over in the coming years. Here, in the most masculine, most intrepid of male contests — a voluntary *mano a mano* with death — a woman not only appears in the arena, in the ritual attire, but even holds the sword and muleta, which none but the consecrated matador, like the knight of medieval chivalry, has a right to use. Anybody can wield a cape, but only a matador can kill. This image of Victorine, understandably incongruous and disturbing at the time, is very different from the Goyaesque trousered figure *Young Woman Reclining in Spanish Attire* that Manet painted the same year for his friend the photographer Nadar. In the first place, the languor of the pose exudes a certain eroticism, reinforced when one learns that the model was Nadar's mistress at the time. The evocation of Spain, in the spit curl and the clothing, injects an aura of passion into the painting. Second, the model for the pose seems clearly to have been Goya's Maja, photographs of which Nadar had made for Baudelaire a few years before. Nadar later provided Manet with photographs of both Majas. It has

been said that the painting, dedicated to "My friend Nadar," was Manet's way of thanking him for the pictures.

As important as the pose is the clothing in this painting. In a world where a woman's legs were concealed not only by floor-length skirts but also by hoops and crinolines, the mere sight of a thigh molded by pale fabric was enough to accelerate a male pulse. Only working-class women commonly wore trousers, and since such women were considered more natural and thus more "animal," the association of trousered women and sexuality was instantaneous. Frontal photographs of women dressed for manual labor were circulated like pornographic pictures. These same women, when they posed for a formal photographic portrait in high-collared hoop-skirted black, were always seated sideways in the three-quarters pose of upper-class women.

Total nudity was normal in a brothel, but a respectable woman was hardly ever seen even by her husband in anything less than a shift. Only a courtesan, out of the reach of most men, might appear in such suggestive attire as trousers, far more exciting than the nudity of readily available prostitutes. Consequently, a woman in light-colored breeches, especially reclining, her delineated thighs calling attention to the provocative Y, was in a costume and pose often used for pornographic pictures, and thus totally feminine. Victorine, in contrast, standing in a bullring, wearing unrevealing black breeches, is anything but feminine.

Why would Manet choose such a subject? If he was attracted to things Spanish, he had only to continue sketching and painting the sensational dance company that was the hit of Paris between August and November 1862. His interest in Spain had been awakened in boyhood by the Spanish collection at the Louvre and by the Hispanomania that had continued unabated in French literature and music since the 1830s. The troupe of singers, dancers, and guitarists, led by Mariano Camprubi, Lola Melea (known in Paris as Lola de Valence), and Anita Montez — all of whom are seen in Manet's *Spanish Ballet* of 1862 — were appearing nightly at the Hippodrome, their castanet-clicking, heel-tapping, hand-clapping rhythms inspiring delirium among Parisian audiences, subverting the decorum of well-bred spectators.

Manet had not yet been to Spain, not yet seen a corrida, but his imagination was piqued by the vitality of these performers. Is Victorine in the bullring, like the torero working the bull, the mesmerizer

of her painter? Is she the repository of the courage and vitality expressed by the figure of a matador? Or is the matador's right to use a sword, to kill — the ultimate representation of masculinity — mere posturing, a bombastic gesture signifying, in the hands of a woman, nothing — like so many gestures men elect to conceal their fear, their vulnerability, their mortality? The one male matador Manet painted is a dead one — *The Dead Toreador,** an ironic pun in Spanish, *el matador matado,* which Manet may have understood — isolated even from the scene of his heroism when Manet cut off the top half showing the *barrera* and three toreros (Fig. 23; see p. 181). Manet had just witnessed the decline and death of his father from syphilis. He also may have looked with an ironic shrug at his own weakness vis-à-vis Suzanne, whom he was soon to marry because of a youthful indiscretion ten years earlier. When it came down to it, masculine authority, masculine valor, even masculine freedom were like costumes; underneath was just a naked human being.

Manet's innovative production of the early 1860s, however offensive to the academic establishment that judged painting in Salon juries or newspaper columns, was in fact grounded in ideas that had long before received official approval. Victor Cousin's dictum of 1828, "Eclecticism is the philosophy of the century" determined the kind of art that the public had been enjoying since the 1830s, an art that sought to reconcile the different schools rather than choose among them. Delacroix combined classical subjects with a romantic style of painting and was already, in spite of himself, an avant-garde artist, though he resolutely considered himself classical. Couture drew on classical, Renaissance, and Venetian art. Eclecticism — defined at the time as the ability to appreciate the individual and contradictory qualities of the various schools — characterized the Universal Exposition of 1855. Coming as it did during Manet's formal art training, this exhibition, which also may have provided his first contact with Japanese art, made a lasting impression on him. To understand how this event affected a budding French artist it might be worth a step back in time.

Toreador is a misnomer, used only outside Spain; in Spanish the general term for bullfighter is *torero,* and for the one who kills the bull *matador,* from the verb *matar,* to kill.

In 1855 Louis-Napoleon was in the third year of his imperial reign. Anything that could glorify Paris would glorify his regime. And this Universal Exposition was intended to outdo in splendor and modernity the one held four years earlier in London. Although Maxime du Camp — critic, writer, and Flaubert's friend and travel companion — maintained that for the emperor "painting [was] a closed book; music a dead letter; poetry unintelligible,"[6] painting was well subsidized by the imperial treasury and its importance appreciated. In Patricia Mainardi's notable study *The Art and Politics of the Second Empire*, we learn that 38 percent of the fine arts budget was spent for religious works, most of them copies of museum pieces. This was dictated by the emperor's desire to ingratiate himself with the Church, which had supported his dismantling of the republic. In fact his debt to the Church had been prepaid by his betrayal of faith to the young Italian republic in 1849 when, as elected president of the French republic, he sent troops to Rome, ostensibly to protect the pope, who had fled when Mazzini entered the city. Thousands of French troops laid brutal siege to Rome, provoking the collapse of Italy's first attempt at unification — a principle Louis-Napoleon had been committed to defending until imperial ambitions distracted him.

The many copies of major religious works sent to provincial churches around France were thus a nod to the renewed status of the Church in France and to Louis-Napoleon's legitimacy on the throne. This explains the large number of copyists employed during those years — a boon for struggling artists — and the familiarity of the lay public with works of old masters. Artists also were encouraged to paint imperial events, victories, and portraits. According to Mainardi, close to three-quarters of the budget for fine arts was politically motivated.

All the more reason for the Universal Exposition of 1855 to establish Paris as the art capital of the world and Napoleon III as its patron saint. The grandiose project of building a rival to London's Crystal Palace, constructed for the previous Universal Exposition, was thus undertaken to house exhibits from all over the world, but the final plans projected a building only half the size of its English model. Because its 40,000 square meters were evidently inadequate for a world's fair, two smaller constructions were added, along with a temporary pavilion of 12,000 square meters on the Avenue Montaigne to serve as the exhibition hall of the fine arts. Twelve thousand French

artists and as many foreign artists submitted their works to a jury, overseen by the emperor's illegitimate half brother, the duc de Morny (fathered by an illegitimate son of Talleyrand). The duke, three years younger, had brilliantly engineered the coup d'état and plebiscite of 1852 that persuaded the French electorate to subject itself to another Bonaparte emperor.

The guiding principle behind the exhibition of France's leading artists in 1855 was to present a global view of all the French schools, which were supposed to be seen as a single national school. "France," Théophile Gautier proclaimed in his review of the exhibition, "possesses in its art all climates and all temperaments. It can oppose Ingres to Delacroix, Decamps to Meissonier, Flandrin to Couture . . . reconciling all opposing camps and accommodating the most diverse originalities."[7] Eclecticism was thereby sanctified as the national genius. Cousin's observation that different peoples have different ideas within the same period led Gautier to propose England as the representative of individuality, Belgium of savoir faire, Germany of intellectualism, and France of eclecticism. And since eclecticism led to universality, and universality to superiority, France, encompassing the styles of all countries, could thus claim to be the artistic capital of the world.

The exhibition was the cultural consecration not only of Napoleon III but also of Delacroix as a national painter. Ingres, with his classical style and subjects, had been the high priest of conservatism. Commissions, exhibitions, prizes, and honors had been showered on him. Delacroix, though esteemed and even successful, had always been regarded with suspicion. Now the flaming revolutionary was accepted as a tamed colorist. "Depoliticized and neutralized, except for a few diehard extremists," Mainardi explains, "critics and the general public would begin to see [his work] in exclusively formalist terms."[8] Critics, from Zola on, would do the same for Manet. In Delacroix's case this was not too radical a shift in position because his subjects had remained in the grand tradition; it was his technique — loose brushstrokes, absence of precise detail — that had been found "revolutionary." But the effect of the 1855 Universal Exposition on critical thinking paved the way for Manet, although like most prophets he was not recognized by the Sadducees of his time. Mainardi claims that this retrospective exhibition of 1855 "provided a vehicle for a depoliticized self-referential view of art. . . . In its pursuit of eclecticism,

it had dealt a final blow to the traditional hierarchies and had created a pre-condition for a modernist view of art."[9]

With all this behind him, Manet may well have entered his first period of major works with the certainty that the eclectic spirit of 1855 enfranchised him to incorporate museum art into his own, and that the critics and the public would see how the grand tradition continued to live in modern painting. In 1855 many critics were still convinced that "art is aristocratic; accustomed to consorting with gods and heroes, it does not thrive in bad company."[10] But they were reactionaries. In 1855 Courbet was still suffering the contempt of critics and the scorn of viewers for his distinctly nonaristocratic subjects and figures.

When Manet embarked on his boldest venture, *Le Déjeuner sur l'herbe*, seven years had passed since Courbet's monumental allegory had made its appearance. Courbet was then occupying his rightful place as a modern French master. The nature of French art, great art, modern art, was still being hotly discussed. It was to the old masters that Manet turned for his first ideas. Raphael's grouping of three river gods and Giorgione's *Concert champêtre* (now attributed to Titian), long recognized as the sources for the composition of *Le Déjeuner*, had been acknowledged in part by Manet himself. He told Proust about his intention to use the Giorgione model while they were watching some women bathing in the Seine: "When we were at [Couture's] studio I copied Giorgione's women, the women with musicians. That painting is dark. The undercoat has come through. I want to do it over, but do it in the transparency of daylight, with figures like the ones over there. They'll slaughter me. They'll say I'm borrowing from the Italians after I borrowed from the Spanish." But the content of the work seems more likely to have grown out of Courbet's *Painter's Studio* and from the intellectual climate surrounding the 1855 exhibition. Not enough has been said about the shadow of Courbet in Manet's studio.

The cliché "larger than life" was tailor-made for Courbet. Big, boisterous, and boorish, not because he knew no better but because he had a huckster's sense of publicity, Courbet had entered the Parisian art scene the way a fighting bull enters an arena — ready to attack anything that moves. His egomania was notorious, his lack of interest in his fellow painters lamentable. His voluminous correspondence[11] is notably deficient in altruism, except toward Monet, to

whose rescue he occasionally came with a loan. But there is no question that his oversize presence was seen and felt by all who followed him. Manet had been indelibly impressed by Courbet's sublime arrogance in setting up his own one-man show of forty paintings because two of his greatest works, *Burial at Ornans* and *The Painter's Studio,* out of thirteen submitted, had been rejected for the 1855 exhibition. Resorting to the same tactic in 1867, but without Courbet's bluster, Manet would don Courbet's mantle as the leader of the next avant-garde.

Though generally supportive and openhanded toward most of his struggling contemporaries, particularly Monet, whom he helped repeatedly, Manet seems to have said little about the two men who may have exercised as great an influence on him in his early career as did Velázquez and Goya. About Couture we have only the few remarks reported by Proust, none of them flattering or grateful. About Courbet Manet had more to say. Again to Proust: "Yes, the *Burial* is very good. One can't say often enough how good it is, because it is better than anything else. But between you and me, it still doesn't go far enough. It is too dark." And to fellow painter Charles Toché, who had admired in Manet's work the presence of poetry and reality, Manet exclaimed: "Let that ox of a Courbet not hear you! What he calls real. . . . For example in his *Burial at Ornans,* he managed to bury everybody: priests, gravediggers, undertakers, family members. Even the horizon is ten feet below ground level."[12]

Considerably smaller than Courbet's *Painter's Studio* (359 x 598 cm), *Le Déjeuner sur l'herbe* (208 x 264 cm) is nonetheless life-size and no less ambitious. In a single canvas Manet managed to depict the panorama of his art, his aspirations, and perhaps more intimate views, through his restatement of ancient, Renaissance, Venetian, and contemporary art (Raphael, who had borrowed his river gods from an ancient frieze, Giorgione, and Courbet). In his canvas Courbet portrayed himself painting a landscape in his studio, a nude model beside him modestly clutching a length of draped fabric (a classical device to show off a painter's ability); the intellectual world is represented by portraits of real people to his right and the real world by figures of paupers and workers to his left. Manet reduced his cast of characters to four and, more modest than Courbet, left himself out, except for a symbolic presence — a cane, a personal attribute he used repeatedly. His two brothers alternately served as

models for the reclining figure on the lower right, and Ferdinand Leenhoff, soon to be his brother-in-law and a sculptor who would do Manet's portrait in stone twenty years later, posed for the central figure.

It is interesting to note that although Manet turned to his family circle for the male models, he did not ask Suzanne, even though she had previously posed for a number of nude studies between 1858 and 1860, before *The Surprised Nymph*. Victorine had apparently supplanted her by then, for Victorine is the nude in full view, and the reality of her flesh is not to be doubted. Unlike the "wallpaper nymphs" derided by Théophile Thoré, this was a figure whose body had everything of "the natural woman," even the less than idealized fold of her belly. Reviewing the star canvases of the 1863 Salon — Cabanel's *Birth of Venus*, Baudry's *The Pearl and the Wave*, and Amaury-Duval's *Birth of Venus* — Thoré had complained, "These unveiled figures have nothing of the natural woman about them, nor of the woman who displays her voluptuousness. No bone, no flesh, no blood, no skin. One might find the Venuses of Titian immodest... but our Parisian Venuses do not have even this quality of reality. Inoffensive phantoms like the wallpaper nymphs of cafés. They should be made into pink-tinted lithographs for the boudoirs of the rue Bréda [quarter of prostitutes]."[13]

Manet's entire canvas seems to be about painting, past and present. All the genres are there: the nude, classical figures, portraiture, landscape, still life, allegory, modern life, even history painting in the reference to Raphael's *Judgment of Paris* (recognized by Ernest Chesneau in his review of the 1863 exhibition). Raimondi's engraving of Raphael's work was widely known among artists, critics, and even cultivated laymen. In *Le Déjeuner sur l'herbe*, Manet encapsulated the myth in which the Trojan prince Paris awards the golden apple to Venus over Minerva and Juno and placed Venus herself in the group of river gods — the modern Venus of the modern Paris, capital of the modern world. The studio model who throughout the history of painting was, and remained, a female portraying a mythical or allegorical figure, and was thus eliminated from the painting as an individual woman, is here brought into the painting as a realistic portrait. No longer an Olympian goddess accessible only to epic heroes, she is the chosen companion of ordinary mortals, the law students and art students represented by the two male figures. She is the grisette, the

popular figure of the time with whom they shared their love, their longings, and often their work as well. Henri Murger portrayed her in his very successful novel of the late 1840s, *Scènes de la vie de bohème.* Today her most familiar embodiment is Mimi, in Puccini's *La Bohème,* based on Murger's novel.

Goddess of the mid-nineteenth century, Venus was again the choice of this modern incarnation of Paris (the Trojan prince), in the form of a painter — suggested by the pointing finger of the reclining figure (a reference to Michelangelo and his God of Creation in the Sistine frescoes?) — and a stand-in for Manet himself, identified by the cane at his side. Manet has never been recognized in the profiled figure for which both his brothers posed, but Françoise Cachin notes that "the bearded profile is less individualized than the third party's full face."[14] This provided a subtle way of inserting himself into the picture. Just as Manet brought the studio model into the subject of the painting, so he brought the landscape into the studio. But it is not a landscape à la Corot or Daubigny, which gives the viewer the impression of looking through the frame of a window onto an outdoor expanse. Here it is the reverse: it is a background — even if identified by some as the countryside of the Manet family property in Gennevilliers — intended to make us aware that the frame is around a canvas, that we are looking *into* the studio, not *out of* it. Finally, as a modern subject (the work was first titled *Le Bain*) the bucolic landscape and its bathing women portray the modern pastime of picnics and boating along the Seine, a subject dear to younger painters of the time. There is also a great deal of playfulness in this work. Privately (to Proust), Manet called it *La Partie carrée,* a clear sexual implication, a *partie carrée* being an exchange of partners in a two-couple debauchery.

In the myth Paris elected Venus the fairest of the goddesses because she had granted him the love of Helen, most beautiful of mortals. Is Manet discreetly thanking Victorine for initiating him into the arts of Venus? At the same time, Manet plays with classical symbols — the goldfinch, the frog, fruits, oysters, water, an overturned basket — leaving open myriad possibilities of interpretation, which need not be exclusive. In addition to his broader scheme, Manet was playing with sexual symbols. The oyster shells are a dead giveaway, oysters having been regarded since antiquity as an aphrodisiac. At a time when iconography was not yet the arcane specialty it has become, the amatory connotation of peaches, cherries, and figs was readily under-

stood, just as the overturned basket was recognized as signifying the loss of innocence. Numerous writers have offered numerous glosses, many of them summarized in Margaret Siebert's comprehensive chapter on this painting.[15] There seems to be general agreement that an allegory was intended but little agreement as to what it means. George Mauner exhaustively analyzed the painting for its moral allegory and found that symbols such as the earthbound frog and the soaring bullfinch point to the duality of human nature, the life of the flesh and the life of the spirit: "Manet used a bird and a frog which, like the figures they help us interpret, do not struggle for the dominant position but serve to call attention to man's condition, to the inevitable paradox of life."[16] Others see the classical theme of sacred and profane love, treated by Titian, and still others the allegory of the Prodigal Son.

Whether Manet's purpose was to present some kind of moral allegory, or simply an allegory of painting, or a complex interweaving of multiple ideas, his motivation was neither irreverent parody nor deliberate provocation, as some have argued. He may well have been the most surprised of all by the uproar that ensued. Tabarant insists that all of Manet's friends knew the noble source of the painting's inspiration, "which allowed them to laugh at the fools who cried scandal."[17] Ernest Chesneau, the first to spot the reference to Raphael, was nevertheless one of Le Déjeuner sur l'herbe's most virulent critics: "M. Manet wants to attain celebrity by shocking the bourgeois."[18] If the presence of a nude female with two dressed males was so offensive, Manet riposted, then he evidently should have undressed his two men, since in the Raphael group they too are naked. Mauner convincingly argues that the presence of the animal symbols, the common use of the opposition of spirit and flesh, and, above all, the fame of Manet's sources make it "all the more astonishing that the work's philosophic content was apparently not understood by anyone. . . . It seems clear that Manet expected the cultivated viewer to make the basic identifications necessary for a penetration into the moral sense of the picture and from there, to a recognition of the timeless concerns in modern life."[19]

Judging from his disappointment, Manet would seem to have expected some understanding of his intentions, even if his style of painting met with hostility. What he got instead was notoriety of a kind he had not bargained for. Earlier in the year of Le Déjeuner sur l'herbe's

composition, his first one-man show had been held in Louis Martinet's gallery. Fourteen paintings, among them the recent Spanish themes, had been poorly received, particularly *Music in the Tuileries,* which was threatened with violence if not removed. Manet was now recognized in the street. It was not the success he had hoped for, but his name no longer evoked a vacant stare.

Submissions for the Salon of 1863, limited to three works, were to be made between March 20 and April 1. Manet's three were *Young Man in the Costume of a Majo,* posed by his younger brother, *Mlle V . . . in the Costume of an Espada,* and *Le Déjeuner sur l'herbe* (then titled *Le Bain*). All three were refused. By April 12 the art world of Paris learned that out of 5,000 paintings submitted by 3,000 artists only 2,000 were accepted. "The patriarchs of the palette could not remember a debacle of this magnitude," wrote one journalist of the jury's wholesale eliminations. The reaction was violent. Louis Martinet, in his publication *Le Courrier artistique,* had notified his readers six weeks before that artists were protesting the regulation of sending only three works to an already inadequate biennial Salon, and that Manet and Gustave Doré had been appointed by their colleagues to present a petition to the minister of state to increase the number of submissions.

On April 24 an article in large type on page two of the official voice of the government, *Le Moniteur,* carried the following report:

> Many complaints have reached the Emperor regarding the works of art that were refused by the jury of the exhibition. His Majesty, wishing to let the public judge the legitimacy of these complaints, has decided that the rejected works of art are to be exhibited in a section of the Palais de l'Industrie [built for the 1855 Universal Exposition, it became the site of the Salon]. This exhibition will be optional and those artists who do not wish to participate have only to inform the administration which will return their works without delay.

So was born the most clamorous and documented art exhibition ever held, the Salon des Refusés.

On May 15, 1863, two weeks after the opening of the official Salon, the other exhibition, variously termed "Salon of the Outlaws," "Salon of the Pariahs," and "Salon of the Censored," depending on

the writer's viewpoint, opened to an impatient crowd. Seven thousand people, each paying one franc, crowded through the turnstile that led from the official exhibition into the adjacent gallery of twelve hundred rejected works, hanging in twelve rooms. More than a thousand artists had withdrawn their works, fearing contamination by these "refuseniks," who were certain to be spattered by the mudslinging of the offended establishment. From the most reflective to the least, from those with an open mind to those who may have written their articles even before they saw the rejected works, the press was as derisive as the audience. Even the eminently respectable Jules-Antoine Castagnary, politically liberal and a defender of Courbet's realism, heaped scorn on the enterprise in *L'Artiste*: "Before the exhibition of the *refusés*, we could not imagine what a bad painting could be. Now we know. We have seen it, touched it, ascertained it. We will venture to say that of all silly artifacts, the silliest is not made with the pen but with the brush. The man of letters stops halfway to imbecility [but] the painter enjoys the privilege of . . . pushing back the boundaries of stupidity." Maxime du Camp proffered the coup de grâce: "So these are the unrecognized geniuses and this is what they produce! Never have the decisions of the jury been given more resounding affirmation, and we should thank it for having tried to spare us the sight of such lamentable things."[20] These "lamentable things" included paintings by Jongkind and Harpignies, Pissarro and Fantin-Latour, Legros and Whistler, as well as engravings by Bracquemond and sculpture by Cros.

Manet stood out among them like a flaming torch, and a few writers had the courage to say so. Zacharie Astruc, a man of multiple talents and an unbridled Hispanophile who became Manet's friend and collaborator, lost all sense of restraint in his article on the Salon des Refusés: "He is its sparkle, its inspiration, its flavor, its marvel." And Edouard Lockroy, the most clairvoyant of all his colleagues, wrote in *Le Courrier artistique* the day after the opening, "M. Manet has the gift of displeasing the jury. If he had only that gift there would be no reason to be grateful to him, but he has many others. M. Manet has not yet had the last word. His paintings, whose qualities the public is incapable of appreciating, are filled with good intentions. We have no doubt that one day M. Manet will triumph over all the obstacles he is encountering, and we will be the first to applaud his success." Arthur Stevens, the painter's brother, writing under the pseudonym

J. Graham in *Le Figaro*, declared, "A great hubbub has arisen around the name of M. Manet. . . . Mediocre men do not arouse such a clamor on their appearance."[21]

At a time when newspapers were avidly read for entertainment as well as news (novels were serialized; major artists produced cartoons), public opinion on artistic as well as political issues was formed by the newspaper one read. Parisian newspapers were then, and still are, distinctly partisan, reflecting the many voices of a multi-party system. Every literate Parisian knew that the Salon of 1863 was unlike any other, that the emperor had humiliated the jury of distinguished academicians by imposing his imperial will and granting exhibition to the rejected works. Moreover, the entire Salon system had been overturned, to the unbelieving joy of artists. As of 1864 there would once again be a yearly Salon, but the Institut would no longer constitute the jury.

Emile Zola, who was to become an ardent defender of Manet's a few years later, drew on his memories of this phenomenal exhibition, which has remained an unparalleled event in the history of art. In his novel *L'Oeuvre,* he composed his main character, a painter named Claude Lantier, from three contemporaries — Manet, Cézanne, and Monet — whom he knew very well. But the painting to which he devotes singular attention is instantly recognizable as Manet's *Le Déjeuner sur l'herbe,* only in its title altered, *Plein Air* (Fig. 10). The description of its exhibition, however, is unaltered reality, including mention of another actual painting that also attracted much attention, James Whistler's *Woman in White*. Opening his Chapter 5 with the exact date of the opening of the exhibition, May 15, Zola describes a shimmering afternoon at one o'clock:

A few carriages, unusual at that hour, were drawing up, while a tide of people, moving like an ant colony, forced its way under the enormous arcade of the Palais de l'Industrie. . . . Claude raised his head and cocked his ear. A tremendous noise . . . rolled in the air with a steady din: it was the clamor of a storm pounding the shore. . . .

"What is that?" he murmured.

"That," said Bongrand, who moved ahead, "is the crowd upstairs, in the galleries." And the two young men . . . climbed up to the Salon des Refusés. . . .

Subdued at the entrance, the laughter grew louder as he ad-

vanced. In the third hall, women were no longer stifling their laughs in their handkerchiefs. It was the contagious hilarity of a crowd that has come to be amused . . . finding beautiful things as funny as detestable ones. . . .

Claude, who had remained behind, heard the steady rise of laughter, a mounting uproar. . . . And as he finally penetrated into the hall he saw an enormous wriggling mass . . . piled up in front of his painting. The laughter of the entire gallery swelled, bloomed, reached its apogee there. It was his painting they were laughing at.[22]

Manet was the star of the Salon des Refusés, rivaled only by Whistler for his *Woman in White*. Manet's three canvases made everything else look pale, but the strangeness of *Le Déjeuner sur l'herbe* resulted in a *succès de scandale*. It was not just the undressed woman that offended critics and spectators. Ernest Chesneau found the painting lacking in perspective and draftsmanship, as well as morally objectionable: "We cannot consider a work perfectly chaste that seats a girl in the woods, wearing only the shadow of the leaves, surrounded by students in coats." Adrien Paul was equally shocked: "Some seek ideal beauty, M. Manet seeks and finds ideal ugliness. . . . His two students chatting with the most vulgar of women provoked the astonishment of many people." But the general reaction has to be placed in the overall context of the articles written at the time, many of which praised certain aspects of the painting.[23] The same Adrien Paul saw qualities in the landscape and the light: "If only that shameless naiad were not there!" Others, also disturbed by the presence of an undressed woman among dressed men, one of whom "did not even have the presence of mind to take off his dreadful hat," nevertheless remarked on the color, the light, and even the realism of the nude.

All in all, Manet was catapulted into celebrity, even though he had transformed the classic nude into an ordinary woman. The most disquieting aspect of the figure was the awareness that she was disrobed and soon would rerobe, which made her *naked* rather than *nude*, unlike the classic nude, who can be imagined no other way. Manet's other two paintings had their admirers, and even *Le Déjeuner* was not without them. Most writers found it less morally repugnant than disturbing, bizarre, or incomprehensible. An earlier exhibition at Martinet's gallery had already introduced Manet to the public as a controversial and versatile new artist. The Salon des Refusés estab-

lished him as an original artist with links to the past, of dubious taste perhaps, but as one critic concluded, "The public does not cease being astonished by this painting which at the same time irritates laymen and makes art critics jeer. . . . Finally, although art lovers claim to see in M. Manet's manner imitations of Goya and Couture — a slight difference — I believe that M. Manet is entirely himself: that is the highest praise one can offer him."[24] Another, under the fanciful byline Capitaine Pompilius, wrote that he could not grant Manet the title of innovator because Goya and Courbet had preceded him, but he could present him to his readers as "one of the most powerful artistic personalities of our time. . . . M. Manet, I hope, will one day become a master: he possesses candor, conviction, power, universality, in other words, the stuff of great art."[25]

Manet was now a name to be reckoned with. Legend has it that the emperor turned away from *Le Déjeuner* in disgust. Had this really happened, it would surely have been reported in the newspapers. The story would have spread at once. The fact is that no such event was reported.[26] Manet was pilloried by some but gained the respect of others. Antonin Proust hosted a dinner in Manet's honor with a group of fellow students from Couture's studio at their old haunt, Dinocheau's. And Commander Lejosne and his wife, who often entertained artists and writers, held a party for him at their home. Had Manet's success been no more than notoriety over an indecent nude, there would have been little to celebrate.

On October 6 of that year, by which time art critics and chroniclers had moved on to subjects other than the Salon des Refusés, Manet left for Holland. Only hours before his departure, he informed Baudelaire of his forthcoming marriage, which Baudelaire, in a note dated the same day, communicated to their mutual friend the photographer Carjat. The surprise rings true. Baudelaire would have been even more surprised to learn that Suzanne had been living in Paris for more than a decade, as had members of her family. When Manet first knew Suzanne in 1849, she had five siblings, two of them brothers who were dead by 1851. A year after their meeting, Suzanne's sister, having married a French painter, settled in Paris, followed soon after by her two youngest brothers, Ferdinand, born in 1841, and Rudolphe, born in 1843, all of whom Manet knew during the years before their marriage. He may not have known her parents, since his only other trip to Holland, in 1852, a few months after Léon's birth,

may not have included a visit to Zaltbommel. This time he remained in Holland for three weeks before the wedding, the required time for the banns to be published at the town hall. It is hard to imagine that he would have spent all of those weeks in Zaltbommel, but no letters to his family have surfaced to give us an idea of his activities, his reaction to the Leenhoffs, or his state of mind during that period.

Little more than two weeks before his departure for Holland, on September 17, a marriage contract had been drawn up, witnessed by Manet's mother and two brothers, as well as by Suzanne's brother Ferdinand, her sister Marthe, who had gallicized her name from Martina, and Marthe's husband, the painter Jules Vibert.[27] Suzanne is listed as having no profession and residing at her father's house in Zaltbommel. What is striking about this contract is the concern over the dowry Eugénie Manet advanced on Edouard's inheritance from his father. The estate had not yet been distributed among the three sons, since it consisted of some two hundred acres of land in Gennevilliers and Asnières from which they collected rents from tenants. Only about fifteen acres had been sold in August 1863, netting sixty thousand francs. Edouard's share of the estate was ten thousand francs, plus eight hundred more on the estimated rents. Ten thousand eight hundred francs did indeed represent a significant sum at the time, but there is something curious about the stipulations regarding the future of that money: "The widow Manet . . . has constituted as a dowry to her son, an advance on the legacy of his future inheritance, the sum of 10,000 francs payable before the wedding, and has reserved for herself the right of return of this dowry in the event that her son should predecease her without descendants."

No Manet money would remain with Suzanne unless she and Edouard had officially recognized children. The only property that was to remain with the surviving spouse was the common fund, to which each contributed 500 francs, and the personal effects each had brought to the marriage. Edouard's personal effects were valued at 2,500 francs in clothing, jewelry, and linens and 4,000 in furnishings from his home and studio; Suzanne's effects were valued at 2,000 francs. All future legacies, whether in personal effects or real estate, were to remain the separate property of the spouses. Since Suzanne's family had little or nothing to pass on, the wording of the contract was clearly designed to prevent Suzanne from inheriting anything other than what Edouard could legally call his own. It also must have

been evident that if Suzanne were widowed early in life, she would be without any means of support. Manet's sales by 1863 gave little assurance that his paintings would take care of her. Reading the contract, one wonders whether Eugénie had hoped to discourage the marriage by so manifestly denying Suzanne any benefit from the family fortune. One also may wonder whether this was perhaps punitive for not legitimizing Léon, as suggested by the letter quoted earlier that Eugénie wrote to her lawyer nephew: "that is the punishment for her crime, let her suffer it!"

On October 28, two days before Suzanne's thirty-fourth birthday, the thirteen-year liaison of the bride and groom was finally legitimized in a civil ceremony, even if their eleven-year-old son was not. Since Manet was at least a nominal Catholic who never abjured the faith into which he was baptized, the marriage did not take place in the church where Suzanne's father, Carolus Antonius Leenhoff, was organist and choirmaster. It is also ironic to think that at the time of Manet's death, his marriage had never been officially recognized by the Catholic Church, so that even after its legal consecration, in the eyes of the Church into which Manet was born and buried, he had lived his entire life with Suzanne in sin — an irony that surely had not escaped him. Léon was understandably not present at his parents' marriage, having been left in his boarding school under the surveillance of his paternal uncle, Eugène Manet. It was only after the marriage that the travesty began in earnest, when Léon was introduced to Manet's circle as Suzanne's brother. Her own brothers knew perfectly well who Léon was, or at least who he was not. But family and friends in Zaltbommel surely wondered about this curious match between their dowdy kinswoman and this lithe, elegant Parisian, more than two years her junior, who was there unaccompanied by family or friends to serve as his witnesses. It must have been apparent to all that even if this marriage had been made in heaven, in Paris it was a nonevent.

Everyone who ever wrote about Manet has stated that Suzanne's mother came to stay with her after, or for, the birth of Léon and that she lived with them until her death in Paris in 1860. Suzanne's mother had a husband and children to look after, which no one seems to have questioned, and in any case official records list her date of death as 1876, in Zaltbommel, preceding her husband's death by two years. It was rather Suzanne's paternal grandmother who was with her in Paris

when Léon was born. The municipal archives of Zaltbommel disclose the interesting fact that in 1810 Suzanna van Aanholt, or Arnoude, married Abraham, also known as Joseph, Leenhoff, a musician in the regiment of the Prince de Ligne, later listed in official records as *"muzikmeister"* in Delft. Their son, Carolus Antonius, had been born three years earlier, in 1807. Both sides of the Leenhoff family are impeccably documented, even to the various spellings of their names. Suzanna van Aanholt Leenhoff, born in 1781, was two years younger than her husband, with whom she had only one child. Widowed in 1832, she did not remarry. The year her granddaughter and namesake gave birth out of wedlock, she was seventy-one years old and free to do as she pleased.

A woman who had herself conceived a child out of wedlock may well have been compassionate enough to leave her home, her habits, and her country when the same fate befell her grandchild, so that she could look after the young mother and child. She may have accompanied Suzanne when she first came to Paris. Liszt's encouragement, at the time of his stopover in Zaltbommel, could have convinced Suzanne and her family that such talent had no future in a provincial Dutch town. For the granddaughter and daughter of musicians, the idea of a career in music was less shocking than for the child of merchants. This also might explain the profession listed for the phantom father of Léon: *"artiste musicien."* If not his biological father, certainly his forefathers were musicians. Still, to send a girl of twenty alone to Paris would have been unseemly, so that her grandmother would reasonably have accompanied her as a chaperone and housekeeper. She may have failed in her first duty, but she did provide a suitable home, later looking after her two young grandsons who came to Paris to study art.

These records help to clarify Léon's notes, jotted down late in life.[28] When he says, "I lived with the grandmother and Ferdinand, and later Rudolphe" (*Je demeurais avec la grand-mère et Ferdinand, puis Rudolphe*), he is referring not to *his* grandmother but to his mother's. And when he adds, "After the grandmother's death, the three of us lived on the rue de l'Hôtel de Ville," he clearly means Manet, Suzanne, and himself, for had his two uncles lived with his mother and him that would have made four. Moreover, his description of the one-bedroom apartment leaves no room for two other occupants. By 1856 both Suzanne's sisters were married to painters and

living in Paris, first Marthe, five years younger than Suzanne, to Jules Vibert in 1850, then Mathilda, eight years younger, to Joseph Mezzara in 1856. Manet was therefore surrounded by four artist brothers-in-law, one of whom, Ferdinand, was a sculptor rather than a painter. But it would seem from published eyewitness accounts that Manet's social and intellectual life was outside the circle of his in-laws. In view of Suzanne's many siblings and their children to occupy her, Manet may have had few compunctions about conducting a separate life.

Before leaving for Holland, Manet had completed yet another major painting for which Victorine was the model. This is his *Olympia*, rivaled by few other works of art for celebrity or mystery. As Françoise Cachin has pointed out, "Except for the *Mona Lisa*, never has paint been varnished with so many layers of literature . . . , never has a painting so tempted the gluttony of the art historian."[29] And yet a mystery it remains. Some saw and still see it as Manet's greatest painting; others saw a common whore and were offended by the subject. To anyone familiar with museum art, Titian and Goya irresistibly come to mind. And indeed, there is no argument among critics about Titian's *Venus of Urbino* having provided the composition. Manet had copied it himself at the Uffizi on his second visit to Italy in 1856. He also must have thought of Goya's *The Naked Maja*, which he knew from Nadar's photo. What Manet's intentions were we can never know for sure, but we can venture a number of guesses as to what he might have had in mind.

Olympia (130.5 x 190 cm) is smaller than *Le Déjeuner sur l'herbe* (208 x 264 cm), but nevertheless life-size if we estimate that Victorine was probably no taller than five foot two or five foot three. Her pose combines the classical pose of Titian's mythologized nude with Goya's demythified nude. And just as Aphrodite/Venus herself was known to have dual aspects,* so *Le Déjeuner* and *Olympia* may be seen as representing both sides of the modern Venus, the grisette and the courtesan.

As background to this painting, an extended parenthesis must be opened here. A sexual revolution had taken place in nineteenth-century Paris, concurrent with the rise of the bourgeoisie. Although

*Pure or spiritual love was represented by Urania, and carnal love by her better-known representation, Aphrodite or Venus.

Figure 1.
PORTRAIT OF M. AND
MME AUGUSTE MANET, 1860.
Oil on canvas, 110 x 90 cm.
Musée d'Orsay, Paris.
Photo R.M.N.

Figure 2.
PORTRAIT OF MME EUGÉNIE
MANET, 1863.
Oil on canvas, 105 x 80 cm.
Isabella Stewart Gardner Museum,
Boston.

Figure 3.
THE SURPRISED NYMPH, 1861.
Oil on canvas, 148 x 114 cm.
*Museo Nacional de Bellas Artes,
Buenos Aires.*

Figure 4.
BOY WITH A SWORD, 1861.
Oil on canvas, 131 x 93.5 cm.
*Metropolitan Museum of Art,
New York, Gift of Erwin Davis, 1899
(89.21 2).*

Figure 5.
Photo of Suzanne Manet from Manet's personal album.
Bibliothèque Nationale de France, Paris.

Figure 6.
Photo of Léon Leenhoff from Manet's personal album.
Bibliothèque Nationale de France, Paris.

Figure 7 (*above*).
LA PÊCHE (FISHING AT SAINT-OUEN),
1860–61.
Oil on canvas, 76.8 x 123.2 cm.
*Metropolitan Museum of Art, New York,
Purchase, Mr. and Mrs. Richard J.
Bernhard Gift, 1957 (57.10).*

Figure 8 (*left*).
POLICHINELLE PRESENTS
"EAUX-FORTES PAR EDOUARD MANET."
Etching.
*New York Public Library,
S. P. Avery Collection.*

Figure 9 (*opposite, top*).
THE OLD MUSICIAN, 1862.
Oil on canvas, 188 x 248 cm.
*National Gallery of Art, Washington,
Chester Dale Collection.*

Figure 10 (*opposite, bottom*).
LE DÉJEUNER SUR L'HERBE, 1862.
Oil on canvas, 208 x 264 cm.
Musée d'Orsay, Paris. Photo R.M.N.

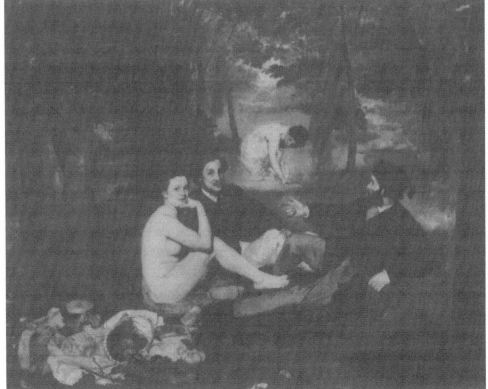

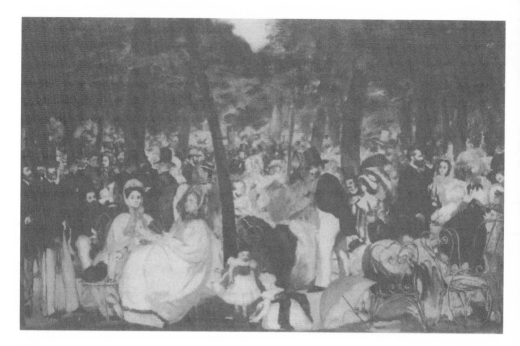

Figure 11.
MUSIC IN THE TUILERIES, 1862.
Oil on canvas, 76 x 118 cm.
National Gallery, London.

Figure 12.
VIEW OF THE INTERNATIONAL EXPOSITION, 1867.
Oil on canvas, 108 x 196 cm.
Nasjonalgalleriet, Oslo.

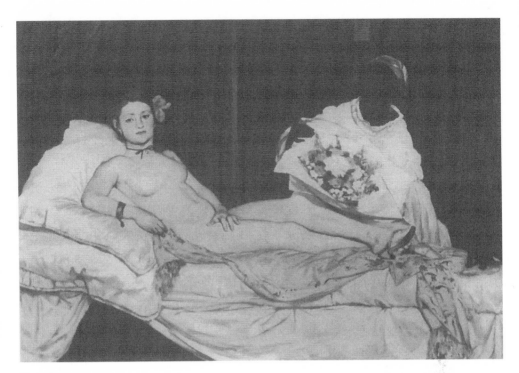

Figure 13.
OLYMPIA, 1863.
Oil on canvas, 130.5 x 190 cm.
Musée d'Orsay, Paris. Photo R.M.N.

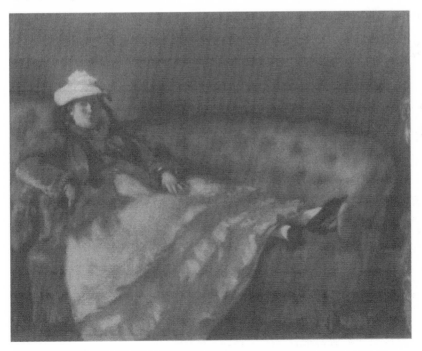

Figure 14.
MME EDOUARD MANET ON A BLUE SOFA, 1878.
Pastel on paper, 50.5 x 61 cm.
Musée d'Orsay, Paris. Photo R.M.N.

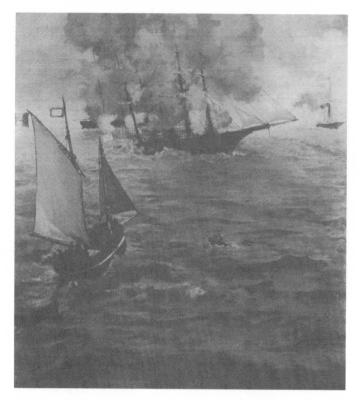

Figure 15.
THE BATTLE OF THE
"KEARSARGE" AND THE
"ALABAMA," 1864.
Oil on canvas,
134 x 127 cm.
*Philadelphia Museum of Art,
The John G. Johnson
Collection.*

Figure 16.
ESCAPE OF ROCHEFORT,
1880–81.
Oil on canvas,
146 x 116 cm.
*Musée d'Orsay, Paris.
Photo Giraudon /
Art Resource,* NY.

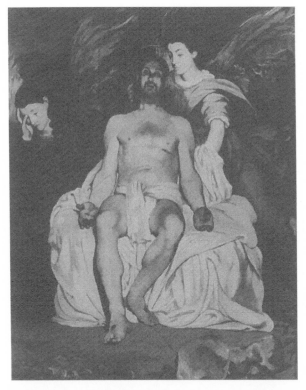

Figure 17.
CHRIST WITH ANGELS, 1864.
Oil on canvas, 179.5 x 150 cm.
Metropolitan Museum of Art,
New York, Bequest of
Mrs. H. O. Havemeyer, 1929,
The H. O. Havemeyer Collection
(29.100.51).

Figure 18.
JESUS MOCKED BY THE
SOLDIERS, 1865.
Oil on canvas, 190.3 x 148.3 cm.
Art Institute of Chicago,
Gift of James Deering, 1925.703.

Figure 19.
WOMAN WITH PARROT, 1866.
Oil on canvas, 185 x 132 cm.
Metropolitan Museum of Art, New York,
Gift of Erwin Davis (89.21.3).

Figure 20.
THE TRAGIC ACTOR, 1865.
Oil on canvas, 185 x 110 cm.
National Gallery of Art, Washington,
Gift of Edith Stuyvesant Gerry.

Figure 21.
THE FIFER, 1866.
Oil on canvas, 160 x 97 cm.
Musée d'Orsay, Paris. Photo R.M.N.

Figure 22.
LA LECTURE (READING), 1865–75.
Oil on canvas, 61 x 74 cm.
Musée d'Orsay, Paris. Photo R.M.N.

Figure 23.
THE DEAD TOREADOR, 1864.
Oil on canvas, 76 x 153.3 cm.
National Gallery of Art, Washington, Widener Collection.

Figure 24.
THE EXECUTION OF MAXIMILIAN, 1867.
Oil on canvas, 252 x 305 cm.
Kunsthalle, Mannheim. Photo Mannheim / Art Resource, NY.

Figure 25.
SPANISH CAVALIERS AND BOY
WITH TRAY, 1859.
Oil on canvas, 45 x 26 cm.
Musée des Beaux-Arts, Lyons.

Figure 26.
THE BALCONY, 1868.
Oil on canvas, 170 x 124.5 cm.
Musée d'Orsay, Paris. Photo R.M.N.

Figure 27.
REPOSE (Portrait of Berthe Morisot), 1870.
Oil on canvas, 148 x 111 cm.
Rhode Island School of Design, Providence.
Photo Giraudon / Art Resource, NY.

Figure 28.
BERTHE MORISOT WITH A MUFF, 1868–69.
Oil on canvas, 73 x 60 cm.
Private collection. Photo Bulloz.

Figure 29.
BERTHE MORISOT WITH A BLACK
HAT AND VIOLETS, 1872.
Oil on canvas, 55 x 38 cm.
Private collection.
Photo Giraudon / Art Resource, NY.

Figure 30.
BOUQUET OF VIOLETS, 1872.
Oil on canvas, 21 x 27 cm.
Private collection.
Photo Giraudon / Art Resource, NY.

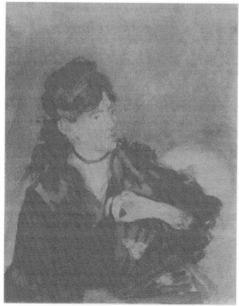

Figure 31.
BERTHE MORISOT WITH A FAN, 1872.
Oil on canvas, 50 x 45 cm.
Musée d'Orsay, Paris. Photo R.M.N.

Figure 32.
BERTHE MORISOT, 1874.
Watercolor, 20.9 x 16.8 cm.
Art Institute of Chicago,
Helen Regenstein Collection, 1963.812.

female virtue had always been treated as a volatile commodity, certain expectations remained unchanged. Young girls of respectable, meaning dowried, background were expected to arrive at the marriage bed intact; wives were expected to remain faithful primarily to protect the bloodline of progeny and their rightful inheritance of property. A king could choose mistresses among the wives of his courtiers without dishonoring them, and aristocratic women were expected to take lovers, without which society would wither. But for lesser mortals, adultery was a serious infraction of social as well as religious laws — except when committed with a prostitute.

In the nineteenth century, as kings fell and the middle classes rose, increasing numbers of women were literate, entering into the urban workforce and the arts. A romantic notion of love superimposed itself on the earlier image of eighteenth-century licentiousness. The French Revolution and artistic bohemia fostered a more egalitarian ideal of relationships. A woman could love passionately and choose freely, and young women of underprivileged backgrounds could aspire to a better life than that of their mothers. The proliferation of shops and the growing market for fashionable clothing and accessories that expanded with increasing and broader-based prosperity provided employment for girls who would otherwise have had few alternatives to prostitution to escape poverty. But many, faced with poverty and limited ability, could easily believe the oft-repeated counsel that they were sitting on a treasure. Was marriage to someone of their own condition any better? As prostitutes they could at least dream of a time when their savings would allow them to open a shop or a small business away from Paris, where they might pass for widows, and with their new income find a husband to grant them respectability.

The increasing number of brothels provided opportunities for such girls to live more securely than streetwalkers, and in some cases to acquire a protector in a former client who set them up independently. By mid-century a hierarchy was in force, analyzed at great clinical length by the sociologist of prostitution of the first part of the century, Alexandre Parent-Duchâtelet, and by Alexandre Dumas père — more connoisseur than social scientist and better known as the author of *The Three Musketeers* and *The Count of Monte Cristo* — in 1874, in a wise and witty little volume titled *Filles, lorettes et courtisanes*. Warning the reader that his pages were not written for young ladies fresh out of convents, he explains that "just as the man of the people

was seized with the desire to rise up, so the man of high society was seized with the caprice of wanting to sink down. From this double displacement was born the neutral terrain where the guttersnipe and the gentleman crossed paths."[30] These neutral terrains were the masked balls of the popular theaters — the Porte St. Martin, Variétés, Odéon, and Opéra — as well as the nightly spectacles at the Bal Mabille on the Champs-Elysées, where the polka prowess of a one-time prostitute eventually earned her the title of countess.

Céleste Vénard, known in her Bal Mabille days as "La Mogador," successor to "La Reine Pomaré," had been reared in the sordid misery of the backstreets of Paris. Barely literate as a girl, she lived out the last decades of her life writing her memoirs and more than a dozen plays and novels, signing them comtesse de Chabrillan, her legitimate married name. Her last published work, in 1885, was a five-act drama. She was not unique at the time; there were others equally fortunate, though not all as talented, and most had come up through the ranks.

The lowest rank, that of *fille*, consisted of three categories: *fille de maison*, *fille de boulevard*, and *fille de cité*, in descending order. The *fille de cité* was the dregs of society. Living among thieves and thugs, and perhaps so named because until Haussmann cleaned it out, the Ile de la Cité was the foulest pocket of vice and crime in Paris, she went by slangy nicknames: "La Calorgne," "La Bourdonneuse," "La Trimarde" (a *trimardeur* is a bum). The *fille de boulevard* worked out of a furnished room and sported pious, innocent names such as Crucifix, Parfaite, Rosier (rosebush), and Bouquet. Most girls who worked the streets had a pimp to protect them, but some managed to remain independent.

The *fille de maison* came in two types: the *fille d'amour*, who, like an indentured servant, worked in a brothel for her food and clothing but on her day off could keep whatever she earned outside; and the *pensionnaire*, or boarder, a full-fledged member of the company who shared her take with the house, paid for her own clothing and board, and was usually so deeply in debt to the house for all the little luxuries she could not resist that she rarely managed to retire with a nest egg. This upper class of the profession bore high-flown names taken from epic poems or the ancient world: Armide, Arthémise, Aspasie, Isménie, Lucrèce, Octavie, Olympe. As noms de guerre they went back to the courtesans of Rome and Venice.

The most notorious Olympia in history was Olympia Maldachini

Pamphili, widowed sister-in-law and openly acknowledged mistress of Pope Innocent X, over whom she exercised ruling power. This Olympia may have held a special interest for Manet, since Velázquez painted her in 1649 during his stay in Rome when he painted his famous portrait of Innocent X. In Manet's day such historical trivia were better known than they are today.

The lorette was a nineteenth-century invention, named in 1841 by Nestor Roqueplan, director of the Paris opera, after the quarter of Notre-Dame-de-Lorette, northeast of the Opéra. Settled in the 1830s and 1840s by celebrities in the arts such as the actress Mlle Mars, George Sand, Frédéric Chopin, and Alexandre Dumas père, this was an affluent quarter that bordered on the upper fringes of the demimonde. This was not where a nouveau riche bourgeoise came to live, but where the more successful *filles* set themselves up in style when they acquired a few steady lovers with means. "Arthur" was the lover of the lorette: "Up to the age of 18 he is known by his Christian name; after 30 he is called by his family name. . . . Arthur is multiple; he is an artist, a man of letters, a speculator, a playboy; his situation ranges from 100,000 in debts to 25,000 francs in income. . . . Like those pitiful filles de boulevard who join forces with two, four and even six other girls to keep their pimp, so six, eight or twelve Arthurs get together to keep a lorette."[31] Unlike her lower-class sisters, a lorette went by a bourgeois name and a bourgeois background, often invented, letting it be known that she was the orphaned, abandoned, or illegitimate daughter of an army officer, a bankrupt industrialist, or a nobleman.

The lorette, if she were lucky enough to attract the attention of one or more very rich men, could rise to the aristocracy of *grande courtisane*. This distinguished lady of gallantry dictated fashion throughout the century, held court in her salon or in her box at the Opéra, and on occasion even married into aristocracy. A few of these truly remarkable women have entered into the history of the Second Empire: Cora Pearl, mistress of the duc de Morny and related royalty; La Païva, whose fabulous residence on the Champs-Elysées still stands at number 25; Apollonie Sabatier, Baudelaire's idol, mistress of the sculptor Clésinger, and widely recognized as the model for his orgasmic statue *Woman Bitten by a Serpent;* and, of course, "La Mogador," comtesse de Chabrillan, godmother to the daughter of Alexandre Dumas père.

The best remembered is surely Marie Duplessis, whose yearlong affair with Alexandre Dumas fils — a worthy successor in love and literature to his father — was immortalized by him in his novel *La Dame aux camélias,* published in 1848. One day before the fifth anniversary of her death, on February 2, 1852, his own dramatization of the novel opened at the Théâtre du Vaudeville before an audience that had already relished his roman à clef. In the society of the demimonde, no one had failed to recognize the true identity of Marguerite Gautier and Armand Duval.

In the audience that night was Giuseppe Verdi, still a bachelor but living with the singer Giuseppina Strepponi. Wagging tongues in Verdi's very provincial hometown of Busseto had made him leave with her for Paris. (He would eventually marry her, but in the intervening years he would take a wife, father two children, and lose all of them to disease.) Strepponi, though certainly not a courtesan, was not entirely acceptable in society. Already suspect as an opera singer, she also had been the mistress of La Scala's director, was the mother of children from a previous marriage, and was now involved in a liaison with Verdi, all of which placed her in the demimonde of *La Dame aux camélias.* Verdi's response to Dumas's drama was *La Traviata,* premiered a year later in Venice to an unsympathetic audience, and in many ways disturbingly similar to his own situation. Even Strepponi's health, like Dumas's heroine, was fragile.

Dumas's moving novel and play — both hugely successful well beyond the nineteenth century — followed by Verdi's opera, subsequently well received and still moving audiences today, made a beloved heroine out of a courtesan. Dumas, within the richer capabilities of the novel, expressed views widely shared by men of his day, though perhaps not admitted with such poetic ardor:

> To be loved by a chaste young girl, to be the first to reveal to her the strange mysteries of love, is surely a great joy, but it is the easiest thing in the world. To capture a heart that has not experienced attack is like entering an open city without defenses. . . . To be truly loved by a courtesan is a far more difficult conquest. In such women, the senses have consumed the heart, debauchery has hardened emotion. The words one says to them they have heard many times before, the means one uses they know all too well, even the love they inspire they have sold before.[32]

Could this perhaps account for part of Manet's fascination with Victorine Meurent? Not known to have sold her body for sex, she was nonetheless selling her body as an artist's model and was thus associated, at its lower level, with the demimonde — defined as the society of loose women and the men who frequented them. The radically different way Manet painted Suzanne and Victorine seems to reflect the contrast described above by Dumas's hero. *The Surprised Nymph,* painted two years before *Le Déjeuner sur l'herbe* and *Olympia,* shows us Suzanne concealing her generous body, a frightened look in her eyes, a face lacking personality, as chaste as any biblical Susanna. Victorine, whose pose in *Le Déjeuner* is almost a mirror image of *The Surprised Nymph* and only slightly more revealing, immediately kindles the imagination. Except for *La Pêche* and *The Surprised Nymph,* and possibly the earlier *Woman with a Pitcher,* there are no paintings of Suzanne before their marriage. Her absence cannot be explained by fear of compromising her, since she had already posed in the nude for him in 1861. After that date there is a five-year hiatus before he painted her again and then only in a rough oil sketch of Suzanne's openmouthed face topped by a winged black hat. The only finished portrait of that period, uncertainly dated 1866–68, offers us a bland matron with a pleasant smile. A photograph of Suzanne in Manet's photo album, showing a woman far homelier than the one he painted, proves that he did not misrepresent her (Fig. 5). But even an unattractive woman can be made appealing in the eyes of an admirer. In the thirty-odd years of their relationship, prenuptial and postnuptial, Suzanne appears fewer than a dozen times in Manet's entire oeuvre of more than four hundred works, and only one, *La Lecture* (probably painted before its dating of 1868), can be called a major work. Each of the ten paintings of Victorine — always vital, always intriguing — is a major work, and a number of them are undisputed masterworks.

By the time Manet painted his reclining nude, the *grande courtisane,* also known as the *grande horizontale,* had long since entered the public imagination. Scorned by bigots and hypocrites, she was a mythic figure in the eyes of most others, including women who envied her freedom and her pleasures and who, if they had the means and the looks, aped her dress and manners. She might die young, abandoned, penniless, and diseased, but she was an icon of nineteenth-century life. She was cultivated, self-educated, independent, and

stimulating, and her gaze was as direct as her conversation — unlike the simpering virgins displayed by their mothers on the marriage market and trained to snare a husband. When one considers that the minds and emotions of respectable young women were kept as straitlaced as their bodices, it is not surprising that young men shied away from marriage and continued to sow wild oats well past middle age.

If Manet chose so scabrous a subject, it was not to shock the public or parody the classic nude. Such a motive would hardly be consistent with Manet's unwavering determination to be accepted by Salon juries, who were far from congenial to irreverence or radicalism in any form. Manet's choice was rather to portray a modern subject, very much in the Parisian consciousness, based on the hallowed theme of Venus/Aphrodite as a courtesan (Fig. 13). In 1863 Manet set out to paint a nude to top all nudes, as his remark to his friend Proust implies: "It seems I have to do a nude. All right, I'll give them a nude." And he did. He gave them white flesh as well as black skin in a setting of whites on whites and flesh tints, rendering visual Théophile Gautier's mixed-medium poem of 1852, "Symphonie en blanc majeur," a bravura piece of word painting.

Not a detail in the painting has escaped critical discussion. Even the flower in Victorine's hair has been the subject of argument, most writers finally accepting it as a variety of orchid, although more probably it is a common red hibiscus. But Manet's intent seems to have been more than visual. Zola in his impassioned defense never even suspected such a possibility, any more than later writers did. Calling it Manet's "masterpiece," Zola insists, "I said masterpiece, and I will not withdraw the word." He then goes on to apostrophize the painter: "You needed a female nude and you chose Olympia, the first available; you needed bright, luminous spots and you inserted a bouquet; you needed dark spots and you placed a black woman and a black cat in a corner. What does all that mean? You hardly know, nor do I."[33] Gautier, in a different vein, also found the painting incomprehensible and, moreover, poorly done, calling the figure "a puny model stretched out on a sheet." Almost a century later George Heard Hamilton agreed with him: "*Olympia* is a puny model, stretched out on a sheet, and the Negro woman and cat are there. That is all. There is no need to explain them; it is impossible to explain them, except as elements which occur in the work for primarily pictorial necessity." The problem raised by this painting, according to Hamilton, is re-

solved through the viewpoint of modern realism and those elements that compose the design.[34]

While many elements in the painting are there for pictorial purposes, Manet might have presented his nude in countless other ways. His choice of Titian's lovely *Venus of Urbino*, long assumed to be a courtesan, for his basic composition provided him with museum status right from the beginning. But Titian domesticated his Venus by adding such homely symbols as the sleeping dog (fidelity), the chests in the background (marriage), and the view of trees (fecundity). Her gaze is coy, and her hand curling into her crotch is relaxed and easily removed, more inviting than concealing.

Olympia, on the contrary, while similarly propped on large pillows, is in a closed interior, suggesting that there is no way out of this kind of life for this kind of woman. The animal at her feet is not a gentle lapdog but an arching cat, symbol of promiscuity and independence. And the flowers brought by the servant betoken illicit sensuality, not marriage. Olympia's unabashed gaze at the spectator, her indifference to the expensive offering, the aggressive pose of the cat, and, especially, the splayed fingers on her thigh, which call attention to her mons veneris but forcefully express her protection of it, all serve to demonstrate the unremitting independence of this woman. Unlike Titian's alluring goddess, this modern Venus is not a sexual object, a plaything of gods or men, but a self-possessed, self-assertive individual. Her body may be her stock-in-trade, but it is she who has full control over it. Though a courtesan rather than a deity, she is not a sordid streetwalker, victim of society. The opulence of her bed, the stylishness of her mules, the presence of a well-dressed servant, and the extravagant bouquet clearly indicate her status. What may have offended the viewers of 1865 far more than the painting's disregard for established techniques of modeling and half tones is the brazen look that defies the male gawker. "You may buy my favors," she seems to be saying, "if I choose to grant them, but only I own me."

Titian's classic Venus is voluptuously available. Manet's slender modern Venus is the embodiment of the century's phenomenon, the demimondaine, the woman who could negligently lie on a shawl worth hundreds of francs, whose household expenses could exceed one hundred thousand francs, and who, like Verdi's Violetta in her famous first-act aria, lived by the principle of *sempre libera* (always free). Despite Hamilton's contention that Olympia "explains nothing

about human conduct,"[35] there is more than style here to make the painting modern. There is also the artist's interpretation of the world he lived in. Just as Dumas's dramatization of *La Dame aux camélias* marks the first appearance of realism in the French theater and Verdi's *La Traviata* the first work of verismo on the opera stage, so Manet's *Olympia* stands as the first nude to represent modern reality.

In 1932 the poet Paul Valéry, who had been a disciple of Manet's close friend Stéphane Mallarmé, looked back in "Manet's Triumph" — his introduction to the catalogue of a retrospective exhibition marking the centenary of Manet's birth. That far into the twentieth century, he could still say of *Olympia*, "She is scandal and idol, power and public presence of Society's wretched secret. . . . Bestial Vestal consecrated to absolute nudity, she makes us think of everything that conceals and preserves primitive barbarity and ritual animality in the customs and practices of urban prostitution." Like most critics, Valéry saw little more in this phenomenal painting than a realist subject, but that "little" is distinguishing. "The naturalists aimed at representing life . . . just as it is . . . but their achievement seems to me to have introduced *poetry* . . . and in some cases of the highest quality, into certain . . . subjects that even they regarded as ignoble. But in the realm of the arts, there is no theme or model that cannot be ennobled or demeaned, rendered disgusting or ravishing, by its rendering."[36]

"A Recidivist of the Monstrous and the Immoral"

In 1863, the same year Manet painted his two nudes, a work appeared that created a far greater scandal than anything at the Salon des Refusés: a biography of Jesus, written by a distinguished scholar of Semitic languages, Ernest Renan. Born in 1823 to a modest Breton family, all his studies until the age of twenty-two had been directed toward the priesthood, but a crisis of faith following his discovery of modern science led him to the secular profession of teaching. In 1862 he was appointed to the prestigious Collège de France, and in June of the following year he published the first of eight volumes collectively titled *Histoire des origines du christianisme* (History of the Origins of Christianity). The first volume, *Vie de Jésus* (The Life of Jesus), presents a human rather than a divine Jesus, a historical rather than a religious figure, based on a close reading of Scripture in its original languages. Renan intended no irreverence. He was nonetheless accused of atheism and heresy, and in 1864 his career at the Collège de France came to a rapid end, by which time his *Vie de Jésus* had gone into its thirteenth printing. Sixty thousand copies had been sold within the first six months after publication. Within the first year the book went into multiple translations and became one of the most widely read and discussed books of the century.

Renan's views did not emerge from a void. Ever since the early 1830s, a movement had flourished in Paris to reform Catholicism, revive its early simplicity, and grant women their place in a church that had excluded them from the time an ecclesiastical hierarchy was instituted. It was a movement associated with some of the leading intellec-

tuals of the day, less concerned with doctrine than with meaning. However, when *Vie de Jésus* appeared, France was ruled by an emperor. The spirit of republicanism had been stifled, and anything that might question the teaching of the church also might question the authority of the emperor. Nevertheless, *Vie de Jésus* was not banned and had a vast readership among people who were neither intellectuals nor political radicals. Manet cannot have remained unaware of the book for long; everyone around him was reading, writing, or talking about it.

Renan's account of the life of Jesus was founded on his thorough knowledge of all related texts in their original languages, ancient and modern exegeses, and a personal experience of the Holy Land and its archaeology. The task he set himself was to disentangle the meaning of Christianity from the dogma of Christianity and to replace apocryphal miracles with historical and philological scholarship. His portrait of Jesus lends human, thus tragic, grandeur to the one who, according to orthodox theology, was God made man — not the illusion of a man, but a real man — a point overlooked by Renan's critics and later by Manet's. As Renan recognized, "philosophy does not suffice for the multitude. They must have sanctity." One can understand why some were outraged by this book, and others were captivated by it. Renan wrote, "Jesus is the one who has caused his fellow men to make the greatest step toward the divine. . . . In him was condensed all that is good and elevated in our nature. He was not sinless; he conquered the same passions that we combat; no angel of God comforted him except his good conscience; no Satan tempted him except that which each one bears in his heart . . . never has anyone so much as he made the interests of humanity predominate in his life over the pettiness of self-love."[1]

It is the spirit of this human portrait that informs Manet's second pair of paintings of Christ (*Christ with Angels* and *Jesus Mocked by the Soldiers,* Figs. 17 and 18), dating from 1864 and 1865, respectively, and his comment to Antonin Proust made many years later: "There is something I have always aspired to do. I would like to paint a Christ on the cross. . . . What a symbol! One could rack one's brains till the end of time and never find anything like it. . . . [No image] can ever equal the image of suffering. That is the basis of humanity. That is its poetry."

Although there is no absolute proof that Manet read *Vie de Jésus,*

it is most unlikely that he did not. The book was as much appreciated by disaffected or open-minded believers as it was condemned by bigots, and as volubly discussed by those who had not read it as by those who had. Parisian newspapers, cafés, and salons reverberated with heated diatribes and equally heated defenses. Among literate people, like those of Manet's circle, the book was a major topic of discussion, and in Manet's own home it must have occasioned interesting debates, since a number of clerics were among his frequent guests. One of them was Abbé Hurel, by then pastor of the Madeleine in Paris. Hurel was more than a family friend who happened to be a priest; he was also personally concerned with art and religious iconography, and may already have been preparing his book on contemporary religious art that was published four years later. In view of their long friendship and Manet's disdain for any kind of religious observance, Hurel was either a very patient prelate or, more probably, a man of tolerant views. For in the eyes of a priest, Manet was living in sin with Suzanne even after their marriage in a Protestant ceremony. Between Manet's First Communion and his Catholic burial, there is not the vaguest suggestion that he set foot in a church, except for obligatory attendance at his elementary school run by a priest and at ceremonies for other people. If he was not a conscious atheist, he was not preoccupied with matters of faith. But the figure of Christ, especially Christ on the cross, intrigued him as an expression of human suffering.

In November 1863 Manet announced to Hurel that he was "going to do a dead Christ with angels, a variation on the scene of the Magdalene at the sepulchre according to Saint John."[2] The conjunction of this decision with the appearance of Renan's book, published only five months earlier, is too close to have been accidental. One can reasonably presume that Manet read and discussed the book with Hurel and that the book determined the choice of scene, for the passage that most enraged readers is Renan's account of the scene at the sepulchre: "Let us say that the powerful imagination of Mary of Magdala played a capital role in this event. Divine power of love! Sacred moment in which the passion of a hallucinating woman [*une hallucinée*] gave the world a resuscitated God!"[3]

Many found this sacrilegious, but among the educated public of mid-nineteenth-century Europe, many others had been affected by the scientific movement that had come out of eighteenth-century France, England, and Germany and by the new school of history that

had followed in its wake, of which Michelet and Renan were the second generation. Aside from the book's humanistic interpretation of sacred texts, there was something else to interest Manet. Renan's entire approach coincided with Manet's view of art, already formulated in Couture's studio: "I paint what I see and not what others choose to see, I paint what is there and not what is not there." Renan makes a similar point in his preface. Legend, myth, and faith have their place, and Renan gives credit to the theologians who constructed the texts that have made modern scholarship possible. "But there is one thing a theologian can never be," he writes, "and that is a historian. History is essentially disinterested. The historian has only one concern, art and truth (two inseparable things, art holding the secret of the most intimate laws of truth)."[4]

What Renan did with the hagiographic texts of the Gospels, Manet did with the mythical judgment of Paris and Venus in *Le Déjeuner sur l'herbe* and *Olympia*: he gave them a human context. Even Manet's use of earlier paintings — condemned by some as plagiarism or lack of imagination — can be seen as analogous to Renan's evolutionary explanation of Christianity:

> . . . too complex to have been the work of a single man. In one sense, all of humanity collaborated in it. . . . On the one hand, the great man receives everything from his era; on the other, he dominates his era. To show how the religion founded by Jesus was the natural consequence of what preceded it is not to diminish its excellence. No doubt Jesus proceeded from Judaism, but as Socrates proceeded from the . . . Sophists, as Luther proceeded from the Middle Ages, Lammenais from Catholicism, Rousseau from the eighteenth century. One is of one's century and of one's race even when one protests against one's century and one's race.[5]

"Il faut être de son temps."

This last sentence could have been a <u>motto for Manet</u>, who repeatedly insisted, *"Il faut être de son temps"* (One must be of one's own time), while proceeding from the past and incorporating it into his work. In another of his few doctrinal statements about art, echoing Castagnary's pronouncement of 1857, he said, "Whatever holds the spirit of humanity, the spirit of today, is interesting."[6]

Manet's *Christ with Angels* was his translation of Renan's contemporary vision into pictorial language. The pose, once again, was bor-

Christ with Angels

rowed from an older work. The one it most closely resembles (others have been proposed) is Mantegna's *Pietà* of 1489 (Statens Museum for Kunst, Copenhagen). Not only is the figure seated in the same frontal view (right foot extended, left drawn back; hands open at sides revealing the wounds), but Manet's draping of the body, reduced to a loincloth against the open winding sheet, is a simplified version of Mantegna's more elaborate draping around the hips and legs. Like Mantegna's, Manet's Christ is a very human figure of bone and sinew, eyes half open and lips parted. In both paintings the angels register grief, not triumph or joy, over a scene that traditionally represents the Resurrection. But in late-fifteenth-century Italy, Mantegna was painting for humanistic patrons in a world that held firmly that all images of Christ reveal not only a man of flesh and blood but also a visibly masculine male. Renaissance painters made a point of exposing detailed genitalia in images of the Christ child,[7] just as in images of the adult Jesus they expressly drew the eye to the rounded draping over the groin (as in Mantegna's *Dead Christ* of 1480 [Pinacoteca di Brera, Milan]).

Manet's Christ was not only human; he was shown to be realistically cadaverous, his body darkened by decomposition. To viewers this was aesthetically offensive even before it was theologically objectionable. At least one unnamed critic linked the work to Renan: "Do not miss M. Manet's Christ or *The Poor Miner pulled out of a peat bog*, painted for M. Renan."[8] It is curious that no one remembered Philippe de Champaigne's *Dead Christ* hanging in the Louvre, which depicts a cadaver as mortal and unglorified as Manet's, the soles of his feet shaded by death. Only freethinkers could accept Renan's explanation that what Mary Magdalene thought she saw, or wanted to see, gave rise to the myth of Resurrection, without which Jesus would have been just another in a long line of failed prophets. Manet made the Gospel reference very clear: as though engraved in the rock at the bottom right of the canvas, he painted the words: *"evang. sel. St. Jean/chap. XX v. XII"* (Gospel according to St. John, chapter 20, verse 12). At the same time, he just as clearly subverted the text, which relates that Mary Magdalene "seeth two angels in white sitting, the one at the head, and the other at the feet, where the body of Jesus had lain." In the verse below, she weeps "because they have taken away my Lord, and I know not where they have laid him" (John 20:13). In the painting, however, we see the mortal remains of Jesus,

still in the tomb, flanked by two angels, not the empty shroud we expect to see. It is Mary who is missing. This is indeed a very radical "variation on the scene of the Magdalene," for the absence of the witness and the presence of the corpse emphasize the nonoccurrence of the foremost miracle of Christianity. Manet made graphic his acceptance of Renan's explanation: Mary Magdalene was hallucinating.

Manet may have been utterly true to his artistic convictions and perhaps to his revised view of the Resurrection, but this was no way to gain the acceptance of the critics or the public when he submitted the painting to the Salon of 1864. Not even the reference to artists as unimpeachable as Mantegna or Champaigne would have been enough — had the reference been recognized — to protect Manet from the puritanical philistinism of the nineteenth-century middle class. El Greco, Veronese, and Tintoretto were all proposed as models, in no way to Manet's credit. Théophile Thoré, the least vicious of his critics, remarked that it was no longer Velázquez but El Greco whom Manet now "pastiched with equal fury." All that most other critics saw in the painting was the lividity of the body, mocked as "an abuse of black and ugliness," or more wittily, the result of a quarrel with Manet's paint supplier: "M. Manet has decided to use only his inkwell from now on."[9]

In view of all the hostility generated by this painting, it is curious that no one attacked it for a significant iconographic inaccuracy. The wound is on the left side. Baudelaire pointed this out in a note of April 1864 asking if he might come to dinner that evening: ". . . it seems that the lance wound was decidedly made on the right. You must therefore go and change the position before the opening. You can verify this in the four Gospels. And take care not to invite the laughter of ill-willed people."[10] It was too late to retrieve the canvas before the Salon opened, but when Manet went back to the same subject a year later, he could have made the change. He did a watercolor that reverses the entire image, suggesting to Françoise Cachin that "it was made as a preparatory drawing for the print [1866–67] . . . confirmed by their virtually identical dimensions."[11] Tabarant argues that the print was an attempt to rectify the "betrayal" of Scripture. But the print, like the original painting, shows the wound still on the left side. Is this not, like the left-handed guitarist playing a right-handed guitar, a signal that we are once again dealing not with reality but the painting of reality? This is not Christ, nor is it a sacred image of Christ, but

a painter's model posed as the dead, not risen, Jesus, which doubly undermines the subject, both as reality and as hagiography. As in *Incident in the Bull Ring** — the matador is merely a dead man once stripped of his death-defying gestures — Manet here too proposes an antiheroic optic: in death, even the Messiah was only a corpse.

Considering Manet's continued failure to produce pleasing works, one may well wonder why the jury accepted, almost unanimously, *Christ with Angels* and *Incident in the Bull Ring,* his two submissions to the Salon of 1864. Was it, as Tabarant argues, that they did not want this *écervelé* (madcap) to benefit from another succès de scandale as he had the year before? Better to let him hang himself this time. The public, knowing the works were hung alphabetically by painter's name, raced ahead to the Ms to renew their amusement, and the critics, barring two or three, singled him out for abuse. But Théophile Gautier, while highly critical of "the dirty black shadows that the Resurrection would never get clean," recognized that "Manet has his admirers, quite fanatic ones. . . . Already some satellites are circling around this new star and describing orbits of which he is the center."[12]

Whether Gautier wrote his qualified praise out of solidarity with Baudelaire or out of the generosity of his own heart is impossible to know. By 1863 he was fifty-two and far removed from his longhaired, red-vested youth as a fiery supporter of romanticism. He had a government pension and an air of respectability (at least in public). He was not prepared to take up the cudgel for the latest avant-garde of Refusés. He wrote not a word about them in 1863. But he knew about Baudelaire's admiration for Manet from personal contact, and he respected Baudelaire's artistic judgment, even if in this case he did not concur. In 1864 Baudelaire made a concrete attempt to help Manet by writing a warm letter recommending Manet and Fantin-Latour to Philippe de Chennevières, at that time inspector general of art exhibitions in charge of the Salon; Baudelaire and Chennevières had been residents of the same boardinghouse when both were university students. "M. Manet is sending an *Incident at a Bullfight,* and a *Resurrecting Christ Attended by Angels.* M. Fantin is sending an *Homage to the Late Eugène Delacroix* and *Tannhäuser in the Venus-*

*Title of the original canvas out of which *The Dead Toreador* was later taken (see p. 158).

berg. You will see what marvelous talent is revealed in these paintings, and whatever their category, do your best to place them well." [13]

Despite his affection for Manet ("It seems to me difficult not to love his character as much as his talent," Baudelaire wrote to Eugénie Manet in March 1863) and their almost daily contact over a number of years, which included numerous visits to Manet's studio, Baudelaire published almost nothing about Manet's paintings. One of Baudelaire's most devoted scholars, Claude Pichois, comments reproachfully, "No artist did more than Manet to please Baudelaire, or give form to the ideas expressed in "The Painter of Modern Life," but Baudelaire himself never publicly recognized Manet's originality . . . nothing in his published or personal writings gives any hint that Manet was ever put on the same pedestal as Delacroix or Constantin Guys." [14] Although this remark is accurate, Baudelaire did speak warmly of Manet's work in his 1862 article "Painters and Engravers" in *Le Boulevard,* a throwaway publication of weekly events. This was the only time he did so, placing Manet in the company of Legros and Jongkind: "M. Manet is the author of the *Guitarist,* which caused a great sensation in the last Salon. We will see in the next one a number of paintings by him imbued with the flavor of Spain, which leads one to believe that the genius of Spain has fled to France. MM. Manet and Legros add modern reality to their decided taste for reality — which is already a good sign." Further on he speaks of "men of genuine and mature talent (M. Legros, M. Manet, M. Yonkind [*sic*], for example)," which indicates that as early as 1862 he was well aware of Manet's capabilities.

Baudelaire's celebrated "Painter of Modern Life," begun, according to Pichois, in the summer of 1860, though not published until three years later, presents ideas that are intimately related to the kind of painting Manet had been thinking and talking about since his days with Couture and had already produced in 1862. Between 1860 and 1863 Baudelaire had numerous opportunities to follow Manet's progress, both in and out of his studio. In addition to the graphic works Baudelaire saw exhibited in 1862, Manet painted during that same year a portrait of Baudelaire's aging mistress, Jeanne Duval. She was by then stricken with syphilitic paralysis, as is suggested by the stiff legs protruding from her hoop skirt. Antonin Proust twice speaks of Manet's influence on Baudelaire. Recalling their daily lunches at Pavard's, on the rue Notre-Dame-de-Lorette, in

Baudelaire's "Painter of Modern Life"

the company of a group of writers (among them Henri Murger, author of *Scènes de la vie de bohème;* Jules Barbey d'Aurevilly, polymath writer, twenty-four years older than Manet, and one of Baudelaire's fellow dandies; and Baudelaire himself), Proust contests the general assumption that Baudelaire greatly influenced Manet:

> It is the contrary that is true. Baudelaire was ten years older than Manet. He made his debut in 1845 with reviews of Salons. In 1851 he continued writing these reviews, but his frequent presence at Pavard's and Dinocheau's . . . the conversations he had with Manet in both of these restaurants, the long discussions they later had at the Divan Le Pelletier, considerably altered his way of seeing and judging, and if around 1860 Manet and Baudelaire were extremely close, it was Manet who influenced his friend.

In an essay written four years later, speaking of Manet's very early attempts at creating a brighter, fresher art, Proust stresses the point:

> If these attempts had taken place within the four walls of a studio, little would have been said about them; but Manet often drew and painted outside the studio, in the street, and his blond silhouette quickly became familiar in the quarter of the Place Pigalle. Moreover, Baudelaire, who was then doing art criticism, and who from the very start had been taken with Manet's theories, did not limit himself to talking about him in private, he mentioned him as an innovator in one of his articles.

Yet Baudelaire placed at the center of his brilliant essay "The Painter of Modern Life" not the young innovator Edouard Manet, whose *Spanish Singer* had won honorable mention in the Salon of 1861, but Constantin Guys, an obscure self-taught illustrator for an English newspaper. His rapid sketches of *mondains* and demimondaines may have corresponded to Baudelaire's own ideas of "the fleeting moment," but Guys was neither a painter nor a thinker of the caliber proposed in the essay. Was it safer to construct a theory of modern art around a minor, uncontroversial illustrator than around an already-notorious painter of major talent and original ideas? Seventeen years earlier Baudelaire had hitched his wagon to a star, discovered two decades before. In his *Salon of 1845,* Baudelaire wrote,

"M. Delacroix is decidedly the most original painter since ancient times and modern times."[15] He was no less hyperbolic as the years passed, doubtless hoping to secure his own reputation by contributing to Delacroix's. He prided himself on his overstated familiarity with Delacroix, had the effrontery to borrow 150 francs from him, and found himself kept increasingly at arm's length, especially after the 1857 trial of *Les Fleurs du mal* for offense to public morality.

Even if there were no personal advantage in singling out Constantin Guys, it was perfectly consonant with Baudelaire's eccentricities in art, as in everything else. Baudelaire at one point insisted that Bronzino was the greatest painter of any school, although he was a lifelong admirer of Velázquez — a taste he could share with Manet. But he also had ideas about art that Manet must have found intolerable, such as his dictum in "The Painter of Modern Life" regarding the way Guys worked: "He draws from memory and not from the model, except in cases . . . when there is an urgent need to . . . set down the principal lines of an object. In fact, all good draftsmen draw from the image inscribed in their brain, and not from nature."[16] This runs absolutely contrary to Manet's insistence on having a model at all times; lacking a model, he turned to photographs. His contempt for the standard academic practice of working from memory dated back to his earliest days in Couture's studio and doubtless led to his concern not only for the physical reality of the model but also for seeing the model in natural light.

Baudelaire was seventeen and a student at the Lycée Louis-le-Grand when his teacher noted that he was "deceitful and untruthful" and that his attitude was "cavalier and shockingly affected."[17] With age he only tried harder to astonish, shock, and outrage, moving from paradox to cynicism, from bizarre clothing to makeup and green hair, from debt to debt and lie to lie. But his intelligence was scintillating and his poetic gifts unparalleled. Manet remained an indulgent friend to the very end.

On any number of subjects the two were irreconcilable. Manet, an ardent republican, could scarcely have sat quietly by when Baudelaire expounded his reactionary opinions: "Aristocracy is the only reasonable and secure government. Monarchy or republic, if based on democracy, are equally absurd and feeble."[18] Baudelaire was no less virulent a misogynist, despite his obsessive passions for Jeanne Duval and Apollonie Sabatier: "Woman is the contrary of the Dandy. She

must therefore horrify! Woman is *natural,* which is to say abominable. As such, she is always vulgar, or, the opposite of the Dandy."[19] This could not be further from Manet's vision of women. Even if he, like Baudelaire and many other men, shared an interest in women of low society, Manet could never have said as did his friend, "Why does an intelligent man enjoy prostitutes more than women of society, despite the fact that they are equally stupid?"[20]

In April 1864, a few weeks before the ritual opening of the Salon on May 1, Baudelaire, discouraged, impecunious as always, left for Brussels, where he planned to give a lecture on Delacroix. His publisher, Poulet-Malassis, had fled to Belgium seven months earlier after his release from debtors' prison. Baudelaire was forty-three years old, had a passing acquaintance with everybody in publishing but few supporters, announced works he never wrote, and wrote works he could not publish. He could no longer deceive himself about being in remission from the syphilis he had contracted years before. In 1860 he declared to Poulet-Malassis, "No one is healthier than the person who has had syphilis and has been fully cured, as army doctors and those who treat prostitutes know. It is a real rejuvenation."[21]

For Baudelaire, as for many of his contemporaries who confused gonorrhea with syphilis, "the day a young writer corrects his first proof he is as proud as a schoolboy who has just caught his first case of syphilis [*vérole*]." But recurring attacks made him lose faith in a belief commonly held at the time that the disease was curable, and in 1862 he noted, "I cultivated my hysteria with pleasure and terror. Now I have constant dizzy spells and today, January 12, I experienced a singular warning. I felt the wing of imbecility brush over me."[22] It was a prophetic statement.

A fabulist in every sense, a poseur, he delighted in pranks and mystifications, among then a concocted defense of Manet when Théophile Thoré accused him of having "pastiched" El Greco, Velázquez, and Goya in his portrayal of the dead matador. In June 1864 Baudelaire responded to Thoré's review, surely chuckling over his bald-faced invention: "The word *pastiche* is not fair. M. Manet has never seen a Goya, M. Manet has never seen a Greco. M. Manet has never seen the Galerie Pourtalès. That seems incredible to you, but it is true. I myself have admired with stupefaction these mysterious coincidences. . . . It is true that he saw some Velázquez, I know not where. You doubt what I tell you? You doubt that such geometric

parallelisms exist in nature? . . . Quote my letter, or a few lines. I have told you the unvarnished truth."[23] A notion of such "parallelisms" coexisting despite the absence of direct knowledge was perhaps of greater benefit to Baudelaire, who by then had a debt to Poe as well as to Manet for ideas he could pass off as "mysterious coincidences." Thoré, very much the gentleman, replied in newsprint to Baudelaire's explanation in June 1864: "The apparent resemblance between the two artists may only be the result of 'mysterious coincidences.'" But more important than a halfhearted retraction of "pastiche" was Thoré's praise: "We are pleased to repeat that this young painter is a true painter, more painter all by himself than the whole company of Rome prize winners."[24]

Manet, dragged through the mud by most critics, had at least the rare distinction of having been noticed. Most of his unconventional coexhibitors were ignored in what appeared to be a conspiracy of silence. The excitement of 1863 had been a novelty, not to be renewed. It was high time for all those *rapins,* those daubers, to understand that from now on the jury would have the last word on what was worth showing. Even more humiliating than the attacks against his *Christ with Angels* were those directed against his *Incident in the Bull Ring:* "A wooden torero killed by a rat." The perspective was considered a proof of Manet's technical inadequacy: "M. Manet has not yet seized the bull by the horns," Thoré quipped in his review, while at least granting him the magical handling of "luminous effects and flaming tones that are pastiches of Velázquez and Goya."[25]

The general criticism did not fall on deaf ears. Manet brought his two paintings back to his studio when the Salon closed, took a long look at his bullfight, and performed a piece of ingenious surgery. The "microscopic" bull — so labeled by Hector de Callias, art critic of *Le Figaro* — was cut out, leaving only the edge of his back, one horn, and the tip of the other at the lower rim of the painting. The proportions were reversed. Now, instead of the "rat" seen by Manet's detractor, we are aware of a large, barely perceived menace looming before three toreros, one of whom has just sought refuge against the barrera, above which the spectators are peering — a prefiguration of one of the versions of the execution of Maximilian that he would paint three years later. And occupying the entire field of the remaining canvas is the dead matador — a superbly painted figure that

gained in its isolation the meaning that was lost in the banality of the original composition.

In June 1864 the U.S. Civil War was in its third year. France had been covertly helping the Confederates, although it paid lip service to abolition and had in fact abolished official slavery in its own colonies in 1848. England also was helping the Confederates by allowing their ships to be outfitted in English ports, which the U.S. government saw as a serious act of provocation. Announced for June 19, 1864, like a sporting event, was a naval battle between the Confederate *Alabama* and the Union *Kearsarge* in Channel waters fourteen kilometers (nine miles) off Cherbourg. Since the captain of the *Alabama* had destroyed sixty Union vessels by then, the adversaries and their ships were already familiar to newspaper readers in Paris. Hotels in Cherbourg were besieged with requests for reservations as journalists and gawkers rushed to watch the event.

There has been long-standing dispute over Manet's presence at the battle. Did he see it, or didn't he? Considering the distance from Paris — 360 kilometers (about 220 miles) — it is questionable that Manet would have sacrificed the time needed to see this spectacle. Every detail of the encounter was amply reported in the newspapers, with illustrations. He hated leaving Paris, even for a summer holiday, and wrote nostalgically to his friends in Paris when he was away. To the engraver Bracquemond in mid-July 1864, a month after the naval duel, he wrote, "I am enjoying my seaside holiday, but I miss our discussions on Art with a capital A, and what's more, there is no Café de Bade here." In the same letter, he reported that he had done "some studies of small boats on the open sea. On Sunday I went to see the *Kearsage*, which was lying at anchor off Boulogne. [Manet and most French writers left the second r out of *Kearsarge*.] I will bring back a study."[26] On July 18 Philippe Burty wrote a notice in *La Presse* about Manet's painting of the battle, then being shown at Cadart's gallery, on the rue Richelieu. A few days later, writing from Boulogne, Manet acknowledged "the few complimentary lines that you wrote about my picture. I thank you and hope you will not apply the proverb *One swallow does not a summer make* [*Une fois n'est pas coutume*]. The *Kearsage* happened to be anchored off Boulogne last Sunday; I went to look at her. I had made a pretty good guess at her. Moreover, I painted her at sea. You will be the judge"[27] (Fig. 15).

The evidence suggests that Manet did not see the *Kearsarge* until she rode at anchor off Boulogne and that his painting of the battle was based on newspaper accounts and magazine illustrations. Whether he was present or not, whether the ships are accurate or not, what matters is that the painting is primarily a masterful seascape, showing us more about the power of the sea than the power of two warships. For this his personal experience of a stormy Atlantic in 1848–49 was more instructive than the exact lines of the Union vessel. "I learned a lot during my crossing to Brazil," he told painter Charles Toché in 1875. "How many nights I spent watching the play of light and shade in the wake of the ship! And during the day, from the top deck, my eyes never left the line of the horizon. That is what taught me how to set a sky."[28] What is accurate, and of primary importance, is the movement of the water, the smoke, and the confusion. This is not a history painting, despite the specificity of the subject, but an evocation of all sea battles, of death and destruction amid rolling waves. The heroism of the engagement is lost in the greater strength of the waves.

When the painting was shown in the Salon of 1872, Jules Barbey d'Aurevilly, one of Manet's old lunch companions at Pavard's, wrote a glowing article in *Le Gaulois* on July 3:

> According to some, M. Manet has no talent. He is a systematic and deliberate dauber, who has been mercilessly *ridiculed* of late, which does not mean that he *is* ridiculous. . . . If there is anyone skilled and clever in the world of art that man is Monsieur Manet. His picture (a picture of war and boarding parties, planned and executed with all the skill of a man who by any means possible is trying to escape the commonplace which is engulfing us) contains everything that is most natural and primitive within the scope of any paintbrush since the world began. All this has been expressed by M. Manet in his picture of the *Kearsage* [*sic*] *and the Alabama*.

Barbey d'Aurevilly, of seafaring Norman and Scandinavian ancestry, had been "carried away on the waves of M. Manet's sea; I recognized that this was something I knew." Less experienced mariners found fault with Manet's high placement of the horizon and the diminution of the vessels. But Barbey understood. Instead of placing the warships in the foreground, as would a newspaper photographer,

he saw that Manet did what Stendhal had so masterfully done in his handling of the battle of Waterloo, in the *Charterhouse of Parma;* we do not see the battle but rather feel its confusion and terror. "M. Manet has thrown back his ships to the horizon," Barbey explained. "He has had the happy idea of making distance diminish them in size. But the sea which surges all around, the sea which stretches right up to the frame of his picture, tells enough about the battle. . . . One gets an idea from the billows, from the mighty swell, from the depths of these surging waters." For once a critic perceived what Manet was doing. But between the painting of this picture in 1864 and its deserved recognition in 1872, Manet endured bitter years.

Also dating from 1864 is a painting by Fantin-Latour that placed Manet at the center of the avant-garde. Delacroix had died in August the year before. For more than thirty years, until his official rehabilitation in 1855 as a "colorist," he had been regarded as "the harbinger of Revolution, Sin and Individuality,"[29] individuality at the time being virtually synonymous with subversion and romanticism. He was the undisputed leader of the Romantic school in art. When Baudelaire defended Manet against Thoré's charge of imitation by explaining that Manet, "thought to be raving mad, is simply a very loyal man . . . doing everything he can to be reasonable, but unfortunately marked with romanticism since birth,"[30] he was associating Manet with the sensibility that he extolled in Delacroix and that he himself represented. In the Baudelairean lexicon the very words "marked" and "romanticism" carry hidden praise, for romanticism implies a way of feeling — in Baudelaire's view, the only viable way — rather than a choice of subjects. "Romanticism," he wrote in his "Salon of 1859," "is a celestial or infernal grace that has left its stigma on us forever."[31]

Manet was still a student of Couture's when, after a visit with Proust to the Louvre where they looked at Rembrandt, Velázquez, Chardin, and Watteau, he declared, "All that is very good, but there is a masterwork at the Luxembourg [the museum of contemporary art at that time], and that is the *Barque of Dante.*" It was this painting that inspired Manet to pay a visit to Delacroix and ask permission to copy the work — the only contemporary painting he ever copied. He would later inherit Delacroix's epithets — "the apostle of ugliness" and "a painter of decadence" — and perhaps console himself with the thought that Delacroix had nevertheless lived to see himself covered with glory.

With this as background, it is easier to understand why Fantin-Latour chose to place Manet, and only Manet, directly under Delacroix's gaze in the group portrait titled *Homage to Delacroix*. If the critics, among them Théophile Gautier, objected to the lack of coherence in the painting, and especially to the placement of the figures — all of whom have their backs turned to the framed portrait of Delacroix in the center of the canvas — they may have overlooked the allegorical significance of Fantin's painting in their haste to honor Delacroix now that he was dead. Ten men are portrayed: the painters Alphonse Legros, Louis Cordier, James Whistler, Albert de Balleroy, Manet, and Fantin in a self-portrait; the engraver Félix Bracquemond; the writer/critics Champfleury, Duranty, and Baudelaire. All of them — including Baudelaire, who had capitalized on Delacroix but led the crusade for modern subjects — represented new visions of a new world. They were not interested in looking back to Delacroix but ahead to newer means of expressing reality.

Henri Fantin-Latour, four years younger than Manet, had come to Paris from Grenoble to study with Lecoq de Boisbaudran, known as a second-rate painter but a first-rate teacher. He first met Manet at the Louvre in the mid-1850s, when artists, students, and members of the Académie walked through the galleries to look at the great masters, examined each other's copies, and struck up friendships. Fantin was painfully shy, hardworking, and a passionate music lover who made his living then as a copyist. At the Louvre he often chatted with a man he found interesting but did not know outside of their occasional exchanges, one of which led to a dispute, with Fantin staunchly defending Ingres against his interlocutor's jibes. Then, at the Salon of 1861, where Manet was showing the portrait of his parents and *The Spanish Singer*, Fantin was so impressed by the works that he asked to meet the artist and was astonished to discover he already knew him. From then on their relationship remained untarnished by time or events, as did their mutual admiration. Their correspondence reveals genuine affection. Curiously, throughout their long relationship they retained the formal *"vous"*; they seem not to have shared the comradely intimacy expressed by the second-person singular, which Manet used with Proust and Astruc.

Zacharie Astruc was a close collaborator as well as a friend, a polymath of unequal talents alternately wielding a paintbrush, a chisel, and a pen. In 1862 Manet portrayed him in *Music in the Tuileries*,

and the following year Manet illustrated a serenade for which Astruc had written both the music and the words. Dedicated to the queen of Spain, it was titled *Lola de Valence*. It may have been Astruc, captivated by Spain and everything Spanish, who took Manet to see the Spanish troupe of which Lola Melea was the star. A lithograph based on Manet's painting of the dancer appeared on the title page. Astruc is assumed to have given Manet's great nude her name. If not the name, he was certainly responsible for the vacuous verse that Manet ill-advisedly submitted as an epigraph for the Salon catalogue when *Olympia* was shown in 1865. Manet did a portrait of Astruc in 1864, which cleverly identifies his association with the painting. The background of the portrait is a reverse image of the background of Titian's *Venus of Urbino*, which Manet had used for *Olympia*. But in this portrait of Astruc, Manet recaptured the domestic iconography of the original by placing Astruc's wife in the scene at the back, where she is seen from the rear while her face is reflected in a mirror. As it turned out, neither spouse was pleased with the painting, and it remained in Manet's studio.

Astruc was Manet's vociferous defender when *Olympia* was being stoned by all the other critics. In a broadsheet published every evening during the two months that the Salon was open, Astruc wrote an article on the Salon des Refusés that appeared on May 20, 1863: "Manet! One of the greatest artistic figures of the day. I will not say that he has been awarded the triumph of this Salon . . . but he is its sparkle, its inspiration, its flavor, its marvel."

Astruc was also one of the group that congregated at the Café Guerbois. He appears in Fantin's *Studio in Batignolles* as the model Manet is painting. Manet's regular attendance at the Guerbois did not change his devotion to the fashionable cafés on the Boulevard des Italiens. In May 1865 he was still to be found at his favorite haunt, as his first letter to Emile Zola attests: "Where might we meet? I am at the Café de Bade, 26 boulevard des Italiens, every day from 5:30 to 7 o'clock, if that suits you."[32] But the Guerbois was the café of choice for the artists and writers who gravitated toward Manet and came to constitute the misnamed "Batignolles School," immortalized in Fantin-Latour's painting of 1870. "What has been termed the Ecole de Batignolles was the Guerbois, and never anything else," Tabarant declares, meaning that there was no such cohesive school, merely a gathering of like-minded artists at a location convenient to most of

them.[33] In 1864 Manet rented an apartment at 34, boulevard des Batignolles, a stone's throw from the Guerbois, at 19, avenue de Clichy. The café stood opposite Hennequin's artists' supplies shop and next door to the restaurant known as Père Lathuile, a popular establishment that would provide the setting and title for Manet's sunlit couple in 1879.

From 1863 to 1875 a nucleus of twelve — caricaturized by one cartoonist as a Christ-like Manet surrounded by his disciples — and later more drifted in most days, but Friday was the day they congregated as a group, and two tables to the left of the doorway were reserved for them. Among the painters were Legros (who did a fine portrait of Manet in 1863), Fantin-Latour, Renoir, Degas, Whistler (he and Legros later settled in London), Bazille, Monet when he came to town from Argenteuil, and Cézanne on occasion. They were joined by a few writer/art critics: Hippolyte Babou, Emile Zola, Edmond Duranty, Philippe Burty. As recalled by one of the later habitués, "The clients of this group drank little. They talked a lot. They discussed recent exhibitions; took interest in new talent; thought above all about the works they were still to produce. Pettiness, jealousy, envious niggling played no part in their conversations."[34]

The summer of 1864 saw Manet's completion of three more seascapes, The "Kearsarge" off Boulogne, painted after Manet had seen the ship; Ships at Sea, with porpoises cavorting in the right foreground; and Leaving Boulogne Harbor. Inspired by his seaside residence, Manet also painted three superb still lifes of fish. Presumably before that, since the growing season of peonies does not extend into July, he began the first of a series of peony paintings that rival any flower still life ever done (Fig. 66). Manet was particularly fond of peonies; although he later painted other flowers as well, it is the peony that holds first place in his flower paintings. He did these flower still lifes only rarely during his career. They fall into two periods, 1864 and 1882, both of which correspond to his state of mind at the time, as we shall see.

Still lifes had been painted since antiquity, as the story of Zeuxis's grapes attests. Throughout the ancient world they served a decorative purpose. They later appeared in Italian illusionist, or trompe l'oeil, works that graced Renaissance palaces and Baroque churches. But as a genre, the still life came into its own in Holland in the seventeenth century, where it served as more than decoration. Religious, moral,

and social symbolism entered into the sumptuous paintings of flowers, fruits, game, and household objects produced then. It was a dazzling feat to portray glass goblets with white wine or water in them, or ornamented silver whose gadrooning could almost be felt under the fingers. Still today we stand in amazement before the breakfast compositions of Pieter Claesz. We are no longer conversant with their meaning, but the seventeenth-century spectator understood the pictorial language of the time. A table groaning with food referred to the new society of free men, no longer in thrall to a feudal lord, who were producing for their own profit on an open market. Seventeenth-century Holland was the hub of European banking, a model of industry and prosperity. But this was tempered by the teachings of the Church and the prevalence of war and disease, all constant reminders of the fragility of the human condition. The *vanitas* still life, with its skull, clock, soap bubbles, or heaped-up objects, told the viewer that wealth, fame, youth, and beauty were passing, that only loss was predictable, only death eternal.

How interested Manet was in the metaphysics of Dutch still lifes is a matter of speculation. But he cannot have been unaware of the similarity between the newly enriched society of seventeenth-century Dutch burghers and nineteenth-century French bourgeois, both groups being self-made capitalists. Manet's flower of choice in his *vanitas* still lifes is the peony. While never attaining the exorbitant prices of Dutch tulipomania during the seventeenth century, when a single bulb could sell for the present-day equivalent of thousands of dollars, peonies were highly prized in France, and a tuber commanded as much as two thousand francs (more than five thousand dollars in terms of today's buying power). Manet cultivated peonies, his favorite flower along with the white lilac, in the garden of the family property at Gennevilliers. The new affluence of the French middle class created a market for smaller, more intimate paintings than the somber *grandes machines* of historical scenes; flower still lifes were much in demand. Cut flowers for the more affluent had become a booming business. Demimondaines were especially noted for their extravagant purchases in flower shops, as were the "Arthurs" who courted their favors. Even among more conservative clients, an entire culture of flower symbolism was fashionable at the time, making a bouquet as eloquent as a love letter or a poem.

All or some of these factors may have entered into Manet's produc-

peony still
lifes 1864 (handwritten annotation)

tion of seven peony still lifes in 1864, each demonstrating technical brilliance and ravishing beauty. But the impulse to paint still lifes just then may have sprung from his mood at the time. Depressed over the general hostility of critics and public to his works, he may have been loath to undertake another controversial subject. Even his skill as a painter was being questioned repeatedly. Flower paintings could show the most intractable critics how capable he really was, and also attract potential buyers.

Beyond these factors, it would be a mistake to overlook the emotional intensity of these paintings, especially if compared with the flower still lifes of other notable exponents of the genre, such as the earlier Flemish and Dutch painters. Their botanically accurate paintings may have conveyed a political symbolism or, in the case of tulips, have served as the only available samples for a wild futures market, but they do not have the emotional impact of Manet's canvases. In eighteenth-century France, Elisabeth Vigée-Lebrun produced opulent flower arrangements for her aristocratic clientele, and among Manet's contemporaries Fantin-Latour created undisputed masterworks in the genre. Their sumptuous bouquets are not infused with the melancholy and sensuality of Manet's peonies, or with the note of evanescence that recalls the classic theme of *vanitas* — loss, emptiness, withering. Delacroix's still lifes of 1848 do, however, reflect a state of mind similar to Manet's, though for a different reason. Delacroix was so dejected by the political situation of 1848 that he did virtually no painting. In September of that year he undertook a series of flower and fruit studies, which T. J. Clark explains as "Delacroix's . . . deliberate grand withdrawal to a world of private sensation, a world of traditional painterly problems."[35]

In each of Manet's peony paintings, we see cut flowers lying on a table while others stand in a vase. In some of them we even see the shears used to cut them. In the most elaborate, *Vase of Peonies on a Pedestal* (Fig. 66), one writer has seen an allegory of the death of the flower, from the buds on the upper right, the opening blooms on the left, and the full-blown flowers in the center to the dropped petals on the lower left.[36] A personal allegory can be read into this as well: the budding painter, cut down by insensitive critics, left to wither without achieving the fulfillment of his talent or the recognition of his achievement. *Vanitas*, true, but the painting remains.

When *Olympia* was exhibited in the Salon of 1865, the renewed

hostility provided the proverbial final straw. Had this been Manet's first experience with the malice of critics and lay viewers alike, he might have taken it in his stride. But this was his fourth Salon, and he was thirty-three. If Dante was right, half his life was behind him. The painting aroused so much fury that *Incident in the Bull Ring,* which had been found so execrable the year before, was now cited as indicative of Manet's talent, whereas *Olympia* indicated nothing but his contempt for the public. If Manet's faith in himself was not undermined by these attacks, they nevertheless took their toll. "Suffering does not kill," Proust remarked in one of his few asides, "it is the effort to sublimate it that erodes life and destroys the will life is made of. Manet's oeuvre, impressive as it is, would have been even more so had the animosity of his contemporaries not been so violent." Recalling this period in later years, Manet bitterly admitted the irreparable damage done to him: "The attacks directed against me broke in me the mainspring of life. No one knows what it is to be constantly insulted. It disheartens you and undoes you."[37]

The question arises again: why, after the uproar over the paintings he submitted to the previous two Salons, did Manet send *Olympia* to the Salon of 1865? According to Léon Leenhoff's notes, it was Baudelaire who convinced Manet to submit it (*"C'est Baudelaire qui a décidé l'auteur à exposer"*).[38] Jacques-Emile Blanche, on the other hand, claimed that it was Suzanne who encouraged him to do so. Blanche, however, was only four in 1865, and thus is not a reliable source. There is no indication anywhere that Suzanne exercised any artistic influence over her husband or that he ever consulted her. She did not even have right of entry into his studio unless specifically invited. But Baudelaire's opinion did carry weight and may well have overridden Manet's hesitation.

The fact that Manet kept *Olympia* in his studio for two years before deciding to show it suggests that he was uneasy about it. What may have contributed to his decision to submit *Olympia,* as well as its companion piece, *Jesus Mocked by the Soldiers,* is an anecdote related in a widely read biography of Titian first published in English in 1830 and later translated into French. When Titian came to the court of Charles V, he presented "the august monarch" with two paintings, "a Christ scourged and crowned with thorns . . . and a Venus of such rare beauty that as the first one moved everyone who looked at it to repentance, so the other awoke youthful feelings even in the hearts of

the old."[39] Theodore Reff, whose 1964 article on the meaning of *Olympia* is still a benchmark for studies of this painting, sees in this the possibility that Manet identified himself "with the Renaissance master not only in the forms of his two pictures, but in the very act of submitting them together to that 'august monarch' of his own society, the jury of the Salon."[40] Not until thirty years after Manet's death did anyone notice the relationship between Manet's *Olympia* and Titian's *Venus of Urbino* — one of the paintings Titian brought to Charles V — despite its accessibility in the Uffizi in Florence, where Manet copied it in 1856, and in illustrated books. At least one critic in Manet's day recognized the more arcane reference to Raphael in *Le Déjeuner sur l'herbe*.

The storm of abuse unleashed by *Le Déjeuner* pales in comparison with Manet's submissions to the Salon of 1865. This time he was not even in the company of the Refusés; this time he was singled out for insults more virulent than those hurled against Delacroix or Courbet. Now he was a "recidivist of the monstrous and the immoral."[41] The hostility was doubtless exacerbated by the association of *Olympia*, in the minds of some critics, with the new form of advertising used by prostitutes — photographs of themselves in enticing poses on calling cards. The ill-advised accompaniment of Astruc's stanza — only one out of his ten pseudo-Baudelairean stanzas — provided the head for a hundred arrows, particularly the last line, "L'auguste jeune fille en qui la flamme veille" (The august young maiden in whom the flame keeps watch). She was "ignoble," "obscene." One critic, bereft of suitable adjectives, wrote despairingly: "I do not know whether the dictionary of French aesthetics holds expressions to characterize her." Nothing about her was acceptable: "her face [is] stupid, her skin cadaverous" and her creator "a brute who paints green women with dish brushes." Young girls and pregnant women were advised to "flee this spectacle."[42]

As though the ignominy of being personally attacked for the subject and facture of both his entries were not enough, Manet was further vilified as a disgrace to the nation. Perhaps more disheartening than to be reviled for one's own deficiencies is to be compared to someone of lesser ability. The pride of the Salon of 1865 was a painting by Jules Breton, *The Repose of the Haymakers*, bought by a Prince Napoleon, a cousin of Napoleon III. Edmond About, a major critical voice at the time, confidently wrote, ". . . long after Prince

Napoleon who bought it, I who speak to you about it, and you who read me, have taken our resting place under the ground, [Breton's] painting will . . . inspire in our descendants esteem for all of us." Another critic concerned with the national image, writing appropriately enough in *La Patrie*, reported that a noted foreign artist, standing before Manet's "abominations," said, "This is what French painting has come to!" To which the critic proudly replied, leading him to Breton's canvas, "You are mistaken. This is what it has come to!"[43]

The general consensus was that Manet got what he deserved, that it had been far wiser to accept his two paintings than to reject them, for it was time to make an example of these daubers who held the French tradition and the French public in such low esteem. Chennevières, who had obliged Baudelaire by placing his friend's paintings in a good position, now ordered them raised so high that they were hard to find, let alone see. A month after the opening, a critic who had nothing good to say about Manet nonetheless reported sardonically, "A barbarous administration has deported the *auguste jeune fille* and used Nadar's *Géant* [hot-air balloon] to hang it at a terrifying altitude."[44]

The probability that Baudelaire was behind the submission of *Olympia* explains Manet's two letters to him in the spring of 1865. In March *Olympia*, accompanied by *Jesus Mocked by the Soldiers*, was accepted by the Salon jury after having been rejected when submitted alone. Manet informed Baudelaire: "You are a sage and I was wrong to despair, for just as I was writing to you my painting was being accepted. I even believe from the rumors reaching me that this will not be too bad a year." Then in May, after the Salon reviews had appeared:

I truly wish you were here, my dear Baudelaire, for insults rain down on me like hail, and I have never before found myself in a situation like this. . . .

I would have liked to have your sound judgment of my pictures, for all these outcries are irritating, and it is evident that someone is mistaken. Fantin has been charming; he defends me and with all the more merit since his own picture this year [*The Toast*], though it has many qualities, is less striking than last year's (and he knows it). . . .

I wish our newspapers and reviews would publish more of your

work, for example some of the poems you must have written during the past year.

The Academy in London has rejected my pictures. Goodbye dear friend, I clasp your hand.[45]

To this Baudelaire replied on May 11 with a frigid homily that seems incomprehensible from a friend:

> I must therefore speak to you once again about yourself; I must make the effort to show you your worth. What you demand is really silly. *They deride you; their mockeries exasperate you; they do not do you justice.* . . . Do you think you are the first man placed in this situation? Is yours a greater talent than Chateaubriand's and Wagner's?
>
> They too were derided. It did not kill them. And in order not to arouse too much pride in you, I will tell you that these men are paragons, each in his own field, and in a very rich world, and that you, *you are only the first in the decrepitude of your art* [emphasis in original]. I hope you will not hold against me the candor with which I treat you. You know my friendship for you.[46]

It took the intricacy of a Baudelaire to contrive a compliment so backhanded. That same month Baudelaire wrote to the critic Champfleury: "Manet has a great talent, a talent that will prevail. But he has a weak character. He strikes me as depressed and over-whelmed by the shock. What also strikes me is the delight of the idiots who think he is defeated." Champfleury shrewdly replied, ". . . like a man falling into snow, Manet has made a dent in public opinion."[47] Baudelaire's literary achievements far outweigh his judgments of people. As an artist, Manet never betrayed his principles and rarely sought the favor of kingmakers, however gnawing his hunger for recognition. And as a man, his openhanded, open-minded generosity toward others attests to a decency few men of his time demon-strated — hardly the traits of a "weak character."

Who would not have doubled over from such blows as fell on Manet in three successive Salons? *Jesus Mocked by the Soldiers* was received no less scathingly than *Olympia,* or his *Christ with Angels* of the year before. His attraction to the subject just then can be seen as a reflection of his own abuse at the hands of the Parisians. The motley

of possible sources (Titian, Velázquez, Van Dyck) and costumes suggests an all-encompassing image across time and place, which would be suitable enough for the literal subject and all the more fitting for an allegorical one. The pathos of this very human, very humbled figure of Jesus — who looks beyond his tormentors — suggests a personal identification with the abused Messiah, and the vulgar and variegated figures of the soldiers are a symbolic representation of the world that treated the painter with such brutishness. This was not bathetic posturing on Manet's part, but the use of an archetypal representation of incomprehension and derision. Nor was it the first or the last time that he entered into one of his own paintings. What is more, he prominently inserted a characteristic prop to designate himself, analogous to the brush and walking stick that appear elsewhere. Here it is the reed, mentioned in the Gospel account, which also can be seen as a paintbrush. Also noteworthy is Christ's beard, which is the color and shape of Manet's own, to judge from photographs of him taken in the 1860s. If the critics saw nothing valid in the painting, cartoonists saw in it a fine opportunity for caricature.

There is ample evidence in the letters and memoirs of Manet's contemporaries that he was already deeply dejected after his fiasco of 1864, for in January 1865 Mme Meurice reported to Baudelaire that Manet was "tearing up his best studies." And Proust relates that as of 1865 Manet's habits were no longer the same. He rarely went to the cafés; he often remained idle at home, took long aimless walks, and read. "However disposed he may have been to work had he received encouragement, his fervor collapsed before the cruelty and injustice of those who did not understand him," Proust notes. The favorable response to a seascape by Monet shown at the Salon of 1865, which one critic attributed to Manet, added mistaken identity to misunderstanding. Embittered not just over the confusion of name but over the inability of that viewer to see how good he was, Manet ironized: "Who is this Monet whose name sounds like mine and who is taking advantage of my celebrity?" His celebrity was assured by the prurient interest generated by *Olympia*. Among the very few who had the vision to appreciate what he saw was one reviewer who never wrote another Salon review. He not only recognized the artistry of Manet; he also saw talent in James Whistler and in Berthe Morisot, exhibiting at the Salon for the first time. "Manet's *Olympia*," he wrote, "is more than something good. . . . But the public, the gross public that finds it

easier to laugh than to look, understands nothing of this art which is too abstract for its intelligence."[48]

In _Olympia_ Manet directly confronted the problem raised by Velázquez in _Las Meninas:_ that of the beholder. Manet candidly tells us that there is no illusion here, no Venus caught napping or frolicking in the waves. "I am looking at you looking at me," says Olympia. And the viewer cannot even hide behind the gaze of the painter. This daring act of revealing the viewer to himself may have played as much a part in the outraged response to the painting as did the flatness of the forms. How could a visitor to the Salon of 1865, whose eyes were accustomed to the illusion of three dimensions, see more in _Olympia_ than Courbet saw? He reportedly found it flat, unshaded, "a queen of spades out of a deck of cards, just out of her bath." Viewers today, accustomed to art that bears little if any resemblance to reality, have no problem with this, as Manet predicted: "How fortunate those who will live a century from now; the organs of their vision will be more developed than ours. They will see better."[49]

In July Manet took his wounds to heal in the sea air of Boulogne. Disheartened by the reviews, he stopped reading newspapers altogether and avoided contact with most people, themselves too embarrassed to know what to say to him. Zacharie Astruc persuaded him to go to Spain.

An Old Passion, a New Friend,
a Public Defender

During the thirty years preceding Manet's visit to Spain, Spanish painting had become a major attraction in Paris, as had all things Spanish even earlier. Literature and painting, romanticism and realism, Alfred de Musset and Théophile Gautier, Delacroix and Dehodencq all had drawn from Spanish culture, high and popular. Manet's interest in Spanish art had been nurtured by repeated visits with his uncle Edmond Fournier to the dazzling collection amassed for Louis-Philippe by Baron Taylor in the 1830s. Taylor's acquisitions, 412 of which were exhibited in the Galerie Pourtalès, then in the east wing of the Louvre, had been enlarged by the 134 Spanish works donated by Frank Hall Standish, shown in an adjacent hall. There was, in addition, the superb private collection of Field Marshal Soult, which remained on display until 1852. Taken as booty during the Napoleonic invasion of Spain, it consisted of more than two hundred paintings, though none by Velázquez or Goya. Like Manet, Delacroix had gone to the Louvre to copy Velázquez and also had copied a painting wrongly attributed to Velázquez (the model for Manet's *Little Cavaliers*; the painter has since been identified as Juan Bautista del Mazo). Also like Manet, Delacroix, thirty-three years earlier, had gone to Spain to absorb the style of the Spanish masters in situ.

In 1845 Prosper Mérimée's novella *Carmen* appeared in *La Revue des Deux Mondes*, offering its readers the tale told to a French traveler about the riveting figure of a Spanish prostitute. Georges Bizet was then seven years old. Thirty years later, considerably transformed by Bizet's librettists, Carmen would become slightly more respectable

and live on as Spain's most famous heroine in what is arguably the world's best-known opera. Also in 1845 Gautier's account of his trip to Spain two years earlier appeared in an expanded edition titled *Voyage en Espagne*. His association with Spanish art had already been established with his preface to an 1842 catalogue of Goya's graphic works. *Voyage en Espagne,* written by an enthusiastic tourist, contains everything one would have wanted to know about travel to and inside Spain — customs, women, food, drink, art, and, of course, bullfights: "Up to now, nothing in our experience justifies the charges of uncleanliness and shabbiness that travelers make against Spanish inns; we have not yet found scorpions in our bed, and the promised insects have not made their appearance."[1]

In the 1850s the Spanish vogue enjoyed a fresh surge of interest after the marriage of Napoleon III to the lovely young Eugenia de Montijo (Eugénie), daughter of a Spanish count. Sales of privately owned Spanish paintings were being held in Paris. The Louvre began acquiring new Spanish works to replace the collection that had reverted to Louis-Philippe following his abdication in 1848. Spanish dance companies and books on Spain and Goya were appearing in France one after the other.[2] Antonin Proust notes that in Italy Manet had been "very taken with Titian and Tintoretto, little enthused by Raphael and Michelangelo, and was always obsessed by the idea of rediscovering Spanish painters and seeing Spain." A painting by the French artist Alfred Dehodencq, titled *Novillada at Escorial* and shown in the Salon of 1851, made a deep impression on Manet. Referring to it on his return from Spain, he said, "Dehodencq saw and saw well. Before going there he was blind. There are people who don't believe in miracles. As for myself, ever since Dehodencq I believe in them."[3]

Manet's cicerone for his Spanish adventure was Zacharie Astruc, who had last been there only the year before and knew the country and the language well. Astruc prepared a twenty-page guide to Spain telling Manet exactly what to see and do and even what to avoid. In August 1865, not the most comfortable month to be in Spain, Manet precipitously departed, leaving his family at a great-uncle's country house near Le Mans, 120 miles southwest of Paris. At no point in his plans does he seem to have entertained the thought of taking Suzanne with him. This is all the more surprising in that Astruc's itinerary was

planned for a stay of no less than a month, with time allowed for work: ". . . the trip must not be unfruitful . . . I seriously urge you to take with you some kind of materials, if only water colors." The stops were to include Burgos, Valladolid, Avila, Madrid, Toledo, the Escorial, Segovia, and Valencia — "Valencia is all of Andalucia, a masterpiece!" — with Manet returning via Marseilles; "and if you have projected in your implacable brain to return by the same route you came, like a mad Parisian in a hurry," then the absolute minimum was the first four cities.[4]

Regretting that he could not accompany him, Astruc explained that he lacked the money to do so, that he was working frantically to finish a book in order to earn some, and that his wife was "preparing a volume that will have required no less than nine months of work." He also intimated that his trip to Spain engendered both: *Mes rimes et mon cher petit enfant seront tous deux de Tolède* [My verses and my dear little child will both have come from Toledo]." Armed with Astruc's recommendations and warnings, Manet had every chance of a successful trip. However, knowing Manet's impatience and suspecting that he might set out by himself, Astruc foresaw that the visit would be too hasty and that Manet, alone and without knowing the language, ran the risk of "dreadful disappointments and a deplorable trip." Astruc was genuinely distressed to let him go, since "there is assuredly reason to be fearful."

Manet's return letter is a delightful sample of his personality and his tone. He would have joyfully paid for Astruc's trip had *Olympia* brought him the means to do so, but he refused to accept an offer below his asking price. In fact a year later he doubled it:

> Now that is a letter, very detailed, very clear, it challenges me to leave without any companion at all; you alone would have been the one I wanted, and if I had sold *Olympia,* which was about to happen recently, I would have offered myself the luxury of your delightful company. But I thought I owed myself the impertinence of asking 10,000 francs for it. And so, it will be for another time. I was to have left with Champfleury and Stevens but they are still undecided. . . . In short, they're a pain in the ass [the French is pithier — *enfin, ils m'emmerdent*]. Overlook this scarcely literary expression, since my letter is not intended for publication I can be relaxed. I am almost tempted to leave at once, perhaps the day after tomorrow,

as I am in a great hurry to see all those beautiful things and seek the counsel of Maestro Velázquez.

Your itinerary strikes me as excellent; I will follow it point by point, but I am told there is cholera in Marseilles, which will prevent me from returning by that route. . . .

Convey to Mme Astruc all our wishes for the safe arrival of your heir. *We would so much wish the same for ourselves* [emphasis added; *Nous voudrions bien qu'il nous en arrive autant*].

His closing line confirms that Suzanne and he had not succeeded in producing a child in the three years since their marriage. It is indeed curious that Suzanne had not borne another child in the thirteen years since Léon's birth. The sadness and envy expressed in Manet's wish that they might be as lucky as the Astrucs raises the question of cause. Had Suzanne miscarried over the years? Had Manet become sterile? Repeated cases of gonorrhea are still the most common cause of male sterility, and there is every reason to believe that Manet contracted more than one venereal disease. Long after his letter of 1865, by then gravely affected by syphilis, he wrote to Berthe Morisot that one of his doctors "seems to believe in an origin that might allow for some hope."[5] It may be inferred from this that gonorrhea, which can produce severe arthritis, was proposed as the less threatening cause of his symptoms — lancing leg pains — rather than the suspected last stage of syphilis.

By the end of August Manet left for Spain, unwilling to wait any longer for his indecisive travel companions. As he irritably wrote to Baudelaire after his return to France, "I had to leave alone after having waited for Stevens and Champfleury, two more individuals on whom I will not count in the future, not even to cross the Boulevard." His haste to leave, and the absence of a single letter to Suzanne during his trip, indicates his eagerness to get away not only from newspapers and Parisian acquaintances but from the family as well. Responding on September 5 to a letter from Baudelaire to Manet, which she had opened because it was marked "urgent," Suzanne told Baudelaire, "I still have no news from Edouard. This silence makes the time even longer for me."

The only letter Manet seems to have sent, at least the only one to have survived, was one to Fantin-Latour, probably penned two days after he reached Madrid. "I found in Madrid, the day of my arrival, a

Frenchman who is interested in art and who knew who I was. I am therefore not alone." His new companion was <u>Théodore Duret</u>, the cultivated twenty-seven-year-old heir to the family's cognac business who traveled regularly to Portugal and Spain. Soon after their meeting, Duret settled in Paris and became an art critic, publisher of a republican newspaper, one of Manet's closest friends, later his artistic executor, and one of his early biographers. "In 1865," Duret recalled, "one could say that to be in Spain was to find oneself outside of Europe. To get there meant undertaking a trip so complicated that few people ventured there. In Madrid it was fairly rare to meet foreigners."[6] This may be somewhat overstated, since French pilgrims, merchants, artists, and travelers, not to mention armies, had been crossing the Pyrenees since the Middle Ages. Gautier, writing about Madrid twenty years before Duret, commented, "Everybody speaks French to perfection, and thanks to a few elegant people who spend the winter in Paris and go backstage at the Opéra, the shyest ballerina novice, the most obscure boutique, are very well known in Madrid."[7]

However irreconcilable these two impressions, travel to Spain was surely arduous, safety was a problem, and food and wine often were not to the liking of foreigners. Spanish olive oil was more pungent than fragrant and, for those accustomed to a butter-based cuisine, or to the more delicate olive oils of southern France and central Italy, as offensive to the nose as to the palate. Wine at that time was transported in goatskin bags treated with resin, which left a taste enjoyed by few not used to it, as many tourists in Greece even today can testify. Astruc warned Manet about money changers, about wandering around alone at night except in Madrid, and about Spanish tobacco, which not even a Hispanophile like Astruc had ever learned to enjoy ("Take a supply of tobacco for your cigarettes"). He urged him to drink a lot of water ("Thirst is an illness there, but the waters are of a rare quality"), to order Manzanilla (a medium sherry) in the taverns, to travel second-class on the train, and to go to the Café Suisse in Madrid for good coffee, pastries, and lemonade.

In Madrid Manet stayed at the newly opened Grand Hotel de Paris, in the heart of the city. Duret, just back from Portugal, starved and broken after forty hours in a stagecoach, found the hotel a veritable paradise and the lunch a Lucullan feast. "The dining room was empty," he recalled almost forty years later, "only one other guest was seated at the large table, some distance away. He found the cooking

abominable, kept ordering other dishes which he then irritably rejected as inedible." Each time the irascible guest sent the waiter away, Duret called him back and indiscriminately devoured every morsel set before him. Suddenly the irate gentleman stormed over and unceremoniously addressed Duret: "Well then, Monsieur, is it to ridicule me, to make me look like an idiot [in the cruder French, *pour vous foutre de moi*] that you insist on finding this revolting food tasty, and bring the waiter back each time I send him away?" Duret's blank incomprehension calmed his aggressor, who then asked, "You know me no doubt, you know who I am?" Duret had no idea until they exchanged introductions, after which Manet realized that no malice had been intended and they finished the meal companionably. Duret explained Manet's paranoid outburst: "The thought of finding in Madrid a renewal of the persecutions he hoped to have left behind in Paris instantly exasperated him."[8]

For Manet the pleasure of Spain was limited to the visual. The ubiquitous presence of oil made most dishes unpalatable; he scarcely ate. "Here was a Parisian who, in the final analysis, was only happy in Paris," Duret comments. In October, after he returned home and recovered from some kind of dysentery — cholera was then making the rounds in Paris, and there had been outbreaks of the disease in France and Spain before he set out — Manet wrote to Duret: "I would very much enjoy seeing you again and recalling our adventures in Spain, but I will never grant, I warn you in advance, that we ate well in Toledo."[9] In Madrid they went together to the Prado, to a bullfight, and made an excursion to Toledo, a mere fifty miles away but a three-hour train trip with a change of trains. Before that, on his way to Madrid, Manet dutifully followed Astruc's instructions and visited Valladolid and Burgos.

After a week in Madrid, Manet had had enough. His enchantment with Velázquez, the mantillas that floated past him in the streets, and the excitement of the bullring was not enough to retain him, let alone sustain him. As he wrote to Baudelaire upon returning to France, "One may find in that country great pleasures for the eyes, but one's stomach is tortured. When one sits down to dine, one is more tempted to vomit than to eat." Astruc was disappointed that a bon vivant like Manet was so set in his tastes: "Edouard, Edouard! . . . And so the cuisine remains for you the dark side of this beautiful country that has no dark side."

Velásquez

It was Velázquez who gave Manet his greatest pleasure. "The entire trip is worth making just for the work of Velázquez," he wrote to Astruc on September 17 after rejoining his family. "He is the painter of painters; I was, however, not at all surprised; I found in him the realization of my ideal in painting; the sight of these masterworks gave me great hope and great confidence. I was not at all satisfied by Ribera and Murillo. They are decidedly painters of the second rank. . . . Two others, after the Master, captivated me: Greco, who is bizarre . . . and Goya, whose masterpiece, in my view, is at the Academy (The Duchess of Alba, what an entrancing fantasy)." He was referring to *The Clothed Maja; The Naked Maja* was kept out of sight and shown only by special permission. Since he never made contact with Astruc's painter friend whom he was to have found at the Café Suisse, he did not get to see the Spanish forerunner of his *Olympia* or the fabled collection of Goyas and eighteenth-century French painters belonging to the duke of Osuna.

Replying to Baudelaire's "urgent" letter the day after his return, on September 14, Manet repeated his conviction that Velázquez was the greatest of all painters: "I saw in Madrid some thirty or forty [of his] portraits or paintings, all of them masterpieces; he is greater than his reputation and he alone is worth the exhaustion and the unavoidable discomforts of a trip to Spain. I saw very interesting things by Goya, among them a portrait of the Duchess of Alba in the costume of a majo that has incredible charm." He was dazzled by the corrida — "one of the most beautiful, most unusual, and most terrifying spectacles to be seen" — and announced his intention to put on canvas its "brilliant, shimmering, and at the same time dramatic qualities."

Baudelaire's reason for writing to Manet at that time had to do with his chronic need for money. He asked Manet to buy the portrait Courbet had done of him, which Manet regretfully said he could not afford. Instead, he proposed their common friend, Commander Hippolyte Lejosne. A staff officer of the army for the defense of Paris, Lejosne and his wife, Valentine, often entertained Delacroix, Barbey d'Aurevilly, and the younger generation of artists and writers, among them Baudelaire and Manet. Two weeks after Manet's refusal to buy the Courbet, Baudelaire wrote to Lejosne asking for a loan of five hundred or six hundred francs, which Lejosne declined to give him. Baudelaire often made pressing requests of his friends. In July 1865 he had borrowed five hundred francs from Manet to repay part of a

five-thousand-franc debt to his publisher, Poulet-Malassis, although he had not yet repaid the thousand francs he had borrowed in January 1863. The closing lines of Manet's reply to Baudelaire, who was still in Brussels with no end in sight to his residence in a hated city, have the ring of a mild reprisal for Baudelaire's advice the preceding May: "Adieu my dear Baudelaire, warmest greetings and believe me, your affairs will only be well handled by yourself, do not count on others, nothing good can come to you so long as you stay in that awful country [*ce sacré pays*]."

Six months later Baudelaire would collapse after a stroke left him paralyzed and before long unable to speak. After his death in 1867 Manet gracefully wrote to Baudelaire's notary, "When everyone has ceased making claims and if something is left, I ask you to think of me."[10] It took three letters and two years before he was finally repaid his 1,500 francs.

Manet's most expansive account of his stay in Madrid was the one he sent to Fantin-Latour telling him "what a joy it would have been for you to see this Velázquez," none of whose great contemporaries, exhibited in the same museum, could hold a candle to him. Even Titian's portrait of Charles V seemed "wooden" when compared with Velázquez. Manet now recognized the difference between the works attributed to Velázquez in the Louvre and the authentic ones. In his view the most astounding piece among all of Velázquez's works "and perhaps the most astounding piece of painting ever done" was the portrait of an actor who was famous during the reign of Philip IV: "the background disappears, it is air that surrounds this fellow dressed entirely in black yet vibrant." This is *Pablo de Valladolid*, both the title of the painting and the name of the subject, whose stance and extended right arm immediately suggest a theatrical pose, as does his direct gaze at the viewer. Dating from the 1630s, this work, regarded by many art historians as a forerunner of modern painting, unquestionably exerted the greatest influence on the second phase of Manet's career, which began after his return from Spain.

Even if Manet had already begun his portrait of the actor Philibert Rouvière before leaving for Spain, as Tabarant argues convincingly,[11] it is documented that it was still unfinished when Rouvière died on October 19, 1865. In fact Manet called in his two best friends to stand in for the subject — Antonin Proust for the hands and Paul Roudier for the legs — since he did not believe in painting figures

from memory. There was, therefore, ample time for the finished work to reflect Manet's exposure to Velázquez's actor. The handling of the blacks alone is worthy of "the Master," and the shadow of the legs recalls *Pablo de Valladolid,* as does the absence of a clearly defined plane. But instead of air surrounding the figure, as he described Velázquez's figure, Manet has indicated that we are seeing Rouvière onstage, the light coming from the footlights. And Rouvière has his own individual character (he was a trained painter himself, a pupil of Gros's, who left his brushes for the stage). This actor is more histrionic than his Spanish model, and his pose is more reflective than Pablo's declamatory one, as is fitting for the role of Hamlet, Rouvière's greatest triumph. That Manet chose to title the work *The Tragic Actor* (Fig. 20) rather than use the actor's name, as Velázquez did, suggests a bit of serious wordplay. For not only was this an actor of tragic roles, but the actor himself became the tragic protagonist of his own untimely death.

In a letter written in March 1866, Manet explained the title to Baudelaire, who had published an article on Rouvière in 1859. Because Rouvière was so famous, an anonymous title was a way of avoiding any carping about the likeness. If indeed Manet had a grander vision than a lifelike portrait, it would have been out of character for him to announce so grandiose a purpose. But this kind of ironic playfulness, this concern with the larger picture — though few have been willing to grant him that — are so characteristic of Manet that his intention deserves examination.

The title he chose was *The Tragic Actor,* not *A Portrait of Philibert Rouvière* or *Rouvière As Hamlet.* Just as his *Dead Toreador* (Fig. 23) is anonymous — representing the likely death of any matador and the ultimate meaninglessness of even so courageous a calling as that of bullfighter — so *The Tragic Actor,* in his twin role of Shakespearean hero and dead actor, recalls the lines from *Macbeth:* "Life's but a walking shadow, a poor player, / That struts and frets his hour upon the stage, / And then is heard no more. It is a tale / Told by an idiot, full of sound and fury, / Signifying nothing." In the preceding three decades Shakespeare had been widely read and often performed on the French stage. To quote from or allude to Shakespeare immediately endowed a work with an aura of universality. Long before Manet knew how brief his own life would be, he had recognized the emptiness of so many of our attempts to endow the evanescent with perma-

nence. The only thing that endures, he seems to have discovered early, is what the artist leaves behind; that is the only reality. *Manet et manebit,* he remains and will remain, through his work.

Manet's truncated, indigestible trip to Spain appears to have restored his vitality and led him toward "the full maturity of his art."[12] In the remaining months of 1865 he produced a dozen works, some of them masterpieces, all of them touched by what he had seen in Spain. *Monk Praying,* mentioned earlier, combines Spanish and Dutch painting in its evocation of Zurbarán, Hals, Rembrandt, and Goya; *Angelina,* or *Woman at the Window,* is strongly reminiscent of Goya; the three philosopher-beggars recall Velázquez and Ribera; the three corrida scenes capture the tension of Manet's personal experience of the arena as he related it in his letter to Astruc: "The Prado [the tree-lined Paseo del Prado] with all its mantillas pleased me enormously, but the unique spectacle is the bullfight. I saw a superb one and plan on my return to Paris to put on canvas the fast-moving aspect of that variegated assembly of figures without overlooking the dramatic part, picadors and horses overturned and plowed by the horns of the bull, and the army of chulos trying to distract the furious animal." Manet's fascination with the dynamism of movement in the bullring — unusual for him since most of his subjects are static — was to be revived in his remarkable studies of the racecourse, particularly *Race at Longchamp,* in which the viewer seems to be on the turf in front of the galloping thoroughbreds. A curious painting from this period shows a young woman reading, with a painting on the wall beside her; it is Manet's *Dead Toreador,* another case of Manet quoting himself, as he would again in his portrait of Emile Zola.

In February 1866, as Zola was about to move into the Batignolles district, Antoine Guillemet, a young landscapist and member of the Batignolles circle, took him to the Café Guerbois, where he met Manet. Zola was then twenty-six and writing a column for a newspaper that had originally been founded by Paul Meurice, a playwright and coadapter of the *Hamlet* performed by Rouvière, and a friend of Manet's and Baudelaire's. Zola was immediately charmed by Manet, whose paintings had been so vilified over the preceding three years.

Born in Paris in 1840, Zola grew up in Aix, where his father, a Venetian engineer, relocated the family when Emile was three. He and Paul Cézanne met as schoolboys and remained friends for the next forty years. Having failed the *baccalauréat,* which was essential

for the pursuit of any professional career, Zola left with his mother, widowed since 1841, and went to Paris in 1857 in search of work. He eventually found employment as a clerk in a publishing house and four years later made his debut as a journalist by covering the Salon of 1866, under the pseudonym of Claude, a name so intimately associated with art in his mind that twenty years later he would bestow it on the painter-hero of his novel about art and artists, *L'Oeuvre*. Zola's familiarity with painting began early and at close range thanks to his friendship with Cézanne. Later, Zola became a frequent visitor to Manet's studio on the rue Guyot, where he watched Manet at work and listened to him talk about painting.

The jury for the Salon of 1866 included Cabanel, Gérome, Meissonier, Corot, Robert-Fleury, Daubigny, and Breton — all successful painters and previous jurors — seconded by the critics Théophile Gautier, Charles Blanc, and Paul de Saint-Victor. Whatever the differences between them, they were unanimous in their decision to bar Manet. They wanted no more of the previous year's hoopla over *Olympia*. They wanted no more causes célèbres. Ironically, Manet's submissions in 1866 were the least controversial he had ever made. Writing to Baudelaire, he announced, "I have sent two paintings to the exhibition; I plan to have photographs taken of them and send them to you: a portrait of Rouvière in the role of Hamlet . . . and a fifer in the Light Infantry Guard — but they must be seen to be judged fairly."[13]

Despite the anonymous title of *The Tragic Actor*, Manet had no doubt that everyone would recognize the celebrated actor — an unimpeachable subject for a Salon submission. And *The Fifer*, now generally recognized as one of Manet's greatest works, also could not be faulted as an unacceptable subject (Fig. 21). The expression on the boy's face and the nebulous luminosity behind him make this one of the most striking paintings ever produced. Manet, in fact, accomplished in *The Fifer* what he most admired in Velázquez's *Pablo de Valladolid*: "the background disappears" and "it is air that surrounds" this young boy, like a sacred figure in a Byzantine icon, out of time or place. Manet made no attempt to suggest perspective; only the short shadows behind the boy's heels indicate a source of light and depth. Françoise Cachin sees this as "a work in which, more than any other, Japan and Manet's Spain are merged."[14] Zola, probably primed by Manet, countered the prevailing objections to the flatness

of Manet's figures: "It would be more to the point to compare this simplified painting to Japanese prints, which are similar in their strange elegance and splendid areas of color."[15]

The model for the figure in *The Fifer* has been identified as a boy trooper in the Imperial Guard, brought to Manet's studio by Commander Lejosne. But the face of the boy is strikingly similar to Léon Leenhoff's if one compares it to Léon's portrait of 1868 in *The Luncheon* (Fig. 33): the same ear standing away from the head, broad nose, and flared, fleshy nostrils. The eyes of the fifer are dark, whereas in *The Luncheon* Léon's eyes seem to be fair. But in another painting for which Léon posed in 1867, *Boy Blowing Soap Bubbles*, the eyes are similarly dark, and this time the left ear sticks out. Photographs of a hatless Manet and a drawing of him by Degas in 1864 all show a prominent ear (particularly in the full-length seated pose by Degas, where the right ear is shaped very much like that of the fifer's).

The identity of the fifer becomes important in connection with Manet's other paintings of young boys. The trooper who first posed for Manet could have provided facial contours as well as the overall lines of the figure. Given Manet's speed, he could have had him in one or two sittings. The boy was probably not as available a model as Manet required, and in any case the painting was not intended as a portrait of that particular boy. It is, therefore, possible that Léon modeled for the details of the face, just as Manet's friends posed for the missing parts of Rouvière's portrait and later for the many figures in *Ball at the Opéra*. Was it Léon's presence that gave the final figure its poignancy?

However lukewarm Manet's remarks about Goya in his letters from Spain, there is little doubt that *The Third of May* left an indelible impression. He may have seen it in the Prado and remembered it two years later when he began his *Execution of Maximilian*. He also is certain to have seen, perhaps in Paris even before he went to Spain, Goya's *Disasters of War*, which had been published in 1863. Goya's technique of suggesting rather than depicting "the violence of the physical movements, reserving detail for that which contributes to the iconographical meaning of the scene,"[16] must have struck Manet at the time. Goya's romanticism, however, was not Manet's approach to a subject. But a genre subject, a fifer, elevated to the grandeur of a portrait, and in the dimensions of a Salon painting, implies a signifi-

cance beyond the virtuosity of the painting, although in itself that is enough to make it important.

A mere child, this fifer was already trained to lead troops into battle and to raise their spirits, often a nameless sacrifice to the glory of the fatherland. It would have been easy enough to transform this subject into a jingoistic, heroic image. Instead Manet presents us with a sad, thoughtful expression, detached from any context as though to suggest that the uniform is meaningless, as meaningless as the dead matador's suit of lights. Disguised here again, Léon dourly peers out of his uniform. Like the fifer, he too is anonymous, he too plays the tune he has been taught — in this instance, the false tune of his identity.

Paul Jamot, director of the French national museums in the 1920s and one of Manet's more sensitive critics, noticed a kinship among the numerous paintings of young boys: "Manet's interest in the somewhat rude innocence of masculine childhood is a noteworthy trait in a century almost exclusively focused on feminine attractions. *The Boy with Cherries, The Boy with a Sword, Boy Blowing Soap Bubbles, The Fifer,* the boy with the straw hat in *The Luncheon,* form a poetic and accurate cycle of boyhood: nothing similar can be found elsewhere in the nineteenth century."[17]

What Jamot failed to notice, or chose not to comment on, is that all the paintings he mentioned, except *Boy with Cherries,* had the same model — Léon (Fig. 6). The dozen paintings in which Léon appears chronicle his boyhood from eight to nineteen, childhood to adolescence, after which time he virtually disappeared from Manet's canvases. From *Spanish Cavaliers and Boy with Tray* of 1859 to *Boy Blowing Soap Bubbles* of 1867, Léon is either disguised or generic. *Spanish Cavaliers and Boy with Tray* is a noteworthy example of Manet's focus on Léon. The figure of the boy reappears in a watercolor, an etching, and, barely distinguishable, in the background of *The Balcony* of 1868. Even the title of the painting begs the question: why mention so insignificant a figure as a serving boy, let alone repeatedly reproduce him?

Although Jamot makes no reference to Léon, he was struck by the element of disguise in *The Fifer:* "[Manet] lends an unforgettable grace, both bizarre and naive, to this *gamin* disguised as a warrior, planted on his feet in oversized shoes and white spats."[18] This "cycle of boyhood" is no chance interest. It appears rather to be a thematic

Manet's hidden son, Léon

preoccupation and a personal one, and the word *gamin* serves as a keystone to that theme, since it can denote a child left to fend for himself. Though not literally abandoned, Léon was denied his birthright at the same time that Manet was denied his fatherhood. Instead of developing into a cultivated upper-class Parisian like his "godfather," we see him in this cycle of boyhood growing into an unpolished adolescent, rudimentarily educated, a bank runner at fifteen.

Manet's denial of Léon's true identity is made graphic by the use of costume. He is always presented as someone other than himself; if not disguised, he is an extra, as in *View of the International Exposition* of 1867. On the one hand, he can be seen as a studio prop transformed into the artist's creation, which implies a symbolic paternity. On the other, he appears to be a thematic compulsion that has to be camouflaged. Even his modern dress in *The Luncheon* of 1868 loses its actuality in the fanciful setting.

Almost every image of Léon projects some aspect of his sorry condition. He is seen seated all alone on a riverbank while the well-dressed couple across the water turns away from him, denying his presence (*La Pêche*), carrying a tray as a servant (*Spanish Cavaliers*), bearing someone else's heavy sword (*Boy with a Sword*), piping a soundless tune (*The Fifer*), blowing the bubbles of fruitless dreams (*Boy Blowing Soap Bubbles*), disengaged from the complex domestic scene behind him (*The Luncheon*), hidden in the background (*The Balcony* and *La Lecture*), and standing alone on a balcony (*Oloron-Sainte-Marie*). The solitude of these figures endows them with an emotional power that transcends their purely technical brilliance.

By the time of the 1866 Salon, Zola was ready to make his mark on the reading public of Paris. He had left the publishing house of Hachette, where he had risen from shipping clerk to head of publicity. The polemical urge that was to reach its apogee over the Dreyfus case in 1898, in *J'Accuse,* was already present in his defense of Manet following the jury's rejection of Manet's two submissions. Manet was not alone; so many others were rejected that artists and critics were militating for another Salon des Refusés. The news of one painter's suicide over his exclusion cast a pall on the opening of the Salon and gave Zola a weapon for his assault on the jurors.

A painter from Strasbourg, Jules Holtzapfel, who had exhibited in previous Salons, was found sprawled on his bed, the suicide pistol in his hand. His note left no doubt as to his motive: "The members of

the jury have rejected me. I therefore have no talent. . . . I must die!"
The circumstances and setting of this event, which took place in April
1866 and are described by Zola in a preface to his Salon articles, are
strikingly similar to the scene depicted by Manet in a painting titled
Suicide, variously dated 1875, 1877, and 1881. Given its unusual sub-
ject, it seems more likely that Manet would have painted it close to
the event, when everybody was talking about Holtzapfel's tragic end
and the newspapers were denouncing members of the jury as assas-
sins. Holtzapfel's despair could not have failed to arouse Manet's
compassion at a time when he suffered the same treatment by the
same jury.

Zola, not yet acquainted with Manet at the time, had immediately
recognized in *Le Déjeuner sur l'herbe,* shown in the Salon des Refusés
of 1863, and *Olympia,* in the Salon of 1865, that Manet was alone in
the vanguard of his art, that a painting by Manet *"crève le mur,"*
breaks through the wall, as he put it. In the first of the seven articles
he published in *L'Evénement* on the Salon of 1866, he began by de-
molishing the jury, shooting down each of the twenty-eight members
like so many clay pigeons with his irony and ridicule:

> Théophile Gautier, who sets off such pretty fireworks in *Le Moni-
> teur* [a Parisian daily] in honor of the paintings he has been given,
> evidently does not remember 1830 when he wore a red vest.* . . .
> M. Gérome, a cunning and able juror, anticipating the deplorable
> task ahead, fled to Spain the day before the jury met and returned in
> time for the closing session. . . . M. Cabanel is so busy keeping his
> laurels from slipping that he does not have the time to be mali-
> cious. . . . M. Meissonier . . . the reigning painter of Lilliput . . .
> missed almost all the meetings. I have been told, however, that [he]
> did participate in the decision regarding artists whose names begin
> with M. . . . M. Breton . . . a militant young painter, is said to have
> exclaimed on seeing the paintings of M. Manet, *If we accept that
> we are lost.* . . . M. Robert-Fleury, very much opposed to any inno-

*In defense of Victor Hugo, attacked by royalists and literary conservatives,
the younger generation of writers, Gautier and Gérard de Nerval among
them, staged a demonstration in the Théâtre Français on the opening night of
Hernani, February 25, 1830. They manifested their radicalism as much by
their red vests and long hair as by their noise.

vative movement, served as a juror . . . but his rightful place during the past month was in Rome where he has been named director of our school [the prestigious Ecole de Rome, the Mecca of young academic painters]. To think that M. Gérome had no excuse and left, where M. Robert-Fleury had an excuse and stayed! . . . M. Théodore Rousseau, rejected for ten years, now renders an eye for an eye. . . . M. Dubufe, who paints portraits with makeup and chalk, joined the chorus with MM. Breton and Brion. He almost fainted at the sight of *The Fifer* by M. Manet and pronounced these ominous words: *So long as I am a member of this jury I will not accept such paintings.*[19]

When Zola later reprinted his articles in book form, he prudently excised the entire passage on the jury. Three decades later, writing about his contemporaries, Breton continued to assert that Manet's influence, regrettably widespread, "led to the facile painting of mere sketches, a kind of painting accessible to innumerable amateurs who proliferated their daubings all over the place to the detriment of the art of true artists."[20]

For all of his twenty-six years and fledgling status, Zola took on the establishment with flying invective. If he was intrepid in shaming the jurors, defending the right of innovative artists to be exhibited, and condemning the philistinism of the average Salon-goer, he was at the same time cannily aware of stamping his name on the public consciousness. Always adept at self-promotion, Zola began his career with a bang. Many of his views were remarkably prescient, heralding the kind of art that was to come long after him, as when he wrote (on May 4, 1866), "The public sees in a painting a subject that takes it by the emotions and asks no more of the artist than a tear or a smile. For me — for many others, I would hope — a work of art is, on the contrary, a personality, an individuality. What I ask of the artist is not to give me sweet visions or horrific nightmares; it is to reveal himself, body and soul, to assert forcefully a powerful and personal point of view."[21] From a modern perspective, this would seem indisputable. It was the perfect credo for a defender of Manet. But the ideas that consolidated into Zola's artistic philosophy for his own fiction lost their relevance to Manet's art. The two men's paths may have started with Courbet and naturalism, but Manet's more meandering itinerary

soon veered away from Zola's route to realism. A decade later Zola would register his disappointment.

On May 7, ten days after his first article on the jury, Zola published a long piece entirely devoted to Manet.[22] It began with a call to order to his countrymen: "Although we like to laugh in France, we do have, when needed, exquisite manners and perfect tact. We respect the persecuted, we defend with all our might the cause of men who fight alone against the mob. I come today to offer a compassionate hand to an artist who was kept out of the Salon by a group of his colleagues." He minces no words about the outrage done to an artist whose works were not found worthy of appearing among the two thousand "incompetents" (the French is much stronger, *impuissants,* here used as a sexual metaphor to imply artistic impotence) who were received with open arms. Zola offers his highest praise in an apostrophe to Manet: "Be consoled. You have been set apart and you deserve to be apart. You do not think like all those people . . . yours is a personality that asserts itself. Your paintings are ill at ease among today's froth and sentimentality. Stay in your studio. That is where I will come to look for you and admire you." The public at large, Zola adds, assumed that Manet was out to make an impression even at the cost of appearing to be grotesque. But it is rather the public and the banal works they admired that deserved derision: "Here are people who laugh out loud without knowing why. . . . They laugh the way a humpback would laugh at another man because he has no hump."

Zola, who admits having visited Manet's studio only once at that time, claims he "understood M. Manet completely." This overconfidence was not lost on Manet, who, with a subtlety alien to Zola, responded in his portrait of Zola begun late the following year. Zola was impressed by Manet's modesty and gentleness, his energy and intelligence, and, above all else, by his strength: "I was in the presence of a committed fighter, an unpopular man who did not tremble before the crowd . . . but tried instead to tame it, to impose his personality on it." Heaping sarcasm on sarcasm, he recognized that Manet had offended public and professional taste by not painting "with M. Cabanel's powder puff" or like others whose *"images à un sou"* — the equivalent of calendar art — hung prominently on the walls of the Salon. *Olympia,* he notes, "has the grave defect of resembling many other damsels known to the public" — a little barb to remind profes-

sional and lay critics, all men of course, that their outrage was born of familiarity rather than modesty. As for "that masterpiece, *Le Déjeuner sur l'herbe*," it has figures from everyday life that can be faulted for "having muscles and bones, like the rest of us." His favorite work remained *The Fifer:* "I said earlier that M. Manet's talent consists of accuracy and simplicity, remembering above all the impression that painting made on me."

Zola declared that Manet's place was in the Louvre. So convinced was he of Manet's future celebrity that had he possessed the means, he says, he would have bought all of Manet's works: "In fifty years they will be worth fifteen and twenty times more, at which time certain pictures now commanding 40,000 francs will not be worth forty." The remark suggests business acumen rather than the passion of a collector. Fearing that he would be treated with the same contempt as the painter, and accused of mistaking ugliness for originality, he insisted that one day they would both be avenged; one day Manet would "crush the pusillanimous mediocrities who surround him." At the time, Zola claimed to have no ideology; he cared as little about realism as about nationalism: "I don't give a hoot about realism, in the sense that this word has no precise meaning for me . . . there is no doubt whatever that all artists must be realists. . . . I don't give a hoot about the French school! I personally have no tradition." But others saw him as the proselytizer of a new religion, the painting of the future, because he praised Manet. He was not interested, he said, in fostering a new ideology that others would carry on, for "each genius is born independent and leaves no disciples." This would vindicate Manet from the frequent charge that he had no followers.

Having been accepted three times before and having won an honorable mention, Manet was deeply wounded to be cast out of the Salon like a second-rate beginner. Support, albeit from a novice, a voice without real power despite its feistiness, was a much-needed tonic. *L'Evénement* had a sizable readership, so much so that its influential publisher, Hippolyte de Villemessant, while prepared to grant Zola a forum for his minority opinion, decided to let another reviewer from the other side share the columns devoted to the contested Salon of 1866. On the same day that Zola's article on Manet appeared, May 7, Manet penned a heartfelt note of thanks:

Dear Monsieur Zola,

I do not know where to find you in order to shake your hand and tell you how happy and proud I am to be defended by a man of your talent; what a splendid article! A thousand thanks.

Your earlier article [May 4, "*Le moment artistique*"] was outstanding and left a deep impression. I would like to talk with you. Where can I meet you? If it suits you, I am at the Café de Bade every day from 5:30 to 7.

In the hope of seeing you soon, I ask you to accept the assurance of my warmest feelings and to believe me your much obliged and grateful

Ed. Manet[23]

Eight months later Zola published another piece on Manet, this one a monograph of nearly sixty thousand words[24] inspired by a visit to Manet's studio, where he saw the paintings Manet planned to send to the Universal Exposition later that year. In this Zola explicates not only Manet's personality and technique but also theories of Manet's art, which is to say Zola's own theories of art in general. When he wrote, "The role of those of us who judge works of art is limited to ascertaining the language of personalities, to studying those languages. . . . I only want to analyze concrete things [*je ne veux analyser que des faits*], and works of art are simply concrete things,"[25] he was already formulating the guiding principle of his first important novel, *Thérèse Raquin*, which centers on a would-be painter, his portrait of the man he murders, and his affair with the victim's wife. Some have seen the way Zola describes the title figure as painterly, reflecting Manet's style of rendering a face.

In his preface to the novel, Zola says that he wanted "to study personality and not character. . . . I chose characters . . . bereft of free will, swept into each action of their life by the necessity of their flesh."[26] Zola saw Manet much as he did his characters: "The artist lets himself be guided by his eyes which perceive the subject in broad strokes of color that dictate one another."[27] A head against a wall is no more than a splash of pale color against a darker tone. In Zola's eyes those were the realities of art and all there was to it. Apparently forgetting his earlier summons to the artist to assert "a personal point

of view," Zola banished emotions, thoughts, and memories from the work of the artist; only an artist's eye determines his art as it captures unmediated phenomena from the everyday world. Zola was so sure of his judgment that he inserted a completely gratuitous disclaimer:

> And I take advantage of this occasion to protest against the relationship that some have tried to establish between the paintings of Edouard Manet and the poetry of Charles Baudelaire. I know that strong affinities brought the poet and the painter together, but I think I can affirm that the painter — unlike so many others — has never had the foolishness of wanting to insert ideas into his painting. The brief analysis I have just made of his talent proves with what ingenuousness he confronts nature; if he assembles a number of objects or figures, he is entirely guided in his choice by the wish to achieve lovely splashes of color [de belles taches], lovely contrasts. It is ridiculous to want to make a mystical dreamer out of an artist with a personality like his.[28]

The authority of Zola's views remained undisputed for decades. Did Manet not write him letters of gratitude? If Manet did not evolve into a bona fide impressionist, he was certainly pegged as a proto-tachist for more than a century. Zola placed Manet at the forefront of a new movement that broke radically with the past, completing the gradual divorce that had been taking place since Delacroix. The Barbizon group of landscape painters had been instrumental in banishing mythological and historical scenes from nineteenth-century painting. Their canvases portrayed actual forests and rivers that required no nymph or goddess to lend them academic validity. The natural, the real, even if not beautiful, replaced idealized beauty. For Zola, Manet was the hero who slew the anecdote; painting no longer had a story to tell; it was merely a rectangle of canvas with colors and forms, a network of relationships determined solely by the artist's eye and temperament, even if the result was a coherent picture. The painting no longer had any function, meaning, or content beyond its material surface.

Zola was no more curious about the possible meaning of a painting than he was about the complexities of his protagonists' personalities; both served to define his theoretical principles. Zola's strictly formalist view would determine the critical optic on Manet's art for

more than a century. It also may have accounted for the limbo in which Manet remained since he did not fit the prevailing categories; he was neither an academic nor an impressionist, neither a realist nor a symbolist. Was he the last romantic or the first modernist? Zola never saw that Manet was both. He may have been incapable of accepting the very nature of Manet's (and Baudelaire's) modernism: its amalgam of romanticism and realism, of such contradictory elements as elegance and crudeness, artificiality and candor, quotidian subjects and traditional resonances. Where Zola failed most lamentably as Manet's self-styled first public defender was in not seeing the unique quality in Manet that some call poetry and that distinguishes the artist from the craftsman, that magical ability to capture the emotions and memories of a split second or an entire past — personal, social, and cultural — in images.

Given the dearth of supporters among art critics, Manet was hardly in a position to quibble. Far better the laudatory articles of a Zola, however shortsighted, than the vicious attacks of the backward-looking Salon jurors and reviewers. Moreover, when Zola's monograph appeared, Manet had received the crushing news that he had once again been rejected by the jury of the Salon that was to take place simultaneously with the Universal Exposition. This rejection was even more insulting than previous ones, since the initial selection was to be made merely on the basis of the titles of the works and their dimensions, which had to be submitted by each artist before December 15, 1866. Manet's exclusion from the Salon explains the bold decision he announced to Zola on January 2, 1867, the day after Zola's monograph had appeared.

My dear Zola,

That is a marvelous New Year's gift you have given me; your remarkable article is very gratifying to me. It arrived at the right time, for I have been judged unworthy of benefiting, like so many others, from the advantages of submitting by list. And so, since I can expect nothing good from our judges, I shall make sure not to send them my paintings. They would only have to play me the dirty trick of accepting one or two and as far as the public is concerned, the rest can be thrown to the dogs.

I am of a mind to hold a private showing. I have at least forty pictures I can show. I have already been offered a very well-placed

lot near the Champ de Mars [on which he planned to build a temporary pavilion]. I am going to place a bet and, with the support of men like you, I will count on winning.

Everybody in my family is delighted with the article and asks me to thank you.

What Manet may have said privately about Zola's analysis has not been reported, but what he thought can be gleaned from his portrait of Zola, begun in November 1867, the same month *Thérèse Raquin* was first published and the same year the monograph appeared. Despite the many sittings for this portrait, first in Manet's studio and then in Zola's study, it might just as well have been painted from a photograph (Fig. 41). Unlike Manet's portraits of Zacharie Astruc (1866) and Théodore Duret (1868, Fig. 42), both of which focus our attention on the personality of the subject and his personal ambience, the portrait of Zola, as Odilon Redon observed, "is more like a still life than the representation of a human being."[29] Before Redon, Castagnary had written in his review of the portrait, "The accessories, table, books, pictures, everything that is still life is treated masterfully. The principal figure is less felicitous . . . looking like a profile pasted on a background."[30] This is hardly accidental. There is little if anything in the painting that is not functional, including Zola's vacant gaze and expressionless features. Just as Zola used Manet to expound his personal theory of art, so Manet used Zola to create his own artistic self-portrait and to inject an ironic criticism of his subject's myopia. Zola holds in his hands a major work of the mid-nineteenth century, Charles Blanc's *Histoire des peintres de toutes les écoles*, which, beginning in 1849, had been acquainting everyone seriously interested in painting with the works of the Dutch, Flemish, Venetian, and Spanish schools. For Manet, who kept volumes of Blanc's book in his studio, it was a virtual Bible. By 1868 (Zola's portrait was completed the year before), all but the Spanish school had been reprinted in this magnum opus that would comprise fourteen volumes. Zola seems as indifferent to the book as he is to the images on the wall, each of them intimately associated with Manet: Velázquez's *Los Borrachos*, a Japanese woodcut of a sumo wrestler — both significant influences on Manet's art — and *Olympia*, Manet's masterpiece, in Zola's opinion.

Was Manet hinting that Zola's knowledge of painting was purely

bookish, that he read and wrote about it but did not really see the whole work? Olympia's altered gaze, falling here on Zola instead of the viewer, seems more of a mocking glance than an expression of gratitude. Had Zola not reduced this painting, while hailing it as a masterpiece, to the mere fulfillment of the artist's wish to paint some flesh? As for the Japanese woodcut and screen, both reflect the enormous interest in Japanese art that reached its peak at the Universal Exposition of 1867 (the Japanese pavilion received the largest number of visitors). In artistic circles at the time, Japanese art was associated with such modern techniques of painting as Manet's black outlines, with stylized representation rather than the three-dimensional illusion of conventional painting and with figures from daily life.

Finally, Manet's name appears clearly on Zola's monograph — a clever way of signing his painting. But much more telling is the absence of Zola's name, which Manet could have made just as legible had he wanted to give equal billing to the author. The figure of Zola, though a good likeness, is one more object — the books, the inkwell and quill, the screen, the studded tapestry chair — in this allegorical still life. Jamot is quite right when he points out that "Manet clearly had the intention of composing the background of his painting with elements endowed with a psychological and moral as well as pictorial significance and to make of this a kind of interior landscape."[31] What is projected here is less the "interior landscape" of the writer, proposed by Jamot, than that of the artist. Unlike most of Manet's friends, Zola was not a man of visual needs. Even when Zola had the means — he had a very successful career — the only painting that adorned his walls was Manet's portrait of him, and that was "relegated to a vestibule."[32] In her catalogue entry Françoise Cachin hits on the true tone of the painting: "This carefully staged portrait does have a quality of constraint, *reflecting a relative and circumstantial intimacy* [emphasis added], and perhaps some slight reserve on the part of Manet, who did not necessarily see their respective artistic causes allied in the same struggle, as Zola proclaimed them to be."[33]

It hardly matters whether the portrait resembles Zola or not. What it reveals about him is his flatness. In this painting Manet perpetrated one of his cleverest tricks. Zola had praised Manet effusively and made Manet the standard-bearer of his own ideas of realism in art, but he had not understood what Manet was doing. Manet repaid him by painting his portrait, making him pose for thirty-six sittings and

then producing a work that amounts to an allegorical portrait of the painter, not the subject. Manet's gratitude was nonetheless sincere, and their correspondence proves that Manet not only accepted Zola's support but also read his works appreciatively: "I have just finished *Thérèse Raquin* and send you all my compliments. It is a very well-written novel and very interesting." A year later, on the publication of a new novel serialized in *L'Evénement,* Manet wrote, "My dear friend, I am deep into *Madeleine Férat* and do not want to wait to finish it before sending you my compliments. The way you paint the red-headed woman makes one jealous, and your description of the love scenes could deflower a virgin." The novel was dedicated to Manet, but he made no mention of the tribute. Over the years he was similarly enthusiastic about *L'Assommoir,* which he termed *"épatant!"* (great), and *Pot-bouille:* "It's astounding. I wonder if it isn't the most powerful of them all."

Their relationship continued to the end of Manet's life, and Manet's letters were always cordial, though not without reservation. In the case of Zola's proposal to sell his monograph at Manet's private show in May 1867, two letters reveal Manet's tact, deft circumlocution, and sound judgment: "My dear Zola, I confess that it could only be pleasing to me to see your pamphlet about me sold at my exhibition. I would even wish that many copies were sold, which could happen, and after all nothing ventured nothing gained." The rest of the letter continues in the conditional. But the letter that followed expresses his true feelings: "My dear friend, On second thought, I believe it would be in bad taste and would pointlessly use up our means to reissue and sell at my show so extravagant an encomium of myself. I still have too much need for your friendship and your valiant pen not to use them most discriminatingly where the public is concerned. It could be that I will be violently attacked; might it not be better to do something in that event and reserve your strengths for that?"

May 1867 was indeed an event — for Paris, for Manet, and for the entire art world.

10.

"The Family, Beware
of the Family!"

The art exhibit of the Universal Exposition of 1867, like that
of 1855, was not organized to project the future of French art
but to reflect the stars of its immediate past: Meissonier, Gérome,
Bouguereau, Breton, Rousseau, Daubigny — members of the very
Salon jury Zola had ridiculed the year before. In 1867 the jury for the
exhibit at the Universal Exposition, composed of these same painters
and others of the same generation, reserved for itself more than half
of the available seven hundred places on the grounds that the purpose
of the exhibit was to provide a retrospective view of French art since
the last Universal Exposition, in 1855. It was the function of the
Salon, to be held concurrently but on another site, to show the works
of the younger artists. However, of the 3,000 submissions to the
Salon, 2,000 were refused, a rigor paralleled by the jury for the expo-
sition's exhibit, which accepted only 550 works, whereas twelve years
earlier 1,872 had been admitted.

Courbet sent four paintings to the exposition, all of them accepted,
which ensured his place in the pantheon of anointed painters, but he
nonetheless set up a private exhibition, as he had in 1855, "to receive
all the foreigners who will come to Paris, and to show all the works
that I own and that other collectors will be willing to lend me."[1] In all
he showed 135 paintings, although by then he had produced more
than 600. The private pavilion at the Pont de l'Alma, on which he
spent fifty thousand francs, was, in his own words, "a cathedral on
the most beautiful spot in Europe . . . on the banks of the Seine and in
the heart of Paris. . . . I have astounded the whole world. . . . All of

European painting is on display in Paris at this moment. I triumph not only over the moderns but over the old masters as well."[2] This throwaway remark about "moderns" may refer to Manet, not only the front-runner of the day but also a fellow exhibitor at the Pont de l'Alma.

Manet also had a pavilion constructed at his own expense where he showed fifty paintings, representing a third of the catalogued works he had completed by that date. Instead of reprinting Zola's article as the preface to his catalogue, he presented a brief manifesto whose tone is the very opposite of Courbet's puffed-up blustering. When Manet was mentioned at all, the two painters were nonetheless lumped together by the critics, one of whom labeled them "the two ringleaders of Realism," distinguishing a hierarchy between Courbet's "Church" and Manet's "Chapel."

When Manet told Zola that he was going to gamble on a private show, he was not being metaphoric. To build his pavilion he had to borrow 18,300 francs from his mother, a very sizable sum (the equivalent today of about fifty thousand dollars), especially in light of his previous prodigalities. A note in his mother's hand details his income over the four years since his father's death in 1862, all of which he had spent: "Seventy-nine thousand four hundred eighty-four francs divided by four years comes to nineteen thousand seven hundred eighty-one francs per year. I think it is time to stop this ruinous slide."[3] When Manet decided to take his case to the public by holding a private exhibition, he was risking money he did not have and had little prospect of earning. Courbet spent almost three times as much, but he had his place assured in the official exhibition and could count on sales and commissions. Manet's reputation was yet to be made, and his sales to date had been pitifully few.

The ideal arrangement for any painter, especially one who was not a member of the Académie, not a fashionable purveyor of rosy buttocks or a portraitist of society ladies, was to exhibit in the Universal Exposition as well as the concurrent Salon. Manet was denied access to both. His resolve to exhibit privately seems to have been strengthened by the summary rejection he had received. Doubtless aware that Zola's twenty-three-page essay of January 1, 1867, had aroused more antagonism than support, Manet decided to present himself in the least aggressive light possible to a public that by then had decided he was a lunatic or a sensation seeker.

In his preface to the catalogue for his private show, Manet explained that ever since 1861 he had tried to show his works, but more often than not he had been rejected by Salon juries. The least an artist should be granted, he argues, is the chance to exhibit. "The artist does not say now, come and see flawless works, but come and see sincere works." The text is carefully worded and intended to be conciliatory:

M. Manet never wished to protest. On the contrary, it was against him, who did not anticipate it, that protests were raised because there is a traditional school of forms, means and aspect of painting; those who were taught such precepts allow no others. Their hasty intolerance is based on them. Outside of such formulas nothing has any value, and they turn not only into critics but adversaries. To exhibit is the vital question, the sine qua non for the artist, for it happens that after a few viewings one becomes familiar with what was surprising and even shocking. . . . To exhibit is to find friends and allies for the struggle.[4]

1867

Manet's one-man show opened on May 24 with a fifty-centime admission fee to see fifty original paintings, three copies (Titian's *Madonna of the White Rabbit*, Tintoretto's *Self-Portrait*, Velázquez's *Little Cavaliers*, now attributed to del Mazo), and three etchings (*The Gypsies*, *Portrait of Philip IV*, and *The Little Cavaliers*). According to Antonin Proust, "it was breathtaking." But the public was no more enlightened than in 1863 or 1865. "They laughed in front of masterpieces," Proust relates, "husbands took their wives . . . wives took their children. Everybody had to offer themselves and their relatives this rare opportunity for a belly laugh. . . . It was a concert of paunches in delirium." The whole artistic world of Paris was there as well, most of the critics at one with the crowd, behaving like the typical Parisian *badaud*, the gawker with an uninformed opinion about everything. "Never," Proust laments, "has the spectacle of such revolting injustice been seen before."

Aside from the Batignolles artists — caricatured in the newspapers as disciples around a Manet/Christ — who appreciated the technical genius of their reluctant leader, and Zola, who inaccurately prided himself on being the first to praise him in print (Zacharie Astruc, in his daily pamphlet during the Salon of 1863, was the one who could

claim that honor), it was a rare critic indeed who acknowledged his talent. One of them, Jules Claretie, who had dismissed *Olympia* in 1865, saw "few colorists among the younger painters to equal the painter of *The Fifer*, or *The Portrait of Rouvière* [*The Tragic Actor*] . . . even if he does not have the outstanding originality that M. Emile Zola has very sincerely discovered in him, at least he deserves the attention of the public and the critics who make the public."[5]

What must have been a cruel shock was to read that even Théodore Duret, who had become a friend since their meeting in Spain, betrayed a total ignorance of Manet's formal training and an insensitivity to his work. The same publisher who reprinted Zola's monograph as a pamphlet also printed one by Duret on the French painters of 1867, written with astounding arrogance. Duret, a total newcomer to art criticism, spoke about Manet as though he were a rank amateur. Not even Manet's harshest critics were more insulting. "After all the fury aroused by Manet's works," Duret said, he was disappointed "to see nothing particularly extravagant about them. One might have expected to find a man painting as no one on earth has ever painted." Instead he saw paintings whose chief defects were attributable to the fact that the artist had "started to paint before knowing enough about the use of the brush."[6] Duret's considered conclusion was that Manet painted too fast and too sketchily.

This devastating condemnation from a twenty-nine-year-old bantamweight just entering the critical ring doubtless left Manet aghast. Duret apparently knew as little about Manet's six years with Couture and his painstaking methods as he did about what the younger painters were trying to achieve. Like most of the rubbernecks who crowded into the Salons, Duret's eye had not gone beyond the *léché*, the high finish of Ingres or his lesser followers such as Cabanel and company. In his later years Duret recanted: "I was in good faith. I was afraid that Manet's head would be turned by the acclaim of his comrades. Moreover, I was not sufficiently informed about modern art."[7] This did not inhibit him from pillorying a friend who had staked his all on a confrontation with the public.

Duret was nonetheless the one to whom Manet, in 1870, when Paris was under siege and he risked losing his life in the uniform of the National Guard, entrusted his most important works. And again, when he made out his will, it was Duret who was appointed his executor. In spite of all this, Duret remains an equivocal figure, lacking

the courage to come out squarely in defense of his friend. Manet was not one to be duped by his own sentiments or by Duret's other qualities. A year after Duret's critique, in 1868, Manet painted a portrait of him that, read attentively, expresses Manet's wry commentary on his friend's missing backbone.

George Mauner, always sensitive to Manet's subtleties, identified the model for this painting, thereby arriving at an interpretation that is wholly consistent with Manet's personality — not fractious but not long-suffering either. The portrait of Duret, according to Mauner, is a paraphrase of Goya's portrait of Manuel Lapeña. Certainly the stance, the position of the cane, and the foppishness are strikingly similar. Whether Manet knew that Lapeña was a fainthearted general is impossible to know, but that he knew the painting — either from Charles Blanc's illustrated volumes, which Manet owned, or from his visit to Spain — is hard to doubt. The most salient similarity is the ingenious use of the cane: in Goya's painting it points to the name of the subject and that of the painter, seen traced in the sand right side up; in Manet's it points to his signature and the date, printed upside down, but there is no mention of the subject. Manet had evidently chosen the Goya model before starting Duret's portrait, but he repositioned his signature afterward.

On receiving the painting Duret wrote Manet a letter that once again raises doubts about his attitude toward Manet's art. The sum total of his compliment consists of "My dear Manet, I find your chap very jaunty. Most assuredly, that is painting," followed by a description of his cook's fright on taking the lifelike portrait for an apparition. The paragraph that follows makes clear the purpose of the letter, which does indeed leave one wondering about Duret's sincerity.

However, here is what bothers me, and why I am writing to you. You have signed the painting in full light, and as soon as one enters, one sees your name. Knowing human stupidity, above all when it comes to you, I am sure that anyone seeing your name, *Manet*, before looking at the painting and the chap in it, will start snickering and backbiting. It seems to me that you ought to erase your name in the lighted part and either not sign it, or sign it *invisibly* in the shadow. That way, you would give me the time to have the picture and its painting admired. I would be able to say, depending on the circumstances, that it is a Goya, a Regnault, or a Fortuny. . . . Then

I would let the secret out and the bourgeois would be unable to back out. . . . All gimmicks are good to catch a bourgeois.[8]

Mauner sees this as a piece of cowardice; Duret did not want a painting instantly identified as a Manet on his walls, especially after his own appraisal had been so unflattering. "While Duret's motives making this request have not been questioned in the Manet literature," Mauner writes, "his duplicity could hardly have escaped the thin-skinned Manet."[9] Manet's response to the request was to leave his name in the same highlighted place with the cane still pointing to it, but he turned it upside down, while a book, carelessly tossed under the stool, suggests to Mauner Duret's own *French Painters in 1867.* This is not unlike Manet's portrait of Zola — a surreptitious laugh at the subject, who prided himself on "understanding" the artist's qualities and defects. Duret, portrayed as a much livelier figure than Zola, also has been stripped of critical authority. There is nothing in Duret's portrait to indicate that this man has an intellectual life, not even the book — its cover is blank, a mere device for color, like the still life on the tray. Here Duret is little more than a fashion plate, "the last of the dandies," Manet used to call him. With humor and wit Manet settled scores, leaving his own mark in greater evidence in both portraits than the identity of the subjects.

Hippolyte Babou, who became a regular at the tables of the Café Guerbois, was one of the few voices in the Parisian press to speak up for Manet in June 1867. Reviewing the three independently mounted one-man shows of Courbet, the sculptor Clésinger, and Manet, he had little to say about the first two, finding nothing new in Courbet's vast hall: "Let us look for a more recent newness, let us take a few more steps along the avenue and try our luck at the private exhibition of M. Edouard Manet. Here . . . I see nothing that looks like a hall; I enter mysteriously into a small square salon, arranged with elegant discretion. A perfume of gallantry floats in the air, and as soon as you inhale it, a voluptuous meditation takes hold of you." He goes on to describe the little catalogue titled *Reasons for a Private Exhibition,* whose preface by Manet "reveals a man of breeding and intelligence. It is impossible to be *more unlike a painter* than is the author of these few lines that disclose a spirit of pride and modesty." As for the artist, Babou, with a clarity not found among Manet's few defenders at the

time, and certainly not found among the generation of critics after him, declares:

> There is in M. Manet an artist's intelligence; and that is what will save him, if he is not already saved, from those petty theories that would reduce the artist to the role of infallible automaton, doomed to spontaneous generation and instantaneous production. . . . [His] keen intelligence, already shaped by curiosity, meditation and study, delights me because it avoids the mindlessness that so often passes for originality, because it makes me think and dream, because it is essentially *suggestive* [italicized and in English in the original French text].[10]

The exhibition was to continue into October, but by midsummer Manet had lost hope of changing public opinion. It was a disaster. He was hardly mentioned in the press at all. Jules Claretie's invocation of fairness had come from Brussels; in Paris the critics were busy with the paintings at the Universal Exposition and with their duties to the Salon. Manet sulked in his mother's apartment at 49, rue de Saint-Pétersbourg, to which he and Suzanne had moved the previous autumn. A ground-floor room had been rented for Léon at number 51, where Manet would later rent a studio. In that district recently constructed by Haussmann, called the Quartier de l'Europe and radiating from the Pont de l'Europe — the bridge over the tracks of the Gare Saint-Lazare — new apartment buildings had been rising to receive well-bred middle-class tenants, among them a few intellectuals and artists who had some means. The buildings were five or six stories high, with large windows and wrought-iron balconies on either side of straight wide streets, as seen in Caillebotte's *Paris, A Rainy Day.* The district offered light, modern amenities, and, for Manet, the proximity of his old haunts — Café Guerbois and the shop where he bought his supplies. He would move his studio four times over the next two decades and his apartment once more, but never farther than another number on the same street or the next one over, the rue d'Amsterdam.

During that summer of Manet's discouragement, Baudelaire lay dying. He had been brought back to Paris the summer before, paralyzed on his right side and unable to voice more than a syllable or

two, most often only *"crénom,"* from the expletive *Sacré nom de dieu* (Holy name of God). Baudelaire had been admitted in July of the previous year to a private clinic near the Arc de Triomphe, which specialized in the then popular treatment of hydrotherapy for neurological disorders. His ground-floor room, looking out on the garden, was decorated with only two pictures, both by Manet. Baudelaire's memory was his sole remaining faculty; his only means of communication were his eyes, facial expressions, and gestures with his left hand. When Manet's name was mentioned, he was reported to have "smiled delightedly."[11] Over the months Manet often went to see him, and Suzanne Manet played transcriptions of Wagner's operas for him on the clinic's piano.

In August Manet finally dragged himself away from Paris, stopping first in the seaside town of Boulogne, a major fishing port and a fashionable resort at the time. Restless and depressed, he then went to Trouville, farther to the west on the coast of Normandy, where he walked on the long sand beach and where Proust joined him for a few days. Expecting more bad news about his show each time the mail arrived, Manet told Proust, "Here comes the mud flow. The tide is rising. I'm not the one who's soiled by it." During those last weeks of the summer of 1867, work held no interest for him. But if Proust is right, Manet left Trouville in a somewhat better mood.

While Manet was cleansing his spirit with seascapes and his lungs with sea air, Baudelaire, declining rapidly after an eighteen-month agony, was calling for his old friend and, to the amazement of everyone around him, even pronouncing his name; it was one of the last comprehensible sounds he made. He died on August 31 and was hastily buried two days later in the cemetery of Montparnasse. Manet returned to Paris for the funeral. Because it was too hot to keep the body for more than two days, there had not been enough time to notify everyone, and many were still out of the city. One of those present, the critic Arthur Stevens, described the scene at the cemetery in a letter to his brother Alfred: "There were about a hundred people at the church but fewer at the cemetery. The heat prevented many people from following [the hearse] all the way. A thunderclap, which boomed out as we entered the cemetery, nearly sent the remainder running." Alfred Stevens, who had not attended the funeral, wrote in reply, "The incident you related, about Baudelaire's coffin as it en-

tered the cemetery, battered by wind and strewn with leaves that fell from the trees, moved me deeply."[12]

The scene thus described seems to have been captured, both visually and emotionally, in Manet's unfinished painting *The Burial*.[13] However inaccurate the topography (the cupolas of the Val-de-Grâce and the Observatory are not really that close), the scene is dominated by the huge dome of the Panthéon, where France's great are buried. Symbolically, Manet appears to have placed the dead poet under this glorious monument rather than in the unidentified cemetery with its pitiful cortege under an ominous sky. Although there is no proof that this is what Manet had in mind, Baudelaire's death was of no small account to him. It is conceivable that Manet would have been tempted to record his impressions of it, especially visual impressions as memorable as an impending storm, in conjunction with the powerful emotions of loss. Whatever his shortcomings, Baudelaire was surrounded by genuinely grieving friends during his final months. Moreover, Manet's use of actuality was becoming more frequent — not only modern themes but events of the day and, quite particularly, two events of the spring and summer of 1867: the Universal Exposition and the execution of Mexico's Austrian emperor. The burial scene also seems related in time and nature to Manet's other two subjects of 1867, like them an actual occurrence and filled with personal resonances.

In her study of the Second Empire's two world's fairs, Patricia Mainardi tells us that Manet's *View of the International Exposition*, painted between June and August of 1867, is the only painting of that event. If, as appears, it was painted on the site itself, it would have the further distinction of being Manet's first true plein air, or outdoor, painting (Fig. 12). It was also his first and only panoramic view of Paris (outside of the unfinished *Burial*). "Most cities," Mainardi points out in her brilliant analysis of the painting, "have one or two viewpoints which . . . come to symbolize the city itself," largely because of the artists who portrayed them (for example, El Greco's *View of Toledo*). Having eliminated "the middle ground completely and jammed together the two areas of maximum interest — the immediate foreground and the distant panorama . . . a few significant landmarks come to stand for the whole: the oval exhibition hall . . . the tall French lighthouse . . . and that symbol of Paris, the domed church of the Invalides."[14]

This metonymic rendering of an entire city is a striking innovation, Mainardi says; it is the deliberate compression of space and monuments to produce a point of view rather than a mere vantage point. The "modernism" of the work is further emphasized by those landmarks that Manet chose to emphasize: the new twin-spired church of Sainte-Clothilde, the twin towers of the Universal Exposition, the hot-air balloon, and an oversize Pont de l'Alma, the site of Manet's private one-man show. The traditional symbols of Paris also are included, but sketchily: the domes of the Invalides and Panthéon, the towers of Notre-Dame. However, the dome of the military academy above the parade grounds of the Champs-de-Mars, on which the exhibition hall was built, is very clearly depicted and even enlarged to point up the irony of placing a world's fair dedicated to peace on the only military site in Paris — noted by Daumier in his newspaper caricatures.

What Manet did with the architecture of 1867 Paris, he did with the characteristic figures of the day. Mainardi notes, "Manet presented one isolated figure of each 'type' with no repetitions. This further reinforced the emblematic rather than the genre aspect of the painting. Although Manet's interest in Parisian 'types' — from the lower classes of *The Old Musician* to the upper classes of *Concert in the Tuileries* — has been well documented, he never before, or after, attempted to paint the entire spectrum in a single picture."[15] It is a spectrum that also includes a few personal references. Léon is seen in the right foreground walking a large dog on a leash, dressed in the same boater and jacket he will wear in *The Luncheon* of the following summer. Here he subsumes the *petit crevé*, the fop. Similarly subsumed by single figures are the *cocodotte*, the female clotheshorse; the *cocotte*, the kept woman who often set fashions; and the *amazone*, the horsewoman, the latest craze among aspiring *grandes courtisanes*. The hot-air balloon is a nod to Nadar — photographer, balloon builder, and member of Manet's circle of close friends. His famous balloon, the largest ever made, was justly named *Le Géant* (The Giant). Nadar hoped to convince skeptics not only that *Le Géant* could remain afloat but that aeronautics had a future. Seen as a symbol of hope and a metaphor for the world of the future, the balloon comes to stand for the entire exposition. It also may express Manet's optimism regarding his future success and his immediate hopes for his show, which had opened but had not yet been reviewed. It was,

and remains, an ambitious work that combines a real moment in
the life of Paris with "a more suggestive treatment of types and sym-
bols."[16]

The painting stayed in his studio during his lifetime, unshown, un-
sold, unsigned (Suzanne signed his name to it when she sold it after
his death). Manet's exhibition, on which so much had been staked,
was almost totally ignored by the critics. Babou, in his admiration for
the elegant simplicity of the pavilion, had predicted in his review that
"refined people will come, and devotees . . . but where is the public?
Will the public come?" The public came, encouraged by one of the
few other published reactions to the exhibition's existence — three
pages of caricatures in *Le Journal amusant* — to laugh, as they had in
1863 and 1865. Is it any wonder that Manet lived for weeks in reclu-
sion?

Bazire, Manet's first biographer, wrote with questionable senti-
mentality: "He had near him a child, the second brother [sic; if he
had been a brother, he would have been the third] of Mme Manet,
Léon Koëlla-Leenhoff, whom he raised and looked on as would a fa-
ther. . . . Between his wife and this son — for this brother-in-law was
a son — he was protected from despondency and humiliation."[17]
There is little in Manet's art to substantiate such consolation. What-
ever affection Manet may have felt for Léon, the paintings, in which
Léon is always kept at a certain remove, tell us more about Manet's
state of mind than about Léon's personality.

As for Suzanne, she is virtually absent from Manet's work between
1860 and 1866. When she does reappear, it is in two insipid portraits,
both from 1866. Compared with the two paintings of Victorine
Meurent of the same year — the intriguing *Woman with Parrot* and
the graceful *Woman Playing the Guitar* — Suzanne seems to have
been an uninspiring model. The first of the two portraits is more fin-
ished than the second, but neither suggests much effort or enthusiasm
for the enterprise. *Woman with Parrot* also was regarded as unfin-
ished, but even in 1866 it was recognized for its merits. Théophile
Thoré had seen it, as had Zola, in the spring of 1866, when Manet
opened his studio to friends for a small showing of a few paintings:
The Fifer and *The Tragic Actor, A Matador Saluting, Woman Playing
the Guitar,* as well as three corrida scenes. "Those pink tones," Thoré
wrote about *Woman with Parrot,* "would challenge the subtlest of
colorists. It is true that it is a sketch, but so is Watteau's *Isle of*

Cythera in the Louvre. Watteau could have perfected his sketch, but Manet is still struggling with this great pictorial problem: whether to finish certain parts of a painting in order to give greater strength to the whole. Still, one can see that Manet will eventually win the day, as have all the others who have been victims of the Salon."[18]

However "unfinished" *Woman with Parrot* may have appeared at the time — it fared even worse in the eyes of Gautier and others when it was shown in the Salon of 1868 — it is a work on which Manet clearly lavished all his attention (Fig. 19). The face and hands are done in exquisite detail, as are all the accessories: the violets, the monocle, the gold locket, and, of course, the parrot. If the dressing gown was then seen as "sketchy," today we see it as a deliberately impressionistic rendering of light-catching silk taffeta. The presence of violets, which will later reappear in connection with Berthe Morisot, suggests an intimate dialogue between the subject and an admirer — the painter perhaps? — as does the monocle, commonly a masculine article, hanging around the model's neck like a trophy. Are we to understand them as an acknowledgment of amorous pleasures? At that time, when the "language of flowers" was widely used to communicate discreet messages, violets were commonly offered by lovers. Whatever the symbolic value of these accessories — the interpretations range from courtesan (suggested by the parrot) to lesbian (on the assumption that the monocle is an exclusively masculine accessory)[19] — they are evidence of more than mere experimentation with light and color.

In the two sketches of Suzanne there is no dialogue, no detail, not even of the hands reported to have played Schumann with sensitivity and Wagner with power. The profile with hat is a virtual caricature. Suzanne seems to have a crow sitting on her head, one large wing flapping behind as she emits a startled "Oh!" The more finished full face depicts a bland stolidity in the dull eyes and heavy neck. It is not just an unfinished painting; it is a tarnished vision.

How different her portrait in *La Lecture*, uncertainly dated between 1865 and 1875 (Fig. 22). Here we see a much younger Suzanne, her ample form made winsome under the diaphanous muslin, her hands prominently displayed in almost balletic positions, her plump face youthfully firm, and her gaze soft. Everything in this painting points to the artist's total commitment to his canvas, his exuberant handling of whites, and his bravura rendering of a model against the light. This image of Suzanne obviously predates the two

portraits of 1866 by more than a year. It is more likely to have been painted in 1862, when Manet was in full experimentation with whites: his portrait of Baudelaire's mistress, Jeanne Duval, in her voluminous white skirts; his first portrait of Victorine in white blouse trimmed with black; the white trousers in *Young Woman Reclining in Spanish Attire*; and shortly thereafter the apotheosis of whites in *Olympia*. Even the contrasting black braid on white and black ribbon on flesh in the 1862 portrait of Victorine seem related to this portrait of Suzanne, with her black necklace, earrings, and belt. Although the figure is placid — Suzanne's dominant trait, according to those who described her — it is more serene than dull, the skin glows with wholesome robustness, and the painting pulsates with light.

That Manet returned to this painting some years later is not disputed. He inserted into the dark background a Léon who is manifestly older than the thirteen he would have been in 1865, the earliest date proposed. In fact he looks a good bit older than in *The Luncheon* of 1868. His appearance therefore argues for his insertion in the early 1870s, when Léon was twenty and Manet was using the broader brushstrokes we see in the retouches to Suzanne's dress and the couch.

Beyond such technical and chronological concerns, *La Lecture* documents personal viewpoints that bear upon Manet's state of mind and heart. The painting holds an affectionate, if not a passionate, vision of this woman with whom, by 1862, he had already shared more than a decade of secret intimacy. This tender image of Suzanne — the only one of its kind except for *Woman with a Pitcher* of 1860, which also bears an indication of betrothal, a ring on the left ring finger — suggests a prenuptial portrait, a statement of intention, as was the slightly later *La Pêche*. Only here the candid gaze of the subject and the precise portraiture imply a certainty that is not yet apparent in *La Pêche*, where the traits of the woman, though identifiable as Suzanne's, are barely distinguishable, and like her predecessor in *Woman with a Pitcher*, she looks demurely away from the viewer. In *La Lecture* Suzanne sits in the plenitude of her forthcoming legitimacy.

The subsequent insertion of Léon is almost a denial of this image of Suzanne, a defamation of that radiant bridal figure (it is perhaps not without meaning that Manet chose to pose her against the light in the first place). Léon's coarse features in this portrayal — remarkably

similar to van Gogh's *Potato Eaters* — and the monochromal rendering of them that is totally inappropriate to the rest of the painting, raise the question, why? Why make this gratuitous addition to a finished picture? Without him the painting has a harmonious look of completion, the dark wall providing a necessary contrast to all the whites. Léon seems almost sinister leaning over the couch, his body wholly in the shadowed area. Only his left hand is finished and flesh-colored, as though to establish a living link with the ringed left hand of the seated figure. Is the addition of this young man a denunciation of the woman who, years after the legitimation of her union with the painter, had still not avowed her own son? By that time Léon was an adult. Was he too a disappointment? Or was it the secrecy, the chicanery surrounding him, that was a source of bitter regret?

Léon's appearance in *Boy Blowing Soap Bubbles,* a work of classical resonances painted in September 1867, is another intriguing case of biographical reference. Léon was then close to sixteen, but in the painting he looks like a child. The theme of the painting, traditionally associated with *vanitas* — the passing of time, the loss of youth, the inescapability of death — would indeed be more congruous with a prepubescent child than with the full-blown adolescent he was when he posed for *Soap Bubbles.* In an earlier painting of the same year, we saw him as the young dandy at the Universal Exposition in his summer finery. In *Soap Bubbles* we see the tender face of a young boy engaged in the innocent pastime of blowing bubbles. Françoise Cachin observes that "while Manet has retained the traditional elements of the *vanitas* theme in which soap bubbles symbolize the precariousness of life," he has reversed the emphasis, "giving the subject an unprecedented immediacy and removing all trace of sentimentality."[20]

This image of a Léon younger than his actual years is nevertheless disturbing. Manet's sudden return to seventeenth-century art — his allusions to Chardin's painting of the same theme seems deliberate — at a time when he was concentrating on modern subjects seems to suggest a personal impulse, a private allegory. Was he seeing Léon with nostalgia? Or was he recording the loss of a future that once held promise for the boy? The child he had portrayed until then as a sweet-faced innocent will soon become the arrogant youth in *The Luncheon* (1868), the morose *Young Man Peeling a Pear* (1869), and the increasingly distant, barely recognizable figure in *The Departure of the Folkestone Boat* (1869), *Oloron-Sainte-Marie,* and *Interior at*

Arcachon (both of 1871). In *The Balcony*, painted nine years after *Spanish Cavaliers and Boy with Tray*, Léon makes a return appearance out of that early painting and, as in *La Lecture*, once again in the background, as though the recognition of this otherwise unrecognized boy were a confessional compulsion.

If the addition of Léon to *La Lecture* was made in 1872, as appears likely, there was a reason for the intrusion of this figure into a painting of his mother that had been conceived without it. On September 11, 1872, Léon's uncle, sculptor Ferdinand Leenhoff, submitted a request for an *"Acte de naissance reconstitué,"* a reconstructed birth certificate, which Léon had to present to register for one-year voluntary military service.[21] The original had been destroyed along with countless other municipal records during the Commune, the civil war of the year before, when *mairies* all over Paris were torched. Proof of Léon's identity was his baptismal certificate, which identifies the child as "Léon Edouard, son of Koëlla and Suzanna Leenhoff, godfather Edouard Manet, godmother Suzanna Leenhoff."

This would have been the moment to lay bare the charade and declare Léon's true parentage. Instead it was prolonged until Suzanne's death in 1901, at which time Léon's name was the first of the relatives listed on the notice of the funeral, before her brother Ferdinand, who was eleven years Léon's senior. This at least was as close to a public statement as was ever made that Léon's relationship to the deceased was closer than that of siblings, since their names follow his. Nevertheless, once his mother died, Léon, outwardly docile about the travesty that had been inflicted on him, rejected the name by which he had been known to everyone. His death notice in 1927 reads "Léon-Edouard Koëlla." Only seven years earlier he had told Tabarant, "Within the Manet and Leenhoff families I always called them godfather and godmother; in society, they were my brother-in-law and my sister. A family secret, about which I never knew the whole truth, having been pampered, spoiled by both of them who indulged all my whims. We lived happily, the three of us, above all I myself, with no concern whatever. I therefore had no reason to question my birth."[22] And yet it was not an indifferent matter, since he chose to revert to his legal, though no less fictitious, name after being known almost half a century as Leenhoff. His ultimate refutation of the name foisted on him by his mother would seem to indicate a long-simmering rancor; but does his retention of the name Edouard imply his exoneration of

Manet? After Manet's death Léon did not hesitate to mutilate and destroy paintings that he thought he could not sell, or to have others copied by his cousin and fraudulently signed.

In the summer of 1867 Manet's protective family life could do little to shield him from dejection, nor could it compensate for his professional miseries. He had ricocheted from one defeat to another; his hopes for success, or at least for a more sympathetic response from the public, had been shattered. In fact the series of paintings to come from his easel over the next months reveals much about the way he felt. Even in his dejection he did some outstanding work before leaving Paris for the seaside. During the month of June, when he was chafing over the neglect of the critics and the obtuseness of the viewers, an event occurred far from Paris that triggered in him a powerful reaction, and resulted in the series of paintings devoted to the same moment — the execution of Mexico's emperor in Querétaro, 250 kilometers (160 miles) northwest of Mexico City.

Through Napoleon III's complex geopolitics, Maximilian, brother of the Austrian emperor, had been proclaimed emperor of Mexico in 1864. For more than a decade the French were the largest foreign presence in Mexico. Napoleon's "Grand Design" for French influence in Latin America was motivated by the fear, shared by other major European powers, of American expansion. Mexico was a presumed source of great mineral wealth and the projected site of a canal connecting the Atlantic and Pacific oceans.

In 1861 Benito Juárez, an orphaned Indian who had risen to the offices of minister of justice and acting president after a civil war, was elected president of the Republic of Mexico, a country deeply in debt and torn by divisions over the power of the Church. Mexico's creditors demanded repayment, forcing Juárez to declare a two-year moratorium on foreign debt, which in turn led to a punitive expedition sent by Britain, France, and Spain. It was at that juncture that Napoleon III saw his chance to influence the fate of Mexico.

His choice of a monarch for Mexico fell on the ideal vehicle for his Grand Design — the young Austrian archduke Maximilian, who had been governor of Lombardy, until 1859 a province of Austria. Because France had fought beside the armies of Piedmont to expel Austria from Italian soil, Napoleon, in his desire to placate Austria for his intervention, proposed that Maximilian become Mexico's ruler. He hoped thereby to establish an alliance with Austria and to retain some

control over Mexico, which had wrested its independence from Spain in 1821. Napoleon calculated that Maximilian would be a compliant ally if he were given the throne. To encourage his acceptance, Napoleon promised Maximilian that twenty-five thousand French troops and eight thousand Foreign Legionnaires would remain in Mexico until a native army could be trusted.

By the end of the War Between the States in 1865, American aid to Juárez increased, as did pressure inside and outside France for the withdrawal of French forces. Austria's defeat by Prussia in 1866 vitiated the usefulness of Austria as an ally. Napoleon's Grand Design turned into a disaster: seven thousand French soldiers died on Mexican soil defending France's interests against Juárez; the cost of maintaining a French presence there proved to be ruinous. Napoleon had no choice but to cut his losses. The withdrawal of all French troops in March 1867 left Maximilian at the mercy of Juárez's superior forces, yet he refused to abdicate, convinced that Europe would come to his aid. He sent his wife to Paris to plead for help. On May 15, after a siege at Querétaro, he finally surrendered. A law passed under Juárez's presidency exacted the death penalty for anyone who aided foreign intervention in Mexico. This was no more extreme than Maximilian's law of 1865, which required the instant execution of unauthorized armed bands and was directed against Juarista supporters. Had Maximilian taken Juárez prisoner, he would have done exactly what Juárez did to him: he was executed by firing squad. News of the execution reached Paris by the end of June, when the Universal Exposition was in full swing and Napoleon was entertaining the monarchs of Europe. On July 8 the first of the detailed reports was printed by *Le Figaro*. It was far from complete, but it did report that Maximilian had been executed with his two leading generals, Miramón and Mejía, and that they had been shot point-blank by squads placed only three paces away. Throughout July and into August additional details were published, illustrated by photographs and drawings made on the scene.

Aside from its human and political interest, the execution of this Hapsburg prince with his two faithful aides inspired a unique enterprise in Manet's career. It also provides the viewer with a unique perception of the artistic and psychological workings of the artist in the process of creation.

As a student Manet had expressed his contempt for history paint-

"Execution of
Maximillian" 1867

ing. By 1867 the kind of history painting traditionally devoted to the exploits of gods, kings, conquerors, and warriors had become synonymous with retrograde ideas, academic art, and autocratic rule. Maximilian's execution was history in the making. This was the world of the moment, not a mythicized distant past, and with ramifications that went beyond the protagonist. Here were the kinds of irony Manet relished: an emperor shot like a bandit, a pathetic pawn on Napoleon's chessboard who saw himself as a Christ-like martyr, a victim who died like a hero. Here too was an emblem of Manet's own victimization by the autocratic Salon juries and a portrait of death that gave rise to a work of art. Manet's long-standing republican fervor was provoked by this example of authoritarian wickedness: lives lost, resources squandered, all to satisfy the misguided policies of an absolute monarch.

That Manet should have chosen such a subject for a large-scale painting was found baffling. Critics over the decades accused him of "neutralizing" the subject to the point of depoliticizing it. Georges Bataille stripped the painting of any connotation: "Manet deliberately rendered the condemned man's death with the same indifference as if he had chosen a fish or a flower for his subject. True, the picture relates an incident, no less than Goya's [*Third of May*] does, but — and this is what counts — without the least concern for the incident itself."[23] This echoes Zola's critique of 1876: "He treats figure paintings as it is only allowed in art schools to treat still life paintings; I mean that he combines nothing, composes nothing, and is satisfied to paint objects he has grouped in a corner of his studio. Ask no more of him than a translation of literal accuracy."[24]

The choice of Maximilian's last moments — for three large canvases, one small oil sketch, and one lithograph — can hardly be equated with painting "objects . . . grouped in a corner of his studio." With every new report of the event, Manet made changes, added details, and suppressed others. X-ray evidence of his many pentimenti and his repeated attempts in three different paintings, done over a period of some eighteen months, prove how determined he was to arrive at something far beyond a "translation of literal accuracy." For that there were photographs. The size of all three versions suggests that he intended at least one of them for Salon submission, although he cannot have been naive enough to think that so inflammatory a subject might not be censored. At the height of the newsworthiness of the

event, only verbal accounts were permitted; photographs, prints, and drawings could not be reproduced in Parisian newspapers: "The authorities were particularly wary of the power of the visual image — in the form of a print, a painting or a stage representation. In the context of Maximilian's execution, this emerged most immediately in the suppression in September 1867 of the photographs of the firing squad and Maximilian's bullet-riddled clothes, while verbal descriptions were widely printed."[25] Two years later Manet's lithograph of his *Execution,* as yet untitled, was suppressed as soon as it was printed. He could at least take pride in the impact of his representation. Writing to Zola about his indignation over the censorship, he remarked, "That speaks well for the work."[26]

What the three versions illustrate is not the detachment of which Manet has been accused, but rather his growing awareness of the broader implications of the subject. As art critic John House points out in his splendid essay on *The Execution of Maximilian,* the conventional way to convey meaning was to highlight the most important elements in a picture and to treat them with greater detail than the rest. "Manet's whole scene is brightly and evenly lit," House observes, but "the key point of the picture, Maximilian's face, is treated particularly indistinctly."[27] It is characteristic of Manet's light to be even; there is no time of day in a Manet painting. This he surely learned from Japanese art, which does not depict shadow. In the *Execution* series the shadows on the ground serve more for depth than for determining the source of light. And this is what contributes to the immediacy, the stunning presence of his figures. A French critic, reviewing Manet's posthumous retrospective, spoke of his extraordinary luminosity and how the eye (still in 1884!) was "accustomed to the practice of dark painting and the artifice of studio daylight." The reviewer's Japanese guest was astounded by Manet's light: "I thought at first that the figures were materializing and were going to emerge from the canvas to speak to me; a sensation I have rarely had in your [European] exhibitions of painting."[28] For the German romantics the light of dawn or twilight endowed nature, primordial and eternal, with a metaphysical significance. For Manet the human figure replaced nature as the source of meaning — human frailty, human mortality, human futility. And the light he cast on it has no beginning and no end; it is a light as eternal as nature.

A comparison of the three large versions reveals how much more

there was to Manet's treatment of his subject than his originality as a painter of figures in natural light. The first version (Museum of Fine Arts, Boston) is a spontaneous, impressionistic rendering of the early accounts of the execution. There are no portraits of Maximilian and his generals; the number of soldiers is indeterminate. Mexican soldiers were commonly portrayed in flared leather trousers and sombreros. By August photographs had been smuggled into France that were described in *Le Figaro:* "The squad responsible for the emperor's execution consists of six soldiers, a corporal and an officer. The uniform looks like the French uniform: the kepi and tunic appear to be of gray canvas; the belt of white leather." In the second version (National Gallery, London), presumed to have been painted after September 1867, the surviving portions (Léon had cut the painting to sell the pieces separately) show a squad of seven, blue hills in the background — exactly as Querétaro was described in the newspapers — and a cloudy sky with light low on the horizon. The third version (Kunsthalle, Mannheim; Fig. 24) has a squad of eight (clearly seen in the oil sketch, Ny Carlsberg Glyptotek, Copenhagen), a recognizable portrait of each of the victims, as does the second (Maximilian has retained his sombrero from the first version, corresponding to a photograph published at the time), a completely new background of a wall on which onlookers are leaning, a patch of cypresses against an indigo sky on the left, and crowds descending the hill in the distance.

Even if Manet missed Goya's *Third of May* on his visit to the Prado, where it hung in a dim corridor, he surely saw it when it was reproduced for the first time in France in April 1867, by a critic Manet knew.[29] Despite Manet's apparent familiarity with Goya's painting when he started his *Execution,* there are noteworthy differences between the two works. Goya's firing squad is intent on its task; the soldiers' bodies are curved, braced for the recoil with one knee bent and one leg outstretched; the spectators are seen in poses of intense grief; the central victim stands in a dramatic pose of heroic resistance, his white shirt the focal point of the composition. In Manet's final version the firing squad appears almost amateurish in its Chaplinesque stance of turned-out toes, bodies stiffly erect, the sergeant not even watching as he prepares his own rifle for the coup de grâce. The crowd peering over the wall, as other writers have noted, does indeed evoke a bullring audience, and particularly the scene in Dehodencq's *Novillada at Escorial* that Manet so admired. Manet was

entranced by the corrida and, judging from the letters he wrote on his return from Spain, responded to it with the enthusiasm of an aficionado, for whom it represents a ritual of noble death. Even a bull that fights bravely is honored, while one that does not is jeered as loudly as a mediocre torero. The bullfight evocation in the painting is, therefore, less concerned with victimhood than with the heroic gesture — martyrdom perhaps, standing up to the ultimate adversity with dignity.

The pathos of death was not what interested Manet in *The Execution*, but the nobility of dying, the posture, however ineffectual, that grants manhood to a man even if the outcome changes nothing. Whereas heroes of the past typically sacrificed themselves — to slay a monster, bring fire to mortals, redeem humanity — for the common good, the modern world no longer produced intercessors; every man died for himself, signifying nothing. Although some have seen Christological implications in Maximilian's halolike sombrero, which was a factual detail, his death was as meaningless as his rule: Juárez regained his presidency; Napoleon III remained on his throne. What is so striking about this series of paintings is not what Manet took out but what he put in. As he progressed from one canvas to another, he moved from the local to the universal without ever losing sight of the particular. The portrait of Maximilian remained as identifiable as the postcard photograph that may have been its model. Manet did not depoliticize the execution. In fact he brought it closer to home by making the uniforms look more French than exotic. He did, however, make it ambiguous so as to allegorize an event that had reawakened his ire against the imperial regime. Maximilian was not Napoleon's only victim; Manet himself and his friends also had been victims of imperial policy.

The final version is a painting about death, indicated by Manet's brief quotation of the cemetery cypresses from his own *The Burial*. Valéry might have called this a poem, for a real event, the reality of three separate squads gunning down three widely spaced victims, with Maximilian at one end, has been condensed into a single platoon firing at three linked men, their solidarity in life and death symbolized by their joined hands. Manet's obsessive reworkings of *The Execution* should leave little doubt about his moral and political response to the event. How different Flaubert's reaction, despite their shared revulsion: "The death of Maximilian filled me with horror!

What an abomination! and how sorry a thing the human species! It is so as not to think about the crimes and stupidities of this world (and so as not to be tormented by them) that I take refuge in art, with total abandon. Pitiful consolation."[30]

Degas, through whose dogged efforts we have the four fragments of the dismembered second version of *The Execution of Maximilian*, bought the sergeant examining his rifle from Léon, who considered the painting inferior. Having removed it from the wall because it took up too much space, Léon detached it from its stretcher, cut off the only part he deemed marketable — the fragment he sold to Degas — rolled up the rest, and shoved it out of sight. When Ambroise Vollard, the great art dealer, expressed an interest in buying some of Manet's sketches, Léon retrieved the banished canvas, showing him only the central portion that contained the firing squad. Because of its poor condition, Vollard decided to have it transferred to a new canvas. The restorer on seeing it thought it might be related to the fragment Degas had brought him for similar restoration. When Vollard showed the canvas to Degas, he immediately recognized it and was beside himself with rage. "He found only these words to express his indignation — 'Again the family! Beware of the family!'"[31]

Degas asked Vollard to go back to the family and retrieve the legs cut from his fragment, as well as the piece depicting Maximilian and his two generals, cut from the left side of Vollard's, and to tell them he would pay for the lot. Disappointed to discover he had missed a sale, Léon — introduced as Suzanne's brother and so designated throughout Vollard's book — explained: "I thought that the sergeant looked better without those legs that dangled like a rag, just as the soldiers firing were better off without the group of generals and what remained of Maximilian's head. . . . If I had imagined that shreds of canvas all rotted by the saltpeter in the wall had any value, I would not have used them to light the fire." Only the two fragments of the head and body of General Miramón were eventually salvaged; they are now in the National Gallery of London. Suzanne's appreciation of the painting was no greater than Léon's, for she lamented to Vollard: "What a misfortune that Edouard worked so stubbornly on that! How many beautiful things he might have painted during all that time!"[32] No wonder that every time Degas showed his Maximilian fragments to visitors, he always intoned, "The family, beware of the family!"

Friends and Models

For the better part of three decades the artists and writers who formed the so-called Batignolles group maintained steady, if not always amicable, contact. They appeared in each other's works in paint and in print, but they never constituted a school. They agreed on the notion of a "modern art," if not always on its execution. Some members were closer than others, pursuing their favorite subjects in the more private setting of their dining rooms; some were seen only around the café table. There were fallings-out and reconciliations. Some, like Antonin Proust, were intimately associated though professionally marginal; others, like Cézanne, were marginal more for personal than for professional reasons. But most of the group survived the transfer from the Café Guerbois to the Nouvelle-Athènes. What remained of it in the 1890s did not survive the animosities that arose during the Dreyfus case. Degas and Renoir, both unflinching anti-Dreyfusards, no longer even spoke to Zola, Monet, or Pissarro.

Critic and novelist Louis Edmond Duranty was one of the more assiduous habitués of the Café Guerbois, often appearing twice a day, after lunch and again after dinner. In a now forgotten novella[1] he described the Guerbois and its denizens. The outer room looked like most cafés on the streets of Paris — white and gilt, with mirrors — but the inner room was more than a café. There were five billiard tables, and their green baize tops created an indoor lawn that merged with the garden beyond the windows at the back. The café was dark, smoky, masculine, and intimate; the walls were painted brown from the wainscoting down.

A singular event occurred there in February 1870. Manet, in a fit of rage, stormed into the café and slapped Duranty in the classic gesture that challenged him to a duel. All that is known about its antecedents is that Duranty had written only one terse sentence about the two paintings Manet had sent to an exhibition sponsored by the Cercle de l'Union Artistique, which opened on February 18 on the Place Vendôme: "M. Manet showed a philosopher trampling oyster shells and a watercolor of his *Christ with Angels*." Both men were known for their quick retorts, but Manet was never accused of nastiness, whereas Duranty was notoriously provocative. According to a police report, the two met with their seconds (Zola was one of Manet's) in the forest of Saint-Germain at eleven in the morning on February 23. The choice of weapons was swords, and "their single encounter was so violent that both blades buckled. M. Duranty was wounded above the right breast. . . . Seeing the wound, the seconds declared that honor had been satisfied and that there was no need to prolong the duel."[2]

The two adversaries, relieved that the outcome had not been fatal, resumed their formerly cordial relations, reinforced three months later by Duranty's review of the Salon of that year in which he devoted 120 lines to Manet. The review was filled with praise though still critical: "Apart from M. Courbet, our current painters lack power. M. Manet has that power of tonality which makes a painting stand out among all the others. But if it is not held together by the desire for total execution, all those bright patches float and sink." In spite of his reservations, Duranty continued to predict that Manet would prove to be "one of the greatest painters of our time."[3]

Edgar Degas was two and a half years younger than Manet, and like him was born and raised in comfort. His education gave him "a solid culture comparable to that of Manet and Caillebotte, richer and more diversified than that of other painter-colleagues like Monet or Renoir."[4] Degas's father, very much an esthete and possessing appropriate means, did not thwart the artistic inclinations of his firstborn. The family's affluence came from Edgar's grandfather, who found prosperity in Italy. After fleeing the Terror of 1793, he found employment with a broker in Naples and married his daughter. Edgar's grandmother was a full-blooded Neapolitan, but his grandfather's family has been traced back two centuries to Orléans, where they

were simple tradesmen. Spelled "de Gas," "De Gas," or "Degas," the origin of the name was never noble.

Degas's grandfather proved so successful that he eventually opened a branch of his Neapolitan bank in Paris, where he sent his eldest son, Degas's father, who married another French expatriate, the daughter of a man who had made his fortune in cotton in New Orleans. When that business failed under the stewardship of Degas's brother, coinciding with the death of their father, Edgar gave up his share of the estate to save the business, leaving himself for a time with little more to live on than his artistic gifts could provide.

In his notebooks Degas made no mention of Manet or his works before the mid-1850s. Their legendary meeting may have taken place somewhat earlier, since Degas was already registered as a copyist at the Louvre in 1853 and Manet would surely have noticed his outstanding draftsmanship during his own frequent copying sessions there.[5] Like Fantin-Latour — admitted with Degas to the Ecole des Beaux-Arts in 1855 — Degas was an assiduous copyist of his great predecessors, as were all would-be artists throughout the centuries. Michelangelo, Titian, Watteau, and Rubens all copied their elders and were in turn copied by later artists. Delacroix told Manet that it was his duty to "see Rubens, be inspired by Rubens, copy Rubens; Rubens was a god."[6] Decades later when Degas was asked how one becomes a painter, he replied, "One must copy and recopy the masters before one has the right to do a radish after nature."[7] Of the three coevals, Fantin-Latour was the most faithful copyist; Degas and Manet took liberties in their attempts to produce an interpretation rather than an accurate copy, as in the case of Manet's striking rendition of Delacroix's *Bark of Dante*.[8]

The two men are said to have met in the Louvre, where Degas was copying Velázquez's *Infante* directly onto a copper plate, instead of making a preliminary drawing on paper. "That's pretty cheeky," Manet commented as he passed by. "You'll be lucky if you can get away with it."[9] Degas did not, in fact, get away with it and may well have resented Manet's unsolicited remark, but from that encounter a lasting friendship grew, interrupted by occasional friction. Both men were masters of repartee, Degas harsher by far, generally misanthropic, and almost proud of his intractability: "I don't know how to play piquet or billiards, how to be ingratiating, work from nature, or

simply be pleasant in society. And if I weren't the way I am I wouldn't have a minute to myself for work." Even having him as a dinner guest posed problems: he would eat nothing cooked in butter; could not tolerate flowers on the table, perfume on his female table companions, or his hosts' pets in the same room; dinner had to be served promptly at half past seven; and the light had to be soft. Later in life his aversion to bright light could be excused by his deteriorating vision, which left him nearly blind. But much earlier he declared his distaste for natural light or natural settings: "If I were the government, I would have a police force to investigate people who do landscapes after nature." In his view, a good landscape could only be painted inside the studio. He firmly believed that a work of art was pure artifice, totally outside nature and requiring "as much cunning as a crime." Ballet provided him with the ideal motif. Nothing could be less natural. His cynicism and grumpiness protected a lonely man who enjoyed the company of his colleagues even if he could not resist carping about them: "It is sad to say, but in the world of artists, I have rarely seen people who were jealous of the talent of others, merely of the noise made around that talent. They would be utterly unconcerned if there were a Raphael or a Michelangelo in their midst, so long as he remained completely unknown." [10]

If Degas made no mention in his notebooks of *Le Déjeuner sur l'herbe* or *Olympia* during their tumultuous exhibition, one can assume that he was then embarked on a very different route, more in the wake of Ingres, whose gift for drawing seems to have been passed on to him, than in the vanguard of the future impressionists. In 1862 Degas was still painting historical subjects, such as *Semiramis Building Babylon*. Manet used to say, "When Degas was painting Semiramis I was painting modern Paris." [11] It took Degas much longer to hit his stride. In Renoir's estimation, "If Degas had died at the age of fifty, he would have left behind the reputation of an excellent painter, nothing more; it was after the age of fifty that his work grew and he became Degas." [12] George Moore felt that Degas's painting suffered from his intellect: "The Mona Lisa and [Degas's] Leçon de Dance are intellectual pictures; they were painted with the brains rather than with the temperaments, and what is any intellect compared with a gift like Manet's!" [13]

For a short time in 1867 Manet and Degas were not on speaking

terms. Degas had painted a portrait of the Manets in which Suzanne was seen in profile playing the piano. Displeased with her appearance Manet — or was it Suzanne herself who protested? — cut her off the canvas, leaving only the back of her head and torso. He left himself intact, reclining on a sofa behind her, looking more distracted than attentive. The most characteristic images of Manet, except for Fantin's superb formal portrait, are to be found in this half canvas and in drawings Degas did of him at other times (Fig. 38). Degas was so offended by this act of vandalism that he took back his mutilated painting and huffily returned Manet's gift of a still life, which he later regretted; Manet sold it in the interim.

A year later Manet painted Suzanne in the same pose. It is hard to believe that Degas's image of her was less flattering. Each object in the painting — the clock on the mantel, the piano, the tapestry-covered stool, even the paneling of the wall — seems to have been painted with meticulous interest. Suzanne's chignon, held by a single hairpin, also is rendered with finish. But of Suzanne's face we see only a homely profile on a short, thick neck. Even her hands, which might have been the focus of our attention, are sketchy, especially if compared with her hands in *La Lecture*, a work obviously done at an earlier time, when her appearance and Manet's response to her were quite different.

Degas had good reason to resent the amputation of his work, but after seeing Manet's version, he must have had the satisfaction of knowing that Suzanne was no more fetching in Manet's eyes than in his own. The rift was soon healed, and they were once again exchanging ideas and quips. Despite their artistic affinities and long friendship, they had none of the easy intimacy that Manet shared with Antonin Proust and Zacharie Astruc, or that Degas maintained over a longer lifetime with his classmates from the Lycée Louis-le-Grand — the brothers Henri and Alexis Rouart, wealthy industrialists and amateur artists who were to become great collectors of the art of their time.*

*Henri's son Ernest was Degas's pupil; in 1900 he married Julie Manet, the only child of Berthe Morisot and Eugène Manet, thus linking four major figures in the life of Edouard Manet.

Auguste Renoir was a charter member of the Batignolles group and like Manet was often excluded from the Salons of the late 1860s. Manet's purported opinion of his talent, which originated from a joint painting session, has been repeated almost verbatim by one writer after another, as is often the case with celebrity anecdotes; no one questioned its intention or plausibility. During a visit to Monet in Argenteuil one summer day in 1874, Manet decided to paint Monet's wife and son in their garden. Renoir, also present, followed suit. After looking at Renoir's canvas, Manet reportedly took Monet aside: "You who are so close to Renoir, you should advise him to find another line of work. You can see that painting is not for him!"[14] Tabarant devotes five pages to denying that Manet ever said anything so outrageous, quoting every version thereof, and citing as contrary evidence Renoir's central position, just behind Manet, in Fantin-Latour's *Studio in Batignolles* of 1870. Since Monet himself is said to have related the incident — his son claimed to have heard it, long after the event, from his father's lips — it may be more useful to try to understand it than to deny it. Rather than a belittling of Renoir's ability, which Manet admired on numerous other occasions, the remark may well have been a teasing one, and even perhaps a tribute to Renoir's rendering of the same subject, since it can suggest the recognition of a younger rival. The element of humor or facetiousness is often overlooked in figures who become sanctified. Once the context is lost, so too is the laughter. Less good-humored perhaps, but no less facetious, was Degas's opinion of Renoir's work: "so fluffy it had to have been painted with skeins of yarn."[15]

Born in 1841, Renoir was the youngest of the Batignolles group. His father, a tailor, seeing his son's artistic talent, apprenticed him to a porcelain painter. The family had come to Paris in 1850 from Limoges, famous for its delicately decorated porcelain. French eighteenth-century painting, with its sensuality and feminine sensibility, was to be Renoir's elementary school, and Watteau, Boucher, and Fragonard were his first teachers. "Under his brush, the men who posed for him took on an indefinable feminine quality, and he conferred even on landscapes something of the tender succulence of female flesh."[16] Although his work, like Monet's, came to diverge widely from Manet's, during the Guerbois years both were convinced of Manet's supreme importance as a pathfinder for the new painting. Only a year older, Monet was the one who gave Renoir moral and

artistic support. "I would have given up, if not for him," Renoir admitted years later.

Claude Monet, born in Paris in 1840 but raised in Le Havre, was the son of a wholesale grocer. Because his father saw no reason to support a would-be painter, Monet's first decades as an artist were spent in the misery associated with bohemian life. He lived with his model, Camille Doncieux, for years before marrying her in 1870, three years after the birth of their son Jean. In 1879 Camille died, leaving him with a second son, born the year before, by which time he was already involved with the unhappy wife of another man, Ernest Hoschedé, a prosperous department store owner who was less interested in his numerous offspring than in avant-garde art. His important collection was to include Manet and many of the impressionists. A year after Camille's death, Monet set up house with Alice Hoschedé, her six children, and his two sons, but he could not marry her until she was widowed in 1891.

In the days of the Café Guerbois, Monet was still a satellite in Manet's orbit. But even after he became the leader of the impressionist school, his conviction that Manet was a great artist remained unchanged, as did his well-founded gratitude. It was he who undertook in 1890 the daunting task of raising enough money in the world of arts and letters to buy *Olympia* from Suzanne Manet so as to present it to the Luxembourg Museum, the museum of contemporary art at the time. Only ten years after the death of an artist could his work enter the Louvre.

The list of contributors who provided the sum of 19,415 francs comprises enough names of artists, collectors, and writers to fill a page, including some who had been highly critical of Manet and others who had been rivals rather than colleagues, like the much more successful Giovanni Boldini. Outstandingly absent is the one name one would have expected to be the first — in fact to have been the initiator of the idea. In his response to Monet's request, Emile Zola explained his refusal to contribute to the fund: "I have supported Manet with my pen enough to fear now the reproach of bargaining for his glory. Manet will enter the Louvre, but it must be on his own, through the recognition of his talent by the entire nation, and not in this devious form of a gift which will smack of parochialism and publicity."[17] Zola's sanctimonious reply smacks of pettiness and parsimony. He was by then a best-selling author; those early days of art

criticism, when he had made his name with his daring defense of Manet, were far behind him. Manet was no longer a cause that interested him.

The beginnings of the relationship between Manet and Monet were not exactly amicable. Manet was made aware of this younger near homonym before he met him. In the Salon of 1866 Monet's *Woman in a Green Dress,* a full-length portrait of Camille Doncieux, won considerable attention. André Gill, the renowned newspaper cartoonist, wrote as a caption to his caricature of the painting, "Monet or Manet? Monet. But it is to Manet that we owe this Monet; bravo Monet, thank you Manet." Manet, already irritable over his own bad reviews, fumed: "He makes a success for himself under my name while they throw tomatoes at me!"[18] Monet later recalled that it was Zacharie Astruc who finally brought them together. They must have met before May 1867, because a letter dated May 20 from Monet to Frédéric Bazille (Monet, Renoir, and Bazille had entered Gleyre's studio at the same time) speaks of Manet in a way that indicates he knew him by then: "Manet's opening [of his one-man show] is in two days and he is in a state of agitation."[19]

Throughout the 1870s letters from Monet document the generous help and interest he received from his older colleague, from finding him a cheap house owned by friends of the Manet family in Argenteuil to repeatedly lending him money, which Monet was rarely able to repay. A letter to Manet dated May 14, 1879, which epitomizes many of the earlier ones, was written in a moment of despair. At other times Monet at least made the pretense of believing in future success.

I think of you very often and of what I owe you, and you are really very kind to have refrained from asking me to return the money, the absence of which you must be feeling. I know that at the moment you are somewhat pinched and that you were planning to write to me concerning this subject. Since the reply I would make is not the one you would like to receive, I prefer anticipating your letter and confessing to you the absolute impossibility of returning to you the smallest amount at this time. I hope you won't hold it against me, for I am myself in extreme distress and in trouble up to my ears, and the little money I had of late has gone entirely into medicine and doctors' visits since my wife and child have been constantly sick; on

top of that, dreadful weather that makes any work impossible, or almost. So that I have really hit bottom, I am discouraged, and I have paint coming out of my eyeballs, for I see it will be necessary to continue dragging out this miserable existence all the way to the end without any hope of ever succeeding.[20]

The only member of the Batignolles group older than Manet was Camille Pissarro, born in France's Caribbean colony of St. Thomas in 1830. He was considered the rarest of men — teacher and pupil in one, who taught and encouraged his younger colleagues as willingly as he learned from them. Zola, writing about Pissarro in his review of the Salon of 1866, admired his bleak landscape, *The Banks of the Marne in Winter*: "I know you were admitted with great difficulty and I warmly congratulate you. Moreover, you must know that you please no one, that your picture is seen as too bare, too dark. So why the devil do you have the glaring clumsiness of painting solidly and studying nature candidly! . . . Yours is an austere and serious painting, with a deep concern for truth and accuracy. . . . You are supremely clumsy, monsieur — you are an artist I like."[21] Paul Cézanne, who had worked alongside Pissarro and so many of their colleagues at the Académie Suisse, became Pissarro's pupil, later remembering him as "humble and colossal, something like God the Father."[22]

Pissarro was nevertheless ostracized as an enemy alien by Degas, Renoir, Cézanne, and their anti-Dreyfusard friends the Rouart family, once the Dreyfus case divided friends and relatives into warring factions. Being a Jew and a Dreyfusard, Pissarro was no longer considered French or a friend by those of his former colleagues who were in the other camp; even his art was seen as inferior. When Degas was reminded that he had once admired Pissarro's work, he replied, "That was before *L'Affaire!*," as the Dreyfus case was called at the time.

The artistic world of Paris was no less affected than the rest of France by the virulent hatred engendered by this ugly episode. In her diary Julie Manet (the only child of Berthe Morisot and Eugène Manet) expressed the general sentiments of many conationals after Emile Loubet became president in February 1899: "It is horrible . . . to think that the army is obliged to serve and defend a man who sides with its enemies; he is not French since he is a Dreyfusard." In an entry of January 1898, she quotes Renoir on the subject of Jews in

general: "They come to France to make money and then if there's a need to fight they go hide behind a tree." But almost in the same breath, Renoir says that there are many Jews in the army, "because the Jew likes to parade around in military braid. If they are chased from every country there is a reason for it, and they should not be allowed to become so important in France. There are people who want the Dreyfus case to be brought out in the open, there are, however, things that can't be said, but they don't want to understand that." As for the Jewishness of Pissarro — whose sons aroused Renoir's ire because he thought they had avoided military service — Renoir remarked, "It's tenacious, that Jewish race; Pissarro's wife is not [Jewish] yet all the children look even more Jewish than their father." Pissarro fathered seven children by his mother's maid, whom he married after the first two children were born. All five sons became painters. Renoir's anti-Semitism reached such a pitch that when talking about the work of the non-Jewish Gustave Moreau, which he disliked, he categorized it as *"de l'art pour juifs"* (art for Jews), meaning in bad taste.[23]

Pissarro's pupil Paul Cézanne was never a regular patron of the Café Guerbois, nor can he be regarded as a bona fide member of the Batignolles group, but his artistic affiliation with its members, his equally intense admiration for and resentment of Manet, and his close ties with Zola, Bazille, Renoir, and Pissarro granted him auxiliary acceptance. During the 1860s he came to the Guerbois erratically, sometimes joining the table, then suddenly taking umbrage and storming out, not to reappear for weeks on end. On one of his irregular appearances, he shook hands all around, but to Manet he said, "I won't shake your hand because I haven't washed mine in a week." His father, a successful hatter turned banker, supported him quite generously all his life, but Cézanne chose to affect the boorishness of a down-and-out bohemian, particularly in the presence of Manet, whose refined dress and demeanor annoyed him, as did Manet's position of leader among the younger painters. Manet, not much more sympathetic to Cézanne, found his painting as uncouth as his manners. When Manet affably asked Cézanne if he was sending something to the Salon that year, Cézanne replied, "Yes, a jar of shit!" (*Oui, un pot de merde*).[24] The two, even if there was little warmth between them, had views, friends, and tastes in common, among them Zola, Baudelaire's poetry, and a commitment to the institution of the

Salon. Manet was apparently a constant irritant during the early part of Cézanne's career.

In 1863 Cézanne had shown a still life, largely overlooked, in the same Salon des Refusés as Manet's much-defamed *Déjeuner sur l'herbe*. Two years later *Olympia* caused another uproar. Both works were to reappear in a number of variations by Cézanne in oils (*Rum Punch*, his own *Déjeuner*, *Afternoon in Naples*, and later *A Modern Olympia*), sketches, and watercolors, all recognizably inspired by Manet's two great succès de scandale. Like Manet, seven years his senior, Cézanne was convinced that the Salon was "the only battlefield on which an artist can reveal himself at one stroke"[25] to both the critics and the public, and in this he apparently set out to surpass Manet at his own game by outraging the public with themes taken from Manet, but crudely rendered. Cézanne's admiration for Manet's painting was later contaminated by his resentment over Zola's effusive praise of Manet. In his many articles on the painters of his day, Zola never mentioned Cézanne, despite a friendship that dated from their school days in Aix. The friendship ended in 1890 when Cézanne recognized himself in the protagonist of Zola's *L'Oeuvre* — yet another bond with Manet, who, with Monet, provided many other traits of Zola's painter, Claude Lantier.

At first Cézanne and Manet were incompatible because Manet found repugnant Cézanne's manners and appearance — his nervous twitch, filthy clothes, irascible temper, and uncouth language. By 1866, after seeing *Afternoon in Naples*, Manet could no longer sustain even the interest that Cézanne's earlier still lifes had held for him. He was amazed that Antoine Guillemet, the painter who served Manet as a model for *The Balcony*, continued to defend Cézanne's work. Monet claimed that it was because of Cézanne that Manet refused to exhibit with the impressionists, adding that "many of the other exhibitors cared little for this comrade [Cézanne]."

Frédéric Bazille, with Renoir the youngest of the Guerbois regulars, was a gifted painter whose career was cut short by the Franco-Prussian War; he was barely thirty years old when he was killed in action. Manet's influence during Bazille's formative decade of the 1860s is very apparent in Bazille's work, which nevertheless has its own stamp. In Bazille's *Artist's Studio in the rue de la Condamine*, a number of the Batignolles group appear (Monet, Renoir, Zola, Bazille himself), prominently among them Manet, who took over

Bazille's brush and painted the artist at his easel. Bazille's membership in the group was consecrated in Fantin-Latour's *Studio in Batignolles*. His unusual height, well over six feet, makes him identifiable in any painting or photograph of the time. It was he who first had the idea of a joint exhibition of "the new painting," which finally took place in 1874 after his untimely death, and in which Manet refused to participate.

Arguably the most important figure in Manet's personal and artistic life as of 1868 was one who could never sit and argue at the tables of the Café Guerbois or the Nouvelle-Athènes. A respectable woman did not cross the threshold of such establishments, and Berthe Morisot was eminently respectable. Rosa Bonheur, twenty-one years her senior, might have been seen wherever artists gathered, but she was a bohemian and a professional artist, the daughter of a minor artist in Bordeaux. Like George Sand she wore trousers, but instead of appearing at Parisian salons, she went to country fairs and slaughterhouses to paint farm animals and peasant scenes. Although she won medals at the Salons and was made a chevalier of the Legion of Honor in 1865, Rosa Bonheur would not have been fit company for a woman of Morisot's breeding.

Like Manet, Morisot was born into the upper bourgeoisie, with a background of cultivation and taste, though lacking both great wealth and formal education. Her mother, Cornélie, was a woman of impressive intelligence and considerable wit. Her chatty letters, written in a minuscule, almost illegible hand, offer a vividly candid picture of her family and friends. She encouraged her daughters to develop their artistic talents and provided solid training for the two younger ones, Berthe and Edma, but she never dreamed that either one might become an artist. A woman painter was an abomination, as was any female professional.

The second half of the nineteenth century was particularly hostile to this phenomenon, perhaps in reaction to the gains made in the 1830s and 1840s by a number of prominent women writers, not all of them as unconventional as George Sand. Balzac grudgingly recognized what he called "the great female emancipation of 1830," and although he accepted George Sand among his friends, his feminist sympathies were limited to the educated women who bought and read his novels. A Marie d'Agoult writing under the name Daniel Stern, who had left her husband and children for Franz Liszt while re-

taining her title of countess, or a Louise Colet, who had an illegitimate child with Victor Cousin, stabbed the journalist who ridiculed her affair, and later became Flaubert's mistress, was hardly a suitable model of feminine behavior. But by the 1840s the notion of an educated, talented, independent, and successful woman — who earned money for her writing (George Sand, Virginie Ancelot, Juliette Adam) or her singing (Maria Malibran, her sister Pauline Viardot, Adelina Patti) — had gained limited currency in London and Paris.

As the century progressed, the old fear that educated women, especially professional women, would undermine society regained strength. A woman musician might be tolerated, or a novelist, preferably writing under a pseudonym about uncontroversial subjects. But an actress or a dancer was tantamount to a prostitute. As for a woman painter, Renoir made clear the view of most men: "I regard women writers, lawyers, politicians, like George Sand, Mme [Juliette] Adam, and other troublesome females as monstrosities and nothing but five-legged calves. The woman artist is simply ridiculous, but I do favor the female singer and dancer."[26] It is one of those ironies of life that Morisot's paintings were to be accepted by the same Salon juries that rejected some of her male colleagues, among them Manet.

When Berthe was born in January 1841, three years after her eldest sister, Yves, her father was prefect, or chief government official, of the Cher, one of the administrative regions of central France. The family lived in Bourges, whose magnificent cathedral rivals the better-known Chartres. Another daughter, Edma, two years older than Berthe, was closer to her than an identical twin in taste, talent, and temperament. Until Edma's marriage in 1869 to Adolphe Pontillon, a fellow cadet of Manet's on the *Havre et Guadeloupe*, the two were inseparable. In 1852 the Morisot family — by then augmented by a son, Tiburce, his father's namesake — resettled in Passy, at that time a wooded suburb of Paris, now part of the sixteenth arrondissement. Like Manet and many Parisians today, Berthe would remain faithful to her neighborhood throughout her life.

In 1858 the three sisters began taking drawing lessons. This was not like the one-hour weekly music lesson imposed on most children of middle-class families; the Morisot sisters spent twelve hours a week with their drawing teacher, of whom all three soon tired. Yves decided she would rather sew, but Berthe and Edma wanted to continue with someone else. Joseph-Benoît Guichard, a Salon painter de-

scribed as having blended Ingres and Delacroix into his art, lived on the same street as the Morisots. He was uninspiring as a painter and a teacher, but he took his young charges to the Louvre, exposed them to great art, which he taught them to copy, and soon recognized their talent to the point of fearing that he might be creating monstrosities. In a remarkable letter to Mme Morisot, he warned her about the dangers his teaching and her encouragement might unleash: "My teaching will not endow them with polite little talents; they will become painters. Do you realize what that means? In your upper class milieu, this would be a revolution, I would almost say a catastrophe. Are you quite sure that you might never curse the day when art, having once entered your respectably serene house, would become the sole master of the fate of your two children?"[27] He may not have known it, and surely their mother did not, but Berthe and Edma had in fact already decided that they wanted to become artists.

At that time countless women of various social strata were studying art, painting, drawing, and copying. They were even exhibiting at the official Salon, but no studio would accept a woman as a student. A drawing master, even an established painter like Guichard, might teach talented ladies privately in his home. But studios like those of Couture, Picot, Gleyre, Flandrin, and Lecoq de Boisbaudran, to mention a few of the most respected, would not entertain the thought of a woman's presence, however gifted she might be. A woman was thus unable to study anatomy or work from nude male models, not even fully clothed male sitters, except relatives. This explains why most women painters across the centuries, with the extremely rare exception of Artemisia Gentileschi and a few of her Renaissance colleagues, painted flowers, landscapes, portraits of women, and interiors. No one ever doubted that women had talent, but it was unseemly for women to practice art, to be exposed to nudity, and to enter into the commerce of selling their works — or into direct contact with men — despite the fact that women, among them the Morisot sisters, were showing their works in the Salons and in the windows of art dealers, occasionally even selling them.

An even greater "monstrosity," to use Renoir's term, than a woman painter was a woman sculptor, yet a rare few managed to work, show, and sell. Exceptional among them was Adèle Colonna, an aristocrat by birth and marriage, known professionally as Marcello. Well after the turn of the century, the case of Camille Claudel, who worked with

Rodin and produced major sculptures (there are those who think Rodin attributed some to himself), indicates how little opportunity a woman had to be taken seriously as an artist.

If propriety was not the overriding concern, then a woman's artistic commitment was questioned. George Moore, writing at the beginning of the twentieth century, declared: "[A woman writer] will make no sacrifice for her art; she will not tell the truth about herself as frankly as Jean-Jacques [Rousseau] nor will she observe life from the outside with the grave impersonal vision of Flaubert." Moore had come to Paris in the 1870s, when he was in his early twenties. He stayed eight years, studied painting, became acquainted with Manet and his circle, posed for Manet, and later went on to write about the artists of his youth. He had even less admiration for women painters than for women writers, with two exceptions: "Whatever women have done in painting has been done in France . . . twenty Englishwomen paint for one Frenchwoman, but we have not yet succeeded in producing two that compare with Madame Lebrun [Elisabeth Vigée-Lebrun (1755–1842), noted for her portraits and flower still lifes] or Madame Berthe Morisot."[28]

Writing only three years after Morisot's death, Moore acknowledged her achievement in almost hyperbolic terms: "Madame Lebrun painted well, but she invented nothing; she failed to make her own any special manner of seeing and rendering things; she failed to create a style. Only one woman did that, and that woman is Madame Morisot, and her pictures are the only ones painted by a woman that could not be destroyed without creating a blank, a hiatus in the history of art." One wonders how he could have said about this same painter: "No deep solutions, an art afloat and adrift upon the canvas, as a woman's life floats on the surface of life."[29] The conditioning was so deep-rooted that Morisot herself was torn between her compulsion to paint and her reluctance to take herself seriously. Her letters to her sister reveal an almost pathological insecurity, a distrust of compliments, and an insatiable need for reassurance.

By 1860 Morisot was beginning to look beyond the Louvre and Guichard's studio to the outdoors; she wanted to work from nature. This Guichard would not entertain. He suggested that the two sisters turn to Corot, whose muse was Nature. Camille Corot was then sixty-four. He was a highly respected Salon painter who showed only landscapes of France and Italy in official exhibitions (except for the

Salon of 1869, in which he presented his famous figure painting, *Interrupted Reading*). Though much older than the generation then entering maturity, he was a friend and admirer of many of the realist, naturalist, and impressionist painters and critics, and they of him. Very much a Parisian and a habitué of the café and boulevard life of the city, he preferred the poetic landscapes of rural France and sylvan Italy to the urban scenes favored by his younger colleagues. He agreed to advise the Morisot sisters in a kind of informal tutorial, but he never had a teaching studio, strictly speaking, nor did he formally accept pupils.

The sisters remained under Corot's tutelage for six years. In addition to outdoor sketches, they were required to make accurate copies, in some cases of Corot's works. His insistence on accuracy was so stringent that he made Berthe do over her copy of one of his Italian studies because she had left out one step of a staircase. Edma, more precise than Berthe, was rewarded with Corot's original; even more flattering, he kept her copy. This may explain why Berthe destroyed all but one of her copies of Corot. Her free-spirited approach to copying, not unlike Manet's, rebelled against such constrictions. This also may explain why Edma, equally skilled but not equally talented, remained an amateur.

Corot became a friend of the family, and an important one, since he was able to introduce Berthe and Edma to professional painters under conditions suitable for respectable young women. He had a country house outside of Paris, at Ville d'Avray, where the sisters went during the summer for painting sessions, often in the company of other artists but chaperoned by Corot, and he became a regular at the Morisot soirees, often bringing other artists with him. Through him they met the landscape painter Achille Oudinot, who took over as their teacher when Corot left for an extended trip and who in turn introduced them to Daumier, Daubigny, and Manet's friend Antoine Guillemet. Earlier, at Guichard's, they had met another student, Félix Bracquemond, best known for his engravings, though also a painter, and married to a painter who was the same age as Berthe. Bracquemond was close to Manet as both friend and colleague, often doing engravings of Manet's works, and to the entire circle of artists and writers around him.

Social relations among artists of bourgeois manners, if not birth and property, were made possible by the frequent and regular

soirees — less formal, pretentious, and costly than the grand weekly salons of the aristocracy, the very wealthy bourgeoisie, or the demi-monde — held by ladies such as Mme Manet and Mme Morisot or by the artists themselves if they had the means. Alfred Stevens, the successful Belgian painter, and his charming wife held theirs on Wednesdays; Mme Manet received on Tuesdays, Mme Morisot on Thursdays. Many within the same circle attended receptions on other days given by writer Paul Meurice and his pianist wife; Mme Loubens; and Mme Lejosne (both ladies are seated in the foreground of *Music in the Tuileries*) and her husband, the Commander.

The Morisots, whose fortune was not quite commensurate with their social standing, were nonetheless able to entertain *comme il faut*, thereby facilitating their daughters' contact with interesting people, including but not limited to artists. Manet entered their circle in 1868. Very quickly the Morisots and the Manets began receiving one another, with regulars of both houses creating a continuous chain between the two, so that even in cosmopolitan Paris, social life was as closely meshed as in a village, at least for women who had no access to café life. In their correspondence the repetition of the same names by the Morisot sisters and their mother sounds like the gossip of any small community.

In August 1868, in his letter from Boulogne, Manet wrote to Fantin-Latour: "I agree with you: *les demoiselles* Morisot are charming. What a pity they are not men. However, they could, as women, serve the cause of painting by each marrying an Academician and bringing discord into the camp of those old fogies. But that would be asking great devotion. In the meantime, present them my compliments."[30] These facetious remarks have been seen by some as reductive and antifeminist, and could even lend weight to George Moore's contention that Manet disparaged Berthe as an artist. "My sister-in-law would not have existed without me," Moore quotes him as saying. To which Moore added his own view: "In her it was the art of Manet transported *en éventail*,"[31] a reference to the minor art of fan painting so fashionable at the time (Manet and Degas both did a few) and perhaps to the feminine subjects of Berthe's works. It also may be a pun on the constant presence of a fan in Manet's portraits of Berthe.

Every art historian, as Beatrice Farwell confirms, "has wondered what emotional undertones reverberated beneath the ostensibly proper

relationship between this married man and the disturbingly attractive, still young, unmarried colleague who sat for him so often and who ended up married to his brother."[32] In view of the patently expurgated correspondence published by one of Berthe's grandsons, it is not possible to quote Berthe's words concerning her feelings about Manet, other than those deemed suitable by her descendant. We do not have her descriptions of their sittings, nor of her visits to his studio before and after her marriage, though they are mentioned. But a careful reading of what remains of her letters provides a foundation for rational conjecture, amplified by the paintings themselves.

Twelve paintings document the relationship between artist and model; she posed for and appears as herself in eleven of them, and the one from which she is absent (*Bouquet of Violets*) depicts both her symbolic presence and his. Even if all the letters between the two were to reappear, they would probably contain little that was sensational. It is unlikely that they would have exchanged compromising notes in the first place, and if they had, it is even more unlikely that they would have kept them. They had many opportunities to speak, since they saw one another in society as often as once a week, and even more often, and more privately, when she was sitting for him.

The confidential letters exchanged between Berthe and Edma are another matter entirely; if their elisions were restored, they might have a great deal to tell. Some letters were prudently destroyed. Married barely two weeks and writing from her new home in Brittany, Edma warned, as early as March 21, 1869: "I know how you leave your letters lying around; therefore, burn this one as well [*brûle donc encore celle-ci*] and continue writing me your babbling, as you call it; I have nothing better to do than to decipher it." Her instruction to "burn this one as well," implying that others had been burned before, allows us to assume that the practice would and did continue. In this instance, Edma had personal reasons for wanting her letter destroyed. She was bored — "Always the same existence; sitting by the hearth, the rain falling. [*Toujours la même vie ici; le coin du feu et la pluie qui tombe.*]" Her husband, she assured Berthe, was kind and attentive, but that was inadequate compensation for the stimulating company she had left behind in Paris: "Consider me crazy if you like, but when I think of all those artists, I tell myself that a quarter-hour of their conversation is easily the equal of solid qualities."

This is hardly the euphoria of a new bride. She sorely missed paint-

ing beside her sister in their studio, their discussions about art, the gossip and teasing among artists, and the amusing soirees with their friends. Her mother had just written to her, "Wednesday, when [Alfred] Stevens handed me a letter from Puvis [de Chavannes] asking both of us to come and visit him the next day, Manet took Berthe into a corner to say to her: 'Don't hesitate to tell him all the nasty things you can about his painting!'" While Berthe was being entertained by the wit of Manet and Degas, all Edma had was snow, rain, the fireplace, and her husband's chatter ("Adolphe, who is always talking, has repeatedly urged me as I write to send you his warm greetings").

In the letter that Berthe neglected to burn, Edma also had written, "My crush on Manet is over [*Ma toquade pour la personne de Manet est passée*]." She then made a pointed distinction between her former feelings for Manet and her interest in Degas: "*c'est différent.*" She was merely "curious to know what [Degas] could have said to you about me and what he finds strange about me." This is a noteworthy confession. The sisters shared many secrets, many talents, many tastes. Was Edma's infatuation among them? There is no proof that Berthe was equally candid with her, but it is not unlikely that both sisters were similarly taken with this man whom men also found irresistibly charming. Berthe had appreciated Manet's originality as a painter long before they met, and over the years her admiration grew. She may have been the only one of his contemporaries who understood the complexity of his art.

Berthe's letter to Edma of March 19, 1869 (to which Edma's of the 21st was a reply; in those days mail traveled fast), reveals their mutual bereavement as well as Berthe's view of a woman's condition. The way it is phrased suggests that Berthe was preaching more to herself than to Edma, having come to the conclusion that her fate was already sealed.

If we continue like this, my dear Edma, we shall no longer be good for anything, you cry on receiving my letters and I, I did the same this morning; your notes, so affectionate but so melancholic, and your husband's kind words made me burst into tears; but I tell you again, this attitude is unhealthy; we lose thereby what remains to us of our youth and beauty; for me, it is unimportant, but for you it is different.

Yes, I find you childish; this painting, this work you miss, is the

cause of many worries and many upsets, you know that as well as I and yet, child that you are, you already lament what depressed you only a short time ago. Come now, you do not have the worst share, you have a serious affection, a devoted heart that is entirely yours, do not be ungrateful to fate, think how sad it is to be alone; whatever one says, whatever one does, a woman needs immense affection; to try to make her fall back on herself is to attempt the impossible.

Both sisters had given potential suitors the impression that they had no wish to marry, that they were serious about painting and not mere dilettantes. Their mother had very different notions and made every effort to have them meet suitable men, knowing in advance, since she was a very bright woman, that like her other initiatives this too would come to naught. Like most mothers she could not abide her daughters' sloppiness: "Let it be said in passing, I think it is rare to find more negligent individuals than the two of you; how many things you must botch, and . . . must always be missing." To have daughters who were allies and accomplices in all things, to the exclusion of the rest of the family, was indeed a burden. Their elder sister, Yves, had written to them during the summer of 1862 while they were painting in the Pyrenees: "Father said last evening that we would never be privy to all the events of your trip, but that over the next six months you would talk about it between yourselves in the privacy and secrecy of your rooms; we will have to listen at the door if we are at all curious to hear about your impressions."

Life in the Morisot family was complicated, but Mme Morisot was very lucid about it, as she wrote Berthe in June 1869, when Berthe was visiting Edma:

Your father seemed very touched, *cher Bijou*, by your letter, he seems to have discovered in you unknown treasures of feeling and, particularly with respect to him, an unaccustomed tenderness . . . so that he often says he regrets your absence; but I wonder why? You hardly speak to each other, you are not in tune with one another, *is it over money or being a caged bird?* I try to prove to him that, on the contrary, it is much more restful not to see your poor little lost face and *your disgruntlement with a fate about which we can do nothing;* it is a relief. So that is how things stand and we end

up by agreeing with each other that it is much better for you to be with Edma, and that you should remain together for a while [emphasis added].

Apart from its revelation of family tensions and Berthe's "disgruntlement," what is most striking about this letter is the sequence of sentences within the same paragraph. Immediately after telling her that everyone concerned is better off if she remains with Edma, Mme Morisot suddenly mentions that she went to the Manets' to return "the books" — *les livres,* not the indefinite *des,* which would merely be "some" books. This seems to imply that the books in question had been lent to Berthe by Manet and would explain the link in Mme Morisot's mind between Manet and Berthe's anguished state: her attraction to a married man, a "fate" that her parents were powerless to change; her feeling like a "caged bird" because she was trapped in her condition — a woman without an income of her own and a social position that did not countenance "bohemian" relationships.

The correspondence among the Morisots reveals a distinctly modern family. Despite Mme Morisot's desire to see her daughters married, it was she who encouraged them to paint, she who busied herself with the progress and exhibition of Berthe's paintings, she who set the tone of objectivity and honesty. It is, therefore, not surprising that Berthe could write to Edma, "Adolphe [Edma's husband] would certainly be astounded to hear me say such things; men readily believe that they fill one's entire existence; whereas I believe that however much affection one may have for one's husband, one does not easily break the habit of work; sentiment is a lovely thing provided it is accompanied by something to fill one's days; that something I see for you in motherhood." Edma had already intimated that she might be pregnant, which to Berthe seemed a way of giving meaning to a life of provincial domesticity; it was not enough just to be married.

For herself such a life would have been death. Much as she feared the loneliness of spinsterhood, she could not settle for marriage with just any respectable man. In her milieu "respectable" meant someone with a similar social position and a secure income, though not necessarily great wealth. In Mme Morisot's eyes the Manet brothers had money but could hardly be considered rich. It was indeed much more than most of their artist friends had, and those were the men Berthe found interesting. Her parents were certainly not fortune hunters for

their daughters, but as they could not ensure a comfortable future for all their children, they hoped their daughters would marry well. Their youngest child, Tiburce, a promising ne'er-do-well who knew more about spending than earning, was another concern. All around Berthe were reminders that she was a misfit, that it was all very well to be talented but that time was running out, and that she was a disappointment — to her parents, who expected to see her suitably married by the age of twenty-eight instead of moping at home and still their dependent; to herself for her lack of resolve and for still floundering as an artist.

The independence Berthe craved, the kind enjoyed by her sculptor friend Adèle Colonna, known as Marcello, was closed to a Morisot. A wealthy noblewoman, five years older than Berthe and married, Marcello could do as she pleased. To make matters worse, the man who had given Berthe a sense of her own worth was now distracted by a younger, officially recognized disciple; not only was Eva Gonzales studying with Manet, but she was posing for him as well. Mme Morisot reported in a series of unconnected phrases that she found Manet

increasingly jubilant about his model Gonzales; *la mère* [Mme Manet] made me touch the hands of her daughter-in-law [Suzanne] telling me that she was feverish; *la fille* [Suzanne] gave a fake laugh and reminded me that you were supposed to write to her. As for Manet, he did not budge from his stool. He asked me for news of you and I replied that I would communicate his coolness. You are out of his mind for the time being. Mlle G.[onzales] has all the virtues, all the charms; she is an accomplished woman; this is what the poor girl whispered in my ear as she led me out.

That Mme Morisot would be reminded of Manet when talking about Berthe's "disgruntlement over [her] fate" suggests her suspicion that he might have been its cause. This seems to be confirmed by her strangely contemptuous references to the other members of the Manet household: "*la mère*" is the way one might speak of a peasant woman, not of the dignified lady who was hostess and guest of the Morisots; "*la fille*" and "*la pauvre gosse*," more accurately translated as "the poor kid" and as inappropriate in French as in English, are both ironic and patronizing terms for a woman nearing forty. It is almost as if anything having to do with Manet had become distasteful

to her, even to the point of commiserating with the neglected wife, *"la pauvre gosse."*

Eva Gonzales was pretty, twenty-one (seven years younger than Berthe), and a passably talented artist. She was the daughter of Emmanuel Gonzales, a noted journalist and writer, president since 1863 of the Société des Gens de Lettres. Through her father she knew many artists and writers, some of them Manet's friends, to whom she expressed her admiration for his work. It was Alfred Stevens who introduced her to him. Her enthusiasm must have been fairly overpowering, for Manet took her on as his first and only pupil in February 1869, five months before Mme Morisot made the remarks just quoted.

The portrait for which Eva sat cost him two years of frustrating work. She is seen in flowing white muslin, looking like an avatar of Mme Vigée-Lebrun, painting a floral still life. The palette and brushes in her hands do not make her a convincing artist at work. She seems rather to be posing as one in her immaculate garden-party gown, making a pretty picture that allowed Manet to insert himself with an amused and amusing touch: he signed his name on a rolled canvas beside a superbly painted peony, a signature flower, in the lower right-hand corner. She may be practicing his craft, but the work of art is his: in fact she is entirely his creation. Her *Enfant de troupe*, obviously inspired by Manet's *Fifer*, is no great tribute to her teacher, although some critics found her work admirable. Other portraits of her reveal a prettier face than Manet painted, but his portrait flattered her artistic ambitions.

What is most significant about this figure compared with the similarly attired Berthe Morisot in *Repose*, which was painted contemporaneously and with much greater ease, is its remoteness from the painter. Gonzales is frozen in her pose, her expression sweetly blank. In *Repose*, as in every other portrayal of Morisot, there is a dialogue of sorts between the model and the painter, a flirtatiousness in the pose (behind a fan, an ankle revealed, half reclining), an intensity that can make the viewer almost uncomfortable. The fact that Manet never painted Morisot at work does not mean that he looked down on her. Manet never painted Fantin-Latour or Degas before his easel. Morisot interested him as the model for a modern woman. Her painting was her private world. She was never his pupil, although much advice was given and many corrections made. She was already an accomplished painter by the time Manet met her, and she had studied

with distinguished teachers. He may have had a great deal to offer her in terms of originality and technique, but she was far beyond the level of a pupil, and far beyond the accomplishments of Eva Gonzales. Had Morisot been able at the time to see Manet's vision of her as it unfolded over the coming years, she would have found little reason to be jealous.

Manet painted Gonzales twice, the formal portrait mentioned above, and seen from the back standing at an easel while working on her *Enfant de troupe*. In both she is "the young painter at work," in the latter not even recognizable except by her canvas of *L'Enfant de troupe* (Léon also is in the picture, this time in Spanish costume: a studio figure). In his eleven portraits of Morisot, Manet painted a woman who captivated him for eight years at the very least, and in a way that no other woman ever would. In later years his flirtation with Isabelle Lemonnier and his more intimate relationship with Méry Laurent would result in some excellent works, but none would ever recapture the passionate fascination of his portraits of Morisot.

Gonzales was young enough and unfinished enough for him to play the role of teacher, and Manet surely enjoyed her adulation. He may have hoped that his position in the art world would be enhanced by his new role of teacher of Emmanuel Gonzales's daughter, or at least that critics would think twice before attacking him. (He was not above pandering to a useful connection now and then, as in the case of the persistently negative but powerful critic of *Le Figaro*, Albert Wolff, whose portrait Manet undertook, ostensibly because Wolff's "anthropoid face interested him as a beautiful monstrosity," Proust explains, though more likely to sway him through personal contact.) Gonzales did not involve his thoughts or his sentiments; she was no more than a delightful diversion. He may even have used her as a means to cure Morisot of dangerous longings, and himself as well. So much the better if he seemed cold and she was jealous. Had Morisot's feelings for him been more neutral, she might have been more confident in her ability. Instead she became painfully self-conscious and increasingly insecure about her person and her talent. The hopelessness of the situation eventually took its toll on her health.

During the spring of 1869 Morisot sat for the intriguing portrait paradoxically titled *Repose* (Fig. 27). This was the second time she modeled for him, *The Balcony* having been the first. She is seen in a most unconventional pose, slouched on a sofa, lost in thought, her

left forearm resting on the seat, her graceful fingers carefully rendered, her right wrist on the arm of the sofa, her hand holding the fan that had already become her attribute. A powerful feminine presence emanates from the pose — from the ankle revealed in its white stocking to the dark eyes that look off nostalgically to one side. This is a beautiful, desirable young woman, captured in the intimacy of a personalized interior setting, rather than the formal portrait of a proper young woman, which would have had her sitting upright in a chair against an impersonal background. The indecorous pose in no way impugns the respectability of the model, but she is seen in what appears to be the privacy of her thoughts in her own home.

Since the model was an unmarried woman, unrelated to the painter, so personal a depiction seems almost compromising, especially in view of the fact that it was shown in the Salon of 1873, where so many mutual acquaintances easily recognized her. Unlike Olympia, whose direct glance makes no pretense about being seen surreptitiously, this figure does not implicate the viewer. Only the painter and the model are in communication, and so intensely that the painter himself seems to have entered the scene. We feel his penetrating gaze, his privileged access to this young woman whose melancholic reverie seems to be concerned with him, since she has allowed him to observe her. In such a reading, *Repose* can be seen as a double portrait of the painter's desire and the model's disquietude.

Anne Higonnet has caught the essence of Manet's extraordinary images of Morisot, all of them "entirely generated by her presence," in contrast to his portrayals of Victorine Meurent, who is "only one part of their effect, and an auxiliary one at that. . . . His portraits of Morisot are about how she looked, not just in the sense of her appearance but also in the sense of how she gazes at him. She is not merely the object of his vision but a respondent to his art. She elicits from him a recognition fuller and more nuanced than of any other woman he ever painted, more impressive — if only in sheer extent — than of any man. Their relationship as painter and model is less one of control than of exchange."[33] The male figure most often painted by Manet is Léon. Does this not indicate the special importance each held for him? The closest runner-up is Victorine Meurent. She appears in eight works, but they, like those for which Léon posed, are not concerned with the model as subject; both models are almost always in costume, actors in a pantomime. In contrast, all the works

depicting Morisot are entirely devoted to her — her person, her moods, her eyes, her hair, her clothing. She is never disguised to play someone other than herself, as are Victorine and Léon, never a supernumerary, as is Léon in *Spanish Cavaliers and Boy with Tray* or *View of the International Exposition.*

Even in *The Balcony,* a painting Morisot ostensibly shares with two other figures (and in which Léon makes a barely perceptible appearance), hers is not only the leading role but the only *real* one (Fig. 26). Both of the other figures, though posed by friends (the amateur violinist Fanny Claus, who later married another friend of Manet's, the painter Pierre Prins, and the landscape painter Antoine Guillemet), are mere mannequins, puppets, providing the backdrop for a psychological drama. Most writers have reported that *The Balcony* was inspired by the sight of a group of people on a balcony, which may have reminded him of Goya's *Women on a Balcony.* Certainly the Goya model is hard to discount.

Although this may explain the composition, it does nothing to explain why, as most critics have objected, "there is no thematic link between the figures; each stares out fixedly at something different."[34] Perhaps another approach will provide an understanding of the mysterious, disconnected quality that *The Balcony* shares with its immediate contemporary, *The Luncheon* — about which all critics have complained since its first exhibition in the Salon of 1869 that the oysters, lemon, coffee cup, and weapons hardly go together, or, more recently, that although these disparate objects justify the title, "far from emphasizing a formal cohesion, they tend on the contrary to prevent it."[35]

Both paintings were conceived during the same stay in Boulogne, where Manet was bored to death. In his letter to Fantin-Latour dated August 26, Manet complained, "It is obvious, my dear Fantin, that you Parisians have all the distractions one would want; but I, who have no one here to talk to, envy you the opportunity of discussing with the great esthetician Degas the undesirability of an art within reach of the lower classes, which would permit the sale of paintings for a few pennies. I have not been able to discuss painting with anyone since I came here."[36] Two paragraphs later, after expressing his desire to make some money, he shared Fantin's despair: ". . . there is nothing to be done in this stupid country of ours, with its population of civil servants. All I think about is returning to Paris; for I am doing

nothing here. Decidedly, two months is a long time." There is not a positive statement in the entire letter, outside of his agreement with Fantin that the Morisot sisters "are charming." He was depressed by his own lack of success and by the success of others, isolated from his adored Paris and the company of his friends. Suzanne and Léon were clearly no substitutes. It is they who kept him from being where he wanted to be; he was stuck in Boulogne out of family duty. Alone, he would have returned to Paris, or never left at all. Given this frame of mind, it does not seem irrelevant or excessive to look for a personal interpretation of the paintings that emerged from this period.

Richard Wollheim has proposed that Manet's late single figures are "about the inner psychology that organizes their form specifically around reverie, attachment and communication, not about social or art-historical matters."[37] To some degree this also can be said of his earlier multifigure paintings, *The Balcony* and *The Luncheon*. But it would be a mistake to exclude art-historical factors. To disregard Goya when looking at *The Balcony* would be to disregard a fundamental aspect of Manet's art, which was his attempt to create a totality of museum art into which he placed his own as a natural successor.[38] To dismiss social influences would be to ignore the undeniable modernism that marks his works. *The Balcony* is only the first of his many paintings — most of them portraits — that communicate the isolation of the individual in modern society. Like a photograph of people taken without their knowledge, each individual in *The Balcony* is engrossed in private preoccupations.

Odilon Redon's observation that a portrait by Manet is closer to a still life touches on a deeper, nonpictorial truth in Manet's rendering of reality. The here-and-now quality of modern life is captured in patches of color, in a two-dimensionality expressed by the absence of depth in the background, the absence of any view outside the subject. Communication is reduced to a visual dialogue within an enclosed space between the subject and the spectator (who in many cases is the painter himself).

It might be argued that the absence of any clear emotion, certainly the lack of joy in Manet's subjects, suggests a personal despair, perhaps a notion that outside of individual courage, there is only one's own creation to express the heroism of endurance in everyday life. Only the individual remains, no longer idealizable but particular; not a torero, but a woman in the garb of a torero. Even the traditional

portrait on Manet's canvases has lost its iconic value. In his day Manet's critics saw none of this. In the words of Paul Mantz, "the characterization of a feeling or an idea would be sought in vain in this painting [*The Balcony*], devoid of any thought."[39] But is it?

During those long summer days of 1868 when Manet was neither engrossed in work nor enjoying his dolce far niente, there was little left but reading and walking, the aimless strolling of the flâneur. The chance vision of other vacationers on a balcony, vaguely watching their counterparts on the street below, was imprinted on his mind like a photograph. This in turn apparently triggered the recent memory of Goya's *Women on a Balcony* — the Goya influence was recognized by Gautier and others in their reviews of *The Balcony* — which Manet would surely have seen in Charles Yriarte's signal book on Goya, published in 1867, if he had not seen it earlier in Spain.

Eric Darragon offers an interesting reading of the painting as a portrait of the artistic upper class of the 1860s.[40] However, this does not explain the shadowy presence of Léon in the background, nor does it account for the "frozen" poses of the two standing figures. The accent placed on the shiny blue cravat of the male figure and on his central position, his hands raised as though to be purposely visible (the left holds a cigarette, but the right might more reasonably have been placed in his pocket), make him the key to the picture, especially in view of Léon, lifted out of *Spanish Cavaliers and Boy with Tray* (Fig. 25), just behind him. Everything about this figure points to his function as a surrogate for Manet: the fashionable dress, the obvious concern with the cravat (Manet was known for his fastidious selection of ties and is seen wearing a similar blue tie in Fantin-Latour's portrait of him painted only the year before, in 1867), and the almost subliminal presence of Léon, spatially linked with this imposing gentleman, himself a painter, and psychologically linked with the painter himself.

As for the ladies, Paul Mantz in his 1869 review spoke of the hatted figure as a woman, "*une femme*," and the seated figure as a girl, "*une jeune fille*." Fanny Claus was in fact younger than Berthe Morisot, but in the painting she looks like a dowdy though youthful matron, properly attired for her round of visits or shopping, her unredeemably plain face set in an empty stare. By contrast, the seated figure is strikingly sensual — a certain determination in the face, the bare suggestion of a smile at the corner of her lips, deep in a wide-eyed reverie. Something of this was perceived when the painting was

shown in the Salon of 1869, for Berthe wrote Edma after seeing it there, "I am more strange-looking than ugly; it seems the epithet *femme fatale* has been circulating among the inquisitive."

None of this may have been intended when Manet decided to put on canvas the Boulogne/Goya balcony scene. But if we think of his mental state at the time — depressed, bored, apparently already interested in Berthe, since he asked her, not Edma, to pose — *The Balcony* can be understood as a representation not only of his own world, the hypocritically decorous bourgeois society of the Second Empire seen against the more accommodating morality of Goya's balcony sitters, but also of his own private reverie. His attraction to Berthe is undeniable, liberally confirmed by all his subsequent paintings of her. In this one her grace, sensitivity, intelligence, and sincerity are visible at a glance. She is presented with considerable precision, to the last twist of the curl falling over her shoulder and the flounces of her diaphanous gown.

Fanny Claus, on the other hand, is a barely filled-in cutout, her umbrella and the flowers on her hat the only details Manet took pains to render. The rest is sketchy, characterless, flat. Although she does not resemble Suzanne, she seems to stand for Suzanne's solid conventionality, as in the bizarre transmutations of a dream, and she stands quite literally in front of the male figure, Manet's double, metaphorically blocking his way. In an oblique line he is flanked by Léon in the background and Suzanne in the foreground, his freedom curtailed by their presence, their very existence, as in Boulogne during those interminable summer months of 1868.

However much Manet may have been drawn to the beguiling woman leaning on the balcony, who was everything Suzanne was not — a woman who excited not only his senses but also his mind, with whom he could share the problems and joys of their common vocation; a woman of his class, his city, his language, his culture — he dared not approach her, as the hands of his stand-in suggest. This was not a Victorine or a demimondaine, nor was he a cad who would compromise the reputation of a woman of her background, as proved by his marriage to Suzanne. Any thought of a more committed relationship was precluded by his own confining domestic circumstances. And yet, as *Repose* clearly suggests, there was more to their relationship than polite receptions at each other's apartments and posing sessions in his studio.

Berthe's correspondence, though heavily edited, is as revealing by what is missing as by what is there. The sparse mention of Manet in her letters, except in unequivocal circumstances, becomes perplexing as one reads the letters. Given the frequency of their social contact, the innumerable hours she spent posing for him, the importance of his work to her, and the pleasure she took in his company, we would reasonably expect to find his name in virtually every letter Berthe wrote to Edma between 1868 and 1874. Instead we read about him more often from the pen of Mme Morisot or Edma. Their remarks are not without interest. During the crisis surrounding Manet's portrait of Eva Gonzales, Edma wrote: "Mlle Gonzales really irritates me, I don't know why: it seems to me that Manet vastly overrates her and that we have, or rather that you have, as much talent as she does . . . [editor's ellipsis]. *To have seen Manet again is already something in one's existence;* that should have restored you after yesterday's family visits . . . [editor's ellipsis, emphasis added]."

During the summer of 1869, when Berthe was in Brittany with Edma, she did a painting of the port of Lorient, which Manet complimented warmly. In a letter to Edma dated August 14, Mme Morisot reported with obvious annoyance that Berthe "gave her picture to Manet; thus nothing will remain in the house. That souvenir of Lorient would have been not at all unpleasant [to keep]." She then complained about Berthe's desultory work and her disturbing mood: "Berthe is not pleased with what she does and I only urge her enough to see her occupied, for to replace idleness with agitation does not strike me as better for her health." She had confided the week before, on Berthe's return: "Our great joys on being reunited are more imaginary than real; it is painful to admit but easy to explain. Berthe does not find me as communicative as when she left, and then claims that I look at her with surprise, as though I found that she looks terrible; which I do, in fact."

On August 13 Berthe herself wrote to Edma: "Manet sermonizes me and proposes that tiresome Mlle Gonzales as an example; she has self-discipline, perseverance, she knows how to see a thing through to the end, whereas I am capable of nothing. In the meantime, he has done her portrait over for the twenty-fifth time; she poses every day and in the evening, her head is washed off with black soap." A month later, she was still talking about the portrait: "We spent the evening together [with Fantin-Latour and Degas] at Manet's house; he was hi-

lariously funny; he came out with a hundred crazy jokes each funnier than the last. For the moment, all his admiration is concentrated on Mlle Gonzales, but her portrait is still not progressing; he told me he was on his fortieth try and the head continues to be erased, he is the first to laugh about it." She then added that the Manets came over on Tuesday as usual and visited her studio, where "to my great surprise and satisfaction, I collected the highest compliments; it would seem that [my work] is decidedly better than Eva Gonzales's. Manet is too honest for me to be mistaken, I am sure that he was genuinely pleased; only I remembered what Fantin said: 'He always likes the paintings of people he likes.' Then he talks to me about finishing and I admit I don't understand what more I can do. . . . Since he is excessive in everything, he predicts my success in the next exhibition after having told me a lot of unpleasant things . . ." [editor's ellipsis].

Berthe's mood swings over the months seem to have hung on Manet's approval of her and on his success with the portrait of Eva Gonzales; she reveled in every erasure. Even his admiration upset her: "Ever since I was told [by Manet] that without my being aware of it I produced masterpieces in Lorient, I remain bewildered in front of them and no longer feel capable of doing anything." These alternations finally undid her. From her mother's letters to Edma during the next year it is apparent that she became virtually anorexic. "Since you left, I think Berthe has not eaten a half-pound of bread; nothing goes down her throat without disgust," Mme Morisot wrote in March 1870. Some time earlier, during the winter of 1869–70, Berthe herself, in a most curious succession of thoughts, admitted to Edma, "I feel a great weight on my stomach and am forever disgusted with painters and friendship. It seems that Fantin was sick over our visit; yet another foolishness on the part of that madcap Manet!!!" The next paragraph begins, "Never has Manet done anything as good as the portrait of Mlle Gonzales; it may have even more charm than when you saw it."

Meeting Manet, posing for *The Balcony* and *Repose*, seeing herself on the walls of the Salons of 1869 and 1870, and believing herself supplanted by a rival created an upheaval in Berthe's life. Less distraught by virtue of age, sex, and situation, Manet was nevertheless deeply affected. Over the next four years the brush would document a relationship that the pen could not preserve.

The Lady with the Fan

Nothing remains of the Boulogne Manet lived in for two months except the old city high above the port within its ramparts, begun in the thirteenth century. The port and lower city were heavily damaged during World War II and jerry-built immediately after, but Boulogne has since become the most important fishing center in Continental Europe. Already in Manet's time heavy traffic crossed the Channel to and from Boulogne. Prints and photographs of the period show a bustling harbor with bobbing masts and small two-story fishermen's houses hugging the cobblestoned hill of Saint-Pierre, which descends to the shore. The rue de Boston, where he rented the house of a sea captain, still twists down to the port, but the view is now blocked by modern constructions.

When Boulogne was a fashionable seaside resort, horses pulling smart carriages clip-clopped along the promenade above the dike; ladies walked on the fine sand of its short beach, protected from the sun by parasols and broad-brimmed hats, anchored against the wind with veils tied under the chin; gentlemen sported blazers and visored caps. It was not a place to thrill the likes of a Manet. Had he been a painter of the "high life," recognized by the "fashionables" who came to Boulogne, he might at least have had the pleasure of celebrity, of invitations. But succès d'estime or de scandale, the only kind he had, made him the sort of celebrity such a clientele would shun. His mind needed the stimulation of Parisian cafés; his self-esteem needed the adulation of his comrades. Not even his eye was inspired by the life of the city — its white-coiffed market women, weathered fishermen, or

elegantly attired French and English visitors. Paris was what fired him — its familiar streets, its noisy cafés, the discipline of his studio, and its privacy. In Boulogne he was in the unrelenting presence of Suzanne and Léon.

During that two-month exile his one escape was a brief but exhilarating trip to London. He was warmly received by painter friends from Paris — Alphonse Legros, who had moved to the English capital, and Edwin Edwards, a longtime English friend of Fantin-Latour's; Whistler was away on a yacht. Degas was to have been his traveling companion, but he wound up going on his own, as in the case of his trip to Spain. In a letter to Zola written after his return from London, he expressed renewed optimism: "There is something for me to do there. I think I will give it a try next season."[1] The painters he met, "almost all of them gentlemen," gave him the impression that London might not only be more receptive to him but also freer of "that kind of ridiculous jealousy we have here." In almost the same breath, to Fantin, he vituperated against the official honors distributed that month in Paris and was generally ill-disposed to his more successful colleagues who sat on juries and obtained medals and commissions — "that mediocre world whose only strength is its unanimity." Only the charming "demoiselles Morisot" and his much-regretted café cronies inspired warm feelings.

The Legion of Honor, about which he would later do an about-face, was a *"sale hochet,"* a corrupting bauble that flattered the vanity and made one an accomplice of the government that awarded it; Millet had been right not to go to the ceremony to receive it. "I will really respect him only if he doesn't wear it," Manet quipped. Daubigny's son, another laureate, had "no talent," and his father, the landscape painter, was *"un mufle"* (a boor). Bracquemond, *"le veinard"* (the lucky stiff), had been asked to do a portrait of the wife of Albert de Balleroy, Manet's former studio-mate, causing a twinge of envy in Manet, though he acknowledged Bracquemond's ability. Manet had learned from another friend that Degas was now *"le peintre du high life"* (a society painter): "That's his business, and I'm all the sorrier for him that he didn't come to London," the capital of high society. In other words, everybody else was getting recognition. Why was he less deserving?

It was in this frame of mind that he began the first of the two masterpieces to come out of 1868. Neither painting reflects this sojourn

at the seaside — no boats, no waves, no fashionable strollers, not even a basket of fish — beyond the documented, but otherwise unrecognizable, Boulogne location of a balcony and the interior of a sea captain's house on the rue de Boston. In the context of the period during which he painted the two works, the pictorial problems he dealt with in both of them, and his mood at the time, *The Luncheon* can be seen as a diptych whose pendant is *The Balcony,* the second reversing the first. Whereas *The Luncheon* (Fig. 33) establishes Léon as a powerful, even intrusive presence as he stands before the table, turning his back on the figures behind him, in *The Balcony* (Fig. 26) he lurks almost invisibly in the background. Here it is Berthe Morisot who dominates the foreground, embodying a conscious reverie, a recognition of desire. The disparate trio in *The Luncheon* do not contain the figuration of a longing for someone else, but the scene emits a powerful longing for somewhere else. The map on the wall, the conquistador's helmet, the Turkish saber, even the evocation of a Dutch interior in the still life grouping on the table all evoke a poetic "elsewhere," consistent with the smoker's reverie. The very presence of a smoker — a common representation of the modern dreamer — establishes the imaginary quality of the painting.

If ever a painting cried out for a psychological interpretation, it is this one, consistently characterized as "enigmatic." Numerous other approaches are, of course, equally valid. A modernist interpretation might concern itself with the figure of the *"petit crevé,"* the fop, now enlarged, lifted from *View of the International Exposition* of the year before, with Léon in the same outfit. An art-historical analysis might consider *The Luncheon* in its relationship to Dutch genre and still life, or the problem of viewer and viewed, the self-absorbed subject and unseen viewer.[2] However profound and enriching such approaches might be, they do not explain, do not even confront, the relationship between the artist and his creation in terms of the feeling, thinking, restless, frustrated human being who created the work.

At first and even second glance, *The Luncheon* poses the problem of the artist's relationship to his art. In many respects the painting is about art: modern portraiture, seventeenth-century Dutch and Flemish still life and genre, studio art versus reality, light, flesh, perspective. But at the same time it deconstructs its own givens. There is a window in the painting, yet the light comes from elsewhere, unlike paintings by Caravaggio, La Tour, or Vermeer in which we see the

source — window, candle, hearth. Is this daylight or artificial light? The still life on the right is deliberately contrasted with the armor on the left; neither has any reality. They are artistic conceits, like the lemon peel and knife hanging over the edge of the table that demonstrated an artist's mastery of perspective ever since the seventeenth century. Here, everything seems to be disconnected. The figures appear to be as unrelated to one another as to their setting. Are these models in a studio or the residents of a common dwelling?

It would be easy to admire the execution of the individual parts of this painting — as was done at the time — and dismiss the rest as a meaningless mystification. That would be a great pity, for Manet's overall intention was, on the contrary, to be understood, as expressed in a stunning passage in Proust's recollections of him. Speaking of Gustave Moreau, for whom he had *"une vive sympathie"* (warmest feelings), he nonetheless felt that Moreau was "going off in a wrong direction . . . [he] is a fanatic who will have a deplorable effect on our time. He is taking us back to the incomprehensible, we who want everything to be understood. . . . It is he who has the upper hand for the time being, so much so that what people admire in Corot today is not the certainty of a study done after nature, but the uncertainty of a picture done in the studio."[3]

Manet was not only a supremely able painter; he was also a man who thought hard about the modern world and about the renewal of painting. He was a dreamer, unfulfilled in his life and his profession, in whose work psychological symbolism made its appearance. Certain elements of this can be traced back to three earlier works linked to *The Luncheon*. In May 1862 Manet did an etching to serve as the frontispiece for an album of eight of his prints to be published by Alfred Cadart. It was Cadart's idea to revive the art of printmaking by organizing a "Société des aquafortistes." Manet, Bracquemond, Fantin-Latour, Jongkind, and Legros were its founding members.

Although the eight etchings were advertised in Cadart's *Eaux-fortes modernes* by September 1, the frontispiece, titled *Polichinelle Presents "Eaux-fortes par Edouard Manet,"* was done at a later date (Fig. 8). If Auguste Manet had been the impediment to the marriage promised in *La Pêche*, painted two years before, he no longer was. By the time Manet made the etching, the wedding that would take place in Zaltbommel was looming close, even if no date had been decided.

Polichinelle's glum expression sets the mood of the scene. The balloon is seen moving from the city in the background (Paris?) toward a rural scene of windmills in the foreground (Holland?). Given the multiple references to Holland,[4] it is hard not to see them as pointing to his imminent marriage, not only to a Dutch woman but in Holland. He also knew how little joy it inspired in his family.

The twin themes of deceit and confession are ingeniously treated. Nothing is solid, nothing real. Polichinelle is a puppet, an actor's costume, a commedia dell'arte clown, alternately timorous and boastful, whose traditional attribute is a bat or a cane — other sword cognates already present in *La Pêche* and *Boy with a Sword,* emblematic of Manet himself.[5] By the early nineteenth century the figure of Polichinelle, or generically a clown, was a recognized self-representation of the artist. Perhaps most telling in this particular work is the figure's association with the commonly used locution *un secret de polichinelle,* a secret everyone knows. Translated into images, this kind of verbal playfulness was as characteristic of Manet the painter as it was of Manet the conversationalist.

Polichinelle looks dismally past the summary sketch pinned to a board. What could be more tentative? Against the wall hangs the useless sword, once symbolic of masculine victories, now of martyrdom.[6] Below it lie discarded items of Spanish dress, evoking dreams of Spain not yet realized. This Polichinelle, with his flowing mustache and goatee, bears a striking resemblance to the conventional depiction of Don Quixote, an unsurpassed exemplar of failed illusions, the dreamer frustrated by reality. The descending balloon suggests deflated hopes, an inauspicious symbol for a forthcoming marriage. Even the wall lacks solidity — a flimsy screen for the similarly insubstantial figure that makes a partial appearance on the scene where his youthful fantasies lay abandoned.

Polichinelle's pose recalls Manet's role in his life with Suzanne and Léon, in which he is only a partial participant. This absence of commitment is reflected in all his subsequent paintings of two or more figures, among whom there is no dialogue, no candid exchange. The parted curtains around Polichinelle's head indicate concealment — something that we cannot see has been taking place — but also perhaps the curtains of a confessional. What Manet as Polichinelle "presents" here is a disguised confession and a two-sided image of

himself — the clown laughing and joking, while behind the mask a dark secret weighs heavily.

In *The Luncheon*[7] three works that preceded it — *La Pêche, Boy with a Sword,* and *Polichinelle Presents* — are brought together in an expanded pantomime by means of the repeated motif of the sword, this time a curved one, propped against a helmet on the left. Whether these objects were found in the sea captain's house or borrowed from his painter friend Monginot, as has been pointed out,[8] is of little consequence. Manet was not obliged to use them. However incongruous, their presence may have some purpose. As for the identity of the models, the fact that there was a servant in Boulogne, or that Auguste Rousselin or Claude Monet may have sat for the bearded figure, does not explain their poses, let alone the entire composition.

If we assume that the elements in the picture are not gratuitous but, as in a dream, have a symbolic function, the sword and helmet, cast aside, could denote a fallen hero, diverging from his path of freedom and future success because of an amorous escapade.[9] Here Léon has apparently shrugged off the burden of the sword, symbolic of the father, and of his own travestied identity, treated six years earlier in *Boy with a Sword.* Unlike that younger image he no longer looks to his maker but gazes indifferently, if not defiantly, past him. Long after Manet's death, Léon claimed that he was untroubled by any question of his origins.[10] As he said himself, he was pampered as a child — the not uncommon behavior of parents who feel guilty toward their progeny. Some writers have reported (without any evidence) that Léon was told the truth. If that were so, he might have found it easier to keep the secret, having been made an accomplice. Is this reflected in the self-assured pose of *The Luncheon?* Compared with the touching innocence of the ten-year-old in *Boy with a Sword,* the sixteen-year-old in *The Luncheon* has turned into a vapid young man, or so at least Manet portrayed him.

What emerges from the composition of *The Luncheon* is the noncommunication among these three figures, which can be seen as the graphic rendering of an oppressive situation. Yet this son/stepson/godson/brother-in-law, who is as central to this apparently disjointed scene as he was to their mendacious relationship, is said to have been loved by Manet "like a son" and to have given Manet "the attentions of a son."[11]

The pensive bearded man, similar enough to Manet to serve as a double, is not really part of the scene. Nor is he any more realistic as a paterfamilias, seated before a still life repast, than his earlier double, Polichinelle. Would a man wear a top hat throughout a meal at his own table? He sits smoking in his hat, his gaze directed toward the pile of armor beyond the boy and the woman, lost in a reverie of un-attained glory, unrealized dreams, far from this banal scene. Its ba-nality and his detachment from it are further emphasized by the map on the wall behind him, as though an echo of Baudelaire's "anywhere out of this world." It was from that very room, where he started *The Luncheon*, that Manet complained to Fantin-Latour in his letter of August 1868: "You Parisians have all the entertainment you could want but I have no one here to talk to."

As for the servant, although she has not been generally accepted as a representation of Suzanne,[12] she too is a credible stand-in with her soft white cap, reminiscent of the traditional Dutch coif, and Suzanne's girth and coloring. Even if the model had been the servant who came with the house, Manet could not have been blind to the re-semblance; had he wanted to conceal it, he could easily have altered the figure. Instead he seems to have deliberately identified her by the silver coffeepot she holds, marked with a capital *M* on its rounded belly.[13] Why would a painter reproduce a monogram, and so promi-nently, unless he had some purpose in mind? This was not the first time Manet used this initial as a personal cipher: he signed his *Span-ish Cavaliers and Boy with Tray* of 1859 with a similar capital *M*. The engraved coffeepot, heavy enough to require two hands, allegorizes her pregnancy. Its lip, pointing toward the boy, and its gleaming sur-face, as though mirroring his image, connect him to her. And why a servant at all? An earlier sketch of this composition shows only the two male figures. As the work evolved in size and scope, another fig-ure was needed for balance. However, the figure of a servant has more than a spatial significance. A servant can provide the comforts of a home but is not an equal, not a life companion. In the painting she alone looks directly at the painter with an expression that could be construed as resignation; she has accepted her limited status.

Suzanne was similarly a presence in the Manet household, but she was not the woman in charge of its management as a wife would nor-mally be; that remained the domain of her mother-in-law. Nor was she central to other aspects of Manet's life. She was only tangential to

his artistic life, and perhaps even less involved in his amorous life. She surely filled his need for stability and respectability, but she also created a yearning for more exciting women to satisfy his masculine and intellectual desires. In 1868 the contrast between the placid Suzanne he married and the vibrant Berthe Morisot he had begun to paint brings to mind Yeats's painful observation: "It is terrible to desire and not possess and terrible to possess and not desire."

The setting of *The Luncheon* is as ambiguous as the figures in it. It is not a home, nor is it a studio. Like Theodore Reff's description of the frontispiece as "a studio strangely transformed into a stage,"[14] this dining room is strangely transformed into a studio, though not Manet's own studio. The unreality of the setting underscores the sham of the relationships, for as a servant the woman is no more related to the boy than to the bearded man. Does this not also suggest Suzanne's fictitious relationship with Léon? As for the young man, he has no role here, no place at the table on which he turns his back; his presence, however large he looms, is tenuous. If the elements of the scene do not provide compositional unity, they do create psychological unity. But even the composition has a certain circular cohesiveness in the way the knife on the table points to the woman in the back while the sword curves toward the boy, and the two adults in the background — both remote, the male literally marginal — flank the boy. The apparent disconnectedness of the picture sets up a symbolism of disconnected familial relationships.

In the summer and fall of 1868, Suzanne was less alluring a subject than she had been over the previous six years. It would seem that Manet had been disinclined to paint her, for in March 1869 Mme Morisot wrote to Berthe, *"Il a reproduit sa femme, je crois qu'il est bien temps"* (he has portrayed his wife, I think it's high time).[15] Since there is no portrait of Suzanne dated 1869, this may refer to his other attempt to capture Suzanne at the piano, discarded ten years later when he painted himself with palette over it. It has been said that Manet did not flatter his female models. But one has only to look at the four enticing portraits he painted of Berthe between September 1868 and the summer of 1869 to see how beautiful a woman could be under his brush.

From 1868 to the end of his life Manet painted his wife barely half a dozen times, most often as a shapeless mass. In *The Departure of the Folkestone Boat*, seen from the back amid the dockside crowd,

she would be unrecognizable if not for Léon's identified presence beside her. In *Interior at Arcachon* she is equally featureless, a round head seen from the side, a seated dark form with feet raised and pointing out. In *On the Beach* she is a large coated shape under a heavily veiled hat (Fig. 36). The most unflattering image he left of her is *Mme Edouard Manet on a Blue Sofa* (Fig. 14). *Mme Edouard Manet in the Conservatory* (Fig. 53) is the exception.

The reclining female figure has long been associated with seduction and sensuality. Canova's statue of Pauline Borghese and David's portrait of Mme Récamier are famous nineteenth-century examples. Manet's other reclining figures are all in this tradition: *Olympia* (1863), *Berthe Morisot Reclining* (1873), *Woman with Fans* (1874). *Mme Edouard Manet on a Blue Sofa*, compared with *Olympia*, its 1863 prototype, would seem to be a willful caricature. Suzanne is shown in the same pose and same orientation as is Olympia. But what a difference! Olympia is all gentle curves and slender lines, with her high little breasts, flat belly, and gracefully crossed ankles. Suzanne appears to have just come in and plopped herself on the sofa — one can almost hear the creak of the springs — her feet pointing outward, as though unable to cross one leg over the other. Even her hands are in the same position as Olympia's, but they are hardly provocative. Like the body on the sofa, they too rest heavily. Her hat is squarely set on her head, its ribbons dangling limply, the very antithesis of coquetry. Her body is as wide as her skirts, and though Manet was little concerned with modeling, the roundness of her midsection has been given the care that is absent from her vacant face. This painting resembles *Olympia* too closely for the caricatural pastiche it contains to be overlooked. Manet surely knew what he was doing. Just as he modernized Titian's Venus by turning her into a contemporary courtesan, so he domesticated his own Olympia by transforming her into an overweight housewife. Even if he painted her with a good-humored smile on his face, the parody is more meaningful here than painting a mustache on the Mona Lisa.

There is no way of making a convincing argument that Manet was indifferent to his wife's appearance. He was hypersensitive to the appearance of all women. When Tiburce Morisot's liaison with a married woman, neither young nor slim, became known in late 1871, Mme Morisot wrote Berthe: "Everybody now knows the object of

Tiburce's affections and it is a major subject of astonishment; Degas admires his daring, Manet is appalled and says that in a few years [Tiburce] will be ashamed of his wife, not that Manet doesn't admit she has a lovely face, but he cannot get beyond the body." Earlier that same year she told Berthe about her visit to Manet in his studio, where he was "doing a portrait of his wife and laboring to make of that monster something slender and interesting!" Suzanne was no beauty in the eyes of any beholder. Berthe herself, generally more magnanimous than her mother, wrote to Edma in 1872, "I saw *l'ami* Manet yesterday; he left today with his fat Suzanne [*sa grosse Suzanne*] for Holland and in such a bad mood that I don't know how they will get there."

Manet's biographers have not shown much interest in his domestic life, except to perpetuate the image of a devoted couple. His first biographer, Edmond Bazire, could not touch the subject, since all parties except Manet were still alive and in 1884 such inquiries would have been unthinkable. In 1935 Adolphe Tabarant published and annotated the letters Manet wrote to Suzanne during their separation at the time of the Franco-Prussian War, which provided the outlines for a vague picture of domestic bliss. In his 1947 biography Tabarant revealed their prenuptial relationship and established the identity of Léon as Suzanne's child, but he shied away from the question of Manet's paternity or his fidelity. No attention has been paid to the probable dissatisfactions of both spouses. Manet's letters do contain concern and affection heightened by the dangers of the war, but the affection seems more conventional than spontaneous and not very convincing when compared with other letters written at the same time.

Many marriages defy explanation, but few affect a legacy of great paintings. Manet married Suzanne thirteen years after their affair began and eleven years after Léon was born — hardly an impetuous act of passion. Had Suzanne been the choice of his heart and reasonably presentable in his society, he not only might have married her earlier, but the wedding would have been celebrated with customary rites of prior announcement and some kind of family ceremony. Instead Suzanne erupted into Manet's world as a fait accompli. In view of the general nature of matrimony at the time, such a marriage was in no way aberrant. Respectability, especially the avoidance of scandal, was far more important than compatibility. Suzanne had every-

thing to gain and Manet little to lose. A husband was expected to provide little more than security and position, both of which Suzanne acquired with her marriage.

Nevertheless, she had reason to be dissatisfied. However passive and accommodating her nature, hers was a humiliating position. At the time of her marriage and for a while thereafter she was still passably attractive, as attested by *La Lecture,* and Manet was not given to prettifying his subjects. But she soon lost what little appeal she may have had, becoming much heavier and even plainer in her facial traits, as can be seen in a photograph and from the discreetly partial views Manet later presented of her. Not only was she lacking in feminine or social charm, but she did not even have the status of mistress of her own house. Her mother-in-law was her husband's hostess and the focus of their guests' gratitude and attention. When Baudelaire wrote a note of acceptance for an invitation, it was addressed to Eugénie Manet, as was later the case for the Morisot family and all other guests. Suzanne's only function appears to have been playing the piano for the entertainment of the company. It takes little to imagine the resentment that festered in her over the many decades she lived with her mother-in-law.

Manet's letters during the Franco-Prussian War, when the two women and Léon were packed off to a small town in the Pyrenees while he stayed to help defend Paris, indicate that he was aware of friction and worried about it: "I hope that both of you are getting along with each other — you have common concerns and anxieties; it would be a great sorrow for me if I thought that the best understanding did not exist between you."[16] This kind of wishful enjoinder would have been unnecessary if sweetness and light had been the rule. He was equally uneasy about Léon's attitude, for he restated the same concern in numerous letters: "I hope that you are pleased with Léon and that he is taking good care of *maman* and you. I sent him with you to protect you, let him remember that, for here many boys his age are fighting." As for Eugénie Manet, her letters written after Edouard's death to Gustave, her youngest son, and to her nephew Jules De Jouy, executor of Manet's estate as well as her own attorney, leave no doubt about the bitter feelings that lay beneath the surface of her affectionate language in direct address to Suzanne. In an unpublished letter to her nephew written two months after Edouard's death, she minces no words about their cohabitation in 1870. Suzanne, who was making

claims to which Mme Manet did not feel she was entitled, had evidently tried to elicit Jules's sympathy:

> I do not understand, Jules, how you could have written to Gustave that I am making life difficult for myself with regard to Suzanne and Léon. On the contrary, I say to anyone who wants to hear it that Suzanne is filled with solicitude toward me, who am so ill at the moment. Beware of this system of complaints of which I was the victim already once before when we were in Oloron-Ste-Marie. Suzanne used to write her husband a thousand complaints about me, and when he was able to see for himself what was going on, since he knew her well, he recognized this system of complaints about me as a self-serving ploy vis-à-vis her husband. He clearly saw, on the contrary, that my attentions and consideration toward her were maternal. Her jealousy was always there, against me! But this case is not the same, this is a goal both of them are pursuing which is intended to make a dupe out of me. You are blindly naive when it comes to them.[17]

It is a marvel of endurance, courtesy, and hypocrisy that these women continued to share a roof until Eugénie's death two years after Edouard's. Granted, they had little choice but to tolerate each other; Edouard would not let his mother live alone — it was, moreover, to his advantage to share household expenses with her — and Suzanne had no other resources.

Berthe Morisot's appearance on Manet's horizon was understandably dazzling. She was unlike any woman of his society he had known. Her mother knew full well what a problem she had on her hands. Berthe's dreams of being a serious painter would scare off most men who merely wanted a wife. Cornélie Morisot had no faith whatever in Berthe's ability to survive as a professional, but she knew that Berthe's talent had been acknowledged early on by serious artists like Corot, Fantin-Latour, Manet, and Puvis de Chavannes (whose interest for a while was more than artistic). In addition, Berthe was always making a mountain out of every molehill, unable to reach a decision, agonizing over everything.

The years 1869–1872 were difficult ones for Berthe Morisot. The letters exchanged between mother and daughters, examined in the light of Manet's portraits of her, suggest that the relationship between

Berthe and Manet went beyond that of model, younger colleague, or social acquaintance. Berthe's biographer, Anne Higonnet, characterizes those portraits as "elegant, sensual, beautiful, engaging, passionate and delicate."[18] Moreover, painter and model were reluctant to part with the results of their collaboration. During his lifetime Manet kept five of the eleven oil portraits he did of her and gave her two; after his death she managed to buy a third.

Berthe's own work suffered during the period of those portraits, as did her health. She complained of abdominal pain and rejected food. These can be classic symptoms of severe nervous tension. In March 1869 she wrote Edma, "My inaction is beginning to weigh on me; I am impatient to do something fairly good; here is a worry you don't have! Since you left I have not seen a single painter. I live as far from Paris as you do." Immediately thereafter, referring to an exhibition of their friends' paintings that was to open the next day, she added, "I wanted to write a note to Manet to ask him to send me an admission card; I hesitated to do so and as it turned out my attempt would have been perfectly useless since my eyes do not yet let me go out" (some kind of inflammation had virtually closed one of them). Why the hesitation over so minor a favor? The implication is that she was embarrassed to approach him. She would not have hesitated to ask Fantin or Degas, who was neither gallant nor even encouraging. Two months later, when the Salon opened and Berthe went to see *The Balcony* for which she had posed, she related her visit to Edma:

> You understand that one of my first concerns was to head for room M [the exhibition was hung alphabetically]. There I found Manet, his hat on his head in the sun, looking bewildered; he asked me to go look at his painting because he did not dare approach it. Never have I seen a more expressive face; he was laughing, looked troubled, declaring all in one breath that his picture was very bad and that he would have great success. I definitely [*décidément*] see in him a charming personality that gives me infinite pleasure [*me plaît infiniment*]. His paintings always make me think of a wild, or even a not quite ripe fruit. They are far from displeasing me, but I prefer the portrait of Zola.

However reserved her appraisal, the degree of her interest comes through in expressions such as "*décidément*," indicating that she

thought about this previously, and *"infiniment,"* suggesting an unrestrained delight in his presence. She was obviously very taken with him and writes with unusual good humor. More often than not, she indulges in what she herself called her *"manie de lamentations."* A week later she was in fact lamenting the rain that fell in torrents: "I drag myself from place to place; I say twenty times a day that I am bored. *Voilà ma vie,* this is how I live; I am humiliated to be so weak-minded, but what to do?" Hers was a very difficult situation. To do what she might have liked would have taken courage and resolve that she did not have, at least not at that time. By then she already knew what her mother would formulate succinctly two years later, although she had not yet come to grips with her problems. In July her mother would write to Edma when Berthe was visiting her and would be likely to read the letter herself:

> The general opinion is that it is better to get married having made compromises than to remain independent and in a position that is no position. She should consider that in a few years she will be lonelier, have fewer contacts, and as her charms pale, she will have many fewer of the friends she now thinks she has.

After Berthe's return to Paris, Mme Morisot once again confided to Edma failings that were not unknown to Berthe, for she had few illusions about herself:

> Berthe regrets having left Cherbourg now that it is so warm and beautiful and she could have worked so well, or so she thinks. She always assumes she will work wonders where she is not and will not go after resources that are within her reach . . . she may have the talent it takes [to be a painter] . . . but she does not have the talent for commercial or public purposes, she will never sell anything of the kind of work she does and she is incapable of working differently. Manet himself, while being very complimentary, said that Mlle B has not wanted to do anything so far, she has not applied herself to anything, when she wants to she will succeed. We know all too well how she can want things and want them passionately when she puts her mind to it. She makes herself sick, that's all. . . . [My] family is fairly distinguished, fairly gifted, but incapable of the efforts that allow one to reach certain rungs of the ladder. . . . I am

therefore somewhat disappointed to see that Berthe will not try to settle down like everybody else. It is the same as in art; people will pay her compliments, since she seems to be asking for them, but will keep her at a distance when it comes to entering into a serious arrangement with her.

With such traits, it is hardly surprising that Berthe would have reached a state of near mental paralysis, especially when, during the same winter that Manet painted two portraits of her — *Berthe Morisot with a Muff* (Fig. 28) and the less attractive *Berthe Morisot in Profile* — he was also giving lessons to Eva Gonzales, singing her praises, and starting a portrait of her. How could Berthe not have been consumed with jealousy? Given Manet's habit of keeping his models until a work was finished, the two portraits of Berthe represent incalculable hours spent together, during which many words were exchanged, many longings awakened. If Berthe's mother chaperoned her when she posed for *The Balcony,* she was not always present when Berthe came to the studio thereafter, for Manet had since become a friend of the family. There were other times (mentioned in Berthe's letters) when Mme Morisot, pleading a headache or fatigue, let Berthe go off with Manet to visit the Salon exhibition. They were not without opportunities to talk to each other in confidence. However correct Manet may have been, Berthe basked in his attention and guarded it for herself. It was too easy and too painful to imagine him in his studio with Eva, laughing, joking, complimenting her. Perhaps he preferred Eva's company to hers. He repeatedly expressed his esteem for Eva's diligence, which she knew he found woefully lacking in her. And Eva was much more self-assured.

What Berthe could not yet know was how much more captivating he found her as a model. In time she would see the difference between Eva and herself on canvas. Eva's single formal portrait, inspired by eighteenth-century French art, would leave him exasperated after uncountable sittings and erasures. Berthe's multiple portraits vibrate with freshness and modernity; they have a magnetism that pulls us close. *Berthe Morisot with a Muff* shows us a young lady elegantly attired in a fur coat and stylish bonnet, wisps of dark hair falling seductively over her forehead and ear. This is not a primped fashion plate but rather an intensely feminine figure who looks tentatively toward the painter. After 1870 her eyes look straight at him — talking to

him, listening to him, watching him re-create her — in each of the six portraits to follow, until the last in 1874, after her engagement, when her raised left hand prominently displays a ring on the third finger and her eyes, seen in three-quarter profile, look out to her left, beyond the painter into another space altogether.

If we compare the four first paintings Manet did of her — *The Balcony*, the two portraits of 1868–69, and *Repose* of 1870 — with those done in 1872, we see a changed relationship between painter and model. In *Berthe Morisot with a Veil, with a Pink Shoe, with a Black Hat and Violets, with a Fan*, and, most notably, *Reclining* (1873), the progression from demureness to unembarrassed familiarity is quite striking. Interesting in this regard is the background of *Berthe Morisot Reclining*. This was originally a full-length pose, showing her feet up on a sofa. Since a reclining figure was associated with less than ladylike ladies, the lower part of the painting may have been cropped to depict her in a more decorous pose, even if the title states that she was not sitting up straight, as propriety dictated.

Perhaps the most intriguing portrait from a biographical viewpoint is *Berthe Morisot with a Black Hat and Violets* (Fig. 29). It is the first of two that betray an intimacy, a candor, not seen before. In all the preceding works there is either a setting that limits the contact between painter/viewer and subject — the railing of *The Balcony* or the bourgeois interior of *Repose* — or some accessory — a muff, a veil, a pink shoe, a fan — that establishes the artifice of the image. We are made to understand that this is a studio model, with studio props, posing for a painting. We are not intruding on a moment of reality.

However, in *Berthe Morisot with a Black Hat and Violets* her gaze leaves no doubt as to where her glance is directed. But we wonder why the accessory of the title is barely visible and why it is tucked into her open bodice. Why not held in her hand? At a time when violets were emblematic of lovers, that would have been much more proper. The placement of the bouquet is as noteworthy a detail as the choice of flower, not easily attributable to impersonal relations or to modesty, which also is associated with violets. Here, far from modest, Berthe's expression is filled with trust and tenderness, nothing is held back, and the violets themselves suggest a shared understanding. Was this a kind of flirtatious playacting? Or were they in fact exchanging confidences that could not have been put into words? This exquisite portrait was followed by a still life, a gift offering, showing a bouquet

of violets, a fan, and a note bearing the message *"A Mlle Berthe,"* signed "E. Manet" (Fig. 30).

What could be a more delicate, a more eloquent tribute? If Matisse was right when he said that Manet was "the first painter to have translated his sensations immediately," then this little painting — scarcely larger than a sheet of stationery — can be regarded as the immediate translation of Manet's feelings for this exceptional woman. The nature of the objects in it points to the personal, feminine side of Berthe Morisot. A decade later Manet would make her the gift of an easel, from one artist to another. But the portrait and the still life are addressed exclusively to the woman. Paul Valéry, writing about the portrait, calls it "a *poem*" that combines "the solidity of his art with mystery . . . firmly stating the distinctive and essential charm of Berthe Morisot."[19] It is a harmony of blacks — black hat, black cape, black ribbons, black silk, black wool, dark eyes — all against the pale shades of highlighted skin, wisps of chestnut hair, and the nacre tones of the background.

For a woman of Morisot's insecurity, to have seen herself through Manet's admiring eyes must have been immensely satisfying though deeply troubling. "The curiosity, involvement, rapt attention to the artist portraying her, and profound complicity" that Françoise Cachin rightly sees in this portrait,[20] are tempered by what Valéry describes as a *"je ne sais quoi d'assez tragique dans l'expression de la figure"*[21] (something quite tragic in the expression of the face) — perhaps an awareness of the impossibility of this relationship.

Anne Higonnet uses the word "passionate" to describe Morisot's feelings about Manet as a painter; throughout her life Morisot was convinced that none of their contemporaries surpassed him. But painting was not her only passion. However serious she may have become about her career, it was barely embryonic before 1870. Her correspondence reveals that between 1868 and 1871 she was responsive to masculine attention to the point of gullibility, as she admitted herself in connection with Oudinot; reproachful when a suitor's ardor cooled, as in the case of Puvis de Chavannes; jealous when another woman, Eva Gonzales, younger and a painter to boot, elicited Manet's enthusiasm. Even her periods of anorexia point to the repression of a vital and personal side of her. It would be stretching credibility to believe that a woman nearing thirty, still unattached and as hungry as Morisot was for admirers, would have remained strictly professional

under such circumstances. No scandal was attached to Manet; he was Morisot's social equal; they were guests at each other's receptions, attended exhibitions together, spent hours together in his studio. The only impediment to a lasting relationship was his marital status. When has that ever precluded desire?

In the final analysis it is of no great importance whether Morisot and Manet ever became lovers. More interesting is the role each played in the other's life, in the tensions, the prohibitions, and inhibitions between them, and in the way they were expressed. Whereas it is taken for granted that writers draw on personal experiences for elements of the characters and situations of a novel or for the ideas and emotions of a poem, it is assumed that painters put on canvas only what they see. But the human eye is infinitely more than a lens in a black box; there is also the "mind's eye," which continues to see long after the object has disappeared and which translates images into mental processes. For Manet, Morisot was manifestly the inspiration for his most sensitive, most sensual, most unforgettable portraits. "What is pure art in the modern conception?" Baudelaire asked. "It is to create a suggestive magic containing at the same time the object and the subject, the world outside the artist and the artist himself."[22]

This Manet did sublimely in his portraits of Morisot. She was also the person who probably understood him and his artistic aspirations better than any other, and the one to whom he may have revealed more of himself than to any other. Morisot was a woman of keen intelligence and sensitivity, and as qualified as any of Manet's male colleagues to discuss the present and future state of painting. What is more, she was not a rival. In addition, Manet genuinely appreciated women, maintained friendships with them, and enjoyed their conversation, their capacity for generosity, their fashions. He was even known to have remained with the ladies at a dinner when the men left to smoke. "The fact is," wrote Paul Alexis in 1880, "that Edouard Manet is one of the five or six men of present-day Parisian society who still knows how to talk to a woman. The rest of us . . . are too bitter, too distracted, too deep in our obsessions: our forced gallantries make us resemble bears dancing the polka; we may pretend to have velvet paws, but the sudden appearance of our claws terrifies and shocks. . . . Edouard Manet is a happy exception."[23]

For Morisot, Manet was a mentor, a mirror, a model, a man she loved to the end of his life, and possibly to the end of her own. Al-

though physical intimacy cannot be ruled out, it is more probable that what existed between them can be defined as _une amitié amoureuse_ — more profound than a flirtation, less physical than an affair, and more durable than either. One may even wonder how much her attachment to him entered into her decision to marry his feckless brother Eugène, who looked remarkably like Edouard — same complexion, same balding pate, same red-blond beard, even trimmed the same way, and same initials.* For the rest of her life she was Mme E. Manet — a detail she could not have overlooked, for that was how she signed her formal letters — and for the rest of Edouard's she could see him in his studio, or in hers, without causing raised eyebrows. As the wife of any other man, she would have found that close to impossible.

Berthe was not without the ability to see the comic side of their relationship. In the spring of 1870 she was suffering over a painting she planned to submit to the Salon, a double portrait of her mother and her sister Edma, who had come to Paris during the winter to await the birth of her first child. To the comments of every viewer, Berthe responded with more retouchings that left her more uncertain. Finally, with only two days left before the deadline for submission, she went to Manet's studio, later reporting the entire episode in a letter to Edma. Seeing her distress, Manet offered to look at the painting. "Trust me," he told her, "I will tell you what has to be done." At one o'clock the next day he appeared at her studio, expressed his approval of the painting except for the lower part, and then, as she related, "he takes up some brushes and dabs a few accents that look good. My mother is in ecstasy. That is when my troubles begin; once started, there is no stopping him. He goes from the skirt to the bodice, the bodice to the head . . . he makes a thousand jokes, laughs like a lunatic, hands me the palette, takes it back, finally at five o'clock we have made the prettiest caricature ever seen. They were waiting to take it away, so like it or not I had to put it on the cart. . . . My only hope is to be rejected."

The rest of the story comes from Mme Morisot's account to Edma.

* Photographs and a painting by Morisot show Eugène to have been as fair-haired as his older brother, yet Edouard always painted him with dark hair and a dark beard as though to establish that it was not a self-portrait.

"It seems I made matters worse by saying that in my opinion Manet's improvements of my head were atrocious," she wrote. Seeing how miserable Berthe was, Mme Morisot thought she would do her a favor by retrieving the canvas. But that would only create a new problem, for when Manet learned that Berthe had withdrawn the painting, he would be offended. After all he had spent an entire afternoon working on it and had even sent it off himself. "All this would be childish to relate to anyone but you," Mme Morisot concluded, "but you know how here the slightest things take on the dimensions of a catastrophe." This was not overstated. After Edma's departure Berthe hardly ate at all. Before long she was in the throes of a full-fledged depression, though not because of the painting. When the Salon opened in May 1869, her lovely double portrait of her mother and sister, titled *Reading*, was admired by almost everyone, the one exception being Degas, "who has supreme contempt for anything I do," she told Edma.

Manet's relationship with Berthe during the winter of 1868 and spring of 1869 seems to have had the opposite effect on him. His flagging spirits of the preceding autumn were infused with renewed energy. He produced two portraits of her, one of them the charming *Berthe Morisot with a Muff*. His portrait of Eva Gonzales was still being done in the morning and undone in the evening, like Penelope's tapestry, but he was working feverishly and by the end of the year had produced more paintings than during the two previous years combined. His total surviving output for 1867 consisted of seven paintings, and for 1868 even fewer. During the summer of 1869, unlike the year before, he was remarkably prolific: seven paintings, five of them devoted to the port of Boulogne, one of the beach, and one seascape. The first five were painted from a window of the Hotel Folkestone, overlooking the harbor, where the family took rooms that year instead of renting a house. The most stunning canvas is *The Port of Boulogne in Moonlight*, a masterful treatment of blacks and grays with the pale accents of moonlit patches and the white caps of the fishwives. It was this work, along with an earlier still life, *The Salmon*, that in 1872 attracted the attention of his first important buyer, an American, Henry Osborne Havemeyer, and the first time a sizable credit offset the enormous debits incurred over the years.

On balance, the year 1869 gave Manet a sense of achievement. His two Salon paintings, *The Balcony* and *The Luncheon*, had been at-

tacked but not ignored as in previous years. And the earlier stir in February over his lithograph of *The Execution of Maximilian* raised public awareness of him in an unusually positive light. Between his painted versions of the subject, Manet prepared a lithograph, somewhat different from the paintings in that it includes two sides of a wall, at right angles; above one is a view of tombstones, and above the other is a crowd of onlookers. Both elements are incorporated into the final canvas, but seen above a single line of wall.

Knowing how much bile he had poured into the earlier oil versions and how deeply he felt about Napoleon III's treacherous treatment of Maximilian, he could not have had any illusions about his chances of exhibiting the work in the Salon of 1869. He was nonetheless unprepared for the unofficial letter he received in January from official sources, informing him not only that his painting would be rejected by the Salon but that his lithograph could neither be published nor even printed.

Infuriated by the repressive tone of the warning, he sent it to Zola, adding a note of his own: "I thought they could prevent the publication but not the printing. This in any case is to the credit of the work, since there is no caption beneath it. I was waiting for a publisher before inscribing the stone with death of Max., etc. I feel that a word about this ridiculously arbitrary act would not be a bad idea. What do you think?" We may presume that it was Zola who inserted an unsigned notice in *La Tribune*, the paper for which he often wrote: "M. Manet has just been refused permission to print a lithograph representing the execution of Maximilian. Since M. Manet has treated the subject from a purely artistic point of view, it would seem that the government will soon be prosecuting people who dare claim that Maximilian was shot."[24]

The printer Lemercier, fearing reprisals if such a potentially seditious print were to emerge from his shop, may have been the one who notified the authorities and then, doubtless so instructed, refused to return the stone to Manet. After nearly two months of outraged newspaper reports as well as legal action, Lemercier released the stone in late February. This very same Lemercier finally printed the lithograph in a posthumous edition. Although Manet never had the pleasure of seeing the print published, he had in his possession three proofs and the satisfaction of reading in *La Chronique des Arts*: "The question raised over the seizure of a drawing on lithographic

stone is of highly exceptional seriousness and we must be grateful to M. Manet for the firmness he has demonstrated in this matter. It is important for everyone to know what rights the prefect of police has over the ideas of an author or an artist."

The following year Manet sent off two works that were accepted for the Salon of 1870 — the portrait of Eva Gonzales, which he finally took off his easel, and *The Music Lesson*, for which Zacharie Astruc posed playing the guitar. They were badly received by most critics, as always, but "as always they draw a lot of attention," Berthe Morisot reported. When Edma commented that Berthe's enthusiasm for the two paintings seemed to have waned, Berthe replied, "I can't say that Manet ruined his paintings, since I saw them in his studio the day before and was enchanted by them; but I don't know how to explain the washed-out effect of Mlle Gonzales's portrait . . . there are subtleties of tone . . . that enchanted me in the studio but that disappear in broad daylight . . . the head has always been weak and not at all pretty." This may have been an objective judgment, but it was not without its subjective satisfaction.

For Manet the Salon of 1870 proved to be a sharper thorn than usual; even Castagnary recanted his praise of the year before: "I have nothing to say about a painter who for the past ten years seems to have made it a duty to show us at each Salon that he possesses the requisite qualities to make pictures. I do not deny those qualities, but I am waiting for the pictures. To make it his mission to provide . . . an image of the society around us and to see in that immense spectacle only oneself and one's familiars does not offer proof of either great intellectual concerns or powerful faculties of observation."[25] At least Duranty, his recent dueling opponent, and Duret, critical in the past, both came to his defense. In an article of May 5, 1870, that was devoted to Manet, Duranty made a striking observation about Manet's work: "In every exhibition, at two hundred paces, seen through the succession of galleries, there is only one painting that stands out among all the others: it is always a painting by Manet. One may laugh at it because when something does not look like everything else, it seems bizarre. But painters, even those who do not like [his work], have always acknowledged the great and beautiful qualities of Manet."[26]

In late June or early July of 1870, before his annual departure for Boulogne, Manet accepted an invitation to stay with Giuseppe De

Nittis, the Neapolitan painter who left such warm reminiscences of Manet (quoted earlier). Only twenty-four at the time, De Nittis was living with his wife in Saint-Germain, just west of Paris, which had the same kind of lush wooded countryside as Gennevilliers to the north, where the Manets had their property. During that visit Manet painted an outdoor scene whose models and setting, disputed by various writers,[27] are less important than the painting itself. *In the Garden* is believed to be the first work he ever began and completed entirely out-of-doors. Writing a few months after Manet's death, Bazire, somewhat excessively, attributed to this work the origin of impressionist painting: "Light inundates the painting . . . and dissolves in reflections and patches. The landscape lives and vibrates. . . . This revelation is a revolution. The school of *plein-air* painting, followed and extended by others, began with this picture."[28]

Manet had assuredly been the generative factor during the early 1860s in his insistence on bringing natural light into painting and treating it with a simplified technique — the elimination of half tones — that more closely reflected the way the eye sees. However, none of his works before *In the Garden* had put his theories entirely into practice, since all the others had been finished in the studio based on preliminary studies. *Music in the Tuileries* of 1862 is a case in point, and perhaps the earliest. By the time Manet did *In the Garden*, Monet had already done his *Women in the Garden*, which deals with the same problem, as does Berthe Morisot's *Harbor at Lorient* of 1869 — which Manet admired so much that she gave it to him, to her mother's chagrin.

Proust, however, disputes not only the origin of the term *impressionism* — disdainfully coined in 1874 by a critic in response to Monet's painting *Impression, Sunrise* — but the very concept, both of which he maintains were "born out of our discussions in 1858," when Manet talked about the immediacy of capturing impressions: "An artist must be spontaneous [*spontanéiste*]. That is the right term. But to have spontaneity, one has to be a master of one's art. Gropings never lead to anything. You have to translate what you feel, but translate it on the spot, so to speak. . . . Invariably, in fact, you perceive that what you did yesterday is no longer compatible with what you do tomorrow." For Manet, art was too vast to be cramped into a single school, a single style, whether naturalist, realist, or impressionist. What mattered to him was that it be rooted in its own time and re-

lated to the entire "spirit of humanity," rather than made to conform to an artistic theory. "Everything that contains the spirit of humanity, the spirit of contemporaneity, is of interest. Everything that does not is nil."[29]

In the Garden also is interesting from a nonpainterly perspective. Manet originally conceived a two-figure composition of a mother and child. He later added the male figure, suggesting, as has been pointed out, that "Manet must have decided that the child needed a 'father' and so [fit] the reclining male figure . . . into the spaces once left empty on either side of the woman."[30] Although this speculation was not related by the writer to Manet's personal life, it can serve to illustrate how Manet's buried preoccupations surfaced in his frequent reworkings of a canvas.

As it turned out, the visit to De Nittis was to be the only vacation the Manets had that summer. Before their intended departure for Boulogne, political events erupted that had been two years in the making. Ever since a military coup had deposed the queen of Spain in the autumn of 1868, a new head was being sought for the crown. The leading contender was a cousin of Wilhelm, king of Prussia. His chancellor, Otto von Bismarck, felt that a member of Wilhelm's family on the Spanish throne would provide a bulwark against any future war with France: the French army, preoccupied with defending its border with Spain, would be unable to throw all its weight against the Rhine. Unbeknownst to Wilhelm, Bismarck began actively supporting the king's young cousin, who was prepared to accept the crown in June 1870. Once he learned about it, Wilhelm was less enthusiastic about the plan than his chancellor. However, when Queen Victoria and Napoleon III expressed their disapproval, Wilhelm refused to intervene against his cousin's acceptance but made it known that he did not favor it. On July 12, 1870, the candidate withdrew, to the Kaiser's great relief.

But Napoleon was not yet satisfied. He secretly sent his ambassador to Bad Ems, where Wilhelm and Bismarck were taking the waters, with the bizarre request that the king guarantee that he would publicly oppose any renewal of his cousin's candidacy. This Wilhelm refused to do, upon which Bismarck sent to the newspapers his famous "Ems telegram," making public on July 13 an awkward but secret negotiation between France and Germany and framed in language that was intended to infuriate France. Napoleon's foreign min-

ister, the duc de Gramont, considered this betrayal of confidence a slap in the face. France's honor was at stake. On July 15 the French army was mobilized; four days later France declared war.

The Prussian army was a well-oiled war machine, having defeated Austria only four years earlier under Bismarck's grand plan for a German empire. The French army, despite its recent addition of a breech-loading rifle, the *hochepot,* and a new machine gun, the *mitrailleuse,* was far less efficient than its enemy. By September 1 Napoleon III had surrendered with his troops at the fortress of Sedan, near the Belgian border, bitterly remembered in 1940 when Hitler's army invaded France at that very place. Three days after Napoleon's surrender a provisional republican government, the Government of National Defense, was formed, with Léon Gambetta one of the ruling triumvirate. Only thirty-two, he proved to be a brilliant minister of war and the interior and was head of the Union républicaine. Manet knew him, admired him greatly, and proposed doing a portrait of him. But the project had to be abandoned because Gambetta was unavailable for the kind of sittings Manet required.

On September 15 the National Guard called up all able-bodied men between thirty-one and sixty years of age. Together with the units of the army that had resisted capture and the Garde Mobile, an emergency cadre of gendarmes recruited into the army, a force of more than half a million men was organized to defend Paris. Four days later, with the German high command installed in the Palace of Versailles, Paris was under siege.

During the weeks following the capitulation of Sedan, Parisians had been thronging the roads and railway stations to escape before the city was surrounded. Manet sent his mother, Suzanne, and Léon to Oloron-Sainte-Marie, a small town in the lower Pyrenees not far from Pau, along with Suzanne's sister Marthe Vibert and her son. Léon, then within three months of his nineteenth birthday, left his job to accompany the women, although most young men his age remained to defend the city. He had by that time left the Banque De Gas (as it was spelled by Degas's father) for another bank, but he was not much farther advanced in a career. Manet's repeated recommendations about Léon during their separation sound familiarly parental: "I hope he is behaving himself well. Tell him to work hard and to satisfy you in every way."

Once the family's safety was ensured, Manet placed his paintings

in safekeeping. Some he left in the cellar of his apartment house at 49, rue de Saint-Pétersbourg, and twelve he entrusted to Théodore Duret, who had a vaulted cellar. The works Manet chose to leave with Duret suggest an uncanny sense of their future market value: *Olympia, The Luncheon, Woman Playing a Guitar, The Balcony, Boy with a Sword, Lola de Valence, The Port of Boulogne in Moonlight, The Reader* [1865], *Repose,* and three still lifes (*The Rabbit, Fruits,* and a third listed only as *Nature Morte*).

All three Manet brothers joined the National Guard, as did Degas and other friends; Bazille, on active duty with the army, was killed in November; Monet and Pissarro sought refuge in London. Many men who remained to defend the city sent their families away, among them Eva Gonzales and her mother. But Cornélie Morisot would not leave her husband, her husband would not leave their house, and Berthe would not leave her parents. During the biting winter months while the siege dragged on, Manet wrote almost daily to Suzanne, and Berthe and her mother wrote to Edma. These letters provide a three-way view of the writers, of their friends, and of the events that were to have long-term repercussions in Europe.

A City Under Siege

Paris in September 1870 was rapidly turning into a military base. Troops converging on the city from all over France camped on the street or were billeted in private houses: two slept in the room formerly occupied by Léon; others stayed at the Morisot apartment in Passy. Civilian volunteers and regular army alike drilled in the streets, no one could leave or enter the city without a permit, and everybody was soon carrying or trying to procure handguns. Manet gave up the studio on the rue Guyot where he had worked since 1861. He and his brothers met for meals in the apartment on the rue de Saint-Pétersbourg, now under the ingenious stewardship of their maid, Marie, who tried to devise menus out of dwindling supplies.

Over the next few months the evenings would weigh heavily. Manet's one pastime was writing to his absent family and friends.[1] To Suzanne, who had fretted about leaving him alone when he sent the family to Oloron-Sainte-Marie, he wrote that although the house was very sad when he came home from guard duty or drills and found no one there, he was grateful that she had left, since "women would only be in the way of the men and what is more, few women have remained." As for the men who left, it was decided to publish their names and confiscate their property. With the threat of attack and occupation by the Prussian army hanging over the city, it was still politics as usual: "The present provisional government is not at all popular and the real republicans seem to be planning to overthrow it after the war." He was right on the mark; less than half a year later Paris would erupt in a civil war.

Barely two weeks after the surrender at Sedan, the countryside near Paris was already scarred by the imminence of war. Manet reports that he went to Gennevilliers for provisions and found that trees had been cut down, haystacks and fields burned to deprive the enemy of supplies, most of the inhabitants gone or preparing to flee. So long as mail continued to leave Paris, Manet sent off a letter every day. Nadar, whose ridiculed vision of aeronautical transport was finally vindicated, organized a balloon service for mail, which also carried Gambetta to Tours on October 7, where he was able to organize the defense of Paris.

Manet's frequent transition from the informal singular *tu* to the plural *vous* in the course of his letters reveals that they were more often familial than personal: "I am impatient to rejoin you [*vous*] and to embrace you [*vous*]. I think of you [*toi*] all the time. If I had news of you [*vous*] I would be consoled for not seeing you [*vous*]." He rarely failed to mention Léon, even voicing a concern that he would need new clothes, but most often the subject was Léon's behavior. Manet's repeated admonitions that Léon be respectful and helpful to "*maman* and to you" not only suggest that Léon may have been an intractable adolescent at the time but also imply Manet's paternal authority.

As the eldest son, he had taken it upon himself to look after his brothers, trying to find a suitable post for Eugène in the Ministry of the Interior, where Antonin Proust was working on Gambetta's staff, and "to shake up Gustave, which is very hard." He complained that he could not get his brothers to write a letter. It is interesting to note that when Gustave finally began writing to his mother, after Edouard left Paris to rejoin the family, he never failed to send his love to "my brother, Suzanne, and Léon."

Manet's September letters are almost wholly given over to news of the attack: on the 14th the bridges were blown up; on the 21st Paris was hit by twenty-five thousand shells and fires were raging all over the city; on the 24th people were getting used to the incessant shelling and, in response to Bismarck's outrageous demand of surrender, were determined to hold out; by the 30th café au lait was a memory, as were eggs and cheese; what little milk there was went to the young and the sick; butcher shops were open only three times a week and were cleaned out before the last in line were served, the first having arrived at four in the morning. To protect himself and his brothers, Manet concocted a bulletproof vest for each of them made of two

hundred sheets of tissue paper, and he tried to buy revolvers, at the going rate of one hundred francs apiece. The city was being well fortified, and as of five in the morning those not on duty were out in the streets training to become "real soldiers." While on duty himself, he spent a few nights on the fortifications sleeping on hay when there was enough to go around.

By mid-October the streets were empty after 10:00 P.M. and cafés closed at 9:30. A week later smallpox broke out, as close to home as the apartment of Manet's lawyer-cousin Jules De Jouy, whose caretakers were stricken with it. "Life is deadly in the evening . . . there is nothing to do but go to bed. On the other hand, the days are hard work. . . . Don't be too concerned, we don't run much risk behind our sandbags, and in any case, Paris won't be attacked from every side." In his personal messages to Suzanne he urged her to continue playing the piano and to enjoy herself, but he warned that she would "have to say goodbye for a long time to the idea of playing a sonata with a German." After hunting for her photograph, he finally found it and wrote that he could now look at her nice face (*"ta bonne figure"*) in their bedroom.

On December 7 he announced that he had left the artillery, which turned out to be "too hard" for a thirty-nine-year-old soldier, and expected to be transferred to the general staff, where he would "be safe while being able to see everything." Ten days later he was still awaiting his commission. By the hundredth day of the siege, which fell on Christmas Day, it was cold enough "to crack stones," but there was nothing to burn for heat. Laundresses could no longer boil linens. The peat he had managed to buy the month before was being reserved for cooking, but there was not much to cook. "As for food, I won't even mention it; we sit down at the table out of habit. We are nevertheless in good health," he reassured Suzanne and his mother, advising them to "store up a lot of health, for the air in Paris is and will be infected for a long while."

At the beginning of 1871 he melancholically remarked to Suzanne that this was the first time in all their years together that he would be unable to give her a New Year's kiss. On New Year's Day he and his brothers visited the Morisots: "They are not well and are having a hard time enduring the deprivations of the siege." Rather pointedly he added, "They would willingly change places with you." In the same letter he told her again that except for their separation, he was not

suffering: "If at least I knew that you are well and are not in need of anything, for I have accustomed you to being coddled and looked after for so long that you must miss me very often, if not to say every moment. I feel your absence too, I assure you." This is a rather curious protestation of affection, as is the opening of a letter in mid-January: "My dear Suzanne, How slowly the time passes, and how willingly I would now spend pleasant evenings with you, without thinking of going out by myself." He may have spoiled her, but evidently not with his presence. In this, however, Manet was hardly alone; men commonly maintained a private social life in cafés, cabarets, theaters, and public balls, where "respectable" women would never be seen. One example of his own "coddling" can be seen in a moment of annoyance when in early December he complained, "It is really too bad that *maman* did not want to stock up. There is nothing to eat here." By then even a cabbage had become a delicacy that would sell for twenty francs if it could be found. After seven years of marriage *maman* was still running the household, leaving Suzanne free to practice the piano.

Despite all the hardships and the dangers of mail not arriving, Manet managed to send money to his mother and to look after his sister-in-law Marthe's belongings. Fearing that her apartment building might be destroyed, he informed her that he was storing her valuables, which her blood brothers, Ferdinand and Rudolphe Leenhoff, had not thought of doing, and jokingly added: "I hope you won't hold it against me if no damage occurs."

In January shells fell on the rue Soufflot and the boulevard Saint-Michel, and much of the quarter of Saint-Germain was forced to evacuate because of relentless shelling. Outside of the New Year's Day visit to the Morisots, Manet's only other mention of them had been in early September: "They will doubtless decide to leave Passy, which will doubtless be bombarded." In fact they waited until March before moving to the suburb of Saint-Germain. In a letter to Edma dated September 12, Mme Morisot provided more details of that visit. "The account the Manet brothers gave us of all the horrors that await us was enough to dishearten the stablest of people [among whom she was not counting her husband, whose fragile nerves Berthe seems to have inherited]. You know their customary exaggerations. . . . They said to Berthe: 'You will be in great shape if you are wounded in the legs or disfigured' . . . she nonetheless does not want to leave."[2] Al-

though Manet spoke only twice of the Morisots to Suzanne, we know from Mme Morisot that between September and December he was one of the few people they saw.

Interspersed between Manet's letters to Suzanne are some he wrote to Eva Gonzalès, in Dieppe with her mother and sister, containing the same news but delivered more colorfully, and with a flourish when lamenting her absence: "One of our besieged lady friends recently asked me how I endured your absence, since the admiration and friendship that I have for you are public knowledge. I shall allow myself to respond to that directly to you: among all the deprivations that the siege has imposed on us, no longer seeing you is certainly what I place at the top of the list." Despite the gallantry of the remark, he told her that he had not heard from Suzanne, which makes the extravagant compliment slightly less flirtatious. But as one writer has observed, "He speaks of Suzanne to Eva, but not of Eva to Suzanne."[3] He also told Eva in November that he carried his paint box and a portable easel in his military knapsack — "everything I need so as not to waste my time, and I am going to take advantage of the opportunities I see everywhere." But he does not seem to have done any work, or if he did, nothing remains. And in November he was still light-hearted enough to be vain: "I count on your doing a portrait of me in my artilleryman's greatcoat when you return."

A few months later, promoted from enlisted man to lieutenant, he was posted to the general staff, where his commanding officer was Ernest Meissonier, seventeen years his senior, a member of the Académie, and a renowned painter of battle scenes. Degas had dubbed him "a giant among dwarfs."[4] During meetings Meissonier's incessant sketching irritated Manet, who, unlike his fellow officers, did not snap up the abandoned sheets. Colonel Meissonier had not deigned to acknowledge Lieutenant Manet as a fellow artist, although as a frequent member of Salon juries he was very well aware of Edouard Manet, creator of the most controversial works since Delacroix.

With Suzanne and Eva both out of the city, Berthe may have hoped to see more of Manet, and less formally than at his or her mother's receptions. The scarcity of letters from her during the siege, and the rarity of Manet's name in those that have survived (all of them edited by her grandson), make it difficult to ascertain the nature of their relationship during those months, and equally difficult not to suspect deliberate omission or destruction. The collapse of her health during

that winter and the bitterness she expressed in February have not been adequately explained. In December Mme Morisot wrote, "I am very worried about Berthe. Consumption seems to have taken hold of her; she had a fainting spell last week. For almost two months she ate well and did not look unhealthy, all this is almost gone. We see no one; on rare occasions, Manet, M. Dally [a doctor friend], and Riesener [an artist, cousin of Delacroix, and father of Berthe's friend Louise], and that is all."

Those were months when shells fell day and night and food was critically short. As Manet reported to Eva, by November the city had been reduced to eating what Victor Hugo labeled *"de l'inconnu"* (the unknown): "Horse meat is a feast. Donkey is priced out of range. There are butcher shops selling dogs, cats and rats." This was no exaggeration. Hugo corroborated this in his daily jottings, down to the last animal. He had returned to Paris on September 4, the day the republic was proclaimed, from his nineteen-year self-imposed exile after Louis-Napoleon made himself emperor. By the beginning of the new year animals in the zoo were being slaughtered, among them the elephant, described by Hugo with lapidary pathos: "He wept. He is going to be eaten."[5] Manet's own horse, provided by the National Guard, was in constant jeopardy.

Until late December Berthe had been eating normally and looking well, despite the deprivations. On February 9, 1871, she wrote Edma that the reason for her long silence was that she had been "sick and equally demoralized" but that she was now "very well." It was their mother, she added, who was then very thin and often tired. On February 27 she wrote, "All our friends have come out of this war without a scratch, except poor Bazille [killed in November in combat]. . . . The others have made a big fuss over not much. Manet spent his time during the siege changing uniforms; his brother wrote us today that in Bordeaux [where Manet went after joining his family in Oloron-Sainte-Marie] he related a lot of imaginary campaigns." Why the sudden mockery? Did she hold him responsible for her "demoralized" state? Her rancor was short-lived, for less than a year later Manet began painting the second series of four portraits of her, which includes the one with violets.

But during that dreadful winter Berthe's health was sufficiently altered, though not by any disease, to raise questions about her psychological state. She herself wrote in March that she was surprised by her

own resiliency: "... life during these past six months has been a dreadful nightmare and I am amazed that I am strong enough to tolerate it." She was nervous, she was uneasy about many things, but she was not as fragile as she has been made out to be, except during periods of great stress, and the winter of 1870–71 was surely one of the worst. Her brother had been taken prisoner by the Prussians. He later made a heroic escape, returned to Paris, and rejoined the army. When on January 20 Mme Morisot learned of her son's safety, she wrote Edma in Cherbourg, from whom they had been without news: "Your father wept on learning that you were all safe and well; his son's condition moved him less than yours."

This gives some impression of the atmosphere in the Morisot family, and especially of M. Morisot, who was "always afraid to be pleased," according to his wife. A more personal cause of anxiety may have been Berthe's situation at home. Out of filial duty as the only remaining child — both her sisters were married and had children, far from Paris — she felt that her place was with her parents: "... if some misfortune were to occur I would have eternal regrets. I can't say that my presence gives them any pleasure; I am very sad and totally mute." Communication was no longer possible.

Manet's republican views had influenced Berthe as profoundly as his artistic vision. In 1871 she was in constant disagreement with her father's rigid conservatism. Even when they both disagreed with her elder sister, who was somewhat to the left of Manet, they could not agree with each other: "We speak so rarely that it doesn't really matter." She felt the desperate need for independence, which may not have been caused by her friendship with Manet but was assuredly exacerbated by it. In March 1871, when she was considering an extended stay with Edma, she asked her whether she would be able to work while in Cherbourg. "The question is indelicate, but I hope you can put yourself in my place and understand that this is the only aim of my existence and that indefinite inactivity would be fatal for me in every way. ... I no longer want to work just to work. I may be deluding myself but it seems to me that a painting like the one I gave Manet could perhaps be sold and that is my sole ambition." She had come out of the siege frustrated, disappointed, "disgusted with my peers [*mes semblables*] and even with my closest friends. Egoism, indifference, narrow-mindedness, that is what you see in almost everybody."

Her private despair is reflected in her view of the political and

moral desolation around her. This is retrospectively confirmed by a letter to Edma written in late summer 1871, after her return from Cherbourg. She felt rejected by her parents — her father had lost patience with her crises, and her mother, while affectionately concerned about her, had little faith in her ability: "My mother politely told me yesterday that she had no confidence in my talent and thought me incapable of ever doing anything serious." She felt rejected by Manet; he had not made her feel that she was a more talented artist or a more interesting model than Eva Gonzales: "Last Thursday he was very nice to me; he sees me once again as not too ugly and would like to have me as a model again; out of boredom I will end up proposing it to him myself." She felt dejected by her inertia. Only recently Manet had expressed his opinion of her to her mother: "She has not wanted to do anything so far, she has not applied herself." An unpublished letter from her brother, sent while she was in Cherbourg with Edma, states quite flatly that she has to put her life in order: "I went to see your friend Manet, as crazy as always and as always on the track of a huge fortune. What he said about you, if it is not tainted with the same exaggeration as the rest of his conversation, gave me much pleasure. *It is high time for you to make an independent life for yourself, and success in the form of money is the only key to any kind of freedom*" [emphasis added].

Whatever the reasons for her collapse during December and January, her work and the experience of the siege contributed to it but did not cause it. It would be easy to romanticize the situation: Paris in flames, the Prussians at the gates about to occupy the city, a today without a tomorrow. In September Manet had expressed his fears to Eva: "I fear that we poor Parisians will take part as actors in something horrendous. It will be death, fire, pillage, carnage, if Europe does not arrive in time to intervene." By January four thousand Parisians had died of smallpox and other diseases: "More people are dying from disease than from the enemy's shells," Manet reported to Suzanne. Given Berthe's dissatisfaction with the present, Manet's solitude, and the uncertainty of the future, she may have worked herself into a feverish infatuation. And Manet, out of sincere attraction, boredom, or self-pity, might have encouraged it. Berthe was one of the very few women of Manet's circle still in Paris, and her appeal for him is documented by the 1868–69 portraits.

Was Berthe's bitterness toward him the result of her own wounded

vanity? Manet's eventual retreat was dictated by duty and prudence. When he left Paris on February 12, after France had surrendered, it was to take up his responsibilities toward his family and perhaps to flee his own inclinations. Berthe's accusation that he did nothing during the siege but change uniforms was unjustified. Proust and others who saw him at work attest that he served first as a volunteer gunner in an artillery unit of the National Guard, then as a lieutenant on the general staff. His patriotism at that time far exceeded any fears he had for himself. In fact his solidarity with the defenders of France was such that he almost came to blows with a fellow painter who was attacking the army for its repeated defeats. "If the misguided politics of the Empire are at fault then the Empire should be overthrown, not the army insulted."[6] And later, looking back on that period, he spoke of the "many cowards" who had left, among them his friends. Zola had fled to Marseille; Fantin-Latour had lived like a mole in his cellar; Monet and Pissarro, unwilling to risk their necks for Napoleon III, had gone to London; Cézanne ignored the call to arms and remained in the hills of Provence.

Morisot was similarly bitter about her compatriots when the Prussians finally occupied the city: "The French are so frivolous they will quickly forget this sad arrival." And yet so many others, including her mother, admired the fortitude of the Parisians throughout the siege: "Paris does not lose heart; I think it is magnificent, and yet how many miseries, how many pressing needs." Morisot's barbs began in early February, when she wrote to Edma of her disappointment in her friends, adding, "We have so many things to tell each other, so much to lament together." She continued in the same vein later that month, after Manet's departure. By the spring, although she was recovered physically, her mood was still dark. Her mother announced to Edma on May 2 that Berthe was coming to stay with her: "the thought that you will be together again warms my heart a bit. Berthe will not fail to be bored in Cherbourg, that is certain, but since she will be settling there in order to work, she will be less so than here . . . with parents who have become morose because of illness or worries. *Don't be upset by her occasional sadness, it has become like a second nature . . .* [emphasis added]."

On June 10 Berthe learned from her mother that the Manets were back in Paris: "He is in no rush to see me; it is true that you are not here." And on the same day Manet wrote to her himself:

We returned to Paris a few days ago and the ladies ask me to send greetings to you and to Mme Pontillon [Edma] with whom I assume you are staying.

What dreadful events and how is it all going to end? Everybody places the blame on his neighbor and, in fact, we are all accomplices in what has happened.

I met Tiburce [her brother] a few days ago and have not been able to put into effect my intention of seeing your mother. But here we are, all of us more or less ruined; we will have to put our talents to use.

Eugène went to see you in Saint-Germain; you were out that day. I learned with pleasure that your house in Passy was spared. . . . I think, Mademoiselle, that you will not stay long in Cherbourg. Everybody is coming back to Paris; for that matter, it is not possible to live elsewhere.

Later that month Mme Morisot wrote the long and confidential letter to Edma that contains her homily on marriage addressed to Berthe ("it is better to get married having made compromises than to remain independent and in a position that is no position"). She also spoke of both Edouard and Eugène in paragraphs flanking her cryptic warning: "I know well that the animation of Paris and the artistic sensibility are vastly appealing to Berthe. *Let her beware of succumbing yet again to a false illusion and chasing after a shadow, while forgetting what is important.* . . . *Oh, how I wish that dear child might overcome the torments of her heart and her imagination* . . . [emphasis added]." Immediately before this passage she voiced the opinion that Eugène Manet was "three-quarters mad" and that "all those characters," meaning all the Manet brothers, were unstable. Immediately after it she wrote: "Returning to Manet, I wonder if all his cavalier talk is not merely to be forgiven for the little effort he has made to help Berthe. He may be attributing to himself a premeditated action which he did not seem to have in mind, thinking, in fact, only of himself at the time he left. If the brother [Eugène] has the slightest inclination, he does not need the caprice of circumstances . . . to present himself, for he would then be giving way to an impulse that he would regret the next day."

This obscure reasoning appears to mean that Edouard, aware that his presence was inhibiting, claimed to have left Paris in order to give

his brother an opportunity to court Berthe. A proposal from Eugène would have been a way of resolving an awkward situation. But Mme Morisot was not taken in: "We see only too often that this is not how one gets married, for when the attraction is genuine, all the pragmatic details of the association are readily dealt with. . . . Men disgust me; I am revolted by them and am beginning to like no one any more." Mme Morisot did not beat about the bush when it came to her daughter's resistance to marriage: "I am rather disappointed to see that Berthe will make no effort to get settled like everybody else [*ne trouvera pas à se caser comme tout le monde*]." She was equally forthright about her son's choice of a wife: "Tell Berthe that I hope she guides her boat wisely, prudently, not like her reckless brother; then, when one has made a permanent mess of one's life, it is others who are to blame." Added to her anxiety over her children was a political situation that looked more menacing than the Prussian occupation.

Ever since the emperor's surrender on September 1, rancor had been running high against the generals who had failed him. Particularly despised was Marshal Achille Bazaine, who had been Napoleon's emissary to Mexico, the power behind Maximilian, and who evacuated French forces in 1867, thereby abandoning Maximilian to his tragic end. Bazaine was thus already associated with the most ignominious episode of imperial policy before the war with Prussia. Now, instead of holding out at Metz as the commander of the only remaining field army, he surrendered while at the same time entering into direct discussions with Bismarck and Wilhelm as though he were head of state. His precipitous capitulation freed the Prussian armies to surround Paris. Charged with treason in 1873, his trial was assiduously attended by Manet and Proust, who took the train every day from the Gare Saint-Lazare to the courtroom in Versailles. "What struck Manet," Proust reports, "was the indifference of the accused, which he found revolting. He would have liked to see a man courageously confess his plans and stand up to the accusation."

The provisional government that had organized the defense of Paris and the remainder of the war did not win national approval, despite its remarkable success in raising another half million troops after the surrender of two field armies, the emperor's at Sedan and Bazaine's at Metz. Outside of Paris — where fighting continued from Le Mans in the west, the Loire in the south, Amiens in the north, and

almost to the Swiss border in the east — general opinion favored a negotiated peace with the Prussians.

On January 28, 1871, Paris capitulated after five grueling months, and an armistice was signed. Manet's last two letters of January recount that bread was rationed to three hundred grams, "and what bread!" — some kind of hardtack, according to Mme Morisot. They had all survived. The three Manet brothers were skin and bones. Edouard advised the family — he wrote ostensibly to Suzanne but throughout the letter addressed all of them (*"je vous embrasse tous, ne vous inquiétez pas trop, portez-vous bien, faites des provisions pour le retour à Paris"*) — to buy at once whatever they could get their hands on because after the long hunger of the siege prices in Paris would be out of reach.

Léon Gambetta, the most effective and enterprising member of the government, who had set up a defense council in Tours after his escape from Paris in October, was being held responsible for both the hardships endured and the humiliating defeat. A month after Paris fell, Edma wrote from Cherbourg, "He is the one who did the most for the defense yet is the one who arouses the most recriminations today. People in the provinces are unanimous in . . . blaming him for our failure; success is everything in this world."

Gustave Manet's unpublished letters to his mother written during the siege and its aftermath reveal the same tension as Mme Morisot's, but from another political perspective.[7] The Prussians were to enter the city at ten in the morning of February 29. "Paris is very agitated, great events are in store and the city may be massacred and set aflame without being able to defend itself," Gustave wrote. Many Parisians urged resistance against the occupation, as they urged continuing the war, which meant opposing Thiers's armistice and any peace treaty. On March 2 Gustave wrote that "Paris, despite the occupation of the Prussians, managed to stifle its hatred and indignation — only temporarily. . . . Those who betrayed it will be held accountable, if those old fogies try to steal the republic away from it once again."

The split between Paris and the provinces over the continuation of the war had led to a political separation when a new general assembly was elected on February 8 in Bordeaux, its provisional seat, while Paris was still surrounded by Prussian armies. Strong antirepublican sentiment in the provinces elected reactionary, monarchist deputies ("those old fogies"), while Paris elected equally determined leftist re-

publicans. In his letter of March 2 Gustave reported that news had reached Paris that morning of the acceptance of a preliminary peace treaty — "*Quelle honte!* [what a disgrace]" — and that Paris was in a state of total anarchy: "The government no longer exists. The people are completely in charge and are proving that they are capable of accomplishing a great act. Will there one day be a government that is finally based on them?" In spite of his republican elation he advised the family to stay in Arcachon as long as they could because "the state of sanitation in the city is far from reassuring" and the warmer weather of the coming spring would breed more disease.

A curious remark follows: "Has Edouard finally recovered from the ailments he contracted during the siege, and does he understand at last how much he would have saved himself had he bought the essentials from time to time? He would not have fallen sick." Edouard had written to Suzanne about a number of ills, though minimizing them so as not to alarm her or his mother; he had boils from long hours on horseback, came down with a bad cold, and was having unspecified trouble with his feet. Gustave seems to be blaming him for neglecting himself. He then expressed the hope that they were finally past the worst — still uncertain whether "M. Thiers [will] save us or set off the uprising."

On March 3 Gustave related, "Shame has been consummated. The Prussians have just left the city. Their occupation was far from triumphal." All the shops remained closed. Only one restaurant, on the rue Montaigne, stayed open to serve the invaders, and "they gave themselves up to an orgy. I have just witnessed the sack of that establishment, nothing is left. The National Guardsmen demolished it." Women found there were dragged to the Place de la Concorde, stripped, slapped, and thrown into the fountain, their faces smeared with "the manure of the horses of their Prussian friends." He wrote admiringly of the people of Paris, who behaved with dignity, and wondered whether the present government would take them seriously: "They are already announcing the arrival of 50,000 troops."

Mme Morisot, writing on the same day, felt that since there was no hope of winning the war, it would be better to seek a compromise with the Prussians than to be swallowed up whole. France was about to lose Alsace and Lorraine in the peace settlement. She wrote, "M. Thiers merely acted as the interpreter of sensible people. Now the

revolutionaries will use this to throw us into chaos." "Sensible people" were those like the Morisots who looked on the protesters in Paris as rabble, leftists, and troublemakers. Those who did not approve of Thiers, like Degas and Gustave and Edouard Manet, though not "revolutionaries," were irresponsible.

Adolph Thiers, by then seventy-four, one of the architects of the 1830 July monarchy and a man of law and order, was elected premier. The National Guard refused to give up the cannons already in the city. Mme Morisot, writing about this event to her eldest daughter, Yves, who favored resistance, commented sarcastically, "Paris does not want the Republic to be filched, and it wants the right kind, the one of *partageurs* [sharers — protosocialists, opposed to the principle of private property] and of disorder." Seeing the danger of an armed National Guard in a Paris at odds with the conservative majority, the government hastily left the city and established itself in Versailles. Thiers's order of March 17 to capture the cannon of the National Guard, aborted because the troops defected, led to the establishment of the Commune by infuriated Parisians, who refused to submit to the peace treaty signed by Thiers. Paris, in effect, was seceding from the rest of France.

On April 12 Gustave wrote his mother that "the Versaillais are bombarding Paris as it never was by the Prussians. *Quels misérables*. People everywhere are talking about proposals for conciliation. In vain . . . Eugène is leaving today. . . . Paris is very calm. . . . Every day, the republican position, especially among merchants, is gaining ground, and everyone is volunteering to take up the struggle if the government and the assembly persist in refusing to understand the revolution that has just taken place in Paris."

The end of May saw an apocalyptic week of bloodshed and violence. Communards, defending their "workers' republic," torched all the symbols of authoritarian order — the Hôtel de Ville, administrative center of the municipality of Paris, and many of the *mairies*, the borough halls of the twenty arrondissements comprising the city. Records of every kind went up in flames — birth, marriage, and death certificates, police records. Because of these conflagrations, a year later Ferdinand Leenhoff applied for a reconstructed birth certificate for Léon, who needed it for his military service, thus sparing his sister the possible embarrassment of having to identify herself at

the *mairie*. Since she had no proof of a marriage to Koëlla or of its dissolution, she was either an unwed mother or the bigamous wife of another man.

Returning to Paris from Saint-Germain on May 25, Mme Morisot described the condition of the city: "Paris in flames is beyond imagining . . . bits of charred paper and other still legible fragments wafted in the wind all day long, a column of smoke covered Paris; at night a red glow, horrible to see, looked like an erupting volcano. . . . It is said that the insurrection is over, but the firing continues without interruption. . . . If M. Degas were to be slightly roasted he would have it coming to him." A few days later she saw the Hôtel de Ville, a lacework of shell holes on all sides, the Louvre pockmarked, the Tuileries a shambles. Her husband wanted the debris of those monuments kept "to consecrate the horror of popular uprisings." Her son Tiburce, then an officer in the Versaillais army, ran into two *"communaux,"* as she derisively called them instead of Communards, "Manet and Degas, while all the shooting was going on. Even now they are still condemning the forceful measures of the repression. I think they're insane, don't you?"

Between May 22 and May 29 prisoners were indiscriminately executed by Versaillais forces. Somewhere between twenty thousand and thirty thousand Parisians died regardless of age, sex, or politics. Surviving political figures were exiled to a Pacific island, among them the republican journalist Henri Rochefort, whose striking portrait Manet would paint in 1880 after the amnesty allowed Rochefort to return to Paris.

There is no evidence that Manet was a Communard or was even a sympathizer of the Commune, beyond his revulsion over the mass slaughter. Mme Morisot's charge cannot be taken at face value and is even more inappropriate with regard to Degas, whose position was more conservative than Manet's. Manet was a steadfast republican whose politics were center/left — what the French call radical republicanism, which has always been a moderate position in European politics. Today the word *radical* creates an unfortunate confusion with the more common connotation of an extreme ideology. Months before the repression ordered by Thiers, Manet had already expressed his contempt for him.

Manet had left Paris on February 12 for Oloron-Sainte-Marie, where he stayed only a few days, hastily painting two pictures of Léon:

in one he appears on a bicycle, in the other leaning over a balcony. From there he went to Bordeaux, arriving during the last week of February, with politics on his mind. Ever since the 12th, the National Assembly had been in session there. Through the influence of his old friend Albert de Balleroy, who had just been elected deputy, Manet was able to attend a meeting. Writing to Bracquemond in March, he expressed his reaction to it: "I did not imagine that France could have itself represented by such a senile crew, not excluding that small-minded Thiers who I hope will croak one day on the rostrum and rid us of his aged little self."[8] Despite his disappointment in the complexion of the Assembly — Republicans had won only 150 out of 768 available seats — Bordeaux was the locus of the new republic. A peace treaty was being negotiated; France had lost a war but gained a republic; the future of the country was being deliberated.

Manet's patriotism, as devout as his belief in the republic, was stimulated by the moment and the place. His *Port of Bordeaux* is seen in the muted gold of early morning, a vertical architecture of black masts and mauve-gray spires rising from the flat stretch of pale quay and water (Fig. 34). More than a conventional seascape, it recalls Frans Hals's *Militia Company of St. George*, with their raised lances against a strong horizontal plane. Just as the civic guard represented the republican spirit of Holland, so Bordeaux, not Paris, represented republican France and the future at that moment. But unlike Hals's proud rendering of individual militiamen, Manet is celebrating his country rather than his compatriots — the industry of its ports, the enduring grandeur of its cities. The drooping white sail may signify the humiliating defeat in the Franco-Prussian War and the wheeled cart the abandoned cannon, but the multitude of straight masts on unrippled water suggests an optimistic vision.

Proust reports that "Gambetta was in raptures over this painting which reminded him of the final hours of the defense." Manet wanted to give it to him. "'No, my friend,' Gambetta replied, 'I am not rich enough to buy it and I am unable to accept it as a gift.'" Even taking into account Manet's appraisal of Gambetta as "more enlightened than the adherents of his party," compared with most other republicans who "become reactionary when they talk about art," Gambetta's enthusiasm (Proust's term *s'extasiait* is strong indeed) was more likely to have been for the allegorical rather than the aesthetic quality of the work. Manet himself underscored the importance of

the specific setting by writing "Bordeaux" in the lower left corner. This was more than a study of real life in the open air; this was a chronicle of French political history, deliberately understated so that it avoided the rhetoric of history painting — which is not to say that Manet avoided the historical events of his time.

Historian Philip Nord observes, "Over a twenty-year career, the artist [Manet] exhibited a remarkable and persistent penchant for politically charged subjects and themes." Until very recently art critics viewed Manet's treatment of such subjects as "amoral," "depoliticized," "neutral," and "indifferent." Nord establishes Manet's political position as "radicalism" in its adherence to that "narrow stretch of France's political spectrum, extending from Henri Rochefort . . . on the left, to Léon Gambetta on the right," a position concerned not with class struggle, but with "the struggle to realize the radical potentialities that [Manet] perceived within the bounds of bourgeois life itself."[9] This is confirmed by his participation in politically oriented committees seeking to democratize the Salon system, his unbroken association with radical republican journalists and political figures, and his choice of subjects. If his political engagement was overlooked or undervalued in his painting, it may be because viewers had been trained for centuries to see moral significance only in the grand and unequivocal gestures of academic art.

John House has broadened that view.[10] Although his essay is entirely devoted to *The Execution of Maximilian*, the arguments in it can be extended to all of Manet's works concerned with the political or social aspects of his time. When his lithograph of the *The Execution* was suppressed, Manet insisted, in print, that the work was purely artistic. He might have said the same of his two images of the Commune, *The Barricade* and *Civil War*. "Did this 'artistic' sphere locate them apart from questions of politics, or did this very notion of the 'artistic' represent a political position?" House asks. "The appeal to the 'artistic' was a repudiation of bourgeois values and a statement of the transcendence of 'artistic' vision," and in the case of *The Execution*, it was an unsuccessful diversionary tactic to escape censorship.

Opponents of Manet's "modernism," which eliminated dramatic poses and lighting, were the first to accuse him of detachment: ". . . life's spectacles do not move him. This indifference will be his undoing."[11] Ever since, the prevailing opinion has been that Manet's

choice of subject bore no relationship to any personal position, thought, or sentiment, that whenever he elected to depict a contemporary event, he defused its actuality and depoliticized its content so that, at best, he was presenting a modernist version of what might once have been a historical painting. This viewpoint is very strange indeed, since every time he chose a loaded subject, he identified it by name: *The Execution of Maximilian, The Battle of the "Kearsarge" and the "Alabama," Civil War*. It is hard to imagine that anyone in his day could have failed to associate the works with events that filled the front page of every newspaper.

Manet was as much a political animal as he was a consummate artist. His political consciousness began in adolescence, as is documented by his distrust of Louis-Napoleon in 1849. His friends Burty, Degas, Gambetta, Zola, and Duret, as well as his brother Gustave, were all committed republicans of the same moderate stripe as Manet; none were Communards, all were opposed to the Commune's violence, and all were equally opposed to the violence of the Versaillais repression. The degree of Manet's political involvement is revealed in Mme Morisot's remark that "France is divided between the lunatics, the Manet clique and others, and the imbeciles, Chambord and company."* She was also exasperated by Manet's "railing against M. Thiers," whom he called "that demented old man." In Manet's opinion the only capable politician was Gambetta. "When one hears such talk," Mme Morisot concluded, "little hope remains for the future of this country." Not only was Manet agitated at her table, but she had heard from him that even at his own there were political quarrels. *"Cette famille n'est guère séduisante"* (that family is far from appealing), she sniffed. She also made a clear distinction between the overpoliticized Manet and Fantin-Latour, who "did not put his nose outdoors the whole time of the siege and the Commune and went on painting."

The very "indifference" of which Manet was accused was a newer mode of expression, intended nevertheless to convey meaning, just as anger can be expressed by dropping the voice to a mere whisper rather than by shouting. As House points out, "an assumed and

* Count Henri de Chambord was the Bourbon pretender to the French throne in the aftermath of the February elections.

ironic distance was a cogent, but less tangible mode of opposition than overt confrontation."[12] This certainly characterizes Manet's political paintings, but it also describes the stance he took vis-à-vis personal preoccupations or social phenomena, both of which he inscribed in his art. He no longer used the unambiguous language of traditional rhetoric, which even in painting was based on oratory — the art of persuading the listener by ringing speech, dramatic gestures, and examples drawn from classical literature, once familiar to most educated people. Instead he turned to a rhetoric of reticence — irony, humor, understatement, a communication predicated on the absence of common understanding in a fragmented world. Yet he used some of the same devices as in traditional rhetoric — analogy, allegory, satire — and drew on the familiar images of high art, in the same way that orators turned to the writers of antiquity, only he brought them down to earth. His last year at the Collège Rollin served him in ways he could never have imagined when he was shifting restlessly in his hard seat.

Ever since his days in Couture's studio in the 1850s, Manet had been arguing for simplicity and naturalness, for a new means of conveying what was meaningful or beautiful in the actual world. Twenty years later, in connection with his unfulfilled desire to do a portrait of Gambetta — who apparently came to the studio for a few brief sittings, but Manet needed a full day, not a few hours — Manet voiced what amounts to an artistic credo:

> It is so convenient to adopt ready-made formulas and to bow to what is called ideal beauty [le beau idéal] — a beauty that would be definitive when everything else changes. Let them stop bothering us with these old chestnuts. When I say that beauty changes, that's not quite accurate. But beauty adapts. What would you say to a painter who would study the head of a man like Gambetta and would then go off to the Louvre and copy The Discobolus, saying: "Only that is beauty." Yet that is what we are told to do. . . . In truth, our only duty is to extract from our era what it offers us, without however ceasing to admire what earlier periods accomplished. . . . I would have liked to leave an image of Gambetta as I see it.[13]

Looking at Port of Bordeaux today, we would have no inkling that it has any content beyond its title, any more than we would The

Battle of the "Kearsarge" and the "Alabama," which is a stunning marine painting, and that may be all that matters now. But in 1864 when Manet painted the latter, a political undertone would have been caught by like-minded viewers who shared Manet's sympathies with the North in opposition to Napoleon III's support of the South. Since the *Alabama* was destroyed by the Union's *Kearsarge,* "representation of a confederate defeat afforded a rare opportunity to take a backhand slap at the Empire," writes Philip Nord. It is not surprising that Manet, long an opponent of slavery and of monarchy, "brought such intensity to the project. Little wonder too that radical critics showed such a liking for the painting."[14] Throughout his career Manet maintained an unemphatic approach, confronting the intellectual or emotional content of his paintings obliquely rather than directly, with the irony of the dandy, the deadpan manner of Japanese prints, and the wary eye of the subversive.

After a week in Bordeaux he rented a house in Arcachon, on the Atlantic coast north of Bordeaux, where he spent a month. Four canvases document his stay: three views of the coastline and sea and one titled *Interior at Arcachon.* None is a major painting, but the interior scene is worth a closer look. Depicted are Suzanne and Léon before an open balcony window facing the sea. Léon is seen in profile looking off into space, with an open book on his lap, while Suzanne, viewed from the back, is a series of circles representing her head, her featureless round profile, the mound of flesh above her legs, which are propped on a folding stool. Charles Moffett writes in the 1983 exhibition catalogue, "Mme Manet and Léon seem perfectly comfortable in each other's presence, but both are entirely absorbed by their respective interests."[15] What remains to be said is that nowhere in this scene is Manet's presence felt; he is completely outside what would appear to be a family scene — a family reunited after months of separation and weeks of travel.

In July, after the Manets returned to Paris, Mme Morisot sardonically told Berthe, who was still in Cherbourg, that Suzanne had lost some of the weight she had apparently gained in Oloron: "His wife has made a little progress, but he must have suffered a terrible shock at the sight of this rustic filling out [*cet épanouissement campagnard*]." After months of near starvation in Paris — Manet spoke of himself and his brothers as being "thin as rails" — Suzanne's ampler contours may indeed have been a shock to eyes that had seen only

haggard faces and bony bodies. Moffett states that "in all subsequent paintings for which she modeled [after *Interior at Arcachon*] . . . she is seen from behind . . . her face is obscured, or the painting is unfinished." The one exception is *Mme Edouard Manet in the Conservatory* of 1879 (Fig. 53), which nevertheless makes a disturbing contrast with the canvas immediately preceding it in the identical setting, *In the Conservatory* (Fig. 52), showing an elegantly attired young woman of delectable proportions (see Chapter 17). Even more telling is the drawing Manet did of *Interior at Arcachon*, in which Léon is brought farther into the foreground and Suzanne recedes to the right. "If he had made the changes in the painting that are indicated in the drawing," Moffett says, "Léon would have become in effect the subject of the painting and Mme Manet's role would have become almost incidental" — as in the placement of the servant in *The Luncheon*. Moffett cites X-ray evidence that Manet painted her face and scraped it off three times when attempting the unfinished 1866 portrait of her with a black hat; X-ray evidence also reveals that "before he painted over the portrait of Suzanne that is covered by his self-portrait [with a palette of 1878–79; see jacket], he scraped off her face with a palette knife after the paint was dry."[16]

Seen from a distance, these various elements, like the colored patches of an impressionist work, come together in a picture of controlled but deep-seated rejection. Manet spent a lifetime expiating his manifold guilt, but he could not change the way he saw Suzanne, certainly after 1865. He felt guilty about no longer loving her when he married her, about his loss of interest in Léon, about his little infidelities (which he knew had affected his health but did not yet know how seriously) and perhaps also about the greater infidelity of loving a woman he did not have the courage to claim. For these reasons he spoiled Suzanne in every way he could, turning her into an overfed pet. Léon was similarly pampered, as he admitted himself. Manet was either too moral or too pusillanimous to abandon them, but he was not blinded by his obligation. Léon's vacuity is visible in every picture from *The Luncheon* on, as is Suzanne's rotund inertia. Manet was too much a bourgeois to provoke a scandal, and too much a dandy in the Baudelairean sense to expose his grievances. And so he kept up appearances and continued scraping Suzanne off his canvases.

This was not without some cost. After returning to Paris, he left his easel empty, his brushes untouched for months on end. Tabarant describes him as "wandering aimlessly from the Café Guerbois to the Mulhouse to the Tortoni" but ascribes his "nervous depression" to the experiences of the siege.[17] Manet's physician and longtime friend Dr. Siredey finally treated him, apparently with some success, but it was not until the early spring of 1872 that Manet was back at work with gusto.

It is possible that there were medical reasons for his depression. Recent studies have returned to the fascinating relationship between creativity and mood disorders, specifically manic depression and major depression, or the milder cyclothymia, all of which can range from mild to severe, and with long periods of stability between episodes when artists appear to be in full control of their work.[18] As was recently observed by a psychiatrist working on this subject, "People have trouble with the idea that someone can be both very healthy and very ill. But those with manic depression can be very scared and extremely confident at the same time, and it takes that hyperconfidence when you're breaking down borders in art and doing things that haven't been done before."[19]

Whereas Manet shifted from overconfidence to bleak despair, characteristic of cyclothymic oscillation, Berthe Morisot seems to have been more of the major depressive type, different from cyclothymia in that the euphoric upswing is absent. In Manet's case there may also have been a physiological cause for his mood swings. Since the form of neurosyphilis from which he suffered develops ten to twenty years after the onset of infection, it is probable that by 1871 he had already contracted the syphilis that led to his death. In the pre-penicillin era, tabes dorsalis, which affects the limbs rather than the brain, accounted for one-third of the patients with neurosyphilis. Ataxia, one of the manifestations of tabes dorsalis, was diagnosed when Manet developed its characteristic symptoms and was specifically named by his first biographers, who may not have known its relation to syphilis.

Manet, his mother, and his friends all made mention of the lightning pains in his legs, his increasing difficulty in walking, and the ulcer under the foot that developed at the end of his life, typical of tabes. Syphilis, "the great imitator," can produce a host of commonplace symptoms not readily identifiable as related to the disease, in-

Syphilis

cluding emotional instability and arthritis. Proust repeatedly speaks
of Manet's sudden onsets of irritability; Berthe Morisot and her
mother describe his alternating moods of euphoria and depression.
Earlier in the evolution of his disease, it was said that he was suffering
from arthritis. Later one doctor held out the hope that a disease less
serious than syphilis — gonorrhea is a common cause of infective
arthritis — was responsible for his leg pains. That was not the case,
however; his symptoms were typical of one form of tertiary syphilis.
The various ailments that Manet experienced during the siege may,
therefore, have signaled the onset of tabes, after which ataxia can de-
clare itself anytime between one and twenty-five years. Manet began
to manifest the muscular incoordination symptomatic of ataxia in
1878.

Dr. Siredey, who treated Manet until the end, may already have
suspected syphilis when he was called in during the summer of 1871.
At the time there was no definitive diagnostic test and no cure. More-
over, Siredey may have been able to reassure Manet that however
prevalent syphilis was, many untreated patients, in fact a majority,
lived out their lives with minimal complications, never developing the
devastating and fatal tertiary syphilis that had killed his father and
Baudelaire.

It is also possible that the despair of never being able to change his
life — so like Berthe Morisot's own psychological state — left him
bereft of the will to work once he returned to Paris and to reminders
of Berthe. That she was on his mind is evident from the note he wrote
to her within days of his return. No doubt the siege affected him, but
it should not be forgotten that he did work in the immediate after-
math of the siege, even producing his splendid *Port of Bordeaux* —
painted from the windows of a café — under the stimulus of the
events there. However, *Interior at Arcachon,* and the three bleak
seascapes painted after Bordeaux, may be interpreted as the dismal
recognition of what he had come home to and would have to face for
the rest of his life.

There is no certain date for Manet's return to Paris, but the corre-
spondence between Mme Morisot and Berthe and the date of Manet's
letter to Berthe indicate that it could not have been earlier than the
end of May. He may have come back just in time for the last days of
the insurrection. In any case only one work emanates from the siege
and two from the Commune. *Queue at the Butcher Shop* is an etching

of women under umbrellas waiting to buy meat. Seen out of its historical context, it seems to reflect Manet's interest in Japanese prints rather than personal memories of intense hunger, cold, and guard duty in bone-soaking rain. Contrary to the apparent aesthetic distance of such a work, his experiences of the siege and his letters describing them prove how far from detached he really was.

As for the Commune, his *Civil War* is assumed to have been done from life, although *The Barricade,* as Françoise Cachin demonstrates,[20] may well have been done from photographs, as were *The Execution of Maximilian* and perhaps also *The Battle of the "Kearsarge" and the "Alabama."* There is yet another curious relationship between *The Barricade* and *The Execution* in their shared composition and conjoined existence on the same sheet of paper: a sketch of *The Execution* is on the verso of *The Barricade.* Even if the events of 1871 were not depicted by an eyewitness, their impact on the viewer is in no way diminished, nor is Manet's reaction to them. There is an immediacy to the two scenes of the Commune that makes them entirely convincing.

Manet had seen dead bodies as early as 1851, when the future emperor had loosed an army against Paris during his coup d'état. In the cemetery of Montmartre alone, Manet and Proust had seen more than five hundred corpses lined up for identification, a scene so horrible — made even more chilling by the anguished screams of family when they recognized their dead — that they never talked about it afterward, nor would Manet show anyone the sketch he had made. The horror of violent death in a civil uprising was unrelated to political affiliation. In 1871, as in 1851, there were culprits, but a dead civilian or a dead soldier had no politics.

In his absence Manet had been elected to a committee of sixteen Parisian artists "supporting the principles of the communal Republic," under the presidency of Courbet, a committed Communard who, once the insurrection was put down, was held responsible for the demolition of the column on the Place Vendôme. He was arrested, tried by a military tribunal in Versailles, and sentenced on September 2, 1871, to six months in prison and a fine of 500 francs. He also was made to assume the cost of reconstructing the column, 300,000 francs. Courbet argued that he had not issued the order to topple the column, decreed on April 12 by the Commune, as he had not been elected to the Commune until four days later. However, as everyone

knew, ever since the fall of the empire Courbet had been as vociferous as his fellow Communards about destroying that monument to a hated past. Although perhaps less guilty than others, he was in fact denying his own publicized convictions.

As Petra Chu explains in her notes to Courbet's letters, "The National Assembly, which ruled France between 1871 and 1876, was determined to rid France of all radical tendencies. To that purpose, it intended to prosecute everyone who had been even remotely associated with the Commune."[21] Manet was unaffected by this, since he did not return to Paris until the Commune was put down and never served on the committee. He did, however, attend Courbet's trial and on August 22 wrote to Duret, who was in New York on his way around the world: "You talk to me about Courbet. He behaved like a coward before the Council of War and now is no longer worthy of any interest whatever."

Earlier, in March, three days after the insurrection in Paris had begun, he wrote to Bracquemond:

> We are living in a sorry country where people are only interested in overthrowing the government in order to join it. There are no disinterested people around, no great citizens, no true republicans. Only party hacks and ambitious types . . . [who] are going to stifle . . . the sound idea that was beginning to gain ground, namely, that the only government for honest, peaceful, intelligent people is a republic, and that only this form of government will enable us, in the eyes of Europe, to rise up from the appalling depths to which we have sunk. It is only in the provinces that you feel how much they hate Paris. It was a great mistake on the part of Thiers and the Assembly not to return to Paris immediately after the evacuation; the result was those dreadful riots that have brought despair and disgust to the hearts of all true Frenchmen.
>
> What an encouragement . . . for the arts! But there is at least one consolation in our misfortunes: we are not politicians and have no desire to be elected deputies.[22]

His views were shared by the Morisots, but from a slightly different perspective. Their greatest fear was that Thiers would resign, leaving the country open to a return of monarchy. In contrast, for Edouard

and Gustave Manet the choice was not a monarchy or a republic, but what kind of republic.

The Franco-Prussian War was no small blip on the screen of European history. It brought about the demise of monarchy in France; the birth of the Third Republic, which lasted until France fell to the Nazis in 1940; the rise of the German Empire, proclaimed by Kaiser Wilhelm in the Hall of Mirrors at Versailles on January 18, 1871, and which now included the war prize of two French provinces, Alsace and Lorraine; the disintegration of the Papal States, which had been protected by Napoleon III; and the complete unification of Italy.

In July 1871, Berthe was still with Edma in Cherbourg. Writing from Paris with greater verve than usual, Mme Morisot described the Manet salon as "back to its former state; it's nauseating." She noted that Degas was there, half asleep, adding, "Your father seemed younger than he." Outside of common misfortunes, related by each guest in personal terms, no one had much to say. The overcrowded salon was stifling, and only hot beverages were served. "Mad[ame] Ed.[ouard] played. . . . Mlle Eva has grown ugly. . . . Champfleury was sprawled on the only comfortable chair saying not a word to anyone . . . you can see the scene from where you are. . . . Eugène . . . asked for news of you, but after a moment in my presence, his eyes began fluttering and he struggled to stay awake. Ed.[ouard] repeatedly asked, were you not coming back, was this how you abandoned your adorers, have you found new ones?"

Manet seemed unable to regain his equilibrium. At the end of August he left for Boulogne with his mother, Suzanne, and Léon, remaining there most of September. Of the three paintings he did during that lull, one depicts a group of croquet players, probably on the grassy ramparts of the old city, since the water is seen from a height and at a distance. All of them were intimates — Léon, Eva Gonzales's sister, and Paul Roudier, a classmate from the Collège Rollin, of whom Manet had done a portrait in 1860. The carefree outdoor setting suggests that Manet had his lighter moments in the company of friends. Another painting is a view of the port of Calais, done on a brief excursion from Boulogne.

The third work, a still life, was painted, according to Tabarant, after Manet's return to Paris. There is no continuation of the summertime lightheartedness seen in the croquet game, but rather a sad pen-

siveness in the choice of subject and color. This is a very small canvas (21 × 26 cm) of a pile of green almonds, three of them open to show the kernel, the others closed, on a nondescript surface. Manet painted pears, peaches, and apples a number of times, peonies, roses, and lilacs many times, but only once before had he painted almonds — like these, unripe ones. A much larger still life (54 × 73.5 cm), *Fruits on a Table,* dated 1868, has an almost identical pile of almonds beside clusters of green and black grapes. The similarity is so striking that it would seem to confirm Manet's state of mind in 1871. He was too apathetic to create a new composition and therefore copied this fragment from his 1868 canvas, as writers have been known to copy earlier pages of their own work or that of others just to get started again. The fuzzy gray-green husk may have presented an interesting technical challenge, but it has none of the sensuality of his flower paintings, with their tragic awareness of death; none of the opulence of his fish and seafood, or the succulence of his other fruits set on meticulously detailed tablecloths, every ironed crease, every woven pattern rendered.

This curious little canvas recalls Berthe Morisot's comment two years before, that his paintings made her think of "a wild, or even a not quite ripe fruit." The acerbic, melancholic quality of these isolated almonds reflects the mood of the Arcachon scenes. Still lifes played an important role in Manet's life; they distracted him when he was low and kept his hand and eye in practice. Apart from his remarkable gift of rendering objects, which did not cost him the effort of dealing with flesh tones and facial expressions or scheduling sittings, he turned to still lifes in moments of distress. Much of 1871 had been distressing. The new year, however, would begin with a triumph, and the rest of the decade would be the most fulfilling period of his career.

"As Famous as Garibaldi"

Before there were picture dealers in Paris there were picture lenders. Until well into the 1830s those with the means to buy paintings did so directly from the painter, whose works they may have seen at a Salon, or which they commissioned, as in the case of a portrait. Often a merchant who sold art supplies served as a go-between, either displaying an artist's work in his shop or recommending an artist to a potential client. Unlike later picture dealers, they did not buy up a stock of pictures from an artist and sell them to collectors at a profit. Instead they took pictures in trade for art supplies or paid small commissions when the pictures were leased.

There was a brisk business to be done in rentals to people of unstable circumstances with extravagant tastes. A large clientele comprised women kept by wealthy men who subsidized their fashionable gowns, sumptuous apartments, and grand receptions. But the uncertainty of a demimondaine's income, or for that matter her dwelling, precluded the purchase of paintings. Nor did her lovers consider art to be as sound an investment as jewelry, which could be sold quickly or passed on to a new mistress. Such women were therefore ideal clients of picture lenders, as were nouveaux riches who had to furnish ostentatious dwellings in a hurry.

Over the years some people who had started out as *marchands de couleurs* (dealers in art supplies) became *marchands de tableaux* (picture dealers). Ordinary people did not commonly hang paintings on their walls, but as wealth spread, the more ambitious became collec-

tors, imitating aristocratic patrons of the past. One of the most enterprising among the new art professionals was the father of Paul Durand-Ruel, who, after rising from paint supplier to picture lender, later opened a gallery at 1, rue de la Paix, at the corner of the newly constructed avenue de l'Opéra, in the heart of the fashionable Paris that Haussmann had built. His son Paul inherited and enlarged the business beyond his father's imagination.

In 1869 Paul Durand-Ruel opened a larger gallery on the rue Lafitte, the marketplace of the new art merchants, and launched a publication on art and on what are known today as "collectibles," *La Revue Internationale de l'Art et de la Curiosité*. A year later the Franco-Prussian War interrupted his plans, but, sharp entrepreneur that he was, he knew there were other markets to explore. He shipped his paintings to London and went there himself in September just before the gates of Paris were closed. He had been promoting the Barbizon School, by then the older generation of French landscape painters — Corot, Daubigny, Millet, and Rousseau, among others — who were unknown to the London public. Théodore Duret, on his way around the world just then, wrote to Manet from London that with respect to art, the English were where the French had been a decade or two before. However, Manet's trip to London in 1868 had left him with the impression that the English were less prejudiced against "new" art than the French.

Durand-Ruel began showing the works of Monet and Pissarro, whom he met in London where all three sought refuge from the siege, later adding Degas, Renoir, and Sisley to his roster. At the same time, he opened a gallery in Brussels, where these avant-garde painters also were greeted with interest. By the time he returned to Paris in late 1871, he was on the lookout for more acquisitions. One of his sources was the extremely successful Belgian painter Alfred Stevens, a longtime resident of Paris.

The war had left Manet so short of cash that in March of 1871 he was forced to borrow money from Duret, whose cognac business seems not to have suffered. A letter dated August 22 acknowledges receipt of seven hundred francs sent from New York: "You can imagine that I must have been in dire need ... there is simply no money around these days; the provisional government seems ill suited to the task of restoring the country's finances."[1] Manet's rare sale during the previous year had been in September 1870 to Duret. Manet had sold

him *A Matador Saluting* for twelve hundred francs, asking him not to mention what he had paid; for anyone else the painting would have been no less than two thousand.*

Ever since the siege the only monies coming in had been Mme Manet's pension and some investment coupons. Manet once managed to send three hundred francs to Arcachon — two hundred for his mother, one hundred for Suzanne. But thereafter he told Suzanne to ask his mother for money if she needed it, since he had no sure way of getting any to her even if he could find some. By the end of 1871 he was deeply in debt to his mother, unable to repay her, and unable to manage on the income from his inheritance. It was then that he turned to Stevens — whose pretty and uncontroversial paintings, of ladies attired in the latest fashions surrounded by sumptuous interiors, netted him a hundred thousand francs or more a year — asking whether he might leave two paintings in his studio since dealers often made their way to Stevens's door.

The new year had barely begun when Paul Durand-Ruel went shopping and looked in on Stevens. There he saw the two Manet canvases: "They were the superb *Port of Boulogne in Moonlight,* and the equally marvelous still life [*The Salmon*] which I sold to Mr. Havemeyer for 15,000 francs in 1886 in New York, at the time of my first trip there," he recalled in his *Memoirs* fifty years later. He had paid Manet six hundred francs for *The Salmon* and one thousand for the other. "Amazed by my purchases," he continues, "for one fully appreciates a work of art only when one possesses it, I went the very next day to Manet's studio [the interim space he rented at 51, rue de Saint-Pétersbourg after leaving his studio on rue Guyot]. I found there a remarkable group of pictures, some of which had already attracted my attention at previous Salons, but which struck me as much more beautiful now that I had been able to examine at leisure my acquisitions of the day before. On the spot, I bought everything he had, that is, twenty-three paintings, for 35,000 francs, at the prices he was asking."[2] A few days later, he bought a second lot for sixteen thousand francs.

* In 1870 the rate of exchange was 4.98 French francs to the dollar, which means that 1,000 francs equaled $200. According to the consumer price index, the buying power of the 1870 dollar is equal to $14.63 today.

For Manet this was an undreamed-of windfall: 51,600 francs to be paid in installments of a few thousand at a time. His mood brightened considerably. Joining his friends one evening at the Guerbois, he contained his excitement behind an ironic query: "Would you like to tell me who does *not* sell 50,000 francs' worth of paintings a year?" "*You!*" came the expected reply.[3] Not anymore, his grin proclaimed. The news spread rapidly. Some thought Durand-Ruel had lost his senses, others that he had the flair needed to recognize the outstanding talent of the generation. Even if the sale did little to enhance Manet's finances for the moment — in January he received only sixteen hundred francs for the first two pictures, plus another five thousand toward the balance — it certainly enhanced his reputation. Fifty-two thousand francs for someone who had sold virtually nothing in ten years' time was a dizzying sum. Considering that they now hang in the major museums of two continents, the list of works Durand-Ruel bought in the first lot is breathtaking: *The Absinthe Drinker, The Spanish Singer, The Reader, The Street Singer, The Water Drinker, The Spanish Ballet, Young Man in the Costume of a Majo, Mlle V . . . in the Costume of an Espada, Christ with Angels, The Dead Toreador, The Battle of the "Kearsarge" and the "Alabama," The Tragic Actor, Vase of Peonies, The Philosopher, The Beggar, The Ragpicker, Woman with Parrot, Bullfight, The Fifer, The Pier of Boulogne, On the Beach, Repose, Port of Bordeaux.* The second lot included *Music in the Tuileries* and the Boulogne harbor scenes of 1869.

There is no trace of Manet's activity during the first six months of 1872. He does not seem to have rushed to his easel after the sale. By March, when submissions to the Salon were due, he had nothing new to send, but he was apparently determined to be represented, since this was the first Salon held in two years. He decided to borrow his recently sold *The Battle of the "Kearsarge" and the "Alabama"* from Durand-Ruel, a work, though superb, that had been seen by critics and gawkers alike in Cadart's gallery window eight years before and in Manet's private exhibition of 1867. It was his only submission, "a mere calling card," in Tabarant's words. The jury that year included Meissonier, Manet's superior officer during the siege, who apparently found no fault with Manet's canvas but bitterly opposed the acceptance of Courbet's submissions on political grounds. In fact the entire selection that year was largely determined by political considerations:

no pictures of the insurrection, no pictures by Communards, which excluded a large number of artists.

Manet's canvas was almost unanimously well received by the critics, among them supporters whose voices carried some weight by then. Duranty admired, as did all of them, the agitated sea, which revealed "the powerful and individual tonality with which the painter always sets himself apart from all others." Armand Silvestre compared the usual "ridiculous" rendition of seascapes with "the powerful interpretation given it by M. Manet, whose sea is at the same time profound and profoundly turbulent." And Barbey d'Aurevilly wrote his lengthy encomium with the authority of a man bred to the sea: "Very great, that work, in execution and conception." No one seemed concerned with the historical actuality of the work; it was regarded as a brilliant seascape, no more. The one naysayer was, as usual, Jules Claretie, but this time he recognized "material qualities," while remaining unconvinced by this marine view whose "perspective is a bit too much in the Japanese manner" but whose water "is dark, thick, admirably painted moreover. There are always material qualities in M. Manet . . . but one can really not accept this as a painting."[4]

Manet's bête noire, the critic of *Le Figaro,* Albert Wolff, writing more in the style of a gossip columnist than an art critic, had more to say about the man than about the painting: "People who only know M. Manet through his exhibitions generally imagine the painter of *The Alabama and the Kearsarge* as . . . long-haired, with a red beret, a windbreaker, work pants and a short-stemmed pipe [typical of the working class]. In reality, M. Manet (who can be seen at the café Tortoni every evening from 5 to 6) . . . is a man of the world, with a refined and ironic smile. Very recently the rumor spread in Paris that M. Durand-Ruel bought 40,000 francs' worth of paintings from M. Manet in one fell swoop."[5] The amount was understated, but Wolff was impressed, as were other critics who made mention of the sale in their articles, thus ensuring Manet more celebrity than notoriety. Even the mockery in *Le Journal amusant* seemed less vitriolic than in the past: "M. Manet had the ingenious idea of offering us a vertical slice of the ocean, so that we can read on the faces of the fish their impressions of the battle taking place above their heads."[6]

Some critics recognized in this picture the modernity that was so woefully absent from most of the works shown in the Salon, still concerned — as one critic, and a conservative at that, remonstrated —

with "Venuses, Phrynes, mythological and erotic scenes, little land-
scapes and little people, and we are coming out of the Commune, and
are still held captive by the Prussians!" Barbey d'Aurevilly, who had
written so glowingly about Manet's single canvas the month before,
added in a second article on the Salon, ". . . in making his picture —
a picture of war and naval battle, which he conceived and completed
with the astuteness of a man who wants by any means available to es-
cape the dreadful banalities that swamp us — M. Manet most ably
expressed in his *Kearsarge and Alabama* what is most natural, most
elemental." This is the highest praise, since what was characteristic of
the academism of the Salon was its artificiality, its lack of contact
with the realities of 1872.

If he was not painting during those months, he was keeping him-
self busy getting his new studio ready. With his newly acquired in-
come, he rented a huge space, a former fencing school and firing
range just down the street from his apartment, at 4, rue de Saint-
Pétersbourg. The building still stands, overlooking the place de l'Eu-
rope, which he could see from his balcony windows, facing south, on
an elevated ground floor. Perpendicular to the facade, on the west
side, is the rue de Berne. It was then called rue Mosnier after one of
Haussmann's coworkers, who designed the district known as the
Quartier de l'Europe, its streets radiating from the place de l'Europe
above the tracks of the recently constructed Gare Saint-Lazare, each
named for a city in Europe. Friends Manet made in the 1870s lived
only a few minutes away from his new studio — the composer Em-
manuel Chabrier on rue Mosnier and the poet Stéphane Mallarmé on
rue de Moscou, later rue de Rome.

Two visitors have left recollections of Manet's studio when he oc-
cupied it. The painter Jacques-Emile Blanche, a young adolescent
when he was first taken there, never forgot its dazzling brightness.
"How could he have worked in that room which the sun invaded?
Is that where *Le Linge, Le Chemin de Fer, Argenteuil,* were com-
pleted?"[7] And Léon Duchemin, art critic and novelist who wrote
under the name Fervacques, described the studio in *Le Figaro* after
his visit on Christmas Day, 1873:

A huge panelled room . . . with a coffered ceiling alternating with
narrow beams. A pure, gentle, very even light falls from the win-
dows overlooking the Place de l'Europe. The railway runs nearby

sending plumes of white smoke billowing through the air. The ground, constantly shaken, quivers beneath one's feet and shudders like the deck of a ship at sea. In the distance, one can see as far as the rue de Rome, with its pretty ground-floor garden apartments and its towering houses. Then on the rising boulevard des Batignolles, a dark deep hollow: it is the tunnel which, like a mysterious dark maw, swallows up the trains as they enter its rounded vault with a piercing whistle.[8]

Though not mentioned in the article, *Gare Saint-Lazare* immediately comes to mind in this description of "plumes of white smoke" visible from the studio windows. The painting must have been completed by the time of Duchemin's visit, since Manet signed and dated it 1873. This description of the studio alerts us to the fact that Manet was constantly aware of an unseen railway line whose rumbling trains he represented by a plume of white smoke. The painting, which would arouse so much hilarity when it was shown in the Salon of 1874, thus becomes more comprehensible if we bear in mind Manet's unusual perception of his subject: he could "feel" the train without seeing it, as do we when looking at the picture.

In June 1872, while waiting to occupy his studio, Manet decided to visit Holland, where he had not been since his wedding day nine years before. Toward the end of the month he went with his brother-in-law Ferdinand to see the Hals Museum in Haarlem and the Rijksmuseum in Amsterdam. It was this second museum that seems to have made so powerful an impression that he would shortly produce the first work to win almost unanimous approval. Berthe Morisot had seen Manet the day before his departure and found him in a foul temper. Despite its inauspicious beginning, the trip proved to be very worthwhile. Two paintings, curiously destined to remain together at the Philadelphia Museum of Art, were inspired by that visit. One is the impressionistic plein air *View of Holland,* with three sailboats and a windmill on the coastline, evidently painted while he was there and reminiscent of Jongkind, whom he had long admired. The other, painted on his return to Paris, is the work known as *Bon Bock,* or *Good Beer* (Fig. 43).

Manet's recorded visits in late June to the museums in Haarlem and Amsterdam reacquainted him with a painter he had mentioned as early as 1860 while working on his *Spanish Singer,* when he admit-

ted to Antonin Proust having had Hals in mind. Although Haarlem is the city associated with Hals, it was in Amsterdam that Manet saw the work that most impressed him in 1872, a work he may well have seen a decade earlier — it had been hanging there since 1814 — but for which he may not have been ready until his second viewing. Hals's *Merry Drinker* not only confirmed Manet's profound affinity for the artist, but it also threw down a challenge that Manet was apparently ready to accept.

During the six months that followed his return to Paris, in an extraordinary burst of energy and inspiration, he completed in October *Races at the Bois de Boulogne*, a painting commissioned by a racing enthusiast who paid him three thousand francs for it; began painting the first of four portraits of Berthe Morisot (with a veil, a fan, a pink shoe, violets), all of which were apparently completed by December since all are dated 1872; started work on *Gare Saint-Lazare*, which was already advanced enough by November to show Burty; and was hard at work on *Bon Bock*, since it was unveiled to his friends at the beginning of the new year. The model, Emile Bellot, obligingly sat for him eighty times!

Bellot was an engraver-lithographer, a habitué of the Café Guerbois, and a member of the Batignolles group that gathered there. He looks at us out of *Bon Bock* as though we were sitting opposite him, his lips in a half smile of contentment. We can almost hear him drawing on his pipe and smell the beer in his hand. A discussion of Hals's *Merry Drinker* reads like an analysis of Manet's *Bon Bock*: "the supreme mastery . . . of rendering instantaneous emotion and movement"; "the device of relating the figure represented to the spectator . . . by a glance or a gesture"; the revolutionary use of light "to produce the effect of a pulsating moment of life." Hals's "clear daylight" is equally visible here, "shimmering and animating surfaces" — on Bellot's ruddy face, on the back of the hand holding the pipe, on the white cuff below it, lighting the roundness of his belly encased in the rough gray wool of his buttoned vest. As in Hals's work, "the emphasis shifts from the outlines and the sculptural quality of the subject represented to a most vivid play of values, yet the forms and texture are never lost." Even the brush technique is similar: "Only during the nineteenth century did masters such as Manet appear who understood [Hals's] technique and were able to express themselves in his manner with the necessary skill and spontaneity."⁹ In *Bon Bock*

the solidity of form so characteristic of Hals is respected. Not even Manet's most hostile critic could accuse him of painting a playing card figure in this work.

What Manet produced was neither a copy nor a pastiche of Hals. Both poses are full face, but we see Bellot to his knees, whereas Hals painted only a bust. For the rest, Manet's beer drinker is very much a man of the 1870s — not an anonymous model, but a man of familiar appearance, personality, and habits, known to Manet's friends and to the critics as well. Manet's Bellot is the bohemian equivalent of Ingres's quintessential bourgeois, Bertin. Bellot's whimsical fur hat, rumpled suit, and proletarian clay pipe attest to his disdain for the fancy trappings of Manet's personal style and social position, though without contempt and without any ideology. Although this beer drinker is no Communard, he is an artisan who probably sided with the insurrectionists. Here is a man comfortable in his skin, as the French say *bien dans sa peau*, secure in his talent and in his place. He could serve as an icon for the illusory healing period during the years following the humiliating defeat and the vicious civil war, when political unrest left France unsure of its future government.

For once Manet sent the right painting at the right time to the Salon. One critic, in his review of the Salon of 1873, wrote approvingly, "In our present troubled times this placid drinker symbolizes eternal serenity. He is indifferent to the constitutions being pondered."[10] Even a critic on the extreme right could see Manet's jovial drinker as "an epicure of the tavern, fat, ruddy, jovial, who believes in little more in this world than in his pipe and his beer."[11]

On May 24, while the Salon was in full swing, the National Assembly voted Thiers out of the presidency. For the next four years there would be a republic without republicans to govern it. Thiers, himself a believer in monarchy though a supporter of democratic rights, had brought into being France's first constitutional monarchy under Louis-Philippe in 1830. His position was perhaps not unlike that of Baron Haussmann, who, at the end of his life — in 1891, long after a true republic had been instituted — continued to support the monarchist principle: "I had and still have the deep and personal conviction that in France the only form of democracy is the Empire. Our country, the most single-minded in all the world, needs a government that is also single-minded. It must have one man to govern it."[12]

To all appearances Thiers betrayed his own convictions in 1872 by

appointing three republicans to his cabinet. The conservative major-
ity, elected in Bordeaux, withdrew their support from this no longer
trustworthy moderate and replaced him with Patrice MacMahon, a
count, monarchist, general, and marshal of France who had led
France's armies in the Crimea in 1855 and in Italy in 1859, where his
victory over the Austrians at Magenta had brought him the title duke
of Magenta, bestowed by Napoleon III. A handsome man of sixty-
five, MacMahon was committed to the monarchist constituency that
had placed him in the presidency for the next seven years, to preside
not over a republic but over a holding operation, as it were, until the
monarchy was restored.

The monarchists themselves were divided between those who
wanted the Bourbons back — in this case the grandson of Charles
X — and those like MacMahon who supported the Orléans branch in
the person of Louis-Philippe's grandson. If the comte de Chambord,
the Bourbon pretender, had not rejected the offer to become, in his
own words, "the legitimist king of the revolution," France would have
had a second constitutional monarchy before the end of 1873. On
their side, the republicans were fragmented between conservatives,
radicals (middle-of-the-roaders), and leftists. Gambetta's position,
shared by Edouard and Gustave Manet, had been to continue fighting
the Germans, whereas conservatives like the Morisots thought the
Germans could be bought off for an honorable peace. It soon became
clear that Germany was at war to acquire Alsace, not to rid the
French of Napoleon III. An honorable peace was not in Germany's in-
terest. Bismarck wanted, and got, Alsace, part of Lorraine, and five
billion francs in reparations, as well as the satisfaction of sending Ger-
man troops into Paris in a humiliating gesture of formal occupation.

In this climate of unresolved civil strife, the sight of a well-fed, sat-
isfied Frenchman, more representative of the larger body politic than
a Thiers, a Gambetta, or a MacMahon, was a pleasure to behold.
Solidly ensconced in his chair, his knees spread under the rotund
weight above them, Manet's beer drinker stood for everything that
was lasting, unifying, and natural in a city rocked by disorder, dissen-
sion, and destruction, and in a country now dismembered, having
lost the very region most closely associated with beer. In spite of the
hunger, disease, and bombardments, most ordinary Frenchmen could
see themselves or someone they knew in this picture. Who would not

respond positively to a good glass of beer? It was just then beginning to cross class lines in France, where previously beer had been generally limited to working-class consumers. Brasseries, which were beginning to proliferate, were and still are unpretentious restaurants serving beer on tap, generally from one brewery, and dishes indigenous to France's eastern beer-drinking regions: *choucroute* and *charcuterie* (sauerkraut and pork products).

Perhaps because Albert Wolff, the curmudgeonly critic of *Le Figaro*, was a native German, a naturalized citizen of France only since the end of the war, he was more attuned to such a figure. Most often hostile to Manet's work, Wolff had something positive to say about *Bon Bock* in his review of May 13, 1873:

> The art of M. Manet is vivacious; the essential quality of the painter is his spontaneity. . . . From afar the impetuosity of the painter beguiles the eye. One is forced to admit that an artist who can capture life and movement with such vitality is not someone of no account. . . . This year M. Manet watered down his beer; he has abandoned violent and obstreperous effects for a more pleasing harmony. . . . But we shall have to wait a year or two before judging the artist definitively. It is impossible for a painter as talented as he to remain where he is now.

This, from Wolff, was high praise. A quarrelsome, unattractive man with a vitriolic pen, Wolff met his match in Degas, who dismissed him as an anthropoid: "Wolff came from Germany across the treetops."[13] Temperamentally as well the two were not far apart, both of them inexhaustible in wit and short on warmth. Paul Durand-Ruel maintained that getting angry was Degas's only pleasure.

There were, however, still some diehards among the critics.[14] The anonymous reviewer for the prestigious journal *La Revue des Deux Mondes* declared, "If he were more conscientious he would merely be a bad painter, whereas by defying common sense he at least succeeds in creating a scandal and obliges us to mention his name." This was a holdover from the days of *Le Déjeuner sur l'herbe* and *Olympia*: Manet the scandal maker. Even a colleague as close as Alfred Stevens, out of jealousy or sheer facetiousness, was heard at the Salon to say of Manet's figure, "He is drinking beer from Haarlem," pointedly allud-

ing to the city's association with Hals. Although this remark was patently true, when some good soul repeated it to Manet, he found it offensive and publicly rebuked Stevens, which almost led to a fight.

Despite this critical carping, the painting was enormously successful. In addition to the stream of favorable reviews, photographs of it were plastered all over Paris. A little item in *Musées des Deux-Mondes,* reporting on the fame of *Bon Bock,* stated that 120,000 francs had been offered for the painting. Two weeks later the critic published a correction: "I would not have rectified this error if Manet had not come bearing my article, enjoining me to tell him the name of the madman who was offering 120,000 francs for his *Bon Bock.*" In fact Manet sold his painting to the opera singer Jean-Baptiste Faure for a mere six thousand francs. Still, he had made a sale and to an important collector very much in the public eye.

Bon Bock became virtually inescapable: if not actual photographs, caricatures in the newspapers; a club called "le Bon Bock" founded by Bellot; a brasserie in the Latin Quarter by the same name. Manet was now pointed out as a celebrity when he appeared on the boulevards in his top hat and cane. Degas quipped, "You are as famous as Garibaldi." Manet was no longer the butt of jokes, despite the devastating response to *Repose,* his full-length portrait of Berthe Morisot, which had been shown at the Salon with *Bon Bock.*

Charles Garnier, architect of the new opera house, the most flamboyant example of *le style Napoléon III,* also had his say on the Salon: "These two paintings are almost an artistic scandal, particularly [*Repose*], and the complacency of the jury is really inexplicable. M. Manet has now become . . . the leader of a school, if one can call a school that kind of slap-dash painting." Philippe Burty identified the model of *Repose* as "Mlle Morisot, one of M. Manet's most remarkable pupils," a comment that, though untrue, may have pleased her. Manet's only pupil, Eva Gonzales, had been among the many that year whose works were rejected by the Salon jury. Morisot could take little pleasure, however, in Théophile Silvestre's description of her portrait: "M. Manet has a taste for modern life and an obsession with reality. His intentions may be good but he scarcely fulfills them . . . one need only look at the woman seated on a sofa. . . . Sad creature, pitiful and pitifully dressed, her bony arms seem made of wire, and from her sullen face to her tiny foot she could not be more dessicated, sickly and ill-humored." Other critics were more perspica-

cious. Théodore de Banville saw the interest of the portrait in a
broader perspective than conventional prettiness: "*Repose* is a com-
pelling portrait from which the eye cannot detach itself, and which
imposes itself on the mind through its intense quality of *modernity* —
if I may be permitted this barbarism that has become indispensable!
Baudelaire had every reason to esteem M. Manet as a painter, for this
patient, subtle artist is perhaps the only one in whom one finds that
refined sense of modern life which makes for the exquisite originality
of *Les Fleurs du Mal*."[15]

If *Repose,* painted in 1870, conveys something of Baudelaire's
"spleen" — that late romantic, early modern sense of alienation — it
also illustrates Berthe's depressive nature, her paralyzing insecurity.
Two years later she was still a captive of these unresolved frustrations.
During the summer of 1872 Berthe went with her eldest sister, Yves,
to Saint-Jean-de-Luz, near Biarritz, where she found the weather too
poor for painting and the children bothersome. Her letters to Edma
during her travels are a litany of self-doubt and self-deprecation.[16]

Before her departure she received a note from Manet, written the
day he left for Holland. He informed her that he had recommended
her to a rich gentleman who wanted pastel portraits of his children,
that she should ask a high fee if she wanted to be taken seriously, and
that she should not let such a rare opportunity slip by. He knew her
well; rather than have to deal with money, sittings, and satisfying a
client, she would prefer not to be contacted at all: "I know my nerves
and I know what a transaction like that would cost me in anxiety. If
by chance he were to come, what should I ask: 500 francs, that is,
1,000 for the two? That seems enormous to me!" In the letters that
followed, her tone was increasingly negative. About her work: "I re-
cently began something that was supposed to be very pretty and is
very ugly." About her appearance: "I am amazed to pass as unnoticed
as I do; this is the first time that has happened to me so totally. The
good side is that since I am never looked at I find it useless to bother
dressing up." About her holiday: "In the evening we sit on the square
or by the water and chat. Such is our life here; you would not find it
amusing." About her plans for a short trip to Spain with Yves, whose
husband would take their children home with him: "All these projects
will probably come to naught in view of the shortage of funds."

She finally went with Yves to Madrid, where she met Zacharie As-
truc, who had been unable to accompany Manet in 1867. He placed

himself entirely at their disposal as a guide. But instead of delighting in her good fortune, surely arranged by Manet, all she had to say was, ". . . he knows the city well. We'll content ourselves with him; he has the advantage of speaking French; he is not more common than others [*il n'est pas plus commun que les autres*]. I do not intend to tire myself seeing anything besides paintings; we may go to Toledo and come back here to see the bullfights if we have the stomachs for it." While less gravely depressed than the year before, she was still incapable of any pleasure, without any motivation to work, any hope of future success or happiness: "I have been invited to go to the country where I can ride, paint, etc., all that doesn't really tempt me. I am sad, as sad as one can be. . . . I am reading Darwin; that is hardly suitable reading for a woman and even less for a girl; what emerges most clearly is that my situation is intolerable from every point of view."

In mid-July 1872, Manet held a studio-warming, which Berthe attended. The year before, on his return to Paris after the Commune, he had "rediscovered" her, as she told Edma, finding her "not too ugly" to pose for him again. But he was not working then. Now that he had a splendid place to work, thanks to the bonanza from Durand-Ruel, he repeated his request and began again in earnest to recapture on canvas the woman he had found so captivating in 1869. During the late summer and autumn of 1872 he would turn out four portraits of her. In three of them she is flirtatiously playful with her accessories — a pink slipper, a fan, a veiled black hat. The fourth is arguably among the finest portraits of the late nineteenth century, and the one Paul Valéry called "poetry." In Manet's entire oeuvre Valéry ranked nothing higher than *Berthe Morisot with a Black Hat and Violets*:

> . . . that face with large eyes, whose vague stare . . . offers in some way *the presence of an absence* . . . and fills me with a singular impression of *Poetry*. . . . Many an admirable canvas is not necessarily related to poetry. Many masters produced masterpieces without resonance. It has also happened that the poet is born late in a man who until then was only a great painter. Such was Rembrandt who . . . rose to the sublime level . . . where art itself . . . becomes imperceptible, its object having been captured as though unmediated, its enchantment absorbs, conceals or consumes the awareness of the marvel and its execution. . . . I can now say that the portrait in question is *poetry*.[17]

The other three portraits are very different from the one with violets. They have in common a quality of mystery, play, concealment, and distance, as if Berthe would yield to his brush only if she were incognita — behind a veil, behind a fan, draped in black like a Goya *maja*. But in the one with violets, she drops the pretense and lets him look at her while she watches him. In terms of candor, availability, and femininity, that portrait was surpassed by another done the following year. For this painting Berthe posed in a reclining position, her head facing forward but her body toward the right, her legs presumably fully extended on the sofa — whereas in *Repose* she is seen full face all the way to her feet, which are on the floor. The vagueness of this description is caused by the absence of the lower part of the canvas. Since Manet cut it off, for reasons unexplained, we do not know exactly how she was positioned. But Berthe herself documented the original pose in a diary entry: "My portrait. Torso cut from a full-length portrait, lying on a couch."[18] In *Repose* she is shown slouching in a less than genteel position, but in *Berthe Morisot Reclining* she would have appeared in a pose commonly associated with portraits "restricted to actresses, mistresses, and artists' wives, and with paintings representing idealized harem women or their Western equivalent."[19] Had the lower portion of *Berthe Morisot Reclining* not been amputated, we might be seeing the same pose as that of Victorine Meurent in *Olympia* — the torso at the same angle, the legs similarly crossed at the ankle — only Berthe's head is cocked more toward her left. This is a highly irregular position, for a lady sat up straight, and her feet were always firmly planted on the floor — or at least one foot was, as in the portrait of Berthe with a fan, where she sits with her legs crossed.

Was this a masquerade? Was she playing the demimondaine, a black ribbon tied in a coquettish bow around her throat — like Olympia's, only much wider — her neckline provocatively open in a plunging V? And were they accomplices in a private joke, challenging the critics to recognize in this unimpeachable bourgeoise Manet's scandalous Olympia? His reprise of the same pose in his 1878 pastel of Suzanne on a couch suggests that he saw the comic element in its repetition, only in this instance as a travesty of it. Was it fear of exposing Berthe to embarrassment, even though the painting was never shown publicly, that led to his decision to cut it off at the waist? Even allowing for the possibility of humor, this remains an intensely personal

representation. It has been suggested that just as artists commonly shared the "intimacy of their homes" with the viewer by portraying their consorts in reclining poses, so Manet may have wished "to represent Berthe as his wife."[20]

In this portrait there is none of the innocent reverie of *Repose*, none of the coy distance of *Berthe Morisot with a Fan*, however flirtatious the crossed leg and pink-stockinged ankle, none of the demure albeit direct eye contact of the portrait with violets, that allows one to imagine her lowering her eyes. Here her gaze is unflinching, as in a moment of absolute privacy. There is not even the formality of a hat. And perhaps most significant, there is no visible fan. "Manet found eleven different ways to represent Morisot, none of them as a painter. In several of his most vibrant portraits of her . . . she does hold an instrument — not a paintbrush, but a fan. If masculinity wielded the brush, femininity waved the fan."[21] In the nineteenth century the fan was the essential accessory of a lady; it was the virtual extension of her hand. With it she gestured, flirted, played weak or flustered by fanning herself, or rapped someone maternally. A fan allowed her to establish distance or to abridge it by touching her interlocutor. Its association has been consistent with "a feminine language whose meanings were those of erotic exchange with men."[22] The absence of a fan in *Berthe Morisot Reclining* underscores the intimacy of the scene, for the fan was a public appurtenance, an accessory to the kind of outfit worn outside a woman's private environment, whether her own home or that of someone close to her.

This painting is more than a portrait of a woman in a personal setting; it is a tête-à-tête. Our awareness of the proximity of the one who is looking at her makes us feel like an intruder, a Peeping Tom. We have only to compare this work with the last portrait Manet did of Morisot in 1874, *Berthe Morisot in Three-quarters View*. Here too she is hatless; here too a black ribbon circles her throat, narrower and more severe, and her neckline opens in a V, but not at all provocatively. This was the same model, only one year later. But how different. The lips are narrow, the glance does not cross over the frame as in other portraits but remains within her own space, the face is cold, and even the dark eyes, ordinarily so huge in Manet's portraits of her, seem small. A prim, almost prudish look sits on this face, composed to reveal nothing but correct behavior. These two figures are emotionally unrelated, as though done by two different painters. *Berthe*

Morisot Reclining communicates a compelling sensuality; the other portrays a proper upper-class woman, her little finger delicately raised as if she were holding a cup of tea, her mouth set to emit some polite remark.

That was the last time Manet painted Berthe, and he no longer saw her as the unique individual with whom he had shared emotions, ideas, desires, frustrations, and playfulness. No other woman, neither Victorine Meurent before her nor Méry Laurent after her, nor even Isabelle Lemonnier, who was his last desperate infatuation, ever rivaled Berthe Morisot on his canvases. In his other portrayals of women, the painter's eye is objective, admiring, sometimes unflattering, but not personal — except for his views of Suzanne, which suggest a growing distaste. Not even his nudes communicate the erotic pull we feel looking at *Berthe Morisot Reclining*. Nor do his other paintings of women suggest his presence, whereas in *Berthe Morisot Reclining* it is almost palpable. The only other portrait he ever did in dimensions so small (26 × 34 cm) is the portrait of Mallarmé (27.5 × 36 cm), which also communicates the artist's presence and the understanding he shared with his model.

During the summer of 1874 the Morisots and the Manets — but not Edouard — vacationed in Fécamp, on the coast of Normandy. Its great cliffs on either side of the beach attracted some of the impressionists. Eugène Manet was a man of underdeveloped, or perhaps limited, talents, unable to find his niche in the world. He painted and wrote, but without his family ties he would not be remembered. In Fécamp he often accompanied Berthe and painted beside her. They saw each other almost daily and formed a more personal relationship than the purely social one they had had until then. On their return to Paris Eugène began writing charming, playful letters that revealed his attachment to her. By late fall they began to talk of marriage. Because of her father's death in January of that year, Berthe wanted to wait, ostensibly until the year of mourning had elapsed but more probably out of a lack of conviction.

Once Berthe decided to marry Eugène, her studio relationship with Edouard was over. It has survived only in the paintings. Surely Berthe recorded something in her diary, reported something in her letters to Edma about the innumerable hours she spent immobilized in Manet's presence, when the only distraction from her physical discomfort was their conversations. George Moore, Zola, and others have left

a record of posing for Manet. One would expect Berthe, especially since she was herself a painter, to have left some impressions of the way Manet worked, some anecdotes about the long and numerous sittings, some observations about the studio. Other parts of her diary have survived, as have other letters to Edma. But about the portraits, nothing. No trace remains in her diary or her correspondence; what she herself did not destroy, her grandson apparently censored. One could argue that the very absence of any reference to what was, after all, a privileged relationship with a painter she admired above any other is in itself suspicious. It is unimaginable that she never committed her thoughts on the subject to paper or that she had nothing to say. But one can imagine that after her marriage she carefully destroyed whatever she did not want other eyes to see.

Her friendship with Edouard continued, but on another footing. After 1874 when she came to his studio it was as his sister-in-law and colleague. The occasional letters over the years attest to a familial closeness, the concern and affection of old friends now relatives. They are very different from the note he sent when working on one of her portraits: "Mademoiselle Berthe, I shall ask you to postpone until a later time the visit you promised to make to the studio on Thursday. I have not made enough progress to risk your keen judgment. I am determined not to expose myself to you except to my advantage." After being reproached for having left her alone when they were visiting the Salon of 1869, he told her, as she related to Edma, "that I could expect every kind of devotion from him but that he would never venture to play nursemaid." The tone, while perfectly respectful and teasing, is neither fraternal nor platonic. It expresses his desire to be seen by her at his best, not as a colleague, chaperone, or crony, but as a man who saw her as a desirable woman. He may indeed have played matchmaker to Berthe and Eugène — the joint holiday in Fécamp and his absence from it were not sheer chance — and it was not a bad arrangement, since the many bonds uniting Berthe and Edouard would have been undone had she married someone else. For her to remain unmarried would have meant insurmountable problems for both of them.

But what about Eugène? Did he not see, he who was so sensitive to others, what we see in these portraits? Or did he court her out of a spirit of rivalry, as the younger, less scintillating, less talented sibling? To marry Berthe was not an insignificant conquest. He could have

what his brother could not. And in a less than perfect world, Berthe had an ideal surrogate for the man who really interested her.

Eugène's courtship was successful. His letters are filled with the winning ingredients of wit and ingenuity. And in fact he did win her, on December 22, 1874. He was forty-one; she was almost thirty-four — uncommonly late at that time for a woman's first marriage, especially for a woman of Berthe's means, looks, and social position. A week after her thirty-fourth birthday she wrote to her brother:

It has been a whole month since I got married, isn't that amazing? *I went through this great ceremony without the slightest pomp, in an ordinary dress and hat, like the old woman that I am, and without guests* [emphasis added]. Ever since, I have been waiting for events to take shape but so far fate is not in our favor. The trip to Constantinople [a job offer for Eugène], so certain at first, is no longer certain at all. However, I must not complain for I have found *un honnête et excellent garçon* [familiarly, a really nice guy, but *garçon* sounds almost patronizing, and the adjectives hardly denote more than an intellectual appreciation of decency], and who I believe genuinely loves me. I have entered into the positive side of life after living so long with foolish fancies that did not make me very happy, and yet, thinking of my mother, I wonder if I really fulfilled my duty. These are all complicated questions and it is not very easy, at least not for me, to distinguish clearly right from wrong.

This from a bride of one month. Her lack of effusion over this major event in her life has been explained by the fact that she was still in mourning at the time of her wedding. But her father died on January 24 of that year, and the wedding took place on December 22. Had there been any wish to celebrate a little more festively, social conventions were no impediment. And if the mood was not right, they could have waited a bit longer. A lackadaisical attitude toward the marriage goes farther than her father's death in explaining the absence of a more suitable dress for the occasion and the absence of guests.

Nor does feminine reticence account for her description. She was writing not to some acquaintance, but very confidentially to her brother — about his return to France from the tropics, about their sister Edma, whose health had been affected by the birth of her second child, about her own marriage. Not a word in the letter suggests

love or even affection; at best gratitude for Eugène's love and for erad-
icating the shame of spinsterhood and, worse still, of being an old
maid with romantic dreams of impossible loves — the word she used
is *"chimères,"* unrealizable fantasies. But, she asked, had she done
right by her mother, who wanted her to marry but not Eugène, a man
who had no profession, no job, no ambition, no real talent, and whose
health left her mother uneasy: ". . . it was rather Eugène who was the
focus of my anxiety. You know I think he has a weaving walk, which
makes me afraid that he is unsteady on his legs." Did she suspect that
he might have locomotor ataxia? It was common enough at the time,
even if its association with syphilis was not yet widely known.

Cornélie Morisot knew that Auguste Manet had suffered a paraly-
sis. Rumors concerning its origin had evidently circulated among
their acquaintances, since people close to Edouard later wrote that he
died of the same disease as his father. All the Manet brothers were
suspect. She had the bitter satisfaction of having been right — not
only about Eugène, but also when she predicted for Berthe the same
fate she had endured: looking after an incurable invalid who sapped
her pleasure in life. As early as February 2, 1875, little more than a
month after her wedding, Berthe received a little homily from her
mother, which indicates the tenor of her married life: "Why not go
out when you have the chance? Life is filled with enough tears not to
take advantage of the good moments. I maintain that we must fight
that part of ourselves which leads us to too much sensitivity and
melancholy and that you owe it to your husband to dress up for him
and be attractive to others so as to please him more, for he would be
very pleased to see you enjoying yourself. Without being frivolous,
one has to be young while one still is."

The Salon of 1873 had been almost as inflammatory as that of the
decade before. So many artists had been eliminated that another
Salon des Refusés was held, but without the clamor of the one in
1863; in fact it went by almost unnoticed. Most of the future impres-
sionists had been excluded from the official Salon — Renoir, Pissarro,
Sisley — along with Jongkind and Guillaumin. It was becoming clear
to them that they would have to seek an alternative to the Salon if they
wished to make contact with a larger public than the few who saw
their works in one or two galleries. Under Thiers's so-called republic

there had been little hope of any progress in the arts. The only project to have been undertaken by the Ministry of Fine Arts — headed by Charles Blanc, whose multivolume *Histoire des peintres de toutes les écoles* had been appearing over the past decade — was a Museum of Copies, which offered little encouragement to any but the most traditional painter. At least Meissonier, of whom a contemporary said, "I would not swear that Nadar's lens does not have more soul than Meissonier himself," was voted down from the Salon jury.[23] Jules Breton and a few like-minded traditionalists consequently resigned, making it possible for Manet and some of the more modern painters to be accepted.

In May, after the Salon had opened, Claude Monet informed the press that a number of painters were planning to hold an independent exhibition of "the new painting." This group, which would call itself the Société Anonyme Coopérative when it was finally organized by the end of 1873, was to have its first show in April of the following year. Redubbed "impressionists" by a hostile critic, they made history. For a membership fee of sixty francs any artist could join, send works to be exhibited, and share in whatever profits remained. Manet did not join, nor did he wish to exhibit anywhere but in the Salon. He may have tried to persuade Morisot not to join either, when Degas invited her to do so. Perhaps to assert her independence and to distance herself artistically from Manet, she did become a member, even though she had not been invited to participate in the founding group. When the exhibition opened on April 15, 1874, in a building on the boulevard des Capucines that belonged to Nadar, a number of Morisot's works were on the walls.

[handwritten margin note: 1st Impressionist Exhibition 1874]

However retrograde and exasperating the institution of the Salon, Manet saw it as a necessary challenge; a true professional exhibited in the Salon. And the way to change it — what was accepted, who sat on the jury, how the public gained an understanding of "the new art" — was to stay in it. Rather than create a schism, he felt he had to continue the struggle from within rather than exhibit in a group show with a few kindred souls. As he later said, *"Il faut être mille ou seul"* (you have to be a thousand strong or one alone). In the Salon, pitted against one's established peers, to make the public take notice meant to make a dent in the conventional understanding of high art. It meant gaining acceptance in time as a "classic" oneself, with the prospect of having one's work in the Louvre someday. Manet believed

with all his energy in a new art, but not in a new art that remained perpetually in the avant-garde, on the fringes of the art world.

The American painter Henry Bacon, a friend of Mary Cassatt's, who would herself join Morisot and the impressionists three years later, felt that avoiding the Salon was a form of professional cowardice. In his view the impressionists were "afflicted with some hitherto unknown disease of the eye."[24] Guichard, in a letter to Mme Morisot, acknowledged in good faith that there were a few "excellent pieces" among the more than two hundred shown, but, he added, their creators "are all more or less mentally cross-eyed." Then, as though intuiting Berthe's state of mind, he added, "That a young girl might destroy letters which remind her of a painful disillusionment, I understand; such ashes are justified, but to destroy all the efforts, all the aspirations of so many past dreams, that is folly! Worse still, it is almost a profanation." This may have been no more than a metaphor, but it does apply to what Morisot in 1872 had called her "intolerable situation." By 1874 she knew full well that she could not remain in Manet's shadow, either as a woman or as a painter. To ally herself with the impressionists, a group Manet refused to join although the critics continued to regard him as their leader, was a clear signal that she was now on her own.

Manet himself, well before Morisot's bravado decision, seems to have regained his self-assurance, and perhaps also to have tired of Berthe's neuroses. His newfound elation from sales and the success of *Bon Bock* generated new energy. In 1873 he produced twenty oils, compared with ten the year before. He was working at a frantic pace, basking in his celebrity, accepting and tendering invitations, regaling his café coterie. He had no time for Berthe's dilemmas, and no way of resolving them even if he still cared. Furthermore, other models were occupying him just then. Victorine Meurent had recently returned, pert as ever, from an extended and mysterious stay in America, presumably with a lover. She was posing for Manet in the garden of his colleague and neighbor Alphonse Hirsch for the work that would become one of his masterpieces, *Gare Saint-Lazare*. And the lovely Marguérite de Conflans also was posing for a number of portraits. She and her mother were often seen at Eugénie Manet's receptions. Manet, by chance or design, was filling every hour of every day.

Manet's fortieth year marked a second turning point in his career. In October 1872 Théophile Gautier died at the age of sixty-one. With

his death an era had closed. Although Victor Hugo was still very hale at seventy, the romantic revolution of the 1830s was now history. By 1872 Gautier had become old guard, yet his earlier ideas about art had been seminal. His theory of art for art's sake had liberated his generation and Manet's from the restrictions of classical themes and forms. He did not champion Manet's innovations, but he had in part made them possible, and he regretfully acknowledged the impaired vision that can come with age: "It is probable that the paintings of Courbet, Manet, Monet and *tutti quanti,* contain beauties that elude us old romantics whose long hair is now mingled with silver threads. . . . Am I really an oaf, a wig, a mummy, an antediluvian fossil, no longer capable of understanding anything about his century?"[25] In view of Manet's well-known association with Baudelaire — whose artistic credo can be seen as a bridge between Gautier's romanticism and Manet's modernism — it is surprising that Gautier did not see Manet as a second-generation romantic. Gautier's notion that the true function of poetry was to proclaim the sense of emptiness has its echoes in Manet's art.

Manet may well have begun thinking about time in ways he had not before. He had been exhibiting at the Salons for a decade; Léon was twenty years old; he had only to look at Suzanne to see how much time had passed. Manet certainly saw beyond his own time to a future when his works would be seen with a vision not yet developed. He was confident in his posterity to the point of telling Albert Wolff that he would rather see in his lifetime the laudatory article he was sure Wolff would write after his death. Did he ask himself, now entering his fifth decade, how much time was left to fulfill his aspirations?

In October 1873 he met Stéphane Mallarmé, a young poet who *Mallarmé* had begun to make a name for himself as an original voice. Of the three writers who were close to Manet, Mallarmé was the one with whom he had the greatest personal and aesthetic affinities. Baudelaire was temperamentally very different, given to excesses and affectations of every sort, including makeup, idiosyncratic clothing, drugs, alcohol, lies, and debts — a personal style entirely contrary to Manet's but which Manet tolerated out of genuine affection and intellectual respect for an incomparable poet and brilliant critic. Zola's ponderous way of talking and lack of subtlety did not stand in the way of their amicable relationship — Manet's gratitude for Zola's energetic support had much to do with it — but a gulf separated their sensibili-

ties. In contrast, Mallarmé had finesse of mind and manner and an artistic originality and sensibility attuned to Manet's own; through them the torch of Baudelaire's aesthetics would be passed down to the next generation.

Mallarmé was ten years younger than Manet but shared much the same background. Born in Paris of a Parisian family, Mallarmé spent most of his youth outside the city. His father had been a civil servant posted in Sens, sixty-five miles southeast of Paris and the site of one of the great Gothic cathedrals. After attending two boarding schools where he was a mediocre student, he was enrolled in the lycée of Sens, and like his future friend Manet, he finished with a year of rhetoric, took another in logic, and passed his *bachot* on the second try in 1860. By then he had already begun writing poetry and had distinguished himself in Latin, Greek, and English.

When he returned to Paris in 1871 to settle for good after teaching in Avignon and Tours, he was married and had a seven-year-old daughter and a newborn son, a job teaching English at the Lycée Condorcet (then called Fontanes) near the Gare Saint-Lazare, and an apartment on the rue de Moscou, which crossed the rue de Saint-Pétersbourg where Manet lived and worked. Four years later, when he moved to the rue de Rome, he was still within a few minutes' walk of Manet's studio, where he stopped for a chat every day on his return home from the lycée. His association with Manet continued even after Manet's death: in 1885 Mallarmé was appointed professor of English at the Collège Rollin, where Manet had been a pupil forty years earlier. By another interesting coincidence, Mallarmé's closest friends — Manet, the poet Théodore de Banville, and the American painter James Whistler — were among the very few Baudelaire had counted as his friends.

By the time Manet met Mallarmé, he was already known in Parisian literary circles, having published a number of pieces, and was acquainted with many of the poets and artists who were to be known as Parnassians and symbolists, among them Verlaine, Rimbaud, Villiers de l'Isle-Adam, and Catulle Mendès (married to Théophile Gautier's daughter Judith, herself a sometime art critic who wrote under a pseudonym). Another member of this group, which had no real artistic cohesion, was the poet-painter Charles Cros, whom Manet knew quite well. Cros, described as an "inventor, alchemist, tormented ge-

nius, a personality in a class by himself,"[26] was then the reigning lover of an equally singular woman.

Born Marie-Anne Gaillard, she was variously known as Nina Villard (Villard was the maiden name of her mother, who lived with her, thus providing the household with a modicum of respectability) or Nina de Callias. Separated from her husband, art critic and writer Hector de Callias, after a brief period of conjugality, she was under legal injunction not to use his name. Her freewheeling lifestyle was considered bohemian, but she was not a demimondaine; most of her lovers were unable to reciprocate her hospitality except in verse. She had an independent income from her father, who had been a lawyer, and a completely independent love life, since she was not beholden to any man for his support. She was an accomplished pianist, a woman of great generosity, humor, intelligence, and appeal. Bazire, Manet's first biographer and Cros's predecessor in Nina's affections, waxed lyrical about her: "She had a very high forehead, very large eyes, very pale skin, a very slim waist, a very small mouth. What the painters could not show was her heart which was so good, her soul which was so pure, her mind which was so lofty."[27]

It was to her house, whose doors at 82, rue des Moines were always open, the table always set for midnight suppers, that Cros invited Manet in 1873. Manet was immediately taken with this exceptional woman, who always surrounded herself with stimulating guests. Poets, journalists, musicians, actresses, political figures, demimondaines of high repute, novelists, painters — the most interesting people to be found in Paris — flocked to her open house. It was probably here that Manet met Mallarmé, as well as composer Emmanuel Chabrier, also a neighbor who became a dear friend; Henriette Hauser, official mistress of the prince of Orange, who later modeled for Manet's *Nana;* and perhaps Louise Valtesse, the countess de la Bigne, one of the celebrated courtesans who married into nobility and who later sat for Manet. The names of Nina's friends fill the histories of French culture of the late nineteenth century. Zola was to draw on the hostess, her guests, and her house for the character of Irma Bécot in *L'Oeuvre,* his monumental novel on the painting and painters of the time.

Nina readily agreed to come to Manet's studio and posed for three drawings before he undertook the magnificent oil portrait known as

Woman with Fans later that year (Fig. 48). The reclining pose, the North African costume (immediately evoking the harem), and the fans make this an icon of femininity seen through, and perhaps for, masculine eyes. The importance of the beholder becomes clear if we compare Manet's picture with one by another artist in which the same pose is used. In 1874, the year Manet painted *Woman with Fans*, Morisot also did a painting of a reclining woman with a fan in her hand. The woman in the portrait, identified as Mme Hubbard, seems indolent, perhaps succumbing to the heat, since her diaphanous white dress indicates summer apparel. But this figure is not at all seductive; feminine, yes, but domestic, whereas Nina is exotic.

If Manet, the lonely husband, assured his wife during the icy solitude of the siege that he no longer had any desire to go off gallivanting as he had in the past — *"comme je passerais de bonnes soirées près de toi maintenant, sans penser à aller me promener"* — he had certainly recovered from his attack of sentimentality by the autumn of 1873. An evening at Nina's, which usually continued past sunrise, was scintillating. Nina, according to all witnesses, was a virtuoso pianist, gifted with as much verve and charm as musical talent. Suzanne may not have been a lesser pianist, but Manet did not share her taste for Schumann and Wagner, preferring Haydn (as reported to Baudelaire by Eléanore Meurice, an excellent pianist herself), not to mention all the other charms that Nina had to offer.

Mallarmé was not the man-about-town that Manet was, but he seems nonetheless to have had a hedonistic side that was well concealed under his quiet manner. Antonin Proust describes him, at the time of their meeting in Manet's studio, as "in the full beauty of youth. His eyes were large, his straight nose stood above a thick mustache which his lips underlined with a light stroke. He had a prominent forehead beneath a shock of hair." He was shy and modest, "supremely kind," and endowed with "an imagination that delighted in everything without being satisfied by anything."[28] He dreamed of creating something lasting out of the fleeting, an echo of Baudelaire. The symbolist movement, of which he was to become the high priest, had already begun with Baudelaire. It was to have a long posterity in Paul Valéry, Claude Debussy, Paul Claudel, Marcel Proust, and all the way to James Joyce, T. S. Eliot, and Francis Ponge. Like the impressionist painters, the symbolist writers sought to convey impressions,

to suggest rather than declare, to reveal the eternal in the personal. Ordinary things, memories, dreams, the intangible, the evanescent, and the fragmentary were to coalesce into a meaningful whole.

Apart from their similar backgrounds, their attachment to the genius of Baudelaire, their dedication to formal discipline, and their search for new expression, Manet and Mallarmé seem to have shared a similar view of their artistic production, all of which goes a long way toward explaining the kind of intimacy that bound them. They were even to share, consecutively or perhaps contemporaneously, the favors of the same woman, Méry Laurent, whom Manet was to meet in 1876. "Every day for ten years," Mallarmé wrote to Verlaine after Manet died, "I saw my cherished Manet, whose absence today seems hard to believe."[29] In autobiographical notes prepared for Verlaine two years after Manet's death and fifteen years before his own, Mallarmé explained his artistic aspirations:

> . . . each time a new literary review appeared I always imagined and attempted something new, with the patience of an alchemist, ready to sacrifice every vanity and every satisfaction to it . . . in order to feed the furnace of The Great Work. What is it? That is hard to say: a book, quite simply, in many volumes, a book that should be a book, architectural and premeditated, and not a collection of chance inspirations however marvelous they may be. I will go farther: The Book, since I am convinced that, all things considered, there is only one. . . . I may perhaps succeed; not in producing such a work in its entirety . . . but in showing a fragment of its execution. . . . To prove by the portions that have been done that this book exists and that I have known what I was unable to complete.[30]

Compare this with Manet's avowal to Antonin Proust:

> The fools! they never stopped telling me that I was uneven: they could not have said anything more flattering. It was always my ambition not to remain at my own level, not to redo tomorrow what I did the day before, to be constantly inspired by a new aspect, to try to sound a new note. Those who have a formula, who stick with it and draw income from it, of what interest is that to art? . . . But to move one step forward, and a suggestive step, that is the function of a man with a head on his shoulders . . . in my case, I must be seen

all together. And I beseech you, don't let me enter public collections piece by piece; I would be poorly judged.[31]

From these two passages a single idea emerges of the work as a whole, patiently constructed, "architectural and premeditated," in Mallarmé's words, assembled with increments of one "new aspect," as Manet called it, after another. Both of them rejected the formulaic, the imitation of oneself.

The temptation to see a radical change in Manet during the 1870s, when his style became notably impressionistic, should be tempered by his remarks about his approach, in which he sought to avoid repetition, and his overall view, which links together his total production. There is no doubt that a change took place after 1872. He no longer looked to museum art to validate his vision of modern art. By 1872 he apparently felt that modern art had come into its own and he could explore it without looking backward.

Over the previous decade the problem of natural light had been a major concern for Manet and many of his circle. In 1869 Berthe Morisot, writing to Edma, described a painting by Bazille of a little girl in a light-colored dress seated in the shadow of a tree with a village in the background: "There is a lot of light and sun. He is seeking what we have so often sought: to place a figure in daylight, and this time he seems to me to have succeeded." Proust relates that Manet had been talking about figures in daylight since the late 1850s. Bazille himself is quoted as saying, "Manet is as important to us as Cimabue or Giotto were to the Italians of the Quattrocento."[32] Beyond light Manet was concerned with the same problem that would be explored relentlessly by the impressionists — the transformation of a motif in time — but without Monet's serial obsession and with greater stylistic reserve. "What is still not sufficiently understood," Manet said, "is that one does not paint a landscape, a seascape, a figure; one paints the impression of an hour of the day in a landscape, a seascape, a figure."[33]

Manet's determination to be seen as a whole not only establishes a *correspondance* — a favorite term in Baudelaire's lexicon — between Manet and Mallarmé; it also points to the nature of a work, one of his greatest: *Gare Saint-Lazare* (Fig. 51). Manet had not yet met Mallarmé, but what would later be known as symbolism in poetry and music had been in the air since *Les Fleurs du Mal*. With its "complex

Figure 33.
THE LUNCHEON, 1868.
Oil on canvas, 118 x 154 cm.
Bayerische Staategemäldesammlungen, Munich.

Figure 34.
PORT OF BORDEAUX, 1871.
Oil on canvas, 63 x 100 cm.
Private collection. Photo Bulloz.

Figure 35.
MME EDOUARD MANET AT THE PIANO, 1858.
Oil on canvas, 30 x 46.5 cm.
Musée d'Orsay, Paris. Photo R.M.N.

Figure 36.
ON THE BEACH, 1873.
Oil on canvas, 57 x 72 cm.
Musée d'Orsay, Paris. Photo R.M.N.

Figure 37.
Manet in 1863.
Photo Chardin.
Bibliothèque Nationale de France, Paris.

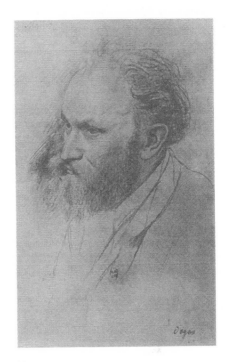

Figure 38.
PORTRAIT OF MANET by Edgar Degas,
1867.
Drawing on paper.
Bibliothèque Nationale de France, Paris.

Figure 39.
Manet in 1867.
Photo Nadar.
Bibliothèque Nationale de France, Paris.

Figure 40.
Manet in 1875.
Photo Reutlinger.
Bibliothèque Nationale de France, Paris.

Figure 41.
PORTRAIT OF ÉMILE ZOLA, 1867.
Oil on canvas, 126 x 112 cm.
Musée d'Orsay, Paris.
Photo R.M.N.

Figure 42.
PORTRAIT OF THÉODORE DURET,
1868.
Oil on canvas, 43 x 35 cm.
Musée du Petit Palais, Paris.
Photo Bulloz.

Figure 43.
BON BOCK, 1873.
Oil on canvas, 94 x 83 cm.
Philadelphia Museum of Art,
Mr. and Mrs. Carroll S. Tyson
Collection (63.116.9).
Photo Bulloz.

Figure 44.
THE ARTIST
(Portrait of Marcellin Desboutin),
1875.
Oil on canvas, 193 x 130 cm.
Museu de Arte, São Paulo.
Photo Alinari / Art Resource, NY.

Figure 45.
CARICATURE OF MANET AND
HIS PAINTING "THE ARTIST," 1875.
Bibliothèque Nationale de France, Paris.

Figure 46.
KING OF THE IMPRESSIONISTS, 1876.
Caricature by Alfred LePetit.
Bibliothèque Nationale de France, Paris.

Figure 47.
THE NATURALIST, 1882.
Newspaper caricature by G. Darre of Manet
on receiving the Legion of Honor.
Bibliothèque Nationale de France, Paris.

Figure 48.
WOMAN WITH FANS
(Portrait of Nina de Callias), 1874.
Oil on canvas, 113.5 x 166.5 cm.
Musée d'Orsay, Paris. Photo R.M.N.

Figure 49.
BALL AT THE OPÉRA, 1873.
Oil on canvas, 59 x 72.5 cm.
National Gallery of Art, Washington,
Gift of Mrs. Horace Havemeyer in memory of
her mother-in-law, Louisine W. Havemeyer.

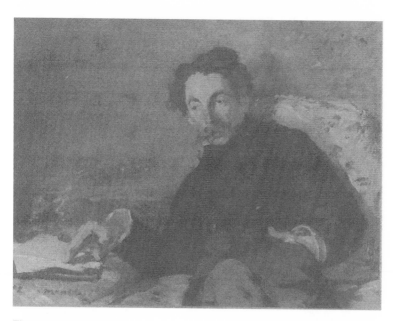

Figure 50.
PORTRAIT OF STÉPHANE MALLARMÉ, 1876.
Oil on canvas, 27.5 x 36 cm.
Musée d'Orsay, Paris. Photo R.M.N.

Figure 51.
GARE SAINT-LAZARE, 1873.
Oil on canvas, 93 x 112.
*National Gallery of Art, Washington,
Gift of Horace Havemeyer in memory
of his mother, Louisine W. Havemeyer.*

Figure 52.
IN THE CONSERVATORY, 1879.
Oil on canvas, 115 x 150 cm.
Staatliche Museen, Berlin.
Photo Marburg / Art Resource, NY.

Figure 53.
MME EDOUARD MANET IN THE
CONSERVATORY, 1879.
Oil on canvas, 81.5 x 100 cm.
Nasjonalgalleriet, Oslo.

Figure 54.
MÉRY LAURENT, 1867.
Photo by Reutlinger.
Bibliothèque Nationale de France, Paris.

Figure 55.
IN THE TUB (Méry Laurent), 1878.
Pastel on paper, 55 x 45 cm.
Musée du Louvre, Cabinet des Dessins, Paris.
Photo R.M.N.

Figure 56.
MÉRY LAURENT IN A BLACK HAT, 1882.
Pastel on paper, 54 x 44 cm.
Musée des Beaux-Arts, Dijon.
Photo Giraudon / Art Resource, NY.

Figure 57.
AUTUMN (Méry Laurent), 1881.
Oil on canvas, 73 x 51 cm.
Musée des Beaux-Arts, Nancy.
Photo Bulloz.

Figure 58.
PORTRAIT OF ISABELLE LEMONNIER, 1879.
Oil on canvas, 101 x 81 cm.
Private collection. Photo Bulloz.

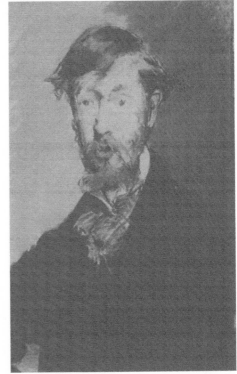

Figure 60 (*above*).
PORTRAIT OF ANTONIN PROUST, 1880.
Oil on canvas, 129.5 x 95.9 cm.
Toledo Museum of Art,
Gift of Edward Drummond Libbey, 1925.108.

Figure 61 (*right*).
PORTRAIT OF GEORGE MOORE, 1879.
Pastel on paper, 55 x 33.5 cm.
Metropolitan Museum of Art, New York,
The H. O. Havemeyer Collection,
Bequest of Mrs. H. O. Havemeyer.

Figure 59 (*opposite*).
THREE NOTES WITH WATERCOLOR, 1880.
Note to Isabelle with peach,
Isabelle with bonnet,
Isabelle diving.
Musée du Louvre, Cabinet des Dessins, Paris.
Photos R.M.N.

Figure 62 (*above*).
NANA, 1877.
Oil on canvas, 150 x 116 cm.
Kunsthalle, Hamburg.
Photo Marburg / Art Resource, NY.

Figure 63 (*left*).
SPRING (Jeanne de Marsy), 1881.
Oil on canvas, 73 x 51 cm.
Private collection. Photo Bulloz.

Figure 64 (*opposite, top*).
CHEZ LE PÈRE LATHUILLE, 1879.
Oil on canvas, 93 x 112 cm.
Musée des Beaux-Arts, Tournai.
Photo Bulloz.

Figure 65 (*opposite, bottom*).
PERTUISET, LIONHUNTER, 1881.
Oil on canvas, 150 x 170 cm.
Museu de Arte, São Paulo.
Photo Giraudon / Art Resource, NY.

Figure 66.
VASE OF PEONIES ON A PEDESTAL,
1864.
Oil on canvas, 93.2 x 70.2 cm.
Musée d'Orsay, Paris.
Photo Giraudon / Art Resource, NY.

Figure 67.
BAR AT THE FOLIES-BERGÈRE, 1881.
Oil on canvas, 96 x 130 cm.
Courtauld Institute, London.
Photo Bulloz.

and nearly endless set of mirrored relationships," *Gare Saint-Lazare*
is "the quintessential symbolist painting, albeit in advance of any
such organized movement," according to Harry Rand, a recent critic.
Defining it as "an essay on consciousness," Rand convincingly relates
it to Manet's earlier works.[34] Manet successively superimposed his
multiple intentions — voluntary and involuntary, unconscious be-
coming conscious — in the manner of a palimpsest. In 1859 Baude-
laire had envisioned a similar procedure when talking about the
somewhat different relationship between the preconceived "dream"
of a painting and its execution: "A good painting, faithful and equal
to the dream that engendered it, must be produced like the world.
Just as creation, as we understand it, is the result of numerous cre-
ations whose earlier ones are always completed by the following one,
so a well-wrought painting consists of a series of paintings superim-
posed, each new layer endowing the dream with more reality."[35]

Gare Saint-Lazare is a perfect example of Manet's intricate method,
combining his requisite spontaneity with a high degree of technical
and intellectual sophistication. Rand points out that "Velázquez con-
structed *Las Meninas* to display the complexities of mirrored space;
in his time Manet constructed the *Gare Saint-Lazare* to mirror the
complexities of mind."[36] The relationship with Velázquez, so often con-
demned by earlier critics as imitation, becomes clearer on examining
Gare Saint-Lazare. Manet was not interested in imitating Velázquez
but in continuing Velázquez's inquiries.[37] By placing them within the
context of his own world, Manet necessarily raised new issues. After
first experimenting with new ways of representing reality, he looked
for ways of going beyond reality. He seems to have had a great deal
more to say than was attributed to him, or even suspected, and a
great deal more than interested his impressionist colleagues. Their
primary aim was to render the physical world as it is apprehended by
the human eye in varying qualities of light. Manet's sympathy with
them lay in the technique of impressionism, which he had initiated
and which was as much as most favorable critics were prepared to
grant him. What had not yet been seen was that for Manet the tech-
nique was not an end in itself as it became for the impressionists. This
may have been another reason for his reluctance to exhibit with them,
and perhaps a more important one than his preference for the Salon.

At the time of the first posthumous exhibition of Manet's works in
1884, Louis Gonse, not an unqualified admirer of Manet, wrote that

plein air painting was primarily concerned with the problems of rendering the modern human figure in its natural setting and with the exact relationship between color values in the diffusion of natural light. This much Manet shared with the impressionists. But in Gonse's view Manet was the great innovator: "In the entire history of European art, no one before Manet had thought of attempting a scientific study of light."[38]

Intellectually, however, Manet and the impressionists were worlds apart. Even his fascination with light may have been less scientific than Gonse claims, more related to personal observation and expression than to the persistent experimentation of the impressionists. Manet had more in common with symbolist poets than with impressionist painters, Zola notwithstanding. From his earliest works he was in search of modern subjects in a bold attempt to reconcile a new technique and a new social structure with older, broader concerns. Far more than a painter of flat surfaces that call attention to themselves — in place of the traditional illusion of three-dimensional reality — Manet was devising and utilizing new techniques to express the concerns of an artist in the late nineteenth century, for whom the "language" of earlier painting was as outmoded as the language of seventeenth-century dramaturgy. Nobody spoke like the characters in Racine or Corneille any longer, but many of the same problems, human and artistic, had endured to link the past with the present.

Manet made as clear a pronouncement of his artistic credo as one could ask for when he said, "Everything that has the spirit of humanity, the spirit of contemporaneity, is interesting. Everything that is devoid of it is worthless."[39] That, terse as it is, points to meaning — meaning in a modern idiom and even a plurality of meanings. Joseph Conrad's understanding of a work of art may be what most clearly defines Manet's art: "A work of art is very seldom limited to one exclusive meaning and not necessarily tending to a definite conclusion. And this for the reason that the nearer it approaches art, the more it acquires a symbolic character." This, Conrad hastens to explain, is not directly related to the symbolist school of poets or prose writers. "I am concerned here with something much larger . . . the symbolic conception of a work of art . . . [which covers] the whole field of life. All the great creations of literature have been symbolic, and in that way they have gained in complexity, in power, in depth and in beauty."[40] This is perhaps a criterion for determining what is truly

great in any of the arts. If it is endowed with the "spirit of humanity," to use Manet's words, it is necessarily symbolic.

Such a perspective of Manet connects a number of writers who over the past few decades and in their different ways have seen that Manet, while using realist and impressionist techniques, had more in mind than patches of color, beautiful contrasts, and the suppression of half tones.[41] Zola's reductive defense of Manet's originality was so focused on separating him from Baudelaire that he denied Manet any mental processes whatever. George Mauner took the opposite position, as the title of his seminal book announces — Manet, Peintre-Philosophe — attributing to him philosophical and moral concepts that surpass any thus far proposed. And Harry Rand argues that Gare Saint-Lazare, "if it is 'about' anything, concerns our awareness and our manner of apprehending the world."[42]

While there is no denying these vaster philosophical possibilities, a somewhat less grandiose reading of Gare Saint-Lazare emerges from Manet's use of a theme he considered more than once, and which in this work he reconsidered in a wholly modernist context. The quality of modernity in the painting has never been disputed and has only gained importance in the eyes of each successive writer. John Richardson sees the painting in terms of "the gaiety which had returned to Paris with the Third Republic," inspiring Manet to "express some of the more agreeable aspects of the life of his time. Outstanding among these are Le Chemin de Fer [more commonly known as Gare Saint-Lazare, or in English, The Railroad] and Le Bal masqué à l'Opéra."[43] Peter Gay raises the painting to a higher sphere as "a poem about speed contemplated in tranquility. . . . I know of no nineteenth century painting that celebrates modernity more unreservedly than this."[44]

However, there is much more to the painting than its modernity. Kathleen Adler is right on the mark when she says that "the role of the imagination in transforming visual experience is important to an understanding of Manet's approach to painting, particularly with regard to the complexity of meaning often found in his work, a complexity that can be lost sight of when Manet is rigidly categorized . . . as a 'naturalist' or as a 'modernist.'"[45] It is precisely this complexity that lies at the heart of Manet's genius. If he had painted only haystacks or ballerinas, he might have been equaled or surpassed by some of his peers. Emile Bernard, a painter of the generation after

Manet, saw his uniqueness: "I only see two men in the nineteenth century in France who really understood the *modern,* and who gave it expression, Daumier and Manet. These two entered into its soul, the others only painted its clothing."[46]

It is not Manet's use of naturalist or modernist subjects or impressionist techniques that distinguishes him. Nor is it enough to say, as many have said, that with *Gare Saint-Lazare* he made a definitive break with museum art. If museum art no longer provided compositional sources, it still provided a venerable topos. In *Gare Saint-Lazare* — as in earlier works such as *The Dead Toreador, Monk Praying,* the peony still lifes of 1864, *The Execution of Maximilian,* and *Boy Blowing Soap Bubbles* — Manet treats the timeless theme of the passage of time, the illusion of duration, the inevitability of death. *Gare Saint-Lazare* appears to be the meditation on time of a forty-year-old whose life expectancy had acquired limits. How many more Salons? How many more years of the stamina needed to stand at an easel? The age of forty is a watershed. The years after forty are tinged with uncertainty, and those before forty can now be seen with the hindsight of a detached observer. Mistakes made are often past correcting; pleasures cannot be recaptured; time accelerates.

The passage of a train can thus serve as a metaphor for time. Infancy (the puppy), childhood (the little girl), and adulthood (Victorine was then almost thirty) all pass in a puff of smoke, reiterated in the child's puffed-out dress of delicate white muslin. She is beguiled by the steam — as a child is entranced by a soap bubble; steam, similarly ephemeral, serves as the bubble's modern analogue. She is unaware that the railing on which she rests her hand separates her from the knowledge that comes with age: there is no beyond out there. There is no sky in the picture, not even an open window. There is only the wall of a building, its shutters closed. But there is a here and a now; there is the solidity of the railroad tracks and the steel bridge.

The woman knows better than to be fooled by steam; it is nothing to hold on to. The plume of steam is only the memory of what has passed by. But some things last: the book in her hands, even if unread. And perhaps once again recalling the painter of antiquity evoked in *The Old Musician,* Manet painted an incongruous cluster of appetizing grapes beside the child. Is he suggesting that this illusionism, this false reality, like the evanescent steam he has captured on his canvas, is the only reality that can endure? For the "reality" of life, allego-

rized in soap bubbles or tobacco smoke, disappears like the steam of a train — a powerful modern symbol — that departs at one point in time and ends its journey at another, like life itself.

Manet's painting is no "slice of life," no candid shot taken by an unseen onlooker, nor is it a portrait. Victorine, though not looking directly at us, seems very aware of her viewer — the painter, whose surrogate we have become. In effect we are forced into a meditation on the painter's meditation. With all its appearance of realism, of the quotidian and the modern, the painting is a poem that gains its poetic quality through images — the Esperanto of imagination — like much of the poetry made of words.

Manet had a very clear notion of the image as poem, revealed in a remarkable passage quoted by Proust. In 1880 Manet finished a masterful portrait of Proust. Sometime later he confided to Proust that his long-standing ambition had been to paint a Christ on the cross:

> Only you could pose for it in the way I understand it. While I was doing your portrait that idea haunted me. It was an obsession. I painted you as Christ in a top hat, with a frock coat and a rose in your buttonhole. That is Christ going to see the Magdalene. But Christ on the cross. What a symbol! One could look till the end of time and never find anything like it. Minerva, that's all right, so is Venus. But the heroic image, or the erotic image will never measure up to the image of pain. That is the core of humanity. That is its poem.[47]

Fourteen years after *Gare Saint-Lazare* was painted, Mallarmé published a "triptych" of sonnets, described as forming "a conscious unity around one main theme: the inexorability of death."[48] Particularly striking is the image of a puff of smoke, in this case from a torch.

Tout Orgueil fume-t-il du soir?	Does all Pride smoke at night?
Torche dans un branle étouffée	A torch in one shake snuffed out
Sans que l'immortelle bouffée	Without the immortal puff being
Ne puisse à l'abandon surseoir!	Able to delay the desertion!

This is not to imply a direct connection between Manet's painting and Mallarmé's poem, but rather to illustrate the depth and quality of affinity between the two friends whose sensibilities were as attuned

to each other as their approach to expression. Mallarmé, hermetic though his syntax may be, does not turn to high-flown rhetoric. His language is simple, but he uses it to arrive at complex ideas: pride of authorship, creation, recognition, as flimsy as a cigar going up in smoke; life, snuffed out like a torch, whose end not even immortal fame, a flimsy puff, can postpone (*surseoir* is a legal term meaning "to stay" an execution or "postpone" a sentence). One could argue that Manet's portrait of Mallarmé (Fig. 50), painted in 1876, was a prefiguration of this poem. Mallarmé is seen lounging pensively in a comfortable armchair, a lit cigar in one hand that rests on a book, while the other hand is in his pocket. But then Mallarmé and Manet surely shared many a cigar without seeing it as a symbol of time's passage. Both of them had a capacity for enjoying what could be enjoyed without artifice, excess, or escape.

Manet's portrait of Mallarmé, even allowing for the evolution of his style, is vastly different from his portrayal of Baudelaire. Baudelaire never sat for him, nor did Manet ever do an oil portrait of him. Baudelaire's only portrayals, aside from the thumbnail sketch in *Music in the Tuileries,* are in two etchings. One of them is reminiscent of his appearance in *Music in the Tuileries,* where he is wearing a top hat and is seen in profile, a mere outline. The other, based on a photograph by Nadar, captures the glassy-eyed expression of the photograph. In neither does the poet make eye contact with his portraitist.

But in the portrait of Mallarmé we have no doubt that the painter is in the same room, smelling the same smoke, perhaps even speaking to his model, who is reflecting on what he has just heard or is about to say. The sense of proximity is made even more manifest by the surprisingly small canvas: "Manet was rarely satisfied with a canvas 35 × 27 [*sic*] cm, and never for a portrait, particularly for a figure seen waist-length. In those dimensions he would have ordinarily found just enough space for a lemon or half a plate."[49] (The only exception, apparently overlooked by the writer, is the shortened portrait of *Berthe Morisot Reclining,* which has similar dimensions in its final state.) What Manet did was to substitute intimacy for formality, a close-up that only a friend would be granted, suggesting not only sympathy but a meeting of minds. Whether sunlight or lamplight, we feel the warmth of this setting; we can imagine the sincerity of the subject, perceive his sensitivity. Whatever Manet's feelings for Baudelaire, they

were never expressed in paint, which is curious considering how important a place Baudelaire occupied in Manet's early professional life.

Not all of Manet's thoughts in 1873 dwelt on such ponderous subjects as time. The expression on Victorine's face in *Gare Saint-Lazare* assures us that awareness is not glumness. And the red fan, repeatedly seen in Manet's portraits of Berthe Morisot, now nestles in Victorine's lap. Are we to understand a cynical substitution? Or is it resignation? The fan has now been passed on: one model leaves, another arrives. Is this another aspect of time's passage: *tout passe, tout lasse?* After all, the pleasures of work and leisure have not ended. The ball at the Opéra still lies ahead.

15.

Polichinelle

During most of the nineteenth century, and particularly during the Second Empire, the masked balls at the Opéra were a major Parisian entertainment. Held from mid-December to the beginning of Lent, they were described in a travel guide of 1874 as the most spectacular of the winter balls. There were Carnival balls at the various theaters and masked balls at the imperial palace, but the opera balls, even for those who could wangle an invitation to the palace, remained the most exciting. The scene glittered with lights, a dance floor replaced the seats on the orchestra level, revelers poured into every space in the theater, clouds of perfume and sweat were raised by the throbbing beat of the waltz and the polka. It was hard to breathe, but it was intoxicating. The crowd was neither too vulgar for the well-born nor too snobbish for the adventurous. Eager hunters stood paralyzed, hat in hand, unable to choose a quarry among the scampering herds. A lady could be detected on the arm of her husband, or a would-be lady on the arm of her lover, concealed under a domino — a hooded black cape worn with a black mask at Venetian revelries.

Available women wore costumes; the more intrepid dressed in the most alluring attire of the period: short trousers revealing the leg from the knee down to a laced or buttoned half boot, an androgynous motley of the feminized masculine costumes of fishermen, gymnasts, stevedores, and court pages. Women also dressed as gypsies, little girls, acrobats, and camp followers; whatever the outfit, a display of leg was de rigueur. In the past all the revelers had worn costumes. By mid-century a true bourgeoise, or a demimondaine whose

success raised her to a level above her more promiscuous sisters, no longer appeared at opera balls in costume — which had become a virtual advertisement for sexual commerce. Gentlemen, too, dispensed with masks and dressed in white tie and tails. Only fools, drunkards, and suspicious husbands out to catch their wives in flagrante delicto came in costume.

Already in 1852 Gautier lamented that all those colorful disguises were falling out of fashion. Attire was now reduced to the black uniform of *croquemorts* (undertakers). Still earlier, in *Splendeurs et misères des courtisanes*, Balzac had described *"la foule noire,"* the black crowd that wove in and out of the Opéra's lobbies like a line of ants; even then no more than a quarter of the men came in costume. In 1846 Baudelaire saw in this uniform blackness something new and marvelous, something that carried a meaning beyond debauchery: "Note well that the black tail coat and frock coat not only have their political beauty, which is the expression of universal equality, but still more their poetic beauty, which is the expression of the public soul; a vast procession of undertakers, political undertakers, amorous undertakers, bourgeois undertakers. We all celebrate some kind of funeral."[1]

Long before, in 1797, Diderot had written in his essay on painting, "The republic is a state of equality. Every subject considers himself a little monarch. The republican will stand tall, tough and proud."[2] The relationship between universal equality, universal dignity, and universal dress was thus established long before Manet decided to paint a universal portrait of his contemporaries — the first that consciously projected the image of Baudelaire's political and poetic beauty.

The opera balls of March 1873 were exceptionally festive and well attended, which may explain why Manet decided to attempt the subject just then. There were also political and social reasons for that year's balls to have been more interesting to him. A bitter chapter in French history had recently come to an end. France saw the departure of the German army from French soil and paid off the last of the war reparations. It was a time for celebration and for looking to the future. For Manet to undertake a painting of the bacchanalia at the Opéra was a major enterprise. An enormous cast of characters was in perpetual movement — a scene far more challenging than that in *Music in the Tuileries*, painted eleven years before, where the setting

was tranquil and the listeners fairly static, even if they chatted over the music. In attempting to render the ball at the Opéra, Manet wanted nothing less than to fix on canvas the mood of the evening in every detail, to depict the scene as it was at that precise moment, a scene not to be confused with the balls described by Balzac, Flaubert, or newspaper illustrators of their day or his own.

Three wash drawings and two oil sketches trace Manet's steps toward the finished painting that now hangs in the National Gallery in Washington (Fig. 49). According to witnesses, he worked and reworked it over many months, returning to the Opéra on the rue Le Peletier to check on details and repeatedly summoning his friends to serve as models. Bazire, who had been among them, recalled that Manet used part of his hatted head, one of his ears, and one of his bearded cheeks in the painting. "He went so far in his desire to capture reality, to paint nothing from memory," Bazire notes, "that he kept changing his models, including the supernumeraries in the back rows where the details of a head or shoulders were all that was supposed to be seen." And he exhorted his models to be completely natural. "How do you put your hat on your head when you are not thinking about it, in a completely spontaneous movement? Well then, put it on like that, without any preparation."[3]

Manet's fashionable friends, who often went to opera balls themselves, came in small groups to his studio to pose for him in white tie and tails. Louisine Havemeyer, the American art collector who bought *Ball at the Opéra* in 1894, confirmed Bazire's account. She learned from Manet's friends that before beginning the painting, he had devoted an entire winter to studying black hats. "He invited acquaintances to come to his studio in order that he might make a study of their hats. He would drop in at a fellow artist's studio and ask to be allowed to make a sketch of his hat. [Edmond] Goncourt came in for a chat and was immediately pressed into service and requested to keep his hat on. Duret's hat was painted, the family hat was painted. Manet's own hat served as a model."[4]

During the interval between his initial sketches and his dogged retouching of the final painting, a catastrophe occurred. Just before midnight on October 28, 1873, the Opéra burst into flames. The entire building was quickly reduced to ashes, and neighbors could hear the roar of the great crystal chandelier as it crashed to the floor when the ceiling collapsed. Whether because the setting could no longer be

verified or because he was finally satisfied with his work, Manet pronounced the painting finished soon after the fire. In November the noted singer and avid art collector Jean-Baptiste Faure came to Manet's studio with money to spend. During the summer he had sold off his collection of paintings by Delacroix, Corot, Millet, and Ribot — Manet's immediate predecessors — and was looking for newer works. After examining Manet's entire stock, he settled on four canvases — *Lola de Valence, Le Déjeuner sur l'herbe, Bon Bock,* and *Toilers of the Sea* — for a total of 14,500 francs. On second thought he decided he had to have the latest work, *Ball at the Opéra,* still standing on an easel, for an additional 6,000 francs. Over the next few years he would accumulate a total of thirty-five Manets.

Fervacques, the journalist who described Manet's studio for the readers of *Le Figaro,* also had seen the painting at the time of his visit. He devoted three entertaining and very observant paragraphs to it.

> . . . a flood tide of black tailcoats, dotted here and there with a Pierrette . . . undulating without advancing. Discreet dominoes . . . circulate amid this human ocean squeezed, jostled, embraced, palpated by a hundred indiscreet hands. Those poor dears round this perilous cape leaving behind a bit of lace, a branch of white lilac from a bouquet that has withered in the noxious fumes of the gas lamps and the acrid human odor that expands in oppressive waves.
>
> . . . a girl in a neckline low enough to challenge the Sixth Commandment, trousered by a piece of red velvet the size of a hand, but with many buttons . . . stands up to a group of white-tied scoffers. . . . Hats tilted backward victoriously, pockets filled with gold coins, they have come to have a good time. And they do. They would proposition their sister if she came by. . . . Perhaps all this is not in the painting; perhaps it is about something quite different. In any case, it is a work of great merit, alive, thought out and admirably rendered.[5]

Many critics have proposed that the painting was a nostalgic look at a delightful institution. But Manet could not have known that the Opéra was going to burn down when he began working on the painting months before the fire. Fervacques was either very perceptive or had the benefit of some remarks from Manet himself to have written "perhaps it is about something quite different." Two recent critics

have placed the work in a context that seeks to expose a deeper mean-
ing — one aesthetic, the other political.[6] Manet no doubt was pre-
serving on canvas a fascinating social institution of his time. He was
not interested in denouncing the moral turpitude of the opera ball, as
did many novelists who nonetheless attended it. Nor was he condon-
ing it, as did the indulgent newspaper caricatures that made it all the
more alluring. Manet was not content merely to capture on canvas
what the camera could capture on paper. But before entering into the
painting, let us see what the setting meant to Manet's contempo-
raries.

Even without so catastrophic an end, the Opéra on rue Le Peletier
was scheduled to be replaced by Garnier's sumptuous new building,
the consummate expression of the period, still under construction at
the time. Finished two years later, it has remained one of the most im-
posing monuments in Paris. The older building, designed by François
Debret and inaugurated in 1821, had been for more than half a cen-
tury the scene of operas, ballets, and balls, and a marketplace for
older connoisseurs of young flesh. It was there, in 1871, that Degas
was introduced to the backstage world of ballet by his lycée classmate
Ludovic Halévy, the acclaimed librettist of Offenbach's most famous
operettas and, later, of Bizet's *Carmen*. Halévy was heartbroken when
it was reduced to ashes: "My old Opéra! The theatre where I spent
my life. . . . How bright and exhilarating the lobby was under the Em-
pire! What charming girls tripped lightly down the six steps of the lit-
tle staircase. . . . All those men in white tie and tails, ministers,
generals, ambassadors, stood gravely among those gamines who chat-
ted with them while gaily thumbing their noses at them."[7]

Although Degas continued to paint dancers long after Garnier's
Opéra replaced Debret's, the setting was always that of his first expo-
sure to their world. Degas's scenes of ballet classes surrounded by
faded walls and low ceilings were memories of the first Opéra's grim
corridors and dusty floors, where exhausted dancers collapsed on tat-
tered plush benches. "The opera house for Degas, who liked to show
the underside of the setting," writes his recent biographer, Henri
Loyrette, "is not a place of ostentation . . . where high society pa-
rades its elegance, but a place scarcely more cheerful than the laun-
dries and the hat shops he was painting then."[8] This dark underside
of what is generally imagined as pure grace, ethereal lightness, and
beauty reveals Degas's uneasiness toward the opposite sex, already

pointed out by Manet in 1869 to Berthe Morisot, who quoted him in a letter to her sister: "Degas lacks naturalness; he is incapable of loving a woman, even of telling her so, or of doing anything." Manet was not being flippant or malicious. This was merely an objective observation. Twenty years later van Gogh seems to have given more thought to the subject: "Degas lives like a little notary who dislikes women, thinking, since he is mentally ill, that if he liked them and fucked them frequently he would become impotent as a painter. His painting is virile and impersonal because he has accepted to be no more than a little notary in his person, having a horror of debauchery. He looks at human animals more robust than himself fucking away and paints them well precisely because he does not have the slightest ambition to do what they do."[9]

And yet Degas was not averse to patronizing brothels, not just as an observer with a sketch pad. "I caught the disease like all young men," he later said of himself, "but I never went in for much debauchery." Even into his fifties, he frequented prostitutes, as corroborated by a letter to the painter Boldini, in which Degas asks him to procure condoms in preparation for their trip to Spain: "Bring a good supply. There may be seductions in Andalucia, for you to begin with, and even for me. And we want to bring back only good things from this trip."[10] Valéry, who knew Degas well in his later years, did not feel that Degas's sexual problems were related to his misogyny: "The character of Degas leads me to think that his past life played a small part in his manner of reducing women to his representation of them in his work. His dark vision saw nothing through rose-colored glasses [son regard noir ne voyait rien en rose]."[11]

In this, as in much else, Degas and Manet did not see things the same way. Whereas Degas was acerbic and short-tempered, ironic and cynical, Manet, though not without a cutting edge, was generally considered loyal, encouraging, and generous — a "luminous" personality according to Giuseppe De Nittis and George Moore, both of whom use this same adjective. His good humor shines through his vision of the masked ball. Degas recorded modern life through the optic of a sullen bystander; Manet commented on it as an ardent participant and with the smile of one who knows more than he professes.

Ball at the Opéra was rejected by the jury of the 1874 Salon. Manet had submitted four works, two of which were accepted — *Gare Saint-Lazare* and the watercolor *Polichinelle*. The other rejected work was

Swallows, showing Eugénie and Suzanne Manet, hatted and veiled, seated on the ground in an open landscape of clouds, windmills, and low-flying birds — far less controversial than *Gare Saint-Lazare* and far less brilliant than *Ball at the Opéra.* What was so objectionable about this painting? It was perhaps too honest a view of actuality, as *Olympia* had been. The jury could not condone this mirror of their own mores, which paradoxically carried no stigma of disapproval. At least overtly, it seems to be a good-natured view of hallowed Carnival excess. It is a masterly rendering of figures, tones of black, portraits, and arrested movement, on a remarkably small surface (59 × 72.5 cm), notably smaller than its earlier companion piece, *Music in the Tuileries* (76 × 118 cm), but similarly constructed like a frieze. For its painterly achievements alone, it deserved admission to the Salon.

Outraged that an artist of such caliber should be subjected to the humiliation of rejection by a jury of lesser peers, Mallarmé rushed into print in April 1874, a few weeks after the Salon selection had been made public. Indicting their "bad faith" rather than their "technical foresight," he wondered whether the jury was trying to shield the public from "the direct reproduction of its many-sided personality," on the grounds that it would "never again tear its eyes from this perverse mirror, or turn them back to . . . an ideal and sublime Art," and that "the modern might jeopardize the Eternal." He then launched into a defense of the painting, which he saw as a "culminating point" from which to gain an overall view of Manet's earlier endeavors:

> What were the perils to avoid in accomplishing this audacity of rendering one aspect of the Opéra ball? The discordant cacophony of costumes that are not proper attire, and the confused gesturing that belongs in no time or place and does not provide plastic art with an inventory of authentic human attitudes. The costumes in the painting merely interrupt . . . the possible monotony of a background of black tailcoats. . . . The aesthetic is irreproachable, and as for the treatment of this piece which the demands of the contemporary uniform make so dreadfully difficult, I do not think there is a reason to be anything but astounded by the delicious range of blacks: tailcoats and dominoes, hats and masks, velvet, serge, satin and silk . . . the utter charm of the dark harmonies made by a group *formed almost exclusively of men.* There is therefore nothing disorderly or

scandalous about the painting, which seems almost to want to step out of its frame; but on the contrary [it is] a noble attempt to make [a painting] contain a total vision of the contemporary world through the pure means required by that art.[12]

After reading this, Manet gratefully replied, *"Mon cher Ami, Si j'avais quelques défenseurs comme vous, je me f . . . [outrais] absolument du jury. Tout à vous, Ed. Manet"* (My dear friend, Thank you. If I had a few defenders like you, I wouldn't give a damn about the jury, Yours).

But in the "dark harmonies" of this "contemporary uniform" is there not also a sly wink at the uniformity of masculine lubricity — all these men thronging to the same place in search of the same titillation? Only the women stand out in their variegated colors and costumes. Even the two masked female figures in their black capes are distinguished from their black-garbed male companions by their gestures and gaze, whereas most of the men are engaged in the same ogling, their eyes directed downward into open necklines or cast obliquely at a more distant morsel. The facture alone makes this painting a masterpiece, and its subtle commentary on the mores of a prosperous, pleasure-driven middle class adds to it the element of modernity. But there is more.

Two recent critics place the work in contexts that propose other meanings. Linda Nochlin raises the question, among others, of the half figure of Polichinelle on the far left. "While there is no reason for him *not* to be part of the crowd . . . it is nevertheless significant that [he] should be the only costumed male figure in the picture. I think that Manet is up to something with this half Polichinelle and this something is a half-joking reference outside the picture." She sees Polichinelle as a partial self-portrait, arguing that "it is entirely in character for Manet to tuck himself modestly into the margin of a scene, as he had in *Music in the Tuileries* more than a decade earlier, so that he could be both a participant in and the observer-constructor of the painting."[13] In this case it seems to me that Manet went beyond his earlier marginal appearance and, though still marginal, was portraying not only the painter-participant but also other aspects of his dual roles and double life: bourgeois-bohemian, husband-adulterer, naturalist artist–reflective commentator.

John Hutton examines the issue of Manet's political intentions in

this painting, arguing that it "is incomprehensible apart from the events of its immediate period."[14] The documented evolution of the painting, from the spring of 1873 to November of that year, allowed for the slow accumulation of ideas and the addition of elements that did not figure in his early studies. When Faure saw the canvas in November, it had just undergone its final revision. This slow overlay of meaning after the initial image was captured is so characteristic of Manet's method in his important paintings that it can stand as a paradigm.

By the time Manet did *Ball at the Opéra*, two major currents were very much in the air. In politics the restoration of the monarchy, Bourbon or Orleanist, was becoming a lost cause. In October 1873 the Orleanist pretender, Chambord, refused to consider a throne controlled by a national assembly, an act seen as irresponsible pigheadedness by some ("There is nothing left for him to do but die"), as admirable sincerity by others ("He preferred suicide to dishonor"). In response to Chambord's decision, Gambetta's newspaper, *La République française,* published an editorial on November 2 addressed to the royalist coalition: ". . . you are at the end of a carnival that has lasted far too long. Your majority of six months ago is mere dust, and you will become aware of this tomorrow: 'Dust you are and to dust you shall return.'" This demise did not take place until a few years later, but it was already apparent, as Hutton states, "that the decisive weight of those with wealth and influence in France swung to the Conservative Republic as that political apparatus which promised the greatest stability for them and their endeavors."[15]

Manet's particular republican stripe was that of moderates like Gambetta, whose republicanism was linked with old personal connections. Gambetta had clerked for Jules De Jouy, Manet's cousin and the family's attorney; Antonin Proust had served in the Ministry of the Interior under Gambetta in 1870, later becoming an editor of his newspaper. It was this faction that gained ascendancy over the next few years, eventually routing the entire spectrum of antirepublicans by 1881, at which time the Chamber of Deputies was composed of a strong republican majority.

If Manet's interest in national politics ran deep, his interest in its effect on the art world ran even deeper. In *Ball at the Opéra* he managed to combine the two in a satire on the hypocritical establishment of both government officials and Salon officials. The "Moral Order"

of President MacMahon was hardly more liberal toward artists than toward other citizens. New regulations governing the Salon limited even more stringently the number of works admissible and, worse still, required the approval of the jury, even in the case of artists who had previously won medals, which in the past had granted them the status of *hors concours*, or the right to exhibit in the Salon. In 1872 the attitude of the government toward the Salon was totally retrograde. The first obligation of the Salon, an exhibition held under the aegis of the state, was to the state; no picture offensive to the political or moral fiber of the regime, which was then predominantly Catholic and royalist, would be tolerated. On the artists' side, a return to censorship, to an ideologically motivated body that determined what was politically correct or morally suitable, was abhorrent to those who had lived through a siege and a civil war and were now within tantalizing reach of a genuine republic.

Reacting to this backward turn of affairs, artists began to look for alternatives to the Salon. The 1874 exhibition of artists who had earlier organized as the Société anonyme des artistes, sculpteurs, graveurs et lithographes, subsequently known as impressionists, was one result. Although some of Manet's confreres reserved the right to exhibit both in the Salon and with the independents, he remained faithful to his principle: "I will never exhibit in the shack next door; I enter the Salon through the main door, and fight alongside all the others [*Je n'exposerai jamais dans la baraque à côté; j'entre au Salon par la grande porte, et lutte avec tous*]."[16]

This complex fidelity to his art, his ambition, and his colleagues was bound to emerge in some form of subversion, which is entirely consistent with Manet's work and personality from the beginning of his career. He would continue to seek recognition through the official venue of the Salon while hoping to make a breach in its stubborn conservatism. And he would support, in every way short of exhibiting with them, the artists who were excluded from it. He also would inject into his work those touches of irony and satire that allowed him to straddle both worlds, just as he rigorously observed the outward forms of bourgeois decorum while gleefully frequenting the demimonde. As John Hutton astutely remarks, "Far from abandoning his provocative strategy of the 1860s, he further refined it, turning it into a sword wielded in a partisan and often deftly pointed manner."[17] It would be hard to prove that the brazen gaze of Olympia or the

"French" uniforms of Maximilian's firing squad were deliberately provocative, but just as hard to prove they were not. On the testimony of Proust, this was not Manet's intention, and he was reportedly surprised by the scandals he caused. What is undeniable is that whatever political or artistic subtext there may be in his works of the 1870s, he handled it with greater subtlety than in the 1860s.

The often repeated charge that Manet did not express a moral or political position in his art is refuted by a number of works done over the years following the Commune. *The Barricade* and *Civil War*, both lithographs done in 1871, manifest Manet's horror at the violence taking place in Paris. Although they do not indicate any solidarity with the Commune, they do convey his sympathies for the victims of the repression. The quotation in *The Barricade* of the firing squad in *The Execution of Maximilian* may have less to do with his deficient imagination — a frequent reproach — than with a desire to conflate the disastrous policies of two antirepublican governments, that of Napoleon III in 1867 and that of Thiers's predominantly monarchist regime in 1871, at the time of the Commune. *Ball at the Opéra* of 1873 and the four versions of *Polichinelle* of 1874 are more satiric than condemning, but equally rooted in the political climate of the time, as are the three paintings of the rue Mosnier, to be discussed later in this chapter.

In *Ball at the Opéra* the only male figure in costume is Polichinelle, which makes one wonder whether he signifies something beyond the Carnival setting. "What better way," asks Linda Nochlin, "of making a covert dig at the Marshal [MacMahon] and his government of Moral Order than . . . to have him confront with apparent alarm the world of Manet, his friends and their women companions — a world obviously neither moral nor orderly?"[18] Since we see this Polichinelle from the back and cannot determine if he is alarmed, trying to halt the commotion, or simply greeting someone, we might consider another meaning for his partial presence in the scene. As the recently elected president of a republic, though an unregenerate monarchist, MacMahon was indeed only half — and not even a very candid half, seen as he is from the rear — in the world represented by the men in the picture: the prosperous bankers and businessmen who frequented the opera ball, many of whom were unshakable republicans. This hidden or duplicitous side of Polichinelle is contrasted with the candor or sincerity of the revelers.

In Manet's artistic lexicon *sincerity* was a key word. The text for the catalogue of his private exhibition in 1867, presumed to have been written by him, contains this key word: "The artist does not say today, 'Come and see flawless work,' but 'Come and see sincere work.'" The word *sincere* was not a neutral adjective at the time. As historian Philip Nord points out, "It is easy to forget the extent to which notions of sincerity were freighted with radical connotations." The word became a republican shibboleth. "To claim for Manet [and] for the new art the mantle of sincerity was to elevate it into a challenge not just to academic bombast but to a prevailing climate of ... reaction."[19] Those who supported Gambetta's vision of a republic in France saw its reflection in the struggle of artists like Manet to democratize the oligarchic Salon system.

Immediately after completing *Ball at the Opéra*, Manet produced four renditions of Polichinelle, now seen full face: a watercolor, a color lithograph, an oil sketch, and a finished oil painting. His live model was a fellow painter, Edmond André, but his protomodel has been widely recognized as the reverse pose of a more conventional Polichinelle by Ernest Meissonier, a man as reactionary in politics as in art. Although it has been found "paradoxical"[20] that Manet should have turned to Meissonier for an image of Polichinelle when there were so many others available, it seems on the contrary quite reasonable that Manet, given his ironic bent, would have wanted to establish a direct link between Meissonier and MacMahon, both enemies of the republic and, in the case of Meissonier, a professional enemy as well.

This was not the first time Manet turned Meissonier around, so to speak. Meissonier had done a scene of the uprising in 1848, titled *Barricade, rue de la Mortellerie* or *Memory of Civil War*. By paraphrasing it in his own *Civil War* of 1871, Manet was remembering, or perhaps reminding others, that people like Meissonier sanctioned the bloodletting during the dreadful repression of the Commune. As for the identification of MacMahon as Manet's Polichinelle, it would be hard to deny that the face, obviously caricatured, resembles the marshal. No other Polichinelle, certainly not Meissonier's, has those features or that facial hair. Moreover, in Manet's image he has a baton, a hefty swagger stick, which could easily have been understood as a reference to "Maréchal Bâton," as MacMahon was mockingly known. Manet may have hoped to fool the censors, since this bluster-

ing commedia figure, whether onstage or in images, generally carries some kind of bat.

Even though Manet refused to abandon the Salon, he retained his position as leader of the new painters, one of whom, Cézanne, was singled out as more rebellious and a potential usurper. A caricature of an early lost painting by Cézanne appeared in a newspaper accompanied by a satiric dialogue between the cartoonist and the painter, who is made to say, "I paint as I see and feel. . . . The others, Courbet, Manet, Monet, et al. also feel and see as I do, but they have no courage, they do paintings for the Salon. I, on the other hand, I dare, I take risks."[21] The opening words are an almost exact quotation of Manet's retort to Couture, *"Je fais ce que vois"* (I paint what I see), which he said more than once in his opposition to the idealized creations of academic painters. Cézanne's early attacks on the Salon by means of crude subjects and thick paint — applied with "a mason's trowel," according to Duranty, who also said that Cézanne seemed to think a kilogram of green was greener than a gram[22] — resulted in nothing more than the persistent rejection of his works.

A recent critic wrote that Cézanne hoped to gain the kind of attention Manet had received by "developing Manet's technical and iconographic innovations even more uncompromisingly" and confronting the public with "even more banal sensuality."[23] Shown at the first impressionist exhibition in 1874, *A Modern Olympia,* the title of a vulgar pastiche of *Olympia,* clearly signaled Cézanne's intention. He brought the previously unseen viewer into the picture by including a male figure who is himself. "It is the work of a painter-voyeur whose relationship with the opposite sex was made up of both fascination and animosity."[24] In this he was very unlike Manet but close to Degas.

Among other differences between Manet and the painters around him, neither the conservative Degas nor the anarchist Cézanne nor even the socialist Monet placed their art in the service of politics as did Manet on numerous occasions. He was prepared to take risks, but sheer sensationalism was not his purpose. He never tried to storm the Salon as if it were the Bastille, but his chagrin and surprise over the scandals he aroused suggests that he had trouble estimating the right amount of innovation to deliver at each Salon. Or was he being disingenuous about works such as *Le Déjeuner sur l'herbe* and *Olym-*

pia? As one who later took as a motto *"Faire vrai, laisser dire"* (Do what's true, let them talk), he must have learned what to expect.

Polichinelle turned out to be another debacle. Although the watercolor had fared well at the Salon of 1874, the lithograph that followed, slated to reach the subscribers of a republican newspaper, was seized by the police as an irreverent portrayal of the head of state. A lithograph could reach a much wider audience than a Salon painting, which might have been uneasily accepted as a familiar commedia figure. But an image that could be identified as a caricature of the president, especially distributed in the tens of thousands by a republican paper, smacked of sedition. Polichinelle, traditionally associated with drunkenness and irascibility, was not going to pass into public hands. What greater mockery of MacMahon, "the butcher of the Commune," and his Moral Order than the disorderly, disrespectful, combative Polichinelle? Twenty-five proofs on fine Japan paper, signed by Manet and destined for collectors, were all that remained of the lithograph. The printer was forced to stop printing, and the police destroyed the first fifteen hundred sheets of the run. This cost Manet his sale of the publication rights, for which he had asked two thousand francs.

Manet had earlier proposed to his poet friends that they provide an epigraph for the picture. The surviving submissions include Mallarmé's quatrain, which was perhaps too hermetic, a couplet by Théodore de Banville, and three stanzas by Charles Cros, Manet's friend in Nina de Callias's circle, which were too pointedly satiric to use:

> He is ugly, double humped, a scoundrel, a drunk,
> He couldn't care less about social order,
> Police officers, the icy kiss of death,
> Or the devil. And yet we love him because he batters.

It was Banville who came away the winner with his couplet:

> Ferocious and flushed, his eyes alight,
> Rakish, drunk, divine, that's Polichinelle.

An even richer layering of political, artistic, and personal meanings can be seen in the three rue Mosnier paintings, particularly the one with the figure on crutches, which Manet did a few years later. These pictures have been ably analyzed by a number of recent critics, most

of whom recognize their political implications, some of whom see them as the culminating social document of Manet's modernist concerns, his last comment on Haussmann's Paris. One writes, "The Baudelairean *flâneur* has forgotten nothing, but here he is at his window."[25] Manet's mezzanine studio on the rue de Saint-Pétersbourg was high enough for an overview of the street but close enough for a sense of contact with the activity below. The first of the series shows workers setting the last paving blocks in the recently constructed street. The second, showing the same view but crowded with horse-drawn carriages, suggests a prosperous neighborhood — which was the case, and a new one at that — where tricolor flags flutter from the handsome facades on the right side of the street. The third is a nearly empty street with an amputee on crutches in a workman's smock making his way up the shabbier left sidewalk, rubble visible on the far left side. Is there a political implication in the animation of elegant figures and vehicles on the right and the lonely, mutilated worker on the unfinished left?

This same figure started out as a brush-and-ink illustration designed for a collection of songs by a singer/composer who was known as Cabaner and invariably called eccentric. He would sit for a portrait by Manet in 1880. The project for the sheet music never materialized, but a sketch for the title page has survived, as has a second ink drawing of the same figure seen from the front. A habitué of Nina de Callias's coterie and also of Manet's circle at the Café de la Nouvelle-Athènes, Cabaner in 1878 set to music a group of poems by Jean Richepin from a collection titled *La Chanson des gueux. Les gueux* were the maimed and crippled street people, the beggars, panhandlers, ragamuffins, and pickpockets who had long been a common type in the cities of Europe. The most famous representation of them is the series of etchings titled "Les Gueux" by the seventeenth-century artist Jacques Callot. *Les gueux* came to stand for the poor and disfranchised and had already acquired a political significance in France early in the nineteenth century, but especially after the Commune. The heaviest casualties during the repression were sustained by the poor workers of the northeastern arrondissements of Paris, who were in the vanguard of Communard street fighters. Richepin's *Chanson des gueux,* first published in 1876, was suppressed by the government after it had been on sale for a few days. The author, publisher, and printer were each fined five hundred francs for offense to public

morality, and Richepin was given a month in jail. A censored version was published six months later. None of this was lost on Manet.

By 1878 MacMahon had completed five years of his seven-year term. The year before, on May 16, 1877, he had attempted to over-throw the entire regime in a coup that backfired. He had dissolved the Chamber of Deputies and called for new elections, which to his dismay resulted in an even stronger republican presence. The restoration of a monarchy in France was now a dead issue; the republic at last gained full legitimacy.

To celebrate the recovery of France from its wartime wounds, a Universal Exposition of agriculture, industry, and the arts to be held in 1878 had been approved two years before. The last one held in Paris, which Manet documented in his *View of the International Exposition,* had been in 1867, when Napoleon III was still on the throne. At that time Manet had been excluded from both the Exposition gallery and the concurrent Salon. In 1878 the situation was to repeat itself, only more bitterly, for Manet was by then a renowned, if contested, artist. Three years before, one exasperated critic had declared, "There is no way of ignoring it, every year there is a Manet problem, just as there is an Orient problem or an Alsace-Lorraine problem."[26] Castagnary, on the other side of the "problem," prophesied that "the day the history of the evolutions or deviations in nineteenth-century French painting is written, it will be possible to dismiss M. Cabanel [of the succulent Venus and cherubs], but M. Manet will have to be taken into account."[27] Nevertheless, Manet was treated with less consideration than a rank beginner. The regulations for submission to the Universal Exposition required that a list of works completed after May 1, 1867, be sent in before June 1, 1877. A selection would be made from the list by July 15. Among the jurors were Baudry, Bouguereau, Cabanel, Gérôme, Lehmann, Meissonier, and Robert-Fleury, all artists catering to current tastes and most of them Manet's previous hangmen.

Antonin Proust, who by then had been elected to the Chamber of Deputies and the Council of the Fine Arts, was able to inform Manet of the decision before it reached him officially. In that first round, the jury unanimously rejected every one of the thirteen titles Manet proposed. They found each work more belligerent than the last and were not about to treat this perennial troublemaker with any indulgence. He would be asked to submit all the paintings to the scrutiny of a ple-

nary session. Manet told Proust what he thought the jury could do with its decision. He briefly considered another one-man show and even drew up a list of about a hundred works. But he soon gave up the idea, since the most modest construction would have cost at least sixty thousand francs. The Salon remained a possibility, but on seeing the names of the jurors, many of them the same as those for the Universal Exposition, he realized that he did not have a chance. He decided to spare himself any further humiliation.

On June 30, 1878, a great festivity was held to celebrate the success of the Universal Exposition and the health of the long-awaited republic. There were fireworks throughout Paris and flags on all the buildings. This was primarily a republican festivity, also documented by Monet in his much more exuberant *Rue Montorgueil*. Manet, in contrast, recorded a scene fraught with the contradiction between his lonely amputee and the festive air of the opposite side of the street. As one critic with the broadest view of the rue Mosnier pictures has remarked, Manet's view of his street is more than documentary; he succeeded in suggesting "the multiple layers of meaning inherent in the popular experience of the event. Interwoven with a sense of national pride and renewed prosperity is a rather introspective patriotism, tempered by painful remembrance."[28] What has not been mentioned is the personal emblem inherent in the scene with the cripple. Amid all the triumphant festivities, Manet, like his hobbling veteran, was not one of the celebrants. Once again he was excluded from the Universal Exposition, which was tantamount to France's Hall of Fame for its artists of the preceding decade. Like this worker-veteran, Manet was one of the disfranchised, an outcast.

The exhibition in May 1874 of "impressionists," as they were soon after to be called, met with little critical success, but one reviewer compared Monet with Manet, to the latter's distinct disadvantage. It was not the first time they had been paired, but by then, with works such as *Bon Bock* enthusiastically received at the Salon of 1873, *Ball at the Opéra* discussed in a feature article though rejected for the Salon of 1874, and countless pages devoted to Manet by admiring as well as hostile critics, he could not have been pleased to read that "M. Monet is establishing a place for himself while his near homonym remains stationary." The writer went on to assure Monet that if he re-

sisted Manet's pernicious influence and weaknesses, such as placing colors side by side without the intervening half tones, plagiarism, shocking the public to achieve success at a later date, and thumbing his nose at composition, Monet might indeed "win out over his fearsome adversary." Accused moreover of "harshness," whereas Monet's "tones sing in a bright and luminous background," Manet was condemned never to acquire the grace that Monet "may encounter along his way."[29]

Manet may well have felt embittered to learn that he who had served as Prometheus for the younger painters, showing them the way out of the darkness, giving them the light, and revealing to them the means to achieve it, did not have the luminous tones of Monet. Not that he blamed Monet, for whom he had, then and always, great fondness. In fact over the next few years Manet was to become one of Monet's most reliable benefactors, as indicated by a letter dated January 23: "My dear Manet, I ask you to forgive me for turning to you so often but what you gave me is used up and here I am again without a penny. *If you can*, without inconveniencing yourself, advance me at least 40 francs, that would be a signal service."[30] Although it was often inconvenient and Manet had long to wait for repayment, he helped Monet as often as he could with sums that ranged from less than one hundred francs to one loan of one thousand. On one occasion he tried to engineer help that he wanted to keep anonymous. In a letter to Duret he said that Monet, whom he had seen just the day before, was desperate. "He asked me to find someone who would take ten to twenty pictures at the buyer's choice for 100 francs apiece. Shall we take it on ourselves, each of us putting up 500 francs? Of course, no one, least of all he, should know we are involved." Having apparently failed to interest Duret, he wrote to his brother Eugène:

I saw Monet recently and he is completely broke; he is trying to lay his hands on a thousand francs, and for that he is offering 10 pictures *of one's choice*. If you have 500 francs at your disposal we can manage this between the two of us — as far as I am concerned, I know that with 5 paintings, which I could dispose of for at least 100 francs, we would recover our outlay almost immediately. If you are game, send me a draft for 500 francs and I'll go and get the canvases from him. Obviously he mustn't know that we are taking

this on, but I've tried other people and no one dares take the risk — it's just absurd.[31]

Manet seems never to have doubted Monet's talent; his faith and generosity were repaid after his death. It was Monet's initiative and perseverance that raised the money to buy *Olympia* from the widowed Suzanne so that a bequest of the painting could be made to the state, resulting in its final place on the walls of the Louvre.

It is not possible, at least not with certainty, to ascribe the motivation that led Manet to Argenteuil during the summer of 1874 to the stinging article that compared him to Monet. But the work he produced then looks like a reply to the accusation that he was "stationary." The charge is particularly ironic when one reads the article written in 1881 by Henri Guérard, who was himself a recognized printmaker and the husband of Eva Gonzales:

> The recent but inadequate medal awarded by a liberal-minded Jury to the painter Manet has offered critics an opportunity for a new discussion in which the stale old bourgeois clichés have been wheeled out yet again. . . . One objection loomed alarming and irrefutable: that Manet had invented *plein air* painting! *Plein air* painting does not necessarily result from simply painting in the open, though of course you have to be out of doors to do *plein air* painting. Real *plein air* painting, that of Manet, is a new art which requires particular execution, observation, sense of hearing; in a word, it is a new art formula.
>
> *Plein air* painting is not simply a matter of painting a tree outdoors. . . . The interest of this famous *plein air* painting, which upsets so many people, is life, the human figure in all its modernity, moving in an outdoor atmosphere with the intense effects and values, the unequivocal contours that . . . invest people and objects with real light and sun.
>
> It is in this sense that Manet is its *first* exponent, its master; and to mention only a few examples of his considerable work, *Doing the Washing, The Boaters, At Père Lathuille's, The Battle of the Kearsarge and the Alabama, Queretaro,* these are the pictures whose equivalents in modern painting I seek in vain, because they are conscientiously observed and frankly expressed.[32]

The first three paintings Guérard mentioned were not done until the summer of 1874, but the last two date back to 1864 and 1867, and there were others as well. It was not for nothing that Manet was called the leader of the new school of painting, now invested with the sobriquet "impressionism." But Manet was fated to prove himself over and over, even when it came to his own innovations. After Corot and his Barbizon colleagues had left their studios for the authentic landscapes of Fontainebleau's forests and Rome's countryside, Manet took their natural settings and made them human.

In the summer of 1874 Manet gave up his usual seaside stay in Boulogne to devote himself to his favorite venue, Paris, and to serious work. He had had enough of pining for the city when he was removed from the life of the streets and the companionship of the cafés. Gennevilliers was now as far as he would stray during the summer months. He could go there for just a weekend and be back in Paris without having to pack a trunk or travel for days. Or he could stay for a week at a time if he chose, leaving his mother and Suzanne if he wanted to return to Paris for a day or two. His hospitable cousin Jules De Jouy had a house large enough to accommodate them all. And there were painter friends nearby. Not only was Monet on the opposite bank of the Seine, but Gustave Caillebotte, then in his mid-twenties, was a close neighbor; in 1876 he would paint Manet's own quarter in his canvases of the *Pont de l'Europe*. Sailing had become a popular pastime along the Seine, and Caillebotte was the president of the Gennevilliers yacht club. Mallarmé was another sailing buff who dashed off to his little skiff at every opportunity.

Seen with hindsight, Manet's decision to work in Gennevilliers is reminiscent of his attitude before producing his *Déjeuner sur l'herbe*, when he felt challenged to produce a nude: *"Je vais leur en faire un nu"* (I'll give them a nude).[33] If the critics thought he had been outdone at his own game by another impressionist, he would show them. *Argenteuil* was the first canvas that came out of that summer. His brother-in-law Rudolphe Leenhoff posed with a damsel known to the local boatmen as a regular at the public dances. Duret, in his early biography of Manet, notes that "the sailors came from various social backgrounds, but the women they brought with them all belonged to the middle rank of *femmes de plaisir.* The one in *Argenteuil* is of that kind. Since Manet, in his attempt to approach real life as closely as

possible, never put on a face what was not inherent in its nature, he portrayed this woman with her common features, seated aimlessly, lazily, in the boat."[34] His skillful rendering of the kind of floozy (Duret uses the slang term *grue*) that he had observed in daily life and evidently recognized in his model was not lost on his viewers.

The painting — Manet's only accepted submission to the Salon of 1875 — unleashed an upheaval almost as violent as that caused by *Olympia*, which had become the measure of Manet's effect on the critics. The greatest outcry was against the "Mediterranean" blue of the Seine, which became a new object of hilarity. The unwillingness to see the intense blue of the river as a reflection of the summer sky that bathes the village of Argenteuil in the background can be explained in part by bad faith, but also by the convention of painting water in shades of green.

But once again staunch defenders took up the gauntlet. Burty came straight to the point: "The very blue Seine, a very accurate blue according to artists who have painted on similar days in similar places. Much too blue! cry the viewers. That blue is for them like red for bulls: it exasperates them, makes them lose all critical sense and all proportion."[35] Burty saw the end to the armistice between Manet and the public following *Bon Bock* and a resumption of hostilities, and he was right. Manet was dragged through old muck and new, accused of taxing the patience of an indulgent public, of being a charlatan, a mere eccentric, an *"épateur"* (attention seeker), as he was called by Louis Leroy, inventor of the mocking term "impressionists." Readers of *Le Figaro* were informed that Manet's "enemies are henceforth authorized to conclude irrefutably and brutally that he is incapable. . . . Not since his beginnings has M. Manet made a step forward. And so farewell to the hoped-for master. The artist has reached the stage of a twenty-year-old student."[36]

Taking up Manet's defense, the highly influential Ernest Chesneau, who had himself been slow to come around, pulled out all the stops in a long polemical article: "Every year he brings to the Salon the result of his observation . . . and you say, he is an *épateur*." Chesneau wrote with a directness that turned into a personal attack on every detractor, starting with Leroy:

The real truth about the exhibitor Edouard Manet, is this: you were disgusted with Corot for forty years, weren't you, and now you

praise him to the skies. Well then, Corot begat Manet. If you make fun of Manet, you make fun of Corot. Whoever likes the one should understand the other.... You see nature, but you do not look at it. If you did, if you knew how to look at it, you would be forced to recognize the victory, or at least the preliminaries of a victory that the art of M. Manet has accomplished.... For the past three years I see him each year surpassing himself.... He painted blue water. That is the great reproach. However, if water is blue on days of high wind and sun, should he have painted it the green of traditional water? ... People boo him, I applaud him.[37]

Art was a serious business then. While many writers made their reputations by the combativeness of their reviews, it must also be said that readers were intensely interested in these Salon reviews. The Salon was *the* cultural event of the year and open to all for a pittance. For a reviewer of Chesneau's stature to come out so vehemently in favor of the yearly pariah suggested that it might be time for the establishment to rethink its opinion. The "Manet question" was now a cliché that reappeared under various bylines. One critic, in his review of the Salon, announced, "All that remains for me to comment on is the painting by M. Manet. But it arouses so many discussions and so much anger that I will have to treat it at length. There is a 'Manet question.' It will have to be treated separately."[38] A week later he devoted a three-column article to it.

The ultimate triumph was Castagnary's accolade. At the end of May, by which time most of the Salon reviews had appeared, Castagnary gave Manet the kind of approval he may by then have despaired of receiving in his lifetime, although he had faith that his posthumous reviews would do him justice: "And M. Manet? For at last I come to him. Given the length of time he has been exhibiting, has he not earned his medals? He is the *chef d'école* and exercises an indisputable influence over a certain group of artists. For this alone, his place is assured in the history of contemporary art.... What M. Manet paints is contemporary life.... *The Boaters of Argenteuil* are certainly a match for *Tamar in the House of Absalom* [Cabanel's benchmark submission that year]; in any case, they interest us more."[39] Although Manet had received a crown of laurels from Castagnary, he would not see a medal for years. Nor was he ever to gain the kind of universal appreciation that his impressionist comrades — Degas,

Monet, Renoir — would achieve and that his academic contempo-
raries — Meissonier, Cabanel, Breton, Bouguereau — already en-
joyed.

When Giuseppe De Nittis, fourteen years younger than Manet, re-
ceived a medal, followed soon after by France's highest distinction,
the Legion of Honor — before Manet had won either award — De
Nittis was treated to Degas's boundless disdain. As De Nittis relates
in his memoirs, Manet, present during Degas's abuse, turned to De
Nittis with his "boyish, slightly sardonic grin."

> "All that contempt, *mon petit*, is baloney. You have it, that is the
> important thing, and I congratulate you from the bottom of my
> heart. . . ."

Degas interjected irritably, but Manet continued without being
rattled for a moment by Degas's acerbic remarks.

> "My dear Degas, if there were no decorations I would not invent
> them; but they exist. And one must have everything that sets
> you apart from the crowd, whenever possible. . . . It's a hurdle
> jumped . . . it's yet another weapon. In this bitch of a life of ours,
> this unending struggle, one never has too many weapons. I have not
> been decorated? That's through no fault of mine, and I can assure
> you that I will be if I can and I will do whatever I can to attain it."

"Naturally," Degas interrupted, angrily shrugging his shoulders.
"It's not today that I discovered what a bourgeois you are."

> "Sure, as bourgeois as you like. But I've paid my dues. Come
> now, however un-bourgeois you may be, you will have all the hon-
> ors, and I will be as delighted for you as I would be for myself."[40]

The official recognition that Manet had been denied at the Salon of
1874 was still seven long years away. In the meantime he seems to
have felt the need for a fresh start, which was entirely consistent with
his determination not "to do tomorrow what [he] had done the day
before." His experiments that summer with full-blown impressionist
techniques — working in Monet's company along the Seine, the fa-
vorite setting of the "new" painters — met with the same critical
disfavor as everything else he did. Coming after *Bon Bock*, such inno-
vations raised the hackles of the critics; he had fooled them into prais-
ing him for that painting, and here he was back to his old tricks.

However, *Boating* brought him the support of a young writer who had not started out as a Manet enthusiast. Joris-Karl Huysmans, better known for his decadent fin-de-siècle novels, wrote about *Boating*, "Water is not that color? But indeed it is at certain times, as well as shades of green, gray. . . . Manet, thank God, has never known the stupid prejudices preserved in the academy. He paints and distills nature as it is and as he sees it. Paintings such as these, alas, we shall rarely find at this tedious Salon."[41] The freshness of *Boating* still remains. The striking composition and the alterations of depth testify to a level of technical sophistication unsurpassed in the nineteenth century.

Another work from that summer is both a delightful scene and a three-way biographical mirror. Monet was then still living in the house on the rue Pierre Guienne that Manet had found for him on his return from London. One day when Manet went over to Argenteuil to visit, he decided to paint Monet as he was watering his garden, while Camille Monet sat on the grass with their son Jean, sprawling against her. She is seen wearing the same hat Suzanne Manet and other models wear in various paintings, evidently a studio prop. Manet produced a thoughtful family portrait that avoids all triteness and suggests more than just human figures in natural light. Camille, in her sun-dappled white dress, is the focus of the scene, but not merely as an area of summer brightness. The distinctive cast of her features gives us the portrait of a specific woman and, on close inspection, a woman who does not seem entirely one with her bucolic setting. Her pose is pensive, and the expression suggests that her thoughts are in our space rather than her own; there is no visible communication between her and her son or her husband. This noncommunication among figures closely grouped (*The Balcony, The Luncheon*) or seemingly related (*In the Garden, Gare Saint-Lazare*) is a recurrent theme in Manet's work that would reappear a few years later in *In the Conservatory,* his most extensive exploration of the distance between intimates.

The same afternoon that Manet painted the Monet family, Monet decided to paint Manet painting (*Manet Painting in Monet's Garden*). Finding both of them at work when he stopped by, Renoir borrowed equipment from Monet and hastily began painting the same scene as Manet, except that Monet was no longer in the picture, since he was

by then at his easel (*Mme Monet and Her Son in Their Garden at Argenteuil*). This was the setting for the misunderstood remark Manet made in teasing rivalry about Renoir's lack of talent.

Another day Manet painted the charming *Monet in His Floating Studio,* in which Monet is seen in the boat he had partially roofed so that he could paint water while he was on it. It is in these strongly impressionist paintings that the difference between Manet and many of his stylistic confreres becomes most apparent. In Manet's work the human figure is of foremost importance. In that respect he was close to Degas; however, Degas was never interested in nature or natural light. Manet represented natural light as faithfully as paint can allow, but primarily as an environment for a psychological portrait, a relationship, or the absence of one, between figures or, even more original, between the subject and the artist. Nature in Manet's work is in the service of the human figure, which stands as the mediator between it and the viewer. The figure colors our view of the natural scene, which reaches us through our mental as well as our visual faculties. In Monet's work, however appealing the rendition, there is little if any emotional or psychological contact between the viewer and the subject.

The year 1874 closed for Manet with two portraits of Berthe Morisot, one of which is a watercolor (Fig. 32) that was probably a preparatory study for the last oil portrait he did of her. In the watercolor we can see the fan that was so often associated with her and that appears in both works. In the oil the right hand in which she holds the fan is no longer in the picture, making it harder to see the black fan against her black dress. All attention is focused on her face and her raised left hand, on which she wears a ring. A month later she would marry Eugène Manet.

There is a noticeable difference in expression between the two works. In the watercolor her expression is soft and pensive, whereas in the oil a severity has crept in, making one wonder whether Manet was expressing his response to her engagement. Her tight-lipped, sharp-nosed face in the oil has none of the charm or youth of her portraits of the past. Even her eyes have lost their earlier fascination. Gone are the huge dark eyes that rivet the viewer of *Repose* or *Berthe Morisot Reclining.* In the watercolor they still have some interest, though less than before.

The most disturbing image Manet left of her was done some

months before the two 1874 portraits with fan. It is almost as though another hand produced it, a hand working much later than 1874. *Berthe Morisot in a Mourning Hat* — her father had died in January of that year — is closer to expressionism than impressionism. She seems old and haggard, which is not convincingly explained by her father's death. She had never been close to him, and it is hard to believe that she could still be so bereaved after close to a year. Even more striking is the violence of the facture: the thick brushstrokes with their slashes of pigment, the harsh highlights and shadows of the face, the bars of black that cut across her arm.

These portraits marked the end of yet another stage of Manet's career. From 1875 on, he devoted himself for the most part to models and subjects drawn from impersonal relationships and concerns: cafés, nude models, and demimondaines, punctuated by the rare portrait of a friend — Mallarmé, George Moore, Proust — and, at the end of the decade, a series of portraits of his last infatuation. Emotional attachments — until the advent of Isabelle Lemonnier — even political concerns, with a few exceptions, appear to have been shrugged off in favor of less complex works. Was Manet trying to conciliate his enemies? Now into his forties, did he think that he could win the favor of the public without betraying his artistic principles?

"Faire Vrai, Laisser Dire"

By 1875 the Batignolles group had deserted its own neighborhood café, the Guerbois, for the Nouvelle-Athènes on the place Pigalle, the next square to the east on the boulevard de Clichy. A number of artists, among them Degas and Alfred Stevens, lived in the immediate area, and for Manet, who arrived every afternoon at 5:30, the Nouvelle-Athènes was only ten minutes farther than the Guerbois. Another habitué was the painter-poet-sculptor-engraver Marcellin Desboutin, never seen without his wolfhound. Before his various artistic apprenticeships, Desboutin had taken a law degree and then spent more than a decade dissipating an inheritance that had allowed him to buy a lovely villa in Florence. He finally returned to Paris and to a hand-to-mouth existence more congruous with his calling than that of a landed gentleman. The contrast between his upper-class manners and his bohemian dress made him something of a local "character." His lean-to studio/dwelling looked over a sordid interior courtyard in Montmartre, its gaping walls hung with Italian tapestries, vestiges of another life. In 1874 and 1875 his paintings were exhibited at the Salon, and he also did a drypoint etching of Manet. In 1875 Manet convinced him to sit for an oil portrait, which meant a serious commitment of time, given Manet's insistence on never finishing from memory what he had begun from nature.

This portrait, *The Artist,* has been compared to *The Tragic Actor* in pose, size, and lighting. There is a certain similarity between them, but Desboutin's is the portrait of a man as himself, caught in the natural gesture of filling his pipe, not in the image of another (Fig. 44). He

is not seen at his easel, as the title might lead one to expect, whereas *The Tragic Actor* delivers its promise: we see an actor in the role of Hamlet; we do not see the tragedian Philibert Rouvière in mufti. *The Artist* is the portrait of a unique personality, presented outside his profession. His bohemian appearance — the baggy trousers and sagging pockets of his suit, the artist's knotted white kerchief, the high-crowned crushed hat and shaggy hair — is the only indication that he might be an artist, but we do not know whether he is a poet, painter, or musician, nor are we supposed to, since the figure is represented as an artistic temperament. The two rings on his left hand and his refined features contrast with his shabby attire, which conceals another existence. His face is rendered with so much detail and masterful lighting that we cannot fail to respond to the reality of the figure. The impressionistic brushwork and absence of black enhance the warmth of the portraitist's vision.

Manet injected into this painting his personal response to his model, which is not visible in *The Tragic Actor* or in the portrait of Jean-Baptiste Faure as the operatic Hamlet, painted two years later. Manet was fully aware of his emotional presence in his painting of Desboutin. Talking about iconic figures, such as Ingres's Bertin or his own paintings of women of the Third Republic, he said, "There is a work, not of a woman that time, which I really enjoyed doing, it is the one for which Desboutin posed. It was not my ambition to capture an entire era, merely to have painted the most singular type in a particular quarter." An interesting footnote to this is his confession at the same time of wanting to do a portrait of Victor Hugo, whom he did not know and was reluctant to approach himself. "I would even be satisfied with a single sitting for a pastel sketch," he told Antonin Proust and Arsène Houssaye, who knew Hugo, hoping they might arrange a meeting. A pity nothing ever came of it.

In early September 1875 Eugène Manet found his brother at work on a canvas so extraordinary that he informed his wife, Berthe Morisot, "Edouard has started a painting that is going to upset all the painters who think they own *plein air* and light-colored painting. Not a drop of black. It seems Turner appeared to him in a dream."[1] On September 19 Manet wrote to Mallarmé, still vacationing near Boulogne, "I have ambitious projects which I will share with you when you return. The weather is favoring me and I work all morning without a break, hoping for good weather until the end of September.

Mme Lecouvé is being very cooperative."[2] Alice Lecouvé (most often spelled Legouvé) was Alfred Stevens's model. She had posed for Manet once before, in the summer of 1873 along with Victorine Meurent, for *A Game of Croquet*. Now she was posing in the same little garden behind Alphonse Hirsch's house on the rue de Rome in which Victorine had sat for *La Gare Saint-Lazare*. She is seen surrounded by flowers, wringing out some laundry, the water falling into a tub placed on a chair, while a small child looks on and the rest of her washing flutters from a line behind her. Unlike Degas's downtrodden laundresses, this is not a woman who spends her day bent over a tub of other people's dirty clothes. This is a housewife, washing the clothes of her own family, cheerful at her task in the warm sunlit air of her garden.

Manet created a domestic scene in a vibrant outdoor setting. *Washing*, Mallarmé declared (in his own English translation), "marks a date in a lifetime perhaps, but certainly one in the history of art."[3] According to Jacques-Emile Blanche, who offers no explanation, the painting quickly lost its brilliance. He had seen it still pristine in Manet's studio, "dazzling with light, a blue so intense and so gay that one wanted to break into song." Only a few years later the pigments had apparently tarnished. "What we are admiring are ruins," Blanche claims, "the ruins of yesterday. You cannot know what *Washing* looked like in its first appearance."[4]

A year after Manet completed the work, Mallarmé published a very long essay, much of it devoted to Manet, on impressionist painters. It appeared in a short-lived English journal and was translated into cumbersome English (Mallarmé was a better translator of Poe into French than of his own prose into English), which makes for arduous but worthwhile reading. The original French text has not been found. Because of its date, 1876, when Mallarmé and Manet saw each other every day, there can be no doubt that Mallarmé discussed with Manet the ideas he set forth and showed him the original French manuscript. Although Manet had some command of English (one of his better subjects at the Collège Rollin), he would have needed Mallarmé to explain certain obscurities that even a native speaker of English finds turgid. The language of the article is too precise, too technical, to have been written without the help of a practicing artist. Since the artist closest to Mallarmé was Manet, it is more than likely that much of what he says about Manet's work and aims,

and specifically about *Washing*, came directly from Manet. More-
over, Mallarmé admits in the article having discussed art with Manet.
Mallarmé writes,

> Open air is the beginning and end of the problem we are now study-
> ing. Aesthetically it is answered by the simple fact that [only] in
> open air can the flesh tints of a model keep their true qualities,
> being nearly [evenly] lighted on all sides. . . . As no artist has on his
> palette a transparent and neutral color [corresponding] to open air,
> the desired effect can only be obtained by lightness or heaviness of
> touch, or by the regulation of tone. Manet and his school use simple
> colour, fresh and lightly laid on, and their results appear to have
> been attained at the first stroke, so that the ever-present light blends
> with and vivifies all things.[5]

(Bracketed words indicate slight editing for clarity; the original words
were obviously literal translations from the French.) When Mallarmé
says that the subject "cannot be supposed always to look the same,
but palpitates with movement, light, and life," these words carry the
ring of Manet's explanation to Proust that "one paints the impression
of one hour of the day in a landscape, a seascape, a figure."

In many passages Mallarmé alerts us to the painter's voice, which
provides a rare opportunity to hear Manet discoursing on his art:

> Manet, when he casts away the cares of art and chats with a
> friend . . . in his studio, expresses himself with brilliancy. It is then
> that he says what he means by paintings . . . how he paints as he
> does.
> Each time he begins a picture, says he, he plunges headlong into
> it, and feels like a man who knows that his surest plan to swim
> safely is, dangerous as it may seem, to throw himself into the
> water . . . no one should paint a landscape and a figure by the same
> process, with the same knowledge, or in the same fashion; nor what
> is more, even two landscapes or two figures. Each work should be a
> new creation of the mind.[6]

Even if the hand retains a technical memory, the eye must forget what
it has seen before and approach the task as if for the first time. The
artist should set aside personal feelings and individual tastes for the
duration of the picture. It is, of course, one thing to say and another

to do. In his portrait of Desboutin, as in those of Berthe Morisot and Mallarmé, Manet's personal feelings are what make the paintings so vital and so captivating.

In September 1875 Manet was in high spirits about his two new paintings. He was quite convinced that *The Artist* and *Washing* would at last give him his due in the next Salon. In the meantime he was making plans to go to Venice with James Tissot, who had promised to send him a buyer. In a letter to Mallarmé, Manet said that the trip depended on a sale to Tissot's collector. Despite his English given name, Tissot was born in Nantes in 1836 and christened Jacques-Joseph. Because of his association with the Commune he had to leave Paris in 1871, settled in London, and quickly became very successful, turning out modern subjects and portraits of fashionable people with a retro polish that Ruskin condemned as "mere coloured photographs of vulgar society." Before he became an expatriate, Tissot had been in close contact with Manet, Degas, and Alfred Stevens, so that when Berthe and Eugène Manet went to London in the summer of 1875, he received them like old friends. Berthe wrote her mother that Tissot was "installed like a prince," commanding high prices for paintings she liked ("I paid him many compliments, and he truly deserves them"). She found him very kind and very friendly, "but a bit common." Berthe seems to have been a bit of a snob, since she had the same objection to Astruc and others. Her extreme refinement left one visitor with a reputation for social grace feeling in her presence like "a country bumpkin and a brute."[7]

Berthe's letters from England, reticent and edited though they are, reveal a good deal about the first months of her life as Mme Eugène Manet. In June, before her departure, Edma, her confidante and soul mate, complained, "You give me the impression of distinctly breaking away from me . . . [editor's ellipsis]. I would very much like to know how you are, what you are doing, and not as though we lived a hundred leagues from one another." Did Berthe prefer silence to revealing her discontent? Edma knew her too well; Berthe could not lie to her. Whether out of pride or the wish not to distress her, Berthe neither wrote nor visited Edma, not even when Edma was in Paris and Berthe was in Gennevilliers. Once across the Channel, Berthe urged Edma to join her, discreetly confessing her loneliness: "Cowes is very pretty, but not much fun; furthermore, I still feel the absence of our family

ways [puis, les habitudes de famille manquent toujours]. Eugène is more taciturn than I am."

The Morisot family had the habit of engaging in voluble exchanges on every subject, continued on paper when they were separated. The silence of life with Eugène must have been disturbing indeed. In London Berthe had some French acquaintances, but in the English countryside, reduced to virtual muteness by her limited English ("I speak horribly and Eugène even more so") and by Eugène's taciturnity, she was discovering that married life was less companionable than life with her family. When her hat was blown away by the wind, "Eugène was immediately in a bad temper as he always is when my hair is in disorder." Eugène still had no job and was making no effort to find one, nor did he concern himself with making contacts in England after pestering Berthe to get letters of introduction: "What is curious is that Eugène, who asked me a hundred times to write to the duchess, no longer wishes to use her letters now that I have them in hand; he would spend his life in a boat on the Thames without thinking of a thing."

She also was disappointed that pregnancy had not resulted from those first months of marriage: "I am horribly sad this evening, tired, nervous, out of sorts, having had yet again the proof that the joys of motherhood are not for me ... there are days when I am ready to complain bitterly about the injustice of fate." Had motherhood been her underlying reason for marrying? Or was it the only justification for spending her life with a man who fell short of her needs? However natural it might be to want children, would she have lamented "the injustice of fate" so early in the marriage if she were living with a man she loved? She had no sooner returned from England in early September than she left Eugène in Paris and went to visit her sisters.

By then Tissot's collector friend seems to have appeared and made a significant purchase, for on October 2 Manet left with Suzanne for Venice, where they spent the better part of two months. Tissot went with them and bought one of two shimmering views of the Grand Canal that Manet painted during his stay. Some critics have found the price he paid, 2,500 francs, rather high for a prix d'ami, but for Tissot, who made 300,000 francs in a single sale, as Morisot wrote her mother, 2,500 was hardly an extravagance. Faure had been paying 5,000 and 6,000 for paintings he bought, and so had Durand-Ruel. The two Venetian canvases are the only pictorial record of Manet's

stay, but a written record has remained thanks to the notes and memories of another painter, Charles Toché, who was a student at the Ecole des Beaux-Arts at the same time as Degas. He came one day to the famous Café Florian, on the Piazza San Marco, where tourists and well-to-do Venetians had been savoring ices and pastries for more than a century surrounded by rococo decorations. A man and his wife sat down beside him. Although they had not met before, Toché recognized the man when he picked up the lady's parasol and handed it to her. Thanking him, Manet said, "I can see you are French. My god, how bored I am here!" They began seeing each other every day, and for once, we hear Manet on private matters. Toché relates that in Suzanne's presence Manet did not hesitate to tease her about her family, particularly her father, whom Manet considered "the perfect example of the Dutch burgher, surly, grumbling, stingy, and incapable of understanding an artist."[8]

In Venice Manet spent much of his time thinking about paintings, planning pictures, and explicating his method to Toché, who took detailed notes of the master's words. "Manet, who was regarded as a wild innovator at the Ecole des Beaux Arts, composed his subject according to rules so classic that Poussin would have been enchanted to hear him." If Toché is reliable (in one case his memory verifiably failed him: he placed Manet's proposal to decorate the new Hôtel de Ville before his trip to Venice, or four years before the fact), Manet found Veronese "cold," Tiepolo "tiresome," but all of Titian and Tintoretto's Scuola San Rocco "higher than anything else," except for Velázquez and Goya. What he could not tolerate were the allegorical scenes drawn from Ariosto's epics. "A painter can say it all with fruits or flowers, or even clouds alone. . . . I would like to be the Saint Francis of the still life [funnier and clearly a pun in French: *le saint François de la nature morte]."*

Watching Manet work, Toché was surprised at how long it took him to achieve the effects he desired; Toché, like everyone else, had been convinced that Manet's paintings were set down once and for all from the first brushstroke. *The Grand Canal* was done over more times than Toché could remember, the gondola and gondolier having been particularly trying. "It's a devil of a job," Manet had explained, "to render the feeling that a hat sits solidly on the model's head, or that a boat was built of planks cut and fit according to geometric principles." Most fascinating in Toché's recollections are the verbatim

notes he took of Manet's comments while they were watching a re-gatta at Mestre. Manet's words paint the picture he thought of doing. There are nine entries, but a sampling will give an idea of what he saw and how he would have translated the image onto a canvas.

I. Faced with a scene like this, so fascinating and so complex, I must first of all select the characterizing episode, and delimit my picture as if I saw it already framed. In this instance, the most out-standing features are the masts strung with multicolored pennants, the green, white and red flag of Italy, the dark waving line of boats overloaded with spectators, and the black and white arrow of gon-dolas moving away from the horizon, then in the upper part of the picture, the horizon line, the finish line, and the airy islands.

III. The lagoon, mirroring the sky, is the forecourt of the boats, with their passengers, masts, pennants, etc. It has its own color, nu-ances of tone borrowed from the sky, the clouds, the crowd and the objects reflected in it. Don't talk to me about precise contours or straight lines in something that moves, but of values which, when accurately observed, constitute the true volume, the unquestionable outline.

IV. The gondolas, the various boats with their generally dark col-ors and reflections, represent the base on which I will place my fore-court of water.

VI. The crowd, the rowers, the flags, the masts, will be executed in a mosaic of colored tones. Every effort will be made to render the instantaneity of gestures, the flapping of the flags, the rocking of the boats.

This painting, if he did it, is unknown, but the two that are known capture the light and color of Venice's great waterway — the dappled light, the pink stone, the blue above and below, the bobbing blue-and-white-striped mooring posts — not the precise, immobilized image of a painting or tinted photograph, but more like a dream image in which one not only sees but feels the movement of the water, the clear light and bracing air.

A month before the Salon of 1876 opened, the "Manet question" exploded in print. His two submissions, *Washing* and *The Artist*, were both resoundingly rejected by the jury. On April 2 Manet was offi-

cially notified. On April 5, 6, and 7 Parisians could read in the newspaper of their choice the "Story of the Jury and Manet," as announced by most headlines. Both paintings, in the words of one journalist, "were blackballed *[blackboulés]* without a word of protest." This was the jury that accepted Victorine Meurent's self-portrait. Two out of fifteen jurors, however, refused to join the otherwise unanimous opinion. Léon Bonnat and Jean-Jacques Henner, both longtime Salon jurors and academic painters, sided with Manet. It was this Bonnat to whom Manet referred when he failed to do a portrait of Gambetta because the model was unavailable for Manet's requisite sittings and because Gambetta's taste in art leaned in a more conventional direction: "Here is another one who is destined for Bonnat," Manet remarked ironically to Proust. He assumed that Gambetta would eventually sit for Bonnat, who would produce the kind of stiff, slick, academic portrait typical of famous people, painted from a few hasty sketches in one or two sittings.

During that first week of April, Parisians could once again discuss the latest disgrace of this unregenerate radical. However many humiliations he had already suffered, he was still vulnerable to the pain of rejection, and perhaps even more so now that he was a major celebrity. The rejecting juries, the damning critics, and the cartoonists had only contributed over the years to his fame; he was recognized wherever he went. But this time Manet's rejected paintings would not be stored in his studio until some providential buyer appeared on the scene. This time he would show them to all of Paris. He obtained permission from the prefecture of police to hold a show in his studio, then sent out cards with the heading *"Faire Vrai, Laisser Dire"* (Do what's true, let them talk). M. Edouard Manet invited the recipient "to do him the honor of coming to see the paintings rejected by the jury of 1876 which will be shown in his studio from April 15 to May 1, from ten until five, 4, rue Saint-Pétersbourg." After the opening day, anyone could enter without an invitation, and hordes of gawkers filed in, more curious about the painter and his studio than about his paintings.

One writer called it "Le Salon d'un Refusé," playing on the historic Salon des Refusés of a decade before. Hundreds trooped in every day, leaving their comments on sheets Manet had prepared for that purpose. Many were the equivalent of subway graffiti, some cleverly encouraging, *"Verba volant, pictura Manet"* (Words fly, painting re-

mains), some not, *"Manet non manebit"* (Manet will not remain). This last is particularly cutting, since it puns on the motto *Manet et manebit* that Manet's publisher friend Poulet-Malassis had devised for him two years earlier.

At the end of two weeks more than four thousand people had seen the paintings, and many more than not thought well of them. Every newspaper sent a reporter, and even in the provinces local papers carried articles about the event. Before the end of April a notice appeared in one Parisian paper informing readers, "M. Manet's experiment has introduced a new statute in the concierge's code. Where formerly, prospective tenants were asked if they had animals, children or noisy occupations, now they will be asked, 'Does Monsieur hold private exhibitions?'"[9] Manet's landlord did in fact refuse to renew his lease because other tenants complained about the commotion caused by his exhibition.

The journalistic feeding frenzy began anew. Many writers bared their teeth and snapped viciously. A rare neutral observer opined that "one can like or not like M. Manet's painting, but he has enough notoriety today to have his pictures among the 3,000 that are hung annually in the Palais de l'Industrie [the site of the Salon]. The jury's excommunication can only harm the judges." Albert Wolff, whose view Manet apparently solicited, obliged with a fairy tale:

> . . . we went to see his two canvases and since M. Manet wants our opinion, here it is. He has the eye of a painter but none of his soul. The good fairy who was present at his birth gave him the ability to catch a likeness on the fly, the superficial appearance of things. But then the wicked fairy immediately appeared and said, "Child! You will never go very far. By my power I deny you the qualities that distinguish a great painter. You will have no imagination!" . . . and that is why we have in Paris a handsome blue-eyed blond, a charming, spirited chap who will continue endlessly to rock his boulder, but will never push it to the top. For those of us who like M. Manet very much, the sight of *Washing* was a great sadness.

To this Manet replied with a note: "My dear Wolff, So be it, I have the eye of a painter and somebody else has the soul of one. The good will you always extend to me personally gives me some consolation." Privately he said to Proust, "That animal revolts me. He is said to be

witty. I don't doubt it. . . . It would really be something if he weren't since that's his stock-in-trade."

Wolff's dislike for modern painting was not limited to Manet. Two weeks before his review of Manet's Salon paintings, he published his opinion of the second impressionist show held at Durand-Ruel's gallery on the rue Le Peletier, the site of the old Opéra, which had burned down:

> Here is a new catastrophe that has befallen the neighborhood. . . . Five or six lunatics, among them a woman . . . are afflicted with the madness of ambition. . . . These so-called artists take canvases, paint and brushes, fling a few colors here and there and add a signature. . . . The woman in the group, Berthe Morisot by name, is worth noting. In her, feminine grace is preserved amid the excesses of a delirious mind. . . . Yesterday a man was arrested on rue Le Peletier for biting passersby after leaving this exhibition.

Manet's greatest compensation came from the irrepressible pleasure of one particular visitor. His neighbor and fellow painter, Alphonse Hirsch, whose garden was the setting for *Washing,* brought a friend to the studio. Manet was out of sight though not out of hearing when a female voice exclaimed, "But that's very good!" Rushing toward her he asked, "Who are you, Madame, to find good what everybody finds bad?" As Proust relates the scene, "Manet wept with joy." He then excitedly told the lady, "You see, that is the real truth. You feel the air around that woman and that child." Throughout the following week Manet was ecstatic about the visitor who had appreciated his maligned painting. "Our era has been calumnied. There are women who know, who see, who understand," he said. She was also a woman of uncommon beauty.

This woman was Méry Laurent, born Anne-Rose Louviot in Nancy in 1849. She came to Paris in her early teens, a lovely fresh-faced strawberry blonde with a perfect body (Fig. 54). Taking the stage name Marie Laurent, she started out as a scantily clad cabaret dancer, later graduating to the operetta stage. In 1867 she became the talk of Paris, playing Venus in *La Belle Hélène,* Offenbach's satiric retelling of the Homeric myth of Helen of Troy. She appeared in a gauzy chiton over some kind of flesh-colored bodysuit that revealed every curve and crevice and drove male spectators to near cardiac ar-

rest. In the audience one night was an American resident of Paris, Thomas Evans, dentist to Napoleon III and a well-known society figure. Marie Laurent was barely seventeen at the time, but Evans offered her a munificent income, an apartment, and his company. He took her everywhere. His Anglicized pronunciation of her name is said to account for its ultimate phonetic spelling.

Her natural charm and taste soon attracted a coterie of eminent men in all the arts — Verlaine, Maupassant, Huysmans, Whistler, Chabrier — many of them friends of Manet's, who gathered in her apartment, a stone's throw from Manet's, and later in a house she had built. Méry Laurent was the model for the first part of Zola's *Nana*. He borrowed Méry's sculptured derriere in the role of Venus for the identical role that launched Nana on her career as the richest courtesan in Paris. In later years Méry's tales of her youth to Marcel Proust led him to endow his unforgettable character Odette Swann with many of her traits. Her relations with Mallarmé and Manet have been shrouded for the most part by an inappropriate fig leaf, considering the *vie galante* she led. But then Mallarmé was a married man, a father, a teacher of lycée students, all of which ran counter to publicized relationships with courtesans. Méry was nevertheless the light of his life and the inspiration of verse that was dedicated to her.

As for Manet, in 1876 he was not only a public figure but also was being cited as a model of bourgeois propriety by critics who wanted to help him and did not think his paintings alone were persuasive enough to rally public support. The studio showing was a stroke of genius, an example of marketing before the practice or the term was current. A rash of personal interviews appeared in the newspapers describing Manet's apartment, studio, appearance, and manners. "M. Manet belongs to the race of proper revolutionaries, well-mannered men of the world who wash their face and are repelled by unkempt beards or muddy shoes . . . he wears gloves and lives in a house where the concierge would make the model for *Bon Bock* take the servants' staircase."[10]

All of Paris now knew that Manet lived in enviable comfort at home, and for those who had not managed to see his studio for themselves, the articles contained detailed descriptions. On the mantelpiece stood Oriental vases and a plaster Minerva with a stuffed crow on her helmet — the model for his illustrations the year before for Mallarmé's prose translation of Poe's "The Raven." On the piano in

one corner lay assorted books, a score of *Fidelio*, literary journals, and *Gil Blas*, the great picaresque novel that had inspired his *Students of Salamanca* in 1859. Elsewhere were a water pipe (seen in *Young Woman in Oriental Costume*) and a Japanese screen with cranes (the background for *Woman with Fans, Nana,* and the portrait of Mallarmé). Along the walls were garden chairs, a couch, and a marble-top café table, the whole lighted by four large windows.

To an interviewer who was received in his apartment, a few buildings from his studio on the opposite side of the street, he said, "Look at me, I'm not one of those long-haired types, I'm a bourgeois — like you — like everybody else. I don't look like an artist, do I? Artists, you know, are no longer recognizable by their hair . . . otherwise what would those of us do who no longer have any?" The interviewer then described Manet's work day, which began early, with a slice of buttered bread and a glass of vintage wine, and was interrupted by his servant, who had to keep reminding him that he was expected for lunch. At home his wife, "a distinguished musician," awaited him, "rocking his reveries with her melodies." And this, in sum, was the "simple, honest, hardworking life of the person who is represented as a revolutionary in art."[11]

This image, if not outrightly dictated by Manet, was surely the one he wanted to project. He had long before decided that his persona was that of a decorous, debonair bourgeois, and he counted on friends to keep that image polished after his death. Unlike some of his more flamboyant contemporaries, whose amorous exploits only enhanced their artistic aura, Manet guarded his privacy against any mention of improper relationships or improper ladies. Even Tabarant, who published his biography in 1947, spoke of Méry Laurent as Mallarmé's "*amie*," his mistress (*"l'amie de Mallarmé"* is the syntax used. Had he meant just a friend, he would have written *une amie de Mallarmé*). Nor did he say that Manet had preceded Mallarmé, as is likely. Antonin Proust introduced her in his memoirs as "Mme Méry Laurent," whose "education was as complete as was received by young girls at that time" and whose salon glittered with celebrities. One would never guess from his description that Berthe Morisot would not have set foot in that salon or that the only women who did were other courtesans or bohemians.

The salons of actresses, operatic divas, and *grandes courtisanes* were held to be immeasurably more brilliant than those of "re-

spectable" ladies. The women were entertaining, enticing, and often available; the men, a fascinating mix of aristocrats, artists, and politicians; the atmosphere enlivened by champagne, the delicacies of the best caterers, flirtation, and rivalry. The salon of a rich bourgeois might have been lavish, and that of a celebrated writer might have been intellectually stimulating, but a courtesan's salon provided excitement as well as opulence, with which few others could compete. It is to Méry Laurent's credit that her salon was so appreciated by men who had access to many others, for it was not the opulence or libertinism of her soirees that attracted them. She lived quite well, but not at all in the style of a Païva or a Cora Pearl, who were kept by men of immense fortunes. Her income of at least 100,000 francs — half of it from Dr. Evans, the other from another lover, augmented by gifts from others — was secure and her style more bourgeois than demimondain.

From Méry's first meeting with Manet she gained a permanent place in his life. They may have had a brief fling that ripened into an uncomplicated, utterly devoted friendship, or they may have remained occasional lovers until Manet's health gave out. Painter Jacques-Emile Blanche, whose memories date from the last years of Manet's life, also identifies her as *"l'amie de Mallarmé,"* as well as of Henry Dupray, a history painter, and "a daily visitor to Manet's studio at the hour when friends came to chat and laugh."[12] Judging from what remains of Manet's correspondence, she was the only woman besides his wife and his mother whom he addressed with the informal *tu.* Perhaps even more telling, he gave her the oil sketch of Maximilian (now in Copenhagen's Glyptotek), which says a lot about his respect for her intelligence and her taste, since *The Execution of Maximilian* was among the two or three paintings he valued most highly of his entire production.

They also saw each other at times when Evans was not to know and would not have approved. George Moore, who became acquainted with Manet in 1875, relates an episode he must have heard from one of the parties, but probably not from Evans. Méry, as was customary, received Evans early in the evening. Then pleading a headache, she asked him to leave so that she could retire. He obliged but discovered shortly after that he had left his appointment book. Returning to get it, he met Méry in a ball gown descending the stairs on Manet's arm. Their clandestine meeting must have been planned

in advance, for as soon as the good dentist was out the door Méry signaled Manet. They evidently had in mind more than some gala public event, for in that case Evans could have joined them. Moore writes that Evans sulked for three days, but "his anger mattered little to Méry" since she could do without him and he knew it. Her little tryst with Manet — the only one Evans discovered — seems not to have affected relations between the rivals, for Manet later talked glowingly about him to Proust, and about his generosity toward the Manet family.

Evans was not only an excellent dentist, at a time when the field was in its infancy; he also had some original ideas about urban planning. It was he who proposed to Napoleon III the design for the broad avenue in the Bois de Boulogne that became a forum of gallantry that lasted into the twentieth century. Ladies of society and their husbands' mistresses paraded in their carriages, gathering gossip, while gentlemen surveying the scene from their horses sought out new challenges. A relatively new phenomenon was the *amazone*, the woman rider mounted sidesaddle; horseback riding became very fashionable among courtesans during the Second Empire. In his novel *Nana*, which chronicles the period, Zola explains that "ever since Lucy [patterned after Cora Pearl, one of the great courtesans of the time] went out on horseback in the Bois, which launched her, all of them were seized by a madness to ride."[13] Evans projected an avenue wide enough to accommodate carriages in one lane, riders in another, and pedestrians in a third, the whole flanked on either side by grassy banks, which the emperor then gratefully named Avenue Thomas W. Evans. "Ah," Manet concluded, "that democracy of the United States is amazing! It produces men who not only have the qualities of our old French culture, but who have an instinct for what is modern. They have a feel for it. . . . Where the devil did they get it? . . . In the future they will stagger the Old World."[14]

Manet's personal experience of the New World, through the intervention of an opera singer, turned out to be disappointing. Emilie Ambre, of middling talent but stellar charms, attracted one night the most illustrious member of her audience at the opera house in The Hague — the king himself. He showered her with wealth, a title (comtesse d'Amboise), and the promise of marriage if she left the stage. That, at least, was her version of the story. The marriage did not take place. In the spring of 1878 she was seen in Paris as Violetta

in *La Traviata* and again in *Aida,* but was found wanting by the critics.

Hoping to find less jaded audiences, she decided to go to America with *Carmen* and asked Manet, whom she had met during the summer of that year, to paint her in that role, although she had not sung the lead in Paris. She also proposed taking with her *The Execution of Maximilian,* which had been languishing in Manet's studio since its proscription in 1867. It was shown in New York in December 1876 and again in Boston in January 1880, but it was publicized more as a freak show than a work of art. The poster in New York read: JUST OPEN! EXHIBITION OF THE GREAT PAINTING OF THE CELEBRATED FRENCH ARTIST E. MANET, "THE EXECUTION OF MAXIMILIAN," 25 CENTS. Neither the New York critics nor the public showed much interest. In Boston there was somewhat more of a response: the critic of the *Sunday Herald* declared the work to be of "real interest" both for its historical subject and for its "own eccentricity," since Manet "is considered an extreme impressionist, and certainly this painting seems to justify such a reputation."[15] The cost of advertising exceeded the receipts.

The painting returned to Manet's studio, unhailed, unsold, and virtually unseen during Manet's lifetime. The only public mention it received in Paris was in an article about Manet's studio. Seeing a canvas turned to the wall, the writer asked what it was. "Ah yes," replied Manet, "that really intrigues many visitors — it is an unfinished painting of *The Execution of Maximilian.* I will unveil it in due time."[16] This was an interesting subterfuge, since the painting in its definitive version had been finished for almost a decade.

One of the more original individuals who entered Manet's orbit a year or two before the studio show of 1876 was the multitalented George Moore, known as the "Parisian Englishman," though in fact he was Irish (Fig. 61). Born in 1852, the same year as Léon, Moore came to Paris at the age of twenty-one to study painting with Cabanel at the Ecole des Beaux-Arts. He learned enough about art to become an informed critic but later devoted himself to the verbal arts, publishing his first novel in 1883. His seven-year residence in Paris marked his sensibilities for life. During those years he came to know many of the great figures of that period and prided himself on having been a member of the Batignolles group *honoris causa:* "I went neither to Oxford nor to Cambridge, but I did go to the Nouvelle-

Athènes." As he relates it, "it was a great event when Manet spoke to me in the café of the Nouvelle-Athènes. I knew it was Manet, he had been pointed out to me, and I had admired the finely-cut face from whose prominent chin a closely cut blonde beard came forward; and the aquiline nose, the clear grey eyes, the decisive voice, the remarkable comeliness of the well-knit figure."

The next day he paid a visit to Manet's studio and was asked to pose, "being a fresh-complexioned, fair-haired young man, the type most suitable to Manet's palette." Moore was astounded to see Manet scrape off the paint used for his hair and start again with the same color. "You can't paint yellow ochre on yellow ochre without getting it dirty," Moore protested. But Manet blithely continued, assuring Moore that there was no need to start afresh on another canvas, and each time "it came out brighter and fresher." [17]

Manet destroyed that portrait, but three others remain — one unfinished, showing Moore seated at the café table in Manet's studio. (There is another rough sketch, presumed to be outside the studio.) Moore explains that since they had met in a café, Manet's first thought had been to portray him in that surrounding. The café setting is no more than a sketch in oils, but when it is compared with the finished portrait, one can see that Manet instantly captured Moore's head, topped with a bowler, as he leans on the marble table. His blond hair and beard are indicated by the light strokes of burnt sienna, the hat and jacket are outlined in black, and the skin tones lightly fill in the hands. The portrait Moore chose for the frontispiece of his *Modern Painting* is the pastel Manet did of the finished oil portrait in which Moore is seen bareheaded, his arm hooked over the back of a chair. In both, the personality is so vivid, so individual that one expects to hear him speak. The cut of his jacket and the tie (rendered with a few loose strokes of pale blue and taupe) confirm the title "Batignolles Dandy," applied by benign scoffers. Another less flattering title was "Drowning Victim Fished Out of the Water."

Manet said that for the final portrait he caught Moore in one sitting:

It was right for me, but not for Moore. He pestered me, asking for a change here, a modification there. I will not change a thing in that portrait. Is it my fault if Moore looks like a broken egg yolk and if his mug isn't straight? That is true for all our mugs, and the plague

of today is the search for symmetry. There is no symmetry in nature. One eye is never the exact match of the other, it's always different. We all have a nose that is more or less crooked, a mouth that's always irregular. But go explain that to geometricians.[18]

Moore may have wanted his portrait touched up to satisfy his vanity, but that did not affect his admiration for the painter. His pages on Manet are among the most acute perceptions ever written. His biographical data are all wrong, but most of his commentary on the paintings is sound. One may quarrel with a number of his generalizations — he had many biases — but what he says about Bon Bock and Washing is undebatable.

> The Bon Bock . . . at once challenges comparison with Hals. But in Le Linge [Washing], no challenge is sent forth to anyone; it is Manet, all Manet, and nothing but Manet. . . . Beside this picture of such bright and happy aspect, the most perfect example of that genre known as la peinture claire [plein air is the more common term, referring to natural light] invented by Manet, and so infamously and absurdly practised by subsequent imitators — beside this picture so limpid, so fresh . . . a Courbet would seem heavy and dull . . . a Corot would seem ephemeral and cursive; a Whistler would seem thin; beside this picture of such elegant and noble vision, a Stevens would certainly seem odiously common.

Manet's last style, dating from Argenteuil, with its violet shadows and loose brushstrokes, was "the germ from which have sprung a dozen different schools, all the impressionism and other isms of modern French art."[19]

By the time Moore wrote these words, Manet had been dead fifteen years. Moore could look back and remember how many art students, in addition to art critics, had thought that Manet's paintings were a joke or intended to shock: "To understand Manet's genius, the nineteenth century would have required ten years more than usual, for in Manet there is nothing but good painting, and there is nothing that the nineteenth century dislikes as much as good painting. . . . Death alone could accomplish the miracle of opening the public's eyes to his merits." Moore nevertheless sold him short, for while he finally recognized in 1906 that "Manet's art was all Manet;

one cannot think of Manet's painting without thinking of the man himself,"[20] in 1898 he said, "Manet was born a painter ... so absolutely that a very high and lucid intelligence never for a moment came between him and the desire to put anything into his picture except good painting."[21] Only in *Olympia* (she "does not lie on a modern bed but on the couch of all time") did Moore see "a symbolic intention," after which "Manet's eyes were closed to all but the visible world. The visible world of Paris he saw henceforth — truly, frankly, fearlessly, and more beautifully than any of his contemporaries. Never before was a great man's mind so strictly limited to the range of what his eyes saw."[22] Moore had fallen into Zola's realist/formalist camp in the early 1880s when he began writing his first novels and in 1898 was as insensitive as Zola to Manet's deeper qualities.

If nothing else, the publicity surrounding Manet's studio exhibition of 1876 established him in the public eye as a respectable figure who, at worst, was eccentric in his painting but perhaps had been wronged by the jury. The extensive coverage in the press of "Monsieur Manet," as he was deferentially titled, at work and at leisure, in his studio and in his home, provided convincing evidence of a man of distinction. Two profiles in two different papers, published at an interval of five days, pointed out the two sides of this interesting individual. For one writer Manet was "paradox incarnate." Some of his paintings had led people to believe that he was alien to ideas. On the contrary, this writer declared, he knew no man in Paris more intelligent or more courteous. "He has travelled and remembers without pedantry, he has read and cites appropriate quotations."[23] The other writer wrote, "Two beings seem to compose his personality: the artist whose life is entirely spent in his studio, rue Saint-Pétersbourg, 4; the man of society — the sedate bourgeois, living with his family at number 49 on the same street."[24]

The proximity of his home and studio seems to symbolize the contiguous yet separate lives of this man. Manet never strayed very far, nor were his two sides very far apart, yet the twain did not meet. Neither his wife nor his mother came unannounced to his studio. Apart from the work he did there, he also received friends, some of whom he would not have considered introducing to his mother. The demimondaines for whom he had a weakness, and whom he rendered with such obvious pleasure, were frequent visitors to his studio, not to his home. And close friends, such as Antonin Proust and Stéphane

Mallarmé, came to his studio for long, intense conversations that would have been impossible at his dining table, although both also were frequent dinner guests.

Of the demimondaines who passed through his studio, a number have been immortalized on canvas. Méry Laurent obligingly posed in the nude for *In the Tub* (1878, Fig. 55) and possibly for related bath scenes done at the same time; in some of her high-fashion outfits (*Autumn* and *Woman in Furs*); and in a series of hats for seven pastel portraits (1882, Fig. 56). She was not at all reticent about her nudity on canvas, for she evidently talked about it to a later lover, Henri de Régnier, who made it a point of pride in a poem titled "Edouard Manet," which was dedicated to "a lady who knew Manet." In the poem he talks about the nude bather whom Manet painted long ago (*"la baigneuse nue / Qu'avait pente jadis Manet"*); describes the fabric in the room, the sponge she holds, and the water dripping into the round tub in which she stands — in other words, the painting *In the Tub*; and further identifies the model by mentioning two portraits that carry her name in the title.

Another lovely lady unacceptable in "polite society" was Ellen Andrée, a professional model before becoming an actress, who posed for *La Parisienne*, *In the Café*, and possibly *The Plum*. In the café scene she is seated at a table beside Henri Guérard, who married Eva Gonzales. Long after, when asked about her experience as a model, she said, "I was pretty good, I can say so now; I had a look that the impressionists considered very modern, sexy, and I held the pose they wanted." It is her splendid body that lies sprawling on the rumpled sheets of Henri Gervex's notorious painting *Rolla,* but she would not let him use her face. Her interviewer commented that she had appeared in some of the masterpieces of Manet, Degas, and Renoir. "So-called masterpieces," she corrected. "Degas only liked what was ugly." She recalled posing for the now famous café scene by Degas, *Absinthe,* in which she had a glass of the condemned yellow alcohol in front of her while Desboutin (Manet's model for *The Artist*) had "some innocent beverage; the roles completely reversed; and we look like a pair of morons." On the subject of Manet she said, "Of all those painters, he was the only one I looked up to. I remember noticing he painted standing up, whereas his friends all sat. He was engrossed, courteous, distant. He was so high class! I felt so inferior in that studio on the rue d'Amsterdam. A really exceptional man."[25]

The most important and most sensational painting of a demi-mondaine in Manet's works was *Nana* (Fig. 62), for which Henriette Hauser posed in 1876. Nana is quite different from Olympia, who was seen as a prostitute and for whom a professional model posed. Hauser was an actress and the mistress of the prince of Orange, heir to the throne of the Netherlands and the son of William III, Emilie Ambre's besotted monarch, mentioned earlier. Like father, like son. The prince, better known among the boulevard crowd as "prince Citron," the "lemon prince" (his title was prince d'Orange), made a vocation of Parisian pleasures and died in June 1879, ending the male line of the house of Orange. Hauser's celebrity went back to the 1860s, when she received the homage of Alexandre Dumas fils in print (he used her as the model for Mme Santis, a character in his novel *Le Demi-Monde*) and of Charles Marchal in paint (he portrayed her in *Phryné*, a work very much admired in the Salon of 1868). Manet may have met her in Nina de Callias's circle, and perhaps even earlier, since she was well-known in the café society of the boulevard des Italiens and the opera balls, which he frequented as well. As an actress she had the charm and grace for soubrette roles and was described as having a Regency face and the body of Venus.

In the autumn of 1876 she began posing for the painting that would be known as *Nana*, which can be regarded as a pendant to *Olympia* — as Goya's *Clothed Maja* is to his *Naked Maja* — although two different models represent the two different periods. Olympia is a classic figure with a modern face in a late romantic setting, whereas Nana is as up-to-date as a fashion photograph. Seen applying makeup in front of a mirror, wearing a pale blue corset over her ruffled white petticoat, embroidered silk hose, and high-heeled pumps, she is no Venus in a modern idiom; she is an entirely new manifestation of feminine beauty. The perfect nudity of ancient statues was now as cold as their marble. What kindled the senses was a partially dressed woman, and nothing was more exciting than underwear. Manet made the distinction himself: "The satin corset may be the nude of our era." Hauser appears to have posed as well for *In Front of the Mirror,* which seems to be a preparatory oil sketch for *Nana* and may have been the subject Manet had in mind: a woman at her toilette, the invasion of a woman's private space — her bath, her dressing table — and a tantalizing crossover from tart to bourgeoise. The model is seen from the back in the same corset and with the same

haircomb; only the mirror is different. The standing mirror in *Nana*, known in French as a *psyché*, actually belonged to Manet and was part of his studio furnishings.

Many inconclusive pages have been written on the relationship between Manet's painting and Zola's celebrated heroine. However, Zola's plan for *Nana* was not completed until August 9, 1878, and only the first part of the novel was written when it was first serialized in October 1879. A widely held supposition has been that Zola's earlier novel, *L'Assommoir*, was the inspiration for Manet's painting. In that novel, which began appearing in serialized form in April 1876, we do not meet the daughter of Gervaise, named Anna and nicknamed Nana, until the end of the book. In Chapter 11 (out of 13) she is only fifteen, and at the end of the chapter, her last appearance in the novel, she is less than a year older. She is described in the chapter's opening paragraph: "At fifteen, she had grown like a calf, whitefleshed, plump, as soft and round as a ball of yarn. Yes indeed, fifteen, all her teeth and no corset. . . . Her pile of blond hair, the color of fresh oats, seemed to have thrown gold dust on her temples."[26] She is still a far cry from the seductively corseted figure of Manet's painting. By the time Chapter 11 of the serialized book appeared, in November 1876, Manet was well advanced in his painting. In addition, his Nana has distinctly red hair and is no adolescent. There is proof that Manet read the novel as it appeared. In the late summer of 1876, in a postscript to a letter, he wrote to Zola, "I have just read the latest installment of *L'Assommoir* in *La République des Lettres* — marvelous!"[27]

Manet did not complete his painting until the early months of 1877. The top-hatted gentleman at the edge of the canvas was not inserted until January, when the model began posing. It is, therefore, possible that when he began thinking about a title, he remembered the character in Zola's book and, perhaps with Zola's encouragement, gave his coquette the same name. By the spring of 1877, when Manet submitted his painting to the Salon jury, he knew that many Parisians had only recently finished reading the last installment of *L'Assommoir* and would not have forgotten the daughter of the laundress Gervaise and her alcoholic husband, Coupeau. Even though she was a minor character, Nana was memorably drawn as the kicked and beaten child of unexemplary parents who held her to rigorous moral standards that she could not accept. For her the only means of escape from their abject misery and cruelty was her healthy

young body, which Zola describes as "dipped in milk, the velvety skin of a peach." She represents an entire class of girls born into urban poverty, whose only hope of a future safe from drunken, abusive husbands was prostitution, low or high. In *L'Assommoir* Zola paints the darkest side of that life and of the kind of death that life led to. Before losing sight of Nana, the reader is left with the impression that she might fare better than her parents. She is reported at the end of Chapter 11 as having been seen dressed to the nines and riding in a carriage.

It is equally possible that the title of Manet's painting was purely coincidental with Zola's character, since Nana, Nina, Nanette, and Ninon were all very common names among women of Nana's calling. Manet's Nana reflects none of Zola's in *L'Assommoir*. Manet's is the kind of woman he knew personally — well-kept, well-groomed, well-read, a *grande cocotte*, not a streetwalker. We are not given any clues about her previous life; we see her only in her prosperity. While accepting the protection of the older man who provides the comfort that surrounds her, she is indifferent to him. She does not even glance in his direction. He is useful, but there are others like him; he is only marginal. It is she who occupies the center of her life, as she does the center of the painting, for as long as she has her youthful beauty, she can manage.

Huysmans associated the subject of the painting with Zola's earlier novel — "Nana, the Nana of *l'Assommoir* is powdering herself" — and then added the significant remark that places the novel *Nana* in the future: "Manet was absolutely right to present in his Nana one of the most perfect examples of the type of girl that his friend and our esteemed master Emile Zola will depict for us in one of his future novels. Manet has made him see her as she necessarily will be with her complex and sophisticated vice, her extravagance and her luxury born of debauchery."[28]

The kinship between Zola's later eponymous novel and Manet's painting is both more apparent and more interesting than has been claimed. In that novel Nana is a composite of a number of models, among them Manet's models and friends, beginning with Méry Laurent, whose performance in *La Belle Hélène* as the nearly nude Venus created such a sensation. Zola's Nana, in a similar costume, plays the same role in an operetta titled *La Blonde Vénus*, a spoof of royalty and the army that has the ring of Offenbach's *La Belle Hélène*. Nana's

ascension into the aristocracy of courtesans is borrowed from more than one true story. One of those models was Louise Valtesse, the comtesse de la Bigne, who married a title and whom Manet portrayed in a lovely pastel that defies the viewer to suspect she was ever anything but a highborn lady.

Where Zola and Manet differ widely is in their attitudes toward the figure of Nana. Zola's is moralistic and judgmental, attributing the downfall of young girls to poverty, the hypocrisy of society, and the insatiable sexual hunger of men. "It's not fair! Society is badly organized," Nana protests toward the end of the novel. "They blame women, when it's the men who make demands. . . . I can tell you now, when I went with them, well, it gave me no pleasure, none at all. It bored me, I swear! And so I ask you, how am I responsible?"[29] Zola did not, however, exonerate women entirely, for he also saw in these *noceuses,* these "party girls," an innate taste for physical and material pleasures.

Manet's Nana carries none of this sociological weight. Unlike the fictional heroine, who is besmirched by "the mud of her origins," Manet's figure is portrayed with humor and delight; he did not judge her. Her top-hatted *entreteneur* is viewed with amusement, but between Manet and his model there is a kind of respectful understanding. He was neither puritanical nor cynical; he had no illusions; he painted what he saw. And what Manet saw was an entire society based on the marketing of sex — that other half of society, the demimonde.

The telling difference between the two artists who portrayed a Nana is that Manet knew his subject and his model firsthand. Zola drew entirely from the experiences of his friends, describing his characters and their world with the prurient revulsion of a provincial and using them as a metaphor for the corruption of the Second Empire. Manet had no such agenda, and what is more, he spent long hours in the company of the women he portrayed. Méry Laurent, Ellen Andrée, Henriette Hauser, and Louise Valtesse were women who had made a life for themselves with their bodies and their wit. Manet seems to have regarded them with respectful admiration. We look at Manet's Nana and imagine her living to a ripe old age, telling stories about the famous men she knew in her youth. There is nothing "noxious" or "corrupting" — Zola's adjectives — about her. In contrast, Zola's Nana dies of smallpox — his euphemism for that other pox,

syphilis — her ravaged face described in ghoulish detail, like the last stage of Dorian Gray's portrait.

Following *Nana* Manet did a series of nudes and café scenes, painted with the bright palette of a man who loved the subjects he depicted and loved his work. He once told George Moore, "I also tried to write, but I did not succeed; I never could do anything but paint."[30] He made no mistake about his vocation. His vision embraced the full range of the spectrum; even black for him was a color. Nothing he painted was ever dirty or undignified — neither in tone nor in aspect. If he did not seek out the sordid, he did not ignore its existence. But he did not choose to pity or condemn. He painted equals at close range; he did not exploit them. And when he himself fell victim to disease, his palette remained sunlit, his canvases without self-pity or anger.

The same year that he finished *Nana*, Manet undertook the portrait of Jean-Baptiste Faure in the title role of Ambroise Thomas's opera based on *Hamlet*. Faure had been singing the role since the opera's premiere in 1868, having sung fifty-eight performances of it during that one season. Thomas is best remembered today for *Mignon*, but *Hamlet* was one of his great successes, and for Faure *Hamlet* was his greatest triumph. Verdi admired Faure so much (which was not the way Verdi felt about most French singers) that in 1865 he entrusted him with what is arguably the most magnificent baritone role ever written, that of the Marquis of Posa in the original Paris production of *Don Carlos*. Faure had the kind of celebrity most often reserved for tenors. And he was not only a brilliant performer; he was Manet's most important private client. Faure commissioned the portrait at the time of Manet's studio exhibition, but it was not begun until the following year.

Shortly before Manet began working on the portrait, Faure sang a performance of Thomas's *Hamlet* that produced rave reviews. Théodore de Banville praised his "miraculous interpretation" of the music and commented on his projection of the character of Hamlet, "terrified, broken, threatening, oscillating toward madness."[31] To judge from Faure's openmouthed stare and from the text of the play, it would seem that he or Manet decided to have him pose in the very scene so much admired by the reviewers — Act 1, Scene 4, when Hamlet meets his father's ghost on the castle ramparts: "Angels and ministers of grace defend us! . . . / Be thy intent wicked or charitable,

thou comest in such a questionable shape, / That I will speak to thee."
His unsheathed sword evokes his angry resistance to the solicitations
of Marcellus and Horatio, who would prevent him from following
the ghost: "Unhand me, gentlemen. / By heaven, I'll make a ghost of
him that lets me! / I say, away!" The position of the feet suggests
Hamlet's firm stance at the beginning of his dialogue with the ghost:
"Where wilt thou lead me? speak; I'll go no further."

Examined in the context of the action, Manet succeeded in bring-
ing together an entire scene, from the head with its highlighted aston-
ished eyes; to the hands, the left outstretched in arrested movement,
the sword hand lowered; to the feet firmly planted. But Faure did not
see it that way. He had come to the studio for more than twenty sit-
tings and then had to leave for an engagement. On his return, as he
related, "I found the portrait entirely changed, with unnatural glitter-
ing blues, and with legs that were not mine. 'Those are not my legs,' I
told him, surprised by my appearance which only half satisfied me.
'What do you care! I took the legs of a model who had nicer ones
than yours!'"[32] Faure would not buy the painting, but he did agree to
let Manet send it to the Salon with its identifying title.

Weeks before it was seen at the Salon, news of a falling-out be-
tween "the king of baritones" and "the king of intransigents" was in
print. Albert Wolff, in his "Parisian Calendar," a regular column for
Le Figaro, wrote on March 27, 1876, "It is known that for a while
Faure collected pictures by the most undisciplined painter in Paris."
He went on to recount that one day Faure arrived with a painting by
"B . . ." (Proust, telling the same story a bit differently, says it was a
portrait Faure had commissioned from Giovanni Boldini; little re-
membered today, Boldini had more commissions than he could han-
dle in the 1870s). "What do you say to that?" Faure asked. "Now that
is art." Manet minced no words: "It's badly drawn and badly
painted." Faure, offended, replied, "That is exactly what is said about
your works, my dear Manet." Manet shot back, "You know Berthe-
lier, you know he's hoarse and sings through his nose. Well, I know
people who claim that Berthelier has more talent than you do." Faure
granted him the point: "You're enormously witty, my dear Manet."[33]

Their relationship did not suffer, at least not for long. Faure con-
tinued to buy Manet's paintings and even commissioned another por-
trait in 1882, with which he was no more satisfied. Of Manet's three
surviving attempts to please him, one now hangs at the Metropolitan

Museum of Art. Manet had been willing to start over, but each time the same face reappeared — "That was how I saw him!" he insisted — and so he finally gave up and added another unsold portrait to his collection. Faure could not remain annoyed with a man he appreciated as much as Manet. "After a sour exchange of letters, we once again became the friends we had been before. Along with that teasing and characteristically Parisian wit that made him so popular in society, he was so fundamentally good."[34]

Even without the clarity of hindsight, the reaction of the 1877 Salon jury to *Nana* and *Faure As Hamlet* should have been foreseeable. Or was it that Manet submitted them pro forma, on the principle of "nothing ventured, nothing gained"? *Nana* was unhesitatingly rejected by unanimous decision for its indecent subject. Nobody on the jury gave a thought to the "whipped cream" nakedness that always found right of entry into the Salons: "The modesty, the decency, the chasteness, all those virtues that M. Bouguereau exhibits in the naked whipped cream goddesses he imagines did not grant asylum to that modern Parisian creature [Nana]," Bazire commented sarcastically four years later.[35] Nymphs cavorting with satyrs, yes, but a half-dressed girl? Absolutely not. Diderot had long ago made the distinction between a woman who was undressed and a nude. A nude could be idealized; a woman who could be expected to get dressed was indecently real.

No sooner was the verdict of the jury communicated to Manet than the owner of a well-patronized gallery of decorative objects on the boulevard des Capucines offered to display the painting in his window. On May 1, the day the Salon opened, Parisians lined up to see Manet's latest folly. Once again, as with *Music in the Tuileries* and *Olympia*, there were outcries and threats of police intervention. But nothing came of it. *Nana* was another triumph — in its own way, the Manet way.

The Salon jury accepted *Faure As Hamlet*, but it was hung near the rafters and trounced as usual. A critic, stoutly declaring that "criticism should make an obligation of maintaining absolute silence when encountering works of this kind," nonetheless filled his column with remarks such as this: "If I had not been informed that M. Faure posed more than thirty-six times for this portrait, I would have wagered that M. Manet took as a model one of those wooden puppets . . . from the Punch and Judy theatre, whose limbs are dislocated."[36] Much was

made of the legs, perhaps because the rumor spread that Manet had substituted a model in Faure's absence, but also because the critics could not accept that kind of perspective. Years later, remembering the reception of the painting, Manet told Toché: "Have they made enough jokes about the portrait I did of Faure in Hamlet? And that left leg they said was too short? When a person moves forward, can both legs be like those of an infantryman at attention? And the sloping floor? Damn it all! I would really like to know how official drawing teachers would go about giving the illusion of Hamlet rushing toward the spectator."[37]

The painting was hung as high as the ceiling of the Palais de l'Industrie would allow, but that made no difference to the reviewers. They craned to see it, complained about what they could not see, or snickered that it was not high enough and then detailed flaws they could barely see. Albert Wolff, never at a loss for a quip, argued that the administration had done Manet a favor: by distancing the painting from the eyes of spectators, Manet would not be charged with "painting like a decorator." Wolff was especially displeased by the unfinished hands. But he was not without a backhanded compliment: "M. Manet erupted into contemporary painting with a highly contested but powerful originality. As he advances in his career . . . he seems to distrust his own art. Better to be a defective painter but an original one, than to become an incomplete painter without originality."[38]

Wolff's opinion seems to have mattered to Manet, despite his reported contempt. "People fight over what pleases that critic as though over pieces of the true cross. In ten years no one will want it at any price," he told Proust. Wolff is the only one on record toward whom Manet behaved so ingratiatingly, writing to him after bad reviews, inviting him to the studio, asking him to pose for a portrait. Perhaps one expects too much of a man who was so lucid, so independent in his work, and so quick with a retort. There is no question that he needed good reviews. He was also a man who knew the rules and occasionally played by them. It is hard to understand why he felt the need to sway Wolff when there were so many other critics to conquer, no less unsympathetic and no less important. True, Wolff was writing for *Le Figaro*, which had a large readership. But it was apparent that Wolff had no eye for modern painting and had only the highest praise for its antithesis, Meissonier, whom Wolff hailed as a *grandissime*

artiste" for his portrait of Alexandre Dumas fils shown at the same Salon as Manet's *Faure As Hamlet.* Manet, certainly not deluded about Wolff's objectivity, nevertheless wrote to him on March 19, 1877, admittedly having been asked to do so, to enlist his support for the third impressionist show, to be held the following month, before the Salon opened.

> My friends Messrs Monet, Sisley, Renoir and Mme Berthe Morisot are going to hold an exhibition and sale at the Salle Drouot. One of these gentlemen will bring you a catalogue and an invitation, and has asked me for this letter of introduction.
>
> You may not yet care for this kind of painting, but some day you will. Meanwhile it would be nice of you to say something about it in *Le Figaro*.
>
> I haven't asked you to come and see my portrait of Faure because it's not yet finished.[39]

The portrait of Wolff was never finished. It was too hot, Wolff complained; then he stopped coming, without offering an excuse. He may have felt that the portrait did not flatter him enough to waste any more of his time. It would have taken a great deal to flatter a man who was willing "to pass for the ugliest man in the world so long as he was considered the wittiest man in Paris."[40]

Manet's growing fame and increasing acceptance by major critics like Castagnary were still not enough. The depth of his discouragement during that spring of 1877 can be seen in a brief note he sent to his former student Eva Gonzales, whose works were gaining regular admission to the Salons.

> Dear Mademoiselle,
>
> It has been a long time since you called me for a consultation. Could it be that my lack of success has incurred your contempt?[41]

The Last Studio

Dispossessed of his spacious studio on the rue de Saint-Pétersbourg in July 1878, Manet found another, at 77, rue d'Amsterdam, only a block away. But he was prevented from setting up his easels until the following April because of extensive renovations. In the meantime an acquaintance, the Paris-born Swedish history painter Johann-Georg Otto, Count Rosen by title, was leaving his studio a few doors down on the same street, at number 70, for a few months, and Manet decided to rent it for the interim. Quite unlike the ordinary barren artist's workplace, containing a few essential bits of furniture, Otto's studio had been turned into a veritable greenhouse with a large variety of tropical and temperate plants that flourished in the glassed space: its unusual decor was known from the fashionable cafés of the boulevard des Italiens to the artists' hangouts of Pigalle. Manet brought with him his piano, his standing mirror, and his couches, and he was soon using Otto's greenhouse as the luxuriant setting for a double portrait of two friends, M. and Mme Jules Guillemet, proprietors of a boutique on the rue du Faubourg Saint-Honoré, where high fashion still reigns.

Many writers have commented on Suzanne's absence from her husband's studios. On the testimony of some of Manet's contemporaries, it would seem that in the eight years Manet occupied the studio on the rue Guyot, Suzanne did not make more than ten appearances there. She even joked with friends about her self-imposed exile from Manet's workplace. "One could easily have counted her visits to 4 rue de Saint-Pétersbourg; as for 70 rue d'Amsterdam, she was a virtual

stranger."[1] But when the Guillemets began posing, Suzanne either asked or was invited to join them. Perhaps because they were often each other's guests, Manet found it desirable to re-create a social atmosphere in the studio and thus avoid the possible stiffness of a married couple posing together. He often told his sitters to "talk, laugh, move around. You will look real only if you remain natural."[2]

Suzanne's presence seems to have had little effect on the Guillemets' sociability, for we see them lost in private thoughts. What Manet caught here is a psychological state that may have corresponded more to the painter's own thoughts than to those of his models. He spent five months working on the painting, from September 1878 to mid-February 1879, during which time he had ample opportunity to alter the mood or the expressions of his sitters, had he so wished.

To judge from its finished state, the painting was intended to provide both portraiture and an image of contemporary life. The conservatory had become a fashionable addition to interior decoration some years before and by 1878 had become a near requisite of the bourgeois style. For Manet's portrait, Count Rosen's conservatory immediately established the social position of the sitters, where clothing alone would not have signified the domestic propriety of the couple. They could have been a demimondaine and her lover, or an adulterous couple. Instead, before we notice other details, we, or the viewers who were expected to see the painting in 1879, recognize at first glance what the original title, *M. et Mme Jules Guillemet dans la serre*, confirms: a prosperous, fashionable, married couple in a setting denoting their status. We then see their wedding rings *almost* touching. But a second look reveals a more complex scenario. An almost-spent cigar physically separates the two ringed hands, just as their independent daydreaming separates them psychologically (Fig. 52). As for the setting, on second glance it too reveals another aspect: it is entirely artificial. All that lush jungle foliage and all those potted palms are not native to Paris, and even less so to a Parisian apartment. The whole scene begins to convey a meaning of mere representation, sham — like the marriage Manet lived with every day of his life.

Did Manet know anything about the private lives of his sitters? Were their lives also a facade? Or was he merely thinking of himself? Very striking, and already noticed by contemporaries, is the resemblance between Jules Guillemet and Manet: same hairline, same

shape of beard, same coloring. That made it all the easier for Manet to see himself in the figure he was painting. There is even a verbal irony in the clear rendering and proximity of the two rings: *alliance* is the word for "wedding ring" in French. If ever there was an absence of "alliance" in a conjugal portrait, this one is exemplary.

In *The Balcony* the figures also are detached from one another, but there is no obvious reason for them not to be; no indication of any link between them exists. In contrast, *In the Conservatory* appears to demonstrate the consecrated, intimate relationship of the two figures. At the time the painting was shown, there was no need for symbolism to identify them as a married couple since the original title included their names, and Philippe Burty in his review described it as "the portrait of an American *[une américaine]* and her husband."[3]

The only other conjugal portrait Manet painted was the one of his parents, in 1860, to which *In the Conservatory* bears a resemblance in the psychological separation of the spouses. Although these two double portraits are hardly enough to determine Manet's view of marriage, it is nonetheless curious that he never depicted a couple, old or young, sharing a glance that might suggest intimacy, sentiment, or even habit. In *Nana* we know immediately that the top-hatted man may provide the gilded cage but the bird is not his; he is there by the hour. The closest Manet comes to an evocation of mutual interest is in a few portraits of Berthe Morisot, where an intense exchange is felt between the model and the object of her gaze. In all other paintings his men and women are together for what amounts to a brief encounter: by chance, at a ball, on a pier, at a public entertainment; by choice, for an afternoon's sail, a game of croquet, a drink in a café. Except for one extraordinary canvas, *Chez le Père Lathuille*, painted later the same year as *In the Conservatory*, we never see any two people within the same canvas, not even the casual lovers of *Argenteuil* or *Boating*, showing any interest in each other. Together or separate, Manet's figures are alone.

When he started painting the Guillemets, Manet may not have known he would submit their portrait to the Salon of 1879 along with *Boating*, painted five years earlier. But he could not have missed the contrast once he paired them, and may even have had *Boating* in mind when he conceived of *In the Conservatory*. *Boating* is an outdoor painting of two unpretentious people, a grisette and a Sunday sailor on an outing. Theirs is a transient relationship — a couple for

an afternoon — in the shimmering light of a summer day. No fakery here. Seen beside *In the Conservatory, Boating* becomes its absolute antithesis: a married upper-bourgeois couple in a hothouse setting, dressed to be seen by others, contrasted with an unmarried working-class couple dressed for their shared entertainment. Even the eyes of the unmarried couple indicate an awareness of the outside: the boatman, facing forward, looks at us; the young woman, seen in profile, looks straight ahead. The Guillemets, however, are looking inward, their glance as blank as the windows of a darkened room.

Another element that might be taken into account when viewing *In the Conservatory* is the painting Manet did of Suzanne, *Mme Edouard Manet in the Conservatory* (Fig. 53), on the same bench, in the same general setting, and immediately following the first. The foliage, however, is different, as is his palette, and the difference between the two women could not be greater. Mme Guillemet was a slender, striking young woman, a paragon of Parisian chic. Suzanne Manet was neither. She is seen surrounded by coarsely brushed, heavy tropical leaves and drab blue blossoms, perhaps hydrangeas. Manet obviously gave some thought to this portrait and seems to have wanted to establish a difference between it and the one of the Guillemets, since he did not repeat the exact background. On the surface the two pictures have much in common: a conservatory setting, same bench, same color for the women's dresses — both are gray, but how very different the two shades and the two dresses. Mme Guillemet's gray is soft and youthful, smartly trimmed with black braid and enlivened with touches of yellow in her hat, gloves, and parasol. The coral of her lips and ear is echoed in the flowers behind her head. Every pleat, every buttonhole, every wisp of hair at her temple is rendered meticulously, as though Manet took sensual delight in every brushstroke that concerned Mme Guillemet. Even the bench on which she sits was painted with absolute accuracy and perspective — each spindle precisely modeled, light glinting off the enamel.

The abundance of detail in *In the Conservatory* impressed the dean of realist critics, Castagnary, who commented in his review of the Salon that the faces and hands were drawn with greater care than usual. "Can Manet be making concessions?" he asked.[4] Perhaps so. Perhaps the care he lavished on this painting was intended to show them all that he could paint circles around the perennial Salon favorites. Perhaps because he had no intention of showing the portrait

of Suzanne, he did not bother to give it the same precision. The silk ribbon of Suzanne's bodice was painted with comparable care, but the white ruffles of her neckline and cuffs were loosely sketched. Mme Guillemet's trim white collar and ruffled cuffs could rival the work of Hals. Her tapering fingernails on her ungloved left hand also were painstakingly brushed; Suzanne's hands are less detailed than the broad leaves behind her, although her wedding ring was clearly rendered and her face and hair were painted with considerable finish. But the dullness of her look and the silly expression of her mouth leave one with the feeling that any inspiration Manet might have had at the beginning was soon squelched. He left the work unfinished even though it was well advanced.

Suzanne's charms had not increased with age. She was adored by Giuseppe De Nittis's little son and perhaps by her own nieces and nephews, but none of Manet's friends sought her out as they did her mother-in-law or Berthe Morisot's mother, and only rarely is her presence at receptions even mentioned. Correspondence from the Morisot side sharpens the unflattering image of Suzanne. A letter from Cornélie Morisot to Berthe during the summer of 1875 advised her to "put aside the misgivings you may have felt about the family at the time of the marriage which, I must concede, it [the family] was reluctant to accept, but I do not think Suzanne's marriage looked any better to them and you can see the place she has made for herself."[5]

Relations between in-laws are rarely easy. "The family" can hardly be anyone but Mme Manet herself; Edouard was, if anything, too enthusiastic in his matchmaking, even arousing Mme Morisot's suspicions about his motivation, and Gustave seems to have been totally outside the event. When Berthe became a Manet, she was not prepared to ingratiate herself with her mother-in-law. They had known each other for years as social equals, she was too old for a filial relationship, she had no intention of trying to rival Suzanne, and she was disinclined to pay court to anyone. But she nonetheless felt that she was being unfavorably compared to Suzanne and as a daughter-in-law was found less obliging. She was reproached for not writing to her mother-in-law when she and Eugène were away from Paris; Suzanne wrote diligently every day when she was away.

A week after the first letter, Berthe received another from her mother intended to raise her morale: "Really, you are so superior to Suzanne that you should be no more concerned about her than if her

stout person were not of this world." In both passages we can hear contempt for Suzanne. Berthe certainly had many reasons to feel superior to Suzanne, but perhaps the most gratifying were her collegial relationship with Edouard and the freedom with which she could visit him in his studio now that she was his sister-in-law.

During the summer of 1876 the Manets had been invited to spend a fortnight at the country house of Ernest Hoschedé and his wife, Alice, in Montgeron, where the Seine and Oise rivers meet. Hoschedé was still in his glory days, lavishly receiving guests with the open-handedness of a magnate. Manet did a number of oil sketches of him and his children. When Alice left her husband, she and her six children set up house with Claude Monet and his two sons. The two families were twice united in marriage: Blanche Hoschedé, Alice's daughter and herself a painter, married Monet's elder son, Jean; after Alice was widowed, she finally married Monet.

Ernest Hoschedé had been an avid collector of the new painters. In his prosperous days the pleasure of ownership, not investment, had been his prime concern. In 1878 he was faced with bankruptcy and was forced to sell everything. When his collection of paintings came on the block, the auctioneer was offended to have to stimulate bidding on works he considered trash: twelve Monets, three Renoirs, nine Pissarros, thirteen Sisleys, five Manets, and two Morisots among more than a hundred paintings. Manet's *Young Man in the Costume of a Majo*, one of the great pieces at the Metropolitan Museum of Art, sold for 650 francs; *The Street Singer*, now at Boston's Museum of Fine Arts, went for 450. A scrap drawing by Meissonier would have sold for more.

During that visit with the Hoschedés Manet first began to feel the effects of the disease that would take his life. For years he would continue to ascribe his symptoms to rheumatism or arthritis, from which he doubtless suffered. But in his case the origin was neither the degeneration of cartilage, osteoarthritis, nor the inflammatory condition of rheumatoid arthritis. For him it was the beginning of the end. The disease that had lain dormant for untold years had, in fact, been doing its insidious destruction. If Manet had noticed the telltale chancre, the first symptom of syphilis, he may have ignored it, or it may have been misdiagnosed. Even if the disease had been correctly diagnosed, little could have been done to prevent its spread, although in some cases mercury seems to have been effective. Syphilis was not

necessarily fatal. Two-thirds of infected individuals in that pre-penicillin era did not develop late symptoms and lived out their lives with few or no complications. But among the remaining third any organ, or any combination of organs, could be affected.

In those who developed neurosyphilis in the third, or last, stage of the disease, the nervous system degenerated chronically and progressively. The two major forms of neurosyphilis are paresis, which affects the brain, causing loss of speech and movement, with death generally following within five years after the onset of identifiable mental symptoms (the form suffered by Auguste Manet and Baudelaire), and tabes dorsalis, which affects the trunk and lower limbs. Its first stages are characterized by sudden paroxysms of stabbing pains, called lightning pains, in the lower abdomen or legs. Later (anywhere from one to twenty-five years) ataxia — the inability to coordinate the voluntary action of the muscle groups used in walking — sets in. This is commonly followed by ulcers, known as *mal perforant,* on the underside of the toes or feet. These ulcers do not heal because the skin and underlying tissue are destroyed through their separation from the nerve supply. They can become gangrenous, requiring amputation of the limb, a therapy that rarely prolonged life for more than a short time.

In the summer of 1876 Manet's left foot started to bother him; it ached, it tingled, it felt numb (classic symptoms of early tabes dorsalis). He was uncomfortable but not particularly anxious, since rheumatism, he said, ran in the family. Rheumatism, however, is not a disease; it is only symptomatic of a variety of diseases, among them arthritis, which had been observed in connection with venereal infections since antiquity. In Manet's time it was known that gonorrhea was the most common cause of infective arthritis, but not all doctors recognized the distinction between gonorrheal arthritis and nongonorrheal venereal arthritis.[6] At various times Manet was given false hope, and in 1876 he may well have been told that his condition was more likely related to gonorrhea than to the more dreaded tabes. But two years later the symptoms had spread; his right leg was now so stiff that he was unable to flex it. He began walking with the characteristic stamping gait of ataxia.

Was it an intimation of mortality that led him to do a self-portrait in 1878? He had never devoted an entire canvas to himself except for a caricatural portrait in the mid-1850s. In that one he portrayed him-

self with a full head of hair, although he was already balding, and added a dedication, *"A un ami!"* (To a friend). Manet kept the painting throughout his life. After his death, Suzanne Manet sold it to art dealer Ambroise Vollard. It was last described by Tabarant, and has since disappeared. Manet did insert cameo portraits of himself into three important works — *La Pêche, Music in the Tuileries,* and *Ball at the Opéra* — but he is not the subject of the paintings. In 1878, however, he undertook two full-scale self-portraits. The one with a skullcap shows him full-length, his right leg stiffly extended, as though he meant to document his condition. With no knowledge of his physical state at the time, the awkward stance would naturally lead one to fault the painter. But Manet can only be faulted for an excess of precision, for he painted exactly what he saw, and it could not have been a cheerful sight.

The painting remained an oil sketch, unfinished. He never went back to it, but he did keep it, unlike abandoned portraits of Suzanne, over which he painted other subjects, including his *Self-Portrait with Palette.* This one shows his upper body as he saw himself in a mirror, the image reversed so that he appears to be left-handed. Except for the left hand and forearm, the work is completely finished. Charles Moffett sees it as a subject from modern life as much as a self-portrait: "Indeed this image of a stylish gentleman painter could serve as an illustration of the dandy as defined by Baudelaire in 'Le Peintre de la vie moderne.'"[7]

In this much-quoted essay, Baudelaire defined dandyism as "a kind of cult of the self that can outlast the search for happiness in another. . . . A dandy can be a man who is jaded or a man who is ailing; in the latter instance, he will smile like the Lacedaemonian in the teeth of the fox."* For Baudelaire, dandyism was much more than a matter of dress. It bordered, he explained in his essay, on "spiritualism and stoicism," a religion as demanding in its doctrine of "elegance and originality" as the monastic rule, requiring even those of the most impetuous temperament to show the world an impassive

*Plutarch, in his life of Lycurgus, tells of the rigorous training of Spartan (Lacedaemonian) boys, who were taught to steal and were severely punished if caught: "One boy, having stolen a fox which he hid under his coat, allowed it to tear out his bowels with its teeth and claws rather than reveal his theft."

face, "Perinde ac cadaver," just like a corpse, never revealing how much pain, suffering, and despair lie behind the proud smile. Such individuals are "representatives of the best there is in human pride. . . . Dandyism is the last burst of heroism in periods of decadence."[8]

At the time he painted his two portraits, Manet, whether he knew it or not, and he probably did, was practicing Baudelaire's "religion." In his moments of private honesty, he could have had few illusions about what lay ahead. But to survive in the present, he had to maintain the demeanor of a man merely afflicted with one of life's little tribulations, a bit of inherited rheumatism. *Self-Portrait with Palette* reveals him in all his elegant stoicism, dressed for the boulevard — a pearl stickpin in his black cravat, a black bowler on his head, a finely tailored camel-colored jacket — imperturbably engaged in applying paint so precisely that no smock is needed. He painted this portrait on a canvas he had previously used for a portrait of Suzanne. By painting himself over her, he made material Baudelaire's notion that the "cult of self can outlast the search for happiness in another."

The portrait shows not only what Manet did but what he was. If he had in mind Velázquez's famous self-portrait in *Las Meninas*, where he stands beside an easel holding a brush in his right hand and a palette in his left, although he too had been looking into a mirror, Manet may have expressly left the mirror image — that is, the inverted position of the hands — to call attention to the painting as artifact. This self-portrait was not an attempt to delude the viewer into believing that the artist had been caught unawares at work. Contrary to his frequent inclusion of the unseen viewer, here Manet is engaged in a totally solipsistic enterprise in which the artist is the only one who sees himself, exactly as he appears in a mirror into which he alone looks. This may have been a deliberate attempt on Manet's part to impose his view of himself on posterity. In such a context, the painting can be interpreted as an expression of the loneliness and the courage of every human being confronting death — a theme that pervades his work.

In 1878 Manet was still trying to fool himself and those around him. He consulted doctors who recommended hydrotherapy, an arduous regimen intended to stimulate dysfunctional nerves. He also sought recovery in various quack treatments, the least fraudulent perhaps a homeopathic cure recommended by his brother Eugène, who found it relieved his migraines.

In November 1878 Berthe Manet, as she always signed her name except on canvas, finally became a mother. She gave birth to a daughter, named Julie but called Bibi throughout her childhood. Berthe was disappointed. "I guess I am like everybody else!" she wrote Edma. "I regret that Bibi is not a boy; first of all she looks like one, then, she would perpetuate an illustrious name, and finally, quite simply, because all of us, men and women alike, have a preference for the masculine sex." Such sentiments would be astounding had they come from any first-time mother living in the capital of Western culture in the late nineteenth century. They are particularly startling coming from a woman who was herself engaged in a career and was already something of a public figure. Until 1879, when Mary Cassatt joined the impressionists for their fourth show, Morisot had been the only woman exhibiting with them. The "illustrious name" is obviously that of Edouard Manet, since in Morisot's time no other Manet, however distinguished, could be considered "illustrious." Her reverence for a name that was still more often ridiculed than esteemed indicates her continued attachment to the man who carried it, and also the importance she attached to bearing his name herself.

Even more noteworthy is her remark in another letter to Edma that "to the great outrage of some people" (this may refer to Manet who, to his dying breath, remained opposed to religious ritual despite his friendship with Abbé Hurel) "Julie . . . has been baptized . . . and vaccinated . . . [she] is a Manet to her fingertips; she is already just like her uncles, nothing from me." How curious to speak of the resemblance between Julie and her uncles, as though her father were not a Manet! The more likely observation would have been that Julie looked exactly like her father. Instead the implication is that Berthe saw Edouard in Julie, to the exclusion of Eugène, who looked much more like Edouard than Julie's other uncle, Gustave.

Writing to her brother, Tiburce, some time later, she enclosed a photograph of Julie and asked him to send her a recent one of himself: "I send you Bibi; this is everything I love, everything I have left of youth and beauty." These are not the words of a woman who was happy in her marriage, but of a woman who had made her child the focus of her emotional life, a compensation for her disappointment as a woman, a surrogate for the bearer of the "illustrious name," whom she saw, or chose to see, in the face of her child.

Perhaps the most puzzling words Morisot ever put to paper are

those set down in her notebook, undated but said by her grandson to have been written around the time of Eugène's death, nine years after Edouard's.

> I like to descend into the depths of pain because it seems to me that one must rise up afterward; but here it is three nights that I have spent weeping, help me! help me!
>
> Memory is the only imperishable life; what has foundered, what has vanished, was not worth living; and thus has not been. The sweet hours, the dreadful ones, remain intact and do we need material objects to relive them as relics? That is really quite vulgar. Better to burn the love letter. . . . [editor's elision]
>
> I wish I could relive my life, put it into words, declare my weaknesses; but that is useless; I have sinned, I have suffered, I have paid the penalty; I would only produce a bad novel by telling what has been told a thousand times over.[9]

Berthe's marriage to Eugène does not explain the language of this dramatic confession. If it was because of him that she wept during three nights, it was not over her loss but rather over her guilt. It was not with her husband that she sinned and suffered *("j'ai péché, j'ai souffert, j'ai expié")*. Rather her marriage — "what has foundered, what has vanished, was not worth living" — seems to have been the penance she paid for those "sweet . . . dreadful" hours that remained "imperishable" in her memory. Only an unhappy love could inspire "a bad novel" that has been recounted time and again, not a good marriage. But a marriage contracted in bad faith, in order to be near the man one cannot marry, that too has the makings of a bad novel, and a very bad conscience.

If there are no incriminating letters between Berthe and Edouard, the letters between Berthe and Eugène reveal the tenor of their relationship as well as Berthe's feelings about Edouard. In 1882, when Berthe took Julie to the warmer, drier climate of Nice to help her recovery from bronchitis, she and Eugène, who remained in Paris, wrote often. On the subject of a show in which her works were exhibited, to which Eugène had devoted much time and care, Berthe thanks him and in her second sentence writes, "You do not tell me what Edouard thinks of the exhibition." Farther down she says, "I think all the time about what Edouard would do." On his side, Eugène sends

his greetings to "you and your daughter [*Beaucoup de tendresses pour vous et votre fille*]," a salutation that close friends commonly use. While the use of the formal *vous* was not uncommon in upper-class families, among whom even parents and children used this form of address, this was not the case in the Morisot and Manet families, all of whom addressed each other with the familiar *tu*. Berthe and Edouard naturally retained the *vous*, but between Eugène and Berthe the continued use of *vous* in their private correspondence suggests a relationship that did not go far beyond their courtship.

The mutual and unfulfilled attraction between Berthe and Edouard brings to mind Edith Wharton's *Age of Innocence*. Judging from the portraits Manet did of her, Berthe seems to have been for him what Ellen Olenska represented for Newland Archer: "the complete vision of all that he had missed in life." And like Archer looking back on his marriage to another woman, Manet may have felt about Suzanne that "their long years together had shown him that it did not so much matter if marriage was a dull duty, as long as it kept the dignity of a duty."[10] For Berthe, marriage seems to have provided remorse.

In April 1879 Manet finally moved into his freshly renovated studio on the rue d'Amsterdam, halfway between the place Saint-Lazare and the place Clichy, at the back end of the interior courtyard. The building housed other studios, among them that of Henry Dupray, a regular visitor of Manet's who later became Méry Laurent's lover. Manet's studio was flooded with light from its wall of windows, but it had none of the charm of his previous two studios. This was an austere work space, vast and empty. He moved some of his furnishings into it, but for the most part it was a repository for his paintings. The walls, Bazire recalled, disappeared behind the paintings hung as closely as in a Salon exhibition, from ceiling to baseboard. "This studio," he wrote, "tells the story of an entire life . . . here, an unfinished copy evokes the trips to Italy; there, gypsies bring to mind the trip to Spain. The famous *Olympia* hangs in the middle of a large wall. Beside it, *The Balcony*, which made such a stir . . . the portrait of Zacharie Astruc, the colossal *Execution of Maximilian* hangs over a doorway that leads to a more intimate little salon."[11]

Paintings from Manet's entire career hung there, some framed, some not, others stacked against walls and propped on easels. The zinc basin in which Méry Laurent stood while posing for *In the Tub*,

the counter for *Bar at the Folies-Bergère*, the mirror in *Nana* — all around were the props of his later works. A few pastels, Jacques-Emile Blanche relates, stood on easels, among them portraits of George Moore and Méry Laurent, "Manet's daily visitor at the hour when people gathered to chat and laugh."[12]

Manet could not hope to recapture the elegant atmosphere of the studio he had been obliged to leave. In this high-ceilinged hangarlike space, he was surrounded by the tools of his trade, as in his first studio. It was the kind of place, Blanche recalled from his own youth, where young painters "pretended to work but received women instead"[13] — except that here the unsold production of a lifetime furnished the emptiness. When Manet could no longer walk to the Nouvelle-Athènes after a day's work, his café circle came to him. Trays of drinks were brought by a waiter, and his callers assembled in a studio transformed into a café — Suzanne called it an annex of the Café de Bade.

Painters, politicians, collectors, old friends and new gathered and lingered. One visitor wrote, "Once one has come to Manet's studio, even for a casual visit, one cannot make up one's mind to leave." They stood around smoking, talking, cracking jokes, spurring each other on to ever sharper witticisms "that sparkle and explode like fireworks." The writer of these lines was a former naval officer, a baron, who started his literary career in journalism in the early 1880s under the name René Maizeroy. In 1882 he published a spirited account of a gathering in Manet's studio, very possibly while posing for one of the two pastel portraits Manet did of him. In *Man with a Dog* he is dressed in a top hat and fur-collared greatcoat, his bearded face finished, the dog sketched in. The other, more complete, shows him without the beard but with a mustache, a consummate boulevardier with bowler and cane, his coat over his crooked arm. Manet, to Degas's dismay, enjoyed such men-about-town — their gossip, their vivacity. These urbane chroniclers who mixed in good society were a diversion after a long day standing before an easel, and especially after his legs could no longer carry him to his favorite cafés.

Unlike Wolff, Maizeroy admired the painter as much as the man. After describing the setting, Maizeroy sketches a portrait of the artist, who, once surrounded by his effervescent visitors, "soon forgets his

model and the canvas he has started," suggesting that the writer is the abandoned model:

> Parisian to his fingertips, highly literate, having read widely with a very retentive mind, as skeptical as one can be, he sprinkles the conversation with his own pinches of pepper. . . . Paradoxes fly. Theories explode. Puns, ironic and boisterous, ricochet. The master smiles. His clever face lights up with a spark of gaiety. His voice is biting as acid. And woe to those he shows up in their true colors — the rich and famous without talent who own their house* and sell a three-penny water color for 25,000 francs. Woe to the professors of the quai Malaquais [the site of the Ecole des Beaux-Arts] and the members of the Institut [who constituted the Salon juries], and to the photographers who take themselves for painters! One could go on till tomorrow, but night falls, enveloping the vast studio in shadows, forcing the talkers to leave against their will, and one goes out, a bit dazed, a bit drunk, as after a rowdy dinner.[14]

Manet had conquered the chronicle readers if not the Salon jurors. Even in England he had become newsworthy. Among his unpublished personal papers, there is a note, in French, from a woman journalist requesting an interview with him: "Your name has gained such renown in England that nothing could be of greater interest to readers of this newspaper."[15]

During that same month of April 1879, when he inaugurated his studio, Manet wrote two letters containing unusual news. One was to Henri Guérard, an engraver and a good friend who became Eva Gonzales's husband later that year, informing him that Suzanne was "better, but we were very concerned. Her convalescence will doubtless be slow."[16] No other source explains her condition, but the fact that it was not good indicates that yet another weight had been added to the heavy burden of Manet's own health. The other letter was written to the prefect of the Seine (the post previously held by Haussmann), regarding the newly constructed Hôtel de Ville, the administrative center of the city of Paris. Manet proposed a project for decorating the

*Most Parisians rented their apartments; if they owned property, it was in the country. Property owners in town were generally aristocrats, newly rich magnates, and *grandes courtisanes.*

council chamber, to consist of "a series of compositions representing, to use an expression that has become consecrated and clearly expresses my thought, *le ventre de Paris*,* with the various sectors shown in this setting which are the public and commercial life of our time. I would have Paris-markets, Paris-railway, Paris-port, Paris-underground, Paris-racecourses and gardens. For the ceiling, a gallery around which would be seen in appropriate attitudes all the living men who contributed or are contributing to the greatness and wealth of Paris." Signed "Edouard Manet, artist-painter, born in Paris, 77, rue d'Amsterdam,"[17] this letter did not even receive the courtesy of a negative reply. However, his ideas were used by other, more acceptable painters, like Henri Gervex, for the decorations of every *mairie* (the borough hall of each of the arrondissements) in Paris. Bazire credits Manet with the original concept of this modern decoration.[18]

Manet himself bitterly related this episode to Antonin Proust. Eugène Viollet-le-Duc, an architect famous for the restoration of many Gothic monuments, including Notre-Dame, and perhaps responsible for the fake Gothic style of the new Hôtel de Ville, had shown an interest in Manet's proposal. But he was then sixty-five, no longer powerful, and not even able to intervene on Manet's behalf, since he died soon after their meeting. "Alas," Manet recalled with regret, "after giving his approval, he sent me to M. Ballu [who] received me like a dog that dares raise his leg on an official wall." Théodore Ballu, coarchitect of the Hôtel de Ville, told him the decision lay with the prefect of the Seine and to write to him. Although not fooled by this classic buck-passing, Manet did write, he told Proust, but never received a reply. His bitterness was as much artistic as personal:

Paint the life of Paris in the house of Paris? Come, come! Allegory, that's what they want. The wines of France, for example: Burgundy by a brunette, Bordeaux by a redhead, Champagne by a blonde. . . . As for the story of Paris, the story of the past, naturally. Like reciting the Old Testament. The New, forget it! How interesting it would be for the future to see portraits of the men who presently direct the affairs of the city. When we go to Amsterdam, the painting

*Emile Zola's *Le Ventre de Paris* (literally, The Belly of Paris), a novel that appeared in 1873, depicted the life of Les Halles, the wholesale food markets in the center of Paris, now replaced by a shopping mall.

of the syndics [by Rembrandt] grabs us. Why? Because it's the true image of something actually seen. But today, it looks as if we put up buildings in order to reconstruct antediluvian history.

He cited Garnier's Opéra, that gilded mausoleum to Napoleon III, as an example — as antithetical to the painter of natural light as his painting was to Garnier. Manet regretted that Degas had not been asked to do the decorations instead of Baudry: "Degas, after *Semiramis* of course, would have left a series of undying masterpieces, on condition that Charles Garnier had agreed to let some light into the lobby of the Opéra."[19]

The Salon of 1879 opened on May 11, and Manet seemed at last to have arrived. He was no longer the whipping boy of the juries. Théodore de Banville in his Salon review for *Le National* pointed out the change that had taken place in the vision of many critics: "To think there was a time when M. Manet was seen as a revolutionary, a blood-sucker, a red menace!" It was not only of Manet that their view had changed. Albert Wolff, a critic whose hostility to impressionism had been notorious, praised Renoir's *Mme Charpentier and Her Children*. But there was still room for history painting. Victorine Meurent's *A Sixteenth-Century Citizen of Nuremberg* hung in the same room with Manet's *Boating* and *In the Conservatory*. There were also those who still saw only color in Manet — no drawing, no modeling, no composition. The last word was perhaps that of Paul Alexis, who had written elsewhere that same year that Manet was one of the few men in Paris who knew how to talk to women: "Now, the legend that made of him a scruffy art student, a jokester who inveigled Paris, is far behind. Now, any number of art critics take him seriously, most notably the one who writes for *Le Figaro* [Albert Wolff]. . . . One would have to be blind to deny it. Manet already has an entire school following him. Manet is a master . . . in Latin, *Manet et manebit*."[20] Manet had waited a long time, and the words were sweet, but he was still a long way from the success he desired. Faure would buy *In the Conservatory*, but for the derisory sum of four thousand francs, a pittance compared with what was paid to Stevens or Tissot for a picture.

The summer of 1879 held a real surprise. In July an article by Zola on the art scene appeared in translation in a Russian publication. On the 26th, a French translation of the Russian text appeared in Paris,

in the *Revue Politique et Littéraire*. The following day, in *Le Figaro*, Adolphe Racot reported that "M. Zola has just severed relations with M. Manet," to which he added a fragment of Zola's article: "To be outstanding, a man has to bring to fulfillment what he has in him; otherwise he is no more than a pioneer. The impressionists to my mind are just that, pioneers. For a time they placed great hope in Manet;* but Manet seems worn out by his hasty production; he is satisfied with approximations. . . . All those artists are too easily satisfied!" The very next day Manet received a letter from Zola, who was then at his country house in Médan, outside of Paris.

> Dear friend,
>
> I read with stupefaction the notice in *Le Figaro* announcing that I have broken off with you and I insist on sending you a warm handshake.
>
> The translation of the passage quoted is not accurate; the sense of the piece has been altered.
>
> I spoke of you in Russia as I have spoken of you in France for the past thirteen years, with solid sympathy for your talent and your person.
>
> Your very devoted,
> *Emile Zola*

Manet answered with equal promptness:

> Dear friend,
>
> Your letter gave me the greatest pleasure, and you will not take it amiss I hope if I ask that it appear in *Le Figaro*. I will admit I felt deeply disappointed on reading that article and was very pained by it.
>
> Regards,
> *Edouard Manet*[21]

Racot, on receiving the two notes, replied to Manet by return mail:

*Most reprints of this article cite the name of Manet, but a recent edition of Zola's art criticism reads "Monet" in this passage. The confusion has not yet ended.

I hasten to return M. Zola's letter. I was obliged to reply to it in *Le Figaro,* and would have done so more sharply, believe me, if I had not been concerned about embarrassing a man of your talent.

M. Zola seems to think that it is *Le Figaro* that translated this passage of his article. I simply copied it out of the *Revue Politique et Littéraire,* and you will concur that M. Zola could have begun by reproaching that publication for having translated the contrary of his words and thought.[22]

Racot was not taken in for a minute by Zola's protests, and rightfully so, as can be seen by reading the paragraph devoted to Manet that precedes the quoted passage. Moreover, Zola's bad faith is transparent once the entire section is read.[23] As for the substitution of Monet for Manet, that serves no purpose, since it was not Monet in whom great hopes had been placed. The truth was that Zola had lost interest in the work of a painter he once thought was the successor to Courbet's realism with a lighter palette. He no longer understood what Manet was doing and felt safe to say so in St. Petersburg, never dreaming he would be heard in Paris. Racot's terse rejoinder in print left no doubt about his view of Zola's lame excuses.

M. Manet has forwarded to us a letter he received in which the author of *L'Assommoir* declares he has "read with stupefaction" the notice in *Le Figaro.* What M. Zola called "the notice" is a textual quotation from the *Revue Politique et Littéraire,* which printed an extract of the article sent by M. Zola to the *Messager d'Europe* of St. Petersburg. It is therefore . . . not to *Le Figaro* that M. Zola should address the reproach of having translated into words unflattering to M. Manet the apparently flattering lines that M. Zola wrote (in Russian) about this distinguished painter.[24]

The mockery is subtle, but Racot is clearly calling Zola's bluff.

If Manet did not take greater offense than is indicated in his note to Zola, it was because, decent person that he was, he remained grateful for Zola's early support, and also perhaps because he had always known Zola's artistic limitations. Two years later he did lose patience with Zola. While lunching with Zola and Proust — a likely candidate for an important position in Gambetta's newly formed government — Manet expressed his hope that he would one day be deco-

rated. Zola said it was demeaning to ask for such things, implying that Manet was asking Proust to obtain it for him. After they had taken leave of Zola, Manet gave vent to his anger, then relented: "It's stupid of me to speak badly of a man who has been so generous toward me."

Manet's thoughts turned repeatedly to two projects in 1879. He wanted to do an outdoor painting that would go beyond his achievement in the two Argenteuil works, in which the contours of the figures would "melt in the vibration of the atmosphere."[25] And he wanted to do Proust's portrait in a single sitting on a raw canvas. In July he found his outdoor subject. A well-known restaurant belonging to the Lathuile family was practically next door to the Café Guerbois, at 7, avenue de Clichy. Manet happened to meet the owner's son, Louis, on leave from military service, as he was entering the restaurant one day in July 1879. Louis Lathuile's recollections of sitting for Manet corroborate those of the first female sitter, Ellen Andrée, whom Manet dismissed for failing to appear on time for the third sitting.

In the original pose young Louis was in uniform, but once Ellen was replaced by another model, the painting lost its élan until Manet had a fresh idea. He told Louis to take off his tunic, gave him his own beige linen jacket to wear, and scraped off his original version, producing what Bazire considered the culminating work of Manet's career. Another viewer, Georges Jeanniot, then an aspiring artist working as an illustrator, saw it in Manet's studio in 1882: "The painting . . . remained in my memory as the most astounding representation of a Parisian restaurant . . . the colors, juxtaposed by a highly perceptive observer, corresponded to the smells, the subtleties, the different kinds of music that Paris offers her lovers, often free of charge."[26]

This scene of summertime flirtation on a garden terrace, in which a young man looks adoringly at a prim woman, conveys the promise of a more intimate encounter to follow (Fig. 64). These are the only two figures in Manet's entire oeuvre who are engaged in an exchange of attention. Their eyes meet, the young man's arms — one resting on the back of the woman's chair, the other on the table — suggest a tentative embrace. And the aproned waiter who observes them from the back adds a voyeuristic touch. This radiant composition tingles with erotic expectation and the warmth of a summer afternoon.

Why would Manet suddenly be attracted to a subject so unusual for him? The year before, he had done a series of café scenes, all of which emphasize the modern theme of urban isolation. The clients, even those seated at the same table, seem unaware of each other, the waitress, or the viewer. Painted after the portrait of the Guillemets, *Chez le Père Lathuille** breaks away from Manet's characteristic treatment of remoteness and introspection. Is it possible that Manet's infatuation with Isabelle Lemonnier had aroused in him this singular image of flirtation?

Théodore Duret commented on the passion written all over the young man's face, "while the woman, seen only in a lost profile, reveals all the more effectively her affected prudery and hypocritical reticence." This description also could apply to the woman we see in Manet's portraits of Isabelle Lemonnier (Fig. 58). In spite of his tender feelings for her, he captured her prissiness, since his eyes never lied to him, which makes all the more understandable his delightful, imagined watercolor caricatures. One, on a note to her when she was at the seaside, shows her from the rear in a bathing costume, about to dive into the water — a humbling view for sure (Fig. 59). The couple in the garden enact a scene that Manet may have envisioned, with Isabelle in the female role and himself seated beside her; in the final version he was looking at his own jacket on his model's torso. "Manet had often been blamed for painting his figures in unintelligible attitudes because no definite action was suggested," Duret observes. "That charge could not be brought against him here for the lovers at Père Lathuille's play their roles with so much gusto that the content of the scene is apparent at first glance."[27]

That same year Manet did a series of portraits of Isabelle Lemonnier, and over the next two summers he would write her enticing little notes illustrated with humorous sketches of herself, a peach, flags, a plum. She was the daughter of one of the great jewelers in Paris, comparable to Cartier or Van Cleef. Her older sister, portrayed by Renoir with her children, had married Georges Charpentier, the publisher of Zola, the Goncourts, and many of the important writers of

*The doubled *l* was added to the name after an earlier painter, Horace Vernet, spelled it Lathuille in his painting *The Defense of Paris,* which includes the restaurant's sign.

the day. They were hosts to the avant-garde in all the arts. Charpentier was so committed to new art that he founded a review, *La Vie moderne,* subsidized by the champagne house of Mercier, and subsequently opened a gallery of the same name where Manet and his fellow painters held exhibitions. It was in this lively and fashionable atmosphere that Isabelle Lemonnier met Manet. Though young and unmarried, she was curious enough about him, or flattered enough by his interest, to return to his studio for six portraits in 1879 alone. As we know from his other sitters, this represents incalculable hours spent together, for each portrait shows her in a different outfit and pose, indicating that each portrait was done from life.

To judge from his images of her, she was neither a great beauty nor particularly alluring. In fact she has a rather insipid look, appearing to be exceedingly proper and stiff. But even if that was how he saw her, even if she was less intriguing than Berthe Morisot, less engaging than Méry Laurent, and less attractive than Mme Guillemet, she was young and unattached, she represented health and vigor, and she raised the collapsing morale of a man whose intimate existence was then a lunar landscape inhabited by an aging mother, an ailing wife, and his own limping silhouette. He had already once fallen in the street because of the sudden, excruciating pain tearing through his legs. To feel, or pretend to himself to feel, an excitement generated by Isabelle was to be vital again.

He made heroic efforts to appear unconcerned about his health, for a year or more even fooling Antonin Proust, who seemed to think Manet was in perfect health in 1879. By the time Proust wrote his memoirs, he had apparently forgotten that Manet was already then under medical supervision. There were two deep creases beside Manet's left eyebrow, and his hairline had made a drastic retreat. In September he finally yielded to the insistent recommendations of Dr. Siredey, his physician and close friend, and went to Bellevue, on the Seine near Paris, where a specialized clinic treated circulatory and rheumatic conditions with showers and massages that took four to five hours a day. He spent six weeks there in a small apartment on the grounds of the clinic, trusting that this rigorous routine would stimulate his nerves and dilate his blood vessels to restore normal leg movement. During his stay he resolutely followed the treatment and the prescribed rest periods. His only other activities were obligatory short walks and painting.

Living nearby was the opera singer Emilie Ambre, former mistress of the king of Holland. She had purchased a manor in the vicinity of Bellevue where she lived and received as though to the manor born. She had not met Manet before, but she knew his work and invited him to paint her in the role of Carmen. It appears that Manet did not finish her portrait until the following year, when he returned to the clinic for a longer stay, at which time he rented from her a little villa that had a garden and more space than the apartment he had occupied the previous year. In the intervening months she traveled to the United States, taking with her *The Execution of Maximilian* for exhibition in New York and Boston. Manet spoke of her in a letter to Eva Gonzales, written from Bellevue in September 1879. "I see that you spend your time pleasantly without me," he said, teasingly referring to her marriage earlier that month. "As for me, I have begun to work again. I am presently doing a portrait of Mlle Emilie Ambre, a landowning prima donna in the region. We [Suzanne was with him] plan to remain in Bellevue until the end of October."[28] His friendship with Eva had continued after she left his tutelage, as had his admiration for her work. A year later, when she received prominent recognition from the critics for a pastel she exhibited, he sent her a touching note dated July 7, 1880, once again from Bellevue: "Allow me to rejoice as well, in view of the fact that you were kind enough to seek my advice once in a while. It seems to me that the success you have long deserved is gaining ground this year. What a pity that you did not turn to a Bonnat or a Cabanel. You have shown too much fortitude, and that, like virtue, is rarely rewarded."[29]

He felt deeply the lack of his own success, measured against that of "a Bonnat or a Cabanel." In his congratulations to his former pupil, "kind enough" to have sought his advice in the past, he saw himself as a deterrent to her success and thanked her for choosing him ("You have shown too much fortitude") instead of seeking a powerful protector, like Bonnat or Cabanel, who would have furthered her career. Celebrity without medals, decorations, high-priced sales, or important commissions was an empty celebrity. By 1880 he had begun to feel that whatever the honors that might come his way, they would be too few and too late. Nonetheless, in 1879 he produced a large body of work, almost exclusively portraits, and he continued to explore the medium of pastels, which was less demanding than oils, being faster — no mixing of colors, no brushwork — and requiring less

standing. In his total production of eighty-nine pastels, seventy of them are portraits of women, and most of them date from 1879 on.

From the time he began to recognize his increasing infirmity, the presence of attractive young women served as a tonic to keep up his spirits. He was really not a womanizer, in the sense of Don Juanesque seductions, but the proximity of women — their clothing, their hair-combs, their hats, their conversation, and, perhaps most important, the absence of rivalry and power play in their company — pleased him, comforted him. He knew that he had few peers when it came to charming women — a small consolation when he was among men who had achieved greater prominence than he. He was not petty enough to be envious, except of the undeserving. On the contrary, he always rejoiced over a friend's success, as attested by a letter from Renoir, written from Capri in December 1881, when he was there without newspapers and without compatriots. He had hoped to learn about Manet's nomination for the Legion of Honor, "which would have made me applaud from my distant island. I hope that it is simply delayed and that on my return to the capital I will be able to salute the painter, friend to all, recognized officially. . . . You do not think, I hope, that a word of this is flattery. You are the joyful fighter, with ha-tred toward no one . . . and I love you because of that gaiety, even in the face of injustice."[30]

Even this "joyful fighter" could be depressed. A glance at the list of his subjects and models from 1879 to 1881 reveals his low morale. Between *Chez le Père Lathuille* in July 1879 and the portrait of Proust during the late winter, all of his paintings are portraits, mostly of women, six of Isabelle Lemonnier. No café scenes, no outdoor scenes — all are studio works, suggesting that he had lost contact with the outside world, which had enthralled him only the year be-fore. Of the thirty-three oils done in 1880, seventeen are of the gar-den in Bellevue, some of them with the figure of a child seen at a distance; thirteen are still lifes. Many of these paintings are superb, but their subjects required no displacement, no demanding poses or sitting schedules; they were simply there, before his eyes. Still lifes were to count for an even higher percentage of his output during the last fifteen months of his life: out of fifty-two oils, thirty-five are of flowers and fruits.

Among the women who sat for him in 1879 were Mme Zola, the ballerina Rosita Mauri (Antonin Proust's mistress), and a lovely op-

eretta singer, another one who owed more to Aphrodite than to Euterpe, Louise Valtesse, who became comtesse de la Bigne. Manet did a charming pastel portrait of Valtesse in which she appears to be as aristocratic as her husband's title. The sittings had begun badly, with each waiting for the other. As she explained in a note, "I am a goose." She thought he was coming to her house; he thought she was coming to the studio. "Be kind and give me another day. I will come to you." When she saw the finished work, she wrote, "Cher maître, I cannot tell you how happy I am to have had my portrait done by you and how much it pleases me. Thank you with all my heart; no one could be kinder or more gallant than you. I say gallant because you have flattered your model. Just let me add that I am very proud to have posed for a master of your caliber."[31] Despite the embossed crown on her pale blue stationery, Manet addressed her simply as "Valtesse" when writing to her. As for his male sitters that year, they included Georges Clemenceau, who would later become premier of France, of whom he did two portraits; Jules De Jouy, his cousin and attorney; and George Moore.

Behind the clever puns, the quick retorts, the Parisian wag par excellence was a highly vulnerable man who, now nearing fifty, had not yet won the approval he sought. Manet's feelings of failure, expressed so poignantly to Eva Gonzales, went all the way back to the early 1860s. His father had died with the disappointment of leaving the Manet name and reputation to a *rapin,* barely out of art school, a rebellious beginner. His insistence on following his own bent had led him to scandal, mockery, and notoriety. He was famous but as an eccentric, a revolutionary, a perpetrator of hoaxes. All the things he had persisted in doing his way had turned out to be less than was expected of him. At least he could pride himself on having behaved honorably.

All those years since his first Salon in 1861, when he showed the portrait of his parents, his mother had stood by him with love, with money, with hope. But how much pain she had suffered seeing his efforts ridiculed in public. And how discouraging the sales, the exclusions from exhibitions. The only way he could redeem himself was with a symbol of achievement that everyone recognized — not a few good reviews among a host of bad ones, a sale for a few thousand francs, or inclusion in *Le Figaro*'s feature on contemporary artists. The compiler of this *Galerie contemporaine* had written to Manet in June 1879 requesting information for the brief biography that would

accompany a photograph of the artist: "I am particularly happy about this in your case, Monsieur, for I am not and never have been one of those imbeciles who believe what other imbeciles have written about you." Nobody would have said that to Alfred Stevens or Giovanni Boldini; even the "imbeciles" considered them great artists. It was not enough merely to be listed with his fellow artists. Manet's heart was set on the Legion of Honor — a red ribbon like his father's.

The treatments at Bellevue had been of some benefit, for Manet returned to Paris in October and over the two remaining months of the year did much good work. At the close of 1879, a fruitful year — twenty-eight oils, thirteen pastels — he began work on the portrait of Antonin Proust that he had long been planning. He started over a number of times, discarding seven or eight canvases, but then, Proust relates, "the portrait came all at once. Only the hands and parts of the background were still to be done." That evening, although it was so close to completion, Manet turned the canvas to the wall, refusing to let anyone see it before it was framed. "It needs a frame," he kept saying as he strode around the studio, visibly pleased, "without a frame a painting loses a hundred percent of its effect. This time I really got it. . . . I'll finish it tomorrow. The hand in the glove is only suggested, but with three strokes, tap, tap, tap, you'll be able to feel it."[32] The painting was finished early in 1880. It exemplifies Couture's highest precept: "Let us not forget that we must place on the lips of a man what he thinks but will not say. We have to force the individual to reveal himself: that is the mission of art."[33]

In the letter Renoir wrote from Capri, he referred to this portrait and to Proust, who had just been appointed minister of fine arts in Gambetta's newly formed government: "I suppose that the intelligent and honorable minister . . . is aware that his portrait is destined for the Louvre and not for him." With Proust in the ministry, could official recognition still be out of reach?

The portrait of Antonin Proust, finished in the first months of
1880, represented much more than the image of a man who
had been a friend for more than thirty years (Fig. 60). It was also a re-
flection of Manet's anguish and his manner of dealing with it. When
he told Proust about the thoughts that had crossed his mind while
painting the portrait, he revealed, apparently for the first time, that
he had always wanted to paint a Christ on the cross: "It was an obses-
sion. I did you as Christ wearing a hat, a frock coat, and a rose in
your lapel . . . Christ going to see Mary Magdalene."

That there should have been so far-fetched an association reveals
the identification of a man, scorned and misunderstood, with the no-
blest symbol of human suffering. There was nothing presumptuous
about it. Manet was not comparing himself to Christ the savior or to
the messianic teacher. He was seeing in the hallowed image of the
crucified Jesus the most eloquent expression of the torment of mortal
man. "But enough," he added, "now I'm getting lugubrious. It's all
Siredey's fault. Whenever I see doctors they always make me think
of . . . undertakers. And yet, tonight I feel much better." This passage
indicates the mental processes linking Proust's portrait, Christ on
the cross, and Manet's personal cross of professional humiliation and
betrayal by his body. When he said these words, Manet was coming
to grips with his situation, despite his denial for public consump-
tion.

There was little he could do to change the course of his life beyond
leaving a few more, perhaps better, paintings. "Who is it," he once

asked, "who said that drawing is the script of form? The truth is that art must be the script of life."[1] This was not mere theory; Manet did exactly what he said. His café scenes of the preceding three years give us a sense of the artist's world that is as immediate and as personal as a handwritten letter. And those scenes tell us more than a photograph could, for we have the vision of the man who participated in them, colored by the emotions they aroused in him. In this respect the portrait of Antonin Proust is one of the most complex, characteristic, personal works he produced.

Proust — same age, same education, same social background as Manet, sharing similar political and artistic interests, sartorial elegance, intellectual refinement, and many acquaintances — was almost an alter ego. He did not have Manet's talent, but he could share his ideas, his aspirations. Proust understood the making of art, having himself been trained in Couture's studio, and he understood Manet's art. When Manet said that only Proust could pose for the kind of Christ he had in mind, he was seeing Proust as an image of himself — a portrait of the other as self. Manet by then had a clear perspective on himself. It was not without self-pity, expressed only to an intimate like Proust, but it was more of an overview than a lament. "I'm in no hurry," he replied when Proust, now in an official position, talked about buying some of Manet's paintings for the Luxembourg, the museum of living artists. "There was a time when I was, but I no longer am. I have become patient, philosophical."

Manet wanted to be seen as a whole — an entire wall of Manets — or not at all. "Do you see me in the Luxembourg with one painting? Olympia or Père Lathuille?" This statement, made more than once to Proust and to others, indicates the connective tissue, the thematic material, that runs through his work, even if it is not immediately apparent. Moreover, he knew how much official opposition there would be to buying even one canvas signed by Manet. When Proust reminded him that Boy with a Sword, all alone, had stirred up "a little revolution" in America, Manet continued to object. That might be all right outside of France, but not in France. "I don't want to look like a swatch in a sample book." He would rather gamble on the future. "I will wait, or at least my work will wait."

He had been mocked, insulted, reviled, rejected. Why would he not have been haunted by the image of a suffering Christ? What other figure was so cruelly misunderstood, so harshly mistreated? For a non-

believer, this was hardly blasphemy. Even believers had long sought martyrdom in imitation of Christ. Manet was not in search of saint-hood; his suffering was not self-inflicted. For him this was analogy, not imitation. His generation had been largely formed by the preceding one — trained to think by eighteenth-century rationalists, to honor reason above faith, however much store the romantics set by emotion. What remained of faith for many like Manet was its icons, a common language immediately recognized, even though they came out of a world that had largely disappeared. For a painter to think of the iconic Christ as an expression of humanity's tortured existence, or of his own, is no more outrageous than for a poet to use Prometheus, or a novelist Ulysses, to express other aspects of human experience.

There is yet another side to Proust's portrait that makes it self-referential. Proust's pose — one hand gloved, the other holding a glove and a cane — recalls Fantin-Latour's 1867 portrait of Manet. Both models are top-hatted, fashionably attired, their white shirt cuffs extending the prescribed three-eighths inch below the jacket sleeve; both candidly observe the viewer with their clear blue eyes; both exude good taste and good breeding. Fantin painted an individual who looked utterly unlike the conventional artist, whereas Manet painted a man whose appearance was typical of an upper-class public servant. What Manet projected in his image of Proust — which may have contributed to the "lugubrious" thoughts he voiced — was the fulfillment of Auguste Manet's dream for his firstborn: a high position in a dignified career. Instead Manet was still regarded with contempt by the establishment, still at the mercy of Salon juries and Salon reviewers. Proust was everything that would have satisfied Manet's father, everything that Manet was not and would never be. And now, how much time was left for him to snatch a bit of success, before it was too late to enjoy it?

The portrait was accepted for the Salon of 1880, along with *Chez le Père Lathuille*. That was already a victory. But Manet still had to worry about where the paintings would be hung. It was one thing to be accepted, another to be visible. He was pleased with the two pictures. He confidently told Proust, "I'm going to have a Salon next year that will make a big splash. . . . So long as those numskulls don't throw me out or, having let me in, don't shove me under the eaves." Every year the pattern had repeated itself. Either his work was rejected outright or it was maliciously hung in the dark. He

was so tired of it all. This time he asked his friend Antoine Guillemet, who had posed for *The Balcony,* to intercede for him. Guillemet had some influence, but not enough. "You ask me about placement," he wrote Manet. "You did not have to mention it, for I will recommend you. Unfortunately, we are highly suspect [those known to be Manet's friends], and they will try to prevent us from participating in the hanging. It's always the same old story. Why doesn't P[roust] use his influence. . . . Until he does, things will not go as you would like."[2]

Soon after, Guillemet congratulated Manet on the position of the portrait, but it was on a strip of wall set across a corner, on the highest tier, scarcely visible. A cartoonist, for once sympathetic, wrote in his caption, "The public will certainly be sorry not to see the portrait of M. Antonin Proust by Edouard Manet. They should complain to the jury about this omission."[3] Bazire reports that in spite of its position, people were attracted by the painting from afar, but when they read the artist's name, "the unbiased were amazed, the fools were sorry, and the smart alecks were enraged by their first impression."

The reviews were mixed, as always, some very good, some stubbornly hostile. One declared, "A portrait by M. Manet is the representation of the physical and moral qualities of the individual." Another scoffed at the hat: "The portrait would be excellent if M. Proust's hat were on his head, or if the genial deputy had his head in his hat." A reactionary satirist, hoping to inflame his readers, wrote that if Proust, the likely candidate, were named minister of fine arts, Manet would become the director of the august Ecole des Beaux-Arts, thus destroying the entire tradition of art: "One cannot deny the originality of M. Manet: it resides specifically in an indifference to drawing forms, in not modeling them, and in replacing light and shadow — which ordinary artists continue to put on their canvases — with flat primary tones." Albert Wolff, complimentary at the beginning of the sentence, all but erased what he had written by the time he reached the period: "What fine qualities in the *Portrait of Antonin Proust* . . . but why must Manet's work always be inferior to his talent, which is great? . . . in spite of enormous work, the picture remains in the state of a working sketch."

But Armand Silvestre, who had not always been a supporter and had not even mentioned Manet in his review of the previous year's Salon, raved about the portrait: "What courageous modernity in the

physiognomy and in the clothing! . . . I have never understood why the public hesitates before a painting whose first effect is to caress the eye with admirable freshness of color." He was equally enthusiastic about *Chez le Père Lathuille:* "There is extraordinary vitality in this little scene of ordinary life. . . . In this somber Babel of stacked canvases, his paintings are like windows open to a view of sky and fields."

Of all the reviewers, Zola was the one most closely watched by Manet and his intimates. Zola had amends to make for his remarks of the year before, published in St. Petersburg. Now his compliments would have to be in unequivocal French, not dubiously translated Russian. For the casual reader of his lengthy section on Manet, it might be hard to see the meaning for the words. But Manet surely found his way through the thickets of prose and saw that Zola was paying homage merely to his influence on contemporary painting, not to the quality of his work.

It is now fourteen years that I have been one of the first to defend M. Manet against the idiotic attacks of the press and the public. Since then, he has worked hard, constantly fighting, impressing men of intelligence with his rare artistic qualities, the sincerity of his efforts, the originality of his color . . . one day people will recognize how signal his position has been in this period of transition through which our French school is presently going. He will remain its most acute, most interesting, most personal representation. Already today, we can measure his importance in the decisive role he has played for twenty years; one need only see the influence he has exerted on the young painters who came after him. And I do not mention certain of his elders who totally pillaged him with incredible skill, all the while smiling disdainfully. . . . As for the young painters who benefitted so much from the works of M. Manet, they comprise a vast school today, of which he should rightly be the leader; *they may try to deny him that role, challenge him, find him incomplete, say that he has not kept his promises, that the artist in him has remained inferior to the new technique he introduced after Courbet and the landscapists,* it is nonetheless true that each one of them has borrowed something from him. . . . That is the true glory of M. Edouard Manet: his influence has reached the pupils of M. Gérome and M. Cabanel, passing through the impressionists, who are his direct offspring [emphasis added].[4]

If nothing else, the lycée trained its students in the art of rhetoric. The lines in italics offer a brilliant example of the rhetorical device of preterition, which allows one to state negatively what one really means. Zola in effect was repeating his own reservations of the year before, but this time under the cloak of Manet's reluctant disciples. For those who had not read the earlier article, the bad faith of this prolix passage (less than half of it is quoted above) would not have been evident; it could have passed as praise and support. So much space has been given here to Zola's review to demonstrate the back-handed compliments Manet continued to receive from those who proclaimed themselves his defenders. If they did not understand, if they could not evaluate his works fairly, what could he expect from the Albert Wolffs? His only hope was in future viewers. How pained he would have been to read what continued to be written more than fifty years later, by the very critics who claimed to admire him in spite of his failings, not seeing that those "failings" were deliberate, were indeed strengths. It would take a more radical undermining of the notion of art as it had been practiced for millennia, the demise of figure painting and objective art, before both critics and public saw him with the kind of modern vision he had been counting on.

A month before the 1880 Salon opened, the editor of *La Vie moderne,* also director of its gallery, invited Manet to exhibit a selection of his most recent paintings, not because the director liked Manet's work, but because he knew that Manet was an attraction. The gallery was ideally located for shoppers and strollers on the boulevard des Italiens, where it meets the Passage des Princes — the smallest of ten marvelous indoor arcades, begun fifty years earlier, reminiscent of the great bazaars of Cairo and Istanbul. One could (and still can) window-shop, browse in bookstores or galleries, or stop for tea at a café, all protected from wind, rain, and heat. The show opened on April 25 with twenty-five works, fifteen of them pastels, among them a portrait of Mme Zola and another of Isabelle Lemonnier *(Young Lady with a Rose).* Mme Zola had wanted him to do her portrait but was too embarrassed to ask him herself, so her husband communicated her desire. We have only Manet's reply to document the exchange: "I am delighted to be able to do something that would give you pleasure and am entirely at your disposal. Shall we start next Monday, twelve-thirty at the latest?" When Manet later asked Mme

Zola to lend him the portrait for the show, his note reveals his deteriorating physical condition: "Forgive me for not making my request in person, but I have been prohibited from climbing stairs."[5]

The pictures were hung against Oriental rugs lent by a neighborhood merchant, for whom this was excellent advertising. The show was very well attended, and midway through its three-week duration, the magazine associated with the gallery published a review stating that in all of jaded Paris, there were only ten people who could arrest the attention of a passerby. "Edouard Manet is one of those ten. . . . The exhibition of his new works . . . has revived old quarrels. This exhibition is without a doubt the event of these past few days."[6] One had to have seen it, if only to talk negatively about it. Even after it was taken down, Manet remained a presence, for immediately following his exhibition, the gallery held another devoted to Monet, whose portrait by Manet was on the cover of the catalogue.

Reviews of Manet's two Salon paintings began appearing within days after his gallery show came down. The ferocity had abated, but even the meticulous portrait of Proust elicited the old charge of "unfinished." Weary and dejected, Manet wrote defensively to Proust toward the end of May:

> It is now three weeks, dear friend, that your portrait has been in the Salon, poorly hung on a chamfered wall near a door, and even more poorly judged. But it is my lot to be demeaned and I take it philosophically. And yet, no one would believe how hard it is to place a single figure on a canvas and to focus all attention on that one and only figure, without losing any of its vivacity and fullness. Compared to that, to do two figures that derive their attraction from the duality of the individuals is child's play. . . . I'd like them to try. But I won't be there to see it. After I'm gone they will admit that I saw and thought right. Your portrait is an honest piece of work if ever there was one. I remember as though yesterday how quickly and summarily I treated the glove of the ungloved hand. And when you said just then, "I beg of you, not another brushstroke," I felt that we were in such perfect agreement, I could not resist the impulse to embrace you. Ah, if only later on no one has the crazy idea of sticking this into a public collection! I have always had a horror of that mania for piling up works of art without allowing any space between the frames, the way the latest goods are displayed on the counters of fashionable shops. Ah well, *qui vivra verra.*[7]

This might have been the moment for Manet to receive a medal. He had not won anything but an honorable mention since his first Salon. His importance to modern painting had been given enough recognition for a prize jury to have been swayed. An anonymous critic reviewing the Salon that year for *Le Voltaire* (in which Zola's articles on naturalism appeared) had expressed an opinion that was far from idiosyncratic. In his discussion of portraits of political figures, he wrote, ". . . and so, here is M. Edouard Manet, who has now become an official painter. . . . The gentlemen of the Académie must, of course, take their position, but we no longer laugh at M. Manet's paintings. His portrait [of Proust] is one of the most interesting in the Salon. It has all the qualities that make a work solid and powerful."[8] Despite talk of a medal, nothing came of it. The gentlemen of the Académie held fast.

Between the spring and summer of 1880 Manet seems to have produced nothing he wanted to finish, if he worked at all. His condition took a turn for the worse, and Dr. Siredey sent him back to Bellevue for another cure under the supervision of Dr. Materne, whom Manet portrayed in a fine pastel. The villa he rented from Emilie Ambre, close to her own manor, now accommodated Suzanne, Eugénie, and, on weekends, Léon as well. Then twenty-eight, Léon had made some headway in life. He had risen through the lowest ranks of the stock exchange, and he was now making a decent living trading on his own with an associate. Still unmarried, he continued to live in the one-room apartment on the ground floor of 51, rue de Saint-Pétersbourg and was extremely attentive to Manet's needs and wants, ferrying mail and running errands.

On May 29, the eve of his departure for Bellevue, Manet wrote to Mallarmé apologizing for not coming to see him while he was ill. "You know it is because I am not allowed to climb stairs. Let us nevertheless wish each other good health and good luck." Three weeks later he wrote again, telling Mallarmé that persistent bad weather had prevented him from working but that the country air was just what he needed, adding unconvincingly that he hoped "to be better after three or four months here."[9] He was not to return to Paris until the end of October.

During those five months he endured boredom, the rough handling of the "rurals" who administered the showers, and weeks of sunless days, but he would tolerate anything, he told Mallarmé, to get well. In

a letter to Méry Laurent, however, he opened his heart: "As for penance, my dear Méry, I am doing it as never before in my life. So long as it turns out well, I will have no regrets. But the cure here is absolute torture."[10] Three times a day he was subjected to this "torture," aggravated by the contrast with Dr. Béni-Barde's clinic, where the "Béni-Bardeuses" were gentle and the Nouvelle-Athènes was accessible.

For much of the first month in Bellevue he seems to have done little more than write to his friends. He was making every effort to sound optimistic, but even so the "joyful fighter," as Renoir called him, had dark thoughts. A long reply to Zacharie Astruc dated June 5, 1880, reveals him with his guard down: "As you put it so well, time is a great healer. And so I am counting heavily on it. I live like a mollusk in the sun, when there is any, and as much as possible outdoors, but without any doubt, the country has charms only for those who aren't forced to stay there. . . . *A bientôt, mon cher ami.* Good luck, and good health. That is still what is most precious."[11] Letters to Mallarmé and Duret disclose his mixed feelings about Zola's recent assessment of his work. As if hoping to be contradicted, he offered to send Mallarmé the articles in case he had not yet seen them, eager to know the impression they made on him and on the public.

Throughout the rest of the summer, Manet wrote persistently to Isabelle Lemonnier. Hardly letters, they are enchanting little notes, each one illustrated with an ink wash or a watercolor and in turn charming, plaintive, persistent, or solicitous.[12] He clung to her as to a life buoy, this young woman who had spent so many hours in his studio, accepting his compliments, encouraging his interest. Later she disparaged his talent: "Manet was unable to draw. He was always starting my portraits over. He destroyed I don't know how many studies before my eyes. I am sure he would have given them to me had I asked, but I already had so many portraits."[13] Now his only contact with her was by mail.

Among his first missives was one with two unsatisfactory ink washes of her head: "What one does from memory is worthless." He had done seven portraits of her the year before, six of them oils, and yet he could not paint her from memory: "If only I had the model before me" — not just for a more accurate image but also because he longed for her presence. "I shall write to you often, since you allow me to do so; it gives me pleasure. And send me a photograph so that I

can do a better likeness when I sketch you." He instructed her to send her letters through the mail, which arrived in the morning. He sent her a brief note — "Just a quick good morning" — and told her he wished the mail brought him a greeting from her every day. "I fear you are not as fond of your friends as I [am of mine]," he wrote. Then, shifting to a third party, he added, "Léon is counting on you for the festivities [of July 14]. Take care not to let the preparations for your move tire you too much." His handwriting in this note is unsteady, increasingly so with each line; by the end it is barely legible.

The first celebration of Bastille Day as a national holiday, with fireworks and parades, was held on July 14, 1880. Three days earlier Gambetta's government had decided to grant amnesty to all Communards who were still jailed or exiled. This event would inspire a series of political works by Manet — some realized, some only projected. It was the occasion for one more note to Isabelle — "*Vive l'amnestie!*" — decorated with a cluster of flags. Below, in paradoxical apposition to the celebration of pardon, he added, "I will not write you anymore. You never answer." He did not keep his word. A recriminatory note written shortly after reads, "I am waiting, dear young lady, for an account from you of the celebration. You were seen taking a stroll in the evening. With whom? Your fireworks and the illuminations in your garden were mentioned in the papers. Keep me informed about what people are saying and doing. I am at a loss to understand your silence."

He continued to get news of her from Mme Jules Guillemet, their mutual friend, and from her sister, Mme Charpentier, when Isabelle failed to provide any. He even complained to Mme Guillemet that he had not seen "Mlle L," who was moving and whose mother was ill. "Still, I'm surprised to have had no news from her," he wrote. A last appeal to Isabelle reads, "Assuredly, you do not spoil me. Either you are very busy or you are very naughty. And yet, one doesn't have the courage to hold a grudge against you." He did not stop trying: "What has become of you? It is probably your move that keeps you from thinking of your friends. A *bientôt, n'est-ce pas;* soon, some news from you, or better still, a visit." He had played all his trumps: the famous painter exhibiting her portrait, charming her with his wit and gallantry, amusing her with his clever sketches. He was finally reduced to jealousy and reproaches.

But when he learned that she was ill, his humiliation changed to solicitude, and he could take up his pen again to ask her sister about her: "You know how much interest and friendship we feel for her. Would you send news of her as soon as you can to reassure the hermits of Bellevue." The plural was mandatory; he could hardly have spoken in his name alone, although he cannot have been naive enough to think that Mme Charpentier did not know whose concern he was voicing. It is painful to see this man hopelessly pursuing a girl young enough to have been his daughter, who at first may have been flattered by the passion she had ignited, but who also may have been annoyed by his insistent attention. His pride was briefly consoled by the thought of her move, her mother's illness, and her own, which allowed him to commiserate: "Everything has fallen on you at once. But you must not exhaust yourself. You are convalescing. I would send you a kiss if I dared."

In August Isabelle left for Luc-sur-Mer, on the western coast of Normandy, with the Charpentiers. A somewhat longer letter from Manet suggests that he had heard from her in the interim, telling him where she was going, and with whom, for there are no recriminations this time; he did not want to discourage her from continuing their correspondence. He sent a message that has the breezy informality of a note to a masculine friend, with a luscious peach at the top of the page (Fig. 59) and a somewhat risqué expression: "It is not my fault if the peaches in Bellevue are ugly, but the most beautiful girl in the world can only give what she has. Tell me what's going on at the beach in Luc and surroundings. Nothing shocks me and everything surprises me. I have worked a bit and except for the weather — almost always stormy, which makes me irritable — I would be fine. You are surely swimming in the sea. Tell me all about it, and other things too. My greetings to Mme Charpentier, to you, and to the amiable publisher." Then, later in the month, when the little yellow plums of a variety called mirabelle had come into season, he sent her a plum-decorated quatrain:

> A Isabelle
> Cette mirabelle
> Et la plus belle
> C'est Isabelle

By the close of his stay in Bellevue, he was still hoping to see her and wrote petulantly on October 20, "You promised to invite yourself to lunch with us before our return. Won't you give me this pleasure? I know it is asking a lot so late in the season. We will be back [in Paris] on November 3."

To his other friends he wrote jaunty notes. "The air of Bellevue has done me a great deal of good," he informed Zola. And to Eva Gonzales, "I am much better and am beginning to regain hope." Even with Méry Laurent he tried to keep up the pretense, but it rings hollow. In his enforced retreat, the absence of news was like a betrayal. Reproaching her, too, for her silence, he asked, "Is it laziness? Even that would be better than indifference. Has the most sensitive of hearts succumbed to a new passion? Quickly, give me news of the one whose life is so dear to me. My health continues to improve, aside from occasional bouts of depression. True, the life I lead is not exactly varied. I am not even inclined to work, but I hope that will change in a flash." Méry's alarmed reply prompted him to retreat behind his mask: "I really do not understand your letter, my dear Méry. Prolonging my stay in Bellevue does not mean that my health is worse. On the contrary, I get better and better, but I expect October to be beautiful and am going to remain in the fresh air."

He could not hide the truth from Proust, who came out to see him. During one of Proust's visits they went for a walk along the Seine. Manet was soon exhausted and had to sit down. A little girl approached selling flowers. Learning that on a good day she sometimes made two francs, Manet gave her three and made Proust give her another three. "Don't you think it's exasperating to be in the condition I'm in? If I were well, in a hop, skip and a jump I'd have gone to get my paint box at the house." As they walked back, he reflected on the child. "How interesting the contrast between the awkwardness of a kid and the poise of a young lady. But I no longer have the strength to convey it. Ah well, that vision made me forget my misery for a moment. That's still something."

The fiction was played out over many months. Even those closest to him had to pretend that he was improving and would shortly be restored to full health. A year later, when his condition was hardly a secret (many friends came to see him and talked to others), he still maintained the public facade. On July 8, 1882, an item appeared in a

newspaper: "We are distressed to learn that M. Manet is presently very ill. The condition of the famous painter of *Le Bon Bock* is not, however, as serious as some are saying, and we do not believe that his many friends need be unduly alarmed." Signed: *The Sphinx*. Manet, in the country at the time, was furious and wrote at once to Méry, "I don't know who played me the dirty trick of putting into *L'Evéne-ment* a dreadful bulletin about my health, which was reprinted in all the papers." To the newspaper he wrote on July 10, "Dear Sphinx, I read this morning a notice about my health which, though extremely solicitous, is inaccurate. I am not at all sick. I simply twisted my ankle before leaving Paris. You will be kind enough to reassure 'my many friends,' as you called them, as quickly as possible."[14]

Manet's return to Paris in November 1880 was followed by an astonishing burst of productivity. The rest, and perhaps the therapy, had reduced the pain, and he could get around more easily. The amnesty announced on July 11 and passed by the Chamber of Deputies on July 21 brought back to France Henri Rochefort, a vitriolic polemicist, who was to become one of the most raucous nationalistic and anti-Semitic voices during the Dreyfus case seventeen years later. Had Manet lived that long, it is doubtful that he would have wished to have any contact with Rochefort, given his close relations with Clemenceau and Zola, both vehement Dreyfusards, and his many Jewish friends. But in 1880 Rochefort had just published a book about his dramatic escape from a penal colony in New Caledonia, the Pacific island to which political prisoners had been sent since its acquisition by France in 1853.

In a fictionalized account titled *L'Evadé*, which caught Manet's fancy for a painting, Rochefort related his escape during the night of March 19, 1874. Fleeing with five other exiles, they made their way across the water in a whaleboat to an Australian three-master waiting to take them to Sydney. From there he went to America, finally settling in Switzerland until he was allowed to return to France. Manet — who had known Rochefort as a militant republican pamphleteer, publisher of the newspaper *La Lanterne*, and a member of Nina de Callias's circle before the Commune — was naturally interested in him, although by 1880 Rochefort was at the opposite end of the republican spectrum from Gambetta. By then Gambetta had become more moderate and had been replaced by Clemenceau as the voice of a more leftist republicanism.

As soon as he was back in Paris, Rochefort founded a new paper, *L'Intransigeant*, for which Edmond Bazire, Manet's first biographer, served as art critic. The ties were many, but what may have attracted Manet to Rochefort in 1880 was his new persona of romantic hero. A shorter, more factual account by one of Rochefort's fellow escapees, Olivier Pain, which had appeared in 1879, portrayed him as a less dashing figure. Rather naively, Manet was proposing to paint a picture that would never find approval with a Salon jury, most of whom had little sympathy for an ex-Communard. Manet's friend and sometime model, painter Mercellin Desboutin, served as a go-between with Rochefort, a relative. "I saw Rochefort today at noon," Desboutin wrote Manet encouragingly. "The project of a sea like the *Alabama* [Manet's naval battle], carried the day! You will have at your disposal not only Robinson [Crusoe]-Rochefort, but Olivier Pain-Friday as well." A few days later Manet reported to Mallarmé that he had seen Rochefort, who had filled in the details about their boat: "The color was dark gray. Six people, two oars." Manet was excited about his new work and talked about it to Monet, who passed the news on to Duret: "I saw Manet, in fair shape, very busy with a sensation-making picture for the Salon, Rochefort's escape in a rowboat, on the high seas." [15]

Manet did two versions of the scene, and in his mania for exactitude he had a whaleboat brought to the courtyard in front of his studio. Although the truth differed somewhat from the first, larger painting — the boat never left the harbor of Nouméa, and Rochefort was not the one at the tiller — Rochefort's account was the one Manet had read and was therefore the one he depicted. Both versions demonstrate his gift for painting open water. The first version, with a recognizable Rochefort at the tiller, shows the boat in the foreground surrounded by shimmering waves (the water was described by Rochefort as phosphorescent) — a treatment of water Manet had learned by experience on his way to Rio and by example from Delacroix. It has been said that almost every modern master painted a brilliant copy of Delacroix's *Bark of Dante*, Manet among them. But another work by Delacroix, *The Shipwreck of Don Juan*, may have had a greater influence than *The Bark of Dante* on Manet's handling of water in his great seascape *The Battle of the "Kearsarge" and the "Alabama*," which in turn was recaptured for Rochefort's escape.

Eric Darragon has written with much sensitivity about the two

paintings, the second showing the boat at a much greater distance, the figures no longer distinguishable, and the waiting ship so small a speck in the distance that the entire picture is a seascape of despair. In this second version, Darragon says, Manet "moves into a vision that is more loaded with anguish and solitude. His first picture is a portrait in action, the second communicates moral values related to the escape itself."[16]

As it turned out, Manet decided against submitting either of them to the Salon, although the themes they express — freedom (the escape) and republican virtue (the amnesty) — might have made for an interesting, albeit controversial, submission. Instead Manet sent a portrait of Rochefort, in the same uncompromising pose he used for Clemenceau at about the same time. Rochefort was not a willing model. His taste in art did not go beyond the eighteenth century, and as for the work being done in his own century, he found it fake and ugly — an opinion he apparently cultivated over many years, for in 1903 he published an article on contemporary art titled *L'Amour du laid* (The Love of the Ugly).[17] But he finally came to the studio and grudgingly posed, though not for long. Manet managed to finish the painting and sent it off to the Salon of 1881 — a life-size portrait of a striking figure whose own fakery did not go entirely unnoticed by Manet. Françoise Cachin sees "the swashbuckler [peeping] out from behind the hero."[18]

Over the next eight years Rochefort would move all the way to the right, giving his support to General Boulanger, a protofascist whose fanatical jingoism might have led to a dictatorship had he not been indicted for treason. Manet could not have foreseen Rochefort's reactionary future, but he must have sniffed out the poseur. It did not take long for him to learn that Rochefort's version of his escape was inflated, but his electrified hair and pockmarked face were authentic.

It is hard to determine how much in this portrait was sincere admiration, how much an interest in actuality, and how much a love of irony. Manet placed great confidence in the work, even announcing in a letter to Duret that he was sending it to the Salon and that he rather expected it to have the same success as *Bon Bock*. It is nevertheless hard to take this "political" portrait as seriously as those of Proust and Clemenceau. This posturing "hero," with pitted skin and wiry hair, is portrayed with a subtler touch than the strange portrait

that preceded Rochefort's by a few months and with which it was paired at the Salon.

Eugène Pertuiset, one of the "great white hunters" of the period, returned to Paris with tall tales of his expeditions. Manet had known him for years and appreciated his support. Pertuiset had already bought a few of Manet's paintings before 1880 and would buy more later. The two men also shared the experience of waiting for an audience with Napoleon III, to whom Pertuiset was making the gift of a black lion skin. He proposed that Manet come along and meet the emperor. They were kept waiting for three hours and then told that the emperor was too busy to receive them. "How Pertuiset fumed! You should have seen him roll up his skin. Napoleon evidently understood that the skin would be useless to him. Had it been the skin of a doe [a pun on *biche*, a courtesan]! And so, I did not see Napoleon III and he did not see me."[19]

The portrait of Pertuiset smacks of farce: the jaeger outfit, more readily seen in the Black Forest than on the Serengeti Plain; the patently taxidermic lion skin; the hunter squarely facing forward, cocking his gun, ready to take aim (Fig. 65). But at what? He has already shot his quarry. At the public, perhaps, the real beast? Darragon provides an excellent historical-political background that includes colonialism, the moral question of new weapons under discussion at the time, and the recently unveiled symbol of French nationalism — the enormous lion statue (seventy-two feet long by thirty-six wide) at Belfort by Frédéric-Auguste Bartholdi, the Alsace-born sculptor of New York City's Statue of Liberty, commemorating the 108-day defense of that Alsatian city during the Franco-Prussian War. (A copy stands in the Place Denfert-Rochereau in Paris.) Pertuiset's Teutonic hunting suit may be an intended reference to that war. "He is thus not only a hunter whose fame goes back to the last years of the Empire," writes Darragon, "he is also a figure of current interest capable of incarnating the colonial dream. In his way, he expresses the supremacy of a modern-day Hercules over the world and the wild."[20] And perhaps as important or more so, he expresses colonialism's underside, nationalism, which was to rage throughout the remainder of the century.

Early in his career, in 1862 with *Mlle V . . . in the Costume of an Espada* and *The Dead Toreador* of 1864, Manet had begun exploring the theme of the antihero, not yet in a comic vein (that was to come

with age), but already containing the irony that was to be so characteristic of his view of life: the grand gestures, the heroic poses, the masks and disguises that conceal a hidden truth — in this case perhaps the ugly truth of colonialism and armaments — but always in layers that themselves conceal an underlying meaning. On a superficial level, a critic of 1881 could appreciate the portrait of Pertuiset for its masterful portraiture. A more adept viewer, like Renoir, could see the humor that was not shared by many: "They did not understand that Manet was making fun of the lion hunter with his blunderbuss." But he also was poking fun at the Salon viewers who would have raved about a realistic painting of a lion hunt. For Manet that was not much of an achievement, neither the hunt scene nor the actual hunt. What has the hunter accomplished with his huge rifle? Another skin, another rug, a trophy. An empty victory. On a much deeper level, we are reminded of death, a long-standing preoccupation of Manet's. In April 1880 his old friend and onetime dueling opponent Edmond Duranty died prematurely of a dreadful infection. A few months later, talking about Duranty in Pertuiset's Montmartre garden, Manet said, "Every time I hear his name it seems to me the poor fellow is beckoning to me to join him."

By then Manet was in much pain, and it showed. "He grew harsh toward those of his comrades he loved most," Proust remembered. The effort of pretending he was well was too much for him at times. He became exasperated over the robust good health of his concierge, Aristide. The contrast between his own diminished faculties and Aristide's inexhaustible vitality was intolerable. He was infuriated when a shopkeeper offered him a chair. "What do I need a chair for? I'm not an invalid!" he growled. As they were leaving the shop, he complained to Proust, prophetically protesting, "She made me look like an amputee in front of all those women!" He could no longer walk without a cane, but he would not admit, especially not to others, that he was suffering; he wanted to believe it was transitory. He was constantly dreaming up new projects, avidly sought the company of friends, and was prepared to go anywhere or do anything that would take him away from himself and those closest to him.

His mother and wife were a constant reminder of the truth. Nothing irritated him more than their anxious solicitude. Méry Laurent was another matter. She and, above all, her maid, Elisa, fussed over him ceaselessly, but they distracted him, they amused him. Manet

wanted nothing more than to be entertained, to be distracted from his growing infirmity by work, by the company of charming women and clever men, anything that represented normal life. In the last weeks of his life, when Charles Toché, the friend he made in Venice, came to the studio and found him working with difficulty, he said, "I work because after all one has to live."[21]

For a while he lost himself in a work that would seem to reflect nothing of the period of his life in which it was painted. Proust had suggested that he do a series of seasons. Berthe Morisot had done a summer in 1878 and a winter in 1879–80, and Alfred Stevens had been commissioned by the king of Belgium to produce the four seasons, which may have added to Manet's interest in the idea. The seasons as a subject had a long history in painting, both in Oriental and Western art, and was traditionally allegorized by beautiful women. A lovely model Manet had painted in the late 1870s, Jeanne Demarsy, took on the tonier spelling of de Marsy when she went on the stage in 1881. It was she who posed for his ravishing *Spring*, in an outfit carefully selected by Manet himself (Fig. 63). Looking at her in her flowered hat and dress, one is reminded of a brief passage in Proust's memoirs. Manet would give in to "bitter thoughts" on days when he felt more restricted in his movements. But the sight of a flower could restore his cheerfulness. "I wish I could paint them all," he exclaimed, "not fake ones, but the others, the real ones." Jeanne, then in her twenties, incarnates an entire garden of flowers, her pretty features framed by the frilly bonnet, against a background of luxuriant foliage. Just to paint her pert mouth and upturned nose, and all the flowers on her person, must have provided hours of joyful distraction.

The Salon of 1881 finally brought a long-awaited reward, though not the one he had hoped for. Nine painters, among them Manet and John Singer Sargent, received a second-class medal. No first-class medal was awarded that year. Now, with only one Salon left in his life, he was finally *hors concours;* he would never again have to submit to a jury's decision. A major change in the composition of the jury had made this possible. A committee of ninety had been elected by all the artists who had been admitted at least once to the Salon. Decisions would thereafter be made by artists alone, without the intrusion of the state through its representatives from the Académie des Beaux-Arts and the Ecole des Beaux-Arts. As of 1881, all Salons would be administered by the independent Society of French Artists for the

Exhibition of Fine Arts, which included the selection of works and the awarding of honors, except for the medal of honor.

Although Manet's was only a second-class medal, awarded to an artist who had been showing at the Salon for twenty years, it nonetheless created a furor. The caption of a cartoon in *Le Charivari* reads, "Ah-hah! So you're going to show your dog at the Tuileries! — Yes, and I've named him *Manet;* perhaps that will help him get some kind of medal." What was so objectionable to the old guard about this award was that it made Manet eligible for the Legion of Honor. A fellow painter, Alphonse de Neuville, wrote him, "You can therefore be decorated immediately, which may annoy a great many bourgeois, but we see it as justice for the sincerity and individuality of your talent."[22]

The Pertuiset portrait was another matter, but despite the snickers, another member of the committee, Ernest Duez, wrote Manet that "it was not too hard to get it through, aside from a few gnashings of teeth. The moral of all this should console you. It proves that you are alive, and very much alive."[23] Most surprising, it was Alexandre Cabanel (of the delectable Venus), presiding over the awards jury of thirty-three, who influenced the vote. *Pertuiset, Lionhunter,* which looked more like a Fauvist work then than it does today, was the stumbling block. To their objections Cabanel is reported to have replied, "Gentlemen, there may not be four among us who could paint a head like that."[24] Each of the seventeen jury members who voted to give Manet his medal received his thanks in a personal visit.

The version of *Pertuiset, Lionhunter* seen at the Salon of 1881 was very different from the painting as it looked some years later. Jacques-Emile Blanche, who often went to Manet's studio between 1880 and 1882, had watched Manet work on *Pertuiset* and wrote about "chemical reactions" in the paint that, over the years, produced almost "miraculous" alterations: "At first, the colors seemed to clash in their violence and crudeness . . . [later] they softened, taking on the patina of enamel. . . . What are now grays in *Pertuiset* were violets shot with pink; the flesh was tomato red, the landscape composed of crimson, winey lilac, and bluish greens, all rather displeasing. Time works *for* Manet and *against* the other modern painters."[25]

Manet wisely did not attend the awards ceremony, during which many behaved like unruly schoolboys when his name was called. The

two antagonistic factions were described by Philippe Burty as "the academic carp and the independent hare."* The younger painters — "fruit of the coupling of the carp and the hare" — looked to Manet as their leader, "the leader of a school without a school," not as their model but as the one to blaze a path for their innovations and for those to follow.[26]

That summer Manet did not return to Bellevue; the treatments had proved useless. Dr. Siredey advised him to stay away from the sea, and Gennevilliers was too humid. Marcel Bernstein, wealthy owner of a lumber business who had a summer house in Versailles, found him a modest house and garden. Manet settled in with his mother and Suzanne at the end of June. Léon, now a banker-broker with a four-room office at the corner of the rue de Clichy, came out on Sundays. He was presumed to be knowledgeable about municipal bonds but not about how to run a business.[27]

Manet continued to make plans for new paintings but made no headway. When Mallarmé wrote from Valvins, where he kept his boat, to propose that Manet illustrate his translations of poems by Edgar Allen Poe, Manet replied disconsolately:

My dear Captain, You know how much I enjoy embarking on any kind of work with you, but just now it is beyond my strength. I do not feel up to doing properly what you ask of me. I have no model, and above all, no imagination. I would produce nothing worthwhile. Forgive me. I have not been happy about my health ever since I came to Versailles. Whether because of the change of air or the variations in temperature, I seem to be doing less well than I was in Paris; perhaps I'll get over it.

A few days later, remorseful over disappointing his friend, Manet wrote again:

Now that I think of it, it was egotistical of me not to accept the project you proposed. But certain things that you wanted seemed impossible to do. . . . You poets are awesome, and it is often impossible to translate your fantasies into images. The truth is, I was not

*The carp figures in the classic simile for stupidity and ignorance: *bête* (or *ignorant*) *comme une carpe.*

well then and I was afraid of not getting it done on time. If it is possible to pick up where we left off on this matter when I return to Paris, I will try to live up to the poet/translator, and then, I will also have you there to inspire me.[28]

Two indifferent ink drawings, *Annabel Lee* and *City of the Sea,* came out of this project.

On September 23 Manet confided in a letter to Eva Gonzales that in spite of all his plans, he had done only a few still lifes and views of the garden: "I set off to do some sketches in the park designed by Lenôtre [at the Palace of Versailles], but had to make do with merely painting my garden, the ugliest of gardens." Aside from the weather ("it has been raining here for a month and a half"), he could not negotiate the distances of the grandiose park Lenôtre created for Louis XIV, the most extravagant of monarchs. He was reduced to shuffling along the little path from his own door to the bench in the garden.

My Garden, also known as *The Bench,* "regarded as a masterpiece of Impressionism,"[29] may indeed be admired for its intimacy, but at the same time it communicates a profound melancholy. The empty bench, the few roses — all the same red — the scraggly grass, and the bare trellis are hardly rivals for the exuberant flowering of Jeanne de Marsy's springtime portrait. The yellow hat abandoned on the bench indicates an absence — the painter himself, who is viewing the scene nearby — both physical and emotional. This is not a *locus amoenus,* a place that warms the heart or the eye. It is all there is: a path that leads nowhere, a space tantamount to a cage for someone who once crossed all of Paris with his rolling stride. The very facture, described by John Rewald as "swirls and splotches, energetic strokes of a pigment-laden brush, rashly drawn lines, short commas, scattered spots,"[30] suggests the frustration and anger of a man reduced to this, *"le plus affreux des jardins"* (the ugliest of gardens).

Looked at outside the context of Manet's physical and mental condition at the time, this may appear to be a charming summer scene: "It differs from the garden scenes of most of Manet's contemporaries mainly in its feeling of intimacy; most Impressionist pictures are characterized by a less personal quality."[31] From the perspective of the man who did the painting, the "personal quality," reflected in the brushwork, projects Manet's pent-up rage at having to keep his hand in practice, not in Lenôtre's vast park, but in this pitiful simulacrum

of a garden, its dimensions suited to his diminished mobility.

Manet returned to Paris at the beginning of October, his physical condition no better than before but his morale much improved. Country air might be prescribed by his doctor, but the air of Paris was what vitalized him. There was always someplace to go, friends to meet, pretty women to look at. A fierce determination fired him to fool them all, perhaps even his disease. He would show all those people who were already writing him off that he was far from finished. Rheumatism, a twisted ankle, a strained muscle, a bad foot — there was always an excuse for the cane, but he would get to the cafés, the shops, the cabarets.

A bevy of lovely women passed through his studio during the autumn of 1881. One portrait after another, in the quick medium of pastels, which he had mastered, came off his easel. Women in hats, bareheaded, with a blue bow, reading in a café. Jeanne de Marsy in a chair by an imagined beach, Jeanne de Marsy in a short cape; Méry Laurent in a side-swept hat; Mme Jules Guillemet; a young woman named Suzon, who worked at the Folies-Bergère, in sober attire; the young daughter of Charles Ephrussi's lady friend. It was Ephrussi for whom Manet had painted the marvelous bunch of white asparagus the year before. When Ephrussi paid one thousand francs instead of the requested eight hundred, Manet sent off a little canvas of a single stalk with the note; "There was one missing from your bunch."

Ephrussi was another in Manet's circle of Jewish financier-collectors. A man of great wealth and refinement, born in Odessa and educated in Vienna, he was often seen at the salon of Princess Mathilde and in other high places. Marcel Proust borrowed much from him for the character of Charles Swann. Manet also found time to paint a portrait of his cherished friend the composer Emmanuel Chabrier. All of these portraits were a rehearsal for the huge cast of characters soon to be compressed into a single painting. Like the dazzling finale of fireworks, his last burst of phenomenal energy was about to be channeled into what is arguably his greatest masterpiece, *Bar at the Folies-Bergère*, in which Méry Laurent and Jeanne de Marsy would appear on the balcony (Fig. 67). Everything he knew and thought about painting, and other things as well, would go into that picture: his summa.

The Folies-Bergère, opened in 1869, is still in existence at 32, rue Richer, a continuation of the rue de Provence, known for its bour-

geois brothels and later its *maisons de rendez-vous,* where illicit couples could meet in a more discreet venue than a hotel. In 1881 the Folies-Bergère was a long-running spectacle: café, cabaret, circus; aerial acts, acrobats, dancers; crowds of men on the prowl after women of varying degrees of availability. It was a nightly event that cost only two francs no matter where one sat or stood, and it attracted a wide range of customers, from shop clerks *(calicots)* to bankers, debutante prostitutes to kept women of various ages. Manet was in his element there, as he had been at the opera balls: the bright lights, the laughter, the movement, the air blue with smoke, the reassuring illusion that anything was possible — pleasure, oblivion, remission. There he could shut out the sound of his fears. He could mingle with the crowds and not betray his infirmity: all the men carried a cane. He went there with his ubiquitous notebook and sketched for hours.

Then one day he asked Suzon, a fresh-faced young woman who actually worked there but had none of the expected vulgarity, to come to his studio in her uniform, a lace-trimmed, square-necked, tight-fitting velvet bodice over a long skirt. He set up a marble-top counter to serve as one of the many bars on the cabaret's galleries, where patrons gravitated. T. J. Clark devotes a brilliant chapter to the institution of the café-concert and to a discussion of the painting. He sees the barmaid as "the face of fashion," which is "a good and necessary disguise." Wearing the right makeup, the right earrings, the right hairdo, she cannot be identified as middle class or working class. "For if one could not be bourgeois, then at least one could prevent oneself from being anything else. . . . The look which results is a special one: public, outward . . . impassive . . . for to express oneself would be to have one's class be legible."[32]

These are acute observations, but the painting points to deeper and more universal concerns than class. Although Manet portrayed modern life, because that was the only kind he considered valid for the modern artist *("il faut être de son temps"),* he was not particularly concerned with social inequality. "I do not pride myself on being more democratic than others," he declared to Proust in 1879. "In fact, I am very aristocratic." His principal concern was with the problem of the beholder and the beheld: art as a mirror of nature — and all that a mirror implies: reversal, displacement, deformation, ambiguity — the mirror as a metaphor for painting, the elusiveness of im-

ages, and the illusion of reality — things are not necessarily what they seem.

Reams have been written on *Bar at the Folies-Bergère*. Is that a mirror? Is she a prostitute? Where is the man standing? Hardly two descriptions of the painting, let alone two interpretations, concur. For some the barmaid is heavily made up and gaudily dressed; for others she is chalky, with a cardboard head and a mediocre body. The majority view is that since the Folies-Bergère was a market for prostitutes, any barmaid must have been one.

This barmaid is not necessarily what she may appear to be. The dislocation of her frontal image with her reflected image conveys the tension between what she represents to the ordinary patron of the establishment and how the painter sees her, or how she regards herself. She is a second-generation Olympia. Titian's Renaissance courtesan representing Venus served as the model for Manet's Second Empire Venus, who in turn informs this Third Republic Venus, only she is no longer for hire. Olympia radiates self-sufficiency; her brazen stare suggests that she will accept or reject as she sees fit, but her nudity underwrites her availability. The barmaid, by contrast, does not even acknowledge the patron's presence or the viewer's glance; nothing suggests that she might be available, except her presence in that place. Had Manet meant her to look like the typical barmaid, he would have used the model in his working sketch — an upswept blonde with bright lips, whose provocative vulgarity was natural for the part. He was not condemning the lewdness of the Folies-Bergère, nor was he protecting the defenseless working girl. She was simply his latest representation of a modern Venus.

Well versed in iconography, he even provided clues to her identity. But no one seems to have noticed, neither the critics of his own time, who were closer to such devices, nor later ones. The choice of roses was not gratuitous: "The rose was sacred to Venus in antiquity and is her attribute in Renaissance and later art. It is also particularly associated with the Virgin Mary, who is called 'the rose without thorns,' i.e. sinless."[33] To make doubly sure that neither of these aspects went unnoticed, Manet placed a white rose, symbol of purity, beside the pale pink one, symbol of divine love, in the glass on the bar (a vessel of water is another traditional symbol of purity), as well as two white roses in the barmaid's corsage. In Manet's eyes, wantonness is not a characteristic of the modern Venus. *Honni soit qui mal y pense.*

This modern image of an ancient deity has yet another claim to modernity: she is Manet's first, and perhaps *the* first, representation of the female dandy. Her impassive expression under the scrutiny of the patron recalls Baudelaire's description of the dandy's stoicism as we see it in Manet's *Self-Portrait with Palette*. Clark's description of her attitude characterizes that of the dandy, but he does not relate it to Baudelairean dandyism or to Manet's other representations of it: "[Her alienation] is felt as a kind of fierceness and flawlessness with which she seals herself from her surroundings. She is *detached*." She is impervious to the customer's assumption that "she is one more object which money can buy, and in a sense it is part of her duties to maintain the illusion."[34] Here the painter and the patron are at odds. The man looking at her, of whom we see only the reflection, subsumes the man outside the painting who is painting her. However, the patron's glance, which attempts to fix her image as a commodity, is contradicted by the painter, who depicts her unresponsiveness and qualifies her with roses. This also may reflect the ambiguous views Manet had of himself. He saw her both as she was seen by others and as he saw her through her eyes. To borrow Clark's phrase (applied not to her but to bourgeois society), "the 'inside' *cannot* be read from the 'outside.'"[35]

Appearances belie the truth. This was a constant preoccupation, expressed throughout Manet's career. His barmaid is dressed like the others, she works where they work, but she is not like them. Concealment, disguise, camouflaged identity — these are old themes, but in this picture Manet has made them more complex by interweaving them with the question, What do we see in art? The presence of the mirror, clearly outlined by its gilded frame just above the plane of the bar, goes back to Velázquez and *Las Meninas*. Only this time Manet is dealing with the ultimate illusion: himself, dying within but a bon vivant without, a debonair gentleman, pressing through the galleries like other men in search of pleasure. It is merely the illusion of a man that we see in the painting.

Bar at the Folies-Bergère is Manet's artistic testament, his last large-scale work, his monument to the Paris of his lifetime. He poured into it his entire craft and the full range of the themes that wove through his major works. It is his most complete representation of the demimonde, itself a metaphor for much of the half century during which he lived and, more personally, for disguise, deception, false

identity — women whose fashionable gowns conceal public bodies; men whose impeccable tailcoats cover vice; pleasure to fill the void of unfulfilled lives, to mask the banality of sorrow, illness, death. Every night at eight, for two francs, anyone could enter the magical world of the Folies-Bergère and melt into its smoke, its din, the arms of its women. All of Manet's Paris and much of his painting went into this work: the crowds of *Music in the Tuileries* and *Ball at the Opéra,* the heads of lovely women, Olympia's stare, Nana's gaze, the white-stockinged legs hanging from the edge of the canvas, the incomparable still lifes.

A touching biographical note concerns the oranges in the crystal compote on the bar. During the period Manet was working on the painting, he received a gift from a client Méry Laurent had sent him. As Manet told Proust, this gentleman from Marseilles had recently bought one of his café scenes and sent him a crate of tangerines, "a piece of his sunshine." When he went out, he filled his pockets with tangerines and gave them to the neighborhood urchins instead of coins. "They would probably prefer money, but I give them a share of what pleases me. Ah, the joys of this world! They are made of things that mean nothing to some, and a great deal to others."[36]

The tangerines were probably in the studio when he painted the still life on the bar. If one looks closely, the fruits assumed to be oranges are in fact tangerines, for they are flatter and glossier than oranges. They provide not only an important note of color — the acidy tone of a lemon or an orange that can be found in numerous other paintings such as *The Spanish Singer* and the portraits of Astruc and Duret — but also an association that Manet surely enjoyed inserting. The orange was a common substitute for the apple in biblical and Christian iconography.[37] And what could be closer to Venus's golden apple than a bright orange (or its near twin, a tangerine)? This is not the first time Manet placed one or more oranges in a painting of a woman with amorous connotations *(Young Woman Reclining in Spanish Attire* and *Woman with Parrot).* It is as though he were chuckling over his challenge to the viewer: "You want a Venus? I'll give you a Venus! Not Cabanel's hackneyed nude, but a dressed Venus, a Venus for today, harder to recognize, but no less deserving of the golden apple." Manet's barmaid is a modern divinity, not of love, but of its illusion.

The end of 1881 brought Manet the realization of his dearest

1881
Legion of Honor

dream. On December 30 the government bulletin, *L'Officiel*, announced that he had been named chevalier of the Legion of Honor. It came not a moment too soon, for less than a month later, Gambetta's government fell and with it Proust's ministry. Bracquemond and Faure also were on the list, and now Faure wanted Manet to do his portrait, not in a role, but as himself, with the red ribbon on his lapel. Ernest Chesneau, the critic who had followed Manet's career since the beginning and had been the first to recognize the Raphael group in *Le Déjeuner sur l'herbe*, wrote to congratulate Manet on his decoration. To his own good wishes he added those of Comte de Nieuwerkerke, minister of fine arts under Napoleon III. Manet wrote back: "Thank you, my dear Chesneau, for your kind letter. . . . When you write to Nieuwerkerke, you can tell him that I appreciate his kind thoughts, but that he could have decorated me himself. It would have made my fortune; now, it is too late to repair twenty years without success. . . . I sympathize all the more with the state of your health since I am not doing too well myself."[38]

On December 29 Manet apologized to Berthe Morisot for not having found the right New Year's gift for her; until he did, he preferred to send only his good wishes. But perhaps the real reason was that he had been unable to go shopping. "The year is not ending well for me with regard to health," he wrote. Someone named Potain seemed to be holding out the hope that Manet's ataxia was of a non-syphilitic origin, "and so," Manet added, "I follow his prescription scrupulously."[39] Whoever Potain was, someone other than Manet's physician, Dr. Siredey, prescribed ergot, made from the fungus on rye and other cereals, which contracts blood vessels and smoothes muscle tissue. Although widely used into the twentieth century, ergot is highly toxic, and taken over a prolonged period, it can cause gangrene. Nothing else Manet had tried until then had been effective. A year later he would try a vegetarian diet, to which Berthe, in a note to her brother, attributed the gravity of his condition: "Poor Edouard is very sick; his famous vegetarian almost sent him into the next world."

Dr. Siredey repeatedly warned Manet against ergot and even asked Proust to persuade him not to overuse it. But Manet was determined to do anything, take anything to hasten his recovery. For the moment, as 1882 began, he was euphoric. Eugène, back in Paris to prepare Berthe's exhibition with the impressionists, wrote her on March 1: "Edouard seems better to me. He is delighted with his decoration." A

few days later he informed her that Edouard was "preparing a disaster for himself at the Salon. He keeps on redoing the same picture: a woman in a café."

The Salon was not at all the disaster Eugène anticipated. There were still, as there had always been, the unconvinced and the outright antagonistic. "In all honesty, should one admire the flat plastered face of the *Bar-girl*, with her bodice lacking relief, her offensive color? Is this picture true to life? No. Is it appealing? No. Then what is it?" wrote one reviewer. Chesneau, who had often been critical in the past, thought that "the creature placed behind the bar by the artist could not be more of a tart," but that Manet's triumph was in his ability "to catch forms in movement, in his accurate vision of things, their coloring, their luminous vibration." He predicted that this original, personal mastery of the artist over the world of external phenomena "would not be lost on the future."[40] Huysmans was bothered by the very effects of light that Chesneau praised: "The subject is modern enough, but what does that lighting mean? Is it gas light or electric light? Come now, it is an indeterminate *plein air*, a flood of pallid daylight! . . . I am all the sorrier because, in spite of its chalkiness, it is certainly the most modern, most interesting picture in this Salon."[41] Perhaps the last word, certainly the most foresighted, was written by Louis de Fourcaud, who asked the readers of *Le Gaulois*, "Do you know any composition more ingenious, more witty, more expressive? . . . A day will come when [Manet] will be classed as a French Goya, endowed with some of the qualities of Frans Hals."[42]

Spring was the success that came closest to that of *Bon Bock*, and Antonin Proust bought it for himself. Manet's nemesis Albert Wolff finally came around, partway. He chose to forgo his usual outrageous witticisms and instead granted Manet his first kudos: "No, I will never be in complete agreement with M. Manet. . . . But in the final analysis, his is an original temperament; this kind of painting is not what everybody does; it is the art of an incomplete artist, but an artist. . . . The Salon is filled with young men to whom Manet taught the modern art of plein air. . . . There is no doubt about it, the art of M. Manet is entirely his own; he did not borrow it from museums; he captured it facing nature." To this Manet replied with obvious irony, referring to his advancing age when speaking of his career: "My dear Wolff, I do not despair that you will one day write the fabulous article that I have desired for such a long time and that you know how to

write when you want to. But, if possible, I would like it to be within my lifetime, and I must inform you that I am moving ahead in my career. In the meantime, thank you for yesterday's article and count on my friendship."[43]

During the first six months of 1882 Manet devoted himself to capturing Méry Laurent in pastels — seven portraits, a fashion show of hats. In October she posed for the second of his projected seasons; the canvas has exactly the same dimensions as *Spring*. She was thirty years old and unruffled by the association with fading beauty in a painting allegorizing autumn. Her infectious gaiety was the best medicine for Manet. Her delight in life was so great that she could share it with generosity.

Manet had wanted to do a portrait of <u>Méry's</u> maid, Elisa, since 1878, but every time he proposed it, she postponed it, telling him he had more important things to do; there would always be time for her later on. She brought him delicacies from her mistress, gave him advice, removed from his tailcoat the wax that had dripped on it from the myriad candles of a gala Bastille Day celebration given by Gambetta. "What a wonderful woman, that Elisa!" he told Proust. "You see, there are good people, many more than one thinks. . . . When I meet a person like Elisa I love and admire humanity. But when it comes to acknowledging the services done for me, that's another matter. I become stupid. I would like to have treasures in order to give them to Elisa, and even then I would remain in her debt."

This exuberance of gratitude was an overflow of his feelings for Méry, whose devotion to him initiated and encouraged Elisa's. George Moore spoke of Méry with great tenderness, remembering not only "her desire to enjoy every moment of her life" but also her consciousness of that desire. This was not the unbridled hedonism commonly associated with demimondaines, but rather the joy she took in herself and in others, together with humor, intelligence, and a genuine taste for ideas and the arts. Her longtime provider, the American dentist Evans, was no match for her. When Moore asked why she did not leave him, especially since the handsome income he had given her was securely hers, she said, "That would be ignoble. It is enough that I deceive him." Every year after Manet died, she brought the first white lilacs of the season to his grave. "Is there one of her many lovers," Moore wondered, "who forgoes an idle hour to lay flowers on her grave?"[44]

This enchanting woman, who preferred to be admired for her mind rather than her beauty, was only fifty when she died in 1900. She left *Autumn,* which Manet had given her, to the museum in Nancy, her birthplace. Her executor was Reynaldo Hahn, the young composer who had aroused a brief passion in Marcel Proust when both were adolescents and who had brought him to meet Méry. Her colorful past would contribute heavily to the background of Odette de Crécy, later Mme Swann, in Marcel Proust's great novel *Remembrance of Things Past.* More than anyone else, this woman brightened the last years, and particularly the last months, of Manet's life. She sat for him herself day after day, brought friends to pose for him (Irma Brunner, among others, of whom he did two portraits), and sent him daily surprises of little luxuries.

It was time once again to think of leaving Paris during July and August. Manet had nowhere to go: the seaside was out; the countryside was boring. Still they could not spend two months cooped up in their apartment. Manet's only requirement was that he be close to Paris. To be deprived of the one place he truly enjoyed was not worth a long trip. Through an agency, he rented a house in Rueil (now hyphenated with Malmaison, where Josephine de Beauharnais's charming house is open to the public), fourteen kilometers (about nine miles) from Paris, even closer than Versailles. It hardly mattered where he went. His left foot made walking a torture; the remission of the winter was only a memory. He had been forced to paint sitting down much of the time he worked on *Bar at the Folies-Bergère,* except for the brief respite he communicated to Berthe Morisot: "For the past two days I've been feeling better; I can do without my cane, which is something." But by July a few steps could be excruciating.

The garden in Rueil made the one in Versailles seem sumptuous. It consisted of a pathetic patch of grass with a clump of red canna, a few red roses, an acacia tree, a bench, and two chairs, all crowded into a circular island in front of the house. As for the house, it was little more than functional. Its minimal comfort and drabness were all the more displeasing now that Manet could not escape from it. Unable to walk more than a few faltering steps, he would sink into a chair, raise his leg, and sit still for hours on end. Eventually, the need to feel a brush in his hand took precedence over his pain. If he did not paint, he would die of boredom.

He set up his easel, took out his palette, and started to sketch the

only subjects at hand: the house, the path, the few flowers. In all he did seven pictures, two with the house and five without. He also started a sketch of Julie sitting on a watering can during a visit with her parents, Berthe and Eugène Manet. In the pictures of the path, the perspective is much shorter than in those he did at Versailles. Here the view is hemmed in, oppressive; the path goes nowhere. The two views of the house are in full sunlight, affording Manet an opportunity to use his cherished violet tones for the shadowed areas, but the sky is totally absent. He painted only what was within the range of his fixed glance, as though his universe ended with the roof of the house. To put in a patch of azure sky would have been to falsify his view, or to idealize it with vistas he did not have.

For the rest of the summer he painted fruits — peaches, strawberries, plums — and roses — in a vase, lying on a table beside fallen petals. The world closed around him. During six weeks of bad weather he was forced to retreat to the dining room, where he sat painting the fruits and flowers on the cloth-covered table. He complained to Méry Laurent that July had not spoiled him with sunny days: "Perhaps the new moon will bring some sunshine." It was not enough to walk around the garden when there was a break in the weather: "To feel truly well and happy, I have to be able to work."[45] His unsteady scrawl, for which he apologized, was blamed on a bad pen, but the truth was that his motor coordination was often impaired. Some days were worse than others, as his handwriting reveals over a two-year period.

In August he confessed to Méry that he had been lazy: "It takes all my affection for you to make me sit down and write. What an awful month; all this wind and rain are not exactly calculated to make the countryside appealing, especially not to an invalid. My only pleasures are carriage rides and reading, for I have scarcely been able to do any work outside." He was still putting on a front, explaining why he might stay until the end of October: "I want to return in better shape, and these last two months have really done me good." To Mallarmé on September 16 he repeated his intention to stay on through October, adding that he had "started a few outdoor studies, but I fear I may not be able to finish them." His pitiable closing line implies that weather was not the only cause of his inability to work: "You are lucky, my dear friend, to be in good health."[46]

His sudden return to Paris on September 27 indicates how critical

his condition had become. He was in his *notaire*'s* office on September 30 writing his last will and testament, both copies in his own hand, as required. He bequeathed his entire estate to Suzanne, with the proviso that Léon be the sole beneficiary of everything he left her. "I trust that my brothers will find these dispositions entirely natural," he wrote, repeating beneath his signature, "It is clearly understood that Suzanne Leenhoff, my wife, will leave by testament to Léon Koëlla, called Leenhoff, the estate I have left her." The only specific monetary bequest was to Léon. His instructions also covered the means by which he hoped to finance his estate: "A sale of my paintings, sketches, and drawings, to be found in my studio after my death, will be held and I ask my friend Théodore Duret to be kind enough to take charge of it, trusting entirely his taste and the friendship he has always shown me to determine what will be auctioned and what will be destroyed. . . . From the proceeds of the sale of my pictures, the sum of 50,000 francs is to be deducted and given to Léon Koëlla, called Leenhoff. The remainder shall revert to Suzanne Leenhoff, my wife."[47] Having seen to his survivors, he made a heroic effort to maintain the illusion of a future.

As early as October he saw that he would not be showing in the Salon of 1883. He had nothing ready to send, and he had neither the ideas nor the energy to turn out one or two paintings in the months remaining before they had to be sent off, generally in March. To have finally reached the status of *hors concours* yet be unable to take advantage of it was a bitter fate. "The hour of justice," he sadly observed to Proust after he was decorated, "which determines that we first begin to live once we are dead, that hour I know." His studio neighbor Henry Dupray, who had posed for the bowler-hatted patron in the study for *Bar at the Folies-Bergère*, suggested a military subject, being himself a painter of military subjects. But Manet managed only an oil study of a trumpeter.

Nevertheless, he tried to work when he could. A sketch of Suzanne, seated with their cat Zizi on her lap, and the two portraits of Maizeroy mentioned earlier date from these months, as do three versions of a woman in a riding habit. Faure, determined to have his portrait,

*In France the *notaire* fulfills the function of a lawyer in the United States and Great Britain for official acts such as marriage contracts, sale of property, and wills. This person is not to be confused with a notary public.

was finally received at the studio at the end of December. Manet did two studies in two different poses and a final version of the head and shoulders, which Faure rejected. But he bought four other paintings — the vertical view of the house at Rueil, *In the Conservatory,* the portrait of Rochefort, and Léon with a pear — for the paltry sum of eleven thousand francs.

Except for the left shoulder, the portrait of Faure was finished, but Manet had to put it aside. He now spent hours stretched out on the divan in his studio with a book in his hands. Proust wrote that "he often interrupted his sketching to read novels, which he had never done before. He did not seek in his reading literary pleasure but distraction from the pain of ataxia." Such remarks have led many critics to the erroneous belief that Manet was culturally illiterate. His correspondence, though nowhere near the voluminous production of some of his contemporaries, is studded with orders for books, praise for authors whose books he had just finished reading, and recommendations to friends of books he had read. His memorialists have failed to notice what struck total strangers who interviewed him: he was a man of very considerable literary taste and refinement who had always read for pleasure and to keep abreast of the times. The winter of 1882–83 was the first time in his life that he read instead of working. If he turned to books for distraction, it was precisely out of familiarity with the pleasure they could provide.

He continued to assure his friends and family that he would feel much better once the sun returned to Paris. He told Bazire that he had great ideas for the painting he would do for the Salon of 1884. Mallarmé and Nadar heard the same fanfaronade. They may have believed it, but Manet did not, as his hastily made will indicates. On good days he managed to get to the studio, venturing sometimes as far as the place Moncey at the head of the rue d'Amsterdam, where there were flower stalls. He had always loved flowers, and now that portraits were too demanding, flowers were his subjects of choice. They did not move; they did not require cheerful chatter from him; they did not watch him suffer.

Méry Laurent brought him flowers and sweets, came to joke with him, and sent Elisa to check on him between her own visits. He and Méry had much in common. Their capacity for living was very similar: there was so much pleasure to be found all around. Manet responded enthusiastically to everything he could hear, see, or touch:

music, conversation, color, light, the nap of velvet, the sweep of a hat. Méry's fur-trimmed coat from Worth made him lyrical: "Ah, what a coat! A tawny brown with a burnished gold lining. I was entranced by it." He made her promise to give it to him when she tired of it: "It will make a great background for things I have in mind."[48] Both of them had those two elusive and indispensable qualities that distinguish the individual from the herd: charm and style. Both wore clothes well, without looking like mannequins. Manet wore his tweedy Norfolk jackets and English jodhpurs with the same easy elegance as his formal frock coat or tailcoat.

He completed a dozen flower paintings, each more poignant and beautiful than the last, during the last months when he could do no other work. Some of the flowers, totally out of season — peonies, lilacs, and clematis — must have been fiendishly expensive. But Méry knew how much flowers meant to him at that time. Roses were, of course, available from hothouses year-round. The flowers that Manet painted were not the garden variety — roses do not bloom with lilacs or tulips — but extravagant gifts from choice florists brought by friends, very likely at Méry's suggestion. Often unable to walk to his studio, Manet now spent as much as half the week in his apartment. His frustration with the unrelenting pain and enforced immobility had become so unbearable that one day, Léon recalled, Manet turned on his mother: "One should not bring children into the world when one makes them like this!"[49] He was rapidly losing the little coordination he had retained, running the risk of falling if he tried to walk.

On March 13, 1883, Eugénie Manet wrote to her nephew Jules De Jouy, "Edouard continues to suffer very much. His leg is now seized by attacks of fulgurating pain that happily do not rob him of his appetite. He is beginning to accept his meals with some degree of pleasure, which makes me hope for a return to health! But I fear it will take a very long time!!!" It is doubtful that Drs. Siredey and Marjolin kept her fully informed of his condition, since she was given to extreme anxiety about her loved ones. The winter before, when Julie had had bronchitis, Edouard asked Berthe "not to alarm my mother about Bibi's health; she gets horribly upset." One can imagine how eager everyone was to spare her now that her adored firstborn was near death. Three days later, on March 16, she wrote to Jules again: "The outcome of the consultation that just took place between the two doctors does little to quiet my fears. The foot is swollen and fever

chills have begun. I am very alarmed. Edouard, however, ate with appetite this morning and slept well last night."[50]

Almost miraculously, he managed to get to his studio just before Easter, which fell on March 25. Elisa came in with a large Easter egg filled with confections from her mistress, and Manet insisted that she sit down and pose for him. He knew that postponements were out of the question. He did as much as he could in that one sitting, capturing her in profile with a feathered hat low on her forehead. But it was not quite finished; he had a little left to fill in. When Elisa returned the next day, he was not in the studio. Her portrait was still on the easel. It was his last work.

For the next twelve days he remained in the apartment; on April 6 he could no longer leave his bed. He was racked with violent chills and a raging fever. On April 14 his agonizing left leg had begun to turn black, unmistakably gangrenous. Five days passed before his doctors decided to operate. Amputation was the only recourse. Manet had been in bed for two weeks. He was terribly weak after his bouts of high fever, symptomatic of the infection claiming his life, but he seemed to rally, and the operation was his only hope of survival. A bulletin in *Le Figaro* on April 20 reported:

> Yesterday at 10 o'clock, Doctors Tillaux [professor of surgery at the School of Medicine], Siredey and Marjolin came to the patient, whom they found in excellent spirits. The limb to be amputated was in a deplorable state. Gangrene had set in, resulting in a condition so critical that the nails of the foot came off when touched. . . . The patient was chloroformed and the leg amputated below the knee. Manet felt no pain. The day went as well as could be expected, and yesterday evening when we came for news, his condition did not suggest any serious complications.

According to some (Duret, Bazire, Monet, Gervex), he did not know that his leg had been amputated. But Léon, responding to Tabarant's questions, wrote a letter in December 1920 stating that "Manet was apprised of the operation. Dr. Siredey spoke to him, but how he phrased his remarks I do not know. The operation took place in the living room. Present were Drs. Siredey, Marjolin, Tillaux, Gustave Manet, and two interns. One of the interns remained in attendance for a week. . . . Both of us spent the night in his room. My

mother came during the day. We never talked about the operation. One day, he raised the sheets of his bed without saying a word."[51] By then Manet was so weak that he hardly spoke.

For the next ten days his fever remained unabated. Only a very few were allowed to visit him: Abbé Hurel, Mallarmé, Nadar, Chesneau, Burty. Proust saw him for the last time two days after the operation. Degas and Manet had parted ways some time before over the impressionist shows, but Degas was nevertheless affected by the news. Writing to a friend, with characteristic sarcasm, he announced that all hope for Manet was lost: "That Doctor Hureau from Villeneuve surely poisoned him with ergot. A few newspapers have doubtless made a point of announcing to him his imminent demise. And I trust they have been read aloud to him. He has no notion of his condition and his foot is gangrened."[52]

The archbishop of Paris offered to come and administer extreme unction, but Léon declined the honor, later recording in his own hand his reply: "It was I who told Abbé Hurel that I saw no necessity for this and that I did not dare mention it to godfather . . . if [he] gives any sign of wanting it, you can count on me [to] notify you at once." But as for anticipating Manet's desire for such rites, he added, "do not count on it."[53] Léon's conviction suggests that Manet expressly instructed him to do just what he did. Abbé Hurel nonetheless gave Manet absolution during his final comatose hours. Death came on April 30 at seven in the evening, three months and seven days after Manet's fifty-first birthday.

The body was placed on a catafalque in the parish church of Saint-Louis d'Antin, which was entirely draped in black, and a Solemn High Mass was celebrated by the vicar. The procession, led by Eugène, Gustave, and Jules De Jouy, made its way to the cemetery of Passy, across from the esplanade of the Trocadéro that Manet had painted in 1867. The pallbearers were Philippe Burty, Théodore Duret, Claude Monet, Antonin Proust, Alfred Stevens, and Emile Zola. Proust delivered the eulogy. Walking behind them, Degas was heard to murmur, *"Il était plus grand que nous le croyions"* (he was greater than we thought).[54]

Acknowledgments

Merely to list the names of the many people who helped to make this a book is far from an adequate expression of my gratitude, as I trust they will understand. Among those whose interest and encouragement launched me on this project I wish to thank, in chronological order, Neil and Angelica Rudenstine, Fred Kaplan, Petra Chu, and Rosalie Siegel. My special thanks to Michael Wood for his meticulous reading of an earlier draft, and to Petra Chu for her judicious comments on a later draft.

At various stages of this project, generous people read the manuscript, made accessible original documents and historical details, allowed me to test ideas and readings of paintings, led me to references I might not have found on my own. To all of them my heartfelt thanks and my hope that this final version reflects their contributions: Porter Aichele, George Bermann, Homi Bhabha, Victor Brombert, Anne Distel, Lynne Fagles, Peter France, John Hutton, Jan Logan, John Logan, Patricia Mainardi, Linda Nochlin, Philip Nord, Roger Pierrot, Anne-Marie Rouart, Kate Ryan, Suzanna Van der Woude, and Juliet Wilson-Bareau. I am most grateful to the staff of the Cabinet des Estampes at the Bibliothèque Nationale for leading me through the maze of their precious collections; to Marianne Delafond of the Musée Marmottan for making my examination of Berthe Morisot's papers so pleasant; to the staff of the Morgan Library for their gracious help with the Tabarant Archives; to the curators of the Archives Nationales, the Archives de la Ville de Paris, the Bibliothèque d'Art et d'Archéologie, and the Bibliothèque du Louvre, with-

out whose expert guidance I would still be searching; to Martine Ferretti, curator of the library at the Musée d'Orsay, for her compassionate assistance; to Bobray Bordelon of the Firestone Library at Princeton University for his invaluable help with currency equivalents; and to Jan Powell and the staff of the Marquand Library at Princeton University for years of help and kindness.

To my agent, Rosalie Siegel, and my editor, Jennifer Josephy, I have a special debt for making their support, their enthusiasm, and their counsel unstintingly available to me over the years it took to complete this book. To Peggy Leith Anderson my warmest thanks for her careful and caring preparation of the final manuscript, and to Barbara Jatkola my grateful admiration for her thorough copyediting.

Without the invaluable research material initially provided by Antonin Proust, Etienne Moreau-Nélaton, and Adolphe Tabarant — their personal notes, the letters and documents they collected and left for others to use, their books — it would be almost impossible to attempt a serious biography of Manet. Juliet Wilson-Bareau has greatly added to their work by making available scattered sources in her superbly edited volumes. Eric Darragon has incorporated their exhaustive research into his own overview of Manet's production and its reception. And my particular gratitude to Françoise Cachin and Charles Moffett for their exemplary catalogue of the 1983 exhibition. Their books were rarely out of my sight. I hope this book adds yet another dimension to their outstanding achievements.

The Manet bibliography has swelled to dozens of pages. Instead of listing only a few selected works, complete references are provided within each chapter's notes. And in order to avoid undue cluttering, short works from which numerous quotations have been taken are cited only once in each chapter.

The major source of Manet's own words, recorded over a period of nearly forty years, is to be found in the memoirs of Manet's oldest friend, Antonin Proust. In 1897 Proust published *Edouard Manet, Souvenirs,* which was reprinted in 1988 (L'Echoppe, Caen), together with a shorter essay that appeared in 1901. These 101 pages are the closest we can come to hearing Manet's voice, outside of his few letters. Wherever the text makes clear that Proust is the source, individual citations are not given. In cases where the source may not be clear, a short citation to Proust, *Souvenirs,* is given.

Unless otherwise indicated, all translations are my own.

Preface

1. Adolphe Tabarant, *Manet. Histoire catalographique* (Paris, 1930), p. 278.

2. André Malraux, "Le Musée imaginaire," in *Les Voix du silence* (Paris, 1951), p. 97.

3. Edmond Duranty, "M. Manet et l'imagerie," *Paris-Journal,* May 5, 1870.

4. Proust, *Souvenirs,* p. 101.

5. Kenneth Clark, *Leonardo da Vinci* (Penguin rev. ed., 1958), p. 14.

6. Charles Baudelaire, "L'Art philosophique," in *Oeuvres*, vol. 2 (Pléiade, Paris, 1951), p. 367.

7. Emile Zola, "Edouard Manet, étude biographique et critique," in *Emile Zola, écrits sur l'art* (Paris, 1991), p. 152.

8. Paul Colin, *Edouard Manet* (Paris, 1932), p. 7.

9. *Picasso on Art: A Selection of Views*, ed. Dore Ashton (New York, 1972), p. 149.

10. Meyer Shapiro, *Modern Art: 19th and 20th Centuries* (New York, 1978), p. 34, n. 24a.

11. Georges Bataille, *Manet* (Geneva, 1955), pp. 24, 32.

Prologue

1. In his biography *Manet* (Paris, 1884), published eight months after Manet's death, Edmond Bazire included as a footnote this text of Antonin Proust's funeral oration, presumably given to him by Proust himself. Fourteen years later, Proust published *Edouard Manet souvenirs* (see introduction to the notes, above), in which he also gives a text of his funeral oration, but it is clearly much expanded and reworked, although some lines have been kept verbatim. Two striking oversights in the first version are the mention of a son (*"un fils,"* never publicly acknowledged by Manet, nor even by Bazire in his biography) and the omission of Manet's mother, who also assisted selflessly during his agony. She was not given her due place in the second version either, but Manet's brothers suddenly appear, and the "son," now replaced by "a child" (*un enfant*), recedes into the heavily embroidered rhetoric.

Version I: "A côté d'une oeuvre encore incomplète, il laisse une femme et un fils, qui, aux longues heures de la souffrance, firent preuve d'un admirable dévouement" (Bazire, p. 124). (Along with an unfinished lifework, he leaves a wife and a son who, during the long hours of his agony, demonstrated their admirable devotion.)

Version II: "L'homme disparaît, laissant derrière lui, à côté d'une oeuvre encore mal comprise, une femme qui a été sa fidèle compagne, un enfant qui, près des frères de Manet toujours si dévoués, a eu pour le grand artiste le culte d'un fils, et qui s'est montré d'un dévouement admirable aux longues et terribles heures de la souffrance" (Proust, p. 75). (The man disappears, leaving behind, along with a lifework as yet badly understood, a wife who has been his faithful companion, a child [Léon was thirty-one at the time of Manet's death!] who, along with Manet's constantly devoted brothers, had for the great artist the attachment of a

son, and who demonstrated admirable devotion during the long and terrible hours of [Manet's] agony.)

Chapter 1: A Manet an Artist?

1. Dossiers Collège Municipal Rollin, Archives Nationales, Paris, are the source of all related information in this chapter, unless otherwise indicated.

2. Jules Breton, *Nos Peintres du siècle* (Paris, 1899), p. 175.

3. Charles Baudelaire, *Correspondance*, vol. 2 (Pléiade, Paris, 1973), p. 386.

4. Claude Pichois, *Baudelaire* (London, 1989), p. 40: "The usual comments [on student's reports] were not always remarkable for their originality: . . . *character* — irresponsible, weak, orderly, docile or bizarre; *work* — inadequate or sustained; *progress* — mediocre or noticeable . . . sometimes, none."

5. Fonds Moreau-Nélaton, Cabinet des Estampes, Bibliothèque Nationale de Paris, SNR Boîte Manet 5.

Chapter 2: At Sea

1. All of Manet's letters in this chapter come from *Lettres de jeunesse, 1848–1849. Voyage à Rio* (Paris, 1928).

2. Pierre Daix, *La Vie de peintre d'Edouard Manet* (Paris, 1983), p. 19.

Chapter 3: The Doubling Begins

1. I am indebted to Albert Boime's superb work, *The Academy and French Painting in the Nineteenth Century* (London, 1971), for much of the information on the history and methods of academic training that appears in this chapter.

2. André Malraux, "Le Musée imaginaire," in *La Psychologie de l'art*, vol. 2 (Paris, 1947), p. 117.

3. Mary Gedo, *Picasso: Art as Autobiography* (Chicago, 1980), p. 258.

4. Jacques-Emile Blanche, *Propos de peintre* (Paris, 1919), pp. 147–148.

5. Boime, *The Academy*, p. 14.

6. Quoted in ibid., p. 191, n. 58.

7. Ibid., p. 14.

8. Quoted in Kathleen Adler, *Manet* (London, 1986), p. 17.

9. Ibid., p. 16.

10. Thomas Couture, *Méthode et entretiens d'atelier* (Paris, 1867), p. 20.

11. Ibid., p. 45.

12. Some writers believe that he began in September 1850; Adolphe Tabarant, *Manet et ses oeuvres* (Paris, 1947), p. 12, says January, which seems substantiated by Manet's permit to copy at the Louvre. Dated January 1850, it already identifies him as a pupil of Couture's.

13. The only available documentation on her life in Holland comes from a memoir written long after her death by a citizen of her native town. The author relates that Liszt, having stopped in Zaltbommel during a trip on a riverboat, played the organ at the cathedral and, on hearing Suzanne play the piano in her father's house, encouraged her to continue her studies.

14. Letter published in Juliet Wilson-Bareau, "Portrait of Ambroise Adam by Ed. Manet," *Burlington Magazine*, 127 (1984): 750–758.

15. Joseph [Giuseppe] De Nittis, *Notes et souvenirs* (Paris, 1895), p. 190.

16. Quoted in Boime, *The Academy*, p. 66.

17. Their views are quoted in *Thomas Couture, sa vie, son oeuvre, ses idées, sa méthode* (Paris, 1932), pp. 38–39.

18. Quoted in Boime, *The Academy*, p. 35.

19. Couture, *Méthodes et entretiens*, p. 299.

20. Episode related in Proust, *Souvenirs*, p. 14.

21. Théodore Duret, *Histoire d'Edouard Manet* (Paris, 1902), pp. 11–12.

22. Couture, *Méthodes et entretiens*, pp. 251–252.

23. Charles Baudelaire, *Correspondance*, vol. 2 (Pléiade, Paris, 1973), p. 497.

24. Proust, *Souvenirs*, p. 18.

25. Tabarant, who knew Antonin Proust, as well as Léon Leenhoff, speaks of *"les mensualités que lui allouait chichement son père"* (the monthly allowance that his father was stingily allotting him) as late as 1859. *Manet et ses oeuvres*, p. 33.

26. Fonds Moreau-Nélaton, Cabinet des Estampes, Bibliothèque Nationale de Paris, Yb3 2402a Cahier Leenhoff, p. 73.

Chapter 4: The Making of Paris

1. *Paris et les Parisiens sous le Second Empire*, ed. Michel Cabaud and Eliette Bation-Cabaud, introduction by Sébastien Loste (Paris, 1982), p. 22.

2. Charles Baudelaire, "Le Peintre de la vie moderne," in *Oeuvres*, vol. 2 (Pléiade, Paris, 1951), p. 355.

3. Adolphe Tabarant, *La Vie artistique au temps de Baudelaire* (Paris, 1942), pp. 338 ff.

4. All quotations in this paragraph are from Baudelaire, "Le Peintre de la vie moderne," pp. 332–333.

5. George L. Mauner, *Manet, Peintre-Philosophe* (University Park, Pa., 1975), p. 4.

6. Baudelaire, "Le Peintre de la vie moderne," p. 335.

7. As reported by Georges Jeanniot, *La Grande Revue* (August 10, 1907). Quoted in Etienne Moreau-Nélaton, *Manet raconté par lui-même*, vol. 2 (Paris, 1926), p. 96.

8. T. J. Clark, *The Painting of Modern Life* (Princeton, N.J., 1986), p. 66.

9. Edmond Bazire, *Manet* (Paris, 1884), p. 7.

10. Ibid., p. 10.

11. Theodore Reff, "Manet and Blanc's *Histoire des peintres*," *Burlington Magazine*, 112 (1970): 456–458.

12. Beatrice Farwell, *Manet and the Nude: A Study in Iconography in the Second Empire* (New York, 1981), p. 22.

13. Alain de Leiris, *The Drawings of Edouard Manet* (Berkeley, Calif., 1969), p. 20.

14. Denis Diderot, *Salons*, "Sur la peinture," in *Oeuvres choisies*, vol. 2 (Garnier, Paris, n.d.), p. 427.

15. Patricia Mainardi, *The Art and Politics of the Second Empire. The Universal Expositions of 1866 and 1867* (New Haven, Conn., 1987), p. 63.

16. Théophile Gautier, *Les Beaux-Arts en Europe, 1855*, vol. 1 (Paris, 1855–1856), p. 5.

17. "Des Tendances de l'art au dix-neuvième siècle," *Revue Universelle des Arts* 1 (1855): 77–85. Théophile Thoré took the Germanic pseudonym Wilhelm Bürger when he went into political exile during the repressive years of Napoleon III's early rule. He could continue publishing in French newspapers, his daily bread, only under an assumed name, although he was known to his editors.

18. Jules-Antoine Castagnary, *Salons 1857–1870*, vol. 1 (Paris, 1892), p. 21.

19. Ibid., p. 15.

20. See Linda Nochlin's excellent analysis in *Realism* (New York, 1971), p. 124.

21. Proust, *Souvenirs*, p. 42. "Ah! c'est rudement difficile de rendre une toile intéressante avec un seul bonhomme. Il ne faut pas seulement faire le portrait. Il y a le fond qui doit être souple, vivant, car le fond vit. Si le fond est opaque, mort, plus rien."

22. Ibid, p. 23. "Je lui en foutrai un tableau dont il me dira des nouvelles."

23. Ibid., p. 89.

24. F.W.J. Hemmings, *Baudelaire the Damned* (New York, 1982), p. 191.

25. The date provided by Nancy Locke's painstaking research in "New Documentary Information on Manet's 'Portrait of the artist's parents'" (*Burlington Magazine* [May 1991]: 249–252), is confirmed by the personal account of a family friend and legal colleague. Charles Limet recalls a dinner at the Manets' in October 1857 to celebrate the marriage of Emile Ollivier, with whom Edouard and Gustave had traveled in Italy in 1852: "I should really say *chez Madame Manet*, since her husband was already afflicted with the onset of paralysis that forced him to live apart." *Un Vetéran de barreau: Quatre-vingt ans de souvenirs* (Paris, 1908), p. 249.

Chapter 5: The Double-Edged Sword

1. Léon learned from his mother that she had been the model. Cf. Julius Meier-Grefe, *Edouard Manet* (Munich, 1912), p. 38.

2. Rosalind E. Krauss, "Manet's Nymph Surprised," *Burlington Magazine* 109 (November 1967): 624. See also Françoise Cachin, in *Manet* (exhibition catalogue, New York, 1983), pp. 82–83, for other views.

3. Charles Moffett, in *Manet* (exhib. cat., 1983), p. 72.

4. In the minds of Western artists and viewers, the sword has long been associated with virility in its literal and metaphoric connotations: "The Western type of a sword, with its straight blade, is by virtue of its shape . . . a masculine symbol," J. E. Cirlot, *A Dictionary of Symbols* (New York, 1971), p. 308.

5. Ibid., p. xxxvi.

6. Meyer Shapiro, *Modern Art: 19th and 20th Centuries* (New York, 1978), p. 34, n. 24a.

7. Linda Nochlin, "A Thoroughly Modern Masked Ball," *Art in America* (November 1983): 188–201.

8. "Je crois que mes frères trouveront ces dispositions toutes na-

turelles." The original text, in Manet's hand, is the source of all quotations from this document (Archives Nationales, Paris).

9. These documents, which I examined personally, are preserved in the Archives Nationales, Paris.

10. "Il y a des choses sur lesquelles je ne reviendrai pas, c'est le crime que lui a fait commettre l'affection qu'elle porte à ce brave garçon qui n'est que la victime de sa triste naissance. Elle a voulu plus qu'elle ne devrait avoir, c'est la punition de son crime, il faut qu'elle le subisse!" Unpublished letter, Fonds Rouart, Musée Marmottan, Paris.

11. The most ingenious explanation of the name Koëlla comes from Harry Rand: "Separated into two sounds, pronounced 'co-ella,' we recognize the Spanish pronoun for 'her' *ella* (close to the French *elle*). Thus, the name . . . literally means 'with her.' In honor of his mother's own surname (Leenhoff) the son's first name, Léon, may have been bestowed as a contraction. He may then have been called Edouard after his father. Each part of the child's name referred to the union of Suzanne Leenhoff and Edouard Manet. The name was thus constructed with the same relationship of parts to the whole as one of Manet's paintings." *Manet's Contemplation at the Gare Saint-Lazare* (Berkeley, Calif., 1987), p. 57. Coello also happens to be the name of a seventeenth-century Spanish painter who produced, among other larger works, some outstanding still lifes that Manet may have known.

12. "Acte de naissance rétabli en vertu de la loi du 12 février 1872 par la 4e section de la Commission dans sa séance du 21 septembre 1872. L'an mille huit cent trente-deux le 29 janvier, est né à Paris dans le sixième arrondissement, fils de Koella et de Suzanne Leenhoff. Par acte dressé devant Me Laurent. Edouard Cotelle, notaire à Paris, le 17 mars, mille neuf cent, en présence de témoins, Madame Suzanne Leenhoff, propriétaire demeurant à Asnières, Seine, Boulevard Voltaire no. 1, veuve en premières noces non remariée de Monsieur Edouard Manet, a reconnu pour son fils naturel l'enfant inscrit ci-dessus. Paris, le 3 avril 1900." Archives Nationales, Paris.

13. Adolphe Tabarant, *Manet et ses oeuvres* (Paris, 1947), pp. 479–480. Despite the logic of his deduction, Tabarant refuted it at the end of the chapter: "However unforgivable Manet's collusion in the monstrous camouflage of his wife's son, it does not prevent one from thinking that had he been the father, he would have ended up by making the avowal. . . . This was the conviction of Théodore Duret, who always protested against so offensive an imputation. And this, in the last analysis, is our own." The argument is not convincing, and by then Tabarant was eighty-five.

14. Moffett, in *Manet* (exhib. cat., 1983), p. 72.

15. Jacques-Emile Blanche, *Propos de peintre* (Paris, 1919), p. 143.

16. Theodore Reff was one of the few to acknowledge this: "The master at whom he gazes and whose sword he carries so reverently is of course the father." "The Symbolism of Manet's Frontispiece Etchings," *Burlington Magazine* 104 (May 1962): 182–187.

17. Léon Lagrange, "Le Salon de 1861," *La Gazette des Beaux-Arts* (July 1861): 51.

18. Cachin, in *Manet* (exhib. cat., 1983), p. 48.

19. See Chapter 4, n. 25. Also, Philippe Burty, in his obituary of Edouard Manet, says that he died of the same disease as his father.

20. André Malraux, "Le Musée imaginaire," in *La Psychologie de l'art*, vol. 1 (Paris, 1947), p. 76.

21. Quoted in Tabarant, *Manet et ses oeuvres*, p. 42.

22. Cachin, in *Manet* (exhib. cat., 1983), p. 63.

23. John Richardson, *Manet* (London, 1958), p. 12.

24. Unpublished notes, Fonds Moreau-Nélaton, Bibliothèque Nationale de Paris.

25. *Sexually Transmitted Diseases*, ed. K. K. Holmes, P.-A. Mardh, P. F. Sparlking, and P. J. Wiesner (New York, 1990, 2nd ed.), p. 165. Auguste Manet's identifiable symptoms date from 1857, five years almost to the month before his death.

26. Alain Corbin, *Les Filles de noces, misère sexuelle et prostitution, 19e et 20e siècles* (Paris, 1978), p. 138.

27. A. Parent-Duchâtelet, *De la prostitution dans la ville de Paris* (Paris, 1836), quoted in Corbin, *Les Filles de noces*, p. 17.

28. O. W. Holmes, *Medical Essays 1842–1882*, quoted in *Sexually Transmitted Diseases* (see n. 25, above), p. 7.

29. Baudelaire, "Sur la Belgique," in *Oeuvres*, vol. 2 (Pléiade, Paris, 1951), p. 716.

30. Corbin, *Les Filles de noces*, p. 40.

31. Ibid., p. 25.

32. *Correspondance de Berthe Morisot avec sa famille et ses amis*, ed. Denis Rouart (Paris, 1950), p. 31.

33. Corbin, *Les Filles de noces*, p. 94.

Chapter 6: A Turning Point

1. Joseph [Giuseppe] De Nittis, *Notes et souvenirs* (Paris, 1895), p. 195.

2. Fonds Rouart, Musée Marmottan, Paris.

3. Mina Curtiss, "Letters of Edouard Manet to His Wife during the Siege of Paris, 1870–1871," *Apollo* (1981): 379. "A highly distinguished and reliable writer, a relation by marriage of the Manet family, confided in recent years that Manet *père* was actually Léon's father and that it was he who had introduced Suzanne into the family." This unverifiable allegation has often been repeated as though fact. Even if the description seems to fit Paul Valéry ("a relation by marriage," having married the daughter of Berthe Morisot's elder sister in 1900, half a century after Léon's birth, and the only "distinguished writer" connected in any way to the Manet family), that does not make him a credible source — if he ever made such an allegation. The hypothetical source of such a story might have been Julie Manet (the daughter of Morisot and Manet's younger brother Eugène and the only descendant of the Manet family), but she was barely seventeen when her mother died (her father had died earlier, as had her aunt). It is unlikely that a scandal of such magnitude about her grandfather, were it true, would have been related to an overprotected young girl at that time, nor does her candid diary make any allusion to it. Moreover, Valéry died in 1945 — hardly "recent" in 1981.

4. Michael Cardoze, *Georges Bizet* (Paris, 1982), pp. 65–67.

5. Charles Baudelaire, *Correspondance,* vol. 2 (Pléiade, Paris, 1973), p. 323.

6. Adolphe Tabarant; and, in their catalogue, Paul Jamot and Georges Wildenstein (*Manet, catalogue critique* [Paris, 1921]). But Anne Coffin-Hanson, John Rewald, John Richardson, and, most recently, Françoise Cachin date it 1862.

7. Françoise Cachin, *Manet* (exhibition catalogue, New York, 1983), p. 126.

8. Théodore Duret, *Histoire de Edouard Manet et de son oeuvre* (Paris, 1902), pp. 120–121.

9. Michael Fried, "Painting Memories: On the Containment of the Past in Baudelaire and Manet," *Critical Inquiry* (March 1984): 522.

10. Göste Sandblad, *Manet. Three Studies in Artistic Conception* (Lund, 1954), p. 61.

11. Edmond Duranty in *Réalisme,* July 1857. Quoted in Adolphe Tabarant, *La Vie artistique au temps de Baudelaire* (Paris, 1942), p. 271.

12. Hervé Maneglier, *Paris Impérial* (Paris, 1990), p. 72.

13. Harry Rand, *Manet's Contemplation at the Gare Saint-Lazare* (Berkeley, Calif., 1987), p. 59.

14. Ibid.

15. Robert F. Storey, *Pierrot: A Critical History of a Mask* (Princeton, N.J., 1978), p. 14.

16. Georges Bataille, *Manet* (Geneva, 1955), p. 38.

17. George Ferguson, *Signs and Symbols in Christian Art* (Oxford, 1954), p. 49.

18. Margaret R. Miles, *Visual Understanding in Western Christianity and Secular Culture* (Boston, 1985), p. 64.

19. Denis Diderot, "La Chaste Suzanne," *Salons*, in *Oeuvres choisies* (Garnier, Paris, n.d.), p. 373.

20. Jane Gallup, *The Daughter's Seduction: Feminism and Psychoanalysis* (Ithaca, N.Y., 1982), p. 35.

21. Kenneth Clark, *The Nude: A Study in Ideal Form* (Princeton, N.J., 1956), p. 29.

22. Beatrice Farwell, *Manet and the Nude: A Study in Iconography in the Second Empire* (New York, 1981), p. 179.

23. Margaret Siebert, "A Biography of Victorine-Louise Meurent and Her Role in the Art of Edouard Manet" (Ph.D. diss., Ohio State University, 1986). I am much indebted to Ms. Siebert's excellent research for many particulars in the early life of Victorine Meurent.

24. Ibid., p. 45.

25. Jacques-Emile Blanche, *Manet* (Paris, 1924), p. 24.

26. Manuscript letter, Fonds Rouart. Also quoted in Tabarant, *Manet et ses oeuvres* (Paris, 1947), p. 488–489.

27. Jacques-Emile Blanche, *Propos de peintre* (Paris, 1919), p. 139.

Chapter 7: Venus Observed

1. Paul Mantz, *Gazette des Beaux-Arts*, April 1, 1863.

2. Proust, *Souvenirs,* p. 51.

3. Kathleen Adler, *Manet* (London, 1986), p. 32.

4. George Moore, "Reminiscences of the Impressionist Painters," in *Manet: A Retrospective*, ed. T. A. Gronberg (New York, 1988), p. 264.

5. George Moore, *Modern Painting* (London, 1898), p. 232.

6. Maxime du Camp, *Souvenirs d'un demi-siècle*, vol. 1 (Paris, 1949), p. 130.

7. Quoted in Patricia Mainardi, *The Art and Politics of the Second Empire* (New Haven, Conn., 1987), p. 69.

8. Ibid., p. 82.

9. Ibid, p. 120.

10. Augustin-Joseph Du Pays, *L'Illustration*, July 28, 1855.

11. *Letters of Gustave Courbet*, ed. and trans. Petra ten-Doesschate Chu (Chicago, 1992).

12. Ambroise Vollard, *Souvenirs d'un marchand de tableaux* (Paris, 1937), p. 178.

13. Quoted in Adler, *Manet*, p. 50.

14. Françoise Cachin, in *Manet* (exhibition catalogue, New York, 1983), p. 169.

15. Margaret Siebert, "A Biography of Victorine-Louise Meurent and Her Role in the Art of Edouard Manet" (Ph.D. diss., Ohio State University, 1986), pp. 121–143.

16. George L. Mauner, *Manet, Peintre-Philosophe* (University Park, Pa., 1975), p. 40.

17. Adolphe Tabarant, *Manet et ses oeuvres* (Paris, 1947), p. 70.

18. Ernest Chesneau's review of the 1863 Salon was reprinted a year later in his volume of essays, *L'Art et les artistes modernes en France et en Angleterre* (Paris, 1864), p. 190.

19. Mauner, *Manet, Peintre-Philosophe*, pp. 44–45.

20. Quoted in Tabarant, *Manet et ses oeuvres*, p. 66.

21. Tabarant identifies "J. Graham" writing in *Le Figaro* as the painter Alfred Stevens, whose works appeared in the official Salon of 1863. Krell (see n. 23, below) cites him as Arthur Stevens, who was Alfred's brother and himself an art dealer and critic.

22. Emile Zola, *L'Oeuvre* (Folio, Paris, 1983), p. 146.

23. Examined by Tabarant in *Manet et ses oeuvres*, pp. 65–72; Alan Krell, "Manet's *Déjeuner sur l'herbe* in the Salon des Refusés: A Re-Appraisal," *Art Bulletin* 65, no. 2 (1983): 316–320.

24. Fernand Desnoyers, *Salon des Refusés: La Peinture en 1863* (Paris, 1863), p. 42.

25. Capitaine Pompilius (Carl Desnoyers, brother of Fernand), "Lettres sur le Salon," *Le Petit Journal*, June 1863, p. 2.

26. See Krell, "Manet's *Déjeuner sur l'herbe*."

27. The document, in the Archives Nationales, has been reprinted in part in Etienne Moreau-Nélaton, *Manet raconté par lui-même*, vol. 1 (Paris, 1926), p. 53, and in Denis Rouart and Daniel Wildenstein, *Catalogue raisonné* (Paris, 1975), p. 12. All quotations in my text come from the original, of which I possess a photocopy.

28. Fonds Moreau-Nélaton, Cabinet des Estampes, Bibliothèque Nationale de Paris.

29. Cachin, in *Manet* (exhib. cat., 1983), p. 176.

30. Alexandre Dumas père, *Filles, lorettes et courtisanes* (Paris, 1874), p. 24.

31. Ibid., pp. 54–55.

32. Alexandre Dumas fils, *La Dame aux camélias* (Livre de Poche, Paris, 1983), pp. 145–146.

33. Emile Zola, "Edouard Manet, étude biographique et critique," in *Emile Zola, écrits sur l'art* (Paris, 1991), p. 161.

34. George Heard Hamilton, *Manet and His Critics* (New Haven, Conn., 1986), p. 75.

35. Ibid.

36. Paul Valéry, "Le Triomphe de Manet," in *Oeuvres*, vol. 2 (Pléiade, Paris, 1966), p. 1327.

Chapter 8: "A Recidivist of the Monstrous and the Immoral"

1. Ernest Renan, *Vie de Jésus* (Paris, 1947), p. 366.

2. Adolphe Tabarant, *Manet et ses oeuvres* (Paris, 1947), p. 80.

3. Renan, *Vie de Jésus*, p. 362.

4. Ibid., p. 15.

5. Ibid., pp. 364–365.

6. Proust, *Souvenirs*, p. 83.

7. See Leo Steinberg, "The Sexuality of Christ in Renaissance Art and in Modern Oblivion," *October* 25 (Summer 1983): 1–198.

8. *La Vie Parisienne*, May 1, 1864. Also in Jennifer M. Sheppard, "The Inscription in Manet's *The Dead Christ with Angels*," *Metropolitan Museum Journal* 16 (1982): 199–200.

9. Quoted in Tabarant, *Manet et ses oeuvres*, pp. 83–84.

10. Charles Baudelaire, *Correspondance*, vol. 2 (Pléiade, Paris, 1973), p. 352.

11. Françoise Cachin, in *Manet* (exhibition catalogue, New York, 1983), p. 204.

12. Théophile Gautier, "Salon de 1864," *Le Moniteur Universel*, June 25, 1864.

13. Baudelaire, *Correspondance*, vol. 2, p. 350.

14. Claude Pichois, *Baudelaire* (London, 1989), p. 285.

15. Charles Baudelaire, "Salon de 1845," in *Oeuvres*, vol. 2 (Pléiade, Paris, 1951), p. 15.

16. Charles Baudelaire, "Le Peintre de la vie moderne," in *Oeuvres*, vol. 2, p. 339.

17. Pichois, *Baudelaire*, p. 42.

18. Charles Baudelaire, "Mon Coeur mis à nu," in *Oeuvres*, vol. 2, p. 646.

19. Ibid., p. 641.

20. Ibid., p. 650.

21. Baudelaire, *Correspondance*, vol. 1, p. 665.

22. Baudelaire, "Mon coeur mis à nu," p. 666.

23. Baudelaire, *Correspondance*, vol. 2, p. 386.

24. Théophile Thoré, *Salons de W. Bürger, 1861–1868*, vol. 2 (Paris, 1870), p. 137.

25. Ibid., p. 98.

26. J.-P. Bouillon, "Les Lettres de Manet à Bracquemond," *Gazette des Beaux-Arts* (April 1983): 151.

27. "Mon cher Burty, Je viens de lire dans *La Presse*, les quelques lignes élogieuses que vous avez écrites sur mon tableau; je vous en remercie et espère que vous n'appliquerez pas le proverbe *Une fois n'est pas coutume*. Le *Kearsage* se trouvait dimanche dernier en rade de Boulogne; je suis allé le visiter; je l'avais assez bien deviné; j'en ai peint du reste l'aspect en mer; vous en jugerez. Je vous serre la main et suis tout à vous." Manuscript letter, Bibliothèque d'Art et d'Archéologie, Paris.

28. Ambroise Vollard, *Souvenirs d'un marchand de tableaux* (Paris, 1937), p. 162.

29. Patricia Mainardi, *Art and Politics of the Second Empire* (New Haven, Conn., 1989), p. 80.

30. Baudelaire, *Correspondance*, vol. 2, p. 386.

31. Baudelaire, "Salon de 1859," in *Oeuvres*, vol. 2, p. 250.

32. All correspondence between Zola and Manet quoted in this chapter appears in my own translation from the French texts in Appendix I, ed. Colette Becker, in *Manet* (exhib. cat., 1983), pp. 518–530.

33. Tabarant, *Manet et ses oeuvres*, p. 118.

34. Edmond Bazire, *Manet* (Paris, 1884), p. 31.

35. T. J. Clark, *The Absolute Bourgeois: Artists and Politics in France, 1848–1851* (London, 1973), p. 130.

36. André Fraigneau, "Lumière sur un bouquet de Manet," *Plaisirs de France* (April 1964): 12.

37. Proust, *Souvenirs*, p. 63.

38. Fonds Moreau-Nélaton, Cabinet des Estampes, Bibliothèque Nationale de Paris.

39. J. Northcote, *The Life of Titian*, vol. 2 (London, 1830), p. 233. Quoted in Theodore Reff, "The Meaning of Manet's *Olympia*," *Gazette des Beaux-Arts* 63 (1964): 116.

40. Reff, "The Meaning of Manet's *Olympia*," p. 116.

41. Tabarant, *Manet et ses oeuvres*, p. 106.

42. Ibid., p. 108.

43. Ibid.

44. Ibid., p. 109.

45. *Lettres à Charles Baudelaire*, ed. Claude and Vincenette Pichois (Neuchâtel, 1973), pp. 233, 497.

46. Baudelaire, *Correspondance*, vol. 2, p. 501.

47. *Lettres à Charles Baudelaire*, p. 84.

48. Gonzague Privat, *Place aux jeunes. Causeries critiques sur le Salon de 1865* (Paris, 1865), pp. 136–138.

49. Proust, *Souvenirs*, p. 101.

Chapter 9: An Old Passion, a New Friend, a Public Defender

1. Théophile Gautier, *Voyage en Espagne* (Paris, 1933), p. 61.

2. An excellent chronology of the Spanish influence in France and on Manet is to be found in Joel Isaacson's introduction to the exhibition catalogue *Manet and Spain: Prints and Drawings* (Ann Arbor, Mich., 1969).

3. Proust, *Souvenirs*, pp. 26–27.

4. The entire correspondence relating to Manet's trip has been painstakingly assembled by Juliet Wilson-Bareau in *Edouard Manet, voyage en Espagne* (Caen, 1988). My translations were made from the manuscript letters from Astruc to Manet and from Manet to Fantin-Latour in the Cabinet des Estampes, Bibliothèque Nationale de Paris.

5. *Correspondance de Berthe Morisot avec sa famille et ses amis*, ed. Denis Rouart (Paris, 1950), p. 102.

6. Théodore Duret, *Histoire de Edouard Manet et de son oeuvre* (Paris, 1902, reissued in 1926), p. 44.

7. Gautier, *Voyage en Espagne*, p. 63.

8. Duret, *Histoire de Edouard Manet*, pp. 44–47, for the entire Spanish episode.

9. Wilson-Bareau, *Edouard Manet*, p. 56.

10. *Lettres à Charles Baudelaire*, ed. Claude and Vincenette Pichois (Neuchâtel, 1973), p. 1018.

11. Adolphe Tabarant, *Manet et ses oeuvres* (Paris, 1947), pp. 103–127.

12. Wilson-Bareau, *Edouard Manet*, p. 26.

13. *Lettres à Charles Baudelaire*, p. 238.

14. Françoise Cachin, in *Manet* (exhibition catalogue, New York, 1983), p. 247.

15. Emile Zola, "Edouard Manet, étude biographique et critique," in *Emile Zola, écrits sur l'art* (Paris, 1991), p. 152.

16. Eleanore Sayre, *Goya and the Spirit of the Enlightenment* (exhibition catalogue, Boston, 1989), p. cxxiii.

17. Paul Jamot and Georges Wildenstein, *Manet, catalogue critique* (Paris, 1921), pp. 35–36.

18. Ibid.

19. Emile Zola, "Mon Salon," in *Emile Zola, écrits sur l'art*, pp. 102–105.

20. Jules Breton, *Nos Peintres du siècle* (Paris, 1899), pp. 200–201.

21. *Emile Zola, écrits sur l'art*, p. 108.

22. Ibid., pp. 112–119, for all quotations in the next three paragraphs.

23. All correspondence between Manet and Zola quoted in this chapter appears in my own translation from the French text in Appendix I, ed. Colette Becker, in *Manet* (exhib. cat., 1983), pp. 518–534.

24. First published on January 1, 1867, in *La Revue du XIXe Siècle*, whose editor was Arsène Houssaye, one of the most ubiquitous figures on the century's cultural scene; later reprinted as a brochure, *Edouard Manet, étude biographique et critique*, at the time of Manet's private exhibition in May 1867, and in *Emile Zola, écrits sur l'art*, pp. 139–169.

25. Zola, "Edouard Manet," p. 150.

26. After its initial newspaper serialization, *Thérèse Raquin* was printed in book form in December 1867, at which time Zola added the preface.

27. Zola, "Edouard Manet," p. 151.

28. Ibid., p. 152.

29. Quoted in *Manet* (exhib. cat., 1983), p. 285.

30. Jules Castagnary, *Salons 1857–1870*, vol. 1 (Paris, 1892), p. 314.

31. Jamot and Wildenstein, *Manet*, p. 40.

32. Jules and Edmond Goncourt, *Journal*, vol. 3 (Paris, 1956), p. 1249. Cited by Cachin in *Manet* (exhib. cat., 1983), p. 285.

33. Cachin, in *Manet* (exhib. cat., 1983), p. 285.

Chapter 10: "The Family, Beware of the Family!"

1. Gustave Courbet to his great patron Alfred Bruyas, February 18, 1867, in *Letters of Gustave Courbet*, ed. and trans. Petra ten-Doesschate Chu (Chicago, 1992), p. 304.

2. Courbet to Bruyas, May 28, 1867, in ibid., p. 315.

3. Manuscript letter, Cabinet des Estampes, Bibliothèque Nationale de Paris, Yb3 2401a.

4. Fonds Moreau-Nélaton, Cabinet des Estampes, Bibliothèque Nationale de Paris.

5. *Indépendance Belge,* June 15, 1867. Quoted in Adolphe Tabarant, *Manet et ses oeuvres* (Paris, 1947), p. 137.

6. Quoted in ibid., p. 151.

7. In a private conversation with Tabarant, ibid., p. 139.

8. Ibid., p. 151.

9. George L. Mauner, *Manet, Peintre-Philosophe* (University Park, Pa., 1975), p. 104.

10. Hippolyte Babou, "Les Dissidents de l'Exposition. M. Edouard Manet," *Revue Libérale* 2 (June 1867): 286, 288.

11. Claude Pichois, *Baudelaire* (London, 1989), p. 360.

12. Jean Adhémar, "Baudelaire, les frères Stevens, la modernité," *Gazette des Beaux-Arts* (February 1958): 125.

13. Although Tabarant and most others date *The Burial* 1870, he was later convinced it had been painted in 1867. Unpublished notes, Morgan Library, New York.

14. Patricia Mainardi, *The Art and Politics of the Second Empire* (New Haven, Conn., 1987), p. 144.

15. Ibid., p. 148.

16. Ibid.

17. Edmond Bazire, *Manet* (Paris, 1884), p. 25.

18. Théophile Thoré, *Salons de W. Bürger, 1861–1868,* vol. 2 (Paris, 1870), p. 318.

19. Mona Hadler, "Manet's 'Woman with a Parrot' of 1866," *Metropolitan Museum Journal* 7 (1973): 115–122 (courtesan); Eunice Lipton, *Alias Olympia* (New York, 1992), p. 90 (lesbian). Numerous portraits and photographs from one end of the nineteenth century to the other show proper middle-class women wearing monocles, e.g., Louis-Léopold Boilly's *Portrait de femme vers 1800,* probably the future wife of the prosperous merchant, seen in a twin portrait. The young lady, in virginal attire, is wearing a monocle on a long chain.

20. Françoise Cachin, in *Manet* (exhibition catalogue, New York, 1983), p. 270.

21. "Koëlla, Léon-Edouard, 29 janvier 1852. L'an mil huit cent cinquante deux, le 29 janvier, est né à Paris sur le 6eme arrondissement, Koëlla, Léon Edouard, du sexe masculin, fils de Koëlla et de Suzanna

Leenhoff. Pièces produites: un extrait de baptême de l'Eglise reformée. Observations du declarant: L'enfant est né Faubourg du Temple 120. Son père était artiste musicien and la mère même profession (cet enfant est dit Leenhoff). Le rétablissement de cet acte de naissance a été demandé par M. Leenhoff, profession sculpteur, domicile à Paris, rue Humboldt no. 25, parenté oncle de l'enfant, Paris le 11 september 1872. Signé, F. Leenhoff." Archives Nationales, Paris, No. 104.012 (baptismal certificate attached).

22. "Dans les familles Manet et Leenhoff, je disais toujours parrain et marraine; dans le monde c'était mon beau-frère et ma soeur. Secret de famille, dont je n'ai jamais su le fin mot, ayant été choyé, gâté par tous les deux qui faisaient toutes mes fantaisies. Nous vivions tous les trois heureux, surtout moi, sans aucun souci. Je n'avais donc aucune question à soulever sur ma naissance." Letter from Léon Leenhoff to Adolphe Tabarant, December 6, 1920, in Tabarant, *Manet et ses oeuvres*, p. 483.

23. Georges Bataille, *Manet* (Geneva, 1955), p. 46.

24. Emile Zola, "Le Salon de 1876," in *Emile Zola, écrits sur l'art* (Paris, 1991), p. 349.

25. John House, "Manet's Maximilian: History Painting, Censorship and Ambiguity," in Juliet Wilson-Bareau, *Manet. The Execution of Maximilian. Painting, Politics and Censorship* (exhibition catalogue, London, 1992), p. 100.

26. All correspondence between Zola and Manet quoted in this chapter is from Appendix I, ed. Colette Becker, in *Manet* (exhib. cat., 1983), pp. 518–534.

27. House, "Manet's Maximilian," p. 97.

28. Quoted by Louis Gonse in "Manet," *Gazette des Beaux-Arts* (February 1884): 134.

29. Wilson-Bareau, *Manet. The Execution of Maximilian* (exhib. cat., 1992), p. 47.

30. Gustave Flaubert to Princess Mathilde, July 18, 1867, in Gustave Flaubert, *Correspondance*, vol. 3 (Pléiade, Paris, 1991), pp. 664–665.

31. Ambroise Vollard, *Souvenirs d'un marchand de tableaux* (Paris, 1937), pp. 69–70.

32. Ibid., pp. 71–73.

Chapter 11: Friends and Models

1. *La Double Vue de Louis Seguin,* quoted in Henri Loyrette, *Degas* (Paris, 1991), pp. 231–232.

2. Edmond Bazire, *Manet* (Paris, 1884), pp. 32–33.

3. Edmond Duranty, "Le Salon de 1870," *Paris-Journal,* May 5, 1870.

4. Loyrette, *Degas,* p. 26. I am indebted to this exhaustive biography for much of the background material on Degas.

5. Theodore Reff, "Copyists in the Louvre," *The Art Bulletin* 46 (1964): 552–558.

6. Proust, *Souvenirs,* p. 15.

7. Ambroise Vollard, *Souvenirs d'un marchand de tableaux* (Paris, 1937), p. 335.

8. Manet made two renditions of *Bark of Dante* around 1854, the first (Musée des Beaux-Arts, Lyon) a beautifully accurate copy, the second (Metropolitan Museum of Art, New York) more impressionistic.

9. Etienne Moreau-Nélaton, *Manet raconté par lui-même,* vol. 1 (Paris, 1926), p. 36.

10. Unless otherwise indicated, all Degas quotes in this chapter come from Armand Silvestre, *Au Pays des souvenirs* (Paris, 1887), p. 176.

11. George Moore, *Modern Painting* (London, 1898), p. 37.

12. Vollard, *Souvenirs,* p. 96.

13. George Moore, *Memoirs of My Dead Life* (London, 1906; reprint, 1928), p. 51.

14. Adolphe Tabarant, *Manet et ses oeuvres* (Paris, 1947), pp. 252–256.

15. Vollard, *Souvenirs,* p. 62.

16. Pierre Schneider, *Manet et son temps* (Paris, 1972), p. 84, for both quotes in paragraph.

17. Gustave Geffroy, *Claude Monet, sa vie, son oeuvre* (Paris, 1922), p. 244.

18. Moreau-Nélaton, *Manet raconté par lui-même,* vol. 1, pp. 91, 99.

19. *Monet by Himself,* ed. Richard Kendall (London, 1989), p. 24.

20. Manuscript letters to Manet, Fonds Moreau-Nélaton, Cabinet des Estampes, Bibliothèque Nationale de Paris.

21. Emile Zola, "Adieux d'un critique d'art," in *Emile Zola, écrits sur l'art* (Paris, 1991), p. 133.

22. Schneider, *Manet et son temps,* p. 86.

23. Julie Manet, *Journal* (Paris, 1987), pp. 158, 126, 178, respectively, for the quotes in the paragraph.

24. Vollard, *Souvenirs,* p. 62.

25. Quoted in Götz Adriani, *Cézanne. The Early Years 1859–1872* (exhibition catalogue, London, 1988), p. 52, n. 9.

26. Quoted in Kathleen Adler and Tamara Gelb, *Berthe Morisot* (Oxford, 1987), p. 10.

27. *Correspondance de Berthe Morisot avec sa famille et ses amis*, ed. Denis Rouart (Paris, 1950), pp. 21–117. Unless otherwise indicated, this is the source of all Morisot family letters quoted in this chapter.

28. Moore, *Modern Painting*, pp. 229 ff.

29. Ibid., p. 235.

30. Manuscript letter, Fonds Moreau-Nélaton.

31. Moore, *Modern Painting*, p. 235.

32. Beatrice Farwell, "Manet, Morisot, and Propriety," *Perspectives on Morisot*, ed. T. J. Edelstein (New York, 1990), p. 46.

33. Anne Higonnet, *Berthe Morisot* (New York, 1990), p. 55.

34. John Richardson, *Edouard Manet* (London, 1958), p. 123.

35. Eric Darragon, *Manet* (Paris, 1989), p. 166.

36. Manuscript letter, Fonds Moreau-Nélaton.

37. Quoted by Daniel Herwitz, "The Work of Art as Psychoanalytical Object: Wollheim on Manet," *Journal of Aesthetics and Art Criticism* 49 (1991): 143.

38. See Michael Fried, "Manet's Sources: Aspects of His Art," *Art Forum* 7 (March 1969): 28–82.

39. Paul Mantz, "Salon de 1869," *Gazette des Beaux-Arts*, July 1869.

40. Darragon, *Manet*, p. 167.

Chapter 12: The Lady with the Fan

1. All correspondence between Manet and Zola quoted in this chapter is from Appendix I, ed. Colette Becker, in *Manet* (exhibition catalogue, New York, 1983), pp. 518–534.

2. Brilliantly examined by Michael Fried in *Absorption and Theatricality: Painting and Beholder in the Age of Diderot* (Chicago, 1988).

3. Proust, *Souvenirs*, p. 50. These remarks, according to Proust, date from the Universal Exposition of 1878. When coming out of the painting exhibition, Manet said: "Ils sont là quelques-uns! Vrai, venir tourner en ridicule les Degas, les Monet, les Pissarro, blaguer Berthe Morisot and Mary Cassatt, se tordre de rire devant les Caillebotte, les Renoir, les Gauguin et les Cézanne, quand on pond de la peinture pareille! Je fais cependant tout mon possible pour trouver cela bien. Je ne peux pas. Puis il y a des choses qui m'affligent. Ainsi voilà Gustave Moreau."

4. "What is so interesting in relation to the frontispiece is his reference to Holland, whose windmills and flat low-lying plains we have al-

ready recognized in the landscape of the balloon print." Theodore Reff, "The Symbolism of Manet's Frontispiece Etchings," *Burlington Magazine* 104 (May 1962): 186. Another Dutch reference is Karel Dujardin's *Charlatan*, suggested as the source for the frontispiece. George L. Mauner, *Manet, Peintre-Philosophe* (University Park, Pa., 1975), pp. 169–170.

5. See Beth A. Brombert, "The Double-Edged Sword: Manet's Confessional Works," *Nineteenth-Century French Studies* (Spring-Summer 1994): 487–504. Passages from this essay have been reworked into this chapter.

6. Ever since the beginning of Christian art, the sword has come to signify not only particular martyrs but martyrdom itself. The position of the sword is also significant: the sword pointing downward symbolizes defeat or a completed action; raised up it designates life, justice, and leadership; in a horizontal position it denotes death.

7. Though commonly referred to as *Luncheon in the Studio*, it was exhibited by Manet in the Salon of 1869 with the title *Le Déjeuner*. The locale has been documented as the house rented in Boulogne during the summer of 1868. Interpretations based on a studio setting are thus based on an erroneous title. As for the windows revealed by X ray, they are more probably the windows of the house, known to have overlooked the harbor, than those of Nadar's or Manet's studio.

8. Adolphe Tabarant, *Manet: Histoire catalographique* (Paris, 1931), p. 189, and every critic since.

9. The sword's oldest association in Western culture is with Mars, who was always depicted with a sword and a helmet, not in full panoply. When he is shown with Venus, his arms have been laid aside, since she alone vanquished this great warrior. A curious detail of the legend, which Manet may have known, is that only Venus found Mars appealing; even his parents disliked him for his intractability.

10. Adolphe Tabarant, *Manet et ses oeuvres* (Paris, 1947), p. 483.

11. Edmond Bazire, *Manet* (Paris, 1884), p. 124. See Prologue, n. 1, for full text. The subsequent editing seems obvious: Proust's reference to "un enfant" who was thirty-one at the time of Manet's death is a case in point, as is his convoluted rhetoric, whereas the first version contained an unqualified recognition of Léon's identity. From then on the charade continued.

12. Françoise Cachin, in *Manet* (exhib. cat., 1983), p. 292: "Behind Léon is a maid at the left — not Mme Manet as has been said." This remark refers to Steven Kovacs ("Manet and His Son in *Déjeuner dans*

l'atelier," Connoisseur 181 [November 1972]: 201), who argues for the identification of the figure as Suzanne Manet: "The rendering of the maid is in fact reminiscent of Léon's mother. Although the face is not Suzanne's, she had a similar heavy build" (n. 1); and "The unknown face of the maid in *Déjeuner dans l'atelier,* is no proof against Suzanne Leenhoff having posed for this composition" (n. 11).

13. Kovacs, "Manet and His Son," p. 201. "She holds a bulbous coffeepot upon whose belly a capital M is inscribed. Could this be an intended clue to Manet's paternity of Léon?" This letter, though appearing to be a straightforward uppercase *M*, has been seen by Michael Fried as resembling Vermeer's more intricate monogram ("Manet's Sources: Aspects of his Art," *Artforum* 7 [March 1969]: 76, n. 171), and by others merely as a reflection.

14. Reff, "The Symbolism of Manet's Frontispiece Etchings," p. 183.

15. All Morisot family letters quoted in this chapter are taken from *Correspondance de Berthe Morisot avec sa famille et ses amis,* ed. Denis Rouart (Paris, 1950), pp. 21–117.

16. All letters quoted from this period are from "Une Correspondance inédite d'Edouard Manet. Les Lettres du Siège de Paris (1870– 1871)," ed. Adolphe Tabarant, *Mercure de France* (Paris, 1935): 262– 289.

17. Manuscript letter, Fonds Rouart, Musée Marmottan, Paris.

18. Anne Higonnet, *Berthe Morisot* (New York, 1990), p. 56.

19. Paul Valéry, "Le Triomphe de Manet," in *Oeuvres,* vol. 2 (Pléaide, Paris, 1966), p. 1332.

20. Cachin, in *Manet* (exhib. cat., 1983), p. 336.

21. Valéry, "Le Triomphe de Manet," p. 1333.

22. Charles Baudelaire, "Curiosités esthétiques," in *Oeuvres,* vol. 2 (Pléiade, Paris, 1951), p. 367.

23. Paul Alexis, "Manet," *La Revue moderne et naturaliste* (Paris, 1880): 289–295.

24. See Appendix II, "Documents Relating to the 'Maximilian Affair,'" ed. Juliet Wilson-Bareau, in *Manet* (exhib. cat., 1983), for all quotations related to this episode.

25. Quoted in Tabarant, *Manet et ses oeuvres,* p. 176.

26. Edmond Duranty, "Le Salon de 1870," *Paris-Journal,* May 7, 1870.

27. Some have identified the sitters as Edma Morisot Pontillon and her firstborn with her brother, Tiburce, behind her, others as Giuseppe De Nittis with his wife and child. See Cachin, in *Manet* (exhib. cat., 1983), p. 318, and Tabarant, *Manet et ses oeuvres,* p. 180.

28. Bazire, *Manet,* p. 65.

29. Proust, *Souvenirs,* p. 83, for both citations.

30. Charles F. Stuckey, "Manet Revisited: Who Dunnit?" *Art in America* (November 1983): 167. "Prunaire's engraving executed around 1873 or 1874 records the pictures with only the seated woman tending a baby in a carriage."

Chapter 13: A City Under Siege

1. Unless otherwise indicated, all quotations from Manet's letters in this chapter are taken from "Une Correspondance inédite d'Edouard Manet. Les Lettres du Siège de Paris (1870–1871)," ed. Adolphe Tabarant, *Mercure de France* (Paris, 1935): 262–289.

2. Unless otherwise indicated, all quotations from Morisot family letters are taken from *Correspondance de Berthe Morisot avec sa famille et ses amis,* ed. Denis Rouart (Paris, 1950), pp. 21–117.

3. Paul Jamot and Georges Wildenstein, *Manet, catalogue critique* (Paris, 1921), p. 8.

4. Armand Silvestre, *Au Pays des souvenirs* (Paris, 1887), p. 176.

5. Victor Hugo, "Carnets," ed. Jean Massin, *Oeuvres complètes,* vol. XV–XVI/2 (Paris, 1970), p. 655.

6. Proust, *Souvenirs,* p. 36.

7. Fonds Rouart, Musée Marmottan, Paris.

8. J.-P. Bouillon, "Les Lettres de Manet à Bracquemond," *Gazette des Beaux-Arts* (April 1983): 151.

9. Philip Nord, "Manet and Radical Politics," *Journal of Interdisciplinary History* 19, no. 3 (Winter 1989): 447–448.

10. John House, "Manet's Maximilian: History Painting, Censorship and Ambiguity," in Juliet Wilson-Bareau, *Manet: The Execution of Maximilian. Painting, Politics and Censorship* (exhibition catalogue, London, 1992), pp. 87–111.

11. Paul Mantz, quoted in George Heard Hamilton, *Manet and His Critics* (New Haven, Conn., 1986), p. 124.

12. House, "Manet's Maximilian," p. 107.

13. Proust, *Souvenirs,* p. 38.

14. Nord, "Manet and Radical Politics," p. 455.

15. Charles Moffett, in *Manet* (exhibition catalogue, New York, 1983), pp. 330–331.

16. Ibid., p. 331. Moffett cites another exception, *La Lecture,* but that was surely painted some years before 1871.

17. Adolphe Tabarant, *Manet et ses oeuvres* (Paris, 1947), p. 191.

18. Kay Redfield Jamison, *Touched with Fire: Manic Depressive Illness and the Artistic Temperament* (New York, 1993), Chapter 1.

19. Kay Redfield Jamison, in an interview with Natalie Angier, *The New York Times*, October 12, 1993.

20. Françoise Cachin, in *Manet* (exhib. cat., 1983), p. 325.

21. *Letters of Gustave Courbet*, ed. and trans. Petra ten-Doesschate Chu (Chicago, 1992), p. 438.

22. J.-P. Bouillon, "Les Lettres de Manet à Bracquemond," p. 151.

Chapter 14: "As Famous as Garibaldi"

1. Published in Adolphe Tabarant, *Manet et ses oeuvres* (Paris, 1947), p. 191.

2. Ibid., p. 196.

3. Ibid., p. 192.

4. Ibid., pp. 197–198, for quotes in this paragraph.

5. Albert Wolff, "Salon de 1872," *Le Figaro*, May 16, 1872.

6. Barbey d'Aurevilly, "Salon de 1872," *Le Gaulois*, July 3, 1872.

7. Jacques-Emile Blanche, *Propos de peintre* (Paris, 1919), p. 135.

8. Etienne Moreau-Nélaton, *Manet raconté par lui-même*, vol. 2 (Paris, 1926), pp. 8–10.

9. Jakob Rosenberg, Seymour Slive, and E. H. ter Kuile, *Dutch Art and Architecture 1600–1800* (Pelican History of Art, Middlesex, 1966; reprint 1987), pp. 59–60.

10. Paul Mantz, "Le Salon," *Le Temps*, May 24, 1873.

11. Dubosc de Pesquidoux, "Le Salon," *L'Union*, June 30, 1873.

12. Quoted in Johanna Richardson, *La Vie Parisienne* (New York, 1970), p. 11.

13. Pierre Schneider, *Manet et son temps* (Paris, 1968), p. 66.

14. Quotations from reviews of the Salon of 1873 in the next three paragraphs are taken from Tabarant, *Manet et ses oeuvres*, pp. 206–212.

15. Ibid., p. 206.

16. All Morisot family letters quoted in this chapter are taken from *Correspondance de Berthe Morisot avec sa famille et ses amis*, ed. Denis Rouart (Paris, 1950), pp. 21–117.

17. Paul Valéry, "Le Triomphe de Manet," in *Oeuvres*, vol. 2 (Pléiade, Paris, 1966), p. 1333.

18. Tabarant, *Manet et ses oeuvres*, p. 236; Moreau-Nélaton, *Manet raconté par lui-même*, vol. 2, pp. 4–5.

19. Beatrice Farwell, "Manet, Morisot, and Propriety," in *Perspectives on Morisot*, ed. T. J. Edelstein (New York, 1990), p. 52.

20. Ibid.

21. Anne Higonnet, *Painting Women* (New York, 1992), p. 63.

22. Ibid.

23. Albert Aurier, "Meissonier et Georges Ohnet," in *Oeuvres posthumes* (Paris, 1893), p. 322.

24. Nancy Mowll Mathews, *Mary Cassatt. A Life* (New York, 1994), p. 107.

25. Théophile Gautier, "Salons de 1868," *Le Moniteur Universel*, May 11, 1868.

26. Tabarant, *Manet et ses oeuvres*, p. 228.

27. Ibid.

28. Proust, *Souvenirs*, pp. 73, 77.

29. Stéphane Mallarmé, *Oeuvres complètes* (Pléiade, Paris, 1974), p. 1620.

30. Ibid., p. 662.

31. Proust, *Souvenirs*, p. 101.

32. Jean Renoir, *My Father* (London, 1968), p. 106.

33. Proust, *Souvenirs*, p. 47.

34. Harry Rand, *Manet's Contemplation at the Gare Saint-Lazare* (Berkeley, Calif., 1987), p. 76.

35. Charles Baudelaire, "Salon de 1859," in *Oeuvres*, vol. 2 (Pléiade, Paris, 1951), pp. 231–232.

36. Rand, *Manet's Contemplation*, p. 75.

37. Paul Jamot, *Manet, 1832–1833* (exhibition catalogue, Paris, 1932), p. 63: "Sauf dans deux ou trois oeuvres de jeunesse . . . il n'a pas fait d'emprunts directs à [Velázquez]. La ressemblance involontaire éclate partout: il continue Velázquez, il ne l'imite pas."

38. Louis Gonse, "Manet," *Gazette des Beaux-Arts* (February 1884), p. 146.

39. Proust, *Souvenirs*, p. 83.

40. Joseph Conrad to Barrett H. Clark, May 14, 1918, reprinted in the Norton Critical Edition of Conrad's *The Heart of Darkness* (New York, 1963), p. 231.

41. Nils Sandblad, Theodore Reff, George Mauner, Linda Nochlin, Anne Coffin Hanson, Michael Fried, Kathleen Adler, and Harry Rand are a few among the outstanding Manet critics who have discarded a formalist view of Manet, granting him nonpainterly concerns that go beyond the use of modern subjects.

42. Rand, *Manet's Contemplation*, p. 47.

43. John Richardson, *Edouard Manet* (London, 1958), p. 31.

44. Peter Gay, *Art and Act: On Causes in History* (New York, 1976), p. 105.

45. Kathleen Adler, *Manet* (London, 1986), p. 29.

46. Emile Bernard, *Tintoret, Greco, Magnasco, Manet* (Paris, 1920), p. 102.

47. Proust, *Souvenirs*, p. 64.

48. Robert Greer Cohn, *Toward the Poems of Mallarmé* (Berkeley, Calif., 1980), p. 196.

49. Jamot, *Manet*, p. 43.

Chapter 15: Polichinelle

1. Charles Baudelaire, "Salon de 1846," in *Oeuvres*, vol. 2 (Pléiade, Paris, 1951), p. 134.

2. Denis Diderot, "Sur la peinture," in *Oeuvres choisies*, vol. 2 (Garnier, Paris, n.d.), p. 435.

3. Edmond Bazire, *Manet* (Paris, 1884), p. 139.

4. Louisine Havemeyer, *Sixteen to Sixty: Memoirs of a Collector* (New York, 1961), reprinted in T. A. Gronberg, *Manet: A Retrospective* (New York, 1988), p. 322.

5. Fervacques, *Le Figaro*, December 25, 1874, reprinted in Etienne Moreau-Nélaton, *Manet raconté par lui-même*, vol. 2 (Paris, 1926), pp. 8–10.

6. Linda Nochlin, "A Thoroughly Modern Masked Ball," *Art in America* (November 1983): 188–201; John Hutton, "The Clown at the Ball: Manet's Masked Ball of the Opera and the Collapse of Monarchism in the Early Third Republic," *Oxford Art Journal* 10, no. 2 (1987): 76–93.

7. Ludovic Halévy, "Les Carnets de Ludovic Halévy," *Revue des Deux Mondes* (February 1, 1937): 547–548.

8. Henri Loyrette, *Degas* (Paris, 1991), p. 313.

9. Ibid., pp. 188–189.

10. Ibid., p. 191.

11. Paul Valéry, "Degas, Danse, Dessin," in *Oeuvres*, vol. 2 (Pléiade, Paris, 1960), p. 1204.

12. Stéphane Mallarmé, *Oeuvres* (Pléiade, Paris, 1974), pp. 697–698.

13. Nochlin, "A Thoroughly Modern Masked Ball," p. 196.

14. Hutton, "The Clown at the Ball," p. 77.

15. Ibid.

16. J. Baudot, *Renoir, ses amis, ses modèles* (Paris, 1949), p. 53. Quoted in Eric Darragon, *Manet* (Paris, 1989), p. 236.

17. Hutton, "The Clown at the Ball," p. 87.

18. Nochlin, "A Thoroughly Modern Masked Ball," p. 195.

19. Philip Nord, "Manet and Radical Politics," *Journal of Interdisciplinary History* 19, no. 3 (Winter 1989): 476–477.

20. Theodore Reff, *Manet and Modern Paris* (Chicago, 1982), p. 124.

21. Quoted in Götz Adriani, "*La Lutte d'amour*, Notes on Cézanne's Early Figure Scenes," in *Cézanne. The Early Years, 1858–1872* (exhibition catalogue, London, 1988), p. 53, n. 27.

22. Ambroise Vollard, *Souvenirs d'un marchand de tableaux* (Paris, 1937), p. 62.

23. Adriani, "*La Lutte d'amour*," p. 45.

24. Ibid., p. 47.

25. Darragon, *Manet*, p. 301.

26. M. Proth, *Voyage au pays des peintres, Salon de 1875*. Quoted in Darragon, *Manet*, p. 241.

27. Quoted in Adolphe Tabarant, *Manet et ses oeuvres* (Paris, 1947), p. 265.

28. Ronda Kasl, "Edouard Manet's 'Rue Mosnier': Le Pauvre a-t-il une patrie?" *Art Journal* (Spring 1985): 57.

29. Marc de Montifaud, *L'Artiste*, May 1, 1874. Quoted in Darragon, *Manet*, p. 236.

30. Manuscript letter, Fonds Moreau-Nélaton, Cabinet des Estampes, Bibliothèque Nationale de Paris.

31. Cited and translated by Juliet Wilson-Bareau, *Manet by Himself* (Boston, 1991), p. 175.

32. Henri Guérard, "Manet's Decoration by the State," *Le Carillon*, July 16, 1881. Reprinted in translation in Gronberg, *Manet: A Retrospective*, p. 171.

33. Proust, *Souvenirs*, p. 30.

34. Théodore Duret, *Histoire de Edouard Manet* (Paris, 1902), p. 102.

35. Quoted in Tabarant, *Manet et ses oeuvres*, p. 264.

36. Quoted in ibid., p. 263.

37. Ibid., p. 263.

38. Camille Pellatan, in ibid., p. 264.

39. Ibid., p. 265.

40. Joseph [Giuseppe] De Nittis, *Notes et souvenirs* (Paris, 1895), pp. 187–188.

41. J.-K. Huysmans, *L'Art moderne* (Paris, 1883), pp. 36–37.

Chapter 16: "Faire Vrai, Laisser Dire"

1. Unless indicated otherwise, all Morisot family letters quoted in this chapter are taken from *Correspondance de Berthe Morisot avec sa famille et ses amis*, ed. Denis Rouart (Paris, 1950), pp. 21–117.

2. Adolphe Tabarant, *Manet et ses oeuvres* (Paris, 1947), p. 272.

3. Stéphane Mallarmé, "The Impressionists and Edouard Manet," *Art Monthly Review* (September 1876). Reprinted in toto in T. A. Gronberg, *Manet: A Retrospective* (New York, 1988), pp. 144–161.

4. Jacques-Emile Blanche, *Propos de peintre* (Paris, 1919), p. 135.

5. Mallarmé, "The Impressionists and Edouard Manet," p. 149.

6. Ibid., p. 145.

7. *Berthe Morisot* (exhibition catalogue, Paris, 1896), quoted from the preface by Stéphane Mallarmé: "Auprès de Madame Manet je me fait l'effet d'un rustre et d'une brute."

8. Toché's recollections and notes were published by Ambroise Vollard in his *Souvenirs d'un marchand de tableaux* (Paris, 1937), pp. 160–167.

9. All newspaper quotations in this section were taken from Tabarant, *Manet et ses oeuvres*, p. 284 ff.

10. Bernadille, "Chronique parisienne. L'Atelier de M. Manet," *Le Figaro*, April 21, 1876.

11. "La Journée à Paris. M. Manet chez lui," *L'Evénement*, April 20, 1876. Cited in Eric Darragon, *Manet* (Paris, 1989), p. 265.

12. Blanche, *Propos de peintre*, p. 145.

13. Emile Zola, *Nana* (Livre de Poche, Paris, 1984), p. 125.

14. Proust, *Souvenirs*, p. 71.

15. Tabarant Archives, Morgan Library, New York.

16. Bernadille, "Chronique parisienne. L'Atelier de M. Manet."

17. George Moore, *Modern Painting* (London, 1898), p. 32.

18. Proust, *Souvenirs*, p. 53.

19. Moore, *Modern Painting*, p. 39.

20. George Moore, *Reminiscences of Impressionist Painters* (Dublin, 1906), p. 14. Cited in Gronberg, *Manet: A Retrospective*, p. 264.

21. Moore, *Modern Painting*, p. 33.

22. Ibid., p. 41.

23. Junius, "M. Edouard Manet," *Le Gaulois*, April 25, 1876. Cited in Tabarant, *Manet et ses oeuvres*, p. 285.

24. "La Journée à Paris, M. Manet chez lui."

25. Adolphe Tabarant, "Des Peintres et leur modèles," *Bulletin de la Vie Artistique* (May 1, 1921): 261–263.

26. Emile Zola, *L'Assommoir* (Garnier-Flammarion, Paris, 1969), p. 360.

27. See Appendix I, *Manet* (exhibition catalogue, New York, 1983).

28. J.-K. Huysmans, 1877. Cited in Tabarant, *Manet et ses oeuvres*, pp. 305–306.

29. Zola, *Nana*, p. 448.

30. Moore, *Modern Painting*, p. 33.

31. *Le National*, April 5, 1875. Cited in Darragon, *Manet*, p. 285.

32. "Manet jugé par Faure," *Le Gaulois*, January 6, 1884. Cited in Tabarant, *Manet et ses oeuvres*, p. 301.

33. Proust, *Souvenirs*, pp. 48–49.

34. Tabarant, *Manet et ses oeuvres*, p. 301.

35. Edmond Bazire, *Manet* (Paris, 1884), p. 100.

36. Emile Cardon, *Le Soleil*, May 19, 1877. Cited in Tabarant, *Manet et ses oeuvres*, p. 308.

37. Vollard, *Souvenirs*, p. 168.

38. Albert Wolff, *Le Figaro*, May 6, 1877. Cited in Tabarant, *Manet et ses oeuvres*, p. 308.

39. *Manet by Himself*, ed. Juliet Wilson-Bareau (Boston, 1991), p. 181.

40. Tabarant, *Manet et ses oeuvres*, p. 160.

41. Manuscript letter, Cahier Gonzales/Guérard, Cabinet des Estampes, Bibliothèque Nationale de Paris.

Chapter 17: The Last Studio

1. Adolphe Tabarant, *Manet et ses oeuvres* (Paris, 1947), p. 341.

2. Ibid., p. 341.

3. Ibid., p. 346.

4. Ibid., p. 348.

5. Unless otherwise indicated, all quotations of Morisot family letters in this chapter are taken from *Correspondance de Berthe Morisot avec sa famille et ses amis*, ed. Denis Rouart (Paris, 1950), pp. 21–117.

6. Neurosyphilis is discussed in *Sexually Transmitted Diseases* (see Chapter 5, n. 25, for complete citation), pp. 162–172 and pp. 239 ff; arthritis, pp. 737 ff.

7. Charles Moffett, in *Manet* (exhibition catalogue, New York, 1983), p. 405.

8. Charles Baudelaire, "Le Peintre de la vie moderne," in *Oeuvres*, vol. 2 (Pléiade, Paris, 1951), pp. 350–351.

9. *Correspondance de Berthe Morisot*, p. 166.

10. Edith Wharton, *The Age of Innocence*, *Novels* (Library of America, New York, 1985), p. 1291.

11. Edmond Bazire, *Manet* (Paris, 1884), pp. 127–128.

12. Jacques-Emile Blanche, *Propos de peintre* (Paris, 1919), p. 145.

13. Ibid., p. 11.

14. René Maizeroy, *Gil Blas*, January 1882. Cited in Eric Darragon, *Manet* (Paris, 1989), p. 316.

15. Manuscript letter, Fonds Moreau-Nélaton, Cabinet des Estampes, Bibliothèque Nationale de Paris.

16. Manuscript letter, Cahier Gonzales/Guérard, Fonds Moreau-Nélaton.

17. Tabarant, *Manet et ses oeuvres*, p. 350.

18. Bazire, *Manet*, p. 143.

19. Proust, *Souvenirs*, pp. 68–69.

20. Paul Alexis, "Marbre et Plâtre. Manet," *Le Voltaire*, July 25, 1879. Cited in Tabarant, *Manet et ses oeuvres*, p. 348.

21. Racot's notice and both letters in Tabarant, *Manet et ses oeuvres*, pp. 350–351.

22. Manuscript letter, Fonds Moreau-Nélaton.

23. Emile Zola, "Nouvelles artistiques et littéraires," in *Emile Zola, écrits sur l'art* (Paris, 1991), p. 400.

24. Tabarant, *Manet et ses oeuvres*, p. 351.

25. Proust, *Souvenirs*, p. 55.

26. Georges Jeanniot, "En Souvenir de Manet," *La Grande Revue* 46 (August 1907): 844–860.

27. Théodore Duret, *Histoire de Edouard Manet et de son oeuvre* (Paris, 1902), p. 221.

28. Tabarant, *Manet et ses oeuvres*, p. 365.

29. Manuscript letter, Cahier Gonzales/Guérard, Fonds Moreau-Nélaton.

30. Manuscript letter, Fonds Moreau-Nélaton.

31. Ibid.

32. Proust, *Edouard Manet souvenirs* (Paris, 1913, expanded posthumous edition), p. 101.

33. *Thomas Couture, sa vie, son oeuvre, par lui-même et par son petit-fils* (Paris, 1932), p. 138.

Chapter 18: Still Lifes

1. Proust, *Souvenirs*, p. 67.

2. Adolphe Tabarant, *Manet et ses oeuvres* (Paris, 1947), p. 378.

3. Unless otherwise indicated, all quotes regarding the Salon of 1880 come from Tabarant, *Manet et ses oeuvres*, pp. 378 ff.

4. Emile Zola, "Le Naturalisme au Salon," in *Emile Zola, écrits sur l'art* (Paris, 1991), pp. 424–425.

5. See Appendix I, *Manet* (exhibition catalogue, New York, 1983), for complete Manet-Zola correspondence.

6. Gustave Goetschy, *La Vie moderne*, April 17, 1880.

7. Complete text in Denis Rouart and Daniel Wildenstein, *Catalogue raisonné* (Paris, 1975), p. 22.

8. Quoted in Tabarant, *Manet et ses oeuvres*, pp. 380–381.

9. *Manet by Himself*, ed. Juliet Wilson-Bareau (Boston, 1991), pp. 247–248.

10. Bibliothèque Littéraire Jacques Doucet, Paris, MNR 1630.

11. Manuscript letter, Fonds Moreau-Nélaton, Cabinet des Estampes, Bibliothèque Nationale de Paris.

12. Bibliothèque du Louvre, Cabinet des Dessins; *Lettres illustrées de Edouard Manet* (manuscript facsimile), ed. Jean Guiffrey (Paris, 1929); and Etienne Moreau-Nélaton, *Manet raconté par lui-même*, vol. 2 (Paris, 1926), pp. 70–71, for all letters to or about Isabelle quoted in this chapter.

13. Michel Robida, *Le Salon Charpentier et les impressionistes* (Paris, 1958), p. 119. The author was Isabelle Lemonnier's grandson.

14. Bibliothèque Littéraire Jacques Doucet, MNR 1632.

15. Tabarant, *Manet et ses oeuvres*, p. 403, for all three letters quoted.

16. Eric Darragon, *Manet* (Paris, 1989), p. 357.

17. Françoise Cachin, in *Manet* (exhib. cat., 1983), p. 465.

18. Ibid., p. 467.

19. Proust, *Souvenirs*, p. 44.

20. Darragon, *Manet*, p. 349.

21. Ambroise Vollard, *Souvenirs d'un marchand de tableaux* (Paris, 1937), p. 168.

22. Tabarant, *Manet et ses oeuvres*, p. 407.

23. Rouart and Wildenstein, *Catalogue raisonné*, p. 22.

24. Tabarant, *Manet et ses oeuvres*, pp. 407–408.

25. Jacques-Emile Blanche, *Essais et portraits* (Paris, 1912), pp. 140–141.

26. Philippe Burty, *La République française*, June 5, 1881.

27. Tabarant, *Manet et ses oeuvres*, p. 415.

28. Ibid., pp. 417–418.

29. Charles Moffett, in *Manet* (exhib. cat., 1983), p. 476.

30. John Rewald, "Theo van Gogh, Goupil and the Impressionists," *Gazette des Beaux-Arts* (February 1973): 105–106.

31. Moffett, in *Manet* (exhib. cat., 1983), p. 476.

32. T. J. Clark, *The Painting of Modern Life* (New York, 1984), p. 253.

33. James Hall, *Dictionary of Subjects and Symbols in Art* (London, 1974), p. 262. There is a striking similarity between the iconography (water, roses, citrus fruits) of *Bar at the Folies-Bergère* and Francisco Zurbarán's *Still Life with Basket of Oranges* (Norton Simon Foundation, Pasadena, Calif.). Even if Manet never saw this particular painting, he was surely aware of the symbolic value of these objects in seventeenth-century Spanish still lifes.

34. Clark, *The Painting of Modern Life*, pp. 254–255.

35. Ibid., p. 255.

36. Proust, *Souvenirs*, p. 60. In the summer of 1880, Manet wrote to Méry Laurent regarding "the Barroil affair," the collector from Marseille, who wanted to exchange the painting he had initially selected for another. Manet was in need of money and asked her to settle the matter. It apparently took some months before Manet received payment. In any case, the fruit could not have been sent before the winter, when citrus fruit is harvested.

37. Hall, *Dictionary*, p. 330. "The apple, usually held in the infant's hand, is traditionally the fruit of the Tree of Knowledge and therefore alludes to him as the future Redeemer of mankind from Original Sin. The orange in Dutch painting has the same meaning." In Spanish painting the orange is emblematic of virginity.

38. Moreau-Nélaton, *Manet raconté par lui-même*, vol. 2, p. 90.

39. All quotations from Morisot family letters in this chapter are from *Correspondance de Berthe Morisot avec sa famille et ses amis,* ed. Denis Rouart (Paris, 1950), pp. 21–117.

40. Tabarant, *Manet et ses oeuvres,* p. 440, for both quotes.

41. J.-K. Huysmans, *L'Art moderne* (Paris, 1884), pp. 277–278. His comments were based on notes taken during the Salon of 1882, but this was not a newspaper review and thus did not appear until his book came out the following year.

42. Tabarant, *Manet et ses oeuvres,* p. 440.

43. Juliet Wilson, *Manet: Dessins, aquarelles, eaux-fortes, lithographies, correspondance* (exhibition catalogue, Paris, 1978), p. 101.

44. George Moore, *Modern Painting* (London, 1898), p. 36.

45. Bibliothèque Littéraire Doucet, MNR 1632.

46. *Manet by Himself,* ed. Wilson-Bareau, p. 266, for both quotes.

47. Archives Nationales, Paris. See Chapter 5, n. 8.

48. Proust, *Souvenirs,* p. 59.

49. Told to Tabarant by Léon Leenhoff; in *Manet et ses oeuvres,* p. 471.

50. Manuscript letter, Fonds Rouart, Musée Marmottan, Paris.

51. Tabarant, *Manet et ses oeuvres,* p. 474.

52. Henri Loyrette, *Degas* (Paris, 1991), p. 489.

53. Tabarant, *Manet et ses oeuvres,* p. 475.

54. Jacques-Emile Blanche, *Propos de peintre* (Paris, 1919), p. 144. Blanche was present at the funeral.

Index

Made in the USA
Middletown, DE
08 September 2020